Utopia and Dissent

Utopia and Dissent

Art, Poetry, and Politics in California

Richard Cándida Smith

University of California Press / *Berkeley, Los Angeles, London*

The publisher gratefully acknowledges the contribution provided by
the Art Book Endowment Fund of the Associates of the University of
California Press, which is supported by a major gift from the Ahmanson
Foundation.

University of California Press
Berkeley and Los Angeles, California
University of California Press
London, England
Copyright © 1995
by The Regents of the University of California
Printed in the United States of America

1 2 3 4 5 6 7 8 9

Library of Congress Cataloging-in-Publication Data
Smith, Richard Cándida.
 Utopia and dissent: art, poetry, and politics in California /
Richard Cándida Smith.
 p. cm.
 Includes bibliographical references and index
 ISBN 0–520–08517–5 (cloth)
 1. Arts, Modern—20th century—California. 2. Arts—Social
aspects—California. I. Title.
NX510.C2S63 1995
700'.9794'0904—dc20
 94–41886
 CIP

The paper used in this publication meets the minimum requirements
of American National Standard for Information Sciences—Permanence
of Paper for Printed Library Materials, ANSI Z39.48–1984 ⊗

For Joel and Eugene

Contents

Illustrations

Acknowledgments

This book began in the course of my daily responsibilities in the Oral History Program at the University of California, Los Angeles. As I delved into background material for interviews with figures from the arts communities, I began to see the outlines of a story. My work pursuing the implications of that story would not have been possible without the generous support, both intellectual and material, that Dale E. Treleven, the director of the program, provided for my research. Michael Frisch published the first manifestation of this project, the essay "Exquisite Corpse: The Sense of the Past in Oral Histories with California Artists," which appeared in the *Oral History Review* in 1989. Mike's comments as an editor and colleague helped me to organize more clearly in my mind the relationship between the theoretical framework provided by the oral history movement and the mass of research material I was uncovering about art and poetry movements in mid-twentieth-century California.

The shape and substance of the book took form as a dissertation for the Department of History at UCLA. I wish to thank all those who were my teachers and advisers. Eric H. Monkkonen, Debora L. Silverman, and Martha Banta were attentive, supportive, yet critical readers of the drafts as they emerged. Bruce J. Schulman and Nicholas Entrikin asked difficult questions that helped me think more deeply about the institutional and geographical implications of my subject. Many conversations with David A. Hollinger

helped dispel the fog that surrounds the concepts "modernism" and "avant-garde." Discussions with Joyce Appleby, Thomas S. Hines, John H. M. Laslett, Anthony Parent, Richard Weiss, and Norton Wise were vital to clarifying components of my work. I want to thank the faculty I encountered for an intellectually stimulating and enjoyable experience.

On the most practical level, this book would not have been possible without the heroic efforts of the San Francisco and San Marino offices of the Archives of American Art, Smithsonian Institution, to collect in depth the papers and memories of those involved in the California arts scenes. Paul J. Karlstrom, the West Coast regional director, and staff members Barbara Bishop, Maggie Nelson, and Laela Weisbaum, were a joy to work with over an extended period of time. They gave of their time and resources without question. More important, they freely shared their own ideas about the material that has become their responsibility. Jeff Gunderson, librarian at the San Francisco Art Institute, went out of his way to find documents that helped me understand the events at the California School of Fine Arts. I also want to thank the staffs of the Department of Special Collections, UCLA; the Bancroft Library, UC Berkeley; the Mandeville Library, UC San Diego; and the San Francisco Poetry Center and Archive, San Francisco State University, for the use of their collections. In each institution, I met highly professional men and women whose jobs have become more difficult due to budget cuts, but who still provided efficient and courteous service.

At several points I needed assistance with the interpretation of Latin, Greek, and Hebrew references. Laura Schwimmer helped me with the Latin, Paul Naiditch with the Greek, and Vimala Jayanti with the Hebrew. The material was not straightforward, and there were always several possible renditions. I chose the reading that seemed to make the most sense in the context, so any mistakes are my responsibility entirely. Many people helped me gather together the illustrations for this volume. I want to give particular thanks to Laela Weisbaum of the Archives of American Art, Jeff Gunderson from the San Francisco Art Institute, John Kaiser of the Menil Collection in Houston,

Tobey C. Moss and her gallery in Los Angeles, and Christine Cheng Lim from Frumkin/Adams Gallery in New York, each of whom was unusually helpful. I owe special thanks to the artist Jess and the photographer Charles Brittin for allowing me to borrow from their personal archives. Finally, I am deeply grateful to James H. Clark and Stanley Holwitz from University of California Press for their enthusiasm and faith. Peter Kosenko brought a deep knowledge of West Coast artists and institutions to his editing of the manuscript. I appreciated Rebecca Frazier's determination to produce a handsome volume on schedule.

It is customary to conclude by thanking one's family for their patience and support. Only until a person has gone through a project like this can he or she understand how difficult it is to find words that adequately convey the debt that is owed. A delicate balance develops over time as the work becomes more and more time-consuming. Everyone in the family recognizes that the writing must be done and innumerable changes in daily routine occur, yet at the same time there is both obligation and desire to maintain the responsibilities and camaraderie of life together. Katherine P. Smith, an artist and an editor, provided critical commentary on substance and form throughout the months of writing. Her trained eye caught many mistakes, but she was also an engaged reader. She challenged sloppy formulations and the use of language that tried to obscure my confusions with verbal pyrotechnics. The argument that follows sometimes delves into dense and abstruse territories. Any success in using language to clarify rather than obscure what is inherently difficult I owe largely to Katherine, who demanded clarity and honesty. As I prepared and wrote this book, my two sons grew from adolescence to adulthood. Perhaps the time entailed with the project helped ease parental pains of separation. While writing, I imagined Joel and Eugene as forerunners of a wider public for whom the past I recount, however recent, lies in the dim years before their birth. I dedicate this book to them and their generation of young men and women now learning to balance potentiality with the claims of necessity.

Introduction

Henrietta Shore explained her decision to become a painter with an anecdote of an accidental encounter: "I was on my way home from school and saw myself reflected in a puddle. It was the first time I had seen my image completely surrounded by nature, and I suddenly had an overwhelming sense of belonging to it—of actually being part of every tree and flower. I was filled with a desire to tell what I felt through painting."[1] Born in Toronto in 1880, Shore moved to New York to study with Robert Henri. She migrated west to Los Angeles in 1913, where she helped found the Los Angeles Modern Art Society in 1916 and worked with others who shared her perspectives to educate the public to experimental art. In 1931 she retreated from an active public life as educator and moved to Carmel, then a small village on the coast three hundred miles north. While running a diner she pursued the all important task of self-discovery through painting until her death in 1963.

Two features in Shore's engagement with modernism in the arts became typical patterns of California aesthetic experimentalists. First, her work sprang from a belief that the creative process was a technique for transforming mystery from an "accidental" encounter into a "natural" foundation to everyday life that viewers or readers could reexperience at will. Shore and those who shared her conception of art believed that they had discovered in the creative process a function that no other human activity could perform. They acknowledged that examples of the power of creative people to reveal pro-

found mysteries existed throughout the history of art, literature, and music. Modern art, however, stripped away everything but the essential. The arts no longer needed to be decoration or illustrations of shared beliefs. Instead, the work presented private truths that emerged from a leap of union between the soul and the cosmos. Aesthetic experiment captured hidden truths about the relationships that human beings created for themselves. The aesthetic process created a stage where both the private and public components of identity comported as mythic and historical actors contending with each other for dominance. The creative process then was a paradigm for representing at one and the same time both dissolution of the self into cosmic being and individuation as a separation from historical necessity.

This subtle, perhaps impossible task could not be done successfully if one's work grew from a desire for fame and commercial success. Worldly ambition tied the creative person back into history, the accidental and temporary aspect of human existence that stood in opposition to mystery. Shore's decision to retire from the world in order to paint points to a second pattern we will see repeated by many others. Isolation, however, was not the same thing as solitude. Artists and poets built "communities" where they imagined themselves successfully challenging a world overstructured by order, hierarchy, and dogma. Sometimes these communities were geographically based, sometimes they took the form of professional associations, but most frequently they consisted of ad hoc networks of friends who supported each other's efforts to create what they hoped would be a new kind of actively engaged audience.

As California transformed into one of the world's metropolitan centers, these complex and contradictory efforts to reconcile privacy with a sense of public responsibility began to shape American and world culture, but it was often misunderstood and reduced to stereotypical images—a "cult of sex and anarchy" one writer labeled the California arts world in 1947.[2] The central figures we will encounter in this book certainly celebrated irrationality, but not in the pathological sense popularized by the surrealists. Irrationality in

the California context stood on more ascetic philosophical ground: the most basic aspect of the human condition was potentiality, and therefore human action could never be predicted or systematically explained with any degree of lawful certainty.

This view posed against all forms of determinism the fundamental role of desire and choice in human development. Against history stood poetry, understood as any meaning-finding reflection on experience. By the mid-1940s, a central political tenet crystallized out of this definition of poetry: the most important corrective to the barbarities of the twentieth century was that people excluded from power claimed the right to speak for themselves about their lives. The narration of human experience in all its complexity, particularly from those who are despised and excluded from society's rewards, challenged all complacent views of social life and subverted the power of any hierarchy pretending to be able to explain human action.

This book examines the emergence and development of this social ideology. What follows is not a comprehensive survey of the art and poetry produced in the state, nor is it a history of arts communities. The focus throughout remains on the analysis of ideas and the influence those ideas had upon both aesthetic practice and the conceptions of the relationship of self to society in the mid-twentieth-century United States. The organizational structure follows a sequence of concepts, each of which emerged and matured in the course of attempting to resolve the contradictions of applying aesthetic thought to questions of social relations. Part 1 outlines the formal, institutional, and subjective factors in the transplantation of modernist ideas into California. Part 2 explores how the post–World War II generation used mythopoetic thinking to establish a realm for personal meaning-finding in opposition to established authority. Part 3 uncovers the ways a mythopoetic interpretation of psychoanalysis contributed to political debates in the 1960s about free speech, cold war policy, the Vietnam War, and the nature of the American polity.

The ability of a small number of relatively obscure artists and poets to influence public policy debates brings us to the underlying question of this book: how and why the concerns of the arts communities came to enter into the general culture. The work of Jerrold Seigel and Carl Schorske has shown that bohemia has a political history long preceding the period covered here. I have found Seigel's argument that the milieux surrounding the arts helped mark the fluid boundaries of bourgeois identity in nineteenth-century France to be persuasive and applicable with necessary modifications to the twentieth-century United States. Similarly, Schorske's examination of the links between psychoanalysis, aesthetic experimentation, and crises of liberal ideology in fin-de-siècle Vienna is a model without equal for understanding how conceptions of subjectivity and public order work together to create new cultural forms.[3]

Studying the California experience contributes to the study of the relationship of avant-garde culture to politics by providing insight into the appeal bohemian ideals had for a broader public. In most societies prior to 1960 the concerns of the aesthetic avant-garde were of interest primarily to small, select, relatively well-educated coteries whose members claimed personal distinction for their appreciation of the difficult and arcane. California, however, was one of the places where the thinning of the line between bohemian and popular culture took place earliest, most clearly, and most systematically. Ideas that had once interested only a handful influenced resistance to the Vietnam War and animated other social movements in which rediscovery and re-creation of identity were particularly important motifs. Countercultural ideas that promoted the truth of experience against all forms of collective authority spread widely into popular music and movies to become an accepted, if contested, current weaving throughout American culture. The result was a greater frankness in public discussion of the varieties of individual behavior. The intellectual framework developed in the arts communities, however, also contributed to a growing distrust of public life and to a fracturing of the myth of a unified national history.

I do not argue that California artists and poets were independent of parallel developments elsewhere. They were part of a global interrogation of instrumental rationality and its potential dangers in a world with nuclear weapons. Formations on the West Coast related to existentialism, literature of the absurd, and varieties of neodada. As important, the juxtaposition of aesthetic and social theory found in California developed through opposition to the institution of canonical modernism after 1945. Nonetheless, to dissolve the local conversation in a broader picture would merely reaffirm without reflection the hierarchical relationship between metropolitan centers and their dependencies. To explain the particular nature of the social power that the ideas of California artists and poets achieved, we need to examine what was unique and autonomous about the local situation. The question then deepens: why did the concerns of marginal creative figures take on significance for others who by and large were unfamiliar with the actual poems, paintings, assemblages, novels, plays, and motion pictures by which this regional avant-garde established a place in the world? The approach to that question opens another field of inquiry with significance greater than the particular histories of regional arts movements: why at this time in American history did the arts in general become an increasingly potent social force, apparently posing questions of relevance to contemporary society that no other human activity seemed as readily poised to answer?

As the answers to these questions develop around changing representations of the self, a significant body of evidence used in this study comes from oral sources. Rather than creating new interviews specifically for this study, I have preferred to probe already existing oral evidence to see what those sources can reveal about subjective states and their changes. Extant interviews had the virtue that my interpretive assumptions shaped neither the content nor the narrative's formal attributes. The "data" of interviews are the ways in which a person reconstructed the past to negotiate the ever-fluid process of identity construction. From this perspective, the factual veracity of interviews is less important than the rhetorical strategies revealing the horizon of speak-

ers and their communities. The methodological hypothesis, following an observation of Luisa Passerini, is that "the protagonists of cultural change—each in his own style, in her own level—carry within them the traces of that change in the structure of their memories, even if the process is still ongoing or in certain cases appears interrupted."[4]

Subjectivity is a term defined by negation. Against the universal, the lawful, the context-free, subjectivity expresses the individual and unique; it is unexplainable by recourse to anything outside it. But because objectivity is singular, so must be subjectivity—at least in a form that allows for external study. Subjectivity separates from the ephemeral flux of pure being through narration. If pure subjectivity is known only to the person who experiences it, practical subjectivity finds expression in the forms that people use to represent, to themselves and to others, the self as an historical actor. The subjective position in narration differs from psychology through an emphasis on exterior manifestation and the element of purposeful activity involved, be it limited only to an ability to draw conclusions from events and to arrange knowledge into categories. Distinct from immediate experience, reflections on the self form the basis for ideas used to ground oneself in the world. In the course of tracking changes in self-presentations, our goal is not to recount how people felt, but to trace how ideas, feelings, and understandings of self grew from and altered more general social and cultural developments.[5]

Because oral evidence is largely retrospective, it must be combined with other sources. The narrator knows how events turned out, and the account involves an effort to explain that conclusion. Original documents from the time narrated—letters, articles, diaries, etc.—have a parallel bias. The pressures of ambition and hope shape primary documentary sources, which often express what a person wants to see happen and therefore tend to ignore or downplay obstacles and weaknesses. Oral sources can reveal what people knew but censored in earlier public expressions. Together, retrospective and projective documents give a more layered view of historical phenomena and

offer for our purposes the possibility of seeing how aesthetic categories used to define the self changed across time.

Creative work and personal statements, both oral and written, represent two distinct, though linked, cultural forms. Statements, particularly those recorded in oral sources, spring from the normally sequestered life of conversation as a forum for working out shared projects. Differences between creative work and recorded statements reflect the distinguishable material, place, and function of each: conversation is the form through which inner-group unity and diversity are marked, while creative work strives for an individualized signature that establishes an ostensibly independent, "authorial" stance. The making of "community" will be an ongoing concern as we discuss how and why particular groups came together and defined their most important aims. Finished work must represent the creator's intentions by being able to stand on its own, capable of varying uses and interpretations; but new work reaches a broader public because of the efforts of editors, curators, agents, critics, and colleagues, who as personal acquaintances have intimate knowledge that allows them to introduce and explain new creative work to a public not privy to the ongoing discussion within which the work took shape. Public institutions such as schools, museums, or granting agencies may often be impersonal, but they rest on networks of intimacy, which, however ephemeral their traces, are immediate and powerful in their ability to mobilize rewards and punishments. One of our tasks will be to bring to the surface the discourses of familiarity that interweave with those of authority to create the matrix for a professional life. Neither analysis of work nor analysis of utterance alone is sufficient, because both contain each other, although in ways that mask the other voice. Throughout this study recourse to one set of evidence must always be provisional until the alternate voice is added.

The confrontation with subjective sources plunges us deep into the power of stereotypes. Discussion of avant-garde arts movements in the United States, particularly those figures related to the beats, has been emotional and

overburdened with stock images of sexual experimentation, drug taking, and mysticism. The persistence of stereotypical thinking is evidence that the topic is connected to deeply rooted fears and confusions about the relationship of public and private life. I will argue that public fascination with the avant-garde was one of the first symptoms of a crisis of confidence in the effectiveness of American institutions. By closing off past polemics that either celebrated or condemned the activities of avant-garde movements and focusing instead on the specific intellectual, symbolic meanings placed on different transgressive acts, we can make stereotypes work to elaborate rather than shut down discussion.

The obstacles I hope to remove are precisely those that insist upon a self-justifying either/or reading of the past. The California situation reveals that aesthetic practice was both a field for the construction of identities that reproduced existing hierarchical relations and an arena for subversion and disruption of those same identities. This should not be surprising. Since subjectivity denies the possibility of there being a stable central point for the self, it tends to disrupt identities and become an arena for conflicts of power on a cultural or symbolic plane, with direct implications for the boundaries for effective action that people believe exist for them. Deeply held stereotypes about ethnicity, gender, and sexuality mobilized through artistic practice became the basic building blocks for oppositional movements against the very hierarchies that grew from those stereotypes. The turn to private experience as a counter to public authority meant, for example, that the ideology of domesticity, which historians have correctly identified as a pillar of conservative social thought, was also, at least after 1945, a source of disruptive change. Utopian vision, we will see, projected private relations as a replacement for a perceived oppressive public order, but without any consideration of their connection. This critical omission caused utopian projects to collapse back into the repressed material of their origins. To state that a highly subjective aesthetic ideology did not escape the limits of its contradictions is not to deny its importance as a source of ferment and change. If there is no external fulcrum from

which the critique of society can proceed, then the questions of social organization that artists and poets addressed return us to a still unsolved puzzle: can efforts to understand social relations root themselves in the immediate conditions that prompted desire for change without being mired in the power of stereotypes, of mental reductions that are identity giving, to define our vision of complex social realities?

The fissure between theory and experience remained a puzzle to the more serious thinkers who sought in the arts a foundation for reforming human relations. The best they could offer in their faith in the validity of personal truth against all preconceived objectifications of that experience was that the solutions that theory provides have no necessity; that theory replaces the actual messiness of life with arbitrary, and ultimately illusory, conventions; that contradictions are the inescapable, tragic components of life. The question for them as creative people with ambitions to affect the quality of social life was something much smaller than a model for social action, but nonetheless still quite ambitious, given the restrictions placed on freedom of expression in the United States until the mid-1960s: to foment a continuous statement and questioning of personal experience. This was no "solution" that claimed to eliminate in one fell swoop problems rooted in long-established social privileges. To speak one's life and to pose interpretations allowed nothing more than the possibility of testing a model of experience against further experience.

Change and confrontation appeared as an open-ended process with no predictable conclusions—and if they were predictable, they would be by definition unfree and therefore contradictory to a goal of human liberation. In the years following World War II, one powerful source of challenge to constituted authority came from those who conceived the poetic act as a form of testimony. To insist on speaking one's "autobiography," even if it assumed forms that were compromised and falsifiable, was to promote the overthrow of institutional arrangements that failed to take into account that experience.[6] The search for authority—be it ideological, national, religious, patriarchal, or

even communal—ended when one was prepared to face the contradictory and ambiguous nature of experience but still trust that experience as the taproot for further understanding and growth. This persistent questioning of the boundaries between reflection and experience became the source of power for California's art and poetry movements as private dreams transformed into challenges to structures of public order.

Part I

Modernism Transplanted

1

Innocence of the Blank Slate

Postsurrealism and the Reception of European Models

In 1927 Lorser Feitelson (1898–1977), an experimental painter from New York, reluctantly moved to California. He and his wife had a newborn child and could no longer make ends meet on Feitelson's modest income. Either he took full-time employment or they cut down on living expenses. His wife had inherited a small home in Los Angeles, and hoping to live more cheaply, they decided to move across the country. Having spent most of his twenty-nine years either in New York or Paris, Feitelson was not prepared for the crushing isolation weighing upon a serious modern painter in California. In 1964 he recalled that he disliked his new home "violently in the beginning, because there was no art appreciation." Yet within six months, he was happy to be in Los Angeles

> because there wasn't any art appreciation [and] therefore the artist had to paint for only one person, himself. There was no one to write about his art; no one ever to show his art; no one ever to buy his art; therefore if he wanted to paint it was only because he himself felt it must be done. And therefore he was going to paint for its own sake and then he would do honest work. That's what I liked about it.[1]

The art scene was "free of competition," without a "star system." While he continued to hope that he could support himself through sales of his painting, he appreciated the lack of a speculative market in art work: "The moment

people see you as money, you no longer exist as art." Isolation meant that to those few for whom art was vital, its role was nothing more, but also nothing less, than enjoyment and enlightenment. A common need to build appreciation for contemporary art meant that California artists ignored the vast distances separating their studios and came together regularly to share ideas.[2]

Kenneth Rexroth (1905–1982), a poet originally from Chicago, migrated to San Francisco in 1927 and had a similar reaction:

> San Francisco, when we came there to live, was very much of a backwater town and there just wasn't anything happening. . . . That's really the reason we stayed here, as it was a long way from the literary marketplace. We didn't know anybody who wasted his time talking about what Horace Gregory thought of Oscar Williams.[3]

Rexroth's memories echoed Feitelson's: there was no competition among writers or painters because there were no significant material rewards. Exchange of ideas and formation of a "creative community" were more important to Californians involved with the arts than competing for access to publication and exhibition. Clay Spohn (1898–1978), a painter and assemblagist born in San Francisco who studied under Fernand Léger in Paris in the 1920s, recalled that the artistic milieux in the Bay Area completely lacked "any such thing as competitive spirit."[4]

A corollary to these shared mythic interpretations of isolated, egalitarian, noncompetitive exchange was pride in autochthonous originality. For Nicholas Brigante (1895–1989) the important pioneers of modern painting were the men and women with whom he had struggled against obscurity. He refused to concede that they were simply following the example of movements halfway across the world in Europe. He mentioned Ben Berlin (1887–1939), who "anticipated Picasso, all the French moderns, but [was] not influenced by them." Feitelson recalled Berlin as "a lovely guy," a hero because of the uncompromising rigor of his work. A 1923 review praised Berlin as the first exponent of futurism in California, but the painter, who would die from al-

cohol abuse, was incapable of taking advantage of even the embryonic exhibition possibilities in his home state that the generally positive response to his work evoked. Too poor to travel outside the state, he learned about foreign art movements from magazines and conversations with friends, such as Feitelson, who had lived abroad. Precursor of Picasso he certainly was not. His work is full of hints that he knew the major currents of experimental painting and absorbed the rudimentary elements of European avant-garde style, not to imitate, but to adapt to his highly personal interior vision (pl. 1).[5]

One aspect of geographic isolation for visual artists was a general inability to see major works in their original form. Although a member of a later generation, Edward Kienholz's testimony on the effects of learning art history from books and journals can be helpful in understanding how isolation could affect artists' conceptions of their own work:

> If you take a mediocre painting and take a picture of it, reduce the scale, and condense the experience of the painting down to a smaller scale, it becomes much richer. And that rich look was the criterion that I always looked toward. I was working toward a picture reproduction.[6]

Helen Lundeberg (b. 1908) thought that isolation in California had stimulated rather than dampened her imagination. She painted things that she wanted to bring into the world, rather than reproductions of other paintings or existing objects.[7] As these California artists remembered their emergence as modernists in the interwar period, they could not separate their isolation from their innovative experiments. They linked the theme of isolation to a shared anticipation that they were on the threshold of a renaissance. They were an avant-garde, but not simply because of their experimentation into visual expression. They were bringing a new culture into the world.

Mabel Alvarez (1892–1984), whose murals were featured in the California Bungalow at the 1915 San Diego Pan-Pacific Exposition and who was a leading figure in the Los Angeles Art Association founded to promote and exhibit

contemporary experimentation, mentioned few living European painters by name in diaries spanning more than forty years. Her entries show that she participated actively in ongoing debates over practical and philosophical questions, but the authorities she recognized were her friends and colleagues, most notably Stanton Macdonald-Wright and Morgan Russell. Prior to 1914, Wright and Russell had worked in Paris, where they founded the Synchromist movement, the only American contribution to the explosion of avant-garde movements in the half decade before World War I. With the outbreak of war, they returned to the United States. Wright settled in Los Angeles in 1920 and quickly established himself as the leader of the city's modern art movement. Morgan Russell joined him briefly in 1927, and the two stimulated local painters to reexamine the images they created.

In 1928 Alvarez, upon returning home from a lecture by Wright, noted in her diary that modern art in Europe had become stagnant with self-conscious experimentation into form for its own sake. "The new renaissance must come. It is up to us to be the forerunners, the primitives of the new movement." She believed a great "faith" would emerge in California, which, combined with the experimental freedom she and her colleagues were forging, would lead to art that was genuinely new and restorative. Indeed, she had believed for many years that "faith" depended upon the study of design. "No good will come from imitating the men who have carried representation as far as it will go," she wrote in 1921. "I must have *organized design.* Simplify form to find its essential spirit." Two years earlier, she had learned in her painting class that "everything in the world was design, the design the world is working out is evolution . . . look for designs in things—inner meaning." Her teacher at the time, William V. Cahill, director of the Los Angeles Academy of Modern Art, regularly included lectures on theosophical principles in his studio classes. "Create everything from the inside out," she wrote in her notes of a lecture he gave in 1917. "Listen to the *inner* self all the time." Artistic expression was the key to the "divine or God part" of humanity. The "truth"

of creative work, be it a poem or painting or piece of music, could be judged by the experience it triggered within the recipient of conjuncture between cosmic and psychic reality. The sensation of truth was personal and private— "a perfect tone on true center vibrates and is enveloped in resonance"—not subject to social verification. The significance and ultimate value of work was always arguable, but the wise person "let go all opinions to see the right in all sides, from above . . . to listen to the Master within."[8]

A noncommercial attitude accompanied by affirmation of their innovative aspirations begin to define for us a group with specific position in society that was more than a sum of individuals. The theme of isolation that runs through participant accounts of modern art and poetry movements in mid-twentieth-century California is itself a cultural artifact, a narrative device that those involved used to impose collectively derived meaning upon individual surveys of their careers, ambitions, and accomplishments. At the same time, the theme asserted a shared project. The creation of identity through collective memory depended upon abstraction, the reduction of a jumble of events into essential attributes that allowed ready categorization. The motifs that arose to constitute informal historical judgment helped transform scattered individuals into a group as each person adopted, repeated, and structured the accounts of their own lives into a schematized representation of experience.[9] The experience that narrative repetition abstracted was intensely real, but consensus-seeking talk rendered it into an identity that favored stereotypicality over ambiguity.

The same sources that stress the isolation of California also contain a plethora of detail showing that interest in modern art and literature was active and lively. Shortly after moving to California, Lorser Feitelson joined the Los Angeles Art Association, where he became a popular lecturer on modern art movements. Newspaper critics in both San Francisco and Los Angeles gave favorable reviews to artists who broke with traditional representational forms and explored abstraction. Shows of the new art were often held over because

of public interest. Artists interacted with a network of individuals who prided themselves on their knowledge of and support for modern art, both European and American.

A center of this network was the home of Walter and Louise Arensberg in the Hollywood Hills. They owned one of the best collections of avant-garde art to be found anywhere in the world, including Marcel Duchamp's *Nude Descending the Staircase.* Galka Scheyer brought her collection of the Blue Four—Paul Klee, Wassily Kandinsky, Alexei Jawlensky, and Lyonel Feininger—to her modernist home designed by fellow émigré Richard Neutra. Hollywood attracted a considerable number of artists, writers, and theater people, many of whom had distinguished collections and some of whom achieved significant careers outside the entertainment business. Eugene Berman, Antonin Heythum, Oskar Fischinger, and Jules Engel were among the European artists who came to Los Angeles to work in the film industry and then became prominent figures in the state's visual arts community. The California School of Fine Arts in San Francisco and Chouinard Art Institute in Los Angeles developed national reputations for the quality of their training. Both schools brought internationally known figures, including Alexander Archipenko, Diego Rivera, José Clemente Orozco, David Alfaro Siqueiros, and Hans Hofmann, to the state to teach.[10]

Without this activity, the anticipation that Californians were about to make a distinctive contribution to world culture would have been merely a pathetic illusion. Instead, the liveliness of the art community generated hope and spurred creative activity. The ubiquitous motif of isolation referred then to elements of personal experience that included but went beyond the inconveniences of location. The theme expressed feelings of inseparably joined opportunity and frustration that could be explained by geography but, more fundamentally, involved the social relations that engaged artists.

The cluster of narrative themes these artists wove together around their sense of California's geographic isolation—honesty, freedom from the ravages of competition, an egalitarian creative community, the new renais-

sance—articulated their experience of a two-pronged challenge. The first was for themselves: those who spoke of their careers in these terms wanted to make cultural life in California as rich, varied, and sophisticated as anywhere else in the world. A few, Kenneth Rexroth perhaps most prominently, argued that this new culture would be superior to what had emerged in the older centers of the United States and Europe. But even for the majority who would not go so far, the theme of isolation contained a second challenge, one directed at the very primacy of European models. It was not isolation California artists wanted, but a chance to participate equally, effected by expanding the boundaries of the art world. The avant-garde in California looked to Europe for inspiration, but even when work might appear derivative, poets and painters had pursued their own revisionist ideas that often criticized and attempted to improve upon the model received from abroad. A case in point in the interwar years was the postsurrealist movement.

Postsurrealism

In 1934 six young painters from San Francisco and Los Angeles—Lorser Feitelson, Lucien Labaudt (1880–1943), Harold Lehman, Helen Lundeberg, Knud Merrild (1894–1954), and Ettienne Ret—organized a show of their work at the Centaur Bookshop on Hollywood Boulevard in Los Angeles. In conjunction with the exhibition, they issued a manifesto, "New Classicism," that declared themselves the first surrealist-inspired movement in the United States. The painting published with the manifesto illustrated the group's focus on metaphoric thought (fig. 1). They were "surrealist" in their reliance upon associative imagery, though they were careful to state that their approach to association was based on logical principles and owed more to their reading in classical philosophy than to the theoretical writings of the French surrealists.

Favorable newspaper reviewers, following up on the manifesto's sharp criticism of surrealism, called the paintings in the show postsurrealist. The

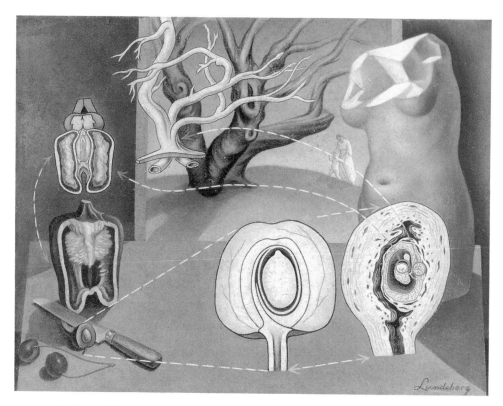

1. Helen Lundeberg, *Plant and Animal Analogies,* oil on celotex, 1934.
Courtesy of the Helen Lundeberg Feitelson Trust, Los Angeles.

name stuck and helped draw crowds of people curious to see firsthand what an American variant of this movement would be like.[11] The following year, Grace McCann Morley (1900–1985), director of the San Francisco Museum of Art, mounted another successfully received show of that group's work at her institution. In 1936 the group, augmented by Grace Clements (1905–1968) and Helen Klokke, achieved a burst of national recognition when they exhibited at the Brooklyn Museum. The term postsurrealism proved a successful, if temporary, public relations boon. On closer examination we shall see that the postsurrealists' intellectual interests and assumptions were antithetical to those of genuine surrealism. The postsurrealists had no interest in direct representations of subconscious fear of or desire for sex, violence, and

death. Nor were they influenced by Freudian psychology. Their intellectual program was as serious, if less literary, than that of the surrealists, but their focus on cognitive process was insufficiently dramatic to sustain the momentum of public fascination their first exhibitions had generated.

The author of the postsurrealist manifesto, Helen Lundeberg, challenged the cardinal position that European surrealists gave to subconscious mental states. She proposed an art that captured the relation of self and environment by focusing instead "upon the normal functioning of the mind: its meanderings, logical in sequence though not in ensemble, its perceptions of analogy and idea-content in forms and groups of forms unrelated to size, time or space." Pictorial elements should assume subjective form but not re-create the text of dream images. With youthful bravado, Lundeberg claimed that the structural unity of intellect, emotion, and form sought by her movement, which she called "classical subjectivism," would make a decisively new contribution to pictorial art. The aesthetic structure in the works of Giorgio di Chirico, Salvador Dalí, or Max Ernst was "of no historical significance," since the work of these artists was "imitative and manneristic in its faithful mimicry of the essential principles of pictorial pattern to be found in Renaissance painting." Postsurrealists had developed an aesthetic that departed "from the principles of the decorative graphic arts" to create a pictorial structure that became the subject matter rather than being imposed upon it.[12]

At first glance, Lundeberg's *Eyes,* painted in 1938 and 1939 (fig. 2), seems derivative of European surrealist models, particularly the Belgian painters René Magritte and Paul Delvaux. The octopus-like eye in the tree, a blank sky towering over the mountain ranges and two lonely clouds squeezed into the bottom of the frame, and the figure with a cane walking in a pathless desert combine to invoke a brooding, mysterious presence confronting the woman at the window, herself squeezed into the margins of the picture. The projection of self so typical of surrealism suggests the confrontation and the triumph of nature over a tentative human subject.

Lundeberg had a different conception of the relationship of subjectivity

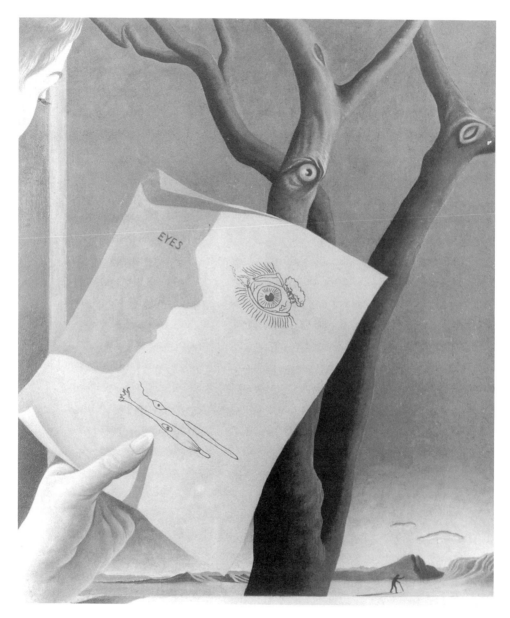

2. Helen Lundeberg, *Eyes*, oil on masonite, 1938–1939. Work unlocated. Courtesy of the Helen Lundeberg Feitelson Trust, Los Angeles.

and the environment. Her placement of the word "eyes" in the shadowed profile highlights the role of intellect in imposing pattern upon vision. Mystery is not dispelled, but its source turn back onto the self as a creator of meaning. The irrational gives way to ordinary thinking processes as the home of wonder.[13] The painting challenges the human propensity to anthropomorphize the universe by projecting emotions onto natural phenomena through associations. It presented an aesthetic radically opposed to André Breton's quest for the "superior reality" found in "previously neglected associations, in the omnipotence of dream, in the disinterested play of thought."[14] The content of *Eyes* is the cognitive tendency to link disparate phenomena through analogy. The process induces emotional and subconscious overtones, but the tensions within the painting dramatize Lundeberg's conviction that everyday cognitive processes are the wellspring of subjective states.

Lundeberg argued for and strived to create painting that researched how the connotations of recognizable forms evoked moods and desires. She believed that painting could achieve poetic form as artists mastered scientific understanding of structure of perception and attribution. They could use this knowledge with greater certainty to stimulate specific subjective reactions through minor variation of form, line, color, and texture. Painters, in control of the language of their medium, could then reveal internal connections between experience, ideas, and moods that structured the subjective reconstitution of the external world. Lundeberg preferred the term "pictorial structure" over "design" or "composition" since "structure" seemed to her to capture more succinctly the interlocking relation of subjective and objective, while "design" and "composition" stressed primacy of the subjective element. Her goal was not to transcend the ego as the surrealists attempted, nor like the dadaists to negate it, but to define and thereby limit the scope of its authority.[15]

As substantial as the postsurrealists' ideas were, their critique never became a socially significant challenge to surrealism. They participated in the Museum of Modern Art's 1937 survey of surrealist, fantastic, and abstract art, but

curator Alfred H. Barr, Jr., noted in his introduction to the exhibition's catalog that the postsurrealists' presence was an anomaly since their attention to
"object-psychology" was antithetic to art exploring the power of the unconscious. In the late 1930s the principal figures who in the following decade
would forge abstract expressionism were deeply committed to the theory and
model of French surrealism. From a viewpoint focused on the development
of significant form, the postsurrealists were ancillary to the primary course of
American art. Unable to alter the terms upon which the national art community discussed its tasks, the postsurrealists remained a movement with
only regional importance.[16] They naively behaved as if their conceptions were
strong enough to hold attention on their own terms and ignored that as
young artists they needed to find a place for themselves in a market they could
not re-create until they were inside it.

Part of the postsurrealists' failure was due to their inability to compete in
an art world increasingly structured as much around the written word as
around actual art objects. Lundeberg was neither a philosopher nor a writer.
"New Classicism" was barely one page in length, and her subsequent statements were even shorter. She expressed her ideas most cogently in quiet,
meditative paintings, purposively restricted in size and color range. Her
subtle gradation of saturation and tone achieved the illusion of space and
depth while bringing variety into her pictures in a way that required attentive
observation if her effects were to be appreciated. The postsurrealist aesthetic
was restrained to the point of being quiescent, with none of the dramatic leaping from the canvas that marked the paintings of Dalí, Ernst, or their American followers.

By sharply limiting color, size, texture, and complexity of image, the postsurrealists emphasized a picture's merger of intellectual and sensual stimulation. Contemplation led to silence, to erasure of the body into a pure mentality that was nonetheless simply one element in a vast cosmic "structure"
that could be called a "composition" only by granting teleological centrality

to subjective consciousness. Her 1937 painting *Microcosm and Macrocosm* (pl. 2) argues instead that consciousness focuses only on small fractions of the knowable at any one time. It constitutes the objects of its knowledge through recourse to formal logical principles that could not function if they attempted to include the full spectrum of experience. Her painting seems to illustrate George Santayana's observation in his essay "The Genteel Tradition in American Philosophy" that a philosophical viewpoint native to the American West would challenge the anthropocentric and "conceited notion that man, or human reason, or the human distinction between good and evil, is the center and pivot of the universe." Addressing the Philosophical Union at Berkeley in 1911, Santayana advanced the proposition that those who had made their home among the forests and mountains that dominated the Pacific Coast geography could not "feel that nature was made by you or for you. . . . You must feel, rather, that you are an offshoot of her life, one brave little force among her immense forces." The reduction of the human scale before the infinitude of the nonhuman stirred "the sub-human depths and the supra-human possibilities of your own spirit," but exposed "the vanity and superficiality of all logic, the needlessness of argument, the finitude of morals."[17]

Santayana's argument points to a principal distinction between post-surrealism and its European model. The surrealists challenged the humanist tradition by elevating irrationality to a source of wisdom. Their preference for automatism and oneiric imagery proceeded from an assumption that human concerns had a privileged relation to universal processes. The postsurrealists felt that unconscious imagery was as much a dead end as rational thinking. Jeanne McGahey, a member of a Berkeley-based circle of poets who adapted postsurrealist ideas to literary practice, argued that "the dream is probably very largely a mechanism for concealment of what goes on in the mind. It reproduces in many ways the same communication faults found in the conscious levels."[18] Dreams create unlikely associations, because they seek to suppress knowledge that has been gained; therefore accidental word and

image associations are skewed toward the irrelevant. The pivotal position of human aspirations had to be displaced into humble acceptance of the incommensurability of the human and nonhuman. Only then could exploration of truly human potentialities begin.

The intellectuals who pioneered European modernist movements wrote from a sound academic background. Lundeberg's lack of academic training in the humanist tradition hindered her attempt to define a program for postsurrealism. Born in Chicago in 1908, she moved to Southern California in 1912 when her father took an accounting job in Pasadena.[19] She grew up in a comfortable, though not affluent, middle-class suburban family that encouraged her to develop her artistic talents and look forward to an independent career. After graduating from public high school, she enrolled in the Stickney Art Academy in Pasadena, where she took both commercial and fine art classes. Her first exposures to fine art were reproductions of Renaissance old masters and of Cézanne, from whom she said she took the idea that composition begins by filling the corners of a picture. She had no hesitation to put herself or other women in as models of the universal correspondent, but almost always on the margins. This stylistic marker coded her recognition of the peripheral place of human aspiration in an expanding conception of the universe, but it also revealed a hesitation to see herself a mover and creator *in* the world.

While self-confident about her paintings and appreciative of positive reviews, in later life she saw no reason to consider her youthful career a success since she had been completely unable to support herself through serious painting. New Deal arts programs helped her escape a career in advertising that she knew would be entirely incompatible with the vision she had developed. From 1934 to 1942 she worked for the Federal Art Project mural program. Among her many projects, she designed and executed murals at Santa Monica city hall, the Inglewood post office, and Jedediah Smith Elementary School in Los Angeles—work later attacked as communist propaganda in the

early 1950s. Though grateful for employment, she recalled she never enjoyed doing public art, which for political reasons had to conform to "the hopeless sterility of the then-rising school of the 'American Scene,' a form of objective painting totally undistinguished by anything which could be called an American contribution to art: a stale rehashing of the styles and techniques of various past masters, more often than not presenting subject matter all too familiar in the daily comic strips." Tired of mixing art with illustration, Lundeberg, on the American entry into World War II, declined a position drafting technical illustrations for aviation manuals, feeling that her manual skills were better utilized in a machine shop assembling microphones for war use.[20]

In the mid-1930s she decided that she would say little about herself or her work. "Verbiage," she said, diverted the public by turning the artist into a performer. She acknowledged that arguments excited a public and built attention, but ultimately the public ceased to think of the art object as record of an inquiry and focused on the art world as a scene for spectacle.[21] The image she developed for herself matched the contemplative vocabulary of her work. Isolation for Lundeberg, symbolized in her self-portrait through a protective wall of mountains (fig. 3), was a strategic choice recording voluntary withdrawal from social processes that tended to put humanity into the center. Her creative freedom depended on limiting arbitrary social controls, be they the need to sell a product, political accountability, or the hurly-burly of the art market. A close parallel existed between her attempt to extricate herself from these entanglements and her attempt to conjure in painting a direct connection between inner and outer reality. In both situations, she relegated social forces to a subsidiary position. Lundeberg's experimentalist philosophy suggested that art was more exploration of natural phenomena than communication between members of a society. Competition between artists was an intrusion of the social world, with its emphasis on relationships and structure, into what properly should be a spiritual zone of timeless encounter.[22]

Her knowledge of the painterly tradition came almost entirely from books and from discussions with teachers and fellow artists.[23] Her most influential

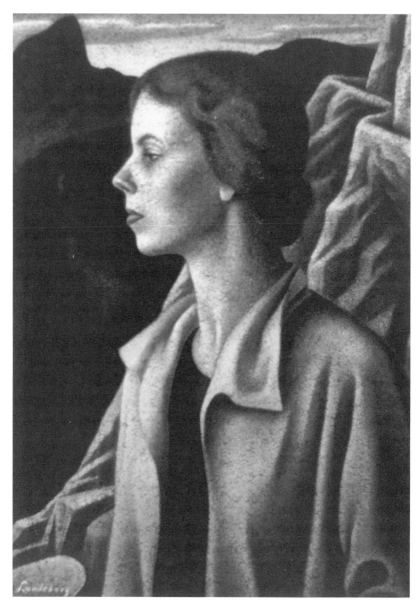

3. Helen Lundeberg, *Self-Portrait,* oil on celotex, 1933. Courtesy of
the Helen Lundeberg Feitelson Trust, Los Angeles.

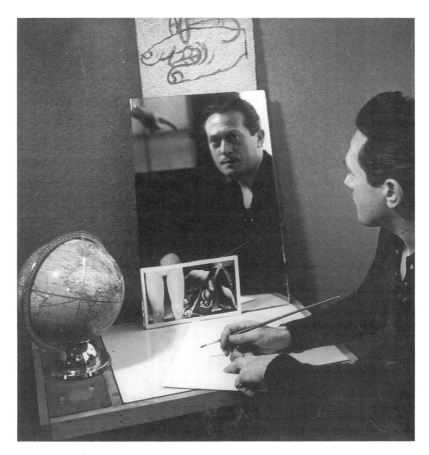

4. Lorser Feitelson, 1936. Lorser Feitelson and Helen Lundeberg papers, Archives of American Art, Smithsonian Institution.

teacher was Lorser Feitelson, whom she later married (fig. 4). Feitelson had lived in Paris from 1922 to 1927. He remembered himself as a loner during his years as a modern abroad, a shy young man who observed the frenetic activity of the world's art and literary capital from the outside. Failing to make friends among the "moderns," he haunted libraries and museums and filled notebooks with sketches of work he liked, old masters as well as modern.[24]

When he settled in Los Angeles in 1927, his ability to talk about futurism, surrealism, dada, and synthetic cubism from firsthand observation made him a popular and sought-after figure. His presence brought Californians

into closer contact with a distant world. With growing self-confidence, he achieved a position as one of the leading proponents of experimentation in the California art world.[25] Feitelson introduces a protagonist group for this history: promoters who deliberately attempt to find attention and end isolation, but are equally deliberate in their efforts to maintain the "democratic," egalitarian ideals that offered a dispensation for isolation. Feitelson was in the forefront of theoreticians who understood the movement of American painting from mimesis to presence, but his work proceeded within a different conception of the art marketplace than the one that emerged in the mid-century United States.

His original sympathies had been with futurism and dada rather than surrealism, which he criticized as overly literary, but he was generally skeptical of all European avant-garde movements. He felt the futurists' attempt to capture the sensation of motion had been particularly critical to helping him define his own interests, but he argued that they had limited themselves by attempting to represent the external activity of the modern city when artists had the power to induce "psychological motion" in the viewer through the manipulation of shape and color. Beyond that he thought that the futurists' proposal to junk the old masters for a painting of modern life was jejune because they did not realize the degree to which their work depended upon a rhetoric developed during the classic age of painting.[26]

Lorser Feitelson's 1936 painting *Susannah and the Elders* (fig. 5) combined three modes of pictorial representation to expose the obsession with textual relay that continued to possess Western art. The painting consists of three panels. The panel on the left parodies an old master, renarrating the biblical story in a pastiche of Giorgione and Renoir, in effect synthesizing a basic unity behind European representational styles from the Renaissance to the impressionists. The center panel transforms the biblical text into allegorical symbols: two pairs of spectacles, a fork, and a peach, all painted in the flat realistic, academic manner favored by the surrealists. The right panel reduces the compositional patterns to biomorphic abstractions reminiscent of Joan

5. Lorser Feitelson, *Susannah and the Elders*, oil on celotex, 1936.
The Buck Collection, Laguna Hills, California.

Mirò or Henri Matisse, jazzy projections that could be read as symbols but
retained a nonrepresentational concreteness. The sequence showed that the
emotional power of the biblical story as painting came from the arrangement
of shape, color, and line.

Literal content was not irrelevant because each panel appealed to a differ-
ent intellectual tradition. The old masters, surreal parody, and abstraction
could equally convey emotional undercurrents in a biblical story, though
similarities might not normally be recognized outside the synthetic unity of
Feitelson's painting because each denotative style privileged a distinct form of
thinking—sensual, intellectual, and mystical. Forms contained within them
"two existences," denotative and connotative. The connotative aspects of art
opened the door to the experience of reality, based on subliminally perceived
connections rising to consciousness. The analogical principle, which the post-
surrealists also referred to as "correspondence," linked the two existences
through painting, which then became a vehicle for expanding not simply per-
ception but an understanding of the nature of universal reality. The power of
the old masters, as of the work of the then contemporary avant-garde, arose
from the cognitive processes engaged by intelligent vision and interpreta-
tion. Painting itself as a process could reveal the everyday power of the senses
to open avenues of speculation far beyond immediate, practical questions.

Feitelson stripped away the apparent value of the denotative level to leave art rooted almost entirely in the connotative, the codes used to convey subjective response.[27]

The postsurrealists proposed that they were engaged in a scientific endeavor best pursued through painterly experimentation into how perception of shape, line, and color generated thought and mood.[28] As a young man studying in the New York Art Students League, Feitelson had already grown obsessed by the mystery evoked by the pure form of objects. Much later in life, he still recalled a formative experience of his career, an encounter with a street pole "to which some wires were tied, or probably it was the support for a sign many years ago, almost lying on its side, kind of tilted . . . that was the greatest piece of sculpture. There's no question: it had all the monumental quality of great sculpture." Feitelson called the power of shapes encountered fortuitously "magical forms," or "subjective objects." They existed entirely in the emotions that the visual form instilled with no consideration of the denotative, use-bound aspect of the object. The emotions these forms generated were the basis for Feitelson's personal definition of "surreality" because they had no apparent explanation. All he knew was that particular objects, such as a sign post on the street, could evoke a sense of mystery.[29] "The forms coming towards us are what I call the inexplicable. . . . I was playing with these objects that have presence for me. But the word I'm using now is *ambiguity*. . . . I didn't say I like it because it has shape alone. It has this other quality that is subjective that I cannot explain. That determines my like or indifference."[30]

The encounter with the street post sparked Feitelson's interest in dada and a decision to live in Europe and participate in the avant-garde movements that attempted to break down arbitrary distinctions between art objects and the experiences of everyday life. When he arrived in Paris, he learned that Duchamp was a "has-been" and that dada was "dead," vanquished by surrealism. Feitelson decided that the European avant-garde movements, while spawning an exciting milieu, were counterproductive artistically. Theorizing and hucksterism were so intertwined that, while theories forced the pace of develop-

ment, the need to compete for attention pushed artists toward the sensational and away from logical, methodical testing of their theories. Elite art did not promote quality, but a form of rarified sensation that became a mark of distinction for those who understood the issues behind the debates. Grounding "the arts in democracy," he hoped, would bring "democracy in the arts."[31]

The Arts in Democracy

The problem of how to create a public for serious, modern art increasingly became one of Feitelson's principal occupations. He talked of knowing many people throughout his life who had shown great promise as artists, but they were "lost," mostly, he felt, because they could not make a living. He had been able to sustain his own career because his parents provided financial support. Feitelson believed that there was "no other way" for most of the people he knew in the 1920s.[32] If painting was to become a serious intellectual exploration into the processes of visual thinking, painters had to be freed from dependence upon commerce and patronage. The development of painting as an intellectually responsible form required a new relationship of the artist to society, a relationship that would bring into being a market for art beyond the rendering of pleasing illustrations. That ground depended upon the development of a broad-based middle-class public for whom the acquisition of "difficult" art would be as natural as collecting books or purchasing a piano. Such a public did not exist in the 1930s, but Feitelson assumed that the conditions in America were favorable. He also thought that this development was more likely to occur outside of New York. The gallery system in the center required high prices, while art for the middle class depended upon relatively low prices.

Seeking a mass public for modern art marked another rupture with the model provided by the European avant-garde. Antonin Artaud could say that "the break between us and the world is well-established. We speak not to

be understood, but only to our inner selves."[33] Feitelson inverted Artaud's proposition: speaking to one's "inner self" created the possibility of communicating with a mass public, of creating a world for the reception of art. In discussing a postsurrealist exhibition, Arthur Millier, art critic for the *Los Angeles Times,* stressed the group's aspirations to communicate: "The mind . . . supplies natural forms by analogy. The next step . . . is to use these inescapable forms of nature to present, not pictures of things, nor unintelligible 'abstractions,' but universally understandable ideas. If the public does not understand such pictures, [Feitelson] says, the artists can no longer blame the public. It simply means that the artist will have failed to achieve a meaningful unity in his work."[34]

Millier overstated what Feitelson viewed as a subtle and complicated relationship. Before the public would find modern art meaningful, artists had to educate them into the aesthetic process. A viewer's refigurative work needed to be as rich as the effort to make the original configuration. The public needed to understand how contemporary art responded to problems in the history of art but made them potentially resolvable by purification to the most fundamental aspects of visual creation. This understanding would not develop spontaneously simply from viewing the work. Careful education was required or audiences and artists would be discouraged and drift toward simplification of ideas into decorative or uplifting themes.

Feitelson gave of himself in apparently tireless efforts to help his fellow citizens understand art. From 1937 to 1943 he worked as Southern California supervisor of the Federal Art Project's easel painting, sculpture, and mural division. Besides doing murals himself, he provided employment to artists whose work he respected. Feitelson hired Ben Berlin to continue doing his experimental canvases, while the government provided Berlin with supplies and a steady paycheck. During his involvement with the Federal Art Project, Feitelson also collected Native Californian baskets and pictographs for the Index of American Design and worked on the restoration of the California missions. In 1944 he joined the faculty of the Art Center School (later Art Center

College of Design), where he taught both fine arts and commercial art students until his retirement.

From 1939 to 1969 he was codirector of the Los Angeles Art Association, which sponsored classes and regular exhibitions. He served as curator or juror for the Pepsi-Cola Annual Art Competition, the *Art News* National Amateur Painters Competition, the Los Angeles City Annual Art Exhibition, and the Third Biennial of São Paulo, when the United States exhibit was dedicated to the art of the Pacific Coast states. He served on the art committees of the National Orange Show, the California International Flower Show, and the Hollywood Race Track, which offered yearly prizes for the best paintings and sculpture capturing the "excitement of the horse life." Feitelson widened the scope of these prizes to include abstract art. He participated in state and local art festivals in all parts of California and traveled to Arizona, New Mexico, and Nevada to serve as juror. He spoke at elementary and secondary schools, lectured at community colleges, and addressed women's groups, bringing his own paintings and those of his friends to allow his audiences to have direct contact with modern art. He was a regular juror in the annual shows of the Young Art Patrons, a women's group in the African-American community dedicated to "nurturing cultural efforts" by black, Asian, and Chicano artists. He worked with Robinson's Department Store to develop space for the exhibition of serious contemporary art in six of the chain's stores. From 1956 to 1963 Feitelson had a television show on KNBC, "Feitelson on Art," which he used to discuss modern art, its relation to European classical painting, as well as non-European traditions. "There is art in everything," he told the television critic for the *Hollywood Citizen-News*. "When you buy a lamp or a two-tone car, whether you realize it or not, you are showing an artistic sense within you." Meanwhile his painting dropped all narrative references and focused on the emotional attributes of space and color (pl. 3).[35]

The scope and variety of his activities underscores the desperate intractability of the problem his generation faced. A program of "art in the democ-

racy and democracy in the arts" was a defensible position in terms of exhibition. But it could not guarantee that a public educated to appreciate visual culture would in fact also become buyers capable of sustaining a stable, if modest, market for artists. Commercial demand for modern art in California remained shallow throughout the period, and galleries devoted to modern art opened and closed quickly. In 1948 William Copley's legendary gallery mounted six well-reviewed and attended exhibitions of René Magritte, Yves Tanguy, Joseph Cornell, Man Ray, Roberto Matta, and Max Ernst, but Copley closed because he sold exactly two pictures in six months. Betty Asher (b. 1914), who would open her own gallery thirty years later after building the contemporary collection at the Los Angeles County Museum of Art, remembered attending Copley's Cornell show and wanting to buy several pieces. The work was inexpensive, with prices between $15 and $75, but she hesitated: "I had a feeling that my friends would think I was crazy if I bought something like that. I was really worried at that time about what my friends would think." She also enjoyed abstract expressionism, but "it just didn't seem like something one owned at that point."[36]

Feitelson was involved in Vincent Price's 1948 project to establish a Modern Art Institute in Beverly Hills, to serve as a West Coast branch of New York's Museum of Modern Art. Feitelson was not surprised by the Institute's collapse after less than a year. Its setup was precarious, he wrote Alfred M. Frankfurter, the editor of *Art News,* "and the deterioration was accelerated by the meddling coteries of self-acclaimed intellectuals, 'philosophers,' and 'psychological-aesthetes,' all arrogantly pimping for their personal panaceas. These ambitious opportunists 'took over' the moribund Institute like so many maggots, completely destroying all possibilities of attracting the necessary confidence and material support. The job was a thorough one, and it is doubtful if any such project can be renewed in the near future."[37]

He felt that the conflicts that continuously engulfed arts activities reflected the division of "contemporary art" into many "contradictory kinds of personal persuasions." For this reason, in 1949 he reversed his opinion on the

jury system. Too many artists were "specialists with a single, inflexible point of view. Though well-meaning, their judgment is of little consequence when confronted with creative work which differs greatly from their own aesthetic bias." Artists fought for control of the few prestige venues to ensure access to more affluent buyers and the best publicity in art magazines. Competition meant, as it had in Paris and New York, that reflective, disinterested examination of work suffered. "The function of the painter is to paint," Feitelson asserted in 1952 in a plea to fellow artists to end verbal theorizing and concentrate on painterly expression. Feitelson argued repeatedly that artists in California did not understand their environment. Contention between various schools of modern art simply confused potential viewers and counteracted the more fundamental work of education.[38]

The other side of the equation, the new public, rooted in middle-class, urban society, remained elusive. "Solution of the problem of the economic insecurity of the contemporary artist necessitates a clear understanding of the artist's own concept of his role," Feitelson stated in a 1950 letter to Arthur Millier, "and his position in his community, as compared to that of the artist in the past." Museum collections proved, he thought, that until modern times the artist had been the iconographical servant of authoritarian state and religious institutions. The artist gave form to the ideology and culture of his community, but without placing his own "free" ideas within the work. By adhering to group ideology, which in any event was obligatory, the artist was guaranteed "communicability, approval, and, therefore, patronage." The originality and individualism that had become essential to artistic success with the introduction of the market into cultural relations also meant an increasing likelihood that an artist would fail to communicate to a public. Publicity that created a market of "initiates" partially solved the problem, but success through familiarity meant that "new" art was no longer new by the time it became familiar to the public. "Intrinsic value" could not replace the need for publicity and education. The artist needed greater opportunity to exhibit and more "literary interpretation," in which writers used their experiences of

visual imagery to test the validity of philosophical assumptions derived from logic and the study of literature. The dealer-gallery system was inadequate and restricted originality in both new and established artists by exhibiting work that mimicked the mannerisms of already successful work. Feitelson, reflecting on his work with the Federal Art Project, considered and rejected state subsidies. "Such aid is burdened with too many non-art considerations and limitations," he said tersely, a realistic position for a period when conservative politicians and businessmen accused all forms of state intervention of being communist. Feitelson's solution was "an honest and dignified effort at private enterprise: . . . opening his own studio, on certain announced days, to visitors." Artists whose studios were geographically adjacent might coordinate their hours to open at the same time, and organizations such as the Los Angeles Art Association could assist by publishing schedules and organizing group tours.[39]

The open-studio concept, while having much to commend it, was too paltry a solution for the immensity of the problem Feitelson described. The atelier had flourished when the artist was a primary provider of images for his or her society, but it was not a form adequate for the era of nonrepresentational art. When Clay Spohn returned from his studies in Paris to San Francisco in 1927, he set up practice as a portrait painter to the middle class and earned a modest living. With the Depression his practice disappeared overnight. Photography replaced painting once and for all as the medium for recording middle-class images. Commercial art was a rapidly growing field, but many artists, like Lundeberg, thought the demands were so different that they could not do "serious" and commercial art at the same time. In effect, commercial art, thoroughly integrated in the mass publication media, had become a separate trade, with distinctive skills, knowledge, and dispositions, both technically and aesthetically.

In the field of fine art, the mass media, which had helped destroy the old system, created a new national market for painting based on publicity. The titanic temperaments and expansive egos of the abstract expressionists

brought drama onto the canvas through action and gesture, sometimes augmented by the scandal of personal life. Feitelson's craftsmanlike values, achieved in rigorous and thoughtful dedication, were eclipsed by promises of grand adventure. The era of craft and workmanlike discipline had passed away and the gentleman-like citizen artist with it. Feitelson's labors were based on a mistaken presupposition that modern art could be integrated into a democratic, entrepreneurial society merely as an extension from, an improvement upon, the old atelier system. Spectacle was essential for the artist who wished to receive recognition. Spectacle dissolved the classic liberal view of the individual as autonomous knower and artificer that moved through the works of Feitelson and Lundeberg and demanded that the artist be simultaneously performer, shaman, and perceptual investigator. Those who ignored the need to publicize themselves in any way available condemned themselves to working in perpetual obscurity. Those who resented and resisted the linking of art as spiritual exploration with an economic system based on marketing the artist's personality had to develop a new paradigm that moved beyond the liberal, democratic faith that guided Feitelson's generation. In the absence of such a paradigm, the artist faced an imperative to find position within the spectacle.

In California the theme of isolation, already a commonplace in the state's artistic communities, provided a ready springboard for an artist eager to assert that he or she represented an absolutely new beginning. The overtones of the theme shifted dramatically in response to the postwar generation's new concerns. Edward Kienholz (1927–1994) observed that in 1953, "When I first came to Los Angeles, it was virgin as far as art was concerned." Billy Al Bengston (b. 1934), who was a student in the mid-1950s, declared, "There was nothing going on in Los Angeles. Simply nothing." Carlos Almaraz (1941–1989), nearly ten years younger but following the same motif, recalled, "In Los Angeles in 1960 there wasn't much on in the arts. Your images and your ideas all came from New York—or Paris."[40] For the pre–World War II generation the theme of isolation signaled a challenge to create a cultural en-

vironment as complex and sophisticated as anywhere else in the world. For the postwar generation the theme transformed into a reductive stereotype that equated provinciality with banality. The Far West was frontier territory, backward but also a clean slate. Each artist then posed as the light-bringer, dispelling the yahoos with the power of culture and discovering in those who admired his work the new saving remnant. Yet in addition to entrepreneurial hyperbole something more fundamental was expressed in the denial of history. The postwar reworking of the isolation motif and the self-understanding embodied within it made sense only if artists had disengaged themselves from the society in which they functioned. To stand on the outside looking upon the benighted was a self-conception incompatible with the citizen-artist ideal that Feitelson promoted and tried to live, though it had already existed as a possibility in the postsurrealist conception of the artistic process. Cognitive processes separated human beings and nature, but also suggested a place of conjuncture: art, tangible record of "reflection and imaginative response."[41] The artist as investigator was but a step away from the artist as prophet, the figure who found enlightenment in the wilderness, voluntarily rejecting society but remaining at its service with a message of natural truth opposed to the mendacity of social convention.

Between the formation of the avant-garde in the 1920s and 1930s and the rise of the younger, postwar generation, new developments severed the links many artists felt with their fellow citizens. They found in their conception of art justification for their sense of difference. For some, autonomy was the first step toward developing a new professional community that would eventually reintegrate artists into society. For many others, disengagement was confirmation of spiritual independence, a yearning for art to assume a sacred function and invoke an emotional intensity lacking in everyday life. If that lack seemed the result of an active denial, and not simply an inevitable, tragic part of life, the emotional experience of artistic creativity could become a force for wanting to change the world. If there were perceived transgressions by the social order against the universal, art as a privileged channel to

cosmic reality provided a self-authenticating ground from which to criticize social evil.

The first steps toward a vision of the arts as a source of subversion of dominant values, mistakenly identified as "traditional," was taken by poets, who were somewhat more insulated from the demands of spectacle and commerce. They rejected the lessons of history and the value of progress. Instead, they claimed themselves the heirs to a long tradition of "hidden" knowledge. The turn to "tradition" developed a relationship to the past that opposed the merely "historical." History they defined as a collective understanding of the past that bound communities together through an ascribed logic in past decisions, the "facts" of which determined the conditions of one's existence. History was a record of the accidental and ephemeral in human life; it sprang from the superficial conditions of an unstable social structure, always giving way to new forms. Tradition, on the other hand, was a personal reconstruction of the past that became a statement of loyalties to predecessors. Looking at the past to discover one's own proclivities, one constructed a narrative of exemplary models for making choices in the face of an uncertain and unstable future. Our discussion must now turn to the process that Kenneth Rexroth called "disengagement," its sources, and the challenges it imposed upon artists and poets as they faced fundamental career choices.

2

After the War or Before?

Kenneth Rexroth Confronts History

In the 1930s Kenneth Rexroth (fig. 6) was one of many young communist-influenced poets who worked in the San Francisco and Los Angeles branches of the Federal Writers Project (FWP). His first wife, the painter Andrée Schafer Rexroth (1902–1940), was a dedicated Communist party activist. What kind of communist he was is open to dispute. In 1931 he wrote Louis Zukovsky that he was a Christian, communist poet in search of perpetual revolution, defined as "the constant raising into relevance of ignored values."[1] For most of his life Rexroth denied that he had ever joined the party, but on his 1940 application for membership in the pacifist Fellowship of Reconciliation, he put down that he had been an active member of the party from 1935 to 1938.[2]

During those three years, Rexroth became a spokesperson for radical literature and painting. At a 1935 national conference of writers and artists, Rexroth urged his fellow writers to put aside arguments over the relative merits of "Proletarian art, Surrealism, or heroic couplets." First and foremost, creative people needed "the minimum conditions under which creative work is possible," which he defined as stable incomes and a plan for developing a popular audience for serious art and literature.[3] Rexroth identified the same problems that Lorser Feitelson grappled with in the 1940s, but their solutions were very different. Feitelson hoped that expanding private enterprise would allow artists to focus on their creative tasks. Rexroth believed that government

6. Kenneth Rexroth, 1945. Courtesy of New Directions.

action was essential. The pool of talented creative people had grown larger than the capacity of commercial outlets. The resulting competition, he argued, had driven down the minimum compensation that commercial publishers offered to levels too low for average writers or artists to survive through their crafts. They had to choose between starving or finding other employment to support their creative activities.

Rexroth circulated a proposal for a national registry of artists and writers, which he saw as an extension of the federal writers and arts projects. Instead of working on specific projects determined by government overseers, however, those enrolled on the national registry would work for any noncommercial institution or agency. In effect, his proposal called for government subsidy for the self-organization of artists and writers into production collectives. He tried to implement that aspect of the plan by developing a magazine for radical political poetry and fiction. Only one issue appeared, printed on FWP mimeograph machines. The lead editorial argued that California suffered from having only commercial magazines that limited themes and ideas to those that would please the widest audience.[4] Merle Armitage, the state director of the federal arts projects, quashed the magazine before a second issue appeared. Armitage later argued in his defense that conservative members of Congress opposed to government funding for the arts were looking for evidence of communists using the programs to conduct propaganda. Young radicals, however idealistic their proposals, did not understand that their magazine threatened the future of the entire program.[5]

Rexroth's interest in government support of artists and writers declined as his political loyalties shifted in 1938. The poem "New Objectives, New Cadres" exposed a break from the organized communist movement. On the one hand he saw leaders who were

imaginary just men
Nude as rose petals, discussing a purer logic
In bright functionalist future gymnasia

High in the snows of Mt. Lenin
Beside a collectivist ocean.

Then there were the rank and file, incompetent, living in squalor:

He who sits in his socks reading shockers,
Skinning cigarette butts and rerolling them in toilet paper,
His red eyes never leaving the blotted print and the pulp paper.
He rose too late to distribute the leaflets.
In the midst of the mussed bedding have mercy
Upon him, this is history.

He portrayed a party theoretician as a "satyriast"

Drawing pointless incisive diagrams
On a blackboard, barking
Ominously with a winey timbre
Clarifying constant and variable capital.

His conclusion to the poem suggested that he wanted action instead of talk:

The problem is to control history.
We already understand it.[6]

In "August 22, 1939," he announced his allegiance to the anarchist tradition of socialism. Opening with the question "What is it all for, this poetry?" he asked "writers and readers" to think of poetry as statements of personal responsibilities requiring immediate action.[7] In the fall of 1939 he circulated a proposal that the Fellowship of Reconciliation, the Women's International League for Peace and Freedom, the National Council for the Prevention of War, and the Keep America Out of War Committee form a coalition to co-ordinate their activities against American support for Britain. The pacifist movement was divided by meaningless theoretical distinctions, he argued. If

pacifists truly believed they had a personal responsibility to prevent war, they should put aside long-term goals to focus on the immediate problem.[8]

The proposal elicited no response, and Rexroth's primary activities during the war were the writing and study that led to the publication in 1944 of his second book, *The Phoenix and the Tortoise*. He separated himself from his closest colleagues of the 1930s by resigning from the Federal Writers Project in 1940. He feared that the project would become an agency for the production of patriotic material in support of the war effort. He found a job as a psychiatric orderly in San Francisco General Hospital, a position that he used to justify his application for conscientious objector status.[9]

A 1940 letter from the poet Robert Horan to Robert Duncan (1919–1988) reveals how some contemporaries saw him. Horan reported to Duncan that Rexroth had tried to join the activist poets group, but they decided not to allow him to attend their meetings. Horan explained that Rexroth hectored people with his pet theories and proposals. He interrupted others as they tried to express their opinions and tended to become abusive with those who disagreed with him. Rexroth spoke as if he were the most accomplished poet in the state. Horan granted that Rexroth had promise as a writer, but Horan also confided to Duncan that Rexroth was untrustworthy and too undisciplined to work in a group trying to define and solve problems.[10]

In interviews done much later in his career, Rexroth projected himself as a man fully in control, able to accomplish his goals because he had extensive knowledge of the world. "I was always luckier than anybody else because I knew more about what I was doing," he told one interviewer.[11] He was proud to be an autodidact. He claimed he *always* knew more than experts because his interests were general and because his omnivorous reading was guided by personal experience. The sketches Rexroth made of American communists in "New Objectives, New Cadres" have the ring of self-portraits. A critique of the Communist party glossed a critical view of himself as a public figure, a self-representation that he could express only in his verse by projecting his negative self-images into "objective" descriptions of others.

By 1945 Rexroth had transcended a reputation as a marginal crank. He was without question one of the best poets working in California. Rexroth's new stature grew out of the publication of 1944 of *The Phoenix and the Tortoise*. The poems collected in the volume recorded Rexroth's reactions to the war and his efforts to locate in marriage the basis for an alternative society. Even reviewers who criticized the political positions in the poetry acknowledged the strength of Rexroth's formal achievement. The book opened with the long title poem, followed by a section of shorter lyrics, and concluded with paraphrases and translations from Tu Fu, Martial, Meleager, and a selection of Hellenistic, late Roman, and Byzantine poets.

In his introduction Rexroth stated that his theme was the "conservation of value" achieved through "supernatural identification of the self with the tragic unity of creative process." Rexroth argued that identification with process was not accomplished by "act of will, by sheer assertion." He sketched the program of the book as a progress toward wisdom achieved by moving from sensual abandon to "erotic mysticism," then to the "ethical mysticism of sacramental marriage," and finally to "realization of the ethical mysticism of universal responsibility." Sexuality was the avenue by which humanity had most direct contact with cosmic "process." The "Dual," the commitment of two people to each other, contained within it the seeds of the "Other," in its most direct sense the family that results from the sexual union of male and female, but also understandable as everything outside the single self and the feeling of communion one feels with those who have shared interests.[12] An interesting visual parallel to these ideas exists in a series of paintings that Lorser Feitelson executed in the mid-1930s in which he located sexuality in a larger conception of cosmic continuity (fig. 7).

The title poem of *The Phoenix and the Tortoise* opens with the ominous "Webs of misery spread in the brain." Rexroth then quickly established a metaphor of edges as central to his theme: the poet and his wife are camping on the shore, on the thin line between desert and ocean, a contrast used to symbolize the soul's existence on the boundary between cosmos and society,

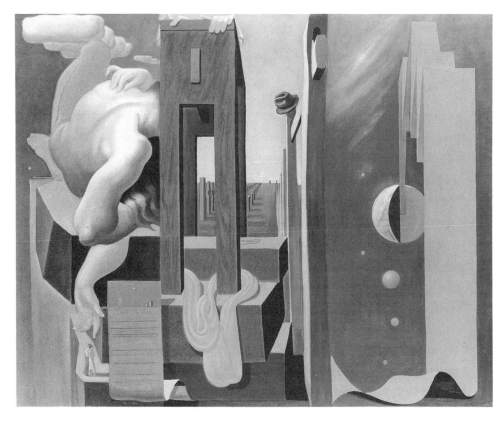

7. Lorser Feitelson, *Love: Eternal Recurrence,* oil on masonite, 1935–1936.
Phoenix Art Museum.

"the gulf / Between essence and existence." The beach is also "on the crumbling / Edge of a ruined polity." A reminder of the war raging around the globe disturbs a much-needed vacation: "A group of terrified children" discover "the body / Of a Japanese sailor bumping / In a snarl of kelp." The horror of the decomposing body described in detail initiates a long meditation on the nature of history. The poet wants to know what is the source of "continuity, / The germ plasm, of history." Unable to sleep, he lies in his sleeping bag all night, while his wife slumbers peacefully. He listens to the cries of sea

birds and turns restlessly while he chews on the questions that the intrusion of the world war has raised. [13]

The events of the poem occur from Thursday evening to Friday morning of Easter week. On an allegorical level Rexroth transformed the historical events of Maundy Thursday into personal rituals. Having dinner and making love with his wife become the reenactment of the Last Supper. Sharing food and sex, acts central to the establishment of family, are sacraments that initiate the poet into the mysteries of Passover and Easter. The poet's sleepless night is a reminder of both Christ's solitary night of prayer on Gethsemane and Jacob's wrestling with the angel at Bethel.

The poet's philosophical ruminations weigh the possible meanings of "process," "value," and "fact"—the terms upon which Rexroth believed so much of human action had come to depend. If he could sort them out and determine their origins, he could render a judgment of civilization as it had developed. Binaries become the principal rhetorical strategy of the poem. Just as cold and heat, shadow and light, yin and yang must remain distinct, so endurance stands against novelty, wisdom against rationality, and what might happen against what did happen. By posing opposites in their antagonistic aspect, the poet forces himself to distinguish natural and social orders, poetic and historical modes of thought. This is no argument, but a set of assertions dividing the world between the lasting and the ephemeral. The fundamental polarity is that of history and poetry. History springs from death, while poetry brings forth "the continuity." To stay on the side of the social is to worship the trivial and to become an instrument of an increasingly more destructive and dangerous system of (dis)order.

Underlying the opening section is the claim that the destruction of America as a society became inescapable with the nation's entry into World War II. Like Greece and Rome, its civilization would pass. Opposed to the event of American society crumbling as have so many cultures before it is the ocean, where time flows "eventless as silt." To learn how to live in a time of

misery and chaos, one must turn to nature. The answer was not poetry as a technique in and for itself. Alluding to Rimbaud as an example, the narrating voice asserts that poetry, even poetry of an advanced persuasion, is a manifestation of rationalism when it is only a form of showmanship. Value is not the same thing as novelty, nor can it be found in the "organized ecstasy" of art that pretends to glory in the irrational but becomes, in the search for new forms only, another manifestation of step-by-step ("pedetemtim") order. The European avant-garde's privileging of emotional nihilism was not a way out of the problem, but only affirmed the "statistical likelihood / Of being blown to pieces."[14]

The posing of antagonistic binaries gives way to revelation that opposites are also complementary. Their natures presuppose one another because they are dual manifestations of a deeper, invisible and mystical unity. Invoking Chinese cosmology, the poet can imagine that "possibly history / Is only an irritability," a temporary perversion and disturbance in the natural order. Poetry and religion are both passageways between the social and natural orders, but being "on the suture," they are abstract. It is the sudden appearance of the poet's wife, "hungry, shouting / For supper . . . / Breasts quivering in their silk blouse," that interrupts his ruminations, brings him back to practical tasks, and thereby makes the natural order immediate and personal.[15]

Throughout the poem, the poet portrays his wife as the secure, stable abode of cosmic peace. As he ponders the place of value and fact, she sleeps peacefully and "her dreams measure the hours / As accurately as my / Meditations in cold solitude." The resolution of the dilemma lies in her body: "Babies are more / Durable than monuments . . . / Process is precipitated / In the tirelessly receptive womb." In the concluding image of the poem, the poet's wife emerges nude from her swim and comes up to meet him.

<div align="center">
The sun crosses

The hills and fills her hair, as it lights
</div>

The moon and glories the sea
And deep in the empty mountains melts
The snow of winter and the glaciers
Of ten thousand thousand years.[16]

The simple, everyday act of love contains the potential of apotheosis, the sur-
passing of history into cosmogony.

Poetry, philosophy, religion, and sexuality are each a potential light of wis-
dom upon the mystery of nothing transforming into something. History has
perverted all forms of wisdom and jumbled them so that they no longer serve
to enlighten. The poet's task, acted out in the poem, is to align those four
ways of knowing oneself so that they are complementary and each can reveal
its unique perspective into universal reality. The poem pits poetry and history
against each other and asks, in which should the poet place his faith and hope
for a future life? The beach site, suspended between ocean and desert, alle-
gorically reformulates the question so that he sees the cosmological ramifica-
tions of the choice he makes. Confrontation with cosmology leads the poet
to consider his choice morally by meditating on the sources of value and fact.
It is the dichotomy of male and female that allows him to experience divine
reality. Sexual difference is both antagonistic and complementary. Aspects of
the male position lie in the realm of struggle and war springing from an end-
less search for change for its own sake. The union of male and female is the
source of change that persists and resolves antagonism into complementar-
ity. Rexroth's maxim, "Against the ruin of the world there is only one de-
fense—the creative act,"[17] had a more basic meaning than writing poetry,
playing music, or painting.

The feminine mystique was not only a "conservative" motion in mid-
twentieth-century America. It was part of a turn of people of diverse political
ideologies to deeply rooted stereotypes about sexual difference in order to
conjure a utopian private realm that could serve, in the imagination at least, as

a haven from the dangers engulfing the public world. To use Rexroth's binary logic, the antagonism of public and private realms could be resolved—or is it sublimated?—by the complementary relationship of male and female.

The separation of private from public modes of being led Rexroth to his own assessment of war and its causes. Sufferings that pertained to history could not be caused by want and fear because those were expressions of the natural interaction of the human animal with its environment. War was then the result of reason ("rigid / Vectors of the fallible mind"). The third section of the poem begins with a machine of war masquerading as an animal. A patrol plane sounds like an owl, but it is an imposture. Owls do not fly over the ocean. The motif reoccurs at the conclusion of the section when a camouflaged cruiser appears like a dark animal prowling the coast. The poet has to remind himself that the equation of war with animality is a trick of human reason to divert attention from its responsibility. War is not part of the processes of nature, but solely the creation of history and society. The terror of Hitler lay not in his demagogic appeal to irrationality, but in the modern state's highly organized, systematic control over the means of coercion and destruction. On this level, the American, British, and Soviet governments were no better. They ruthlessly applied the power at their disposal according to calculations of ends-means relations.[18]

"The State is the organization / Of the evil instincts of mankind. / History is the penalty / We pay for original sin," Rexroth editorialized, and then added to underscore the message, "War is the State." In the final section of the poem he argued that war is the price for believing that "salvation equals autonomy." History, which is to say war, starts with the creation of persons, it is "the price of being an individual monad." History, war, the state, rationality, and individualism function as interchangeable categories, representing different faces of the same phenomenon. They form a structure of equivalences that together represent for the poet the living presence of evil in the world.[19]

One of the most effective leaps in the poem comes when Rexroth contem-

plates the source of individuation, communication, and peace, and suddenly switches to an image of the resurrected Christ confronting his apostles:

> Came Jesus and stood in the midst, and
> Saith unto them, "Peace be unto you."
> And when he had so said, he shewed
> Unto them his hands and his side.

Jesus's wounds from the cross are a pledge of forgiveness, but they can also be a prediction that peace must lead to martyrdom. The poet prays to the Amida Buddha, perfect in body and mind, and to Kwannon, Buddha-nature in female form, for a "turn from peace," for peace has no natural reality.[20] It is solely an historical term because the word expresses a desire to preserve self and self-interest in a world that is always changing. Yearning for peace is itself a cause of war, an aspect of the rationalist desire "to control history," a goal that Rexroth himself shared in 1938. Rexroth's dialectical method required him to say that he was not *for* peace, because binaries become antagonistic when human thought insists upon phenomena having essential rather than relative characteristics. He could not be a pacifist because peace could not exist in his intellectual universe except as a byproduct of the vain hope to preserve individual identity.

Further, Rexroth saw no reason to believe that world war, however horrible it was, would end in "peace." Fascism might be defeated, but the American state would emerge, he predicted, with its faith in the efficacy of war justified by victory. An age of increasingly cruel conflicts had begun. He could not depict the dawn that greets him at the beginning of the third section in its traditionally positive Easter symbolism of a birth of a new age. He thinks it may be "the malignant / Dawn of the literate insect, / Dispassionate, efficient, formic."[21]

Against war Rexroth opposed eros, not to be understood as simply sexuality. Eros was the force for change within each person. Desire heightened

sensibility to the ordered potential of the universe. The erotically stimulated person grasped that natural processes were infinite and that imagination was essential to the operation of choice. Nevertheless, imagination did not necessarily serve the good. It had to be disciplined by ties of love and responsibility. The question of value for Rexroth could not be abstract. Once the individual contemplated what might happen to other individuals he (or, implicitly but never explicitly, she) loved, he voluntarily assumed responsibility for everything that occurs in the world done by human beings, even if he never gave assent:

> The person emerges as complete
> Responsible act—this lost
> And that conserved—the appalling
> Decision of the verb "to be."
> Men drop dead in the ancient rubbish
> Of the Acropolis, scholars fall
> Into self-dug graves, Jews are smashed
> Like vermin in the Polish winter.
> This is my fault, the horrible term
> Of weakness, evasion, indulgence,
> The total of my petty fault—
> No other man's.[22]

Rexroth presented no plan for achieving "responsibility," but the logic of his poem precluded program since his conception of free will followed from the impossibility of ever predicting what will happen. One must respond to the moment or fall into the traps of rationalist thought. In "When We with Sappho," one of the shorter lyrics in the volume, Rexroth assures his wife that humans turn to poetry to hold the essential before them, that is, to do as people have always done as long as they have sung. Spontaneity, if it is not to be formless and solipsistic, must be accompanied by tradition, which provides training and preparation but never a regimen.[23]

The abandon to sexuality that Rexroth saw as the starting point for achieving ethical responsibility was not hedonistic or self-centered. It was the precondition for mystical insight. Rexroth's lyrics belong to the venerable tradition of *carpe diem*, "seize the moment." Nature continues without stop, and for humans to observe its patterns is to understand that no activity in time can aspire to permanence. If we take the manifestations of process—the bees, moths, owls, the stars, the individual soul—as things-in-themselves, we fail to see the experience of sensual reality as an initiation into recurring forces that have no essence. The only reality is the nothingness from which manifestations spring. That nothingness is not material void. It is "nothing" because no manifestation is ever adequate to represent the unending process of which it is a part. In five perfect lines, Rexroth in "We Come Back" captured how everything material is only a temporary effusion of the "endless parabolas" of freedom-giving nothingness:

> Each year, on summer's first luminous morning,
> The swallows come back, whispering and weaving
> Figure eights around the sharp curves of the swifts,
> Plaiting together the summer air all day,
> That the bats and owls unravel in the nights.[24]

Publication of *The Phoenix and the Tortoise* came at one of the most difficult periods in Rexroth's life. Attacked by a psychiatric patient at San Francisco General Hospital, Rexroth suffered a back injury that made it difficult for him to move about or concentrate on his writing. Then his second wife left him in 1944. The woman to whom he had dedicated *The Phoenix and the Tortoise* could no longer tolerate his frequent infidelities, or his explanations that his male nature and his poetic vocation required amatory explorations. He told her that her jealousy would cut him off from the full range of experience he needed to probe the human condition. She continued to pay his rent and provide him with food, but Rexroth was absolutely broke. He wrote a despairing letter to James Laughlin, his publisher at New Directions, won-

dering how at the age of forty he could have no skills that society thought worth reimbursing at a livable wage. Laughlin counseled him to go to school and become a psychological analyst, a career at which he was sure Rexroth would excel.[25] Rexroth ignored the advice and took a job as a sales clerk in a bookstore.

Then positive reviews for *The Phoenix and the Tortoise* appeared. The reviewer for the *Louisville Courier-Journal* thought that the shorter poems were "some of the most exciting lyrical and satirical poems I have come across in a long time." Conrad Aiken in the *New Republic* lauded *The Phoenix and the Tortoise* as an "impressive piece of work, very much alive intellectually, as impressive for its obvious integrity as for its range. Here is a poet to be reckoned with." William Carlos Williams wrote in the *Quarterly Review of Literature* that Rexroth's verse was "strong meat and drink written in a verse which is clear as water." He wished for more verbal invention, but predicted that Rexroth was on his way to becoming one of the leading figures in American literature.[26] Even reviewers who had reservations about one aspect or another of the book recognized Rexroth's growing control over poetic expression. The book won both the California Literature Silver Award for 1944 and the Commonwealth Club's poetry medal. Rexroth's reputation was established.

Over the next five years, Rexroth consolidated his position by editing a compilation of D. H. Lawrence's poems for New Directions, putting together a collection of verse by younger British authors, and issuing two new volumes of his own poetry, *The Art of Worldly Wisdom* and *The Signature of All Things*.[27] The introductions to the Lawrence collection and the British anthology contained declarations of war against the established advanced guard in poetry. In his essay on Lawrence, Rexroth attacked the French avant-garde tradition. He suggested that his readers compare Baudelaire to Catullus. "The contrast, the new thing in Baudelaire makes you shudder," he argued. "Baudelaire is struggling in a losing battle with a ghost more powerful than armies, more relentless than death. I think it is this demon which has pro-

vided the new thing in Western Man, the insane dynamic which has driven him across the earth to burn and slaughter, loot and rape."[28] The French tradition, as those within the field of poetry knew very well, had been the most important inspiration for the modernist experiments of Pound, Eliot, H. D., Gertrude Stein, and their followers. Lawrence, Rexroth argued, had an entirely different conception of the poet. He had not wished to play the devil, as Rimbaud and Artaud had. Nor was he aspirant to heaven, like Claudel. Rexroth argued that for Lawrence the poet was simply one human being among others, a craftsman whose work was to explore the wisdom to be gained from personal experience. Attacking the emphasis on technique that the imagist school valued, Rexroth argued, "Bad poetry always suffers from the same defects: synthetic hallucination and artifice. Invention is not poetry. Invention is defense, the projection of pseudopods out of the ego to ward off the 'other.' Poetry is vision, the pure act of sensual communion and contemplation."[29]

In *The New British Poets,* Rexroth deliberately chose poets ignored by the Eliot-Auden-Spender circle and therefore generally unknown in the United States. Among the writers he anthologized were George Barker, Denise Levertov, Kathleen Raine, Derek Savage, and Dylan Thomas. Like Rexroth, these were poets of personal confession. In his introduction, Rexroth criticized Eliot and Pound for writing "self-conscious philosophical reveries full of indigestible learning" that avoided "the slightest hint of self-revelation."[30] In the course of public lectures he gave in San Francisco in 1947, Rexroth pursued his attacks by contrasting the deadening artifice of most modernist poetry with the simplicity and directness of folk songs and ballads, Chinese and Japanese poetry, and the songs and chants of "primitive" cultures. Only William Carlos Williams, Wallace Stevens, and Yvor Winters escaped his charge that the quest for formal originality crippled the ability of contemporary poets to explore personal experience.[31]

Rexroth aimed to establish himself as the leader of a movement for what he called "autochthonous" poetry, inspired by a revolution away from the

word toward a poetics of immediate expression. His program stood on four basic principles that articulated the radical face of social disengagement. The first, expostulated in *The Phoenix and the Tortoise*, was that poetry should be personal witness against the permanent war state. The second was a decentering of European tradition, which had developed since Augustine, Rexroth thought, as an adjunct to the permanent war state. "The white race is going mad," Rexroth wrote, arguing that the lust for power had perverted the basic means of communication.[32] Asian poets provided a particularly valuable countertradition because Buddhism had given them a sophisticated philosophical base that detached them from their warring societies. Asian cultures also connected to a lost European antiquity. Classical civilization had shared many of the religious and philosophical traditions that remained alive in India, China, and Japan. The "occult" in the Occident was that part of pre-Christian heritage that had been suppressed and repressed but preserved in magic and folklore. Folk art and folk music could then be one basis for the eventual reunification of Europe with the rest of the world that would result after Europeans abandoned their claims to cultural superiority. These claims had rigidified into hierarchies of power in institutionalized cultural monopolies. His opposition to Eliot and Auden centered on their identification with a narrow hierarchical view of culture. He acknowledged that both had written very powerful poetry, but their public role had been to narrow the definition of high culture. His criticism of the *Partisan Review* rested similarly on its editors' attempt to establish standards for the evaluation of contemporary art and literature based on the European classics. He also opposed their active support for cold war policies, and, though he was anti-Stalinist, Rexroth felt that harping on the faults of communism only aided the most reactionary aspects of American society.[33]

The third principle was the vital importance of personal contact with raw nature. Rexroth was not antiurban. He preferred living in the city, but he thought that regular, constant exposure to undeveloped land subverted human-centered values. For this reason only, San Francisco and the urban

centers on the Pacific West Coast had a special role in Rexroth's program, which he otherwise believed could be replicated anywhere. All Californians lived within easy access of the mountains and the desert, and even within the cities people had a much closer connection to nature than the residents of eastern cities did. He thought that a similar situation existed in Latin America and Australia so that the poetry and art from these countries might share special affinities with work from California and the other western states.[34] His emphasis upon access to nature was not Arcadian. He was not interested in establishing utopian communities in the wilderness. On the contrary, he wanted to maintain distinctions between the human and the natural spheres in order that wilderness might remain a source of contrast and spiritual replenishment. In the postwar era, he saw the uniqueness of western American society increasingly in danger from proposals for development. His fifth book of poetry, *In Defense of the Earth*, published in 1956, expounded his ideas about an ecological society.

Rexroth's fourth principle was that religious faith should be present-oriented instead of focused toward the future. He was a practicing Christian, a member of the Anglo-Catholic church in San Francisco, but he rejected the presentation of the Gospels as historical documents. He preferred to think of religious images as recurring themes constantly presenting themselves in the everyday world. The vatic role of the poet that Rexroth and so many of his followers adopted came from a belief that poetry should blur the distinctions between the secular and the sacred by imbuing everyday aspects of life with religious aura. The poet would look inward to confess his or her beliefs and find a voice much larger than any individual's.

Poetry and the Postwar Boom

Rexroth's success came on the crest of rapid changes in California's poetry world. At the end of the 1930s poetry circles were personal and informal,

meeting at homes or bookstores for the discussion of work and practice. Berkeley-based poet Josephine Miles (1911–1985) recalled that the primary form of distribution of new poems in the 1930s had been circulation of typed manuscripts, which might be mimeographed so members of a poetry circle could read them before gathering. Poems were read out loud, but that was not the central focus of evenings. Poetry in the 1930s was meant to be read in private, and circle meetings spent most of their time in discussion. Public poetry readings were more formal affairs. Professional actors gave dramatic renditions of work selected by the organizers. A reading mixed classical with new poetry. Miles recalled that "it was assumed that a poet was not a good reader of his own work. . . . [Yvor] Winters was not good. [Robinson] Jeffers was not good. Nobody thought of themselves—I thought of myself as absolutely terrible, and I don't know anybody who felt he was a good reader."[35]

World War II opened up this hermetic world. Miles recalled that public poetry readings became a frequent and regular occurrence during the war. In Berkeley, senior members of the faculty organized well-attended public readings from Homer, Milton, and other classic poets. The goals of these presentations were straightforward, to strengthen the resolve of the American people by reminding them of the great classical tradition of which they were the heirs. Such readings quickly spread to San Francisco and Los Angeles, where poetry readings became regular occurrences at the San Francisco Museum of Art, the Los Angeles Vedanta Society, and the Wilshire Ebell Club.[36]

Within a very short period of time young people in Berkeley gathered for more informal open readings of experimental and personal poetry. Serious poets and amateurs shared the platform to express their feelings about the war and the dangers facing them. Similar readings became regular functions at Lucien Labaudt's art gallery in San Francisco and Stanley Rose's bookstore and gallery in Hollywood. In 1946, two years after the war's end, Madeline Gleason (1913–1979), working with the San Francisco Museum of Art, organized a Festival of Modern Poetry with events at a number of venues. Gleason's festival combined open readings with musical and theatrical presenta-

tions, as well as exhibitions of work by local artists. Many poets for the first time in their careers presented their work to people who were not devotees of the craft, but who were nonetheless interested and supportive. The increased interest in poetry led to an explosion of small, avant-garde poetry journals.[37]

A new emphasis on reading as a social event tilted the balance toward performative values. A new concept of the poem as a score emerged. Breath, intensity, volume, pitch, and speed provoked workable and more complex alternatives to rhyme and meter. Traditional poetry had maintained a tenuous link with song, the echoes of which were still present in the work of Pound and Eliot. A new performative poetry broke that link by associating poetry with everyday speech. Of the older generation of American modernists, William Carlos Williams had done the most to pioneer a poetics of the spoken word, and his influence among younger poets rose. The speech act that most easily lent itself to performance was the confession, the form which Rexroth had adopted for his poetry.[38]

Rexroth was the center of the group of poets in California whose work became the most representative of the new poetic aesthetic emerging from the cumulative effect of these changes, simultaneously formal and institutional. Many younger poets sought him out, particularly pacifists, for whom *The Phoenix and the Tortoise* had been a heady defense of their beliefs when overwhelming public opinion branded conscientious objectors to the war effort as cowards or traitors. Rexroth recalled these days as a period of "an extraordinary upsurge of what might be called apocalyptic optimism."[39]

Rexroth established his home as an institutional center by opening it every Friday night to reading and discussion of poetry. Each week, a participant presented a critical review of the career of a poet.[40] William Everson (1912–1994), Robert Duncan, Philip Lamantia (b. 1927), Morris Graves, Muriel Rukeyser, Sanders Russell, Thomas Parkinson, and Richard Eberhardt were regular participants. More than personal prestige and aesthetic ideology cemented Rexroth's undisputed position as leader. Rexroth was a close personal friend of James Laughlin, the owner of New Directions press. Rexroth could

help people get published. His recommendation led to New Directions accepting books by Everson and Levertov. He also convinced Laughlin to reissue Christopher Isherwood's *Berlin Stories*, one of New Directions's most commercially successful ventures.[41] Over the next two decades, he helped Gary Snyder, Jerome Rothenberg, David Antin, Lawrence Ferlinghetti, and Nathaniel Tarn get published.

In addition to the Friday evening poetry discussions, Rexroth was a leader in the Libertarian Circle which met every Wednesday night at the Workingman's Club building. Rexroth prepared the lists of books the circle read and led discussions. Most of the poets attending the Friday evening talks also came to the Wednesday evening political discussions. The Libertarian Circle had monthly dances to raise money for its activities. During these dances, experiments with reading poetry to jazz began. The group also sponsored weekly poetry readings on Saturday nights and Sunday excursions for hiking in Marin County.[42]

Ultimately the most far-reaching development to emerge from Rexroth's combination of poetry and politics was the FM radio station KPFA, based in Berkeley. In 1947 Lewis Hill, director of the Committee for Conscientious Objectors, came to address the Libertarian Circle to enlist their support in establishing a cooperatively run, listener-supported, commercial-free radio station that would be peace-oriented. Richard Moore (b. 1927), a poet in the group who had also been on the editorial board of *Circle,* found the idea exciting. He became the principal organizer of the project and raised $250,000 to start the station. Moore was the first general manager of KPFA and turned to his friends in the Libertarian Circle to help develop programming. Pacifica later opened stations in Los Angeles, New York, Washington, and Houston. The project expanded the social influence artists and poets would have far beyond their traditional circles.

For most of the poets involved in the Libertarian Circle, the most critical activity was the launching in 1947 of a new literary journal, *The Ark,* which its editors hoped would become the leading voice of anarchist ideas in the

United States. The collective prepared two issues, only one of which had gone to press before the editorial board fell apart in personal squabbles. The lead editorial announced that the journal was open to literature that promoted "social consciousness which recognizes the integrity of the personality as the most substantial and considerable of values." The editors urged its readers to sever all relations with the state. "We are concerned with a thorough revolution of the relations between the individual and society. . . . The vanguard of such a revolt is becoming a potent force in contemporary literature."[43]

Robert Duncan's review essay on *View* magazine, the semiofficial journal of the surrealist movement, attacked André Breton and his followers in America for having turned the "revolutionary personality" into a commodity for sale to "culture collectors." Since art and poetry were the primary forms for developing a new personality independent of the state, Duncan argued, the commercialization of surrealism was a major setback for social change in the twentieth century. Duncan urged serious artists and poets to avoid the snares of the marketplace and establish networks for exposure and discussion of work free from the exchange of money for profit. Poetry readings, cooperative galleries, and collectively run magazines could provide a basis for serious consideration of new work.[44] Duncan's prescriptive program described the actual art and poetry scene developing in the San Francisco Bay Area, an underground that formed as the quantity of work produced exceeded the capacity of the local museum, gallery, and publishing scene. He projected the limitations of working in a provincial environment into a utopian vision derived from the familiar, as if the personal could exist independently of a public order otherwise found oppressive.

Rexroth did not contribute to *The Ark,* but he expressed his ideas about the social role the magazine might fill in his notorious "Letter from America," published in the British anarchist journal *Now.* Revolutionaries would use the magazine to "win back various declassés, dislocated intellectuals, self-educated workers, young artists and writers" to the cause. "Once effective cadres," he continued, "have been developed from this somewhat unpromis-

ing material, [they will] build study and discussion groups amongst the working class, or rather amongst the general population." For this task, a combination of advanced literature and political essays was essential, literature to stimulate thinking about personal choices and essays to focus discussion on social conditions. Rexroth expressed strong reservations on the quality of the "cadres" available for the work. "The war finished off a generation of USA intellectuals," he observed. "They all went to Hell on a gravy train of human blood. . . . The WPA Writers' Project changed its name to the Office of War Information; salaries were upped handsomely." The most radical non-Stalinist left journals, such as Dwight MacDonald's *Politics*, appealed primarily to "well-dressed academic intellectuals, sociology teachers, social workers. . . . This is the class that staff the New Deal, and for that matter the CP and the Trots. I fail to see how anything can come out of bureaucrats except bureaucracy." That left for the cause writers who were profoundly ambivalent whether their primary loyalties were to their careers as writers or to social transformation. Convinced that the world political situation would deteriorate, Rexroth predicted a generation of martial law, during which time anarchists would have to go underground. "That means carefully picked people, caution, responsibility, and very solid construction, too." Assessing the men he had assembled around him, he could only exclaim that he saw little of practical talents that a revolutionary movement required.[45]

His colleagues in the Libertarian Circle were furious that Rexroth's doubts about their motives and capabilities were first expressed to them in print in a foreign journal. They felt betrayed and demanded to know why had he never brought these subjects up at their regular meetings. Embarrassed, Rexroth withdrew from the Libertarian Circle.[46] At the same time, he found himself deep in dispute with the younger poets about whose work he felt most strongly. Everson recalled that Rexroth had picked out himself, Robert Duncan, and Philip Lamantia to be his lieutenants, the men who would develop and expand an aesthetic of "immediate expression." Each received a specific "assignment." Duncan was to be the group's "celebrative dionysian aesthete

with formalist adhesions"; Lamantia was to be the "dionysian surrealist"; and Everson the "Lincolnesque populist pacifist—the 'pome-splitter.'"[47] At first each was flattered by the attention and advice Rexroth gave them, but all three rebelled by the end of 1948.

The first to break with Rexroth was Lamantia. Rexroth had written the introduction to the younger poet's first book, *Erotic Poems* (1946), and had touted his use of free association of images as an alternative to surrealism. Lamantia, with the most experience working in publishing, had been elected chief editor in charge of the production of *The Ark*. It was a nearly impossible task, since many in the group felt they could make significant changes without clearing them with the rest of the board. Lamantia expected Rexroth to exert discipline. When Rexroth failed to resolve the conflicting opinions, Lamantia quit all connections with *The Ark*.[48]

Rexroth's relations with Everson were more complicated. Rexroth valued Everson as the archetypal autochthone, proof that good American poetry need have no connection with what Rexroth called the "mandarin" tradition, poetry based on scholarly erudition. Everson had been a farmer near Fresno, and Rexroth advised him that it was essential to his career that he always dress in farm clothes. In 1947, when Rexroth had invited Everson to meet the British poet and publisher Cyril Connolly, Rexroth flew into a violent rage because Everson showed up with a haircut and dressed like any other young man his age. Rexroth dragged Everson's wife, the poet Mary Fabilli, into the kitchen and berated her for destroying the effect Rexroth wanted Everson to convey of a creature "emerging straight from the soil." He apologized the following day, but tensions did not die down. Everson felt that he could no longer work with Rexroth after his mentor insisted on using the introduction to Everson's first book, *The Residual Years* (1948), as a manifesto against T. S. Eliot's theory of the poem as "an aesthetic object." Everson wrote Laughlin, asking him to pull the introduction, but Rexroth persuaded the publisher to keep it in. Reviews of the book did, as Everson feared they might, focus on Rexroth's introduction instead of the poetry, and Everson felt betrayed. He

withdrew completely from Rexroth's circles and did not speak to Rexroth for sixteen years.[49]

Rexroth's problems with Robert Duncan began when Rexroth expressed disagreement over some of the poets that Duncan and Madeline Gleason scheduled to read at San Francisco State College. Duncan felt Rexroth was unfairly trying to dictate policy to an organization with which he had no connection, but Rexroth argued that a new aesthetic could not establish itself unless its supporters gave it unwavering loyalty. The issue escalated when Rexroth discovered that poets he despised had received larger honoraria than he had. Duncan did not talk to Rexroth for six years after their break. "What is so fascinating," Duncan commented when thinking back about the anger he felt for so many years toward Rexroth, "is that our period wanted a poet to be a model person, and Kenneth wanted to be a model person." Yet at the time, Rexroth's followers understood what a difficult character he was. They respected his work and valued his ideas, so they overlooked his personal failings as long as they could. In the end, Lamantia, Everson, and Duncan continued to honor Rexroth as their "father figure." He had helped them find their voices as poets. Still Duncan observed that "perhaps Rexroth is a father figure if a father figure is someone who tells you whom to like and you never want to read him."[50]

Just as Rexroth's critique of the Communist party in "New Objectives, New Cadres" contained a hidden but fairly accurate self-portrait, "Letter from America" expressed Rexroth's misgivings over the role he had adopted. After 1945 Rexroth had become far more than a poet, or even the impresario of a new poetry movement. He had assumed the role of revolutionary strategist, and found it beyond his capabilities or even his interests. The conflicting demands upon and within him were complicated by his failure, despite public success, to achieve any kind of financial stability. Demands on his time had increased, but income from his writing remained insufficient for survival. He and his wife reconciled, but his economic dependency upon her was a constant source of friction. Whenever he felt that she was trying to use his depen-

dency to pressure him, his anger erupted in violent, physically abusive episodes. To his publisher he moaned that few poets found the "kind of wives" poets should have. She left for short intervals, but then inevitably returned, feeling that he would be unable to write if she was not there to support him.[51] In 1948, when Rexroth won a Guggenheim fellowship, he decided to cut all the Gordian knots that entangled him. He used the money to leave San Francisco, fleeing his failures with colleagues and his wife. The award allowed him to make his first trip to Europe and escape all responsibilities except those of being a poet.

In "The Dragon and the Unicorn," the poem he wrote about his trip, he confessed that the practical world drove him insane and suggested that what he said about the world of affairs was the voice of "dragon," earthbound and scared. He would retreat to his "ten foot square hut" and let the "unicorn" within him contemplate the world and write poetry. He expressed a change he hoped he could maintain:

> Once I saw fire cities,
> Towns, palaces, wars,
> Heroic adventures,
> In the campfires of youth.
> Now I see only fire.[52]

Rexroth did not in fact withdraw from the world. He married for a third time and fathered two daughters. To stabilize his income he sought out free-lance journalism work. He started writing book reviews for the *San Francisco Chronicle* in 1951, and in 1958 the *San Francisco Examiner* invited him to write a biweekly column on cultural and social affairs. He became a frequent contributor to the *Nation, Saturday Review,* and other journals of cultural commentary. In 1951 he began a weekly radio program on KPFA. His commentaries were often outrageous, scurrilous satires directed at the many aspects of his society that annoyed him. His poetry, on the other hand, projected serious and focused meditation on the juncture of personal, social, and

religious questions. He had to keep these two aspects of his life, these two voices with very different subjectivities, apart. He did not know how to merge the practical and the contemplative. His conception of the private eluded all sense of responsibility for the public. The work of building institutions, or determining exactly how poets would relate to their society, belonged to others.

The "Unground of Freedom"—Model for Postwar Radicalism?

In 1949 Rexroth published his third book of poetry, *The Signature of All Things*. He borrowed the title from a work by Jakob Boehme, the sixteenth-century German Protestant mystic. Beohme's writing had inspired sections of "The Phoenix and the Tortoise," but the later work fully revealed the centrality of Boehme's thinking to Rexroth's.[53] The source of personal identification was straightforward: Boehme was a shoemaker, a craftsman who burst the boundaries of social hierarchy to become a pivotal figure in the history of German philosophy. In opposition to the static theology of the Lutheran clergy, Boehme's visionary work survived persecution to inspire Schiller's theory of the aesthetic and Hegel's dialectic.[54]

In the title poem in *The Signature of All Things* Rexroth presented the illumination that came to him after reading Boehme. The most astonishing thing is how undramatic the event is. The poem's images block the argumentative anger and confrontation typical of Rexroth's earlier work. Illumination took the form of quiescent observation:

> The saint saw the world as streaming
> In the electrolysis of love.
> I put him by and gaze through shade
> Folded into shade of slender
> Laurel trunks and leaves filled with sun.

The wren broods in her moss domed nest.
A newt struggles with a white moth
Drowning in the pool. The hawks scream
Playing together on the ceiling
Of heaven. The long hours go by.

The passage illustrates the inseparability of order and change. The illumination suggests a pattern for purposeful human activity, at once ordinary and necessary and redolent of the work one must do upon one's own soul:

When I dragged the rotten log
From the bottom of the pool,
It seemed heavy as stone.
I let it lie in the sun
For a month; and then chopped it
Into sections, and split them
For kindling, and spread them out
To dry some more.

This simple task is the mystic experience, but since something must "happen" for the poem to conclude, Rexroth brought the lyric to a close with a cosmic experience:

I went out on my cabin porch,
And looked up through the black forest
At the swaying islands of stars.
Suddenly I saw at my feet,
Spread on the floor of night, ingots
Of quivering phosphorescence,
And all about were scattered chips
Of pale cold light that was alive. [55]

"Phosphorescence" might be a metaphor for creative fire bursting within his soul, a poetic use of Boehme's symbol to represent the inner conflict of un-

differentiated nothingness transforming itself into things in order that love, good, and truth be revealed in their purity. The word also simply describes flickering reflection of starlight upon the log lying on the ground by his cabin. Every activity, if offered to reflection, is a key to understanding to the rest of existence.

"The Signature of All Things" achieved what was already well under development in Rexroth's earlier verse—objectification of the subject. Nicolas Berdyaev noted that Boehme wrote of God's relationship to humanity but never uttered one word about his own soul or his own spiritual progress.[56] In his own poem, Rexroth implied but never stated his emotional reaction to the experiences portrayed. Word by word, image by image, he built a description of simply being in the world in order to quicken within the reader a sense of connection. The poem depends upon a subject-subject relation, in which the poet's subjectivity reduces to a mediating factor between the reader and a sensation of a larger order. There was no room for personal psychology in this process. As a poet Rexroth bracketed out his own immediate, personal reactions so that his experience could assume universal proportions.[57]

Rexroth achieved the objectivity of self and experience portrayed in his poetry with a form that stressed regularity and simplicity. In *The Phoenix and the Tortoise* he deployed a unique quantitative line, constructed of seven or nine syllables with three stresses to a line. This approach did not permit him to engage in extravagant technical display. It easily, particularly when paraphrasing philosophical argument, lapsed into the clumsiest chopped prose. Still, the tightness of the form forced Rexroth to restrict the extent of his images into discrete, easily perceived units seldom longer than ten lines and to concentrate his argument into simple, commonly understood language. Despite the erudition that Rexroth sometimes liked to display in his work, his prosody made his poems among the most readable in twentieth-century English-language verse, yet without sacrifice in depth of thought. At the same time, his simplicity and regularity tended to give experience the weight of essence and emphasized order over accident. Rexroth transformed his often

chaotic personal experiences into an idealized expression of spirit moving through the world. When the subject in his poems endures horror, agony, restlessness, sexual passion, or joy, the experience does not seem particular to the poet. By negating individual psychology, Rexroth could create a form of self that represented a generalized movement—not striving—toward freedom, a freedom that grew naturally out of the relationship the self had with natural process. Rexroth's subject was another form of Hegel's *Geist* moving from unconscious nothingness to full self-realization.

The soul becomes a rocket from what Boehme called the "unground" (*Ungrund*), one of the most influential and most difficult of Boehme's concepts. The unground is the dark and irrational abyss that lies outside being. Berdyaev interpreted the unground as nothingness with the desire to become something. "Freedom" is the acting out of this desire. "Freedom is and resides in darkness," Berdyaev observed, "it turns away from the desire for darkness toward the desire for light, it seizes the darkness with its eternal will, and the darkness tries to seize the light of freedom and cannot attain it, for darkness closes in again upon itself with its desires, and transforms itself back into darkness."[58]

If we read "desires" as an expression for psychology, it becomes clearer why Rexroth's Boehmean-influenced aesthetic needed to exclude a psychological understanding of the subject as an entropic twisting back upon itself of a drive toward freedom that seeks to secure the certainty of law. Freedom can never be predictable or probabilistic or it ceases to be free. "Free will," Boehme wrote, "has no beginning stemming from a reason; it has not been formed by anything. . . . Further, free will has within itself its own judgment of Good and Evil, has its judgment within itself, has within itself the anger and love of God."[59] Hence the importance to Rexroth of "the struggle to break out / Of the argument that proves itself."[60]

Free subjectivity required a disengagement from history, from any factor that would limit the exercise of free will tapping its resources of judgment, anger, or love. No social factors, no linguistic or semiotic determinants, no

psychological laws could coexist with free subjectivity. The free self transcends the accidental to open up the nothingness that is its origin. If the self grew from sheer potentiality, whatever form it took was fictional, crafted from the repertory of meanings and behaviors available in a society. By granting universal status to a fiction, Rexroth divorced the self from all causative factors and even from every form by which individual presence became manifest in a given society. The binaries that Rexroth established in "The Phoenix and the Tortoise" substituted stereotypes for causation, while the turn to nature mysticism was an affirmation of free will "ungrounded" in an arena of serious intellectual thought that nonetheless remained outside deterministic paradigms. The philosophy espoused by Rexroth and his followers was unabashedly irrational—but not in the pathological or oneiric sense popularized by the dada and surrealist movements. Irrationality meant nothing more or less than that no epistemological system could *ever* define the ontology of the human soul.[61]

In opposing deterministic views of the self, cosmogony restabilized identity with the possibility of free action, but action that could be only tangentially socially productive. The important goals to be achieved were not in the world, but in one's subjectivity. Disengagement entailed a cult of marginality in relation to social affairs. Poetry that tapped into human participation in natural process was subversive because it elevated the private realm in all cases over the public. Rexroth thought governments could forcibly repress a poetry of disengagement but was helpless to combat or counter it with alternative images because subversive poetry "presents a pattern of human relationships which is unassimilable by the society . . . the kind of love it sings of can't exist in this society. The song gets out like a bit of radioactive cobalt. It just foments subversion around itself as long as it is available."[62] To assert the power of "value," the imagination wedded to cosmic process, was to assert the validity of individual strategies for achieving life aims. The diminution of history and facts was not to dismiss their existence. Indeed, they were the prevailing determinate conditions structuring the field of possible behavior, but Rexroth's

poetic aim was to reduce them to a level where personal strategies were in fact simply possible.[63]

The social reality from which Rexroth and his followers claimed to disengage was the development of a permanent war state, which they held was the result of rationalist, law-bound conceptualizations. Fighting powerful enemies in both Europe and Asia, the American government, aided by most nongovernmental social institutions, promoted values of duty, responsibility, and obligation. Rexroth's poetry was an attempt to transform those values into an affirmation of individual liberty by shifting the source of value onto the cosmos. The attack on individualism that runs through "The Phoenix and the Tortoise" appears to confuse the issue, particularly if we consider the complex ego problems Rexroth carried with him through life. Yet a psychological reading of his aesthetic work that interprets the move toward nature mysticism as an effort to calm a troubled soul limits, however valid it may be on its own terms, consideration of the social influence that Rexroth and the San Francisco poets achieved. We need to examine the social origins of a quest for a freedom that was always specific and finite but infinite in its possibilities for change.

The most obvious answer, one easily supported through analysis of the texts of poems such as "The Phoenix and the Tortoise," is that the assertion of personal freedom was a response to the insecurity caused by the war. Americans believed they were free citizens in a democratic society, but the war showed that free citizens had very little control over the forces that influenced their lives. A government that ostensibly was their creation could take on a dictatorial life on its own to command the utilization of resources, economic and human, needed to achieve its international goals. In an age when the leaders of society have enormous powers under their control, Rexroth suggested that the citizen might require the foundation of the entire natural process to maintain his or her personal autonomy.

This answer raises as many questions as it solves. Presumably the war affected all citizens equally. Why then did poets (and artists) feel insecurity and

powerlessness more strongly than people in other sectors of society? Why were they such a high proportion of conscientious objectors against a war that most of their fellow citizens accepted as a justified, necessary evil? Even of those who did their service faithfully and without complaint, why would artists and poets be particularly inclined to join what one critic in a national mass circulation journal called a "cult of sex and anarchy"?[64]

The answers to these questions are more likely to abide in the specific social relations that artists and poets had with the rest of society. We can advance a working hypothesis: the lack of "minimum conditions under which creative work is possible," that is, the weakness of the institutions through which artists and poets practiced their professions, made them as a group particularly vulnerable and sensitive to feelings of powerlessness.

No direct connection need be made between the weakness of certain cultural institutions and the rapidly consolidating institutional power of the state. The specific insecurity poets felt as poets was reinforced by any insecurities some of them might have felt as citizens. Both their relationships to their profession and to the polity underscored individual impotence, an unhealthy, festering condition in a democracy. The two sources of insecurity formed an harmonic resonance that magnified the sensation of living in a structure the sole purpose of which seemed to crush liberty, or to put it in terms that became more prevalent in the late 1960s, to colonize the private world with the concerns and imperatives of the public.

The experiments of the poets, founded upon the "unground of freedom," lashed back with acts of self-empowerment. The imagination, manifested in its highest form in the aesthetic act, became the most stable source of personal freedom in a world otherwise deterministic and frightening. An absolutized privacy, no matter what the costs, turned out to be the most radical defense against the claims of public order. Bohemian enclaves developed a repertoire of self-images that proved to have appeal to the collective imagination far beyond the limited boundaries of the art and poetry worlds. As feelings of powerlessness spread, the aesthetic avant-garde provided an antidote. A corollary

of this analysis suggests why the avant-garde became a more important source for socially oppositional ideas in the post–World War II period than the American Communist party, which had grown impressively during the depression. Communists idealized institutional power, and their successes came from the manipulation of coordinated mass force. After 1947, when faced with the overwhelming power of the American state, the communists revealed how limited their power actually was. They might have survived had they continued to engage the subjective imagination of those who felt in opposition to developing trends in American society. For people yearning for an alternative to mass institutions, however, the answers communists gave to the nation's social ills seemed irrelevant at best.

But for professional artists and poets there remained a limit on the power of the imagination. The strategy of personal liberation did not answer the questions of daily existence, how to survive by creating work that society could use in some predictable manner. Achieving stability through the creation of solid institutions that would nurture and support practicing professionals remained a pressing need.

As the avant-garde community grew between 1945 and 1965, it remained suspended between goals of personal liberation and institutional stability. The efforts artists and poets made to find equilibrium led to experiments in form, subjectivity, and institutional setting. They attempted to stave off a choice between social opposition and professional commitment, for freedom meant refusing to affirm a single identity or "personality," to leave open the possibility of contrary interests and needs. The immediate practical requirement of the avant-garde was to construct a community of like-minded people who shared the belief that creativity overcame contingency. This would be a community where the distinction between producer and consumer blurred. Poets as professionals faced the need to create an affinity group. To expand beyond coterie circles poets required audiences of nonpoets who considered their reading and listening to be work as creative and restorative as the poet-producer's. Works had to function as emblems of communally shared per-

sonalistic values; performances had to "manifest" the existence of interior reality; "alternative institutions," at first ad hoc and primitive, then branching out to include bars and coffeehouses, were needed as gathering points. Above all, a tradition had to be constructed to replace a history that placed regional movements on the margins. The activity was countercultural in attempting to extend the social existence of small, personally managed enterprise. Opposition to "capitalism" was part of the constructed tradition, but transgressive relations were secondary to aspects that projected personalistic values as an alternative to hierarchy and deterministic thought.

3

Between Commerce and Imagination

The GI Bill and the Emergence of an Arts "Community"

History is a separation, Clay Spohn believed. "I feel that the past, present, future [are] together in a sense—they're one thing. They're part of the same chain, so the past is never dead." What we call history, he continued, is an illusion that people use to divide themselves into discrete parts, but the only absolute he could see in the human condition was continuation. Only things change, and time marks distance between things.[1] These reflections abruptly interrupted his account of his comfortable middle-class childhood in Oakland, California. The gentle decency and moral responsibility that had guided his parents still lived within him. Once he had thought that when he became an artist, particularly an abstract artist, he had betrayed their hopes for him. Finally at the age of sixty-seven, he could admit that the only way open to him to keep his family's values alive in the world had been as an artist.

From 1884 to 1929 his father operated a small advertising and marketing firm in San Francisco. For twenty years after his father's death, old men introduced themselves to Spohn, shook his hand, and congratulated him for being the son of John Harry Spohn, whose talents as a salesman were as legendary as his absolute honesty. His mother, Lena Schaeffer Spohn, had been an amateur painter, talented enough to win prizes for her work in local contests. She was Clay's first art teacher. He recalled that she was an excellent technician, but her philosophy had been important for his development as well. There

was no place for competition in art, she told him. Paint so everybody else could share the things he cherished most. His parents knew very little about the world outside their immediate lives, Spohn thought, but they believed that things of beauty helped people live happier and more ethical lives. The Spohns were not a church-going family, and the arts took the place of religion as an everyday source for basic values. They wanted their son to develop his talents and enrolled him in Saturday classes at the California College of Arts and Crafts, the local institution following the teachings of William Morris. By the time he was sixteen, he too had won several prizes for his work, but he understood that painting was a "private thing," a discipline of meditative self-improvement.[2]

That he might seek a career as an artist never occurred to him until he visited the art pavilion at the 1915 Panama-Pacific International Exposition, where the organizers presented the most extensive presentation of contemporary European and American art in the United States since the Armory Show in New York two years earlier. The cubist work in particular set the seventeen-year-old's imagination on fire. He immediately started to work in abstraction, hoping to capture on canvas "things that you feel in nature that you don't see," things experienced not with the eyes but with the whole being. He began to conceive of art as a form of invention not to be limited to devotional study of what he "cherished." The pastoral idyll of childhood ended as he dreamed of taking his own place in an enlarged world where painting was a great deal more than "self-improvement."[3]

In 1919, discharged from a brief stint in the navy, Spohn dutifully enrolled in Berkeley to study business. After one semester he dropped out, informing his parents that the alternative was flunking out. He intended to devote his energies to painting. But he was not prepared to sever his ties to the practical world. He told his father that business needed good advertising illustrators, and he quickly found a job designing billboards to prove it. His parents wanted their son to get an education, so they offered to send him to New York to study at the Art Students League, where he could learn his craft from

the best teachers in the country. There he studied with George Luks, Kenneth Hayes Miller, and Guy Pene du Bois. It was not a happy experience. He was impatient with their representational approach to art. They ridiculed his interest in cubism and every other form of abstraction emanating from Europe. Draw more and think less, Miller advised his student. Beyond disagreements over style, there was conflict over goals. His teachers reduced art to formulas, he complained, the six rules of perspective, the four ways of modeling masses, the twelve-step color wheel. Everything they had to teach him was a safe and secure way to achieve preconceived effects. His teachers emphasized the importance of creating solid forms on paper and canvas so rich and full that their originals appeared flat and transitory in comparison, nothing more than models. Spohn and his friends, among them Alexander Calder, had no ambition to surpass reality. They hoped their never-before-seen shapes would take them into completely unknown experiences.[4]

After two years of listening to his complaints about school, his parents pressured him to translate his talents into money: decorate department store windows, illustrate newspapers, they wrote him, anything that might put him on the road to self-sufficiency. It was all right to be an artist, but he had to consider how his interests could be useful to others. He found work doing sketches of the "human pathos of everyday life" for the *New York World*, but the pay was so poor that he remained financially dependent upon his parents. They became increasingly impatient: since he had failed to put down roots in New York, why not return to San Francisco and join his father's business, where his talents could be put to use designing packaging. "I was suffering . . . because I'd get these letters from home; my mother used to write such things as: the dollar is your best friend. So corny."[5]

Torn between the thing he "instinctively wanted to do" and the thing that he "had to do from a practical point of view," Spohn suffered a complete breakdown in his health in 1924. He dropped out of school and hurried home, so weak he could not walk from one end of his family's apartment to the other. Recovered, he found work as a muralist for building contractors

and painted allegorical frescos of the muses for the back patios of California homes. Encouraged by the response to this commercial work, he ventured south to Los Angeles to see if he could fit into Hollywood as a set designer, while simultaneously hoping to interest producers in a scheme he had developed for stereoscopic effects in the motion pictures. Both efforts failed, and he returned home with a new plan, this time to study in Paris at the Académie Moderne, Fernand Léger's school. He was surprised when his father thought this a reasonable proposition. The older Spohn hoped an "adventure" might toughen his son, and Léger's academy seemed to qualify as legitimate education. Clay set off for Paris in the fall of 1926 with a promise of two years' subsidy to complete his unfinished schooling.[6]

Spohn spent two years in France, and later he was quite the raconteur of life in Parisian bohemia. His interaction with European artists could not have been very deep, since he never learned to speak French. His notebooks suggest that he often stayed to himself for weeks at a time and that most of his social contacts were with other Americans.[7] He was disappointed with Léger's school. The master wandered through the studios once or twice a month, barely looked at the work, and made only the most vague observations. Most of the instruction came from English-speaking assistants who took care of the Americans and Britons who made up the majority of students.[8] After six months, Spohn decided the school was a scam to fleece cultural tourists. He rented a cheap studio on the outskirts of Paris and set himself up as an independent painter in charge of his own education.[9] His notebooks from the period contain lists of books to read and exhibits to see. He observed the French avant-garde, but he seems to have spent considerably more time studying classical than contemporary work. Interspersed between reports on paintings he had seen, budget calculations, and recipes for mixing paints and glazes, were philosophical observations that reveal an anarchic temperament unable to escape his parents' concern that his desires be reconciled with financial practicality:

My whole life must be full of moving about quickly and traveling from place to place.

[. . .]

Avoid all bad influences both morally and physically.

[. . .]

One should never be conscious of the means, only of the results; or, never conscious of the cause, but only of the effect.

[. . .]

Mind is the only cause, mind is the source of all causes.

[. . .]

One should not think of oneself, but of one's duty.

[. . .]

The making of a picture should be great fun, if it isn't then there is something wrong with it.

[. . .]

If one lends importance to anything he becomes attached to it, and hence his spirit is not free. One must remain non-attached to whatever he does. It is then only that he can hope for salvation . . . he can only accomplish this by his detachment of his spirit to material things, which he can only do when he realizes and understands the unimportance of that which he does.

[. . .]

Thought, not money, is the real business capital.

[. . .]

Anything you can visualize you can do.

[. . .]

And what is your goal? Fame, adoration, respect, recognition—acceptance.[10]

Spohn's jottings were a curious coupling of *duty* with *detachment,* a quasi-Buddhist openness with Yankee positive thinking, in a way that voids both qualities of any practical meaning. Anxiety about money was a permanent feature of his life, as were oddball schemes to make his imaginative talents somehow fit into the entrepreneurial ethic. In October 1929 he announced the formation of a new company, "Ideas Incorporated, or the Idea Factory."

This enterprise would be a "clearing house for ideas, an agency you might say where people come to get ideas or to dispose of them."[11] The announcement was illustrated by a sketch of a robot sofa that could give massages or turn into a "love nest" on command. A sophisticated dadaist joke? or a serious, albeit ludicrous, business venture? His private notes for the scheme were so deadpan that they provide no entry into his motivations. But in either event and whether consciously intended or not, Spohn had made a statement that the artist's task was not representation, but the trial of unusual, perhaps even goofy, ideas. The artist, by exploring the edges of practicality, would be the person who determined which ideas were truly new and which were simply weird. Spohn's persistent conflicts with his parents over how he would make a living, as well as his own internal conflict between making art and making a living, were temporarily resolved in attempting to define a social role for art that went far beyond making images. Art was a mode of invention even when reduced to a parody of Franklinesque ingenuity. Spohn marks the entrance in this study of another character type, the alterego to the promoter transforming limitations into assets: the trickster figure, wandering on the outside of society, apparently wanting to join but only insofar as he can reveal the absurd heart within ambition.

Ideas Inc. came after Spohn's forced return to America. In 1928, as his thirtieth birthday approached, his parents decided the days of adventure had to end. For five months they incrementally reduced his allowance, justifying their action with warnings that family finances were not as healthy as he assumed. He vowed to tough it out and stay but returned home a second time undernourished and on the verge of physical collapse. Once again his parents nursed him back to health. When he was on his feet, they rented a studio on the outskirts of San Francisco's financial district and set Spohn up in business as a portraitist. To his own surprise, he developed a clientele. Spohn's eclectic training allowed him to produce in either traditional academic or mildly avant-garde styles, depending on his buyer's preferences in world culture.

In October 1929 the stock market crash hit and his customers vanished.

His business folded, as did his father's marketing firm. For the next five years the Spohns experienced a tragic unraveling of their fortunes. His father died within a few months of losing his business. Spohn became responsible for his mother's support, while his brother, once seemingly destined for a good career in engineering, became an alcoholic. Spohn confronted the irresponsibility of his youth. His wanderings had overstretched his father's surprisingly limited capital resources, but paternal generosity had achieved nothing. Spohn was talented, but barely employable. He drifted from job to job, and might have permanently vanished from the art world had not the New Deal provided him with his second opportunity to earn a living as an artist.

Federal subvention of artists started modestly in December 1933 when the Treasury Department established the Public Works of Art Program with funds from the Civil Works Administration. Painters and sculptors qualifying for relief could obtain temporary jobs decorating public buildings and parks. Spohn was one of the first people hired in San Francisco in January 1934. Later the same year, this limited program expanded as Congress authorized the Treasury Relief Art Project to employ artists with no other means of support in decorating 2,500 federal buildings in all parts of the country. In 1935 the Works Progress Administration established the Federal Art Project to provide long-term employment for out-of-work artists. Slightly over 11,000 artists went to work for the WPA. Older, more established artists filled the rolls of the Easel Painting Section, which paid them to work in their studios on personal work, which then belonged to the government. Younger artists, such as Spohn, were assigned to the much more visible mural project.[12]

From 1934 to March 1941 Spohn worked on one or another of the three relief-based arts projects. He created murals of California history and legend for schools, post offices, and military bases across the northern part of the state. Spohn was a skilled and frequently praised craftsperson. Publicists for the WPA often presented his work in local newspapers as evidence of quality of Federal Art Project murals.[13] This success gave Spohn some freedom in a program that was frequently frustrating to creative people. He could choose

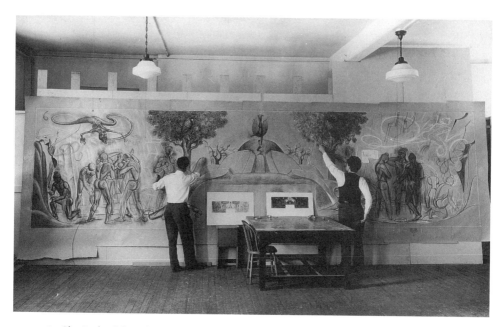

8. Clay Spohn (left) with assistant Alden Clark working on cartoon
for *The Spirit of New Almadén,* 1938. Photograph by Federal Arts Project.
Clay Spohn papers, Archives of American Art, Smithsonian Institution.

his subjects and faced little criticism of his cartoons. The murals were always representational, but Spohn pushed his style as far as he could in the direction of simplified planes. In *The Spirit of New Almadén,* a reworking of a Costanoan myth for a high school auditorium in Santa Clara County, Spohn abstracted the modeling to achieve flatter, less sculpted figures than was typical of WPA art in California (fig. 8).

Like Helen Lundeberg working in southern California, Spohn did not consider any of his WPA work to be "painting." It was all "illustration." He acknowledged that the job had been an interesting experience, but his main satisfaction came from giving his "clients," the people he met in the schools, military bases, and office buildings where he worked, something with which they would be happy to live for years. He hated the bureaucracy that infested the Federal Art Project. He had to submit all his plans to county committees consisting of local politicians and established artists not employed in the relief

efforts. These committees reviewed all project topics and designs for suitability to community tastes. Once they had approved a cartoon for a mural, any further changes, however slight, had to return to the oversight committees for their concurrence. Bureaucratic process made it extremely difficult for artists to engage in creative give-and-take with the local people who would be using the building and whose input Spohn found most valuable.[14]

The New Deal federal arts projects were embroiled in political controversy throughout their brief existence. A majority of state governments, which appointed the county oversight committees, lobbied Congress to transfer the programs entirely to state control. They argued that appointees from Washington were insensitive to local traditions and tastes. Whether such charges were true or not, governors wanted to include jobs in the various arts projects in the patronage they distributed. Established professional artist groups, such as the national Fine Arts Federation and state groups such as the California Watercolor Society and the California Landscape Painters Society, opposed the federal arts projects as unfair competition. Private artists found themselves excluded from most government-sponsored decoration, a market that prior to the depression had been a lucrative source of income for artists with the right political connections. These groups preferred elimination of the means test that limited participating artists to those who would otherwise be on relief. They also supported transfer of art funds to the state level where they would have more influence on contract allocation.

Artists working in the program had to placate federal supervisors edgy about anything that might offend a congressman and state-appointed oversight committees often hostile and out to prove that federal support for the arts was a waste of money. In addition, many artists resented stylistic limitations. The program was a subsidy for the individual, but not for development of the individual's vision. On the other hand, the Federal Art Project allowed artists to develop a body of work. Spohn admitted that the WPA had not been time wasted because the work had forced him to develop disciplined, efficient work habits.[15]

In 1941 Spohn went to work as a draftsman in a naval shipyard. Despite twelve-hour shifts, for the first time in nearly ten years he started producing purely personal work again, depicting the disturbing images bubbling out of his subconscious. The fall of Paris provoked a profound inner crisis for Spohn. One of his first war-inspired works was the mixed-media *Wake Up and Live*. He painted a life-size fly on a board set in the back of a box, then attached a fly swatter with a spring and pull chain so that a viewer could pull the chain and make the swatter hit the fly. "The idea behind it," Spohn explained, "was that if we didn't wake up to the real facts that were going on with the war in Europe, and so on, we might find ourselves in a bad way. But no one interpreted it this way." When it was exhibited in the fall 1941 San Francisco Art Association Annual, audiences thought Spohn was making a satirical comment on the show and on painting in general Spohn submitted the work to the painting section, but the jury refused it, angrily denouncing it as dada junk. He then resubmitted it to the sculpture section, which in turn passed the piece to the commercial and industrial art section. After much debate, that jury panel agreed to include Spohn's piece, but only so that San Francisco would be allowed to see what had upset so many people. After two days, the annual's governing board removed the piece from the show because of attempts to destroy it. San Francisco's first dadaist provocation was particularly ironic; it existed only in the imagination of those good burghers for whom culture was still a trivial form of moral rearmament.[16]

Spohn's next project was a series of gouaches, "Fantastic War Machines and Guerragraphs," painted in early 1942 and inspired by nightmares he suffered after Pearl Harbor (fig. 9). The objectification of inner psychological tension might qualify these paintings as surrealist exercises, but Spohn refused a surrealist label for the series. He preferred a more homespun term, "prankisms." While the surrealists believed that bringing forth the imagination into the light of day was essential to the task of human liberation, for Spohn, the imagination was part of the technology that made America so powerful and,

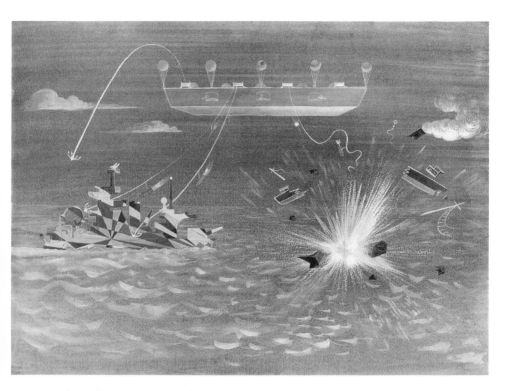

9. Clay Spohn, *Fantastic War Machine*, gouache on paper, 1942.
Oakland Museum, Gift of Peggy Nelson Dixon.

therefore, made life in the modern world so uncertain and frightening. The
Idea Factory he had fantasized about in 1929 had taken root in the war indus-
try; no idea was absurd if invincibility was the goal. In his exhibition state-
ment, the artist explained that war made guarantee of infallible aim the sole
goal of invention, and anything that conceivably might fit that aim was bound
to be tried.[17]

Spohn's new work brought him to the attention of Douglas MacAgy
(1913–1973), curator at the San Francisco Museum of Art. MacAgy observed
that Spohn's war machine gouaches were important statements on the war be-
cause the B-29 was a more vivid and truthful symbol of America at war than
GI Joe. America's victory would flow from the wondrous efficiency of its

machine culture, yet the power of American machinery meant abandoning all pretense to individual empowerment. "The inventer himself is a potential victim. At the service of each side, the machine attacks both," MacAgy wrote in a 1944 essay on Spohn's work. American technology, necessary to prevail, challenged the power of the human spirit and the omnipotence of thought. Citing Freud's *Totem and Taboo,* MacAgy argued that in the era of machines only in art "has the omnipotence of thought been retained." MacAgy predicted that the new society ushered in by American victory would inevitably increase the social power and presence of artistic production. Artists would be called upon to convert the universe-threatening power of the war machine into an object of wonder and thereby restore to humanity "a sense of omnipotence" untenable in the face of the technology society had developed. MacAgy saw art increasingly becoming "a narcissistic adventure," but even more necessary than ever before in history if people were to find the courage to live with the technology their society had brought into being. "The playful ingenuity of these creations gives them an individuality, but of a kind which cannot be mistaken for independence. It appears as a rather exuberant exercise of control over what might have been a wayward monster . . . the vitality of their representation is an effective substitute for the exciting characteristic of self-sustained motion in the machine of wonder."[18]

MacAgy arranged Spohn's first one-artist show. He also secured for the artist a part-time teaching job at the California School of Fine Arts, a position that became full-time in 1945 when MacAgy became director of the school. MacAgy's predictions about the postwar status of art seemed partially fulfilled with a sudden, unexpected expansion of the school's student body with returning veterans. The school under MacAgy's direction and with Spohn as one of the principal instructors became a vibrant center in the evolution of abstract expressionism. From 1945 to 1950, Spohn, approaching and then passing his fiftieth birthday, suddenly was a leader in society, one of those who would alter his country's view of art. Nonetheless, his success has some-

thing uncanny about it, as if it were merely a trickster's illusion. His paintings are seldom seen. His most important work from the period has vanished. His name is known only to specialists, yet his contemporaries considered him a profound inspiration. Spohn's object-image sleights-of-hand show how in the postwar period in America the power of art transferred from objects ("monuments") to ideas, hopes, and memories.

This transfer took place first of all in a special group of students, those veterans who, for absolutely no practical reason, turned to art when they were given the opportunity to achieve their educational dreams. The GI Bill of Rights, passed in 1944, proved to be one of the most important pieces of legislation ever affecting the arts. By offering generous educational benefits to veterans, Congress purposefully expanded education in every field, including those to which it gave no thought. Indeed, it voted down a proposal that would have restricted veterans benefits to courses of study leading to employable skills. Distrusting the process of government rationality, Congress preferred to rely on individual self-interest to achieve the greatest possible good. A desire for self-improvement brought new art, drama, dance, and writing schools into existence, and revivified old, waning schools. Mature artists like Spohn found employment as teachers, employment that, unlike work for the depression-era programs, left them free to pursue their personal vision of art. Perhaps as important, the explication and rationalization of teaching methods may have encouraged them to carry their investigations to logical extremes.

The numbers of students who passed through arts training programs were so large that a "community" was founded, one much larger than the private market for art could possibly engage. It was a "community," in part because the professional basis of the arts was temporarily thrown into confusion. With no possibility of earning a living through their work, most young artists placed more importance upon the spiritual aspects of their vocation than the practical. In this new context, an oddball character like Clay Spohn, far from being simply a maladjusted eccentric, became an exemplary model for a gen-

eration of artists that, like him, sprang into being suspended between commerce and imagination.

Between 1945 and 1956 two and a quarter million veterans attended college-level schools under the GI Bill (65,000 were women). By 1947 total college enrollment in the United States had jumped 75 percent over the prewar record. The number of students attending state universities was more than twice the number enrolled in the prewar period. Even private universities, with higher tuition and often stricter admissions requirements, had record jumps in attendance.[19]

Educators were surprised by the educational choices veterans made. The assumption that their primary goal would be to learn practical skills was overturned when veterans who attended college-level institutions preferred liberal arts education over professional training. A study at UCLA in the 1946 academic year showed that veterans were more likely than nonveterans to enroll in humanities majors and were less likely to choose science, business, or education.[20] The author of the UCLA study also noted that the grades of veterans were "appreciably higher in all groups and in all semesters."[21] The Carnegie Foundation for Higher Education financed a study of veteran performance at twenty-five institutions of higher learning during the 1946 academic year. The researchers found that in every school included in the study, veterans earned higher grades than nonveterans, even though veterans did not feel that grades were, or should be, important motivating factors. Examining background characteristics and motivations to test possible explanations for the superiority of veteran performance, the study's authors determined that, while veterans were more likely to come from families with lower educational levels than nonveterans, both groups of students came from such widely heterogeneous backgrounds that no explanatory conclusions could be drawn from either family origins or prior education. Neither did better utilization of time

account for the veterans' higher grades, since veterans with high grades did not by and large spend more hours studying.

Examination of reasons for seeking a college education yielded answers that were also unexpected. Forty-four percent of veterans responded that "self-improvement" was their principal aim in going back to school, an answer that only 12 percent of nonveterans selected. Fourteen percent of veterans responded that their education was directed toward entering a profession, compared to 37 percent for nonveterans. Nearly equal and sizable blocs—41 percent of the veterans and 48 percent of the nonveterans— indicated that "making more money" was their primary goal. The heterogeneous nature of both the veteran and nonveteran student population makes generalizations about motivations selected from a multiple choice questionnaire difficult. The greater number of veterans choosing "self-improvement" as a goal suggests that many had a humanist rather than an instrumental view of education, which would be consistent with the greater tendency to select majors in the liberal arts found in the UCLA study.

The only factor the authors of the study would hypothesize as a possible explanation of veteran performance was that a larger number of veterans made an active choice to go to school; they were no longer following a predetermined life or career course. "The superiority of the veteran student," they wrote, "was not due primarily to any psychological characteristics associated with greater age or with experience connected with military service." Much more important was "a process of self-selection growing out of a complex of circumstances which included the educational benefits of the GI Bill and the delaying of college matriculation on the part of veterans. Those veterans who decided to go to college included a larger *proportion* of strongly motivated and academically-minded men than would otherwise have gone to college."[22]

The GI Bill profoundly affected colleges and universities by expanding the potential student body. The effects of the bill were even more significant for

art schools. From fall 1946 to spring 1952, veteran enrollment ranged between 40 and 69 percent of total student registration at the five most important art schools in California: the California School of Fine Arts in San Francisco, the California College of Arts and Crafts in Oakland, and the Chouinard Art Institute, Art Center School, and Otis Art Institute in Los Angeles. If only full-time students are considered, the impact of veterans upon art schools was even more dramatic. When part-time, evening, and Saturday students are excluded, the percentage of veterans was never less than 70 percent of students at these schools from 1946 to 1952, and was frequently well over 80 percent. Only in the spring of 1953, as the World War II veterans benefit program wound to a conclusion, did the number of veterans begin to decline.[23] The demand for art education stimulated by the GI Bill was so great that twenty new art schools were organized to offer training to veterans, eleven of which were still open in 1956.

Government subsidy for the arts had shifted from the prewar Works Progress Administration to schools that were in many cases financially dependent upon veterans' educational benefits to a degree that most general-education colleges and universities were not. The subsidy was invisible since it was part of a much larger program that had no policy goals regarding the arts, but it was still there shaping the opportunities for both older and younger artists.

No studies comparable to the Carnegie Foundation report were done of art students to determine their particular motivations. Oral histories have documented the motivations of those who later established successful careers. Some, like Lee Mullican (b. 1917), completed an education begun before the war. In Mullican's case, military service (he drew maps for the Army Signal Corps) was a critical factor in forcing him to confront and define his life goals. As a teenager he knew that he wanted to be a painter. Raised in rural Oklahoma, he had no models to follow for developing a career, and his knowledge of developments in American and European art came entirely from magazines. At the urging of his parents, when he entered college, he prepared for a career as a high school teacher, assuming that painting would be his private

hobby. Then, after the collapse of France in June 1940, selective service registration became mandatory. Mullican decided he simply could not return to the University of Oklahoma and pursue business as usual. At the last minute before fall term classes commenced, he enrolled in the Kansas City Art Institute. He assumed he had only one year before he would be drafted, and in that time he would do only what he wanted.[24]

Mullican's sense of self-determination thereafter was inextricably linked with the exploration of modern art. He "cherished and celebrated every discovery" in music, foreign films, literature, and painting. "It was just all awakening." If he was to survive, he had to live as an artist and painter. Modern art meant first and foremost abstraction, which Mullican defined as the creation of an alternative world. Representation, he believed, limited an artist to interpretation of the currently existing world. The idea that one should paint the world as one saw it was a trap because a representative artist was forced into assuming that the existing world was the only one that could be. Abstraction was the necessary avenue for imaginative freedom, for a full critique of reality and the positing of unlimited alternatives. These alternatives would not yield themselves easily. Abstraction was not simply a flow of fantasy. It required discipline to develop a logically coherent and emotionally satisfying alternative reality, one that *could* exist. The alternate world sprang from deeply emotional reactions to phenomena that presented themselves in nature. "There was a pleasure in doing that thing which did not look like anything else. It was completely the invention of a new world."[25]

Mullican knew that he wanted to be an artist and overcame his hesitancy when he faced the reality of war and its possible consequences for his own life. Others like Connor Everts (b. 1928) had never considered, even in a casual way, the possibility of a career as a painter. Everts was born in Tacoma, Washington, but raised in Los Angeles, where Everts's father was an organizer for the International Longshoremen's and Warehousemen's Union. Everts was drafted in 1945 and spent two years in the navy. After his discharge, he decided on the spur of the moment to enroll at Chouinard Art

Institute. He was surprised to find that most of the men in his art classes were like him: discharged veterans from working- and lower-middle-class backgrounds taking a plunge to see if they had any talent.[26] Everts's near total lack of knowledge about art made his entrance into the professional art world difficult and frustrating. Every critique was "agonizingly embarrassing," he recalled, "because my work was so absolutely terrible. It was so amateurish." He overcame his failing well enough to win a Fulbright fellowship to study in England in 1951.[27]

Robert Irwin (b. 1928) likewise recalled that he had no interest in fine art at any time prior to his discharge. As he thought about what he might do as a civilian, he considered that he had a "natural talent" for drawing pictures of racing cars, airplanes, and surfers. He decided that he would go to art school and find out how to become an illustrator. He recalled that he had been naive and totally unintellectual, but once in school he realized that imagery itself did not interest him. He enjoyed the physicality of art, the pleasures of surfaces, line, and color. Only as he began to work with the materials did he begin to feel a passion for the career he had chosen. Sometimes the reasons for entering art school were entirely frivolous, even if the final result was a lifetime commitment to painting. Jorge Goya (b. 1924) had been stationed in the Bay Area during the war and decided he wanted to stay after the armistice. Art school intrigued him after he saw a show of contemporary art at the San Francisco Museum of Art, but he also figured art school would be easier to enter than a regular college and using the GI Bill would give him the funds to stay in San Francisco without having to find a job.[28]

Certainly it would be wrong to overemphasize the capricious way in which many GIs came to the arts. Frank Lobdell and Nathan Oliveira had both known they wanted to study painting before their military service. Each had taken classes at a local junior college. The GI Bill allowed Lobdell to attend the California School of Fine Arts full-time, while Oliveira pursued both bachelor's and master's degrees at the California College of Arts and Crafts.

Their benefits allowed them to focus on developing their talent and to do it in the best possible environment, instead of going to a less expensive public school. Lobdell, for one, pursued his studies in a systematic way: after spending three years at the California School of Fine Arts, where he was in the thick of the abstract expressionist revolution, he then transferred to the École de la Grande Chaumière in Paris to expose himself to a more traditional approach to training.[29]

As the GI Bill became an established part of American life, some younger artists actually looked forward to military service. Wally Hedrick (b. 1928) had wanted to attend the California School of Fine Arts after he graduated from high school, but his family could not afford the fees. He spent three years hanging around the school, sneaking into classes, but he could not pursue a set course of study. After President Truman sent United States forces into Korea, Hedrick was drafted. Rather than resenting military service, he was hopeful that Congress would extend veterans benefits to cover Korean War service. In 1952 Congress approved extension of the GI Bill programs. Hedrick recalled, "As soon as I got my discharge, I just knew that I had it made because [enrolling in the California School of Fine Arts was] what I really wanted to do." For African-American artist John Outterbridge (b. 1933), military service itself suggested that he might be able to make a living as an artist. Stationed in Germany during the Korean War, Outterbridge began his career by making camouflage. He did the assignment with such skill that he was soon spending his time producing the base's posters, banners, and murals. When he left the service in 1955, Outterbridge followed the advice of his commanding officer and enrolled in an art school to develop his talents more systematically. Noah Purifoy, another African-American artist, arrived at Chouinard Art Institute only after having first earned a master's degree in social welfare. He had to overcome his misgiving that art was too frivolous an endeavor for a black person. He decided that since it was government money, he could afford to experiment. He would spend a trial year in art school. If

his teachers felt he had promise, he would continue, otherwise not. The whole prospect was a frightening gamble, but one he could take only because he felt the conditions were such that a true test of his abilities could be made.[30]

Accounts of the decision made to attend art school tend to combine frivolous and serious explanations. Perhaps Everts, Irwin, and Goya made their tales of entering art school comical and trivial so they could shunt aside the painful doubts they must have felt about the practical wisdom of their course. As Purifoy indicated, his decision was a "gamble," as self-indulgent as a trip to Las Vegas because there was little likelihood that the several thousand graduates each year from California art schools and college-level art programs could find art-related employment, much less establish careers as painters or sculptors. Government support strengthened his courage to explore his self-potentiality, as if the monthly check were some sort of public affirmation that a purely personal interest might have legitimacy. If pursuing personal desire was frivolous, public subvention allowed the adventure to be engaged in a serious manner, increasing the pressure on the individual to live up to his expectations, to make the gamble, which was his country's as much as his, less risky.

Accounts of teachers and fellow students stress the commitment and seriousness of the GI Bill generation. Jay DeFeo (1929–1989) enrolled in the art department at the University of California, Berkeley, in 1947. She thought most of her teachers were stodgy and old-fashioned, imitators of Cézanne and Picasso. Her fellow students, however, so many of them veterans, insisted on the importance of abstract expressionism as a break with previous avant-garde painting styles. She emphasized the seriousness of the veterans in the art department at Berkeley and spoke of their example as a positive challenge to herself to rethink her assumptions about quality in art. Their discipline helped confirm her own efforts to impose discipline upon her own work. To compete with them was a sobering experience. While she acknowledged that many had not been good artists, she recalled that the milieu the veterans created had been more important to her training than the pedagogy

of her teachers. Richard Diebenkorn (1922–1993) taught at the California School of Fine Arts from 1947 to 1950. He thought that the "GI Bill people were rebellious and [set to] turn things over, and didn't paint where they were supposed to paint in the school . . . it was pretty chaotic." The veterans were not necessarily better painters or sculptors than preceding generations, but they did not accept the dictums of their teachers. They wanted more than a set of rules about how to go about the craft of art. Diebenkorn found the students demanded serious intellectual reasons for everything. The shift toward art as a philosophical rather than a practical discipline was grounded in the sometimes endless discussions that increasingly engaged teachers and students.[31]

Elmer Bischoff (1916–1991) also taught at the California School of Fine Arts in the GI Bill period. He felt that the students came in with a spirit very different from what he had experienced before the war as an undergraduate in the Berkeley art department. They had a "sense of urgency about things," "a religious character" that shaped their expectations about how art could help society.[32] Bischoff's reaction to the students was shaped by his own experiences in the war. He served in Britain as an officer in the Army Air Corps at a base conducting daily bombing runs over Germany. When he arrived, he had been "absolutely baffled by the chaos and the complexity" of the tasks involved, but "absolutely amazed at the innate know-how that was displayed. This was very much of a democratizing experience like I'[d] never encountered before." His prior life had been sheltered, giving him contact only with people from university-educated, middle-class backgrounds like his own. Never before in his life had he been so dependent upon people from other backgrounds. He was surprised to find out that "Cal, the fraternity, all seemed less important to being a leader after the war, [it was] not really preparation for getting a job done." War service humbled his opinion of himself, but yet raised his sights. If he could expect more of people, he could expect more of himself.[33]

His experiences teaching after the war replicated his wartime experiences

by challenging his basic attitudes about art and negating most of what he had learned at Berkeley:

> Art to me had been an external acquisition, again like getting a degree, and you learned these things, and you learned those techniques, you learned these powers of composing and organizing and, to a certain degree, of inventing, certainly you learned stylistic attributes. And then you manipulated all this, very much like a commercial artist in that sense. You didn't dig any further, you didn't come up with things that bewildered you. . . . You dealt with things you had full control over, you were certain about. You might even meet deadlines, you were that sure.[34]

Faced with students like the men he had encountered in England, he had been prepared for excitement, energy, and discipline. He had not anticipated how that drive to live up to one's duties would affect the practice of art. The push to explore the possibilities and the limits of abstraction came out of a "free-wheeling atmosphere" in which the distinction between instructors and students dissolved, without anybody planning for it, into a relation between older and younger artists, who in truth were not very far apart in age. There developed an openness in which students and faculty freely criticized each other's work in progress, "nobody trying to be top dog." It sounded idyllic, the interviewer commented, perhaps with a tone of skepticism. "It was idyllic," Bischoff rejoined, "but with still a strong feeling of individuality." The only thing to which he could compare the school was "a community of monks, all praying, but each in his own way." And every piece of art was done "as though you're talking to all mankind over the face of the globe. . . . The assumption was made that there was nothing esoteric and nothing secret about what was being done, about the world of paint and shapes and so forth. That this was innocent and direct and available as anything could possibly be."[35]

No doubt there was an element of nostalgia for a lost paradise running through Bischoff's account of the California School of Fine Arts. He recog-

nized it himself and several times cautioned his listener that darker undercurrents would emerge as they plunged more deeply into the history of the school. But his sense of transformation remained. While teaching at the school, he put behind him the neoclassical cubism that he had learned as a student. He shed the pride of being able to say "I know how" to embrace the paradoxically more goal-oriented position "I don't know how" (but I'm going to find out).[36] The GIs taught him that art did not come from the past but always struggled to reemerge in the present, a lesson that freed him to find his own vision as a painter.

The California School of Fine Arts was an unusual place, not simply because of the nature of the students. A singular pedagogical vision emerged there which allowed the promise inherent in the broadening of educational opportunity to achieve an unusually full realization. We must now look more closely at its history from 1945 to 1950, when it became a center for exploration in American painting and showed how the school environment might provide the institutional grounding that artists desperately needed if they were to be productive citizens.

4 Revolution at the California School of Fine Arts

Abstract Expressionism in San Francisco

The California School of Fine Arts, founded in 1874, was the first art academy west of the Mississippi and the fourth oldest art school in the United States. The school was a division of San Francisco Art Association, a non-profit membership group that brought together artists and art patrons to promote the visual arts. The association also ran the San Francisco Museum of Art, sponsored an annual juried show open to all members, and hosted the Montalvo Summer Opera Workshop in the wine country sixty miles south of San Francisco. The school was located on Russian Hill a few blocks from the North Beach area in a lovely Mediterranean-style building with an extraordinary view of the bay, a setting that made it a popular place for high society gala events in the 1920s and 1930s. The school had the reputation of having the most conservative curriculum in the state, with a faculty that steadfastly clung to the beaux-arts academic tradition.

By the end of World War II the school was on the verge of permanently closing. Depression and war had reduced the student body, but this school suffered more than others in the state. In 1942 the school's director quit when there was no money to pay his salary. William Gaw (1891–1973), one of the faculty members, filled in as acting director until a replacement could be named, but the board was unable to find anyone willing to take over what appeared to be a doomed institution. At the end of 1944, the board of trustees considered shutting the still-directorless school and selling off the real estate.

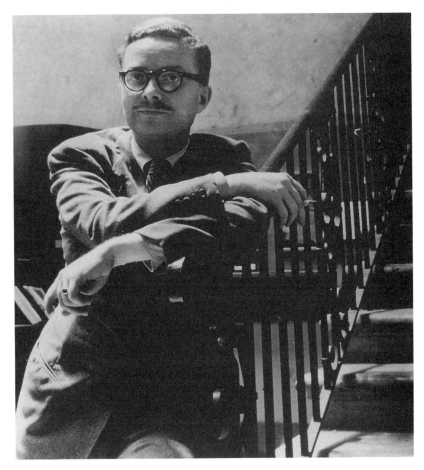

10. Douglas MacAgy, 1945. Courtesy of the Library, San Francisco Art Institute.

Most of the faculty had left by then, only a skeleton program remained, and Gaw, having become chair of the art department at Mills College across the bay in Oakland, was unwilling to continue even as interim director. At that point, thirty-two-year-old Douglas MacAgy (fig. 10) proposed to take over the school, provided that he had a free hand to revise the curriculum and hire faculty as he saw fit. The board agreed to his conditions and appointed him director, effective July 1, 1945.

MacAgy, a student of Albert Barnes, had come to San Francisco in 1940

to be a curator at the San Francisco Museum of Art. His wife, Jermayne MacAgy (1914–1964), found work as curator of education at the California Palace of the Legion of Honor. When her boss went into the navy, she became acting director of this museum dedicated to old master and academic painting. The MacAgys quickly became the most active proponents of contemporary art in the Bay Area. Jermayne initiated an exhibition program of young artists from all over the United States. She staged the first Jackson Pollock exhibition in San Francisco in 1942 and followed it with one-artist shows by Mark Rothko, Robert Motherwell, Clyfford Still, and Arshile Gorky. Douglas focused more on assisting emerging talents in the Bay Area. He also proved to have good instincts for showmanship. Two of his best-attended exhibitions were a survey of circus art and a look at the influence of jazz on visual art and movies, a show that reflected his involvement as the drummer in an amateur Dixieland band.

MacAgy invited several painters he had met as curator to join him in remaking the California School of Fine Arts into an experimental center. Edward Corbett (1919–1971), David Park (1911–1960), Hassel Smith (b. 1915), and Clay Spohn formed the core of the new painting faculty, joined in 1946 by Elmer Bischoff and Clyfford Still (1904–1980), with Richard Diebenkorn added in 1948. He recruited the independent surrealist Dorr Bothwell (b. 1902), who also taught classes in textile design. He invited Ansel Adams to organize a department of photography and hired Adams's younger colleague Minor White to be the principal photography instructor. Mark Rothko, Mark Tobey, Ad Reinhardt, Man Ray, and Salvador Dalí came to teach for individual sessions, and MacAgy spent three years unsuccessfully trying to convince Marcel Duchamp to come out of "retirement" and join the regular faculty of the school. Old school brochures had described its faculty as "meticulous craftsmen"; MacAgy struck out these words from public relations materials and stressed instead that his teachers were "strictly contemporary in spirit."[1] MacAgy was convinced that only by making the school the

center for the most advanced thinking in the visual arts would it be able to survive.

The dire financial situation began to turn around as the first veterans enrolled in the fall term 1945. By the following spring term, the change in the school's fortunes was stunning. Enrollment leaped to 1,017 full- and part-time students, 350 percent greater than the previous year. Full-time enrollment was 71 percent greater than in the spring term 1929, the previous high-enrollment record, while night students increased 38 percent over 1929. MacAgy noted in his report to the board that, in addition to veterans, enrollment had been increased by "many others who are using money earned during the war for further education and refresher courses."[2] Registration and school income increased annually through 1949, and trustees, pleased by the success of the contemporary-oriented program, responded by giving MacAgy and his faculty salary increases averaging 20 percent a year, while agreeing to all of MacAgy's proposals to expand the curriculum.

Every class was reviewed and restructured. An experimental class in the history of art was introduced that substituted student sketches for lectures. Believing that the study of motion was essential to painting, MacAgy introduced a class in abstract filmmaking. Another class attempted to "outwit prejudice," by having the teacher call out subjects for the students to sketch in quick thirty- or sixty-second sketches. Faced with hundreds of sketches on a variety of suggestions—scenes, objects, emotions, actions—students were to learn what their stereotypical graphic responses to various situations were. The faculty organized exercises in surrealist techniques, but they were not supportive of programmatic painting. They used automatic techniques to overcome the subconscious, not to re-create it. Elmer Bischoff recalled that the most fundamental change in the curriculum was ending sequential skill acquisition. In the 1940s most schools, whether they followed beaux-arts, arts and crafts, cubist, or Bauhaus principles, had first-year students work entirely in black and white. In their second year, they moved on to color theory.

Only after mastering a series of exercises did students put paint on canvas. At the California School of Fine Arts, all prerequisites for the painting classes were eliminated. From the first term on, students spent the majority of their time in the studio painting or sculpting, and MacAgy ordered that studio facilities were to remain open twenty-four hours a day so that students could work whenever and as long as they needed. Students were free to choose their theory and technique classes as they explored particular problems in their own personal work. "It was taken for granted," observed former student Hubert Crehan (b. 1918) in 1956, "that almost everyone knew why he was there, that he would work independently, seeking guidance and stimulation in the discussion of ideas and problems stemming from painting."[3]

In one faculty meeting in 1947, the painting teachers debated whether they should continue to offer courses in life and figure drawing. Most agreed that students who wished to "develop an ability to draw what they see" should feel that they could acquire that skill, but they needed to learn that vision was a more complicated affair than mere representation. Hassel Smith, who taught most of the drawing courses, was not satisfied with that formulation. He angrily labeled the belief that vision had access to raw "reality" "a monstrous superstition." Everyday vision was a product of ideology, he stated, and creativity depended upon developing the techniques that allowed an artist temporarily to pierce the illusions of ideologically manipulated sight. To concede that artists could ever draw something "exactly as they saw it" abandoned the goal of all serious artists to force viewers to forget how they had seen things previously. MacAgy commented that Smith's "line of thought" was vital and asked his faculty to consider the relationship of vision, ideology, and representation when planning their courses.[4]

MacAgy continued training in commercial art and in crafts such as jewelry and ceramics because he thought such skills helped artists earn a living. But he argued that students whose primary interest was in making money would, and should, gravitate to other schools that concentrated on the applied aspects of art. His prediction that postwar students at the California School of Fine

Arts would be primarily interested in the pure rather than the applied arts proved correct. Students continued to request new classes in painting and sculpture. They wanted more guest teachers from New York who could bring news of the latest East Coast developments in abstract expressionism. As the GI Bill allowed students to switch schools easily if they were not satisfied with the program, MacAgy warned his board that the school had to put more money into experimental arts or risk losing the veterans who brought in over two-thirds of the school's income.[5]

Indeed, full-time students were much more likely than part-time or night students to focus on fine arts classes. Teachers committed to abstraction taught the largest classes and had greatest contact with the student body. Teachers with a representational approach, generally cubist or surrealist inspired, had approximately half the students of the teachers committed to an abstract expressionist program. Commercial art teachers saw less than one-third the students seen by the fine art experimentalists.[6] MacAgy argued that the students themselves had made his core group of painting instructors the heart of the school he wanted to build, but he also claimed, with justification, that his school was not based on a sectarian aesthetic program. Representational painting and sculpture, advertising art, and industrial design remained important parts of the curriculum, but subordinate to a conception of art as exploration. Serviceability, MacAgy told his students and teachers, need not be "an intrinsic characteristic of art," but for those who wanted careers in industry and commerce, an experimental training would better prepare them to generate truly innovative designs.[7]

The California School of Fine Arts and Abstract Expressionism

In 1944 Robert M. Coates observed in the *New Yorker* that a new style of painting had suddenly proliferated throughout New York's galleries. This work was not abstract, by which he meant compositions of nonrepresenta-

tional geometric or biomorphic forms. Nor was it surrealist, in the sense of recording psychic imagery, though Coates saw that the painters utilized automatic techniques borrowed from the surrealists. The "free-swinging" and "spattery" method of applying the paint reminded him of expressionism, but there were "only vague hints at subject matter." He concluded that "some new name will have to be coined for it, but at the moment I can't think of any." Within two years, the term "abstract expressionism" had come into general usage to describe the new nonfigurative painting that Jackson Pollock, Robert Motherwell, Mark Rothko, William Baziotes, Arshile Gorky, Willem de Kooning, and a score of others were producing. Unlike previous artistic movements in the United States, abstract expressionism was very much associated with one city—New York—and helped establish the city's post–World War II reputation as an international cultural capital.[8]

Few artists in California were immediately influenced by the new development. Only at the California School of Fine Arts was abstract expressionism taken up with unabashed enthusiasm. Hubert Crehan recalled that, when he started at the school in 1945, there was a prevailing sense of dissatisfaction with "the impasse bequeathed by cubism," but that none of the teachers presented convincing alternatives. He thought that the break came from a student, John Grillo (b. 1917), who spent several months in New York before enrolling at the San Francisco school in the spring term 1946. Grillo's work, influenced by what he had seen in New York, presented "partially realized open, free forms." Crehan reported that Grillo's sketches had a sharp and immediate impact upon other students and teachers, initiating a rush to elaborate upon the visual ideas implicit in Grillo's somewhat primitive studies. Exhibits of paintings by Jackson Pollock, Mark Rothko, and Arshile Gorky at the San Francisco Museum of Art in 1946 reinforced the influence of the new work emerging from New York.[9]

The San Francisco school of abstract expressionism was derivative from the original impetus in New York, yet a distinctive look quickly emerged as

artists reworked the ideas within the highly interactive environment at the California School of Fine Arts. Most striking was the absence of action painting, the sublimation of image into gesture stretching across the canvas in brush strokes so individual that the act of applying paint to canvas became a statement of self-identity infinitely more transcendent than any images an artist conceived. Harold Rosenberg felt gesture was so central to the new school developing in New York that he proposed the term "action painting" as a substitute for abstract expressionism. The encounter of material and direct activity without any preconceived image led to a "painting that is an act inseparable from the biography of the artist."[10]

In San Francisco, brush work remained subsidiary to other forms of painterly expression. The paintings remained visual projections rather than muscular extensions. Thomas Albright located the particular characteristics of San Francisco abstract expressionism in the use of large areas of paint, organized into splotchy, irregular shapes, a style that precluded reliance upon gestural showmanship. San Francisco painters also favored the use of transparent washes in order to create layers of overlapping, superimposed shapes. The most common colors were earth browns, dull reds, ashen blacks and greys (pl. 4), sometimes contrasted with bright, not brilliant, oranges and yellows (pl. 5). Albright saw a pastoral element in these paintings; mud, crust, silt, and clouds provided the hidden subtext for forms and colors.

San Francisco painters developed an excessively thick use of impasto that paralleled the surface effects that the New York school derived from gesture. Impasto gave a sculpted quality to the surface and allowed for a wide variety of textures ranging from gentle ripples to "tortured" peaks lifting off the canvas. Streaks of color appeared as cracks rendering masses apart, or sometimes as subsurface phenomena on the verge of breaking through and creating new relationships on the superficial picture plane (fig. 11). Painters layered strokes on top of each other so heavily that often the paint did not dry completely. Wet-on-wet application gave paintings a viscous feeling, as if the images were

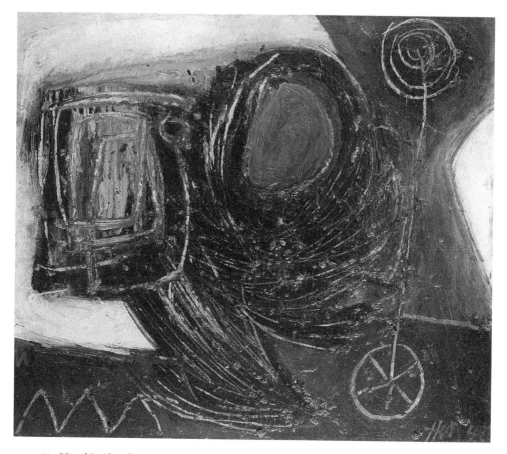

11. Hassel Smith, *Chrystopramos in Turmoil,* oil on canvas, 1948.
The Menil Collection, Houston. Photo: F. W. Seiders.

provisional and tidal forces were trapped beneath the canvas, straining to break free and eradicate the painter's work in the process. The temporary quality of the paintings was often reinforced by the use of substandard, less expensive materials such as denim instead of canvas.[11]

The most commanding presence on the California School of Fine Art's faculty was Clyfford Still, the only nationally recognized pioneer of abstract expressionism whose work developed entirely outside New York. Born in North Dakota and raised in Spokane, Still studied art at Spokane University and Washington State University, where he taught for eight years before mov-

ing to the San Francisco Bay Area in 1941 to work in the war industry. Unlike most other American abstract painters, Still had a profound disdain of cubism and every variety of French avant-garde. In 1929 he turned to Edvard Munch and Chaim Soutine as alternative foundations for a genealogy of modern art. Still's paintings in the 1930s were expressionist studies of the environment around Pullman, Washington, where he lived. The resolution of the problems he posed for himself evaded him as he spent a decade struggling to rework "phylogenetically" the development of painting from 1850 to his time. In 1941 Still abandoned all representation and began experimenting with lines and colors for their own sake, without any element of figurative allusion. He credited the breakthrough to intensive study of Pacific Northwest Coast Indian art, but unlike others who appropriated Native American imagery and myth, Still looked for a way of visualizing that might help him repudiate the "authoritarian implications" present in the "grand tradition" of European painting, but without in any way using imagery meaningful only in the specific context of Indian societies.[12]

His first one-artist exhibit was at the San Francisco Museum of Art in 1943. Critics responded negatively. However, it was not abstraction itself that upset them. Art critics in both the San Francisco and Los Angeles papers were supportive of nonobjective work exploring composition in abstract form. Rather, critics thought the paintings were insufficiently abstract. Still's refusal to provide a clear spatial context for the shapes he displayed seemed a willful negation of the artistic need to bring order out of chaos.[13] For Hassel Smith, however, the show was a revelation. Smith recalled returning several times to view work that was to him of an entirely new approach to painting. The exhibition forced him to consider what he was attempting to do with his own work. In Still's painting the viewer entered an enclosed space ("marsupial, troglodytic, and aquatic," Smith called it), with floor, ceiling, and walls implied, "though none of these limitations upon the space is ever actually encountered." Still's painting, Smith thought, was a "mental bubble" that the viewer entered rather than a window looking at an externalized vision. Smith

was not sure whether this was the discovery of a pure interior vision or of another reality. But his choice of the words *marsupial* and *mental bubble* highlighted the solipsistic aspect of this new approach to painting. Still's painting absorbed the viewer into the cognitive world of the artist. Reference to everything external to that singular vision vanished. The entirely interior statement became universal and established, for that individual work, all possible definitions of "natural." The more a work was a "mental bubble," the more absolute it became. In a process similar to what we observed occurring in Kenneth Rexroth's poetry, Still's approach to abstraction rendered the psychology of individual perception into an apparently universal subjectivity.[14]

It was this "objective" character of Still's work that appealed to Douglas MacAgy and led to Still's joining the faculty in the fall term 1946. MacAgy, as confused as his contemporaries by the new developments in painting, was troubled by the extreme emphasis upon the subjective mental state of the painter that seemed to be a hallmark of the expressionist abstraction sweeping both New York and his school. MacAgy found "authority" in Still's work, a reliance upon an internal structural "logic" that saved the work from the twin dangers of being purely psychological or decorative. He believed Still's paintings were less emotional and thus more directed to further refinement and technical extension than other approaches he had seen. Harold Rosenberg spoke of the painter performing directly upon the canvas, but in Still, the textures, oil washes, color fields, and masses were self-performative, acting out an ideal logic. One of Still's students at the California School of Fine Arts, sculptor Jeremy Anderson (1921–1982) recalled discussions in class when Still proposed that "ideas were souls without bodies," existing eternally but independently of the human realm until an artist through intense concentration caused them to materialize in a painting or sculpture.[15]

In the development of expressionist abstraction, Still stood at the polar extreme of Pollock. As Still's style matured in the late 1940s, color field became increasingly important, and his interests would influence the work of his

friends Mark Rothko and Barnett Newman.[16] But even as he himself moved into color-field painting, Still remained concerned with the material aspect of paint and its application. Still's pictures were marked by thickly troweled textures juxtaposed against thinly applied pigments, while decisively ragged edges helped subvert establishment of a privileged picture plane with stable figure-ground relations.

Still taught two seminars at the school, space organization and drawing composition. In weekly gatherings and in one-on-one encounters, Still spent little time discussing the individual paintings of his students. He spoke instead in general terms of his conception of art history. He frequently used biological metaphors. That ontogeny recapitulated phylogeny, he thought, looking back at his own struggle to master the avant-garde tradition, was as true of artistic development as it was of the evolution of species.[17] A model of biological development suggested that no artist could cling to the past without degenerating. Without rejecting his or her predecessors, the painter died spiritually and creatively. An individual grew by facing the limitations of the past. This could be done by attempting to paint in the style of earlier artists, but the goal was not to emulate "masters." Only by confronting their methods of construction in a direct physical manner could a contemporary painter break the hold of "masterpieces" to stop new vision.

Every authority, Still argued, ossified the least creative aspects of a preceding artist and stymied the development of personal identity. His own path had been one of persistent struggle against the traditions handed to him as sacred. Only painting day after day, he said, trying out but then rejecting the various paths indicated by his predecessors, had led him to a successful resolution of the contradiction between the past and the present:

Neither verbalizings nor esthetic accretion would suffice. I had to accomplish my purpose, my emancipation and the exalting responsibility which I trusted would follow, totally and directly through my own life and hands

. . . until those symbols of obeisance to—or illustration of—vested social structures, from antiquity through cubism and surrealism to my then immediate contemporaries, were impaled and their sycophancy on the blade of my identity.[18]

He put particular importance on the frame of mind that the student artist developed. Most students, he thought, wanted their work to "out-smart, out-original, out-nervousness, out-blah everyone else's." Craving approval rather than success, they "dig and smear and smudge for the Curator. And the Critics."[19]

Still told his students they had no control over their paintings unless they also controlled exhibition and discussion of their work. With his encouragement, in 1949 twelve of his students opened the first "alternative" gallery in California, the Metart Galleries, which occupied the top floor of an old office building in a rundown section of San Francisco.[20] The manifesto of the group stated that Metart Galleries "was formed in direct response to the problem of bringing the work of the creative artist to public attention under conditions which leave the artist freest from outside control." The group rejected the power of commercial dealers to emphasize the decorative aspects of art as they sought sales. They also criticized the power of museum curators to pigeonhole artists and their work in fictional historical continuities that made sense only in terms of an intellectual argument. Art, they said, and this was central to Still's philosophy, lay outside both commerce and history. "The value of an artist lies primarily in his integrity and intelligence as a human being engaged in a cultural activity." In a final rhetorical flourish, the gallery's organizers announced that they hoped to reach "working people" and that Metart would be open in the evenings and on Sunday afternoons.[21]

Most students found Still unapproachable. "Still had a contempt for the general run of people," Clay Spohn thought, "since he felt most of them were stupid fools. He didn't give a damn about anything other than his vision of some kind of ultimate." Ernest Briggs recalled that as a student in the late

1940s, one had to choose between "decorative take-offs, a lot of so-called Klee-type things and very sweet French surfaces" and Still's painting. "It was absolutely a contradiction of all the rest. . . . I mean, if you accepted it, you had to reject the other, and if you accepted the other stuff, you had to reject [Still]." The harshness of the choice had "a very repelling effect, and yet somehow you felt the vitality and fresh air." Jeremy Anderson felt that Still genuinely liberated his students: "The longer people studied with Still, the less their work looked like his."[22]

A small group of approximately forty students coalesced around Still, while a few others ventured to take occasional classes with him. Elmer Bischoff viewed Still and his group as a "school within the school." Refusing even to attend school dances, Still's students held themselves aloof from the rest of the student body and assumed that their work was purer. The hermetic quality of the Still group was emphasized by the studio that he chose as his studio and classroom. Students descended into the basement, proceeded past the boiler room, and then suddenly discovered a cell more appropriate to a monastery. He worked in a large room at the bottom of the school's highest tower. The studio walls rose up a thirty-foot shaft to the ceiling, where a band of clerestory windows let in light without providing a glimpse of the outside world. Still's situation embodied the principle most perfectly, Bischoff thought, that the California School of Fine Arts was "a monastery with a brotherhood composed of members recently liberated from a world of semi-darkness. . . . Once within its walls, the individual felt himself beyond the reach of society in general. Beyond this, for the long haul, the artist himself was seen as needing to stand as a fortress against the dissuading and subversive forces of the outside."[23]

Tensions existed between Still and his fellow faculty because he refused to assume any responsibility for management of the school outside his own classes. He resisted all efforts to coordinate instruction, and he refused to teach any elementary-level classes. He wanted only students who had already determined their artistic goals and had decided that they needed Still to get

there.[24] Disagreements between Still and the faculty led to his resigning in 1948. He removed to New York, but returned to his position at the California School of Fine Arts after a one-term absence. The austere moral stance he imposed on himself required a school environment for support. He despised "the myth of the artist in his studio 'waiting to be discovered'" and proclaimed that "there has never been a time when I was not involved in the art world."[25] He intended to impose his conditions upon dealers and museums. To accomplish that he had to be in the public eye, and his role as star teacher at the California School of Fine Arts provided him with the platform he needed to expound his viewpoint.

Painting as Event

Still's influence on most students and faculty at the California School of Fine Arts was indirect. The intense moral purity of his position appeared validated by his disdain for the market. He was no hypocrite who talked one way, yet acted like everybody else. His work challenged deepest convictions but was so visually powerful that, even if unwilling to walk all the way with him in his aesthetic anarchism, his colleagues at the school had to think deep and hard about what he said, visually and verbally. Hassel Smith, a junior member of the faculty, had been profoundly moved by Still's work since he first viewed it in 1943, but he could not accept Still's idealist philosophy. Smith was a Marxist, and he needed to find a materialist kernel.[26] He struggled with the problem for four years before he began work on his first abstract paintings in 1947 (fig. 12).

In the late 1930s Smith had been part of a painting group that, imitating the example given in France fifty years earlier by Camille Pissaro, Maximilien Luce, and Vincent van Gogh, traveled around the Bay Area painting scenes of California's agricultural life. During the war he worked with the Farm Security Administration providing welfare services to migrant farm labor in the

12. Hassel Smith and Ernest Mundt at exhibition of paintings by
 Smith and Edward Corbett, California School of Fine Arts Gallery,
 January 1951. Courtesy of the Library, San Francisco Art Institute.

Central Valley. During this period he did a body of work that captured living and working conditions in the cotton fields around Arvin and Delano. His subject matter flowed from his concern with social inequality, but he had not wanted "to make a social or political statement in the usual sense. There's nothing ennobling the worker." He had wanted to transmit as accurately as possible the actual conditions he had observed. The people he was employed to help were literally starving to death before his eyes in the richest agricultural region of the United States. He wanted to bring their situation to the attention of the world, and his pictures of farmworker life did find an audience. They were exhibited in five cities, reprinted in popular journals and local newspapers, and eventually the San Francisco Museum of Art bought a selection of the work for its permanent collection. But in the end, nothing changed in Arvin. Moral awakening did not flow, evidently, from a brutally honest brush.[27]

Encountering Still's paintings posed another equally difficult but more metaphysical problem for Smith as he contemplated the limits of representation:

> There is a reality which is corporal (three-dimensional) and your approach to it as a painter is bound to be visual and entirely two-dimensional. This is to disregard the devices of illusionism. . . . The metaphysical impossibility of bringing over three dimensions into two finally just drove me crazy. You cannot succeed the way I was posing the problem to myself. There was no way I could succeed.[28]

He had learned that art could never convey the reality of a "corporal" experience. To show people drawings and paintings of migrant worker life would never give his viewers anything resembling the shock he himself had experienced living among these people. He thought his work had been quite good as art, but that was the trouble. His viewers, including communists, focused on their art experience rather than on the life experience portrayed in the work. Under these conditions, Smith complained, the artist was little better

than a "social toady." For the art experience to have social effect, it had to be itself a "corporal" experience. That conclusion pushed him toward abstraction, because the life experience in the visual arts took place only at the point of contact between artist and material and then, later, between crafted object and viewers as they imaginatively refigured the artist's process of configuration. For art to generate a crisis in the viewer, it had to challenge conventions of perception and cognition.[29]

Despite Smith's slow start, many critics—Alfred Frankenstein, Thomas Albright, Allan Temko—described him as the single most influential abstract expressionist painter in California.[30] In part this was due to Smith's role in the school. While Still retreated into his graduate seminar, Smith did the yeoman work, teaching more students every term than anyone else on the faculty. He was responsible for the introductory figure and life drawing classes, as well as painting technique. Frank Lobdell, Sonia Gechtoff, Deborah Remington, Manuel Neri, Joan Brown, and Roy DeForest are among the former students at the California School of Fine Arts who have mentioned Smith as the key person who pushed them to rethink their work.[31] Smith developed a close relationship with southern California painters and actively worked to keep Bay Area and Los Angeles artists aware of each other. Both Robert Duncan and Jack Spicer thought he was a critical influence upon San Francisco poets. He was always ready to sit down and discuss theoretical issues. When talking to poets, he frequently challenged Kenneth Rexroth's idea that a poem could, or should, be a direct statement of the poet's thoughts and feelings. Language, Smith argued, reconstructed experience in a form as distant from the poet's inner feelings as a painting was from the original view. The problem was how to escape the artifices of representation, which focused the public's attention on the artificer's skills, and create direct experiences that had bearing on other aspects of a viewer's everyday life.

The sensation he had with Still's work of entering a "mental bubble" pointed the way to a solution to the problem. But he wanted to keep his paintings in a more direct relationship with the world at large. By shifting

from a biological to a cognitive paradigm, he could think of a painting as an "event." In 1952 Smith wrote, "My paintings are intended to be additions to rather than reflections of or upon 'life.' . . . I can bear witness that my paintings [are] 'accidents.' I see them but I do not know why they look as they do. They are *crucial events* in my life, but the cause of them, except in an immediate sense—who can tell what it is?" He then compared Leonardo's and Botticelli's reactions to the late fifteenth-century Florentine religious demagogue Savonarola. Leonardo tried to convey Savonarola's power by sketching the reformer. Botticelli was possessed, and years later Savonarola's message came through in the style and content of Botticelli's painting. If painting were to have a possible social effect, it could not have any direct illustrative or political purpose. For a painting to be an "event" that is "real," it must have a quality of contingency. The artist uses his or her craft to concentrate the experience of the "event," but cannot plan for the effect. By 1957 he had reached the point where he wrote friends, "I prefer to make something neither more nor less understandable than nature's works and no less permanent than some, and a lot more permanent than others. To the guy who asks me 'What is that? what is THAT supposed to be?' (and, believe me, I am not scornful of him) I can only say in the deathless words of King Louis the First [Louis Armstrong], 'Man if you have to ask, you will never know.'"[32]

Douglas MacAgy explained Smith's developing position as a reaction to the crisis of aesthetic form brought about by widespread cynicism regarding public traditions and values. Traditional art, MacAgy argued, had contained personal revelation, but until the emergence of the artistic avant-gardes in the mid-nineteenth century, such vision also had to serve other, public needs if it were to be countenanced and preserved for the historical record. These predetermined public values provided the forms framing personal expression. The avant-garde began producing art of personal vision for its own sake, MacAgy thought, but still within a context of putative public service. Artists from Courbet to Picasso had imagined that their personal visions could reform public vision. The triumph of abstraction after 1945 had been possible

because purely individual insights of living people had suddenly seemed to many more important for survival of the world than long-respected traditions. Yet personal insights severed from a conforming ideology had no predetermined forms or rules for explication. Hence the crisis of form which many critics took to be a product of abstraction was, together with abstraction, an expression of the reversal of the priority of public and private values.

As long as individual experience was deemed to be a better guide to reality than social conventions, collective values would also be thrown into crisis, subject to constant reformation as people considered and reconsidered the possible meanings of their experiences. MacAgy, like Smith, was unsure what the public value of art might be in these conditions. He suggested that abstract expressionist paintings framed the epistemological crisis and thus might help people learn to live without the certainty of form, without fixed, preset interpretive viewpoints. He hoped the prejudice that art was guided by laws of necessity would lose its hold. Art was a sign of freedom because it was a realm of human activity that was purely playful and often frivolous. Harking back to his wartime prediction that the "narcissistic" role of art would grow, MacAgy viewed artistic creativity as a revelation of human being rather than a method for grasping "universal law." Freedom and science were in opposition because when necessity entered the picture, choice left. As the impact of science upon society grew, so would the impact of art, because no other human endeavor manifested as clearly the irrational heterogeneity of human purposes. After so many centuries of teleological thinking, aesthetic experimentation, if freed from the necessity of communicating predetermined messages, could help an adjustment to a newer view of humans as purposeful but purposeless beings. The public value of art might then be simply to demonstrate that not everything need have public value, a contradiction he likened to developing a taste for walking "over uneven ground, or breaking through the straggling branches" rather than choosing the straight path "with no collateral interruption."[33]

Irrationality and Democracy

As we reach the point where the intellectual figures behind the California School of Fine Arts' version of abstract expressionism confess that they cannot define the public uses of what appears to them as an intensely private art form, the trickster emerges to show that seriousness and inconsequentiality are not incompatible at all. Filled with nervous energy, constantly talking and joking, Clay Spohn was a popular figure at the school, where he taught spatial organization and a class in abstract painting. His contribution to the school, however, is best seen through a casual project of his, the Museum of Unknown and Little Known Objects. "The Unknown can't be defined," Spohn observed, "because, by definition, the Unknown becomes the Known. It could be any real truth regarding the Known, for the admission of not knowing is a degree of knowing. Consequently, the Unknown becomes the Known and the Known becomes the Unknown."[34]

In December 1949 this philosophical "prankism" became the basis for a "happening" staged by Spohn with the assistance of Richard Diebenkorn, Adaline Kent, Hassel Smith, and Elmer Bischoff. The Museum of Unknown and Little Known Objects was originally planned as an adjunct to the San Francisco Art Association's annual costume ball, but the exhibit was so popular that the school held it over for a month. The idea for the event sprang from MacAgy's desire to make the annual ball something that would suggest to the school's patrons the nature of artistic creativity. Spohn suggested that the event be called "the Ball of the Unknown," in which all would dress up in their interpretation of the "unknown." He hoped that the focus of the event might shift from the spectacle to the process of imagination as "the 'unknown' is in reality the only thing we ever know, since we know it and are aware of it by feeling . . . instinct and intuition and [it is] ultimately the basis for all cognition."[35]

Spohn had been collecting scrap metal and unusual objects which he dis-

covered in trash bins. MacAgy suggested that as part of the ball Spohn use this material to construct a "museum" that would force the party-goers to look at waste in a new light. Spohn recalled,

> I would pick up little pieces of cast-off parts of machinery and then get some wire and a piece of metal and put it all together, wire them together and make an object of it. One had a little watch attached to it that I found; it was called "Starter for a Rat Race," another one was "A Hat Tree for a Neighborly Garden." . . . in my kitchen cabinet way in the back I found a bottle of rice. The rice hadn't been cooked and it had all turned green and I thought, gee, that looks like little mouse droppings. So I put them in a bottle and called them "Mouse Seeds." . . . I gathered up a lot of stuff from the brush of the vacuum cleaner, stuff from the carpet, and called it "Bedroom Fluff."

The dust had acquired a transparent, fluorescent texture unlike anything Spohn had ever seen before, and he thought everyone would find it as fascinating as he did. One of the most powerful pieces was an arrangement of two discolored, oxidized forks the tines of which had entwined. He put the arrangement on a piece of black velvet in a box, an image he read as frustrated hands reaching out of an opulent prison. "Old Embryo" he constructed by stuffing a battered, transparent Halloween mask of an old man with a very long mustache into a two-gallon chemical bottle to give the impression of a little old man with a very large head.

In less than a month Spohn created forty-two pieces for the exhibit. "The thing that fascinated me with the material that went into the making of the museum," Spohn explained, "was the fact that this material was on its way to becoming nature; it was returning to nature from whence it originally came. All things, even the man-made things, having once been things of nature—that is, in a natural state—must again, sometimes, return to nature. Man only borrows them to make what he thinks to be something that is not nature. But

nature, in time, disproves this illusion by reclaiming them again in her own time and her own way." Spohn downplayed the museum as just "a fun thing to do," but noted that the process had been "almost poetic" for him: "It's still the same material, it has just taken another form and what was accepted as wonderful at one point was changed and then rejected at another point." After pausing, he made a statement about the objects he had found that could also have been about his own life and its troubles: "Things of nature should never be considered to be junk or trash or entirely useless or futile."[36]

Little remains from the exhibition. Some pieces were stolen. Others Spohn gave to students to use as still-life material. He made no effort to preserve the work, nor did he think documentation was important. He had demonstrated his point that art was a process of reassembling, revitalizing, reconstituting, and reemploying and thereby keeping an object alive as a product of the imagination. He hoped to demonstrate that the "effect" created the "cause," meaning that the means were the end result and justified themselves. The process of any activity was always the only real aspect of the activity: "Method I always had considered to be the basic and essential subject matter."[37]

Dismantled and dispersed, the museum became a legendary event in the history of the MacAgy regime at the California School of Fine Arts. After all evidence of the event had vanished, the pieces resonated in the memory of those who had participated in its lunacy, leaving an instructive message for many that an "art work" existed first and foremost in the "imaginary lens of the mind's eye," and only secondarily in the object (the importance of which after it had initiated a reaction lay in its possible role as an economic counter). "Whimsical nature mysticism" Spohn called his collection of objects constructed from refuse. The exercise was an early example, together with Sabato (Simon) Rodia's Watts Towers, of assemblage in California, a form that developed into a major genre in the 1950s. Spohn rejected any implication that his project worked in the dada tradition. Dada's purposes, he thought, were ulterior to art, to put across a literary or verbal concept. More fundamentally, he

thought it was ridiculous for anyone to suggest that he was anti-art. While the dadaist wanted to destroy the power of art, Spohn wanted to build it up.[38]

His denial is important because it can remind us that social relationships, not formal attributes, determine the possible meanings of aesthetic production. In California, art lacked sacral power. There was nothing for artists to discredit or rebel against, other than their own lack of significance. The idea of exploding the difference between art and life paralleled dada, but Spohn's aim was to prompt his viewers to see that aesthetic processes underlay every aspect of their thinking and behavior. Life is a search, he thought, for the ideal, that is for the reality in the interior to be manifested in the outer world with the same tangibility that it exists in the imagination. Each person tried to bring his or her inner life outward, just as an artist did.[39] If nonartists recognized that, they might then support serious investigation by artists into the aesthetic component of cognition rather than restricting art to illustration of what was already very well known, such as the historical events he had painted for the federal mural project.

The Museum of Unknown and Little Known Objects might have appeared frivolous in 1949, a passing piece of carnival humor, but it pointed to the provisional nature of human production. Nothing was sacred or final, not even art. What was left was a memento of a process of exploration, like a snapshot, only of an interior state. That activity, flourishing in schools, was more deserving of public support than employing artists to construct "monuments" that simply affirmed what was already well known. Spohn's project helped argue the model of contemporary art as a vital part of humanistic education. Given that the arts required subsidy to arrive, Spohn had demonstrated his conviction that the subsidy developed after the war was better for artists and ultimately might be more productive to the public as well.

As a teacher in 1947, Hassel Smith demanded that his colleagues train students to pierce the ideology of vision by uncovering entirely new ways of see-

ing. Did abstract expressionism present a sufficiently new way of seeing that could be subversive of dominant ideology? As Smith considered the evolution of the California school, his answers evaded the question of sight and returned to ways of construction. As the artist's focus slid from the realm of necessity and law to areas of chance and volition, the form that abstract expressionistic work had taken in California seemed to him to result from the peculiar relationship the artist in the provinces had with society. In 1956, after Hubert Crehan published an article in *Art News* that argued that there was no difference between abstraction on the West and East coasts,[40] Smith jotted down notes for a reply in which he outlined his conception of what made California abstract painting distinctive from work produced in New York. First, he noted geographical separation. His own most consistent exposure to work from New York was through photographs in magazines, while he saw the work of his friends on a daily basis. Since the significant aspects of abstract painting did not reproduce, for better or worse, the only real influence upon California painters was local work. A second factor, he thought, was that abstract painters in San Francisco had more "naive notions of surrealism and dada" than their counterparts in New York, but a more profound attachment to the romantic implications of those movements. They did not want to do work that looked surrealist, but they were committed to showing another reality that would emerge from spontaneity and improvisation rather than trying to materialize the dream world.[41] Third, the artists had a profound love for jazz. Painters frequently discussed their work in terms of a jazz aesthetic—which he defined as virtuoso execution, humor, loudness, self-assertiveness, and assumed naiveté—and valued other artists by their ability to translate these virtues into their painting.[42]

Finally, Smith stressed the importance of the lack of an "organized or effective art market" upon painters. Local galleries, other than a few alternative cooperative galleries with no outreach to people who bought paintings, simply did not show local artists who worked in an abstract manner.[43] This, he thought, was the "number one influence" upon the regional school.

Painters do occasionally sell paintings (for prices under $500) but the *possibility* of sale is so remote that it might just as well not exist at all. However hard he may try to create a painting which will PLEASE a prospective, hypothetical customer, no customer appears and in the end the painter is encouraged to paint without any customer whatsoever (none exists) in mind. The "San Francisco School" is therefore marked by its ungraciousness, its positive unwillingness to please. In no other locality will you find so many paintings being produced about which it can be said, "I wouldn't put THAT on my shit-house wall."

Smith felt that the originator of the San Francisco movement was Douglas MacAgy, who provided a home at the San Francisco Museum of Art and then at the California School of Fine Arts where artists could explore their conceptions as if they were important even if they had no customers. Museum and school could provide an adequate counterpoint to the marketplace if directed by people who were interested in art as a source of new ideas.[44]

Elmer Bischoff likewise pointed to the lack of a market to explain features of California abstraction. "You fully expected that your paintings would just pile up in your studio, your sculpture would just pile up in the backyard," he commented. The result was that "your own appreciation and the appreciation of a few colleagues, that was it, that was the end." Since the work existed only for exchange of ideas, the crafting of work was often careless. The immediate purposes did not require the very best paints, or even care in composition. The idea a painting expressed was always provisional, so an artist might decide to leave a piece half-finished once the drift of an effect became clear. Artists were tempted to be easy on themselves, moving on and trying something new without necessarily stopping to explore the full consequences of any one idea. The result, Bischoff thought, was that abstract expressionism in California became effect-oriented and insufficiently thought through, a fashion rather than a method of investigation. The interior quality of the work became superficial, and thus a break with abstraction had to occur earlier in San

Francisco than it did in New York. This argument was part of Bischoff's explanation for his decision to return to figurative painting in 1952. To reground his work in a disciplined manner, he had to return to things that existed outside of himself and begin to speak of relationships again.[45]

The explanations that these artists constructed for themselves on how the absence of a market for serious painting shaped the development of their work bears deeper examination. Certainly, compared to New York, there were virtually no venues for exhibition and sale: the Lucien Labaudt Gallery in San Francisco and Hazel Solomon's gallery across the bay in the industrial, oil-refinery suburb of Richmond were the only two commercial galleries between 1950 and 1956 that exhibited abstract paintings. Still, lack of market relationships tells only half the story. By 1952 the well-publicized and well-attended annual San Francisco Art Association show was dominated by abstraction, and artists exhibiting in it could sell directly to the public.[46] The San Francisco Museum of Art, under the direction of Grace McCann Morley, remained sympathetic and supportive of the new work, giving frequent exhibitions and purchasing work for the museum's permanent collection. Even daily newspaper critics embraced abstract expressionism, if for no other reason than such local developments could dispel persistent fears that California was indeed an out-of-the-way corner of world culture. In 1950, when the third Clyfford Still one-artist show was held in San Francisco, Alfred Frankenstein asked Still's student Hubert Crehan to write the review for the *San Francisco Chronicle*, guaranteeing a serious if hagiographic explanation.[47] Erle Loran, chair of the art department at Berkeley and initially an opponent of abstract expressionism, writing in *Art News* in 1950, favorably compared the San Francisco movement to the French impressionists as a group movement collectively exploring a new trend in painting.[48] Abstract expressionism gained public acceptance in those areas around which the art world was structured. Galleries ignored the new art, but in California at that time they were not as important players in determining aesthetic attitudes as public institutions. When artists spoke of painting or sculpting only for their friends, that

audience nonetheless constituted a network of relationships that involved exhibitions, publications, teaching positions, and other rewards that made it possible for a person to say, "I am an artist."

The absence of a market, which we should not confuse with absence of institutional infrastructure, did give artists an option of retreating from the immediate public eye and concentrating on their "investigations." In 1951 Frank Lobdell announced that he would have no exhibitions for at least five years while he proceeded to work intensely in his studio. He broke his self-imposed public silence in 1955 by agreeing to Grace McCann Morley's request that he participate in the American pavilion she organized for the 1955 São Paulo Biennial, but he avoided other opportunities to exhibit until his 1959 one-artist show at the Ferus Gallery in Los Angeles.[49] Retreat did not mean that nobody saw his work; his friends, those who needed to see the directions he was testing, were able to come to his studio, observe, and discuss. But there was no need for Lobdell to time his development according to a schedule of public exhibitions, required by both artist and dealer to maintain overhead. The school setting provided an alternative to the commercial gallery, and San Francisco painters believed it gave them more personal honesty (pl. 6).

Clyfford Still told his students that painting was always a statement of personal morals, expressed both in the object and in the conditions surrounding the display of the object. Either the artist was independent or compromised. Writing in 1948 to Betty Parsons, his New York dealer, Still insisted that she not show his work to anybody who lacked insight into the aesthetic and moral values Still proposed in his paintings. He demanded that she prevent anybody from writing about his paintings without his explicit permission. In particular, he did not want either the influential critic Clement Greenberg or Alfred Barr from the Museum of Modern Art to have any access whatsoever to view his work because in Still's opinion they had proven themselves capable only of imbecilities.[50] In 1952 Still announced that he would no longer allow his paintings to be exhibited unless he controlled the conditions of their exhi-

bition, including placement, lighting, and access to the work by critics. His work disappeared completely from public view until 1959, but his international reputation provided him with some protection. Collectors and curators came to his door, increasingly prepared to accede to his demands.

But what about younger artists who were influenced by his example but known only to each other and the small arts communities of California? In their case, an anticommercial position had little meaning as a tactical position, and so it deepened into an existential condition. What are we to make of Jay DeFeo and Wally Hedrick deciding not to attend the opening of *Sixteen Americans* at the Museum of Modern Art in New York in 1959? This was the first exhibition of their work outside California, and it was a major show, the exhibition that established international reputations for Robert Rauschenberg, Jasper Johns, and Frank Stella. Hedrick and DeFeo did not have the money for a trip to New York, but they did not think their presence at the museum would be important in any event and might distract attention from their work. Either critics liked their work or they did not, and the presence of the artists should be irrelevant to an honest qualitative reaction. In recalling this episode, Hedrick went on to comment more generally that museums seemed interested in his work only when he had already moved on to another set of problems and the benefits he might get from a public show were reduced to "a little money."[51] The stance of a fiercely independent investigator developed in a provincial environment made little sense when that artist entered a more developed world. Their art might not have been provincial, but their self-image was.

It was an image in generalized opposition to any concentration of power. Jorge Goya, a student at the California School of Fine Arts in the MacAgy period, recalled that Clyfford Still and Mark Rothko were "dead set against French painting. . . . So they yakked, yakked, yakked against it and the students picked up this opposition to something . . . but it wasn't French painting." Goya could not specify what the opposition attached itself to. When he tried to be more specific, he lapsed into his perception of West Coast abstrac-

tion as an expression of childlike emotions: "All kinds of strange childhood haunts and fantasies got into the painting." Antiprofessionalism rose to take pride, as Gordon Cook did, in the fact that people on the West Coast were not "in any sense technically equipped to be artists, or talented in the historical sense to make art," yet there were so many "total clubfoots, who make marvelous works of art."[52]

Was private vision irresponsible solipsism or genuine effort to carve a place for inner feelings in the public realm? Both aspects were always present, in unstable tension with each other. Only by examining how the ideas embodied in the work functioned in specific situations can we determine the historical meaning of an aesthetics based on private values. The public role art played depended on the uses people made of their interpretations. The conflict between public and private values that Smith, MacAgy, and Still each in their own way identified as the source of abstract expressionism was particularly acute in California, where artists were absolutely dependent upon the public sector for recognition and support. That support was predicated on the public values of education. Could a purely interior vision, which moreover refused to specify any consequences resulting from its interaction with the world, find justification, and not simply a home, within an educational context? Douglas MacAgy had said yes, but in 1950 his conception of the art school as an experimental center was challenged. Perhaps, his board of trustees questioned, public institutions needed to be more directly responsible to social needs.

Abstraction versus Design

As early as March 1948, trustees of the California School of Fine Arts began to worry about the fate of their school when the GI Bill expired at the end of 1956. In June the board discussed options for adjusting to a future without students backed by government funding. All agreed that the school would

need to reduce the number of classes sharply, but debate followed over the areas where cuts would best be applied. MacAgy argued that the fine arts program in painting and sculpture should be maintained without cuts as long as possible, while a slight majority on the board felt that advertising, commercial art, and industrial design courses were likely to attract new students. A person paying tuition out of pocket was more likely to want employable skills at the completion of schooling. For those on the board who took a practical position, many of the new courses MacAgy's faculty had developed in the fine arts were luxuries that would have to be canceled. This discussion began a seven-year-long controversy over the school's direction.[53]

Much of this debate was to be expressed in contesting evaluations of the Bauhaus approach to arts education. The famous Bauhaus school had been founded in 1906 as the Grand Ducal School of Arts and Crafts in Weimar, Germany. The school was not a fine arts academy, but a technical school, focused on product design, architecture, and the manual arts. Emphasis shifted from handcraftwork to design for machine-tooled mass production when the architect Walter Gropius became director in 1919. He gave the school its new official name of the Bauhaus (House of Construction) to mark the centrality of architecture as the primary art form of the twentieth century. Gropius proclaimed that his new school would "create a new guild of craftsmen, without the class distinctions which raise an arrogant barrier between craftsman and artist."[54]

Gropius thought that painting was an obsolete art form that would be replaced by a higher form of environmental decoration. He abolished studio courses in favor of theoretical classes examining optical effects generated by color, line, and mass. Bauhaus-style products were logically determined by the requirements of function, materials, tools, and efficiency, combined with testing of the psychology of perception to achieve a product that was entirely rational in the principles of design, construction, and function. Under Gropius, the school was more than a technical school. It aspired to re-create the humanist tradition in terms relevant to an increasingly technological society.

The work methods and product prototypes developed at the Bauhaus were to spread throughout industry and revolutionize not only design but the manner in which people lived.

Because the school served the future interests of all society, Gropius opposed both production for luxury and individual expression. In 1922 Gropius dismissed the mystic Johannes Itten as director of education because Itten overemphasized the importance of subjective creativity. He admonished Itten that "what is important is to combine the creative activity of the individual with the broad practical work of the world!" Living within good design principles would promote the "transformation of the whole life and the whole of inner man," Gropius told his students as he moved to rationalize the school's pedagogical efforts. Product design would be the source of an "architectonic" order that united the inner and the outer lives of human beings in a uncontradictory whole. The school's faculty and students would be "pioneers of simplicity," combatting the waste of luxury by finding an aesthetically pleasing but "simple form for all life's necessities."[55]

After the Nazis came to power in 1933, many of the Bauhaus's teachers and students fled Germany and eventually settled in the United States. Ludwig Mies van der Rohe taught at the Illinois Institute of Technology and established a private practice in Chicago, where he built his famous Lake Shore Towers. Walter Gropius joined the school of architecture at Harvard University in 1938 and also started a private practice, The Architecture Collective, that designed housing tracts, shopping centers, school buildings, and office complexes. Josef Albers directed the art department at Black Mountain College and then moved to the studio art program at Yale University. Other former Bauhaus personnel assumed leadership of the Rhode Island School of Design, the art department at Brooklyn College, and Harvard University's fine arts department. In 1940 Walter Paepcke, chairman of the Container Corporation of America, funded László Mohóly-Nágy's Institute of Design in Chicago. This private, nonaccredited school was the closest attempt to emulate Bauhaus structure and curriculum in the United States. "What we

need," Moholy-Nagy had written in 1925, "is . . . a synthesis of all the vital impulses spontaneously forming itself into the all-embracing *Gesamtwerk* (life) which abolishes all isolation in which *all individual* accomplishments proceed from a biological necessity and culminate in a *universal* necessity."[56]

Moholy-Nagy's formulation suggests a lurking totalitarian dream underneath the global idealism, for the abolition of "isolation" might very well mean the end of private choice. Neither the idealism nor the totalitarianism impulse translated very well when Bauhaus principles came to the United States. The Bauhaus school in Germany had been a state-funded institution, founded to strive for innovative research that prodded and stimulated new activities in both the private and public sectors. The ideal of the total community that moved through the Bauhaus's work provided an element of indeterminacy, as there was no agreement, nor could there be short of dictatorship, as to the needs of the "total community." In the United States, however, such a program altered as it entered schools dependent upon grants from private corporations. The total community shrank to one segment with relatively predetermined needs. Corporate sponsors, as at the Chicago Institute of Design, did not presume to direct curriculum, but funding flowed from an expectation that students suitably trained for the needs of modern corporations would graduate and find their way into the job market. Attention shifted from the research laboratory ideal to the production of students with definable and measurable skills.[57]

MacAgy feared that the American version of the Bauhaus model turned schools into "laboratories of design for industry." But even if the Bauhaus in America could have reproduced the idealism of the original German school, MacAgy fundamentally disagreed with Gropius's conception of the function of art and the art school. "Exclusive attention in this direction may invalidate the creative function" of the art school, MacAgy warned his colleagues in San Francisco. "If the study of art is to be considered in relation to the full resources of personality, it must be admitted that current forms of industrial product appeal only to some of these resources. It follows that a school deals

with this fraction of personality to the degree in which it concerns itself with such forms."[58] MacAgy wanted to emphasize art that grew out of its own independent existence, not limited in any way by "serviceability." The idea of an architectonic order linking inner and outer lives ran in the opposite direction of a group that wanted to establish a place for the irrational, understood in a philosophical sense as a state of being not reducible to any system of explanation. Instead of order in human life, MacAgy and his colleagues hoped to introduce a place for chance and the mysterious. They rejected the concept that an ideal order was possible, or even to the benefit of humanity.

MacAgy presented his philosophy most cogently at a talk given at the annual meeting of the National Association of Schools of Design in 1949. He wished to counter ideas that the distinction between fine and commercial art had no place in a democratic society and that the best way to bring art to the public was to subsume the fine arts into commercial art. In this viewpoint, the proper place for Mondrian's work was on a Kleenex container and democracy in the arts would be achieved when the drugstore had replaced the museum as the locus for society's most important visual images. MacAgy was not opposed to improving the quality of commercial design, but he did not want to see utilitarian goals become a limit. Advanced-guard experiments could feed commercial art, but such benefits would come naturally as byproducts of expanding visual imagination.

After several explicit criticisms of the Bauhaus school, MacAgy argued that too many art educators in the United States had encouraged this attitude by placing excessive emphasis on plastic form and sensory experience and by neglecting problems of meaning. The visual form of advertising art and a painting might sometimes be similar, but the communicative message contained in commercial packaging derived, he claimed, from a "coercive" effort to increase sales. The effort often failed, but the visual design was subjected to a formula, "A plus B produces C," commodity plus package produces sales. Fine art, MacAgy acknowledged, may also be coercive, and he pointed to the social comment of Ben Shahn and the "admonitory surrealism" of René Ma-

gritte as examples of contemporary art with well-defined messages. Yet he felt that the appeal of Shahn's and Magritte's paintings was not exhausted by their overt messages. In fine art, communication was always uncertain: "Because these 'poetic' resources of the mind can't be circumscribed like units in a production line, they don't lend themselves to manipulation in conventional causal sequences. Rhetorical controls are subject to unknown motives—to hazard and miracle." Inability to predict what the full statement of a piece will be makes experimentation the hallmark of fine art.

The Bauhaus blending of fine and commercial art, MacAgy argued, would lead to a resurrection of the nineteenth-century French École des Beaux Arts, which judged art with arbitrary and limited, because knowable, standards, the universality of which would be derived from a narrow interpretation of psychological science. Academic training had the advantage for educators that students "could be led through a series of commonly understood steps to a predetermined goal. Deviations from established norms could easily be seen and duly punished, while competent conformity could as easily be selected for reward." To make sure that his audience did not misunderstood his position that an academic art could only be antidemocratic, he cited Machiavelli's dictum that "Government is nothing but keeping subjects in such a posture as that they may have no will, or power, to offend you." The canons of a Bauhaus-inspired art as applied in the United States would be "those of salesmanship and industrial efficiency." Instead of art being a mode of experimentation whereby the limits of psychology were constantly tested and expanded, an art philosophy that sought to eliminate the distinction between experimental and commercial expression would function to limit understanding of human potentiality to those aspects most convenient for the groups in American society with the most power.[59]

MacAgy struck a theme we have seen before motivating Kenneth Rexroth, Lorser Feitelson, and Helen Lundeberg: art becomes a vehicle for human liberation when it escapes the requirement of representing a canon of preconceived values and ideas. Only as art becomes experimental and problematic

can it begin to play an active role in promoting democracy. It accomplishes this by providing a counterbalance to propaganda and commercial manipulation. Without in any way being anti–"free market," MacAgy nonetheless expressed a philosophy hostile to exorbitant dominance by wealth and commerce upon culture or education. Against a utilitarian perspective, he posed the ideal of a philosophically inspired school, providing an environment for group exploration of a common set of basic problems without regard for their immediate practical import, but which would have a more general social benefit of helping to create a system of checks and balances for civil society.

As discussion about the school's future progressed, faculty members organized to defend their own interests. In August 1949 the faculty sent a letter to the board of trustees demanding that the school raise salaries to University of California levels and that the school introduce a tenure system guaranteeing job security to senior faculty. While the faculty had prospered during the boom years, they feared that future cuts would be made at their expense and, therefore, in the quality of instruction.[60]

MacAgy supported the faculty and warned his board that only by committing to the philosophy of instruction he had developed would the school maintain its record attendance levels. Serious students wanted a faculty that was truly full-time, who pursued their artistic investigations and their teaching simultaneously. But recognizing the uncertainty of the school's finances with the wind-down of the GI Bill, he proposed developing a core faculty of ten to thirteen individuals capable of teaching all aspects of the curriculum. The core faculty would have the same pay and working conditions as university professors, while adjunct instructors could be brought in to augment offerings as finances permitted. With this plan MacAgy stated he believed he could complete the transformation of the California School of Fine Arts.[61]

The board sat on MacAgy's proposal, and in May 1950 he suddenly resigned, citing as his reason a desire to return to curating exhibitions and writing about contemporary art.[62] Hassel Smith reported later that MacAgy had told him personally he quit because the trustees had refused to add Marcel

Duchamp to the faculty, the first time the trustees vetoed a MacAgy proposal for the school.[63] In 1972, when asked about this, MacAgy laughed and admitted that such a turn of events would have made a "great terminus" to the story, but he did not know how such a "rumor" had started. MacAgy had spent several years trying to convince Duchamp to come out of seclusion and join the faculty in San Francisco, but there is no evidence in the board minutes that MacAgy ever made a specific request for an additional faculty position. MacAgy knew that the school could not avoid cutbacks of some sort, and he admitted that he began to worry about how well his conception of an art program would function in reduced circumstances. He wondered if the board of trustees might not be right and that, with the end of the veterans educational benefits, art schools would return to their traditional student bodies: "throngs of girls who can't make college and want to mark time while they look for husbands" or academic painters "who would trade being artists for being teachers when the cards are down." He came to the conclusion that the postwar situation was unique because government funding had encouraged an unusual group of students to enter an environment normally out of bounds to them.[64]

MacAgy left the California School of Fine Arts to work as a special consultant to the Museum of Modern Art investigating the possibility of opening a West Coast branch. After his wife Jermayne began to work with the de Menil family in Houston, curating shows of their collection of twentieth-century art, the MacAgys moved to Texas, where Douglas became the director of the Dallas Museum for Contemporary Arts. He would continue to have a prominent museum career. In 1968 he became director of exhibitions for the National Endowment for the Arts, and in 1972 he joined the staff of the Hirshhorn Museum in Washington, D.C., as chief curator, a position he held until his death in 1973.

For his replacement at the California School of Fine Arts, the trustees selected Ernest Mundt, a sculptor on the faculty. Mundt was a German émigré trained as an architect before he came to the United States in 1939. MacAgy

had hired him in 1948 so that students at the school might be exposed to Bauhaus principles. Faculty and students interpreted Mundt's selection as a repudiation of MacAgy's vision of the school and an attempt to transform the institution into a training school for advertising and industry. Mundt stated he would maintain an independent fine arts program, but he wanted the curriculum to put greater emphasis upon design principles, applicable to either fine or commercial art, as the circumstances warranted.

In a 1952 speech to the San Francisco Art Association in conjunction with the association's annual show, Mundt criticized the "neoromantic" art so prevalent in the exhibition. He acknowledged that such work was a "thorn in the flesh of complacency, the bad conscience of a society too superficially optimistic about the benefits of progress." But he identified a singular flaw in the thinking of the "neoromantics": as they denied "the possibility of communal relations," they also denied the importance of communication. This characterization by Mundt was not entirely accurate. The possible social functions of art concerned many of the painters, but they did value "self-expression" over "communication," which they defined as the transmittal of a predetermined message. Mundt was right when he argued that emotional intensity had become the yardstick for evaluating work and the tendency to view an artist's work as a unity did shift emphasis onto "who makes a statement rather than on what is being said." But despite the new work's emphasis on individuality, Mundt thought it undeniable that the result of "an approach to art that denies cognition and depends on an excitement of blood and nerves" was that at "the end of the road to introspection, below the base of the superstructure of civilization, there is the unifying fact of undifferentiated biological existence." Conformity inevitably replaced investigation, but he doubted that genuine experiment had ever been involved in expressionistic abstraction (as he phrased it). Self-revelation occurred only because the artist produced work for an intimate group of friends. The positive contribution of this work was that it uncovered the flaws inherent in "traditional ways of conveying meaning through art." Western art tradition had relied on shared codes

and values. A new art might arise on the ruins of communication based on a scientific approach to cognition of symbols and perception of images. The study of both conscious and subconscious responses to visual stimuli would be the basis for a new, truly communicative art which he thought essential to the functioning of civic society.[65]

Mundt's speech showed how democratic rhetoric was used by both sides of the debate, nor need we doubt either side's sincerity that its conception of art would help expand access to the means of communication. The question facing students, faculty, and administration at the California School of Fine Arts in the early 1950s was whether the institution should be a training school or a source of generalized cultural innovation. Neither goal was particularly "undemocratic," although, ironically, MacAgy's apparently impractical program was based on a more realistic assessment of the school's situation.

Mundt's speech was made as the last of MacAgy's closest associates on the faculty were forced from the school. Clyfford Still was the first to leave. He resigned in the summer of 1950, since, with MacAgy's departure, he saw no reason for serious artists to remain in California. He convinced Clay Spohn to move to New York with him. To stem a flood of resignations, Mundt assured the remaining painting faculty that he wanted them to continue. He intended to introduce more classes on the "empirical" aspects of art, but he assumed that the remaining faculty would be flexible enough to take responsibility for a new curriculum tying together the industrial and the fine arts.[66]

Distrust between the faculty and Mundt were exacerbated by Mundt's inexperience as an administrator in a period of contraction. Several weeks into the fall 1950 term, Mundt had to cancel several classes and reorganize others to compensate for budget shortfalls he had not expected. The most divisive issue confronting faculty and administration was the faculty's demand for employment contracts with long-term job security provisions. The faculty expected quick action on the contracts, for reasons of personal security but also as evidence that Mundt and the board were truly committed to continuity in the school's program. To help resolve the issue more quickly, the faculty

withdrew its request for pay parity with the university. Mundt asked the board to approve contracts for a core group of thirteen faculty members. The board tentatively consented in November 1950, but said it would delay signing contracts until April 1951 when the earliest projections could be made of fall term enrollment.

April came and went without a comment from the board about the proposed contracts or any public assessment of the school's financial health. Smith and Park, the leaders of the faculty negotiating committee, were convinced that Mundt wanted to purge MacAgy's faculty and that he was using promises of contracts to string them along while he recruited replacements with philosophies closer to his own. In July 1951, after a series of stormy faculty meetings, the core of the fine arts department, David Park, Elmer Bischoff, Hassel Smith, and Minor White, resigned to protest the board's bad faith. They were joined by Edmond Gross, the school's senior advertising art instructor. Mundt convinced the teachers to withdraw their resignations, but the board continued to delay executing the contracts. Mundt decided that Smith was the main organizer of opposition to change in the social and fired Smith in the middle of the fall term 1951, canceling the courses Smith was teaching. David Park and Elmer Bischoff immediately resigned, and an emergency protest meeting of the student body challenged Mundt's management of the school.[67]

The trustees attempted to regain control of the school by purging the school's faculty. In May 1952, at the same time that Mundt gave his speech criticizing the neoromantic movement in art, the trustees mailed letters to two-thirds of the faculty, almost all in the fine arts department, informing them that their services were no longer needed. Mundt was given free hand to design a school with an explicitly Bauhaus orientation. At the same time, the board made recruitment difficult for Mundt by shelving the idea of a core faculty with long-term employment security. Declaring that teachers at a professional school should be professional men not dependent upon teaching for their livelihood, the trustees cut salary levels while simultaneously equalizing

salaries. All teachers received the same base pay per course no matter his or her level of experience or years of service at the school.

The California School of Fine Art's new program was based on the assumption that the future of art lay in the merger of fine art with commercial and industrial design. The makeover of the school proved to be a disaster that brought the institution to the edge of bankruptcy and permanently closed its doors. As key faculty left, student enrollment plummeted. In the fall term 1952 only sixty-one full-time students registered, down from 325 the previous year.[68] Students unequivocally registered their disapproval with the changes in the school's direction by dropping out. Mundt and the trustees believed they could ride out the crisis by seeking a new type of student. The board voted to institute a degree program in the fall term 1953 and to send recruiters into high schools in the state. Mundt sought contracts with the Department of Defense to train in-service military personnel in commercial art and industrial design, but the military services were prohibited by law from contracting with an unaccredited school. Mundt organized an undergraduate program, and the Western College Association provisionally granted accreditation for a bachelor's of fine arts degree program in December 1953, with the stipulation that the school add courses in science and psychology to its English and history nonart electives.

The number of full-time students rose to sixty-nine in 1953, an increase the school administration considered to be due entirely to the degree program. The improvement in the day program was more than offset by sharp decreases in night school and Saturday enrollment, which Mundt thought was the result of new, free adult education courses that municipal park and recreation departments had begun to offer. By the fall term 1954, full-time enrollment rose to seventy-four, and the school faced three consecutive years of operating annual deficits greater than $20,000. Both the Western College Association and the Office of Veteran's Affairs inquired if students would be able to complete their training. Mundt replied that the school could not guar-

antee this, and the veteran's affairs office suspended the school's eligibility to receive payments for tuition under the renewed GI Bill.[69]

Mundt pursued the possibility of merger with the Art Center College of Design, an art school in Los Angeles that he learned was considering opening an extension in San Francisco. The Art Center had a strong fine arts department, chaired by Lorser Feitelson, but the school's primary focus was on commercial and industrial design. Mundt enthusiastically reported that Art Center turned away hundreds of students every year and was able to expel students who did not work. The president of the Art Center promised Mundt to "pour" funds already granted by Ford Motor Company, General Motors, Chrysler, and "many advertising agencies" if the school redesigned its curriculum to emphasize illustration, industrial design, and graphic design and layout. He also promised to raise faculty salaries immediately, but he warned Mundt that the Art Center could not support any fine arts classes. Students increased in studying painting or sculpture would enroll at the Los Angeles campus. The California School of Fine Arts campus would focus entirely on preparing students for employment in the American corporate world.[70] Mundt and the board of trustees hesitated at the prospect of completely gutting the oldest fine arts school in the western United States of fine arts instruction. Then negotiations collapsed when the Art Center refused to accept responsibility for the California School of Fine Arts's debts.

In March 1954 Mundt informed the School Committee of the board of trustees that he proposed to reorganize the curriculum once again, independently implementing the curriculum that had proved so successful at the Art Center. The Department of Design was to be put in the foreground, and the fine arts "must take a secondary place." Painter Nell Sinton, chair of the board committee with oversight of the school at the time, immediately convened an emergency meeting of the committee, which prepared a report to the board of trustees reassessing the problems at the school. The committee urged the board to acknowledge that the sole source of the school's crisis

was the repudiation of the experimental program initiated under Douglas MacAgy. Only one member of the board, Robert O. Bach, an advertising agency art director and a part-time instructor at the school, supported the changes Mundt wanted to make. He argued that the future of all art lay in advertising and commercial art because that was the art of the people. Only those caught up with outmoded, romantic, and elitist ideals resisted Mundt's reforms. The school needed unity to continue, and Bach urged all trustees and faculty who had no connection with commercial art to resign. Bach predicted that once the cloud of controversy left the school, California business and industry would enthusiastically support an institution providing them with trained, competent professionals in graphic and industrial design.[71]

Bach's lengthy reply to the Sinton report reads like an aria from a tragic opera. Proclaiming the purity of commercial artists and decrying the faithlessness of fine artists lusting after fame and fortune, Bach was not surprised at the denouement; the world was too impure to sustain a noble vision. The board voted against Mundt's proposed changes, and Mundt resigned immediately. The board appointed a junior faculty member, Gurdon Woods, a former painting student of David Park, to lead the school back to its postwar orientation. Woods asked Elmer Bischoff to rejoin the faculty. Together Woods and Bischoff rebuilt the painting faculty by seeking out former students from the MacAgy period. Frank Lobdell, working as a short-order cook in a Sausalito coffee shop, returned to the school to chair the painting program. Enrollment more than doubled in the first year of the new administration as the school's reputation as an experimental center was reestablished.

Irrationality and Democracy Revisited

While the specific issues wrenching the California School of Fine Arts from 1950 to 1954 were fought out at the mundane level of employment-security

contracts and curriculum structure, fundamental philosophical disagreements were at the heart of the struggle for control of the school. For the artists surrounding MacAgy, art entailed wresting a piece of mystery out of primal chaos and embodying mystery into a form that could be contemplated; the value of the product lay in its inexplicable, irrational character. For Mundt, art was a fully "rational" and "empirical" method that led to the creation of works derived from knowable goals and capable of arousing predictable responses.[72] These philosophical differences involved two distinct conceptions of the social value of art: an icon for subjectivity or a product created for a specific use. For Mundt and the majority of the board of trustees in 1950, a design-based program appeared inevitable because rational people did not embark upon a career without knowing what they wanted to accomplish. There was so little possibility for a "free" artist to establish him- or herself, they could not conceive that a school such as MacAgy had brought into being could permanently attract students.

Their decisions were based on a fundamental error in assessing the expanded student body brought into being in the post–World War II period. In this they were not alone. The most prominent national voices worried about the narrow, career-oriented focus they assumed a broader-based, more democratic student body would have. James B. Conant, president of Harvard University, had vocally opposed the education provisions of the GI Bill, proclaiming that the "least capable among the war generation" would flood institutions of higher learning. Robert M. Hutchins, president of the University of Chicago, thought that GIs would turn universities into "educational hobo jungles," dragging down levels of scholarship by their demand for training in skills that could get them jobs.[73]

Jacques Barzun from Columbia University worried that the GI Bill, with its premise that everyone in a democracy who wanted a college education should be able to get one, would inevitably lead to the debunking of both European tradition and faith in natural genius. Inexorably, he warned, Americans had inched to the idea that education was a natural right and, in

itself, sufficient grounds for advancement in employment. While these ideas had advanced the farthest in the United States, Barzun assumed that every nation with democratic institutions would be forced in the postwar period to make university-level training universally accessible. The trend would not stop with undergraduate education. He predicted universal education would expand to include master's and doctoral studies, and the entire university system would be oriented to certifying capability of performing specified jobs. Learning for its own sake, Barzun was certain, would vanish with the advent of mass education, and the modern age so transformative of the world would come to an end. He could see no possibility of intellectual or technological progress with the triumph of democracy and belief in the equality of every experience.[74]

"Mass education always means a certain number of concessions," warned prominent New York art critic Clement Greenberg. The American middle class understood that self-cultivation would define social position, and therefore mass cultivation had become a permanent feature of American society. On the positive side, Greenberg found serious painting and literature appearing in popular magazines, but "high culture," developed on class distinctions, could be swept away as the democratic masses rendered "standards of art and thought provisional" in the process of making world culture part of its life.[75]

Such arguments grew from assessments of the "masses" made by observing popular media such as motion pictures and magazines, as well as witnessing the cataclysmic events surrounding the triumph of "mass leaders" like Hitler. Closer to home, the persistence of racial segregation, religious bigotry, and vigilante action against labor unions suggested to some that expansion of democracy might lead to a more closed society. The potentially dangerous consequences of lowering standards established over a period of centuries worried intellectuals, but warnings also appeared in popular magazines. *Newsweek* advised its readers that the GI Bill might be good business for colleges and universities struggling to make ends meet, but would ultimately prove disappointing to students who expected a serious education. As

colleges competed for "business," standards would be lowered to the lowest common denominator, exactly as had occurred in popular entertainment. *Time* magazine told its readers that the expansion of university education might eliminate the class of educated men who stood above society and criticized it for its own good. There might then be no respectable counterbalance to public opinion, so easily manipulated by demagogues, and major changes in the structure of American society could be made in the heat of passion without adequate discussion of the consequences.[76]

In such a pervasive intellectual climate, reasonable men and women might easily conclude that the future of art lay in advertising and industrial design, though that conclusion was a surrender to the forces of "barbarism" that Conant, Hutchins, Greenberg, and Barzun wanted to hold at bay. Driven by financial concerns, the school's board could not believe that a humanistic art education could survive. Like it or not, student preferences would inevitably be for practical, employment-oriented programs. As we have seen, studies of veterans' actual decisions about courses of study indicated that humanities education expanded with the entry of new students, but these studies do not appear to have affected national discussion of educational issues. The trustees at the California School of Fine Arts disregarded their own school's experience. The actual phenomenon of "mass education" did not coincide with the imaginary construction so many intellectuals had made. Yet not all intellectuals were blind to the positive changes occurring. In 1952 Lionel Trilling of Columbia University wrote in the *Partisan Review* that American culture was "notably better off" than at any other time in the twentieth century.[77] At first glance, this was an astonishing statement. Beyond the obvious fact that 1952 was the height of the McCarthy terror, on a purely cultural level no emerging writers in the United States even remotely approached the caliber of Eliot, Pound, Williams, Stevens, or Faulkner. Trilling's comment made sense only in the context of his personal professional activities in the postwar period. American universities had grown and were educating more students, in part thanks to the GI Bill. The cream of those new students had gone to

elite school such as Columbia, which thanks to the emphasis on private initiative put in the bill, could accept or reject GIs as it pleased without fear of government pressure. Many had majored in the humanities, and several of Trilling's students in the late 1940s then took jobs with publishers, magazines, and book clubs after graduation. Former students working at the New American Library and Signet Classics asked Trilling to choose classic works of literature for reprint in paperback editions to be sold to an expanding market of college-educated readers. Trilling advised three book clubs as to their selections. His observation that American culture was "notably better off" was an expression of satisfaction that university education and fine literature were reaching more people than ever before in America's history. Trilling had recognized that mass education could indeed create a more democratic culture in America, if by that one meant the established classics of Western civilization reaching more people.

Douglas MacAgy was another individual who expected that the opportunity of a broad education would make "high culture" more democratically accessible. He staked out this position at an early date when the possible effects of "mass education" were little more than speculation. If, by mid-1950, he too lost hope in the future of the California School of Fine Arts, his resignation came not from despair over the new students the GI Bill had gathered into his school's studios. Instead, he worried that the experiment in "mass education" was soon to end and the more narrowly based student body traditionally found in art schools would return in full force. His rhetorical statements that art was important to democracy arose from faith in the capacity of people to seize hold of creative possibilities. It was an irrational faith, but, by being open to irrationality, MacAgy and his teachers were sensitive to the variety of human response, a variety that gave them hope for their own project. While MacAgy's short-term efforts were frustrated, the adhesion of students and teachers to the vision he had projected vindicated his general program. Technically, it is correct to say that subsidy for artists came from the government in the post-1945 period in the form of veterans' educational benefits,

but in actual fact, subsidy for the arts came from those students whose conception of "self-improvement" led them into educational courses that offered spiritual growth rather than skill acquisition.

Most of those students left art school without locating a permanent place where they could function as artists. The GI Bill thus had a part in creating a "community" of free-floating artists in the 1950s that would erupt into public attention in 1958 as the so-called beats. The media particularly emphasized the transgressive, anomalous aspects of this generation of artists and poets. We might entertain the possibility that, however outrageous the behavior of some individuals, the thrust of the media's response was not primarily motivated by particular actions of poets or artists. We may instead be observing a continuation of the anxiety that many intellectuals felt in 1944 at the expansion of education. The fears that the basis of education would be destroyed by the influx of people who believed in the "equality of every experience" transferred a decade later to the realm of culture in a heightened form. While the GI Bill gave colleges and universities control over admissions and the conditions of education, the new art and poetry of the 1950s was often literally in the streets, uncontrolled by any responsible overseer. The danger of the new generation of artists and poets lay in their potentiality as a force for unpredictable cultural change.

5 The Avant-Garde, Institution, and Subjective Shift

We have investigated three models put forward in the 1940s to project a role for art and poetry in society. Douglas MacAgy, Lorser Feitelson, and Kenneth Rexroth each attempted to give creative people a basis for understanding what art should be and who an artist is, at a time when previous uses of art and poetry were in question. Each displayed a style of leadership dependent upon personal charm, knowledge, and the ability to talk interestingly on a wide variety of topics. In a society thousands of miles from their culture's historical monuments and devoid of stable institutions, their personal interpretations of tradition helped create a collective imagination of place and time. They did not offer "history" but personal opinion, a feeling for how California poets and artists related to other parts of the world that could be the basis for developing local "traditions." They were not trained scholars, but they were assertive, erudite, and talented. Lacking any of those three qualities, they could not have achieved a leading role for any length of time. Their leadership could exist only when institutions were weak and personalities had to act as centers.

Rexroth, fired by revolutionary ideology, and Feitelson, moved by more mundane entrepreneurial values, believed that creative people could fill the void by building their own cooperative, self-managed institutions. Douglas MacAgy proposed a very different institutional model: the research-based center of higher education, where poetic imagination was joined to a rigor-

ous, methodological study of one's specialty, while also freed from any need to participate in the marketplace. In the 1940s the relationship of creative people to the academy was still new, and the parallels between humanistic investigation and creative process remained to be determined.

Postwar expansion of American higher education proved to be a boon for poets, as well as visual artists. Josephine Miles, who taught in the English department at Berkeley, remembered that "things were very prosperous for poetry in the forties, as they were in other ways too." The influx of veterans had brought a new set of students—mature, more friendly, and wanting to learn. The increased interest in poetry led Miles to expand her once very small poetry classes. In one semester she recalled the department offered sixteen different creative writing sections and she hired former students, including Robert Duncan and Jack Spicer, later to be leading figures in the San Francisco "poetry renaissance," to help meet the demand for these classes.[1]

Regular poetry readings at colleges and universities proved to be popular events after the war and indeed expanded. In 1946 a program of weekly readings, inaugurated by Rexroth, started at the old downtown campus of San Francisco State College.[2] These readings provided a regular forum for local poets and a place where nationally and internationally known poets could come to read. With a regular schedule and good newspaper reviews, the state college poetry readings attracted audiences that averaged in the hundreds. Confident that they could pay expenses and fees, the program's organizers, Madeline Gleason and Robert Duncan, invited poets from across the country and from Britain. Dylan Thomas read three times to packed houses. In 1954 these regular readings were formalized into the San Francisco Poetry Center, a division within the state college under the direction of Ruth Witt-Diamant, who was not a poet but a professional administrator. Once again, Rexroth initiated the new center by giving the first reading, this time focusing on his translations from Chinese poetry and giving extemporaneous comments between each poem comparing the situation in the United States with the conditions that led to the collapse of the Tang and Sung dynasties.[3]

The range of the center's activities grew to include classes for both serious and amateur poets (a distinction difficult to maintain since neither made money), seminars, archives, and theater productions. Growth of college-level writing programs opened a new form of employment for poets, even though Rexroth and his followers scoffed at academic poetry. "Small holes cut in the paper," Rexroth called it,[4] but in 1965 Rexroth finally escaped his persistent poverty by accepting an offer to be poet-in-residence in the English department at the University of California, Santa Barbara, where he taught until 1973.

But in 1950 the relationship of the creative arts to academic education was still uncertain. The poet Yvor Winters referred to his colleagues in the Stanford English department as "you professors," and Josephine Miles observed that philologically inclined faculty looked down upon their colleagues who were also creative writers as somehow less serious.[5] The conflict over the direction of the California School of Fine Arts was part of a larger debate in American society over the appropriate location and the possible functions of art: Could it have an autonomous, independent role, or was it the servant of more strategically placed forces? Was art inevitably of interest to small elites only, or could it develop a democratic public? The answers one had for these questions had implications for who should be an artist and how that person was selected. Although the specifics of the answers given by Feitelson, Rexroth, MacAgy, and their associates were different, a context of common assumptions unified their disparate responses. In addressing the formal, institutional, and subjective problems of poets and artists working in a provincial environment, the California post–World War II avant-garde assumed a distinctive discourse that was evidence of a subjective shift with implications beyond practice of the arts.

That discourse contained four primary semantic categories. In each, the discourse took strong normative positions on the relation of the sacred and profane, individual and society, difference and conformity, dialogue and communication:

1. The avant-garde on the West Coast had a preference for cosmo-logical-theosophical over psychological-sociological understandings of art and of the individual's relationship to larger forces. The sa-cred, which need not involve a personalized deity, was valued over the profane.

2. Private, interior experience was assumed to have a privileged rela-tionship to cosmological process; this belief presumed a crisis in the authority of historical tradition. Individual choice was valued over social unity.

3. Freedom arose from the irrational, nonlawful aspects of cosmologi-cal being; heterogeneity—i.e., difference—was fundamental to the human condition. Conformity was an unnatural attempt to repress what lay inside each individual's soul. Historical "facts" served hier-archy, while tradition was liberating because it grew from a volun-tary personal response to the repertory of the past. Freedom was not an achieved state but a continuous act of moral exertion that rested on the willingness to state, "This is what I believe."

4. Although art could be used to communicate preset ideas and feel-ings, limited pragmatic functions were insufficient to justify artistic creation. Art was exploration of being, "self-expression," but only in the sense of exploring the possibilities of self implicit in heteroge-neity. The models for artistic communication were personal rela-tionships and dialogue. The term "communication" took on a lim-ited, negative meaning associated with the mass media: one-way transmittal of messages from those with power to those without. "Self-expression" short-circuited that process by emphasizing val-ues of sharing and response. Personal belief remained meaningless until it was expressed to others and received response. The desired end result of freedom was not the solitude of individual belief, but a strengthened because uncoerced collective agreement that took into account a greater variety of experience.

These four semantic categories were not uttered in a uniform or consistent manner, nor were they necessarily used to achieve compatible goals. They provided a normative guide that shaped the ways in which many artists and poets expressed a sense of connection with each other and defined the forces they considered hostile to their interests. This discourse was used by both those whose ideological sympathies were explicitly prosocialist and communitarian, such as Kenneth Rexroth and Hassel Smith, and by those who were committed to the liberal values of individual enterprise, such as Lorser Feitelson and Douglas MacAgy. The blurring of ideological distinctions within an aesthetic vision of the relation of psyche, society, and cosmos facilitated its spread, for no sharp commitment to a particular ideal social structure was required. Divisions were more likely to be over the best institutional strategies to secure a position for the arts in United States society. Nonetheless, the religious metaphors permeating the vision of the arts contained within them potentiality for a radical critique of social authority and provided a discourse available to articulate discontents.

To understand how these cultural shifts affected artists and poets in the 1950s and why they thought of themselves as both a social and aesthetic avant-garde, we need now to examine their self-conceptions as historical actors. Expressed in their verbal reflections, their art, and their actions, their subjectivity shaped a broad and diverse artistic range. The artistic community established its own norms, with priority given to self-narration as the key act leading to personal liberation, the partitioning of efficacious and futile historical action, and the location of value. The theory that artistic creation fostered the acquisition of knowledge from sensuous experience required setting limits for personal space within which the public sphere could not intrude. This step had profound social and political consequences, but the first step was always within an individual, who had to mediate between competing loyalties and responsibilities. A growing sense of the inviolability of personal freedom and experience was the contribution these efforts made to public life, though the form often gave that contribution a contradictory character.

Part II

Mythopoesis and Self-Narration

6

The Beat Phenomenon

Masculine Paths of Maturation

Among the thousands of books published in 1957, two works, Allen Ginsberg's long poem "Howl" and Jack Kerouac's novel *On the Road*, captured public attention as definitive revelations of what seemed to many a new, unsettling form of youth rebellion. Neither work is profound, but the simple, straightforward language that Kerouac and Ginsberg used gave readers a conceptual framework for discussing the social position and obligations of young men in the 1950s. Part of *On the Road*'s power came from its providing a word, *beat*, to label this youth revolt. It was a term that anyone could use because it lacked definition. "Beat" conjured images, but particular features and emotional connotations each person supplied according to his or her prejudices. John Clellon Holmes, a friend of Kerouac's and Ginsberg's from their student days together at Columbia, had used the phrase "the beat generation" in his novel *Go*, published in 1952. Holmes's meaning was simple enough: the post–World War II generation, young men and women born in the 1920s, had grown up listening and dancing to jazz; they had a different sense of rhythm, movement, and language than the preceding postwar generation, the so-called "lost generation" of the 1920s, shaped in the dying days of a classical, genteel culture. Yet both postwar experiences were linked by "an ability to believe in anything . . . and the craving for excess which it inspired." In an essay published for the *New York Times*, Holmes wrote that

the word *beat* "implies the feeling of having been used, of being raw." It was the attitude of a man "pushed up against the wall of [himself]." Openness to experience, even curiosity, distinguished the new generation, not cynicism.[1]

Kerouac's sense of "beat" maintained the vital connection to jazz, but he invested the word with a diffuse web of connotations drawn from its glyphic extensions. It variously suggested beaten down, beatific, moving to the beat of the universe, moving to the beat of one's heart. One of the more sustained of Kerouac's definitions of "beat" in *On the Road* occurs when a group of women confront Dean Moriarty, the main character, over the shabby way he has treated his abandoned wife and children:

> Where once Dean would have talked his way out, he now fell silent himself but standing in front of everybody, ragged and broken and idiotic, right under the lightbulbs, his bony mad face covered with sweat and throbbing veins, saying, "Yes, yes, yes," as though tremendous revelations were pouring into him all the time now, and I am convinced they were, and the others suspected as much and were frightened. He was BEAT—the root, the soul of Beatific.

The women are awed and almost silenced by the spiritual power emanating from Moriarty. His primal knowledge underlies their sexual attraction to him, but they cannot possess and domesticate the natural force of maleness. The narrator intuitively understands his friend's response, but it is the physical, seemingly biological state of being young males, not any words they might have shared, that binds them: "What was he knowing? He tried in all his power to tell me what he was knowing, and they envied that about me, my position at his side, defending him and drinking him in as they once tried to do."[2] Moriarty's power, what makes him "beat," is his refusal to accept any male role outside phallic sexuality. He is a trickster offering ineffable pleasures but at the price of exposing the arbitrary character of deeply social conventions. His animal joy attracts women for its power to propel them momentarily out of daily worries into a state in which body and spirit are reunited.[3]

But he refuses all responsibility for the families that result, ultimately causing only misery for women drawn to him. Moriarty loves his three wives and four children, but he cannot provide for them without destroying his inner divinity.

Moriarty's charms endanger men as well. Moriarty's example seems to say that any form of ambition or commitment blocks a full open experience of the world. Choice is a form of self-limitation. To remain free, a man is always "on the go," ready to accept whatever new experience may come his way. The narrator of *On the Road* is a would-be novelist whose talents have been blocked by the interiorization of his relation to the world. Moriarty shakes the narrator out of himself by literally thrusting him into a fast-moving automobile ripping across the continent. Experience becomes a sequence of lightning-fast encounters, each with its own poignant lesson, but nothing can hold the attention for too long or it risks evolving into a commitment. The centrality of the automobile, of being "on the road," is the most direct and effective symbol in the novel of freedom as a state of pure potentiality.

Kerouac's use of the automobile occurred at a time when psychologists and psychoanalysts had developed a model for the stages of personal development that particularly identified the motor vehicle with male adolescence. Robert Lindner, in *Rebel Without a Cause* (1944), *Prescription for Rebellion* (1952), and *Must You Conform?* (1956), warned that the automobile augmented the power of young men to intrude into territories historically under the control of others. This would augment the natural rebelliousness of males in the period of their development when they first began to define their own powers but still remained subservient to the authority of the preceding generation. Lindner also warned, however, that aggressive youth rebellion would become a more pervasive problem in American society, for the means that young people had to express their disaffection had expanded to a greater extent than the ability of society to control or channel youthful passions.[4]

Erik Erikson also spoke of cars facilitating "intrusion into space by vigorous locomotion," which became a way of acting out a desire to explore the

unknown. Fixation on the automobile was part of a pattern of behavior in which young men in preparation to become autonomous adults separated psychologically from parental authority. Mobility, loud talking, loud music with a driving beat, public brawling and drinking, and acting out fantasies of unlimitable, therefore nonresponsible, sexual intrusion into female bodies were the distinguishing characteristics of an aggressive personality stage, Erikson argued. This was a preparatory stage in life in which men tested the limits of their interests and abilities prior to focusing on those relationships that gave them the most satisfaction.

Erikson's vision of psychosexual development was based on a model that assumed that the establishment of domestic relations was the fundamental and necessary conclusion. Erikson entertained not even the slightest doubt that the need to become mothers and therefore the need to choose a mate guided female intellectual and emotional development. Male development was likewise measured by an ideal of achieving a place in the world where a man could provide for a family. At a certain time in life, role experimentation was essential to developing a sense of self-certainty and autonomy, the confidence that one's path emerged from voluntary and informed decisions. To prolong the experimental phase, as Moriarty had, past adolescence into adulthood prevented the formation of a mature identity and locked men into futile, aggressive relations with the world in a personality style that lacked intimacy, defined as the ability to form companionate marriages; generativity, defined as the ability to reproduce society through work others value; and integrity, defined as the ability to maintain a core set of values and goals in a fluctuating world.[5]

In outlining the pathological aspects of a prolonged phallic relationship to the world, Erikson specifically criticized the beat poets as a movement that perversely refused the growth associated with career or long-term emotional ties.[6] The reality was more complicated, as most artists and poets associated with the beats were committed to their professions and many led relatively normal married lives. The beats played a symbolic role in public discussions

in the 1950s that was not entirely consonant with the actualities of their lives. Nor was *On the Road* a celebration of irresponsibility. The novel ends with the narrator choosing career over youthful experimentation. Moriarty acted as guide during a stage when the narrator's blocked identity formation prevented him from realizing his ambitions as a novelist. Intensifying every moment with alcohol, drugs, sex, and sheer physical terror as he accompanies Moriarty on his cross-country escapades allows the narrator to establish a sense of presence in the world. As a novelist, his task is to fix experience, not to live perpetually in a flow of immediacy. He must in the end turn away from his unreformable friend and return to the literary world with a good yarn to tell or fail in his own quest for personal excellence. The concluding image of the novel is a sad vision of Moriarty isolated and freezing on a wintry New York street as the narrator speeds away in a Cadillac limousine to attend a concert with old friends who, like himself, have found a place for themselves in the world.[7]

To the degree that *On the Road* described a general social condition that went beyond the specific situation of Kerouac and his small group of friends, the novel addressed a crisis of maturation facing young men in post–World War II America. The choice that many men made when entering college on the GI Bill to give priority to personal enrichment rather than career development involved a partial postponement of assuming a responsible position within society. As we recounted in chapter 3, many men felt that military service had derailed their lives. A period of experimentation made up for time lost, while allowing men to assert an absolute right to make their own decisions against a society that had subjected them to involuntary servitude. The high percentage of marriages and the large number of children born while GI Bill students were still in college suggests that they did not intend to remain in a prolonged adolescence.[8] The aftermath of military service and the general disruption of world war upon the lives of both men and women led to a superimposition of life stages. Men began making long-term commitments while they were still experimenting with their life goals. The desire to catch

up collided with the desire not to lose any more time, with each stage in the process of maturation being intensified and problematized simultaneously. Anxiety stemmed from the possibility that pursuing personal preferences might indeed prove foolish, and men would have to accommodate to a structured, hierarchical world without having achieved either adequate skills or a sense of personal autonomy.

One of the ways in which Kerouac's novel spoke to these crises of reintegration into society was to reimagine masculinity through an inversion of gender role associations. In Kerouac, male physicality contrasts with a female-defined social order. The irrational connotations of nature, normally associated with female being, are transferred to the male side, but only to the degree that a man has not succumbed to responsibilities. The spiritual salvation of the young man lies in his ability to salvage as much as he dare of his raw natural force and postpone the process of maturation until it can be achieved on the basis of personal experience, that is, a broad if superficial knowledge of the world.

Ginsberg's "Howl" also projected a sense of maleness as an essentially sexualized interaction with the world. Neal Cassady, the mutual friend of Kerouac and Ginsberg who provided the inspiration for Dean Moriarty, also appears in "Howl" as a man

> who copulated ecstatic and insatiate with a bottle of beer a sweetheart a
> package of cigarettes a candle and fell off the bed, and continued along
> the floor and down the hall and ended fainting on the wall with a vision
> of ultimate cunt and come eluding the last gyzym of consciousness,
> who sweetened the snatches of a million girls trembling in the sunset, and
> were red eyed in the morning but prepared to sweeten the snatch of the
> sunrise, flashing buttocks under barns and naked in the lake,
> who went out whoring through Colorado in myriad stolen night-cars,
> N.C., secret hero of these poems, cocksman and Adonis of Denver.

As in *On the Road*, cars become vehicles for conflating phallic and spiritual states when Ginsberg describes Cassady as one

> who drove crosscountry seventytwo hours to find out if I had a vision or
> you had a vision or he had a vision to find out Eternity[9]

In Ginsberg's case, the incorporation of femininity into male identity was part of his growing self-assertion as a gay man. "Howl" was, he claimed, his coming out of the closet. Even though his friends knew he was gay, the poem was "a public statement of feelings and emotions and attitudes that I would not have wanted my father or my family to see." By struggling against his hesitation to release the poem to the public, he gained the strength to reject normative descriptions of his sexual desires as perverse and proclaimed them instead as a gift from heaven.[10] The reason for the beat generation having come into existence, Ginsberg wrote in 1964, was to create a "social place for the soul to exist manifested in *this* world." The soul was not merely "mental consciousness," or ideas, but "feeling bodily consciousness," emotions and physical experiences. Art was the expression of the soul, the unity of body and emotions in intercourse with the world. Secretions, semen and words, were holy because they created an orgasmic community linking spiritualized bodies. The avant-garde was "the only social-public manifestation" forcing into the public "tender shoots of private sensibility, private understanding, rapport, giggles, delicacies."[11] As we shall see, the psychological reunification of body and soul into a single conscious entity was a central theme in the work of this generation and became an important factor in its interaction with the rest of society. The end of dualism was the battleground upon which "eros" contested against "repression."

Arrested for marijuana possession and car theft in 1948, Ginsberg escaped criminal proceedings by agreeing to undergo therapy at Columbia-Presbyterian Psychiatric Institute in Manhattan. It was a particularly painful

punishment because his mother had been committed to a state psychiatric hospital ten years earlier for delusional fantasies. Only months before his arrest Ginsberg had signed papers authorizing doctors to perform a lobotomy on his mother. Ginsberg spent eight months there, biding his time until he could return to his studies at Columbia University. During his stay, he met and became close friends with Carl Solomon, the other hero of "Howl." Solomon, like Ginsberg, came from a left-wing Jewish family. Like Ginsberg, he merged literary with political radicalism, but he had led a more active, adventurous life and was better read in French aesthetic theory. The two spent their free time together talking about literature, the bohemian tradition, Marxism, and the role of Jews in American culture.[12] Unlike Ginsberg, Solomon had entered the hospital without direct coercion and asked that doctors give him a frontal lobotomy, which he thought would be a painless form of suicide. Ginsberg first met Solomon as he awoke from an insulin-induced coma. The brutal shock therapy Solomon received as part of his "cure" provided key images for "Howl." The poem unfolds around Ginsberg's horror that "the best minds" of his generation were "destroyed by madness" because their physical and emotional natures conflicted with social demands. Through their suffering and eventual redemption by accepting the wisdom of their bodies, gay men emerge in Ginsberg's poem as universal subjects representing all poets—indeed, all who sought liberation from externally generated values. To achieve sanity, Ginsberg had to confront the social construction of sexuality with a self that had a biologically revealed destiny.

In the second section of the poem, Ginsberg associated American society with Moloch, the false god whose worship required the sacrifice by fire of the children of its believers. Social conformity was idolatry, and adherence to inner desires, however superficially anarchic, expressed a devotion to the truly divine, which communicated most directly through its demands upon the body. Sexual relationship was the most fundamental component of being-in-the-world. The phallic became the truest representation of nature, and the relationship of men with each other the most perfect and beautiful manifesta-

tion of community. Intrusion upon the world could also be a form of liberation, not only for the intruders, but for those whose lives were disrupted.

As is well known, Kerouac and Ginsberg emerged from a small circle of young men with literary aspirations, most of whom were students at Columbia University in the mid- to late 1940s. Neal Cassady was an outsider to the group. Born in Denver, Cassady had no college education, but was a veteran of reformatories, prison, and itinerant jobs on the railroad. He fatefully appeared in New York in 1946 with his seventeen-year-old wife and asked Kerouac to teach him how to be a novelist. He came east to learn writing, but he lacked discipline to accomplish this goal. Instead he carried Kerouac and Ginsberg west to Colorado and then to California, in journeys that helped them define their poetic voices.

In a story that both Kerouac and Ginsberg told about him, the two New Yorkers paid a visit to Cassady's room shortly after first meeting him. Cassady answered the door completely naked, having been in bed making love to his wife. The image overwhelmed them. Kerouac told his other friends that he had found for the first time in his life a true "Nietzschean hero." Cassady was absolutely comfortable with his body; he seemed unaware of the duality between spirit and flesh that plagued Western civilization. Yet his craving for friendship and the chance to talk was more important than satisfying his sexual needs. At this moment both Kerouac and Ginsberg believed that Cassady existed on a plane of enlightenment denied most men. [13]

While Cassady could not derive meaning from his flow of experience without falling out of his state of natural being, the two writers could. Life in immediacy could be imitated in books through a flood of images tumbling one after another, with no space for readers to rest and reconsider. Since the writer guided and selected this flood, the structure still involved interpretation, but the goal was to re-create an experience of forward motion, unsettling in its lack of established perspectives, but liberating in its projection of a subjectivity that lived independently and perhaps even unaware of a priori interpretative frameworks.

Ginsberg and Kerouac failed to report how Cassady's young wife felt about this interruption. The misogyny everpresent in their writings and lives shaped discussion of the beats in the mass media.[14] In a parody of Freud's famous question about women, Paul O'Neil asked in a *Life* magazine report on the beat poets, "What is it that beats want?" The form of the question indicates how the beats, whose ethos O'Neil inaccurately presented as an exclusively male phenomenon, assumed in their public face stereotypical values associated with femininity: the beats were irrational and emotional, they refused to follow the "logic" of situations, they were concerned about their appearance, they smelled, they compensated for prolonged immaturity by substituting group for individual identity. Their apparent disdain for work and lack of concern for material success appeared to be a rejection of the traditional male role of provider. O'Neil's portrait aligned the beats with the purportedly seductive, dangerously libidinal pole of femininity that challenged the stability of domestic relations.[15]

The negative stereotype presented in the media reinforced normative masculine behavior in American society by creating an Other, a feminine male self, against which the true male could be defined by his ability to overcome rebellious desires and accept the necessity of responsibility. The effects of wartime disruption on the lives of young people might have subsided and faded as a generation of veterans settled into adult positions. The cold war and the perpetuation of a large standing army based on the draft made military duty a typical feature of young male life for over two decades. In 1957 the editors of *Look* magazine observed that the fact that three-fourths of men between the ages of eighteen and twenty-seven served in the military forces might have adverse consequences for civilian life. Military duty seemed, in the eyes of the writers, to encourage either excessive conformity or excessive rebelliousness. The repercussions of arrogant inflexibility and irresponsibility boded ill for the long-term stability of American institutions. The writers suggested that women alone had the power to counter this negative development, for female distribution of sexual favors shaped how most men behaved.

The magazine's solution seemed to favor men who finished their military duty determined never again to be vulnerable to external authority. The writers urged women to give preference in selecting their mates to men that had unconventional and daring attitudes because in the long run they would be more exciting partners *and* better providers.[16]

One could escape service altogether, as both Kerouac and Ginsberg did during World War II, by claiming psychological disability. A more common alternative to service during the cold war was to prolong education and take a student deferment. The creation of a permanent standing army itself increased pressure upon politicians to expand educational opportunities. Some men volunteered for military service in order to qualify for GI benefits and the possibility of subsidy for training, while others decided only after completing their duty that they should go to college. Veterans groups made access to education one of their top political priorities. Between 1947 and 1962 the percentage of the population between the ages of eighteen and twenty-two enrolled in college increased from 28.7 to 44 percent, with higher figures in California, which had the most extensive community college system in the nation. Sixty-two percent of graduating high school students entered college in 1962, while a public opinion poll found that 69 percent of parents in 1959 planned on their children going to college. Such expectations led to rapid expansion of college facilities, largely paid for by state and federal funds. Student enrollment increased from 2.4 million in 1949 to 3.6 million in 1960, and then nearly doubled in the next decade as enrollment rose to 7.1 million in 1969.[17]

The extension and spread of college life was another factor leading young men and women to defer full independence to a later stage in life. By simultaneously expanding college education and military service, American society made subjection to external discipline and deferral of autonomy the most commonly experienced preconditions for eventual participation in the benefits of the "American century." At the same time, the average age for first marriages dropped throughout the 1950s. Young people may have

sought in domesticity an autonomous realm where they could create their own lives independent of the often arbitrary institutions engulfing their youth.

Public images about the beats vicariously satisfied needs for rebellion, while reinforcing the correctness of responsible behavior. Evidence that psychological need for release and reinforcement was sizable may exist in the range of deviant behaviors occupying the mass media in the 1950s. In addition to the beats, the media virtually exploded with images focusing on rebellion. Movies such as Richard Brooks's *Blackboard Jungle* (1955) and Nicholas Ray's *Rebel Without a Cause* (1955) popularized the themes of juvenile delinquency and motorcycle gangs. In 1955 rhythm and blues erupted from a narrow segment of the music market to become the most popular type of music, as Elvis Presley, Little Richard, and Chuck Berry gained a mass audience by flouting parental authority and sexual conventions.[18] The growing attention given to the beats was part of a wider fascination with youth transgression. The focus on youth's discontents went beyond questions of subordinate rebellion against social constrictions, a perennial aspect of popular culture, to suggest that a period-specific crisis of maturation had become a new organizing theme for cultural expression, both high and low.

Douglas MacAgy had not dreamed that artists would become objects of mass consumption, but in 1943 he had predicted the growing importance of elite art for postwar America. As summarized in chapter 3, MacAgy argued that the arts provided an arena for subjective autonomy within a society increasingly organized around the needs of rational, efficient planning. The public would spontaneously turn to the arts to claim for itself the only realm where imagination ruled unhindered by laws of necessity, be they scientific or theological. MacAgy expounded the positive functions of irrationality, but he had forgotten that irrationality was associated with both juvenile and feminine being.[19] The public would not absorb the benefits he described without trepidation, for who could say with certainty where the boundaries lay between the positive and negative aspects of freedom—that is to say, between

adolescence and adulthood, between male and female? The benefits of personal freedom were counterbalanced by potential disintegration of the categories that traditionally defined identity and the appropriate roles for given stages of life.

The polarization between "beats" and "straights" that occurred in public discussion ritually enacted interior conflicts over the limits of freedom. The public debate was artificial as it exteriorized complex personal choices into Manichaean imagery that negated essential questions of context. The combination of discipline with experimentation typical of avant-garde practice demonstrated that it was indeed possible to make freedom and structure, pleasure and responsibility, ambition and ideals, experience and traditions compatible. Possibility, however, never guaranteed certainty. The argument that took shape around the images of the beats favored apocalyptic fantasies: the beats' vision of an inner utopia that resolved all conflicts into grist for personal growth (maturation as a self-determined process) versus a nightmare vision of unrooted individuals succumbing to libertinism (engulfment in perpetual immaturity). This spurious opposition promoted the use of reductive symbols by both sides to generate a polemic endlessly oscillating between enthusiast and moralist faces.

The artificiality of the polemic, even in its own time, is suggested by a national study of attitudes toward conformity conducted in 1953. Nearly 80 percent of those surveyed for this inquiry described themselves as "conventional" in behavior and attitude, but those respondents nonetheless claimed to value unconventionality and difference as important for the future of the country. Study participants ranked academics, writers, and artists higher than business leaders or politicians for social prestige because of the assumed propensity of intellectuals to question things most people took for granted. The sample presumed that leaders of society, be they political, economic, or cultural, were risk-takers and were motivated by a strongly felt desire to demonstrate personal superiority. The subjects of this study valued traditional relationships, but their respect for innovation may be evidence that they wanted

to experience those relationships as voluntary rather than as obligatory. They wanted to retain known boundaries between established social categories such as male and female, but augment the content of each so they might be less one-dimensional. [20]

If this study's results were a valid indicator of general attitudes at the time, the mass relationship to new phenomena like the avant-garde appears not to have been a question of totalistic absorption or rejection. Added to the "marketplace of ideas" was a "marketplace of behaviors" from which the public picked and chose according to individual interests and situations. The drama of the beatnik presented in magazines, motion pictures, and on television brought attention to a new repertory of life-styles, with varying promises of release from unwanted responsibilities. The polemic was an imitation of a debate because the public did not need to make fundamental choices. The appeal that the beats made to reduce mind-body dualism might mean only that one could learn from experience and ought to trust one's desires. The message of "free love" might convey simply that affection rather than obedience should be the basis of marriages, or that a trial period of living together—an aspect of "beat" life inevitably reported in the mass media—might be a reasonable test of compatibility before making a permanent commitment. The beats helped negotiate conflicting demands of subjective experience and institutional rationality by projecting these conflicts onto an imaginary vision of themselves. This exemplary role developed as artists and poets struggled with their personal and professional problems. "Howl" and *On the Road* were two exercises, among many, in the reconstruction of male identity into a form that allowed the poet to have a constructive sense of self in pursuit of excellence while undergoing prolonged apprenticeship, a condition increasingly typical of men's experiences in the postwar period, but particularly exaggerated for those in the creative arts.

To the degree that poets and artists achieved attention, they became generalized symbols in which fragments came to stand for larger phenomena.

"Howl" and *On the Road* defined the beat vision, which even limited to the small group of friends associated with Kerouac and Ginsberg, was more complex and ambiguous (and often far less optimistic, as in the case of William Burroughs's paranoid fantasy *Naked Lunch*) than the movement's two best-known products. The beats, marked by extreme misogyny and a heavy-handed didacticism, overshadowed but did not eliminate the many competing visions within their generation of artists and poets. Most curiously, a generation of young artists symbolized the appeal and the dangers of autonomous identity for their fellow citizens. The relation of the postwar avant-garde to American society is one of intersecting layers of surfaces and depths, in which symbolic functions often obscure a more complex and varied set of experiences. We will need to bracket and suspend stereotypes from those years to look more closely at the manifestations of the avant-garde. Yet for the purposes of our analysis, the meanings captured in stereotypic thought remain a touchstone, for they return to the roles of the avant-garde in the social imagination of the time. Our goal ultimately will be to gain understanding of the peculiar relationship between elite, vanguard art and the rest of society that developed in the 1950s. First we must address the relationship of the beats to other voices within the avant-garde by examining the ways in which Ginsberg's peers experienced "Howl."

The response that sculptor Manuel Neri (b. 1930) had to "Howl" demonstrates the complexity of the interaction between symbolic forms and individual lives. Neri first heard the poem in 1955 when he visited a friend's apartment in Oakland and Ginsberg, who also happened to be visiting, read a draft of the poem. Neri recalled that evening as one of the most moving experiences of his life. The poem seemed to capture nuances of his own life. Ginsberg's famous opening line, "I saw the best minds of my generation destroyed by madness, starving hysterical naked," struck Neri as an accurate description of

the anguish artists felt. As important was the *forgiveness* accompanying anger. "Howl" promised that poets could trap "the archangel of the soul between 2 visual images" and

> recreate the syntax and measure of poor human prose
> . . . rejected yet confessing out of the soul to conform to the rhythm of
> thought

and that this wisdom would blow

> the suffering of America's naked mind for love into an eli eli lamma lamma
> sabacthani saxophone cry that shivered the cities down to the last radio
> with the absolute heart of the poem of life butchered out of their own
> bodies good to eat a thousand years.[21]

It was a heady image that continued martial and millenarian imagery: dedication to the impractical was part of a necessary crusade to restore goodness. Artists attending to their own interests served a transcendent public good, a theme that Ginsberg continued to strike through his career.[22]

Neri was a member of the Six Gallery, an artist cooperative in San Francisco run by students from the California School of Fine Arts. He opened the gallery space for a public reading of "Howl" so that Ginsberg could find an audience outside the living rooms and kitchens of his friends. On October 13, 1955, Kenneth Rexroth presided over Ginsberg's presentation and a reading by five other poets: Lawrence Ferlinghetti, Philip Lamantia, Michael McClure, Gary Snyder, and Philip Whalen. All of the poets who read gained national reputations as leaders of the San Francisco "poetry renaissance," which had actually begun a decade earlier but achieved attention far beyond poetry circles in the late 1950s because of its association with the beat phenomenon.

Neri's conviction that "Howl" accurately described his life and his hopes is an historical fact with significance for future developments. Yet Neri was not gay or bisexual. He was not a conscientious objector, and indeed served

creditably when drafted for the Korean War. As an artist, he was more concerned to develop a formal, aesthetic vision than to project a program of social criticism. Nor was Neri an outcast, suffering artist. Even as a student, he was well received and on his way to becoming one of the most prominent artists in California. His development was a remarkable success story, one made possible in part by the rapidly expanding market for contemporary American art.

Neri was born in California's Central Valley into a family of immigrants from Mexico who spent the year traveling up and down the state as agricultural laborers. Neri worked in the fields with his parents and siblings until he was fourteen years old. When his father and older brother died in an accident, Neri's mother abandoned farm labor and moved her family to Oakland, where she went to work in the canneries. For the first time in his life, Neri was able to attend school on a regular basis. He proved to be an exceptional student with strong grades in all subjects. His counselors and teachers encouraged him to go to college, and he enrolled at Berkeley in 1949 with a practical goal of pursuing a degree in electrical engineering.

An elective course in ceramics changed his aspirations. Hearing about the experiments at the California School of Fine Arts, he went across the bay and audited classes. Overwhelmed by Clyfford Still's work and "his idea of what an artist should be," Neri determined to become a painter instead of an engineer, though he tried to placate his mother's concerns by taking a double set of courses.[23]

In 1952 the army drafted him. He spent the next two years in Korea behind the lines deciphering aerial reconnaissance photographs. Discharged, with a young pregnant wife, he decided, as so many veterans before and after him, not to compromise his ambitions any further. He used his GI Bill to attend art school rather than return to the university. He enrolled first at the California College of Arts and Crafts, but transferred to the California School of Fine Arts after Gurdon Woods replaced Ernest Mundt as director.

His commitment to art led to the breakup of his first marriage in 1955,

shortly before he met Ginsberg. He and his wife had not argued about money, he said, as he later reconsidered the fluctuations of his life. His wife wanted financial security, but she had expected several lean years while he finished his education. The primary problem he thought was one of time and his inability to give both art and his family adequate attention. His wife was not an artist, and their interests were so far apart that he felt his most intense moments in the studio and while carousing with his fellow students.

Liking what he saw of his friend Jay DeFeo's work in plaster, Neri switched from painting to sculpture in 1955, using a medium that was "unimportant, cheap, and malleable." This decision was the critical breakthrough of his career. His plaster figures seemed to peers and teachers alike to be the first true application they had seen of action-painting techniques to sculptural form. Neri worked with the plaster while it was still wet, and he had to form his shapes quickly before the plaster dried. The medium demanded immediate improvisation but could also be reworked easily by lopping off and adding on. A piece was finished, he observed, only when somebody took it away. After the sculptures dried, Neri slopped cheap but bright house paint over the work in broad brushstrokes that treated the plaster as a form of canvas.[24]

His teachers, Elmer Bischoff and Robert Howard, brought his plaster sculptures to the attention of museum curators, and he began to exhibit in both San Francisco and Los Angeles. In 1960 the George W. Staempfli Gallery in New York offered him representation, and Neri had the first of many one-artist exhibitions in Manhattan. In 1964 the art department at the University of California, Davis, recruited him to its faculty, and he gained economic stability. Neri found in the art profession critical acclaim and a dazzlingly rapid escape from the poverty of his youth. Neri's reaction to "Howl" cannot be explained by the facts of his life course, so we must consider that the symbolic importance of the poem referred to nontangible, imaginative aspects of social reality.

The events of the reading of "Howl" at the Six Gallery have been retold many times because it seemed a moment that allowed those present to see that

a new force had arisen in American culture.[25] The response that the poem released was complex, most of it only peripherally related to the poem's force as a jeremiad. For listeners, the content that the language carried was less important than the ritualistic, collective emotions released by scatalogical and sexually explicit language as the poem was read in public. But it would be wrong to separate content and form. The language fit the content perfectly because it underscored the poet's anger and drew upon the everyday use of vulgarity in emotionally intense moments. Still, at the time, such direct, simple expression was unusual for a poem with serious aims. A letter written right after the event reported on the effect of the language and, incidentally, on Kerouac's role in pushing the audience to let go of its inhibitions and accept the spirit with which Ginsberg had written "Howl":

> This Carrowac [sic] person sat on the floor downstage right, slugging a gallon of Burgundy and repeating lines after Ginsberg, and singing snatches of scat in between the lines; he kept a kind of chanted, revival-meeting rhythm going. Ginsberg's main number was a long descriptive roster of our group, pessimistic dionysian young bohemians and their peculiar and horrible feats, leading up to a thrilling jeremiad at the end, that seemed to pick up the ponderous main body of the poem and float it along stately overhead as if it were a kite. There was a lot of sex, sailors and language of the cocksuckingmotherfucker variety in it; the people gasped and laughed and swayed, they were psychologically had, it was an orgiastic occasion.[26]

In *The Dharma Bums,* Kerouac's novel written in 1957 about his friendship with Gary Snyder, Kerouac gave his own account of "the night of the birth of the San Francisco Poetry Renaissance" (thereby launching the myth that the type of performance that evening was something never heard of before):

> It was a mad night. And I was the one who got things jumping by going around collecting dimes and quarters from the rather stiff audience standing around in the gallery and coming back with three huge gallon jugs of

California Burgundy and getting them all piffed so that by eleven o'clock when Alvah Goldbrook [Allen Ginsberg] was reading his, wailing his poem "Wail" drunk with arms outspread everybody was yelling, "Go! Go! Go!" (like a jam session) and old Rheinhold Cacoethes [Kenneth Rexroth] the father of the Frisco poetry scene was wiping his tears in gladness.[27]

Both accounts stress that the poet's performance aimed to incite audience participation. The words Ginsberg read were his, the emotions belonged to everyone in the room. Instead of listening quietly and attempting to follow the complex lines of poetry, the audience joined in as if they were members of a jazz ensemble. They were not oblivious of the content, but their response was an immediate visceral reaction to a performance, which had its own collective truth independent of the words. "A reading is a kind of communion," Gary Snyder observed. "The poet articulates the semiknown for the tribe."[28] As the letter written immediately after the event strongly suggested, part of the response stemmed directly from the use of street language. The comment on the "ponderous" quality of the poem should remind us that neither the ideas nor the images were new. The poem expressed relatively commonplace gripes of young bohemians. The vulgar language as such was familiar as well. As Deputy District Attorney Bruce McIntosh stated during the trial in 1957 against Lawrence Ferlinghetti for violating obscenity laws by publishing "Howl," any man on the street understood the surface scatalogical images even if the poem's purported philosophical content seemed obscure.[29] As a communicative act, "Howl" presented nothing new to its audience; as an interactive event, the poem was a radical experience, even for this audience, because it allowed the audience collectively to thrust into public discourse what had been everyday ideas and language of private feeling. Public use of obscene language for serious purposes broke down inhibitions that haunted everyone in the room with conventional ideas about what was appropriate and inappropriate for "art." As an event, the reading of "Howl" demonstrated that

there was no aspect of internal experience, no inclination, no emotion, that was to be despised a priori.

A New York theater critic reported a similar experience in 1967 when he observed that Michael McClure's play *The Beard* was unlike anything he had ever experienced previously. There was no drama on the stage, but tremendous pressure built up and released in the audience as they watched the actors impersonating Billy the Kid and Jean Harlow insulting each other with repetitious obscenities until joining in what appeared to be actual sexual union at the play's conclusion. "Curiously enough," he found, "by the end of the play, one has completely ceased to be shocked." As the mutual seduction consummated, "There seemed to be a kind of relief round the audience at this point: the ultimate had taken place, all the taboos were down, and it wasn't really so awful, was it? Which, to my mind, not only cleared the air but absolved the play of any possible charge of pornography."[30]

Participating in breaking down barriers through public ritualization of well-known, daily private acts helped to release guilt about private feelings, and not only those related to sexuality. The most basic desires and fears were no longer *publicly* repressed and therefore no longer experienced as shameful, weak, or conversely as a hidden source of masculine strength. Sexual need (and aggression) could openly define the male relationship to the world, even in areas unrelated to genital sexuality. Ginsberg extended to his audience, but not necessarily to his readers, the dispensation from mind-body duality that he had received from Neal Cassady.

The release from guilt helped justify faith that choosing personal enrichment over immediate material benefit was neither foolish nor immoral, neither essentially irresponsible nor libertine. Certainly Neri would have been more practical, if less self-fulfilled, to stick to electrical engineering. That he succeeded as well as he did as an artist was simply, he himself had observed, luck. The ambition expressed in Ginsberg's "Howl" that words and images, if true to personal vision, could liberate America helped assuage anxiety at

moments of crisis such as divorce, for example, when past decisions might seem mere foolish personal whimsy. There was another, more altruistic psychological reality at play: the very real sense of self-liberation that many felt upon daring to choose their own path regardless of risk seemed germane to others. The avant-garde presented itself with a conception of the individual in the world that said, it is all right to take risks, the pursuit of individual excellence will tap creative energies chained by antiquated customs. The poem promised that to be an artist, or to be gay—that is to say, to be any kind of "deviant"—would be beneficial for the world and would help spread the sense of grace discovered when the boundaries between appropriate and inappropriate language collapsed.

The poem's overarching jeremiad provided a capstone, but not the point of origin. Nothing in the poem's program is remotely political in the sense of programmatically addressing specific social needs. The poem's release was not the sharpening of political antagonism but a diffuse sense of promise. Against America's blind mistrust of "difference," poets and artists claimed to produce a healing balm that would reconcile the divisive elements in America and make the country "holy" again, as the coda to "Howl" predicted. The healing of America involved martyrs like Carl Solomon, but those who were true poets would embrace the conflict the poem described. The language of the poem stressed human values over profit, and this gave "Howl" a superficial anticommercial, antimilitarist tone borrowed from the rhetoric of the left. Yet the power of the poem's rhetoric had little to do with reorganization of political priorities. "Can any good society be founded," Ginsberg asked in 1961, contemplating the Cuban revolution, "on the basis of old-style human consciousness?" The mass media in all countries, capitalist or socialist, functioned as subliminal manipulation that alienated its citizens from facing their own inner reality. Revolutionizing social arrangements were less important than affirmation of the authority of personal need.[31]

A focus on consciousness-raising did not mean that beat-generation criticisms of American foreign policy, the development of a permanent standing

army, or the rape of the environment lacked genuine feeling or intellectual substance. Ginsberg's poem "America," written in 1955, developed an alternative vision of patriotism, based on the merger of political, aesthetic, and sexual radicalism. Still, the most important social effects of "Howl" involved the reconstruction of personal identity on a level at which the ideas were epiphenomenal. The social values poetry expressed had their place, but they were structured by the sense of rupture and rebirth that those participating wanted to feel reaffirmed.

More important than the ideas was an embodiment of a new ideal self that became present in group interactions. Joanna McClure remembered that at the first poetry reading she attended in San Francisco, she "looked around at the women there and thought, I like the way these women look. I like their faces. I am right where I belong."[32] Her reaction was similar to the revelation that Kerouac and Ginsberg felt when encountering Cassady. An ideal self emerged in encountering members of the same sex whose state of being one wanted to appropriate for oneself.

Because Ginsberg and Kerouac provided their generation of artists and poets with a new sense of masculine subjectivity, they came to represent that age group, even though most of its members led lives and pursued aesthetic visions that could not be reduced to the single model the beats provided. In confronting images of a reformed, justified self in a ritualistic context, young men could literally shake off old self-images and throw themselves back in the world to pursue their projects with greater bravado. Kerouac and Ginsberg also helped develop a language of communal loyalties among young men, a language at least as important as notions of freedom for a group not yet differentiated and still engaged in parallel projects.

The simplicity of their ideas and language, ideal for the ritualistic reembodiment of bohemian masculinity, was particularly suitable for relay to a mass audience. Translated into the media as ciphers in a public morality drama,

their work spawned overly simple-minded and insulting presentations. Artists and poets faced the public reduced to a parody of themselves. "Woe, woe unto those who think that the Beat Generation means crime, delinquency, immorality, amorality," Kerouac complained in *Playboy* magazine in 1959, angry at the trivialization of his ideas which reduced him to one book that he did not consider representative of his other work. He warned prophetically, "Woe unto those who spit on the Beat Generation, the wind'll blow it back."[33]

Meanwhile, tourist buses brought in visitors to explore San Francisco's North Beach, Manhattan's Greenwich Village, Chicago's North Shore, and Los Angeles's Venice district with their coffeehouses, bookstores, art galleries, and jazz clubs. Quiet neighborhoods where artists and poets had congregated changed as music and comedy clubs catering to a general public opened. Rebellion was marketable as entertainment, allowing those who preferred their conventional lives to experience a simulacrum of the off-beat.

Painter Wally Hedrick (b. 1935) remembered that one bar in San Francisco's North Beach district hired an action painter to work while a jazz combo performed: "That was his job. He made these paintings and while he would paint the musicians would play along with him. He would go like this and they would go doodoo doop. It was very popular in North Beach. The guy would make four or five paintings in an evening." There was a mystique to being beat, Hedrick admitted, but he was never comfortable with the whole concept. Like most, he was never sure what the word meant, but "I had the costume; I had my beard and I wore my sandals." He briefly held a job sitting in the window of a coffeeshop and drawing abstract pictures while tourists passed by. It was stereotypic identity, but nonetheless brought recognition and a sense that personal peculiarities might be meaningful to others.[34]

Bruce Conner (b. 1933), on the other hand, hated both the term and the hype. He thought "beat" was a derogatory term, accompanied by a kind of publicity that "exploited, degenerated, and decayed" artists into "providers for art boutiques." In 1959 he and Michael McClure proposed that artists and poets repudiate the term beat and call themselves "rat bastards" instead, and

they announced the formation of the Rat Bastard Protective Society, the name intended as a playful allusion to the Pre-Raphaelite Brotherhood. Membership of the Rat Bastards included Joan Brown, Jay DeFeo, DeFeo's husband Wally Hedrick, and Wallace Berman from Los Angeles. Since the society had no business to conduct, not even seriously trying to convince other artists and poets to substitute "rat bastard" for "beat," its meetings were simply excuses to have a party. McClure doubted that a beat *movement* ever existed on the West Coast. It was an East Coast idea that poets could form a movement, he claimed. California poets were more "individualistic, more private, more self-centered."[35]

Robert Duncan preferred to continue using the older term "bohemian" to describe the California arts environment because it placed the avant-garde firmly in the context of a one-hundred-year-old tradition. Bohemian meant translating aesthetic achievement into life-style, that is, living with the arts as a natural and necessary adjunct to daily existence:

In a Bohemian household you have immediacy to all the arts so that you are going to have some aspect of music, poetry, painting, and also the decoration of things at the same level. The minute they're picked up, it is part of the thing you do. Much of what you have around is either painted, composed, etc., either by you or your friends. That's part of the flow. The first thing you have regarding the Bohemian thing is that you don't have someone else do your decor. . . . The Bohemian way is also a constant flow of people in and out, lots of entertainment. You're not surprised that so-and-so is married, or not married, to so-and-so. That's part of what we see—this network of people, this constant interchange. The other half of the Bohemia concept is the Bohemia of North Beach, and that is its cafes, cafe life.

Beat was something developed to make money, to give a suitable advertising label so that customers could look for the correct product.

That's the death of Bohemia. It isn't so much that you couldn't have money. . . . Your art has to be posed with no guarantee and actually look like a very remote unreal activity to be in. Something that nobody values, and you couldn't explain why you're doing it—in order for it to be Bohemia. . . . Modern painting constantly tries to occupy an area that would be doubtful enough to be Bohemian, but it has become so much of a commodity that it's very hard to keep the Bohemian sense. It sells overnight. But it's still Bohemian because the fact that it sells does *not* give it solidity. So, the painters live in a good deal of doubt. . . . Bohemian poetry means risk. But it means something more than risk. It means poetry that no one is sure what it is.[36]

However aggravating or confusing the beat phenomenon might be, the attention it generated brought rewards in terms of shows, gallery contracts from New York, and publications. The possibility of success and actually influencing the country and becoming leaders beckoned, even if the trappings were often offensive. New Directions and City Lights Books, small presses specializing in noncommercial literature, found themselves in the unusual situation of going through multiple editions of volumes by living poets who were not yet assigned in college English classes. Major galleries in New York sought West Coast painters, and several galleries opened in San Francisco and Los Angeles to represent experimental work.

Response to worldly interest was frequently ambiguous. The responsibilities of developing a career in a world apparently interested in what one had to say seemed to interfere uncomfortably with the sense of personal autonomy needed to function as a creative person. The unresolved dialectic between ambition and autonomy remained embedded in many recollections from this generation in a double form of self-representation and a corresponding split in the language they used to recall their careers.

We will examine this tension in the careers of two women painters, Joan Brown (1937–1990) and Jay DeFeo (1929–1989). Their response as women

will reinforce the importance of gender distinctions in this period, but it will also suggest that the reactions of creative people, men as well as women, were more complex than the programmatic fantasies that Kerouac and Ginsberg developed for men alone might suggest. Brown's and DeFeo's experiences juggling career, marriage (and in Brown's case, motherhood), ambition, and spiritual values, while blending sexuality with a desire for stable relationships, point to a commonality between young artists and society at large that an exclusively male focus obscures. At the same time, their experiences had some differences. Unlike most women their age, Brown and DeFeo were involved in two-career marriages with men who were also creative people. Brown was better known than her first and third husbands, William H. Brown and Gordon Cook, while she and her second husband, Manuel Neri, had relatively equal reputations. The early work of Brown and Neri was strikingly similar, but both developed their styles before meeting or falling in love. Indeed, they later felt that one of their marriage's deepest problems had been that their attraction to each other had grown primarily from a shared aesthetics. They assumed that because their work was so similar that they were soul mates. Jay DeFeo and her husband Wally Hedrick were distinct personalities, each notorious in their own way, with very different approaches to art. DeFeo was as private as Hedrick was extroverted, but DeFeo briefly achieved a national reputation as one of the significant artists of her generation.

7 A Woman's Path to Maturation

Joan Brown, Jay DeFeo, and the Rat Bastards

From 1957 to 1964 Joan Brown was one of San Francisco's best-known paint-ers. At midcareer she reflected upon the ambitions that nourished her artistic practice, claiming that

> [painting]'s the only thing that I have been involved in, or could think of being involved in, where there's no responsibility to anybody else. And this gets into maybe some of my feelings about galleries and the public. Whatever you do is strictly for yourself. And I want the freedom. Anytime I feel the pressure from anybody, from anything outside, I'll retreat from that and push it away and push it aside. Because it's the only thing I've ever done where there's absolute freedom. . . . At any given moment I can make a total ass of myself and I'm responsible. You know, there's just me in-volved in it and nobody gets hurt, nobody. . . . You can't do that when you're teaching, you can't do that with your family, you can't do that with your child or wife or boyfriend/girlfriend.[1]

We might note immediately that for men art was a way of finding a masculine self, but for Brown art was a way of stepping back from gendered relations. At the time of this statement in 1975, Brown was one of many obscure but talented painters who earned their livings by teaching. Yet at the start of her career she seemed, even more than Neri, on the verge of stardom. She began her artistic career in 1955, at the age of seventeen, with an impulsive decision

to register at the California School of Fine Arts rather than go to a liberal arts college. She had shown no previous artistic inclinations. Two years later, she had her first commercial exhibition in New York. In 1958 *Holiday* magazine, playing on the national interest in San Francisco's bohemia that developed after the publication of Kerouac's novel *On the Road,* featured her in a series on "North Beach Poet-Makers." *Look* magazine ran a profile on her in an article highlighting the most prominent women artists in the United States. In 1959 Staempfli Gallery in New York began paying her a monthly stipend of $300 for exclusive right to represent her work and presented annual one-artist shows of her work. In 1960 she became the youngest person to exhibit at the Whitney Museum of American Art. *Cosmopolitan* and *Glamour* prepared feature articles on her as a young woman making it in a mostly male profession. In 1962 *Mademoiselle* honored her with its annual Outstanding Single Achievement in Art Award.[2]

"Everybody's Darling," art critic Philip Leider called her. Brown's work, Leider noted, heralded the national success of the aesthetic and pedagogic approach developed at the California School of Fine Arts. Paintings such as *Lolita* (fig. 13) epitomized the San Francisco school of painting, with its philosophical preference for ugliness, a coarse four-to-five-inch-thick surface, and cheap materials. Since she came into the art world at a very young age, immature and intellectually undeveloped, Leider argued that Brown focused the ideas of her teachers and peers, without her own ambitions—other than seeking praise—intervening to dilute their expression. Leider sexualized her achievement by describing her as a passive, if talented and energetic, receptacle of "attitudes." Her work "embodied" the "germinating" ideas of Clyfford Still as assimilated by Brown's teachers Elmer Bischoff and Frank Lobdell. Like Bischoff, Brown reduced her figures to the barest amount of information to identify their gender and relative age, while her use of sludgey impasto to create textured three-dimensional shapes echoed Lobdell, although she preferred bright colors to his grimly limited palette.[3]

She recalled the early acclaim she received as "bothersome and difficult."

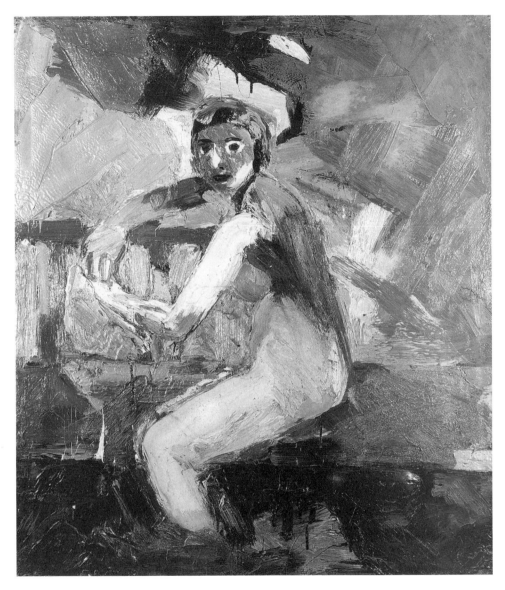

13. Joan Brown, *Lolita*, oil on canvas, 1962. Courtesy of
Frumkin/Adams Gallery, New York. Photo: eeva-inkeri.

Success limited her sense of freedom. "Some of the pressure was coming from the outside, but some was internal too; 'Is this one as good as the last?' The concerns were going outward where they had been inward. Not 'Do I think this is better than the one I just did?' but worrying about what outside reaction would be. I found that very stifling."[4] This conflict between ambition and inner ideals came to a head in 1964, when she and her dealer, George W. Staempfli, clashed over new directions in her work. After her marriage to Manuel Neri in 1961 and the birth of their son Noel the following year, Brown started painting domestic scenes drawn from her son's baby book. The subject of her painting had moved from creative expression itself to the daily experiences of her life: Noel eating his first ice cream cone or taking a pony ride at the zoo. Her stylistic devices adopted to her new concerns. She recalled:

> I was feeling restless and felt there was more than what I knew about. So in January of 1965 I decided to take a new step forward. I put away all my palette knives and trowels, and decided to do some small still lifes in subtle color. I wanted more conscious control of my work at this point. Staempfli couldn't understand why I would want to change since my paintings were selling well, I was showing steadily in New York and L.A., and people were taking notice of my work. I tried to explain that I didn't want to show for a while, that I wanted to pursue this new direction. He didn't agree, so then I realized that we must part ways. I never regretted it, either.[5]

Brown's break with Staempfli and her decision to suspend public exhibition of her work coincided with her divorce from Neri. She confronted a crisis hitting all facets of her life by deciding to spend a year remastering her craft. She asked herself what she would need to learn to become a painter if she had never gone to art school. She began, as if a novice, systematically to work through charcoal, crayon, and water color exercises. Discipline and self-control replaced expression and impulse as the key concepts of her working methods. She purposely limited her palette, restricting herself in order to

force discovery of what she did not know. She worked with small formats because everybody in San Francisco painted very large canvases. If she was to regain a sense of initiative, her art was no longer to speak of presumed painterly absolutes, but only for herself.[6]

The process broke the patterns she had developed while a student at the California School of Fine Arts. When she returned to public exhibition, her work was radically, and for most critics, shockingly different (pl. 7). The precision of her new style was accentuated by a shift from oil on canvas to enamel on masonite board, which made the surfaces flatter and more brittle. Drafting became vitally important, as she created bright representational images, mostly drawn from dream imagery. She forced the viewer's attention away from the language of painting onto the literal content of the images, the details of which were influenced by her studies of hermetic and gnostic philosophy. The cat in ancient Egyptian religion, for example, was one of the four primal emanations of Ptah, the fundamental life force. The image, painted on the occasion of Brown's third marriage to painter Gordon Cook, merged autobiography with mythology.

This work was consciously out of fashion. She knew that her quotations of Rousseau, van Gogh, and Japanese Ukiyo-e prints appeared naive and quaint in a period dominated by postpainterly abstraction. She assumed, contrary to the prevailing wisdom, that the images could be more important than the form of presentation. Representation meant that she was not afraid of what she felt, even at the risk of sentimentality. She would take a stand in the world by making interpretations. She had progressed from being a brilliant exponent of what was virtually a brand-name style to a more masterful but individual approach that did not at the time relate to the formal preoccupations of any other group of painters. This insistence on the primacy of her own vision over any concept of art orthodoxy problematized her relation to the professional art world and contributed to her decline into the secondary rung of artists.[7]

She had no one-artist shows until a 1971 exhibition at the San Francisco

Museum of Modern Art. For ten years she went without a show in New York, and she never again had a commercial gallery as an exclusive representative, although several houses in San Francisco, Los Angeles, and New York exhibited her work. No longer a bright young star or even likely to become famous, she still considered her career to be successful, carefully underscoring that she did not, indeed dare not, use monetary criteria. For her, success meant the ability to create a body of work faithful to her interior vision. She did not conceal her contempt for the purely commercial aspects of the art business. She told *Artweek* magazine in 1971 that she painted only for herself, but she felt a need "every once in a while" to exhibit her work to see how other people reacted to it.[8]

The objectively foolish, but subjectively necessary decision to drop Staempfli left Brown in a difficult financial situation that would endure for a decade. Since 1960 she had taught at the night school program at the California School of Fine Arts, but the work was sporadic and part-time. Her salary was insufficient to support herself and her son. She received money from Neri and her parents, but she needed to feel that she could rely on her own efforts to provide the basis for her standard of living. She supplemented her income by teaching in hospitals, private schools, and by leading art therapy classes for the physically and mentally disabled. "It was tough at that time," she observed later, but felt that the experience of working with so many different types of people outside the art world gave her a better sense of what art could mean in everyday life. Raising a child convinced her that "being an artist is a by-product of being a human being. . . . I'm not any one thing; I'm not just a teacher, I'm not just a mother, I'm not just a painter. I'm all these things plus, and the more areas I can tap the richer each one of the others will be."[9]

Only in 1974 did she gain financial stability when she joined the faculty of the art department at the University of California, Berkeley. The goal of personal, creative freedom was so necessary for her self-esteem that she willingly accepted ten years of personal hardship without ever publicly regretting the

choice she had made. The decision had been hers, she insisted. She refused to blame Staempfli in any way for her difficulties in producing satisfactory product for him. He operated as he did because developing saleable artists was essential to the survival of his business. Brown could not become autonomous working with Staempfli because he himself had no autonomy whatsoever, but led his professional life entirely in reaction to the mechanisms of the market.[10]

Brown's decision was neither unprofessional nor antiprofessional, since her career turned toward an alternative professional model for being an artist, one grounded in the nonprofit, academic aspects of the art world. Her most important shows appeared at museums and university galleries. Her approach to art, shared with many in her generation, included a component irreducibly noncommercial because the institutional framework most important to her advancement took place in the publicly funded sector. She had experienced rebirth in school, and leaving the academy to join the wider world proved difficult and painful. After a plunge into entrepreneurial activity, she discovered that Douglas MacAgy's conception of art as a form of scholarship provided a more secure and independence-giving basis for building a career. She did not reject the value of sales, but she would not make them critical markers of success in her own self-evaluations. The sacralization of creativity in fact helped to support the art market system, because it enhanced the general idea of art as a special autonomous realm. Yet if the public and private sectors were not inherently in conflict, they were not identical, and a potential for conflict underlay the distinction between these two ways of being an artist in America.

The turn from worldly ambition was motivated by a desire to protect personal autonomy and to prevent herself from being reduced to a stereotype. She had discovered that a life based on creativity and work allowed her to live simply and in direct contact with her interior reality. "I trust the unconscious very, very strongly. And I don't trust my conscious, my mind is a mess. It just looks like this painting table. It's just fitted with nonsense, sidetracking,

garbage, and crap." Her conscious mind came from the exterior world, from the repetitious dictates of social pressures. Her unconscious tapped into a deeper level of reality, one independent of society. Her dreams were orderly, clean, clear, very bright in color: "They look just like my paintings as a matter of fact."[11]

Three factors in Brown's account of her life help explain the particular contours of her life-course decisions: her parents' status anxiety; an experience of psychological rebirth that the art student peer group gave her; the linkage of sexual stereotypes to commerce. The first factor was her parents' obsessive anxiety over class status. Brown was born in San Francisco in a lower-middle-class Catholic family, the only child of an alcoholic father who worked as a bank clerk and a devoutly religious mother who suffered from epilepsy. Brown began her life story by stressing the disjunction between her parents' psychological disorders and their desire to maintain the façade of a respectable and affluent *professional* family.

Her father's income was modest compared to the image he wished to project. The family lived in an upper-middle-class section of the city, but in a tiny, uncomfortable three-room apartment. Brown was forced to sleep in the dining room with her grandmother, instead of having a room of her own, as she was certain she could have had if they had lived in a neighborhood more appropriate to the family's income level. Brown particularly recalled that she herself was a public emblem of her parents' aspirations. The family often ate poorly, but she wore expensive clothes and attended the most exclusive Catholic schools. The bank clerk concerned about how his peers viewed him arranged his life to conform to the most clichéd images of respectable life, even to using his daughter, without thought to her needs, to allay status anxiety.[12]

She hated the environment her parents provided for her. Life was insular and deprived, rotating between church, school, and the uncomfortable apartment where each member of the family retreated into a personal shell. "It was dark," she recalled. "I mean dark in the psychological way, and it was crazy."

She could never bring friends over because the family's private life did not live up to its public façade. The street became the only place where she could escape her parents' obsessive fantasies. "As a child, I never spent one moment alone in that apartment. If my parents weren't home when I came home I would wait in the lobby downstairs. I'd wait out in the street. . . . It was black, dark, scary, like a Dracula house to me."[13]

When she graduated high school in 1955, her parents enrolled her in Lone Mountain College, the city's Catholic women's school, but Brown, only seventeen, impulsively switched to the California School of Fine Arts after seeing an advertisement a few days before classes were to start. As soon as she walked into the school's courtyard, she recalled that the school "was a whole new world for me, and I was just ready for it." The students were "sophisticated" and "worldly" veterans—this time from the Korean War. No one seemed afraid to formulate an opinion about art and society. She felt she learned that the world was hers to interpret, that there were experiences "outside of the damn Catholic San Francisco environment" of her childhood. The continuing appeal of the values and perspectives of World War II veterans-turned-bohemians and the processes by which their interests spread to a younger generation of artists are a striking feature of painter Joan Brown's recollections of her career. She repeated almost verbatim motifs we discussed in chapter 3, but her female perspective is a reminder that the male veteran was as much a shared imagination of youthful independence as a sociological reality.

The second critical factor in Brown's transition was the liberating effect of generational confraternity. Instead of competition and infighting, "We'd all meet and be just one big bunch of energies all coming together. . . . We gave each other a great deal at that time. Everybody was excited. It was kind of like a big burst of energy, a rebirth in a sense."[14] Wally Hedrick, a close friend and fellow student, also stressed the importance of a generation developing new lives together: "In this little community we didn't have to have art teachers. It sounds egotistical, but we were our own teachers and we taught each other.

We were so close to one another it was as if I could have called them my surrogate parents."[15] Psychological realignment with one's peers helped one separate from unwanted traditions and values, but it was also a way of emphasizing personal accomplishment. Professional identifications provided sociability, but also the group in which one competed to demonstrate personal excellence. By choosing to be orphans, for whom peers were more important than parents or teachers, postwar artists imagined that each person started on an equal footing and achieved what he or she could, according to the strength of talent and vision.

Languages of independence and ambition were closely linked, and thus we must be careful not to assume that youth rebellion was necessarily or inevitably a revolt against patriarchal authority. Fraternity placed the generation in an ambivalent position vis-à-vis fathers and teachers, as we saw in chapter 1 when younger artists negated the history of which they were heirs in order to magnify their own accomplishments. The myth of inheriting a cultural desert was a formula for asserting on a social level the powerful feelings of rebirth that students such as Joan Brown felt upon entering the art world. The promise of novelty stimulated ambitions and the possibility of rapid advancement within the chosen profession. Confraternity appeared in the guise of rebellion, but it did not overthrow the patriarchy except in the imagination. Indeed, as careers differentiated and competition intensified for prestige and place, the confraternity dissolved into a memory, idealized and romanticized because it represented hope in a timeless state. As long, however, as ambition conflicted with portions of subjective ideals, the individual remained suspended between accommodation to a mature position within a rejuvenated cultural institution and a position of rebellion defending more egalitarian aims.[16]

Evidence of the psychological realignment Brown underwent in school remains in the formulas in her account that shift her career choice into a purely mythic level. She presented the critical decision of her life as an element of chance, as if the hand of fate had directed her to the new environment for

which she, as yet uninitiated into the mysteries of creativity, was totally unprepared.

> I can't really say it was an accident that I ended in art school. I don't believe in accidents, but it certainly wasn't planned. . . . When I went to art school, I had never heard of Picasso. I had heard the name Rembrandt, but never had seen any of the paintings. I had never been to any museums outside San Francisco. All I had looked at was a sarcophagus and a mummy at the de Young Museum.[17]

So foreign was the life she had chosen that she was deeply embarrassed to discover she had to draw life studies from nude models. The first Richard Diebenkorn picture she saw infuriated her because it seemed so pointless. Within a year she wanted to duplicate for others the shock she first felt at seeing an abstract painting.[18]

This motif of chance guiding her continued to appear in her account as she described falling virtually by accident into a teaching career and getting her first shows. The certainty of success that the motif of chance suggested was countered by a second mythic element that introduced factors of suspense *and* personal merit. She loved art school, but she recalled that when she began taking courses, she showed no talent whatsoever and teachers advised her to drop out. To stay in school she had to work extraordinarily hard, fighting lack of aptitude and technique.

> I thought, "I don't have any talent, I have no business here," and I was going to go to work when [William H. Brown] talked me into taking one more class . . . "Landscape Painting." Elmer Bischoff taught the course. . . . [and told her] "You don't have to do things right, just paint from your insides, let it go, I'll help you as we go along." He really started teaching me how to see, rather than to be technically proficient.[19]

Brown blossomed under the influence of the "Bischoff attitude": don't worry about the rules, do what feels right, protect your privacy, never forget that it

will always be hard work to do something good, and be your own strongest critic, never satisfied until you have achieved something new. She acknowledged that having no "natural" talent, she never mastered the basics of drawing, but her technical inadequacies forced her to explore "internal process" and develop a visual language for her philosophical meditations rather than reproduce surface phenomena. [20]

After her breakthrough in Bischoff's class, she never again considered pursuing a career other than painting, because all alternatives meant returning to her parents' world. Thus her life journey took a path of rebellion only so she might discover the otherwise hidden traditional values of community, apprenticeship, and hard work. She continued as a student until 1961, when she completed a master's of fine arts degree. She escaped forever her parents' "damn Catholic San Francisco environment" that she believed was based on appearances only. She had rebelled, but fundamentally she was not a rebel. "You can't keep working if you're just rebelling," she argued. The media, she thought, imposed an image of the rebel and outcast upon artists and poets, but generalizing from her own experiences to those of her friends, she described the motivations of her generation as positive, as the pursuit of interior truth and moral renewal. [21]

The linked languages of ambition and autonomy are represented by two highly distinctive voices alternating in her accounts. One voice used humorous hyperbole to accentuate the surreality of her parents' life or, on occasion, her own foibles and those of her peers. This inflection drew a veil across the more painful elements of her life by rendering them into sharp, quick images designed to shock and get a laugh. The other voice used a more expansive language of wonder and excitement to express the adventure of a young woman on a journey of initiation that would allow her to overcome her fears and enter into enriching relations with others. Part of this journey included following a very traditional pattern for women: marriage at the age of nineteen to a fellow student, William H. Brown, another "refugee" from a Catholic family, with whom she formed a union based on mutual intellectual inter-

est. For two years he was her teacher and guide: "Bill gave me a bunch of books on painting, on the impressionists, Rembrandt, Goya, and Velásquez. . . . I went through all this stuff, and I was just knocked out. I'd never seen any of this stuff, and I felt this tremendous surge of energy."[22] Her marriage conformed to generational patterns, but it also ensured her independence from her parents. In the context of her progression, an apparently traditional act involved consolidating the rebellion begun when she enrolled in art school. The leading trend was toward assuming personal control over one's life, and thus the 1950s was also a period when one in three marriages ended in divorce. Brown's four marriages follow this trend, but also suggest her determination not to make the mistakes of her parents and continue a relationship that no longer provided growth.

This brings us to the third factor in Brown's subjective progress: the linking of commerce with sexual stereotypes. Entering the realm of aesthetics allowed her to escape the contradictions of her parents' aspirations, in which surface devoured substance. Yet the world she entered linked success and gender so closely that she could not achieve success without betraying the ideal personal freedom that she had discovered in art. She found herself repeating the role that her parents had assigned her, but for a larger audience and with greater rewards. Nell Sinton recalled that the young Brown was a "sparkplug." Sinton meant this as a personal rather than sexual attribute, though in the mid-twentieth century the sexual and personal were seldom distant.[23] Brown's magnetic personality attracted both men and women to her; excitement, verve, and energy could assume distinctly sexual overtones in a male-defined environment, as they often did in reviews of her work.

Brown's response to the sexualization of her art both embraced and rejected the importance of femininity.[24] She did not want to deny her personal charms, yet neither did she want to acknowledge that sexuality, rather than the quality of her ideas, might have been a factor in her success. She confronted contradictions in the art world through a double form of self-representation parallel to the double voice discussed above. She used sexual-

14. Joan Brown, *Fur Rat*, mixed media, 1962. University Art Museum, University of California, Berkeley.

ized imagery to portray her interaction with the absurd world of career building. The language and narrative devices that allow this gendered self to speak were closely connected to those used to discuss her relationship with her parents. Early in her life account, she portrayed herself as a liar who learned to use dress and appearance to protect herself; at the same time, she satisfied her parents' desires for middle-class status by impersonating the role of society princess. This mendacious, opportunistic character reappears in her account as the person who participates to excess in parties, drinks too much, and lets herself be carried to unspecified extremes by the energy levels of "a whole bunch of people . . . constantly butting up against each other on an almost twenty-four-hour-a-day basis."[25]

This figure became an element in her work as well, where it appeared most spectacularly in *Fur Rat* as a decaying animal wrapped in mangy fur (fig. 14).

Underneath the fur, Brown had inserted the sharp ends of carpet tacks. The needle points were completely invisible, but if one stroked the work—and only the most privileged patrons of the art world were able actually to touch a work—one's fingers could be lacerated. This object derived from a dream she had in 1961, just as her national career achieved momentum. In later years she recalled that she recognized in the dream her troubled response to the pressures of making a career. The fur rat appeared ironically in *The Bride*, collared and leashed, tamed as a sometimes necessary attribute of dealing with the practical world.[26]

Ironic use of seductive imagery in her art and in her narrative reflected her ambiguous position as a woman in the arts. Like it or not, a woman made her way in the absurd world of practical ambition with "all the dimensions that happen with the absurd—happiness, humor, gentleness, violence."[27] And yet a passion for distinction transformed into ambition for worldly success had led her into a trap. Success under those conditions meant accepting a constricted self-identity, one that gloried in appearances and the ability to use "feminine wiles" to advance herself. To be a successful woman artist was possible, but that life seemed only a reconstruction of her parents' world on another plane.

Opposed to a gendered, sexualized conception of self, another voice called, evoking a vision of an initiate who survived spiritually through recurrent journeys into the freedom of painting. This degendered voice gave her the strength to stand her ground and sever profitable ties with George Staempfli. It also required her to reject the nascent feminist art movement when, in the early 1970s, several feminist critics pointed to Brown's concern with recording personal experience as an example of a specifically female perspective in art.[28] Brown vocally opposed this conclusion and refused to participate in feminist-oriented exhibitions. She accepted feminism when applied to general economic and political questions, but she thought explicitly feminist art was "rotten and contrived" because it elevated one aspect of human experience to universal importance and, perhaps as important, restricted

meaning to a priori conclusions. The central act in recovering subjective will was asserting the freedom to establish the meaning of one's experiences. Feminist ideology, when applied to art, struck her as being as narrow and arbitrary as the commercial art world. Powerful images came from a level of thinking, she believed, that preexisted society and all its distinctions. If she were to use her paintings to reflect her experience, she could accept no political ideology as a filter.[29]

A degendered definition of art allowed her to construct a mature identity, but the price was negation of public value and transfer of personal vision onto an ideal, aesthetic level. This surrender did not mean passivity. Retreat was the only way she could continue to function within society as an active, contributing member without being consumed by the contradictions of her position. By embracing those aspects of her experience that were emancipatory but ignoring those that were confining, she could pursue a career as image maker without actively pursuing a commercial career and exposing herself to the demands of the "fur rat" lurking within her. Instead, she reached for a universal subject that could function simultaneously as artist, teacher, mother, wife. The spiritualized reimagination of mature female self appeared in her work as a "mysterious figure" whose spirit is totally distinct from the dreamlike environment in which it finds itself. Speaking of the series of paintings that included *The Bride*, Brown observed that her figures are "involved in a rather placid kind of setting and then something else is going on. . . . You don't know whether the figure is actually thinking about these things or that's just going on and she's thinking about something else or what. I don't know! I don't have the answers. If I did I wouldn't do it."[30] The separation from the environment she invoked suggests the tenuous character of individual empowerment, constantly impinged upon by practical ties. Brown hoped her art connected her to eternity, while daily life was a constant iteration of need. In art, she said, "people are absolutely timeless." In art, one moved from the trivial world of appearances into a "otherworldly" realm where she could function without betraying her own needs.[31]

Brown's course provides a model of life-turnings that appears with variations and nuances in the choices that many of her associates, male and female, made. The institutional shift away from the school and museum toward the primacy of the commercial gallery generated a subjective shift that dismayed her, because it privileged negative aspects present in her personality from her upbringing. She reacted to assert a form of idealized self, hence of institutional position and ultimately of aesthetic form, distinct from the developing market system of "fine art."

This maneuver had a very worldly foundation: the expansion of higher education provided alternative ways of being in the art world, but this factor was not causative. Brown did not achieve a tenured teaching position until 1974, ten years after she made her break with Staempfli. Withdrawal was a procedure for contributing to the world, being within it, without being overwhelmed by the tremendous pressures one could feel to conform to behavior dictated by the necessities of career building. Refusal to submit to the dictates of a commercial career was her way of affirming her personal freedom to make meaning of the world she lived in, a freedom essential to twentieth-century definitions of successful art. Thus withdrawal was closely tied to ambition, to that pursuit of personal excellence propounded so strongly at the time. In part her decision was a reaction to inability to reconcile hopes and realities, but retreat also allowed her to maintain self-control as an artist and thus to preserve the integrity of her own ambition rather than submit to the demands of those who controlled aesthetic institutions. Withdrawal was a way of remaining active and effective *within* a specific imaginary and then seeking out an institutional environment where that imaginary was most comfortable. By constructing a sense of self separated from social reality, she preserved a sense of subjective independence.

This operation did not negate the possibility of worldly success. Withdrawal set limits as to how far a person would go to cooperate, but within those boundaries freed the creative person to acknowledge the empowering aspects of ambition. Because withdrawal was connected to a transcendent

view of self, it shaded into forms of hubris, an intent to create a body of work that would overwhelm the social forces with which one normally had to negotiate. To influence without being influenced in return was a heady ambition that projected art and poetry, and therefore the aesthetic creators themselves, as completely "free" elements *within* society, the only elements (many of them believed) capable of disrupting it because they could imagine themselves uncompromised.

Maturation as Differentiation

Because college and university training expanded rapidly in the United States in the 1950s and 1960s, Brown had the option of pursuing an academic career in opposition to working within a commercial structure. Her friend and one-time housemate Jay DeFeo lacked the possibility of that kind of security because in 1954 DeFeo was convicted of shoplifting two cans of paint from a hardware store. This misdemeanor on her record barred her for most of her professional life from working in state-run schools, and most private schools also had policies against hiring individuals with criminal records.

Like Brown, DeFeo came from a troubled family, discovered in art an environment that provided a new productive identity, and achieved early recognition of her talent. A pervasive feature in DeFeo's recollections is the use of antinomies to present herself and her parents. Almost at the very beginning of one interview, she joked about being a schizophrenic. Then to prove the point she recounted the story of her father's life. A doctor committed to ideals of social justice, he worked during the depression in rural northern California treating the poor. DeFeo spent the first eight years of her life moving from community to community, until her father suddenly announced he was in love with another woman and abandoned his family. "He was living two kinds of existence simultaneously," she concluded, and "it all ended in a complete split." Thus as a child there was the "country Jay," the young child who

had lived in the woods and the "city Jay," the adolescent who lived in San Jose, where her mother supported herself and her daughter entirely on her own by working nights as a nurse.[32]

She discovered in art a way to reconcile the splits within her by projecting them onto a more abstract plane. Lena Emery, her high school art teacher, recognized DeFeo's considerable talents and encouraged her to consider painting as a profession. Emery was "bohemian," DeFeo recalled, like her father, but her teacher demonstrated that personal freedom required rigorous self-discipline. Emery became a life-long friend, who provided an alternative to the chaos and loneliness of DeFeo's broken family through a vision of modern art as a way of realizing one's potential. For DeFeo, art became a means of physically bringing formal harmony out of chaos, but even here what appealed to her was the possibility of combining the two poles of the artistic tradition coming down to her.

> I think also later I was influenced by two kinds of painting which I'm interested in, or which I consciously or unconsciously tried to resolve in my own work. . . . A kind of classic style, if you wish, for lack of a better word. I don't want to think of it as a sophisticated style necessarily. But something that's classic in nature, influenced by the Renaissance. . . . But at the same time something that is essentially either funky or primitive. Putting it another way, a very close relationship to the use of materials and my relationship to the process of painting.[33]

DeFeo continued to define her artistic goal as sifting through the capricious elements of chance to locate a salvific underlying structure. She hoped to show through visual form the ways in which the chaos of individual existence was neither arbitrary nor empty. The rational and the irrational would present themselves no longer as contradictions, but as two faces of the same phenomenon.[34]

With financial assistance from Emery, DeFeo entered the art department at Berkeley in 1946. Her teachers there also were impressed by her talent, and

DeFeo's first public exhibitions occurred before graduating in 1951. That year she was the first woman to receive the prestigious Sigmund Heller Traveling Fellowship, which allowed her to spend eighteen months in Europe. While living and studying in Paris and Florence, she fell in love with Renaissance and classical art. She did not want to reproduce Renaissance vision, but her personal encounter with the European art heritage helped her preserve an independence from contemporary developments in American art. She remained unawed by the succession of successful artists that appeared every few years. Similarly, Joan Brown remembered her first trip to Europe in 1961 as the beginning of her psychological independence from the art business. She saw firsthand the centuries of work that she had known only from books. The power of it awakened within her suspicions that the achievements of American art since the end of World War II, however significant they were, would not be the last word. This understanding, she thought, gave her courage to change her style and to ignore her dealer's complaints. By placing themselves back in history, both Brown and DeFeo used tradition to distance themselves from the present and achieve a small measure of personal autonomy.[35]

DeFeo returned home and began working in the children's art department of the California College of Arts and Crafts. The certainty of a good academic career was shattered after her arrest. She turned to jewelry making to survive, while she continued to paint. By 1958 she had had several well-received exhibitions in California, had won jury prizes for her work, had seen her paintings published in commercial magazines, and had been selected for the Museum of Modern Art's 1959 *Sixteen Americans* exhibition. Gallery owner Irving Blum recalled that she had developed a reputation of "mythic proportions," not only in California, but in New York. On the basis of three years' work, he and others considered her likely to become one of the very greatest artists of her generation. Edward Kienholz remembered DeFeo as the "seminal force in San Francisco"; her influence extended to Los Angeles, where there was a keen interest in her work among collectors and young artists. Kienholz was impressed by her purist approach. She was one of only two

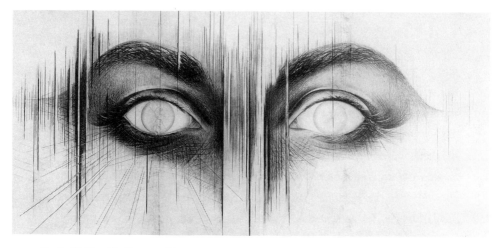

15. Jay DeFeo, *The Eyes,* graphite on paper, 1958.
Collection Lannan Foundation, Los Angeles.

artists he knew who bought pigments and ground her own paints so that she could achieve the exact shades she envisioned.[36]

She had a special affinity for poets, and much of her work derives from poems written by friends of hers. Her monumental pencil drawing *The Eyes* (fig. 15), eight feet wide and four feet tall, was a meditation on a few lines by Philip Lamantia, later published in Wallace Berman's underground journal *Semina:*

> Tell him that I have eyes only for Heaven
> as I look to you
>
> > Queen mirror
> of the heavenly court[37]

On the verge of establishing a national reputation, DeFeo withdrew from public view as she dedicated herself like a monk to completing one painting, *The Rose* (fig. 16). This work was a continuation of her interest with *The Eyes* to capture the mystic underpinnings to human relationships. She had already painted a series of works, including *The Jewel* and *The Cross,* the visual structures of which emanated from a partially submerged central point, but she

16. Jay DeFeo, *The Rose*, oil and mixed media on canvas, 1958–1965.
Courtesy of the Estate of Jay DeFeo. Photo: Frank Thomas.

was not satisfied that she had demonstrated the necessity of working from a center.

Her obsession with *The Rose* stretched across six years.[38] She felt that in resolving the formal problems posed in this painting she would uncover and systematize the merger of classicist rigor with improvisation. DeFeo's struggle took on titanic proportions. All other activity stopped until she mastered the solution.

Unlike Brown, DeFeo's problem came not from a sense of opposition between "fine art" and commerce, though the critical reputation she developed may have stimulated a pride that matched her natural reticence and modesty. The theme of her art was the compatibility of merely human intentions. Does the interaction of myriad personal ambitions lead to a structured order or to a jumble? Because of the contradictions she felt within her background, she could see plumbing her own depths as a test case. The work was to be a redemption of ambiguity, through a romantic eclecticism that defined the self through the combination of what appeared to be opposites. "I wanted to create a work that was so precariously balanced between going this way or that way that it maintained itself," she said of the painting.[39]

The gamble was to strip away the fearful, dangerous aspects of rapid, personal change by uncovering a hidden underpinning of a timeless, cosmic reality. Growth and personal choice did not need to be the same thing as irresponsibility, and yet the nature of the problem as posed evaded the tragic dimension of human relationships. One might forgive the father of irresponsibility, but his abandonment still caused pain. Personal differentiation, which we might call growth, could easily mean that the needs of people who have been linked changed at different rates and often in opposing directions. Part of this she experienced in her own marriage to Wally Hedrick. DeFeo was professionally reclusive, while her husband was one of the most active, vocal figures in the local arts community. He was director of the Six Gallery from its opening in 1954 until 1957; he was administrator of the night school pro-

gram at the California School of Fine Arts after 1957; and he became the leader of the Studio 13 Jazz Band, while continuing to paint and promote his ideas of art as social criticism. In 1959 he mounted what may very well be the first art show protesting American involvement in Vietnam.[40] Antiwar activity would increasingly occupy his time as the pace of American intervention increased. Knute Stiles, commenting on the differences between DeFeo and Hedrick, compared DeFeo working on *The Rose* to Penelope, weaving and unweaving while she waited for her Ulysses to return, struggling through her efforts to keep the ideal of the hearth alive—an ideal that referred both to her marriage and the spiritual necessity of community.[41]

The form of *The Rose* originated in DeFeo's love of hiking in the mountains, where she felt the awesome power of God was most strongly expressed in terms that humans could endure. As she explored the serrated visual structure of valleys, peaks, and canyons, she believed she explored her own spiritual relationship to the earth. Working through the painting's various versions, she found she did not know how to represent female subjectivity. The first version, published in the catalog for *Sixteen Americans*, was called *The Death Rose*, but she decided that this approach was too melodramatic. It overemphasized the existentialist viewpoint that each person must live with her death if she is to find freedom. Because of childbirth, which constantly replenished humanity, she thought women existed at the crossroads of life and death, weaving the two together into an inseparable pattern. She then changed the title to *The White Rose* and recrafted the work to make it more crystalline and airy. This version was significantly larger as she built a new canvas stretching across the bay window of her apartment and glued the old canvas onto the new framework. DeFeo added an armature of wooden beams to *The White Rose*, which gave rigidity to the rays.

Still unsatisfied, she felt that the painting had become too architectural. Her image needed a more organic and biological feeling. She added wire, beads, and pearls, materials she used in her jewelry business, onto the sur-

face; these she used to superimpose a layer of organic shapes on top of the geometric patterns. The overlaying of effects made the painting flamboyant and "super-baroque." Instead of removing the objects she had added to the painting, she painted over them until they disappeared from sight.[42] Their presence, however, was felt in the textures they gave to the surfaces above them. The rational structure that she believed underlay all creation had disappeared under an accretion of emotional reactions. She had to pull back the painting to make it more classic in character. She felt an "absolute necessity to maintain the spirit and freshness of the abstract expressionist ideal—the spontaneity, let's say, and the growth of the image from one layer to the rest. But also I demand from myself and the images, too, a sense of refinement and exactitude."[43] To accomplish this, the painting she remembered "actually had to be carved and hacked." It had become a work of sculpture as well as painting. "It was done with a combination of building up and tearing back during every stage of the game." When she completed the painting, finally feeling that she had embodied a "unity of the opposite ideals," *The Rose* was nearly eleven feet high, nine feet wide, eight inches thick at points, and weighed an incredible 2,300 pounds.[44]

During the nearly seven years she worked and reworked this one image, DeFeo retreated from all exhibition. She turned down inquiries from a New York gallery following her exhibition at the Museum of Modern Art. When her former classmate at Berkeley, Fred Martin, then chair of the exhibitions committee for the San Francisco Art Association, invited her to mount a one-person show, she declined as well, apologizing profusely and hoping he would not misunderstand, but she avowed, "I personally can't do it until I have completed a certain cycle of work. . . . I feel I must be able to understand my work . . . before I hang it up and hope the other people may see it as I do. In this sense, I perhaps place too much importance on the show. . . . As for the actual 'prestige-value' of the show goes—I can very easily give this up as it means little to me. So nothing is lost." Concerned that Martin might be

offended by her refusal, she wrote him another letter that confessed that the idea of the show put her "in some kind of fear of being judged by certain prevalent standards that have nothing to do with my paintings . . . our paintings have not been as much visual experiences as perhaps they are 'ideas' on canvas. . . . Somehow abandoning the show also abandoned my ego fears. I was not ashamed of being egocentric but being in a confused state, I wondered if I was losing respect for the 'me' element—which appeared a tremendous threat to my whole motive to paint. . . . I have constant doubts that I will ever be able to satisfy myself in both aspects—that of the personal and the visual . . . at least I can blunder along—as now, at last, no one cares again."

The intersection of private vision and public value was a torturous contradiction for DeFeo. In a third letter to Martin, she observed that "I used to think that *first of all* art was personal and *secondly* it possibly could extend to greatness if the individual were great, which I'm sure I'm not." Then half-retracting her modesty, she added, "I used to think so, oddly enough." Commenting on the ambitions of her friends, DeFeo expressed amazement at how strongly convinced they were that their paintings were important. "They really feel they are struggling to add to the art history of this century and the personal glory plays a part—but it isn't so shallow as *that,* I don't think, I can't dream that it could be that small, I'm sure it isn't." Success seemed to freeze ideas as artists repeated formulas that had achieved a positive response; therefore success barred the path to transcendence. The artist should remained secluded until she had created the best she hoped she could do. DeFeo returned to her concern for "the personal thing," which, although unique to her, she still felt "potentially extends beyond my personal ego."[45]

DeFeo's isolation was sustained by a select group of friends convinced that she was indeed creating something extraordinary. Dorothy Miller, curator at the Museum of Modern Art, followed the progress of the work and promised to purchase it for the museum's permanent collection as soon as DeFeo completed it. Wally Hedrick encouraged her to stop making jewelry and live off

his salary. Her former high school art teacher, Lena Emery, and a collector, J. Patrick Lannan, provided her money for supplies. Fred Martin helped her out financially—and he hoped psychologically—by arranging for her to teach an occasional class at the California School of Fine Arts. Walter Hopps from the Ferus Gallery in Los Angeles sold her earlier work and sparked magazine interest in writing about her. The work in progress was published in *Holiday* magazine in 1961, and in 1962 President Kennedy (or his staff), in an article for *Look* magazine, "The Artist in America," selected DeFeo and *The Rose* to illustrate what was best in contemporary American art.[46] In 1964, after becoming curator of the Pasadena Art Museum, Hopps began planning two major shows: the first retrospective of the career of dada pioneer Marcel Duchamp and a one-artist exhibit for DeFeo to feature her finally completed *The Rose.*

When the painting was moved in 1965 for exhibition at the Pasadena Art Museum, the movers had to cut out a section of the front wall to her apartment and bring in a crane to lift and lower the work into the moving van. DeFeo laughingly referred to *The Rose* as the "ultimate abstract expressionist auto-da-fé."[47] Bruce Conner, who made a wistful, sweetly sad film on the moving of the painting (*The White Rose*, 1965), described DeFeo's quest as the most heroic of their generation; she had completely subsumed her personality into a single creative act so that the painting reproduced but harmonized the contradictions that moved within her. By this he hastened to add that DeFeo had achieved something few artists had: the painting was physically alive; it was like confronting a living, breathing being.

Except for a thin crust on the surface, the paint had not hardened. This was a common feature to San Francisco painting, but the monumental size of *The Rose* carried a wet surface to another level. The work quivered as people approached it. Viewers could read in the changes on the image's surface a reaction to their own physical, and by extension emotional, effects upon the world. *The Rose* was a physical being, responding to the world around it. The painting recapitulated the action painting aesthetic of projecting the

painter's self onto the canvas, but in a baroque elaboration which made the visual image secondary to the visceral reaction evoked within the viewer. DeFeo had manufactured a being that confronted the world, demanding a response, but it was as unstable as a real life.[48]

The painting grew as an effort to bridge a series of interlinked conflicts within DeFeo's life: the tensions of her family background, with pleasure and duty pitted as opposites, and DeFeo's own inability to choose between the models her parents left her, seeing in both father and mother appealing elements. She entered the art profession partly because her teachers presented the aesthetic process as a way of harmonizing the conflicts she felt through a combination of individual freedom and craft discipline. Her aesthetic then was to present the interlocking of chaos and order, so that one need not choose. DeFeo recognized she existed in a competitive social environment, but she refused to participate on that level. The confraternity had started as a utopian community. In her heart, she still lived in the undifferentiated paths of youth. Her heroic effort rallied her friends around her and allowed a sense of community to cohere. The inner center that her work tried symbolically to materialize preserved a community that had to disintegrate as its members aged. While DeFeo's struggle was not against commerce, her attempt to create a material basis to the utopian dream allows us to understand more clearly the nature of Brown's reaction to Staempfli: commerce was the face of anti-utopia, introducing through the assignment of rewards and distinctions differentiation and hierarchy among the brethren. Commerce meant the acceptance of external authority, a center that came from without and therefore could only be experienced as arbitrary and dictatorial.

The Rose was predicated on the idea that everything proceeded from a single, interior point from which emanated an undeniable, because subjective, mystic sense of order and value. Just as the painting was fragile, DeFeo was unable to find the center that resolved contradiction into perpetual harmony. Her ideal could not be achieved in the mystic form she sought. The watching eyes remained only one's own, with all one's inner crises still operative.

DeFeo stopped painting for six years after completing *The Rose*. She was deeply depressed and disillusioned, her marriage broke up, and she suffered severe lead poisoning from the quantities of lead white paint she had used. Her teeth fell out, and DeFeo was subject to frequent infections and extreme exhaustion well into the 1970s. Yet she also recalled this period away from painting as a second adolescence that gave her a greater sense of humor in facing the disappointments of her life. By 1968 the canvas and wooden frame support for *The Rose* showed signs of buckling under its ton of weight, and she thought her effort might disintegrate. Bruce Conner organized a campaign in 1972 to save the painting, which conservators decided to sheathe in liquid plastic, linen, and paper and then encase in a plaster truss. The painting with its protective covering weighed two and a half tons and lost the shimmering responsiveness that had made it seem alive. The San Francisco Art Institute provided a home for *The Rose* and stored it in the wall of the school's conference room.

Immature enthusiasm bred ambition for worldly success, but the steps taken to achieve that success generated a crisis of conscience. In Brown's case, the immediate cause was external, the attempt of her dealer to dictate the nature of her work. In DeFeo's case, the cause was internal, a questioning whether her work could possibly live up to the expectations that she and her friends had set. She was proud of the work she had done as a painter. She could speak with confidence as a visual thinker, but her work had failed to hold together the imaginary community brought into being by the arts. The cases of both DeFeo and Brown manifest subjective fissure. Brown and DeFeo experienced ambition and ideals as contradictory, instead of resolving into a structured mature, professional life. This led to withdrawal from the "art world," which did not necessarily mean cessation of production. Withdrawal allowed for the construction of a sense of self that could function within self-determined goals. A return to the art world thus followed the crisis, as the artist created work that reflected more closely the ideals and ambitions that had brought her into the art world in the first place. The artist

turned from forms that established the initial reputation and constructed mental categories valuing myth over society, the timeless over the "time-full," freedom over constraint. This resolution was achieved by transferring hopes from worldly to otherworldly success, which allowed the individual to proceed with energy and force since ambition had not been negated but sublated.

I have used two women painters to illustrate a pattern, yet I could as easily have taken male artists and poets as examples, so widespread is this life course in mid-century California. "I want to be anonymous," Bob Kaufman told scholars seeking him out for information on the beat movement. This African-American poet who came to San Francisco in 1957 after discharge from the army was the first person to use the word *beatnik* in print, in his *Abomunist Manifesto*, published by Lawrence Ferlinghetti in 1958. Sales of his first three chapbooks surpassed even Ginsberg's *Howl and Other Poems*, and Kaufman was for a short five years San Francisco's best-known beat poet, a popular figure who held court with his wife, poet Eileen Kaufman, and their toddler at the Coexistence Bagel Shop. He was invited to teach at Harvard in 1963 and New Directions offered him a contract for two collections of his poetry. Then President Kennedy died. Three days later, Kaufman took a ten-year vow of silence, a self-mortification in which he assumed personal responsibility for the tragedy he saw falling on the nation. For a decade he neither spoke in public nor wrote, maintaining his vow until February 1973, when at a gathering commemorating the withdrawal of the last American soldiers from Vietnam he improvised several poems as part of the celebration.[49]

Jay DeFeo's husband Wally Hedrick refused to exhibit his paintings in museums and commercial galleries during the course of the war. He withdrew from full-time teaching and opened a fix-it shop in the suburban community of San Geronimo, while designing costumes and sets for the politically radical San Francisco Mime Troupe. Hedrick continued to paint, but turned down most requests for exhibits even after the war ended. Museum shows, he thought, focused attention on work that was in his past. Curators

did not know how to set up a confrontation between artist and audience that would help the artist discover how to solve his current problems. All a show could do, he declared, "was get me in the magazines, and maybe I'd make more money. Then I would just have too much to drink. . . . I know what happens when I get a little money. So I don't need that stuff."[50]

Assemblagist and filmmaker Bruce Conner came to feel imprisoned by the art he produced:

> The object gets my name on them. And it gets to a point where it exists as a personality. If it becomes historical it exists as a weapon to me as a person, as an artist. It can be used against me. It can be used to destroy me as an artist, a living artist.[51]

Conner rebelled against the fetishized art commodity by bringing his dealer in New York, Charles Alan, boxes of found objects simply thrown together without any particular order:

> I remember I went into the Alan Gallery in 1963. I had a cardboard box which had eight or nine objects in it. I said, "This is a new work." He said, "What do you do with it?" I said, "That's it. It's that box." "You mean you exhibit the box?" I said, "You can if you want to. Or you can take them all out and put them all over the room, or put them in your pocket and walk home, or go to a movie, or put them on a shelf. But you have to remember that they all go together." Charles Alan couldn't deal with that.[52]

Conner's box of objects was as much personal insult against Charles Alan as philosophical reflection on the nature of what made some objects "art." We might recall Joan Brown responding to her success by crafting *Fur Rat* with its hidden nails ready to lacerate the owner's fingers. Wally Hedrick created a sensation in 1958 when one of his mechanical assemblages "attacked" a woman at the San Francisco Museum of Art's annual Christmas party. Three years before, Hedrick had started making sculptures from broken radio and

television sets, refrigerators, and washing machines he found in junkyards. He painted over the surfaces with thick layers of impasto and gesso which incorporated the work into the aesthetic of action painting. He was particularly pleased when he could fix an abandoned appliance sufficiently that at least some piece of it would work and he could turn his assemblages into moving sculptures. His *Xmas Tree,* built out of "two radios, two phonographs, flashing lights, electric fans, saw motor—all controlled by timers, hooked so [they] would cycle all these things," was featured at the 1958 San Francisco Museum of Art annual holiday show. One of the record players played "I Hate to See Christmas Come Around." At the opening, which Hedrick refused to attend, he set a timer so that the piece "suddenly began flashing its lights, honking its horns, and playing its records." One woman who was standing next to the piece when it suddenly turned on found her fur coat tangled into it and then received an electrical shock.

> It caused quite a sensation not because of its artistic merit, but because it attacked this lady, which I thought was very nice. . . . I wasn't making it as an art thing. I was more interested in making a "thing," and if it attacked people—well, I guess I knew it was going to attack. . . . I knew it would probably attack because I laid the trap. So it entertained me; I thought the evening was a success.[53]

Critics concluded that the group of young artists were neodada, and some like Hedrick, for whom Marcel Duchamp was a hero, enjoyed the idea that they were continuing in an accepted and honored art tradition of rebellion. But were the insults that Brown, Conner, and Hedrick crafted assaulting art as a system of meaning, or where they directed against the personalities with which artists had to engage if they wanted to exhibit and sell? Their actions were declarations of personal independence, statements saying that their participation in the professional art world was no longer giving satisfaction, that they would leave to pursue other activities, equally creative, but outside the professional boundaries encasing the "visual arts" in the 1960s. Their insults

did not intend to explode those boundaries, and indeed accepted them as facts of life that an individual working within the system was unable to change. Action was aimed at personal empowerment, creating a distance between the artist and an environment that was only partially escapable, while protesting the loss of community, the family of the young, swallowed up in its march into maturity.

In 1965 Conner "dropped out" of the art world. For several years he developed the light show concept at the Avalon Ballroom, utilizing film clips, slides, and reflectors to create a visual accompaniment to the rock music. It was a performance art that could be repeated but never reproduced, and therefore unlike gallery art or the music he was accompanying, immune to the basilisk eye of commerce. He then worked with Dennis Hopper developing motion pictures. He influenced the decor and editing style of Hopper's 1969 film *Easy Rider*.[54] In 1974 Conner felt that he did not have an aggressive enough personality for Hollywood and returned to exhibition in galleries. His reputation remained strong among those who remembered his work from the early 1960s, but withdrawal had reduced him to a figure of historical interest. He preferred to be a marginalized figure, "operating with concerns outside those of most other artists of his day."[55] When asked for photographs of himself for catalogs or magazine articles, he sent in pictures of other people. He enjoyed submitting multiple biographies to reference works:

> I used to have two totally different biographies—one in *Who's Who in American Art* and one in *Who's Who*. In *Who's Who in American Art*, I was born in India and went to exotic schools. Then I got tired of getting letters in the mail that asked me to update my biography. So I sent them back saying "deceased." *Who's Who in American Art* absolutely believed that and never put me back again. And then they sent me a form for information for *Who Was Who*. I updated all the information way beyond the time I died and sent it to *Who Was Who* and they listed me. Then about

ten years ago I got another letter that they wanted to include me in *Who's Who*—I'd been recommended. Now I am in *Who Was Who* as a dead artist and *Who's Who* as a living film maker.[56]

Folly and Utopia

Insults are just as easily a sign of immature frustration at the inability to resolve the contradictions of social relations. Similarly the neurotic attachment to one painting. The argument that withdrawal was a path to maturity seems to hold only for Brown, who successfully negotiated a transition from commerce to the university. Yet the challenge each of these artists faced was how to remain productive, and their responses were directed to that goal. Each continued producing, creating new and more unusual work after their crises. DeFeo had the most profound physical and emotional breakdown, but in 1970 she resumed painting. Under doctor's orders, she could no longer work in oil paint, so she began using acrylics on paper. *The Rose* had only replicated, not resolved, the conflict between order and chaos. Her post-1970 paintings, each one readable and precise, powerfully succeeded in fusing her interests in classicism and spontaneity (fig. 17).

In 1971 David Meltzer complained to a long-time friend about the trivialization of avant-garde ideas that seemed to accompany success:

[Life] zips by so fast, if you fart, it's gone. It was and is and will be always beyond words, which is why we write and excite them into being, which is why we throw our eyes all over canvas and paper and piss rainbows into anywhere knowing it is all perfect. . . . The ones who worship at art's poor used car lots are lost in a world they never made; they sniff at it and think by owning art they are free of its meanings and responsibilities and joys. We were always right to keep those messages around us at all times because

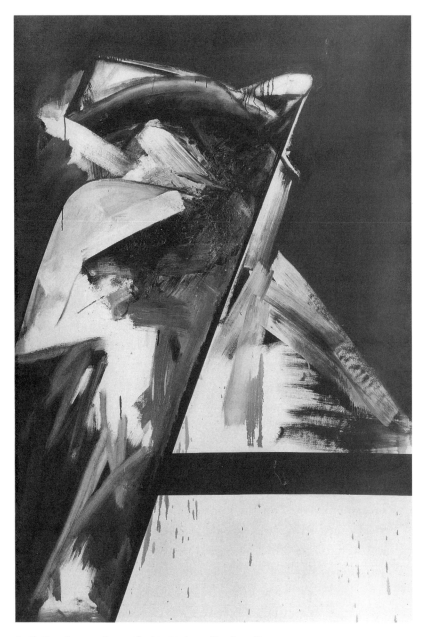

17. Jay DeFeo, *Summer Image (for My Mother)*, oil and acrylic on paper, 1983.
Collection of Mr. and Mrs. Harry W. Anderson. Photo: Lee Fatheree.

those images and works are our amulets, our deepest magics, coming from all kinds of souls in all kinds of knowing and illumination as well as pain and black-hole-in-space density. . . . Our houses are temples, shuls of the most divine reiteration; we can not auction our lives, our magics, our truth.[57]

Long after their activities had generated attention and a market, many in the generation of the 1950s looked back upon its formation and saw a total separation from the arts as commercial ventures. In MacAgy and Still, we saw opposition to art serving an instrumental function subsidiary to other aspects of society. Meltzer's anger hardened into what appeared to be an absolute contradiction between creativity and the market. In another letter, Meltzer returned to the theme as he blamed his colleagues for having surrendered to ambition for worldly success by turning themselves into stereotypes:

I am so fed up, I mean I am fat to vomiting, with precious sacred cowardness & myth-making. I am sick of men that are poets but pee crookedly. . . . I am sick of shamans, hacks & art pushers. . . . Who loves the static man, the man stopped, years ago, copping a safe hole & rotting there?[58]

Meltzer lamented that somehow the original project that artists and poets had embarked upon in the 1950s had gone awry. They had ceased to sing "true songs," coming from the heart in one-on-one communication with reader and viewer so that their work would begin a process of conversion, saying to themselves, "Oh, I never thought of it that way. I never saw it quite like that. Yes, now I see." This art was to create a revolution, to replace the babble of destructive, contentious voices with harmony and productivity.[59] Their generation had the chance to do this, he thought, because creative people had separated from commerce and formed a community. Their ideal of artistic communication was dialogue, the exchange of viewpoints with the goal of achieving some form of higher truth. Jack Hirschman's lines, written to Dean

Stockwell in 1971 to thank the actor for hospitality while the San Francisco-based poet was in Los Angeles for a reading, evoked the transcendent goals that creative people shared:

> like the chorus we've always
> made of each other's dialogues,
> multiplying through the long
> distant intimacy of this town
> on the hill of a high,
>> the intonations on a phone,
> the steady help toward
> some quiet dignity quite close
> to the way nature itself works[60]

By the 1970s competition for shows, jobs, and publishers had taken them in many directions. Choices were made, and those who lived through them might view the sundering as a reduction. They could look back upon the ambition and ideals of their youth and see the hope that young artists and poets could create an audience by offering truthful statements about living in America and a way of resolving the contradictions of modern, urban life. "It was a 'we,'" Joan Brown emphasized. The members of the artistic community in the 1950s saw themselves collectively. "It's been an 'I' ever since. But anybody who's really being straight or honest about it *from that time* really should say 'we'" (my emphasis).[61]

As we have seen, this group of artists' memories of their careers revealed crisis and inner conflict. Participants clung to images of youthful rebellion in preference to those of integration and assumption of power.[62] Reactions against the type of maturity that seemed available short-circuited their rise to authority. Their confusions, however, generated an alternative model for maturation, one based on autonomy and transfer of ambitions to "other-worldly" concerns. They redefined personal excellence to give priority to moral ends, which inevitably in a world of permanent war seemed like a

dream state. In his 1965 poem "Kral Majales," written after he had been expelled from Czechoslovakia, Allen Ginsberg defined the poet's ambition in terms that portrayed the poet as the "wise youth" whose pursuit of personal excellence was a socially essential task:

> And I am the King of May, which is the power of sexual youth,
> and I am the King of May, which is industry in eloquence and action in
> amour,
> and I am the King of May, which is long hair of Adam and the Beard of
> my own body
> and I am the King of May, which is Kral Majales in the Czechoslovakian
> tongue,
> and I am the King of May, which is old Human poesy, and 100,000
> people chose my name
>
>
>
> And I am the King of May, that I may be expelled from my Kingdom
> with Honor, as of old,
> To shew the difference between Caesar's Kingdom and the Kingdom of
> the May of Man—
> and I am the King of May, the paranoid, for the Kingdom of May is too
> beautiful to last for more than a month[63]

Dare to be as much as you can, Ginsberg told his readers, and the enthusiasm of his language drew upon him the wrath of censors on both sides of the iron curtain. As always, he sang of his own small group of friends, but his ode affirmed the morality of student sit-ins to end segregation and racial discrimination. It affirmed resistance to the Vietnam War and three years later to the Soviet tanks occupying Prague. In the struggle against "conformity," poets helped reinscribe sharp we-they boundaries in a society that many, according to David Riesman in *The Lonely Crowd*, had come to see as a seamless, though articulated, organism in which orders had to be obeyed because they seemed to come from everywhere.[64]

The new inscription evaded social forms of organization to project symbolic imagery of death and rebirth as contending social realities. The sense of anticipation experienced in the community of youth peers combined with a feeling of liberation from the compromised lives of one's parents to give rebirth an active, psychophysical immediacy, the tangibility of which could not be denied by those who experienced it. Art, however, compromised by the expanding webs of commerce, could not sustain the dream. The ideals lived on in the ambitions of political and social resurrection that had accompanied personal choice as an ancillary justification. Youth, considered as an image of lost community, became identified with living in a particularly moral state. This maneuver denied the morality of other forces in society, ultimately making it impossible to confront them politically, since they were associated with the absurdity of parents. Opposing forces stood for death, an imagery that was confirmed by the reliance of the national government upon military solutions.[65]

Poets and artists also redefined the boundaries between public and private spheres by insisting upon public expression of experiences that had before been entirely personal. Their efforts brought resistance from the more conservative sectors of American society. In 1957 the United States Customs Office impounded a British printing of Ginsberg's "Howl" when it arrived at the harbor. Lawrence Ferlinghetti then used an American press to publish his edition. The San Francisco police department arrested him and his manager, Shigeyoshi Murao, for violating antiobscenity laws. The judge directed acquittal, but the case confirmed for those, like Manuel Neri, who did not venture to the scatological or erotic extremes of expression, a sense of danger and risk to the artistic project.

It is in this context of a broad-based, apolitical movement to mobilize the agonal spirit and the beginnings of resistance by cultural conservatives that public fascination with the beats arose in 1958. Artists and poets had symbolic importance in the developing contention because they so easily represented both the positive and the dangerous sides of individualism. It was this

contention that imposed stereotypes upon discussion of the avant-garde, even in their own self-presentations.

The contradiction of private freedom and public expression generated a variety of career crises that resulted often in even more powerful art, but also, inevitably, in a sharp curtailment of who saw the work. If we give these artists their due as people who chose their destinies, the impact that many California artists might have made upon the national understanding of contemporary art was limited by their concept of art as spiritual journey that called into being a self independent of the mundane world. The ability to work was the only utopia they could realize. Productivity suspended momentarily the conflict between ambition and autonomy that permeated their relationships with the world. A sense of community decayed as the postwar generation matured and differentiated. Even success could be a mixed blessing because it established conditions within which the work proceeded. As Conner's games with biographical dictionaries allegorized, the happy few were dead to the world and alive to their own creativity.

What was left then was to operate as a dream substratum within American society, influencing without being recognized, exploring the possibility of otherness, occupying the spaces disdained by those who sought overt power and influence. The utopian and the foolish intermingle so closely that it was, and remains, easy to dismiss their activities as irrelevant. But the foolish, an aspect of rejecting the practicality confronting a person, might be the basis for winning out to an alternative standard of practicality. *Might.* Nothing is certain in the never-attained struggle to achieve the utopian. The rejection of the world as it exists flings one into an otherworldly limbo between heaven and hell. By choosing retreat, the avant-garde transformed themselves into a reservoir of pure tendentiousness that would become increasingly attractive and relevant as the mechanisms for extracting consensus in American society collapsed. Like *The Rose,* the avant-garde of the beat era was less a definable image than a response waiting to be activated.

8

Utopia and the Private Realm

Wallace Berman on Career, Family, and Community

Throughout his professional career, Wallace Berman (1926–1976) remained an obscure figure, even though he was comparable in importance to Kenneth Rexroth in his ongoing efforts to build a network connecting poets and artists. He had only four major exhibitions of his work during his lifetime. The first, in 1957, led to his arrest and conviction for violation of antiobscenity ordinances, an experience that contributed to his desire to avoid public attention. Between 1955 and 1964 his creative energies focused on production of his small journal *Semina*. He worked sporadically on a nonnarrative motion picture, completing about thirty minutes when he put the project aside in the late 1960s. After 1964 he pioneered reprographic art, creating collages on a Verifax copying machine. He worked in assemblage, painting, and photography, and designed book covers and posters. Between 1966 and 1968 he had shows at the Fraser Gallery in London, the Los Angeles County Museum of Art, and the Jewish Museum in New York. Only in 1978, two years after his death, was a full retrospective covering the range of his career mounted.

The reasons for Berman's obscurity during his lifetime were complex, and perhaps the term *obscure* is misleading. In 1958 *Look* magazine featured Berman, his wife, and his son as a typical "beat" family. In December 1965 Berman received an unsolicited $2,000 award from the William and Nora Copley Foundation in recognition of "past achievement in the field of art." A year later he was one of the first recipients of a fellowship from the newly

formed National Endowment of the Arts, an honor he had not sought. Perhaps most surprising for someone as arcane and invisible as he was, in 1967 British artist Tony Cooper placed Berman among the host of cultural icons Cooper assembled for the cover of the Beatles' *Sergeant Pepper's Lonely Hearts Club Band* album, where Berman appeared squeezed between Tony Curtis, W. C. Fields, and Edgar Allen Poe. Berman was a friend of Andy Warhol, who shot two of his films at Berman's home in Los Angeles. He appeared briefly in Dennis Hopper's *Easy Rider* (1969) as a sower of seeds in the New Mexico commune, a visual pun on Berman's *Semina* and a token of Hopper's admiration for the man he told a British journal was the "high priest of the scene" in California. In 1990 Hopper reaffirmed his belief that Berman would eventually be recognized as one of the most important artists of the twentieth century, a compliment that suggests the ongoing influence of Berman upon Hopper and his motion pictures.[1]

He had collectors, largely younger people working in the music and motion picture industries, yet Berman chose to give much of his art away, and under those conditions, no gallery owner could represent him. For a short period, the possibility of financial success seemed to excite him. In a letter to Jay DeFeo in 1965, after making his first sale ever to a collector, he crowed that he felt like a "pro." In 1968, after his London and New York shows, he declined further public exhibitions of his work to devote his energies exclusively to his family and to making art. He told Grace Glueck of the *New York Times* that his shows and sales "have been happening, somehow, at just the right time. But I only want a taste of it. This may be the last show I'll have, so why interview me? I really don't make this scene." He felt that the best thing about the recent spurt of sales was that his wife had been able to stop working. He did not spurn buyers, but he had little patience for planning exhibitions, interviews, and projects. He did not want to be, as he put it to another reporter, part of the "straight art hustle wearing beat clothes."[2]

After Berman's death in an automobile accident on his fiftieth birthday, he loomed in the recollections of his friends as a model of the consummate artist,

a modern-day saint, a perpetually self-creative, phoenixlike being.[3] Yet he had assumed no prophetic airs, following instead a path of restrained quietism. The feminist artist Cameron recalled that "Wally was never very expressive verbally. His style was to be very cool, very hip, which meant you didn't talk about things too much. You presented people with things and got their reaction."[4] Both Bruce Conner and Michael McClure felt so indebted to Berman for the direction of their careers that they were wary of the power he held over them. Yet neither could remember a single instance when Berman had actually tried to convince them of his viewpoint. His inspiration came in the form of casual ideas that fermented long after he had gone home.[5]

Jay DeFeo admired Berman because he was "naturally cool," which she hastened to explain did not mean that he put on any affectations. It was his total dedication to creativity that she admired. Joan Brown agreed: Berman was "cool" because he didn't come off like he was cool. She found him to be one of her most supportive friends, a fact she recalled with some curiosity, because she could not recall any instance of his giving her overt encouragement.

> I was tremendously influenced by Wally Berman. But by him as a person, not by his work. He just stood, for me, for the whole idea of the individual. And maybe I could never have articulated it at the time. . . . Well, you follow your nose and you do what's right for you. He sensed that how I was and what I was doing was very right for me. He got those feelings and that message across to me. I understood it clearly, although again, it was not verbal. We were not a verbal bunch and we didn't need to be at that time.[6]

Filmmaker Stan Brakhage thought that Berman was the creator of "whole new forms," not only in his own work, but by his suggestions to his friends.[7] For Michael Fles, an environmental and neon artist, Berman's example created "a very subtle sense of community, a creative community, a certain hip, ephemeral vibe, and that's been lost. The art works per se were simply, as in

all vital art, products of a certain life style."[8] Berman focused attention away from the art work as an object to its function in relationships between people. Berman's creation of an assemblage or a poem demanded something in exchange, a response that allowed two people to expose themselves to each other in ideally more intimate and meaningful ways.

In the memories of his friends, Berman assumed a central symbolic role as personification of actualized youthful ideals. Berman had resolved the contradiction between ambition and ideals plaguing his friends and attained "otherworldly" success. As we look more closely, we shall see that domesticity and art were the two poles around which Berman constructed his life, and in many respects they were inseparable. What made Berman "cool" involved commitment to companionate marriage, shared parenting, dedication to craft, loyalty to friends, compassion for those in pain, values that most Americans of the time accepted as an ideal for personal behavior. He lived with an unwavering focus on private, inward concerns and the truth of immediate experience. Yet he could not ignore public life. His first effort to speak to an audience outside his immediate circle ended in humiliation. The analysis he brought to the relationship of private and public spheres will help us understand more fully the ideal project of the avant-garde between 1955 and 1970, as well as how the concern with inner truth made elite artists relevant to contradictions gripping American society.

Age of Innocence: "Art is Love is God"

"He never thought about having shows," Shirley Berman recalled about her husband:

Occasionally he sold work for hardly anything at all. He usually gave things away. I worked at dress shops in Beverly Hills part-time. As long as he was doing his work and he was satisfied with his work and his friends

were satisfied with his work, he didn't care if he ever showed. If he wanted to show, he would invite people over for a day and fix our front room into a gallery and say, "Here, this is what I'm doing," and serve them wine and cheese.[9]

Their friend, photographer Charles Brittin (b. 1928), observed that

people would just come [to the Bermans' home], and he wouldn't put on a show or entertain you. People came happily and sat down and left four hours later. What happened is that you'd listen to some music and you'd smoke some pot and talk and look at things. What I enjoyed was not the conversation but the things we looked at. We did a lot of that. There were books, pictures, art books, clippings from newspapers. There were evenings where there was not much talk.[10]

The informality of Berman's "shows" is apparent from the announcements that he printed himself on his hand press. The cards gave a time and day of the week, but seldom a date; often there was no address other than "Wally and Shirley's." Occasionally the shows were at the Mermaid Tavern, a local bar in Topanga.[11]

Berman's first public show, drawing from ten years of work in assemblage, painting, and drawing, was in June 1957 at the Ferus Gallery in Los Angeles, owned by Walter Hopps and Edward Kienholz (fig. 18). Shirley Berman recalled his nervousness at presenting his work to a public audience for the first time. He knew how to communicate to his friends, but he was uncertain of the response to his work from people, however intelligent and sympathetic, who did not know him.

The centerpiece of the show was a sequence of four large assemblages: *Homage to Herman Hesse*, *Veritas Panel*, *Cross*, and *Temple*. Berman began working in the assemblage medium in 1949 when he started *Homage to Herman Hesse*, constructed from scrap he brought home from his job as a finisher at the Salem Furniture Factory in East Los Angeles. For six years Ber-

man reworked this piece as he tried to find the simplest but most effective relation of the parts. The struggle with this one work suggests the difficulty that he had with approaching visual composition from a purely formal approach. He did not find his own voice until he stopped worrying about design and began to use found materials to express the relationships that were most important to him. At that point, he stopped calling his work sculpture and started calling them "objects."[12]

With this breakthrough, Berman embarked on rapid construction of the other large assemblages. Both *Veritas Panel* (fig. 19) and *Cross*, also known as *Factum Fidei* (fig. 20), embodied Berman's conception of his relationship with his wife as a revelation of the cosmic union of male and female principles in the universe.[13] At first glance, *Veritas Panel* had the form of a large cabinet. In the center top Berman placed his wife's portrait with "veritas, certior exstat" scrawled across the top and "ea concipiti" written below. The two Latin phrases state a major theme of the show: the interrelation of domesticity and religion. The upper phrase translates as "Assuredly, the fundamental nature of things is revealed." The lower phrase has a number of variant translations, each of which is meaningful. On the most direct level, "ea concipiti" means "She has conceived." The phrase also translates as "She holds things together," pointing toward the metaphysical implications of sexual reproduction, while a more physiological connotation would simply be "She absorbs, draws in, or has received." On each level of meaning, woman as wife and mother is presented as the pivot upon which human beings participate in the continuing process of divine creation.

Above and below his wife's portrait Berman placed two hinged doors. The larger lower door had a drawing made from shoe polish on parchment paper with fragmentary shapes from the Hebrew alphabet. The door opened to reveal a photograph of dancers thrusting their arms upward into light. On the inside of the larger door was the number *12*, the magic number of the zodiac and the apostles, as well as the number of paintings included in the exhibit. Walter Hopps recalled that the paintings, each a rendering of Hebrew letters,

18. Ferus Gallery with Wallace Berman exhibition, 1957. Photograph by Charles Brittin.
Courtesy of the photographer.

19. Wallace Berman, *Veritas Panel*, mixed media, 1956. Photo: Charles Brittin.

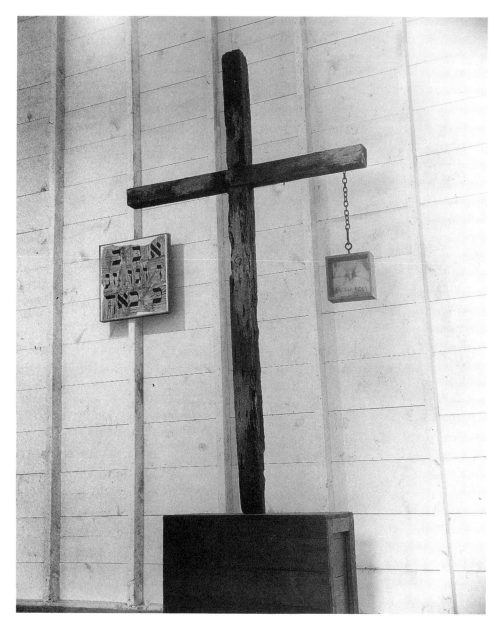

20. Wallace Berman, *Cross*, also known as *Factum Fidei*, mixed media, 1956–1957.
Photo: Charles Brittin.

stood for the "dead poets," unnameable since each person had to select his or her own teachers from the past.[14] On the little upper door Berman placed a letter he had written. When viewers opened the little door they discovered a mirror, a central image that dramatized that the attempt to probe more deeply into things leads back to the self and its own reflection. The understanding of any phenomenon coincides with the understanding of self and of being. To the right of the little door was a box with a rock held inside by leather straps forming a cross. Fragments of paper with Hebrew writing hovered over the rock. The panel was dotted with an assortment of knobs and dowels, the sort of objects Berman used everyday when he had worked in the furniture factory.

While the composition functioned independently of Berman's autobiography and in that sense did not tell a story, the audience to which Berman spoke most frequently knew him and his concerns. A viewer did not need to know the identity of the key photograph to see that the relationship between photographer and subject was romantic and intense, but everyone who saw the piece in Berman's home, and perhaps most who came to the gallery, knew Shirley personally. Their reactions to *Veritas Panel* took into account what they knew about the Berman marriage.

Similarly, many had heard Berman explain that the א, used in the line of Hebrew script above the rock, was aleph, the first letter of the Hebrew alphabet, and that in the kabbalah aleph was the symbol of Adam, the bringer of order out of chaos by naming the facets of creation. Berman had adopted aleph as his personal symbol and had even painted the letter on his motorcycle helmet. The paintings in the exhibition, each presenting Hebrew letters in different combinations on parchment which he had prepared with shoe polish to give a patina of age, were intended to represent his interest in the kabbalah. However, when Philip Lamantia asked Berman for translations of the inscriptions in the paintings, Berman told him that the Hebrew letters had no specific, translatable sense. He had not learned Hebrew as a child, but he liked the decorative form of the lettering and the moods that the shapes evoked.[15]

The word *kabbalah* translates into English as tradition, transmission, reception, or more generally as heritage. Berman's interest in the Hebrew alphabet and its functions in Jewish mysticism was part of an effort to reclaim his ethnic identity. Berman came from a nonpracticing family, but one with a strong cultural sense of being Jewish. His father, who died of tuberculosis when Berman was nine, taught his son that Jews were the "people of the book," but he meant literature and learning in general, not specifically the Hebrew scriptures. His last present to Berman before dying was a complete set of the works of Oscar Wilde and a copy of T. E. Lawrence's *The Seven Pillars of Wisdom*. For Berman, growing up in neighborhoods where many stores had Hebrew lettering on the windows and sold Yiddish newspapers, the alphabet of his ancestors did not spell words, but spoke of traditions and roots discussed at home.

Yet there was a period in Berman's youth when he rebelled against his Jewish heritage. Through the 1940s, as a teenager and in his early twenties, Berman identified more closely with jazz and African-American culture. Bob Alexander, also Jewish, recalled that he and Berman liked the way blacks responded to persecution with "soul," developing a culture based on "a feeling of heart that can be shared." Black culture was an escape from an emphasis on completing formal education, living according to family expectations, or being concerned about developing a profession or business. After his discharge from the navy in 1946, Berman enrolled at Chouinard Art Institute, but he dropped out after six months. He switched to the Jepson Art Institute, then quit that school as well. He sported a zoot-suit and spent his free time in jazz clubs on Central Avenue, the main black neighborhood in Los Angeles at the time. Instead of getting a job, he earned money by playing pool and gambling.[16]

Beyond jazz and pool, his other love was French poetry, which may have grown from his memories of his father's love of modern literature. He recalled later that the books he read about the French avant-garde helped "lift him from the poolroom."[17] In 1949 he went to work in a furniture factory, disap-

pointing his mother, who had worked as a seamstress to support her family after her husband's illness. She wanted her son to be more than a manual laborer, but while he remained close to her emotionally, he rejected all her advice as to what was good for him. Only after his marriage in 1952 to Shirley Morand, who was not Jewish, did Berman return to his roots and begin to research Jewish culture, but he selected those aspects that dovetailed with his interests in poetry and art.

Cross directly addressed the interaction of personal and religious values by juxtaposing sexuality against the principle symbol of Christianity. Hanging from one of the arms of *Cross* was a small box containing a low-contrast photograph of loins joined in sexual intercourse shot from the lovers' point of view. The two sets of thighs framing penis and vagina form a mandala image, so that intercourse became a constantly revolving inner center symbolic of cosmic creation. Inscribed under the mandala was the phrase "factum fidei" (act of faith, act of belief). By suspending the box from the cross, symbol of death and resurrection, Berman created a relationship between the intimate, daily source of regeneration and the distant, impersonal processes of universal renewal that Jakob Boehme, sixteenth-century Protestant kabbalist, had seen in the image of the cross.[18] Whether Berman intended to reconcile or contrast Christianity and sexuality is impossible to say. The form presents the intimate literally as a pendant to the abstract. Berman offered a symbol of suffering and an image of pleasure, both of which represent sources of renewal and rebirth. By size and placement, the cross overwhelmed the mandala image. But the sheer psychic energy released in seeing a photograph of an everyday occurrence, the public representation of which was legally forbidden at the time, might have riveted viewers' attention squarely on the box.

Temple portrayed the creation of art as religious initiation through meditation on the meanings of desire, joy, and sorrow. The enclosure, constructed with scrap lumber painted dull black, was dominated by a white-robed figure, the purified candidate of truth, with a large key across its chest. Berman

twisted the figure's head so that it faced inward. Even though the figure greeted the viewer, its thoughts were always focused on its interior journey. Berman scattered pages from the first issue of *Semina* on the floor, contributions of art and poetry from his friends and spiritual teachers. One of the parchment paintings hung within the *Temple*, as well as another photograph of dancers thrusting toward the light above them.

The exhibition's imagery was primarily religious, but Berman identified the divine with the intersection of marriage and art, the two most important aspects of his life. *Veritas Panel* and *Cross* point to marriage and parenting as facts that demanded that a man like Berman establish himself in a time continuum. He reached back to the past to those elements that were meaningful, the ethnic memories of his childhood and the aesthetic explorations of adolescence, to pass on a legacy. This entering into the flood of time by becoming a parent pushed Berman to consider the relationship of past, present, and future as a source for identity. As Berman's close friend Robert Duncan pointed out, social alienation, however pertinent to some beat poets and artists, cannot account in any way for Berman's positive social values, grounded, as they were, in a deep sense of connection to others.[19]

Berman positioned himself in society through the relationships he developed with his wife and son. Family rather than profession structured his life, and domesticity became the focal point for defining both himself and the art that he created. We have encountered an approach to art in which individual identity is virtually meaningless. Shirley Berman, gazing at the viewer from *Veritas Panel*, could be the face of "the fundamental nature of things" because her happiness, perhaps even existence, was affected by Wallace's actions. In her gaze, he faced the consequences of his choices. The poster Berman designed for the show, with a photograph of himself and his three-year-old son (fig. 21), advertised the unashamed sentimentality fueling his work, underscored by the slogan "art is love is god" handwritten along the bottom of the image. Art was the bridge to a self as nexus, which in Berman's case meant the family he had built, which provided him with a simplified perspective of

the future that focused his attentions and the identity he saw for himself stretching through time. In this context of mutual dependency, the conventional meanings assigned to objects and images paled before the meanings people discovered through the relations that seemed vital to their existence. The cross and the mandala were symbols for divine intervention in human existence, but Berman identified the symbolic mysticism with the everyday act of male and female living together. Religion was not a system of values the origin of which were exterior to daily life, but the revelation of divine intent that emerged within one's soul in the course of meaningful activities: sexual love, both genital and spiritual; parenting; work; friendship.

There can be no mistaking the ethos of domesticity running through Berman's work. The Ferus show presented Berman's image of himself through the relationships he cherished. He had re-created himself through his wife and through his child. Unlike most men, including most artists and poets, he arranged his life so he would not be torn between "career" and family. After the birth of his son, he quit his job at the furniture factory to stay home and take care of the baby, while Shirley worked. His home became the sole focus of his relationship to the world, so that the concerns he had as husband and father constantly informed the topics he handled.

At this early stage in his career Berman's work sat uncomfortably on the border of private and public. His idiosyncratic interpretation of emotions and ideals that were widely shared in the mid-century United States proved to be dangerous. The youthful rebelliousness celebrated in *On the Road* found a prominent place in American cultural life in 1957. An evocation of the sacral character of marriage led to tragic consequences for Berman in 1957. To the degree that career and family were opposing choices for men in the 1950s, allocation of rewards and punishments to Berman and Kerouac stated quite clearly where American society expected male loyalties to be, no matter how much domestic values were touted in the media.

"During the second week of a scheduled month exhibit of my paintings and sculpture," Berman advised the readers of the second issue of *Semina*, "members of the vice squad entered the Ferus art gallery and confiscated a copy of 'Semina 1' which was exhibited as an important part of a work entitled 'Temple.' Brought before the righteous judge Kenneth Holiday [*sic*], who, taking the allegorical drawing in question out of context, declared me guilty of displaying lewd and pornographic matter." Berman had been concerned that the photograph he used in *Cross* could lead to trouble. But since the main gallery was down an alley and away from the street, no pedestrians passing by the gallery could get an accidental viewing of something they might find offensive.[20] Nonetheless, the Los Angeles Police Department received two anonymous complaints about the exhibition, and the vice squad telephoned to advise the gallery that they planned on inspecting it and offered the artist the option to remove any potentially objectionable pieces before they arrived.

When confronted with the choice, Berman decided to defy the threat. More was at stake for him than an abstract right to free speech. To succumb was to accept society's right to dictate religious and family ties. If the intimate and the personal were his source of truth, he had to combat social restrictions on their celebration.

Charles Brittin's photographs of the investigation (fig. 22)[21] reflect the insouciant bravado of youth facing an enemy they considered inferior because of its ignorance and blindness. When the moment of the arrest came (fig. 23), Brittin's picture of Berman shrinking back from the officer in dramatic late-afternoon light starkly captured the feeling of martyrdom that later marked memories of that day.

Yet sacrificial drama did not transpire without farcical entr'actes. "Where is the art?" Walter Hopps reported one police officer saying when he came into the gallery and saw Berman's paintings and assemblages.[22] In their examination of *Cross*, the officers were unable to locate anything objectionable. Berman's thinking was so foreign to them that a straightforward sexual image

appeared as an abstraction. They huddled, confused about what they should do, and decided to arrest Berman for *Temple*, a piece Berman had never considered could conceivably be problematic.

On the floor of the piece, three feet deep in the back, was a small drawing by Berman's friend Cameron that he had published in the first issue of *Semina* (fig. 24). Cameron had composed an allegorical vision of a woman having intercourse with a penis-headed monster as part of "Anatomy of a Madness," a series she executed while suffering a nervous breakdown after the death of her husband. In this series she portrayed her struggles to regain control of her emotions and her life, to battle the irrational desires and fears assaulting her. Art was the way she confronted and mastered her agony, and therefore one of the reasons why Berman associated her work with his concept of art as "white magic." Cameron had triumphed over her pain by facing it as directly and honestly as she knew how.[23]

Cameron's picture was simple enough. Anybody could tell what the "story" was, and for Judge Halliday, that was enough. He refused the defense's motion to present witnesses testifying to the artistic quality of Berman's work, stating, "We have no need to have an art expert tell us what is pornographic."[24] Halliday found Berman guilty and gave him a sentence of thirty days in jail or a $150 fine. On hearing the judge's decision, Berman went to the court chalkboard and wrote, "There is no justice. There is just revenge." Shirley Berman remembered

> Wallace was in very bad shape during this whole thing. It hurt him because he couldn't believe that creative people would still have to go through that. It hurt him to put his mother through that, and it hurt him to put us through that. It hurt him just to go through it himself. He was outraged by the whole situation, and I don't think he really wanted to show to begin with. . . . We left Los Angeles because of this. . . . He was heartbroken.[25]

Their friend Dean Stockwell rushed to the bank to get the money for the fine before Berman could be checked into the county jail for the weekend.

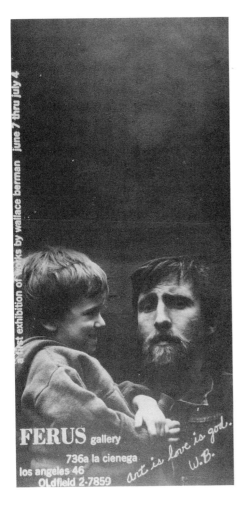

21. Wallace Berman, poster for exhibition at Ferus Gallery, 1957; photograph used in poster by Charles Brittin. Wallace Berman papers, Archives of American Art, Smithsonian Institution.

22. Left to right: Vice squad officers, Wallace Berman bending over, David Meltzer, Bob Alexander, Arthur Richer; sculpture, Wally Hedrick, *Rest in Pisces*, 1956. Photograph by Charles Brittin, 1957. Courtesy of the photographer.

23. Left to right: Arthur Richer, Wallace Berman, John Reed, vice squad officer. Photograph by Charles Brittin, 1957. Courtesy of the photographer.

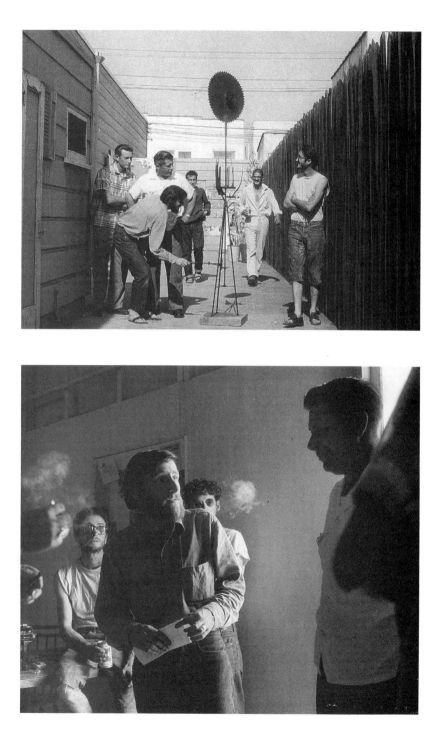

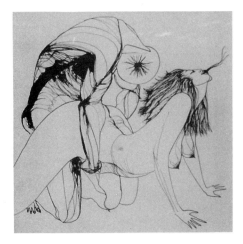

24. Cameron, untitled, *Semina* 1
November 1956).

Otherwise, Berman received little public support; perhaps few outside his circle of friends knew of the case. Neither art critics Jules Langsner nor Arthur Millier commented on the arrest and trial in the *Los Angeles Times*. Charles Brittin felt that the episode revealed the remarkable innocence of his generation. "There was a lack of knowledge about how the real world works or can be made to work, which was probably part of its charm. . . . You get benefits and drawbacks in that innocence."[26]

The "innocence" was widespread and included the two officers who, unable to see either art or pornography, seized on whatever they could find that might be "smutty," possibly feeling that some action was necessary to express their disapproval. Berman's arrest underscored the dangers of the public realm and the very real reasons why many in his generation were hesitant to leave the security of private exchange. The use of illegal drugs was one behavior that required that they shield their activities from public scrutiny. Personal safety encouraged developing one's ideas within the confines of a "community," a tendency that countered the public-building aspect of networking.

The choice for Berman in 1957 was clear: personal autonomy or public humiliation. The public world was clearly and unequivocally his enemy. To hold fast to his ideals, he had to retreat from whatever worldly ambitions he might have had. This was easier for him than for many because of the appar-

ently "free" position he occupied in society. Having dedicated himself entirely to his family, he was neither artist as academic nor artist as entrepreneur. He was completely free to construct his own meanings for his experiences because he stood apart from the institutional arrangements that mediated the relationship of most artists to society.

In response to his brush with the law, Berman retreated even further into a highly personal, hermetic language, arcane even to those who knew him. In this he differed from most assemblage artists, whose irony depended upon retaining the conventional meaning of their found objects as an element within their work and whose artistic statements as a result remained relatively accessible. Berman instead problematized meaning, perhaps as John Coplans thought in 1963 to confuse possible censors and avoid further confrontations with the law.[27] Aside from occasional commissions for photographs for book jackets, for the next several years Berman worked on two projects that privileged direct private communication to a protective social world consisting entirely of friends and colleagues: his journal *Semina* and an underground motion picture, first shot in 16 mm, but then in 8 mm, which made it even more unlikely that it would be projected anywhere other than at a film society or in the privacy of a home.

With these projects, he remained on the boundary between formal objectivity and the preunderstanding that a subjective network of friendship brought to his work. For those who knew Berman, the individual elements took on deeper significance because they understood how he transformed the concerns of his life into poetic statement. The works he created assumed their meaning through mingling two approaches to experience that did not usually intersect: a daily anecdotal intercourse of friendship; an aesthetic sense of every manifestation as pointing to a deeper level of universal reality. This dualism shifted focus from the creative configuration to the self-revelatory act of refiguration. Like Clay Spohn in the Museum of Unknown and Little Known Objects, Berman had arrived at an aesthetic where the object itself was far less important than the care it inspired.

Semina: Secession and Community at Mid-century

Shortly after the trauma of his trial, Berman impulsively abandoned Los Angeles for San Francisco. George Herms, Bob Alexander, and David Meltzer followed, and the circle of intimate friends reconstituted in the north, augmented by new friendships each of them made with young poets and painters in the Bay Area. During his five-year sojourn in northern California, Berman focused almost entirely on the production of his underground journal *Semina* (fig. 25). Already at work on the second issue at the time of his fateful Ferus exhibition, he completed it in December 1957 after his relocation. The nine issues documented Berman's concerns over an eight-year period. The first four issues focused on the relationship of drugs, madness, and the salvific function of art. The fifth issue was dedicated exclusively to representations of Mexico. The last four issues increasingly commented on the relation of art and poetry to social turmoil in the United States.[28]

Aside from a handful of copies sold at Lawrence Ferlinghetti's City Lights Bookstore in San Francisco, *Semina* circulated free of charge to a network of creative people whose work and opinions interested Berman. He printed from 150 to 300 copies of each issue on his own five-by-eight hand press. Of the nine editions, only the second was bound. The third, sixth, and ninth issues consisted of a single poem with a cover photograph. In the other five issues, the journal assumed the form that distinguished it from the dozens of other small literary magazines of its day. Berman placed approximately twenty loose-leaf pages of poems, photographs, and drawings into a pocket glued to the inside of a folded cover. The pages were like cards, printed on a heavy paper stock and cut into varied sizes ranging from three by five to six by eight inches. As a reader spread the cards across a flat surface, the pages of the journal formed ever-shifting patterns.

A model for the concept may have been Jess's 1954 contribution to *The Artist's View* (fig. 26). Jess produced this at the time when Berman and his wife, first visiting San Francisco, made the acquaintance of Jess and his

25. Covers for *Semina* 2 (December 1957), *Semina* 4 (1959), *Semina* 5 (undated), and *Semina* 7 (1961).

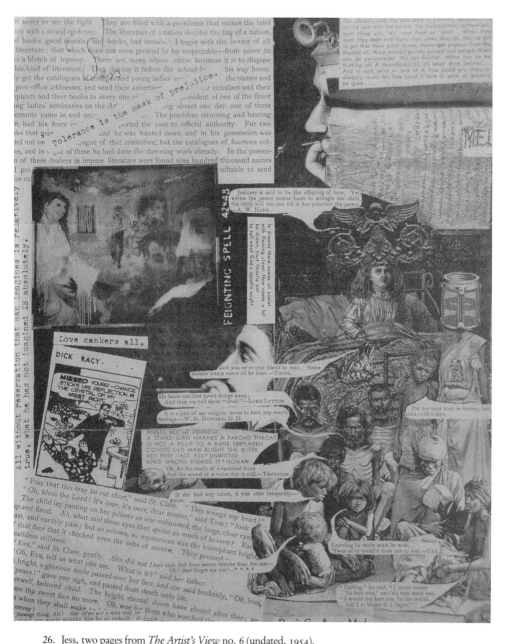

26. Jess, two pages from *The Artist's View* no. 6 (undated, 1954).
Courtesy of the artist.

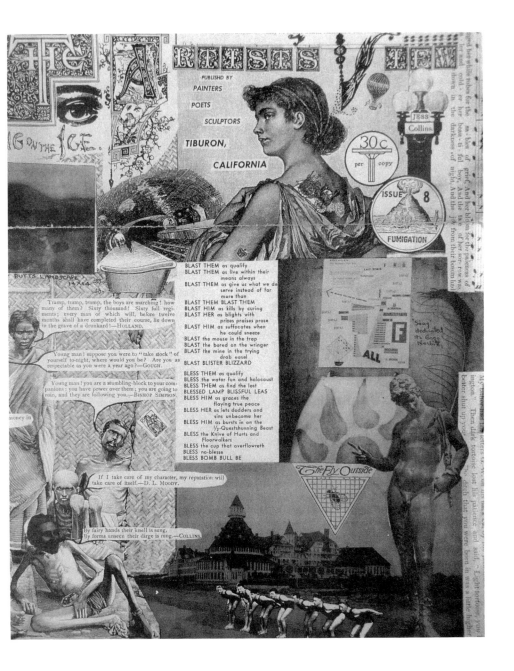

companion, Robert Duncan. *The Artist's View* was a cooperative publication produced in San Francisco between 1951 and 1954. Its purpose was to allow artists and poets to comment on topical events and present an aesthetic alternative to political ideology. Each edition took the form of a broadsheet, the content and design of which was the product of a single person. There was no collective presentation, since the essence of the "artist's view" was personal vision. Madeline Gleason, Hassel Smith, David Park, and Robert Duncan were among the contributors. In his issue Jess collaged words and images into a form that undercut attempts to make literal sense. Broken free from their superficial rational moorings, the clippings that Jess collected suddenly revealed a wealth of alternative meanings as the reader's fancy recast the effusive material. Interpretive freedom came from exploiting the surplus meaning created through sheer quantity and multiplication of potential connections.[29]

In *Semina* Berman intensified the effect of unclosable meaning by cutting the fragments into cards. This simple decision transformed the journal into the equivalent of a tarot deck. Each reading meant a reshuffling and redealing of the materials to reveal an entirely new meaning (fig. 27). Each time readers confronted the cards in a new combination, they discovered potentialities for meaning appropriate to their spiritual state at the moment.[30] The format represented reading as a visualizing of a field of connections that were continuous, multiple, and shifting. Given a potentially infinite field of meaning, focus shifted from the work as a formal piece to the subjective reaction and self-understanding uncovered by the sheer accident of coming across a poem or a graphic image.

A regular feature of the journal were translations of lyrics by classic writers. Poems by Jean Cocteau and Herman Hesse appeared in the first issue. Rabindranath Tagore, Paul Éluard, Paul Valery, and Charles Baudelaire were featured in the second issue. Later issues included excerpts from Antonin Artaud, as well as Chinese and Mexican poets. The classic writers were like the "dead poets" in Berman's Ferus show. They pointed to a wisdom tradition from which young poets could draw, but most of the journal was devoted to

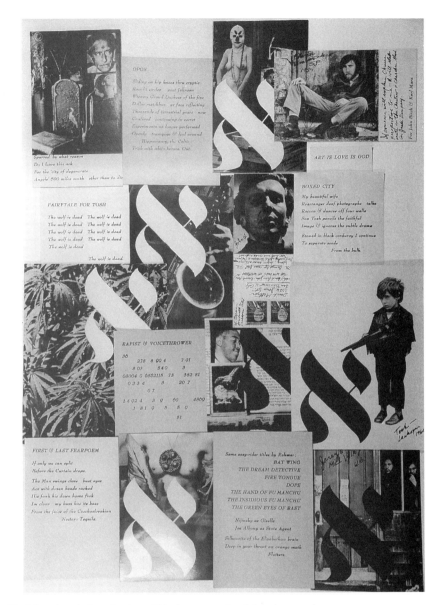

27. Selected cards from *Semina* 7, "Aleph, a gesture involving photographs, drawings, and text" (1961).

contributions from contemporaries. Old friends like Bob Alexander (published under the name of e. i. alexander) and David Meltzer remained steady contributors. Michael McClure, who first wrote to Berman in 1957 on Walter Hopps's recommendation, was the most frequent contributor. The first part of McClure's "Peyote Poem" forms the entirety of the third issue, and McClure's "Dallas Poem," a response to the Kennedy assassination, was the sole contents of the final issue of *Semina*. McClure connected Berman to others, including Jack Kerouac, whose work he thought might fit Berman's purposes. *Semina* was the first publication to print an excerpt from William Burrough's novel *Naked Lunch*, though of necessity, the two short paragraphs gave only a flavor of Burrough's baroque language without conveying its paranoid narrative structure.[31]

Berman's own work appeared in all nine issues. Most of the photographs used were his. In the fourth issue, he included stills from his motion picture in progress. *Semina* 7 consisted entirely of his own work, graphics and poetry. Prior to *Semina* 7, Berman's poetry appeared under pseudonyms, each of which was a constructed alterego. Pantale Xantos presented his attitudes toward heroin and self-destruction.[32] Marcia Jacobs was a reincarnation of the early twentieth-century French-Jewish poet Max Jacob. Peder Carr likely represented Berman in his guise as working-class intellectual. Berman's alteregos underscore that the diaristic aesthetic is not autobiographical, neither in the novelistic sense of constructing a life story as growth through progressive overcoming of obstacles, nor in the empirical sense of drawing upon actual events to seek a harmonizing of experience onto a higher level. Berman used his alteregos to imagine other ways of being, often contrary to the choices he had made. His alteregos were literary conceits that helped him reaffirm the actual commitments that provided the ongoing structure of his life.[33]

A poem by Berman, "Boxed City," published in *Semina* 7, was a key work because in presenting what might be a typical moment in the Berman household he laid bare his aesthetic principles:

My beautiful wife
Rearranges deaf photographs talks
Rococo & dances off four walls
Son Tosh pencils the faithful
Image & ignores the subtle drama

Stoned in black corduroy I continue
To separate seeds
From the bulk.

The work is a snapshot in words, but consider the parallels built into the poem. Seeds might easily refer to marijuana, given the photograph of a marijuana field also used in this issue and Berman's description of himself as "stoned." But in the context of *Semina* seeds also refers to the individual pieces of poetry and art his friends have sent him. It might also refer to images he has discovered in his perusal of magazines. "Separating from the bulk" then could just as easily mean isolating those gems that spark a reaction in him from the "bulk" of ever-present media output, a few of which, nonetheless, like the photograph of the woman stripping, also used in this issue, for whatever quirky reasons have struck him as meaningful. This second reading is supported by the contrasting activity of his wife rearranging "deaf" photographs, meaning, perhaps, that they are objects for themselves, unresponsive to the queries and concerns of their viewers. Art engages in dialogue, a vision that generates an interpretation from the viewer-reader that bounces against the work, provoking another interpretation, engendering a continual shifting of meaning as one probes the possibilities within a statement. This process is what Berman understood the kabbalah to mean: reception is transmission. Mere images (the bulk) evoke no response; they stymie communication. Yet Berman presented himself as "deaf" as the photographs. A suggestion that combined with "stoned" and the nonreflective sense of black points toward his own self-absorption.

Getting no response, Shirley continues to try to provoke a reply with increasingly elaborate talk. Yet that reading might be unfair. Perhaps the talk grows "rococo" and "dances" off the walls because she *is* getting a response, and the two of them are engaged in the banter of fanning the breeze and finding meaning by trading interpretations with ever wilder trajectories—in which case, the seeds might easily be those few photographs that the two of them find meaningful and the bulk are those that remain uncommunicative and will be excluded from the set of cards eventually mailed to readers.

The poem is written for a reader who, like Tosh, literally and lyrically at the center of the poem and penciling a "faithful image" because perhaps not diverted by the drama and taking sides, can see a range of possible meanings in a given moment. The work of art that Berman valued, be it visual or verbal, helped to create an empowered subjectivity by giving it less a point of view than a point of viewing that allowed readers to become present within the scene so that they could determine each in their own ways, in connection with other experiences, what might be happening—or even if it is a meaningful event.

An open aesthetics implied a self critically engaged with its environment without being overwhelmed. The allure of objectification, so strong in the poetry and painting of Rexroth, Still, and other 1940s predecessors, evaporated into another strategy for confronting a world dominated by powerful, often hostile forces: pure subjectivity. Berman imagined himself as a pattern of response. Unlike DeFeo's quest in *The Rose*, he had no redemptive single image that had to be attained at all cost. He gave himself over to mutability and adaptability.

The journal provided a common ground for working out a value structure and a community entirely bounded by Berman's personal interests. His concept of community presumed the coterminous existence of entirely different

communities in each of the people Berman incorporated into his. Community was an imaginary construct, woven together by Berman's perception of overlapping interests. The assumed complementarity was valid only for the task at hand, and for nothing else. Collective imagery became the way that Berman constructed his own self-image, so that his social being in *Semina* had no definition outside the people he valued in the journal. An aesthetic of open meaning allowed him to expand his own capabilities by imaginatively assuming his contributors' lives and thereby experimenting with different roles he could play.

Semina also established a basis for challenging the consensual norms of the broader society that had persecuted him. While one aspect of this imaginary community was the retreat of a wounded ego to a secure haven, another aspect was the creation through a common ideology of aesthetics of a minority consensual group that could propound alternative norms, develop them, and then interact with other groups in society to change legislated norms. Philip Lamantia recalled that Berman spoke of *Semina* as a medium for focusing a coherent and cohesive group of artist-poets into a movement like the surrealists.[34] Yet the model of interventionist vanguard does not fit at all the form of the journal or its method of distribution. Something more intimate occurred with *Semina*—the construction of an imaginary community to provide emotional support in the battle to define that which is most intimate and personal. The community had to be imaginary because any assumption of normative power would simply re-create the coercive structures artists thought they could escape. Having come into conflict with the repressive power of the law, Berman attempted to create a relatively autonomous subgroup within society. This group was particularly fragile because its origin lay in an imaginary mental construction. It substituted affective ties for shared positional interests and included within it individuals with divergent motivations and states of psychological adjustment. *Semina* proposed an ideal collective subjective state for this putative community, one that its members could look upon and project

onto Berman the man, who thereby became the symbol of their own youthful hopes, in part because he brought them together momentarily to define an ideal conception of human sensibility.

Instead of defining an institutional position that would allow his group to negotiate with other powers in society, Berman relied upon the potential within the aesthetic process to subvert the power of normative images and normative subjectivities. By functioning entirely as a private exchange, the journal escaped public scrutiny and challenge. *Semina* engaged the public world peripherally, in a way not calculated to change it in any respect. That the journal's putative community was artificial, however, actually strengthened its capability to thrust a new imagination of consensual norms for social interaction into other sectors of society. By reaching out to people who led active lives in a variety of institutional settings, many in the motion picture and popular music industries, the journal gained a potential to affect symbolic relations beyond its own narrow circle.

The concept of community Berman projected was based in his experience of marriage and parenting, the domestic ideal that he shared with most Americans of his generation. The theme of parenting as an exemplary type of human relations appeared in the first issue of *Semina*, in lines from a surrealist poem by Bob Alexander: "i was no / longer being what i was but i was being / what i am together / me and a little girl, nine minutes old. / glory!" Since the community existed within the heart, much like the ties binding parents and children, the application of sanctions against destructive behavior was emotionally difficult. Relations assumed an unconditional aspect, demanding concern rather than judgment, care rather than punishment. The heavy hand of legal sanctions had fallen upon Berman for expressing his love for wife, child, and friends. His own experience required that his imaginary community had to coexist without any sanctions applied to symbolic interaction.

Yet any community, even an imaginary one, has its share of unhappy and poorly adjusted people who abuse themselves and those who love them. One

of the ruptures within his "community" reproduced within *Semina* concerned the relative virtues of narcotics and psychedelics. "Morphine mother / Heroin mother / Yage mother / Benzedrine mother / Peyote mother / Marijuana mother / Cocaine mother / Hashish mother / Mushroom mother / Opium mother / Mescaline mother," runs one of Pantale Xantos's contributions to *Semina* 4. Robert Duncan observed that this is a chant similar to the transcriptions Antonin Artaud made of Tarahumara incantations sung before the religious rite that includes the ingestion of peyote. In the peyote cult the acolyte pledges loyalty to the mother goddess dwelling in the cactus, for in eating it worshipers give up their bodies to return to the spiritual state in which souls exist before birth. Return to normal consciousness involves a sense of rebirth, the substance taking the place of one's literal mother. The ritual is a sign of maturity. The initiate has learned through bodily experience that the everyday world is only a small part of reality. One has passed from the narrow connections of one's immediate elders to a state of open connectedness to the universe.[35]

In this chant Xantos seemed to equate the various paths to extended consciousness, but the role of this alterego was to manifest what might have happened to Berman had his love of poetry not "lifted him from the poolroom." In *Semina* 7, Berman presented a portrait of Xantos, a photograph of himself as he might appear if he lived on the streets. The tragic aspiration of this picture was undercut by pathos. The cracked open shoe conflicts with the cleancut, youthful face. Xantos is altogether too neat, and perhaps too sorrowful, to be descending into hell. Compared to other heroin-related images in *Semina*, the portrait of Xantos is weak and half-hearted.

The contribution that Scottish novelist Alexander Trocchi made to *Semina* 2 provided a harder vision. Trocchi arrived in Venice, California, in 1957 preaching the liberatory qualities of heroin. It was a strange kind of salvation that Trocchi had found. Addiction provided a practical framework for achieving "systematic nihilism," since he believed all value and loyalties dissolved when the body was in a state of urgent biological need. Heroin allowed

Trocchi to live his "own personal dada." He came from a country where addicts registered with the government and received a daily allotment of heroin. Britain's enlightened policies undercut the crisis that Trocchi sought as the source of spiritual freedom, so he emigrated to the United States, where satisfying a craving involved eluding the dangers of arrest and death from adulterated supply.[36] Berman published eight sentences from *Cain's Book*, Trocchi's novel about his experiences as an addict in the United States. The excerpt begins with a description of the needle going up and down while blood fills the dropper. Elsewhere in the issue was a photograph by Walter Hopps of a dead shark washed up on a seaweed-strewn beach. Berman's readers familiar with Philip Lamantia's poem "Black Sea" might have recalled a reference to turning loose the shark within the soul, with its concluding line, "How brief the pleasure in our pain."[37] Trocchi's selection ends with the heroin user transformed into a wild beast, stalked by "the man" (police, authority), but fierce and contemptuous because it lives under constant threat.

Six pages before this selection, Berman presented two photographs he took of Philip Lamantia injecting heroin into his arm (fig. 28).[38] On the opposite page is a prose poem by Pantale Xantos printed in large, bright red letters. "A face," Xantos says twice, but a face is exactly what is missing from the grim, grainy photographs, a feature that began with the cover, showing a woman's face erased except for her eyes. Erasure of the face was a motif that Berman returned to throughout his career. For the cover of *Semina* 7 Berman showed a woman strapped into the chair of the gas chamber, her face rubbed out. In 1963 he began a series of portraits of celebrities in which again he erased all facial features. Erasure of face suggests erasure of self, but the varying contexts in which Berman used this motif undercut a single emotional reaction. The motif of facelessness may easily portray the insignificance of individuality in its confrontation with the divine. Following this reading, capital punishment is a presumptuous arrogation by society of divine capabilities, while the self-erasure accompanying heroin use is inconsequential. Both merely hurry what will occur in any event, the reabsorption of the individual

A face raped by innumerable
messiahs places into sodden c
otton an anxious needle
A face hisses rules to cathedr
als and prepares for the narco
myth.

PANTALE XANTOS

28. Pages from *Semina* 2 (December 1957). Photographs and text by Wallace Berman.

into cosmic flux. There is no forbidden pleasure in the image of Lamantia nodding out beneath the Hebrew letters ב ב, a double presentation of beth, which in the kabbalah stands for language as the house within which humanity dwells and finds its self-nature. The poet stills that talent of his that most makes him a human being in order to achieve momentarily the mute objectivity of a rock or of the shark belly that a few pages later remains a cold reminder that living creatures are transitory manifestations.

There is no sentimental relaxation of tension in Berman's presentation of heroin use, nor is there is any condemnation. The "narco myth" in Xantos's prose poem is a double-edged sword. On the one hand, "narco myth" points to stereotypical presentations of "junkies" in the mass media, evidence of society's inability to comprehend individual paths to religious experience. On the other hand, "narco myth" refers to the incorporation of narcotics into a

mythic view of spiritual development. Transgression and regeneration were points on the cycle of personal growth that corresponded to winter and spring, decay and rebirth. The withering of the soul in confrontation with ineffable forces was part of the preparation for spiritual resurrection. Stuart Perkoff's poem "boplicity," which appeared in *Semina* 4, presents life as a desert that must be struggled through before redemption can be achieved:[39]

> miles &
>
> miles
>
> for a
>
> to hold that much cool
>
> water water water
>
> when I'm thirsty
>
> plenty of ice cold
>
> when I'm dry
>
> when I die

The thinned connections between the individual lines, with the possibility that the lines could be imaginatively reshuffled to draw out new implications in the game created with any particular set of words, conveys Perkoff's desperation in his search for a state of "cool," that essential accolade his generation spontaneously applied to Berman.

The term "cool" as applied to Berman in his guise as ideal type of his generation meant openness to the multiplicity of meaning inherent to being alive. The coexistence of life and death, as well as the divine and mundane, in every phenomenon undercut the stability of meaning that society imputed to human action. Cool was a response to the potential meaningless of human value that asserted an enjoyment of multiplicity. By treating life as a game of potentiality, the cool attitude assuaged the cognitive dissonance that led to madness, as in Cameron's case, or heroin addiction, as with Stuart Perkoff and Alexander Trocchi. No meaning, no matter what its source, could dominate a

person open to multiplicity because there was always another possible interpretation coming around the corner.

If Berman did not use the pages of *Semina* to condemn those who used heroin, he did not use narcotics himself, and he was critical of the effects that addiction had on people's lives. The dislike he felt for heroin use led him to break off his friendship with Bob Alexander for several years. Berman countered the narco-myth of heroin with his own myths of peyote and marijuana. Berman's most personal issue of *Semina* was originally to be called "Cannabis Sativa," stressing his belief that being stoned helped him experience more clearly the intersection of order and chaos. Three years earlier he had published Michael McClure's "Peyote Poem" in *Semina* 3, a work that provided a statement of how confrontation with the divine through the use of visionary drugs could lead to a sense of greater connection and urgent responsibility for the well-being of others.

Berman had appeared one afternoon in 1958 at McClure's apartment with some peyote buttons. Describing with encyclopedic detail Native American uses of peyote, Berman calmly prepared the buttons for ingestion. He did not ask McClure if he wanted to take them, nor did he recommend their use. He limited his discussion to a third-person, historical account of the origins and rituals involved in the peyote religion. Then, while McClure was distracted with a phone call, Berman vanished, leaving the buttons. McClure decided to take them and recorded the experience in a poem he wrote the following morning.[40] He was surprised to find that spirituality led back to flesh, to a secure sense of understanding that was pacifying rather than threatening:

> I hear
> the music of myself and write it down
> for no one to read. I pass fantasies as they
> sing to me with Circe-Voices. I visit
> among the peoples of myself and know all
> I need to know.

29. Wallace Berman and Michael McClure, ca. 1958. Photograph by Wallace Berman. Wallace Berman papers, Archives of American Art, Smithsonian Institution.

McClure had hallucinations characteristic of psychedelic experiences, but he passed through them unworried, for the peyote had imparted to him the knowledge that, like the gods in Buddhism, these illusions were projections of his own desires and fears, objectified into external forms. They could hurt him only as long as he was ignorant that their sources were the travails of his own ego (that is, historical) formation.

I smile to myself. I know

all that there is to know. I see all there

is to feel. I am friendly with the ache
in my belly. The answer

to love is my voice. There is no Time!
No answers. The answer to feeling is my feeling.

The answer to joy is joy without feeling.

Two sensations accompanied his sense of distance from his own self-formation: spaciousness and stomach ache. On the one hand, the possibility of moving instantaneously to any point of infinity opened before him. All possibility was his. It was not at all ethereal. He had no sense of floating on a cloud. Eternity had the "grim intensity" and firmness of rock. Possibility, however infinite, had the tangibility of "primordial substance and vitality." The connections that the poet sought were not simply his fantasies, but the ability to pierce through everyday illusions and see the alternatives that could come into being. By articulating them, he hoped to make them tangible enough for others to share in the choice between the various layers of "what is." The stomach ache was simply a reminder that this knowledge was gained through a physical substance, a strongly alkaloid cactus that his system had difficulty digesting. McClure announced,

My belly and I are two individuals
joined together
in life

This lesson guided him for the next thirty-five years of his poetic career: spirit could not be separated from flesh. In his work before this experience, he had aspired to be the Shelley of his day, spiritual and ethereal, liberated from the "meat" that kept his soul chained to earthly desires. He decided that during one's earthly life the highest spiritual states were attained through physical states of being. McClure thought that this was unconscious, but common knowledge. Most people sought salvation through physical actions

like sports, sexuality, alcohol, or drugs. They condemned themselves, or accepted the condemnation a repressive elite culture placed on mere bodily activity. Their instincts led the average man and woman to knowledge, but they failed to see their own natural wisdom because their culture had told them that flesh and spirit were distinct. The greatest ages of writers, the Elizabethan dramatists and the classical Greeks poets and dramatists, however, had understood, so their works had to be filtered through the castrating sieve of the Metaphysical poets and neo-Platonist philosophers.

Twelve years afterward, when McClure had stopped taking all drugs, he tried to describe the visions he had experienced. Drugs connected him but did away with his sense of interrelationships between things in the universe. Everything he saw stood "coldly and disparate from one another, with none of what Robert Duncan calls 'glamours' connecting them or weaving between them." Eternity was "an inescapable hall of cold objects radiating their own light." For months afterward, he continued to see light coming out of objects, light that did not warm or attract.

> I had to rewarm the universe by means of my own invention, to actually feel it through again, and say, "Well, alright, I've seen now how it is, I've seen it stripped of its warmth, its glamours, its perfumes, stripped of the masks that we've falsely pulled over it, and now I have to warm that universe again so that I can inhabit it." Because it *was* uninhabitable for me.

To exist, love had to be deliberately and obstinately chosen. The irrational act that made humans free was to will into existence what they wanted and needed. Love meant clinging to that which was most immediate in one's life. Love, as metaphor for choice, created a homeostatic system that allowed the universe to renew itself. Freedom did not exist independently of law or neces-

sity, but was bound to them as the factor that overcame the entropic tendency of rational systems.[41]

The isolating aspect of heroin, explored vicariously by Pantale Xantos and lived by Trocchi, Perkoff, and too many of Berman's friends, derived from grimly accepting the world as it existed as an infrangible given. Narcotics provided an avenue to withdraw from all responsibility for the state of the outer world, from all meaningful connections with other people, in a premature rush to reabsorption to cosmic flux. This aspect of the "narco myth" Berman opposed from the first issue of *Semina*, when he quoted Herman Hesse's "To a Toccata by Bach" as a proposal for what he wanted to accomplish: "Wherever the seeds of light, the magnificent, falls / Comes change, things are fashioned." The "sacred" does not take one out of the body, but deeper into it. "Desire and need," Hesse's poem continued, "form a triumphal arch / Of the vault of Heaven." To move deeper into the body is to discover God through a sense of placement, relationship, connection. Augmentation, rather than diminution, of individual experience led to action to preserve what mattered and oppose what threatened. Thus, strangely, experimentation with drugs need not mean removal from the world, but could, at least theoretically, lead to a sense of social obligation and a desire to change the world as it exists.

The argument remains on an intellectual level. In part 3 we will examine how these ideas led to specific patterns of interaction with society at large. Those events that determined the outcome of the avant-garde as a social force took place in a context in which poets and artists entered into an arena of social contention that was not structured by their needs or desires. Even the messages they tried to transmit assumed importance because they seemed to answer questions poets themselves were not asking. Our goal at this moment is to break through the polemics of the era and consider, foregoing both moralism and enthusiasm, how apparently negative, escapist, and irresponsible behavior such as drug taking could assume a socially positive aspect. Drug

taking was not an unfortunate irrelevancy but an essential element in formulating the social ideology of the California avant-garde.

In McClure's peyote vision, we see a universe based on law, cold and inexorable. It was a world of rationality, without any need for rational beings to think it, for its occupants are compelled to think only what they must. What the vision conjured up as the inevitable reaction was the power of will and imagination to break through necessity and create an environment, however engulfed by law, where humans would want to live. Freedom was McClure's theme, irrational and unpredictable. Love, the choice to need and desire another person, was the key to creating a social environment not dependent upon forms of obligation. Poetry was a form of love, but only because it was a type of labor that linked people through exchange:

> I certainly don't believe now in a big force called Love that's swishing through and permeating the universe, drifting and floating in it because I've seen that objects stand discrete from each other in space. (I don't believe that the universe looks like *this* anymore, either—I'm telling you about how I saw it *then*.) . . . If there *aren't* these warm forces moving through it, then I'm going to have to invent whatever there is—by my own *deeds*, as well as with words. So if there is a Love, I will have to invent it: I'll have to make it—maybe even discover it, or discover the possibilities of it. If there's any Chivalry or Nobility, then I'll have to make those things. And any great poem, or any beautiful poem, or any meaningful poem is a medium toward what can be invented with it, or what can be expressed through it.[42]

The task that McClure described required will power, but it succeeded through collective action. The reality of ties in the present was confirmed by a sense of ties extending across time not only through the recovery of ancestors, but, more important, through progeny.

"Where the children are, there is the Golden Age," wrote Novalis, quoted

by Michael McClure in an appreciation of *Semina*.[43] The poets and artists who came to maturity in the post–World War II years were part of the baby-boom-producing generation. As with most of their fellow citizens, parenting was an important part of everyday life for this generation of artists and poets. Kids running around galleries were a prominent part of art openings in the mid-1950s, Joan Brown recalled, and then added, "My father used to go to the openings and bring my dog and have him do tricks. I would be so embarrassed, I would die, and everybody would tease me." She emphasized that the environment in California was very different from her experiences of the New York art scene because on the West Coast children and friendship seemed more important to people's lives than money and career building.[44]

Certainly painters and poets on the East Coast had families as well, but Brown's memory accentuated the ideal of the arts as a community by picturing artists as a sort of extended family. Thus, representations and reflections of the period added a symbolic value of Edenic innocence to the factual reality of families, children, and friendships. Art is learning "how to rearrive at the cycles and wheels of childhood," Jack Hirschman wrote in his comparison of Berman to William Blake.[45] The use of family snapshots in art exchanged by mail linked the avant-garde to the common concerns of much of their generation. The child playing with an automobile tire became a mandala image, reinforcing the aspect of children as connections to cosmic creativity (fig. 30). Affectionate photographs of Berman with Tosh are similar to pictures that might be found in any family album (fig. 31). They also helped to reinforce Berman's community identity, which linked fatherhood to his conception of art. He was not unique in this concern, for the use of children in posters and book covers was common. Berman put a photograph of himself and his son on the poster for his Ferus Gallery show; David Meltzer used a photograph of his daughter Jennifer for the cover of *We All Have Something To Say To Each Other*. Stan Brakhage's film *Window Water Baby Moving* (1958) presented natural childbirth as a cooperative venture between mother and father

30. George Herms, "Happy Virgo" card, late 1950s. Patricia Jordan papers, Archives of American Art, Smithsonian Institution.

31. Patricia Jordan, photograph of Wallace Berman and Tosh Berman, 1958. Patricia Jordan papers, Archives of American Art, Smithsonian Institution.

1. Ben Berlin, *Duck, Cannon, Firecrackers,* oil and collage, 1937.
 The Buck Collection, Laguna Hills, California.

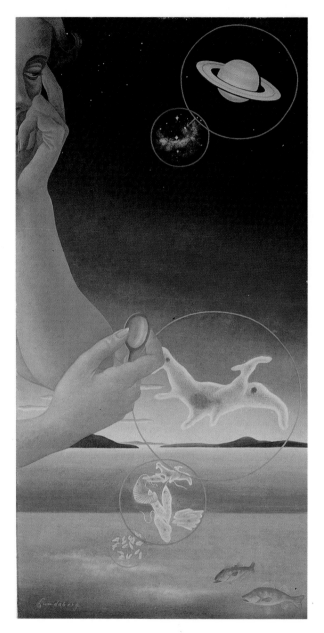

2. Helen Lundeberg, *Microcosm and Macrocosm*, oil on
masonite, 1937. Private collection. Courtesy of Tobey
C. Moss Gallery, Los Angeles. Photo: Doug Parker.

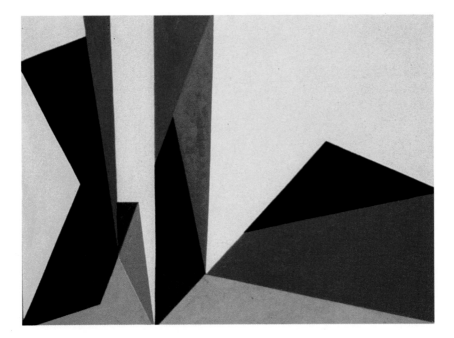

3. Lorser Feitelson, *Magical Space Forms*, oil on board, 1948.
 Courtesy of the Feitelson Arts Foundation, Los Angeles.

4. Robert McChesney, *A-7*, oil, enamel, and sand on canvas, 1951.
 Courtesy of the artist.

5. Jess, *Vistas*, oil on canvas, 1951. Courtesy of the artist.

6. Frank Lobdell, *April 1957*, oil on canvas, 1957. Courtesy of
Campbell-Thiebaud Gallery, San Francisco.

7. Joan Brown, *The Bride*, oil and enamel on canvas, 1970.
University Art Museum, University of California, Berkeley.

8. Wallace Berman, untitled, Verifax collage with hand coloring, 1967.
 Courtesy of L.A. Louver Gallery, Venice, California.

that confirmed the sacramental nature of marriage. When the graphic scenes of a child emerging from the womb led to problems with local police departments determined to protect citizens from images of genitalia, Brakhage took to including clips from the film in letters he sent to his friends.[46]

Joanna McClure compared working with children with poetry readings as giving her "the same feeling of being at home, the feeling of place." The birth of her and Michael's daughter led her to start writing. "The poems were always personal. I never thought of them for publication; they were a way of keeping track of myself and a way to get to certain things that I could not get to without writing." As she started to publish, preparation of her books developed into a family process involving her husband and daughter in the selection of poems, typefaces, and illustrations. She viewed the family as an entry to a wider audience, since one of the key functions she thought art filled was to build and strengthen the affective ties people had to the world around them. In focusing feelings of love, people grasped on to the most concrete and immediate aspects of their lives and defined what was truly essential.[47]

Patricia Jordan's collage of Shirley Berman (fig. 32) romantically juxtaposes its subject with exotic Egyptian, Persian, and Italian Renaissance imagery to suggest her role as muse. The upper image presents a courtship scene, while below is a representation of the myth of Isis and Osiris, in which the goddess resurrects her husband-brother from death. Layered behind the Isis story is a Renaissance image of a woman playing the lute, metaphorically suggesting the general creativity that unfolds under Shirley's presence. It is a casual piece, a greeting card never intended to be exhibited, in which one married woman contemplated the life of a married friend and projected what amounts to an ideal type. The card, and there are many like it, reveals that alongside the interplay of male creative figures was another vision of sexual relationships that placed women at the center of a network based on tightly bonded domestic ties. Within this group that shunned public attention, male and female visions of community tended to blur. If the finished art and poetry was, as Robert Duncan thought, only the by-product of a life-style

32. Patricia Jordan, untitled, collage, undated. Patricia
Jordan papers, Archives of American Art, Smithsonian
Institution.

attempting to "shape a vision of survival," it came out of the interaction of people, and the individual craftsperson only fashioned the final form of what was in effect a collective imagination.[48]

In that sharing, however, women most frequently provided the practical component. Shirley Berman worked as a seamstress, while Wallace stayed at home to take care of their son. Joanna McClure went to work as a teacher, and Michael quit his job. Both Joanna and Michael were published poets, but she took responsibility for the questions of "how to make a living, where to live, what to do about children, the man you live with and your life. Those were my concerns." Through marriage, McClure thought people grasped on to the most concrete and immediate aspects of reality, which were vital to poetry but not always a part of the arts scene. She recalled how she and Shirley Berman opened their homes to friends who needed a calming place to stay. Married couples stayed away from North Beach, McClure added, because the "destructive element was playing itself out" there, and those who were learning how to be parents could not afford to become involved.[49]

The inscription of a women's sphere encircling and protecting men was central for both men and women. They were creating a community from an interlocking network of domestic utopias. The contradictions of this imaginary society fell most acutely upon women, for as Berman portrayed in his *Veritas Panel*, they carried the burden of "holding things together." In *Semina* 2 Cameron declared that she had "surpassed the tomb" men had dreamed for her. Her self-liberation she promised would allow men to liberate themselves, and male and female could recombine in a new strengthened union. "Now I rise up from death and attach my life along its entire length to the boundaries of your body," she stated, "and lock our legs in serpentine strength against the earthquake." The vision came to her in the course of a deep depression. Her husband had died, and only in his death, she admitted in this short piece, did she begin to see herself as an individual. Still she was not ready to claim an independent position as a woman. Her vision looks to marriage as the eradication of gender in humanity's original "one flesh." The

image of male and female intertwined around the tree of life derived from the kabbalistic belief that the first being, created in the likeness of God, was both male and female. The fall was the split into gendered identities, and the sundered parts strove to reunite and regain what had been lost.[50] One function of art was to restore humanity psychically, if not physically, to the state of original unitary innocence.

Cameron's vision points to the difference between how men and women in the avant-garde community experienced the relationship of gender to their identity. Berman, like other young men his age, was concerned with defining and redefining male identity as part of his search for a place in society. The domestic relationship became the way he chose to define himself. Once he made that commitment, it was central to how he viewed himself and the art he created. Young women with artistic ambitions sought to dissolve the importance of gender, both through mystical conceptions and practical actions. Lenore Kandel recalled that when she first lived with poet Lew Welch, he expected her to spend her free time with "women folks" discussing "feminine magicals," while he ran around with other male poets. She insisted that they share both sides of life. The high point of their relationship came when he voluntarily acknowledged that she was as good a poet as he thought he was.[51]

As we saw with Joan Brown, women's recollections from this period more clearly link emancipatory and traditional images of femininity. Women defined a major aspect of their lives through service to another. Freedom did not mean free fall, but taking responsibility for living according to one's ideals. The hearth was an all-encompassing sanctuary that sheltered friends in need of healing. Yet their recollections also involve images of themselves as young women who abandoned their homes to travel to San Francisco or Los Angeles alone, or in the poet Joanne Kyger's case on to Japan, where she arrived in 1958 not knowing the language or a single person. A wonderful and curious aspect of Kyger's voyage abroad is that she spent her four years in Japan studying ancient Greek literature in depth. In Asia, the classics of her own culture suddenly became hers and hers alone.[52]

The ability of "beat" women to be both free and connected was vitally important to the self-image that they wished to project. In some aspects their lives followed very traditional paths, but they wanted to assert the element of choice that had allowed them to recognize and grasp the chances that entered their lives to make a break with older, settled patterns. Joanna McClure at the age of twenty-one abandoned her first marriage to leave Arizona and go to San Francisco in search of a broader life. She came without any preconceptions of what she would find, because "growing up in the desert was mostly a time of waiting. Soaking in the beauty of the place—but waiting and not even knowing what I was waiting for." Her assumption on leaving was that her outlook was so narrow she did not have the experience to imagine the range of possibilities open to her. That her new life included a second marriage, a family, and two careers as poet and educator told her that independence was the precondition for greater involvement and responsibility for other people.[53]

The recollections of both men and women demonstrate how powerful a hold gender roles had upon their lives, even though a theme of their "rebellion"—and this theme was fundamental to mass-media representations of their lives—was to discard obsolete stereotypes about sexual relations and roles inherited from the previous generation. The idea that poetry and art opened daily reality to a transcendent realm may have exacerbated tensions in male-female relations. The putative stakes involved in the pursuit of art were high, and both members of the couple shared in the responsibility for the outcome, even if only one was a direct creator. The expectations men and women brought to relations undoubtedly caused strain, since few could sustain for long the tension, and yet, as Michael McClure's poem from *Semina* 2 suggests, emotional union seemed essential to self-actualization:

> I wanted to turn to electricity—I needed
> a catalyst to turn to pure fire
> We lied

to each other. Promises

are lies. Work is death. Contracts are

filth—the act of keeping them

destroys the desire to hold them

I forgive you. Free me!

Marriage seldom lived up to the promise entailed in the relationship, yet as the last line suggests, McClure could not imagine another road to liberation except through a relationship, the seriousness of which was measured by promise and contract. The mate offered freedom by creating the environment in which masculine ambition could be realized without consuming the male in his own striving to be "pure fire."

If the male task was to harness phallic energy without being destroyed, examining the excesses of personal behavior was vital. For society at large the beats as a media event provided boundaries to effective male behavior, a task performed within the avant-garde by those who succumbed to heroin. Fascination with excesses was essential to striving to accomplish one's ambition, to inscribe upon the world the particular virtues of one's individual excellence. A man needed to push himself, "to turn to electricity" to use Michael McClure's phrase, but he also needed a cautionary model that would allow him to stop long before his ambitions consumed him.

For women the balancing act was more difficult. Domesticity allowed for a centered, stable female self-image, while, as we saw with Joan Brown, a gendered professional identity led to striving to live up to externally defined ambitions. A degendered self was a strategy for grasping an individual, unique, but female history. Each victory, whether in the aesthetic sphere or the domestic, was personal. Equality therefore had a precious aspect, the sign of maturation and autonomy achieved through commitment to the transcendent possibilities of art. Thus women within the arts community projected an ideology of domesticity as a sign of equality and empowerment. It was an ideology that many men were glad to accept as their own. Other men, however,

found the particular powers of women threatening to their ability to tap the phallic reservoirs which they assumed generated their personal creativity. "The social organization that is most true to the artist is the boy gang," Allen Ginsberg argued, "not society's perfum'd marriage."[54]

For those in the media trying to understand the beat phenomenon and present it to the public, focusing on the consistently libertine and misogynist Kerouac was less confusing. His self-destructive tendencies fit more neatly into a tidy, moralistic worldview. Berman was as talented as Kerouac, at least as typical of his generation, but his commonalities with "straight" society lay in family values rather than ambition. Kerouac pursued success as a writer to the point of becoming an "outlaw," and he achieved a name for himself through his efforts. The two men present the hidden Apollonian and well-publicized Dionysian faces of their generation, and the latter fit more easily into public fascinations. The media event of the beats provided a vicarious release from personal responsibilities, yet with warnings in its reports of the self-abuse that these young men heaped upon themselves with alcohol and narcotics. Kerouac helped create a male subjectivity that appeared "free" of constraints. The responsibilities of family were not to interfere with single-minded devotion to career.[55]

To achieve that imaginary freedom, Kerouac's characters exist first and foremost in a state of rebellion against women because through sexual union generational continuity was reestablished, and the individual was placed once again in time, beholden to both past and future. Quoting Buddha, the hero of Jack Kerouac's 1957 novel *The Dharma Bums* says, "Don't dispute with the authorities or with women."[56] In Kerouac's novels, "authorities" inevitably means the police. The aphorism equated women and the police as the foundations of repressive daily society, the local figures immediately present to punish the male pursuit of pleasure or self-knowledge. The hero of *The Dharma Bums* returns home to his mother, who worries about his inability to settle down into a career and make a living from his college education.[57] In *On the Road*, the hero's aunt, who raised him as a surrogate mother, tells him

that the world would never find peace "until men fell at their women's feet and asked for forgiveness." Sal Valentine, explaining this to Dean Moriarty, agrees: "The truth of the matter is we don't understand our women; we blame on them and it's all our fault." Moriarty protests, "But it isn't as simple as that. . . . Peace will come suddenly, we won't understand when it does."[58] Neither faith nor good deeds leads to peace, Moriarty seems to argue. "Peace" is a random occurrence and not likely to be recognized. It has the elusive quality of death, as a state of being going beyond experience. Moriarty's vision of peace also incorporated Kerouac's Catholic faith: redemption can come at the oddest moments. Even those leading the most disreputable lives can experience an awakening of the heart to God when they least expect it.

Maternal figures criticize, but they also offer unconditional support to their men. They threaten men, Robert Duncan observed in a witty anecdote about the relation in the postwar Bay Area of younger male and older female poets such as Josephine Miles, because they are "lady sheep" trying to teach "little wolves . . . to eat grass" and be happy.[59] In times of trouble, Kerouac's male characters return to their mother figures for a meal and a place to stay until they are rested and ready for further adventures. Women as sexual partners are the source of quick money and physical pleasure, the red meat that the wolves need to devour to actualize their wolfness—but at a price of emotional bondage. After two weeks, Valentine complains, "I knew my affair with Lucille wouldn't last much longer. She wanted me to be *her way*. . . . I had nothing to offer anybody except my own confusion."[60] A "*real*" woman" accepts whatever comes her way, Moriarty tells Valentine: "Never a harsh word, never a complaint, or modified; her old man can come in any hour of the night with anybody and have talks in the kitchen and drink the beer and leave any old time. This is a man, and that's his castle."[61]

In *The Dharma Bums*, written six years later, Kerouac tried to reconcile life in the moment with the acceptance of continuity and history implied in literary ambition by turning to Buddhism. The sexual conflicts that gave

structure to *On the Road* yielded to the presentation of a model of idyllic matrimony. Sean and Christine Monahan are a young couple with property in the Marin County foothills. They offer refuge to poets who need a place to stay, but without any of the recriminations that *On the Road's* maternal figures offered along with their food. All the poets need to do is meditate and follow their craft, which all accept as a form of prayer for salvation, the release of humanity from the illusions of material existence. Monahan is a carpenter who maintains his home and car by his own skills. He "had selected a wife who agreed with him in every detail about how to live the joyous life in America without much money." He liked to take days off from work to go into the mountains and study Buddhist sutras. Christine "wandered around the house and yard barefooted hanging up wash and baking her own brown bread and cookies. She was an expert on making food out of nothing." Her willing acceptance of a stereotype of premodern relations frees Sean from all troubles. "Sean in fact was just an oldtime patriarch," Kerouac enthused. "Though he was only twenty-two he wore a full beard like Saint Joseph and in it you could see his pearly white teeth smiling and his young blue eyes twinkling." Because of his wife's housekeeping skills and her love of washing and baking and mending, "Sean, working only desultorily at carpentry, had managed to put a few thousand dollars in the bank. And like a patriarch of old Sean was generous, he always insisted on feeding you and if twelve people were in the house he'd lay out a big dinner. . . . It was a communal arrangement, though, he was strict about that: we'd make collections for the wine, and if people came, as they all did, for a long weekend, they were expected to bring food or food money."[62] While men achieve Buddha-nature through study and writing, women's Buddha-nature subsists in the activities that come most naturally to their social role: washing, cooking, raising children, and making love. Kerouac proposed two models for authentic male behavior: Men who accept the responsibilities of family must be prepared to work and earn the money needed to maintain patriarchal dignity. Men who cannot

work must remain single, though not celibate, as women may also achieve salvation through "yubyum," a form of Tibetan ritual sex with men who have devoted themselves to monastic prayer.[63]

It is easy to ridicule Kerouac's vision of male-female relations.[64] *On the Road* had the virtues of honesty in its self-damning portrayal of emotional confusion when confronted with the unbreakable links between pleasure and responsibility. *The Dharma Bums* escaped into utopian fantasy that confirmed that when female characters are turned into cardboard stick figures with clearly defined and limited utilitarian functions, so too are male representations stripped of the possibility of surprise or change. In this novel, Kerouac crafted a male subjectivity incapable of relating to other human beings except through the driest and most literary of theories. The evasion of responsibility for the personal, intimate relations one develops was a profound strand running through the public aspects of the postwar avant-garde. The fear of ties was the dark side of a philosophy that stressed personal vision and connection with the abstract forces of the cosmos over social relations. It found expression in a subjectivity impervious to the effects of a man's actions upon anybody, including himself. It was therefore a subjectivity that lay helpless before the world.

There was a philosophical sundering within the avant-garde that was no secret within the movement. This split provides another, internal explanation for the reluctance discussed in chapter 6 of many artists and poets to embrace the beat image. In 1959 Stan Brakhage wrote Larry Jordan that he could offset the "horror of the beats" only by contemplating the chills the publicity the beats received gave academics who fetishized "two thousand years of Western Culture." He believed that both the beats (understood as the media event evolving from the success of Kerouac's *On the Road*) and academics crushed the connection of poetry to life.[65] On the other hand, Gerard Malanga's poem on the Bermans reiterates themes Kerouac stated about Sean and Christine

Monahan in *The Dharma Bums*, but also reveals the critical distance that many male poets felt about the kind of life led by those who married, however hospitable their homes might be for spiritual travelers:

> the private lives and poets overlooking
> the enamel sink and tub
> its destinies . . . we try to escape.
>
> Am I moistured, exaltingly, and in this room
> that gives me entrance gives you no exit?[66]

Freedom versus responsibility. Risk-taking self-affirmation versus life-affirming emotional ties. Ambition versus domesticity. For public commentators the excesses of the "beats" were reduced to a narrow set of questions: What is the relationship of freedom to libertinism? Are desire and responsibility compatible? Were the structures of knowledge governing human interaction derived ultimately from experience, or was experience based on a priori systems of rationality and faith? Members of the 1950s American bohemia asked themselves the same questions.

The answers men gave about what to value inevitably affected the work they produced and the example they set for others. The cleavage within the "beats" was hidden to those on the outside, in part because, as we have seen with Berman, the avant-garde expression of domesticity diverged from the mainstream standard in ways that made its manifestations confusing and perhaps even frightening. The ideology of domesticity, for example, crossed lines of sexual preference. Larry Jordan recalled that Robert Duncan and Jess had taught him the meaning of the home as a "magical kingdom" that needs to be protected "from all the wayward vibrations that come and go."[67] A home was not simply a place, but the psychological wholeness of one's connections brought into being by one's imagination. Freedom need not be free fall if linked to the relationships one cherished; freedom came from the creation of self through ties with the new rather than from severance of all

33. Selection of mail art: Wallace and Shirley Berman, Christmas card to Patricia and Larry Jordan, 1965; George Herms, "Dragons-blood," to Ben Talbert, undated, early 1960s; Wallace Berman, cover to *Hero/Lil* by David Meltzer, with handwritten birthday greetings to Bob Alexander. Patricia Jordan papers and Bob Alexander papers, Archives of American Art, Smithsonian Institution.

ties whatsoever. For Duncan, if there had been any one single reason why he could not consider himself a "beat poet," it was his strong belief in the importance of being a "householder" who refused to think of himself as a "professional heretic and exile" always just clinging on to life: "No, because I've surrounded my writing . . . with a position for itself." Respectability, he concluded, a *great* respectability, marked the work and lives who assumed responsibility for their desires.[68]

9

The Flame of Ambition

Public Culture in the Kennedy Years

In the summer of 1962 the Bermans returned to Los Angeles because making expenses meet their income might be easier if they lived in the small house they owned there. Another attraction was the sudden blossoming of the southern California art scene. Seven galleries had opened that were devoted exclusively to contemporary art, and even conservative galleries had begun to promote younger, experimental artists. The Los Angeles Art Association, whose longtime president was Lorser Feitelson, sponsored weekly "Monday Night Art Walks" that brought hundreds to La Cienega Boulevard, where the most advanced galleries were located. Berman's friend Walter Hopps had become director of the Pasadena Art Museum, while Henry Hopkins, another active proponent of local artists, was assistant curator for contemporary art at the Los Angeles County Museum of Art. The two museums began active education programs to encourage collectors to support avant-garde art. For Berman, the possibility of an audience, even of fame, raised new questions about the public role of the artist. As he increasingly engaged social issues, he began to consider the effects of ambition upon the search for inner truth.

Berman began working on a series of portraits with rubbed-out faces. He also became an active member of the Los Angeles Film Society, which provided equipment to would-be underground filmmakers and exhibited films at special midnight screenings. Berman introduced the films of his San Francisco friends Bruce Conner and Larry Jordan to Los Angeles audiences. At

this time, he met Andy Warhol, who stayed in Los Angeles for eight weeks during his one-artist exhibit at the Ferus Gallery. While in Los Angeles, Warhol shot most of his film *Tarzan and Jane Regained . . . Sort of* at Berman's house and gave Berman and his son Tosh parts in the production.

In August 1963, one year after his return to Southern California, Berman completed the eighth issue of *Semina* (fig. 34). Its contents were markedly different from previous editions. The selections conveyed a sense of imminent social turmoil, and the identification of authors by initials added an aura of mystery. This was no aesthetic of impersonality, Michael McClure explained in a comment on *Semina* 8. Anonymity was a necessary protective step against "Zittermokka, Esq." and the "SS deathsheads" gathering strength in America. The military machine was mobilizing to silence all forms of criticism, and those who were not prepared would not survive.

McClure's comments may refer to the persistent threat of war that marked the first two years of the Kennedy administration. The failed proxy invasion of Cuba in March 1961 by United States–organized anti-Castro exiles led to a hardening of Kennedy's foreign policy. The new administration was determined to commit American might to prevent any further communist successes. Crises in Laos, Berlin, and Venezuela rapidly succeeded each other, and Kennedy warned the American people that United States soldiers might have to enter into direct combat, while he continued to increase the number of military advisers stationed in Vietnam. In October 1962 Kennedy placed a naval quarantine around Cuba in response to the Soviet Union secretly installing intermediate range missiles with nuclear warheads capable of hitting targets in two-thirds of the United States. The two-week crisis brought the world close to nuclear war, but in the aftermath, the United States and the Soviet Union entered into a period of détente, leading to the signing of the nuclear nonproliferation treaty in September 1963. But even while discussion of superpower condominium filled the nation's media, so did increasingly violent news from the civil war in Vietnam. In May 1963 Buddhist monks set themselves on fire and burned to death to protest the Catholic-dominated

government of Ngo Dinh Diem. Their sacrifice exposed the shallowness of popular support for the government that the Eisenhower administration had created for South Vietnam. In October a coup widely believed to have been initiated by the Americans overthrew Diem to install a military dictatorship. President Kennedy faced a difficult decision, still unmade at the time of his assassination, whether to increase American military support for the new South Vietnamese government or to find a diplomatic solution.

When one lives in perpetual danger, McClure continued in his comment on *Semina* 8, "one takes care of what is nearest, dearest, knowing." The issue was premonition of a need to keep "shy and private." Despite the presence of socially relevant imagery, McClure's comments, steeped in the underlying domestic ideology of his and Berman's work, indicate that this issue was the opposite of social criticism. There was no attempt to show how power relations affect personal choices in order that private dilemmas can boomerang back into the political arena. Berman's advice was, rather, stay away from public life. And, indeed, he directed the message only to a handful. As McClure put it, *Semina* 8 was "a shot in the dark that wants to stay in the dark." Berman prepared a mere 149 copies to be mailed to "the Friends."[1]

Semina 8 was also, perhaps primarily, Berman's warning to himself not to be swept up by new, exciting developments in the arts. It was as if he saw that in March 1964 John Coplans would identify him as the founder of the California assemblage movement and therefore one of the most important artists in the state, or that in four years his face would be on the cover of the biggest-selling record of the most popular music group of the decade.[2] We may think of it as a warning from a man tempted to seek a public platform that a second chance would bring even more disastrous results than his scrape with the law in 1957.

The use of initials instead of full names thus might be directed to poets and artists as an admonition not to be carried away by the lure of success. Create as if one were to remain anonymous all one's life, as anonymous as medieval troubadors. The card bearing a poem by A. A. (Antonin Artaud) shows a

It is me
　　　Man
who will be judge
at the end of the count
it is to me
that all the elements
of substance and things
will come to refer
it is the state of my
body will carry
The Last Judgement

A. A.

34. Selected cards from *Semina* 8 (1963).

dessicated cadaver wearing a silk dress and holding a bright rose. "It is to me / that all the elements / of substance and things / will come to refer," A. A. says. This is a classic restatement of the *vanitas* theme. Fame and publicity are as absurd and grotesquely macabre as a fine gown decorating a corpse. One ought to live, Berman seems to be saying, as if our motivations will survive our bodies. Poets should beware lest their lives be consumed by gaudy, but ultimately inconsequential, even foolish, concerns.

In examining the poetry his friends had sent him and images from the mass

media, Berman concluded that growing publicity for poetry and art did not mean American society had changed. What could those who tried to be honest about their lives face except disaster? For the cover of *Semina* 8 (fig. 35), Berman photographed a tableau: Thomas Albright, a painter from San Francisco soon to become art critic for the *San Francisco Chronicle*, slumped over his writing desk, seized by the police as he finished sketching a cross. The scene plays as farce, but it points back to Berman's own arrest in 1957 for, in his view, depicting his religious sentiments. What place did J. W. (John Wieners) have in society as long as he continued to express in poems like "Le Chariot" his personal search for transcendence through heroin? Z. W. (Zack Walsh) sketched a geography of the world focused on the sources and varieties of "junk." Berman's collage of comedian Lenny Bruce, laureled by ivy and butterflies but beset by the fist of a policeman beating a prisoner, was a simple reminder to his readers of Bruce's frequent arrests and of the role of the police in repressing free speech. Popularity, such as it would be, meant restricting one's work to material that could slip past the then-existing anti-obscenity codes. His collage of an American eagle swooping upon the battered head of prize fighter Benny Peret slumped against the ropes could read as a reminder that becoming a celebrity meant offering oneself to sacrifice for public enjoyment.

These were somber messages, but the criticism of American life was refracted through a critique that focused exclusively on the roles available to poets and artists. "I am that noise which / must against their / common paraphrase / charge deceit," says the lyric by J. K. (Jack Kerouac). The juxtaposition against the hand of a black person giving the finger might read as a reference to an incipient black power movement. Throughout the previous year, the civil rights struggle in the South had filled newspapers and television screens. In March 1963 the conflict reached new levels of brutality in Birmingham, Alabama, after the Southern Christian Leadership Council organized silent marches to demand that blacks have equal access to public accom-

modations and city jobs. When police chief Bull Connor ordered the use of fire hoses and police dogs to break up the marches, young children joined the marches. The images of snarling dogs lunging at thirteen-year-olds provided powerful symbolization of sheer brute power fighting innocent moral justice. The *Los Angeles Times* and the *San Francisco Chronicle* published three to five pages daily of reports on events in the South, and the network evening news programs seldom spent less than five minutes on the latest demonstrations and brutalities.

At this point the public voice of the civil rights struggle emphasized nonviolent resistance and unassailable moral superiority based not only on justice but on civility. Yet privately, members of the Student Nonviolent Coordinating Committee were uneasy about a strategy that exposed blacks to persistent and growing physical danger but failed to guarantee either adequate outside protection or the right of self-defense. These dissenting views rarely found expression in the national media, and the most visible proponent of black nationalism was Elijah Muhammed's Nation of Islam, the Black Muslim movement that catapulted Malcolm X to prominence for his uncompromising denunciations of all aspects of white society.[3]

The mass media's interest in transgressive behavior led it to emphasize the Nation of Islam's repudiation of white superiority. Within the black community, the messages the Nation of Islam conveyed of black self-reliance and pride were equally important. These values had helped build large congregations in both San Francisco and Los Angeles. In April 1962 Black Muslims were involved in a highly publicized exchange of gunfire with the Los Angeles Police Department, because the Muslims refused to allow the police entrance to their offices without proper search warrants. It is possible that Berman had these events in mind as he conceived of the card on which he put Kerouac's short poem. The statement of poem and image in that context appears to predict what developed in 1965 with the Watts uprising, the emergence of the Black Power movement in Mississippi, and the dissolution of the

35. Cover, *Semina* 8 (1963).

36. Wallace Berman on anti-Vietnam War march, mid-1960s. Wallace Berman papers, Archives of American Art, Smithsonian Institution.

civil rights ideal into a violent, insulting polarity between black and white America. Yet this card is more easily explained by Berman's intense participation in the bop scene in the late 1940s, when the black and white avant-gardes were linked in disdain for middle-class white society. Berman fell back upon the stale equation of African-Americans and the avant-garde as two "outsider" cultures, both marginalized, both impolitely mocking and defying the mainstream by their refusal to conform to proper middle-class life-styles.[4]

The political affinities of Berman the citizen were in radical opposition to the status quo in the United States. He joined demonstrations in favor of civil rights and protection of the environment. He marched in opposition to the Vietnam War, bringing with him a banner displaying the photograph he juxtaposed with the Kerouac lyric in *Semina* 8 (fig. 36). In 1971 he won a Linus Pauling Peace Prize for the best visual art promoting world peace. Yet to the

degree that Berman the artist could be said to be a social critic at all, his stance was irresponsible and defeatist, as he warned of the dangers of active involvement in public life. Rather than commenting on the social events of his day, Berman used *Semina* 8 to reaffirm his belief that poets find their success in the private rather than the public realm. One collage (fig. 37) presented a mysterious cat figure emerging from an impressive set of gates where a soldier stands guard. The writing above the gate seems foreign, and the soldier's beret and striped pants locate the scene outside the United States. We might have here a surrealist comment on foreign affairs. The cat figure's briefcase suggests a politician rather than a prisoner, and the large keylike apparatus in the cat's hands also suggests mastery of the situation. This could be a statement on the imprisonment of the human spirit, suggested by the stone face within the cage, that politics entails. When read together with the Artaud card, this image could augment the warning to poets that participation in public life will make them prisoners of forces much craftier than they. We might, however, recall Joan Brown's interest in Egyptian mythology and the role of the cat god that appeared later in her paintings as a symbol of the artist in control of her life (pl. 7). Following that clue, the image could suggest the artistic spirit escaping social limitations through the exercise of its special magic. Both readings carry equally plausible sense, and neither would close other possible interpretations. Ultimately, an image such as this finds meaning only in the responses of Berman's audience as its members sifted through the cards, compared them, and followed the trails blazed within each imagination.

The ninth and final issue of *Semina*, produced in the winter of 1964, contained only one item, Michael McClure's "Dallas Poem," with a cover photograph shot from a television screen of Jack Ruby killing Lee Harvey Oswald (fig. 38). This was undoubtedly a political and social statement among the most direct that Berman ever made. Yet consider how puzzling and offensive McClure's poem would have been to anybody who was not part of their circle of friends:

37. Card from *Semina* 8 (1963)

38. Cover, *Semina* 9 (1964).

DOUBLE MURDER! VAHROOOOOOOHR!

Varshnohteeembreth nahrooohr PAIN STAR.

CLOUDS ROLL INTO MARIGOLDS

nrah paws blayge bullets eem air.

BANG! BANG! BANG! BANG! BANG!

BANG! BANG! BANG! BANG!

BANG! BANG! BANG! BANG! BANG!

BANG! BANG! BANG! BANG! BANG!

BANG! BANG! BANG! BANG!

Yahh oon FLAME held prisoner.

DALLAS!

No elegy for the lost prince here. No song that transforms public tragedy by finding universal meaning. Simply a comic-book picture of America devouring itself. This was a cold and brutal, though accurate, assessment of a country where psychological strivings to leave a mark meant no one was innocent. McClure's poem paralleled pop art, but its sentiment was entirely different. This poem was not about comic books or Hollywood movies, or about their effects on the public psyche. In 1961 McClure began studying the great carnivores, and his use of "mammal language" was an attempt to develop a nondenotative poetic language that when read aloud would mobilize basic passions of lust and aggression, normally repressed through the built-in censorship of the emotions that everyday language effected. The confrontation in art and poetry with the power of the passions was to provide an alternative to their eruption in sudden, destructive, and remorseless public behavior.[5]

Semina 9 was a coldly distanced response to what their contemporaries felt was one of the most tragic event of their lives. This joint work attempted to give an accurate, albeit psychological, description of social reality. The killing time had arrived, and for all the public sorrow, the dominant fact facing America was the sound of bullets, repeated as in the poem to the point of tedium. This indeed was a remarkably prescient understanding of what would follow— both the escalation of the war abroad and the transformation of ghettoes into battlegrounds.

The work was "nonideological." It presented not even the remotest suggestion of a theoretical understanding of politics, or what might be done. Its truth came from an inward confrontation with personal desires and ambitions. The strivings and tensions wrought up in postwar Americans had reached their point of sublimation. The steam generated by egos determined to escape limitations would power a culture that fed on social chaos. The flame refers certainly to the Kennedy grave site and the televised ritual of lighting a flame as pledge to perpetuate the Kennedy ideal. In gnostic philosophy a sacred, tended flame stood for sacrificial slaughter, the body given to eat to establish communion, as those in the Christian faith affirmed their

membership in the church by eating the transubstantiated body of Christ. Sacrificial slaughter provided the *mysterium fidei*, the mystical transformation of substances that corresponded to the *factum fidei*, the act of physical regeneration, that is, sexuality. Just as sexual union perpetuated natural creation, human sacrifice was the basis for the replication of social order. The nature of the sacrificial victim and the trauma registered on the psyches of those who participated in the victim's consumption set the future direction of social life.[6]

Kennedy's death became a public sacrifice through the intervention of television. For three days the nation endured a sequence of rituals: the death of the president, the rapid apprehension of a suspect, the public slaughter of the suspect who thereby was transformed into a scapegoat for national guilt, the funeral and burial, and the lighting of the flame. What McClure and Berman suggested was that rather than purging the nation of its sorrows, the televised rituals enshrined perpetually mysterious murder, that is death and violence for their own sake, at the heart of American public life.

Semina 9 points to the electronic media as instrumental in constructing a new public consciousness and culture, built around vicarious paranoia that can be satisfied only by more victims. The killing time would result from the tendency of the mass media to engulf authentic private experience in a mythologically intensified, yet existentially shallow public life. Profoundly serious events played themselves out as episodes in a continuing cliff-hanger. Once public life became a creation of the mass media, McClure and Berman could see only murder ahead. Yet the critique was not simply external, offering up television as villain to satiate a need for resentment. Consider the meaning of the line "Yahh oon FLAME held prisoner" against a poem by Robert Duncan presented six months earlier in *Semina* 8:

> Increasing the orange until arrangements of
> animal forms are merged in tallow,
> Increasing a grade until numbers sound as
> tones alike in wandering,

Increasing knots until the orange current is
built perpetual upon the hectic,
Increasing the ocean is boxed in ties to
others and machines as mothers.

Might not McClure's "flame held prisoner" be the poetic desire to achieve transcendence entrapped in spectacle? Duncan's poem also spoke of an intensification of experience, but when we see it on its card with a photograph of Duncan nude, floating upside down toward a brilliant orange ball, a new interpretation follows. The intensification of experience drives poets as well, as they seek to refine their experiences in verbal and visual form. Their own aesthetic ambitions carry the danger of meltdown. Their own desires, presented in the highly focused form of poetry, mirror the transformations of mass communication. All expression carries with it the danger of self-abuse and destruction, self-encasement in a mythological worldview. What Alexander Trocchi and Philip Lamantia did hurt only themselves, but what drove them had deeply frightening parallels in public life.

Berman's and McClure's conjectural observations on American life sprang from their recognition of explosive and dangerous drives within themselves. They believed social collapse would result from the release of long-repressed psychological states, deriving largely from the tensions of masculine identity suspended between the drive to excel and responsibility to others. They had found in satisfying sexual relationships the force to control these reactions, but in a society based upon sexual hypocrisy, many would never find this ballast. Self-recognition projected upon society at large convinced them that difficult days lay before the United States and the world. The apparent relevance of Berman's fixation on the daily lives of poets for developing social crises is evidence that the specific tensions of poets' lives, involving both career and gender identities, replicated broader social contradictions in intensified form. Berman's most original contribution to the understanding of his society lay in extrapolating from his own, relatively narrow experience an understanding

that the desire to excel in the public realm was a threat to inner peace and domestic utopia. Applying these conclusions to the political life of the United States, he saw ambition and public ritual mobilizing the most negative forces in the American psyche. Having severed all but emotional connections to the public world, his observations had little objective foundation. The subjective truth of his meditations on purely personal questions lent his work the character of a prescient vision of social tensions yet to come.

With the ninth issue, Berman put aside *Semina*. His discovery of the Verifax reprographic process gave him a new way of exploring universal connections, in a form that allowed him to confront more directly mass-produced imagery and the transformation of social relations into spectacle, the simulacrum of poetry. His efforts at community building came to an end. The counterculture had emerged as a projection onto mass culture of the private ideas that had motivated Berman and his peers. Inevitably, incorporation into the mass media meant deformation. Berman had warned his colleagues that they were now part and parcel of the dynamic American society, no matter how much they had wanted to stay apart. The task at hand then was to pose more sharply the ability of aesthetic production to sever the power of social construction and allow people to construct their own identities through access to a more powerful, but less noisy universal reality.

In 1964 William Jahrmarkt, owner of the Batman Gallery in San Francisco, gave Berman an old Verifax photocopier, one of the earliest models of reprographic technology, used primarily by architects for duplication of blueprints. Berman spent six months learning how to control chemicals and settings. Even though the Verifax was a system for mechanical reproduction of visual images, the process was so primitive that no two prints were alike. Berman constructed his Verifax collages from images clipped from magazines. He built the collages layer by layer by rerunning the paper through the system to add another image. While the paper was still wet, he often rubbed out sections or applied other chemicals by hand to alter the image.

Occasionally he painted over the photographic collages with bright acrylic

paint (pl. 8), but most of the work preserved the somber, dull sepia and white surface of the paper as it came out of the machine. He could produce either negative or positive images, but generally he preferred the tonalities of negatives. The visual form with repetitions of images that appear nearly identical carried with it the risk of tedium (fig. 39). In Berman's collages, however, no panel in the grid was identical in content. Berman's work presented a fluctuating pattern of images that appeared to be similar only when the grid form fatigued a viewer's attention. Those who look must choose to do so and then look carefully to find the variety underlying the surface similarity. There is little rhapsodizing in Berman's Verifax collages, and a tendency, if only through emphasis on monochromatic tonalities, to mute the emotional appeal of his imagery. Personal values disappear into ambiguity, though the referents to American society are clear and inescapable. By drawing his imagery from motion pictures, television, advertising, pornography, and popular journals, he represented the force of the new media to consume all previous culture and make it more widely available while simultaneously stripping it of context and inherent meaning.

The signature of Verifax collages was the use of the transistor radio as a framing device. Berman had first tried setting his images within portable television sets, but he found the squarish shape limiting. The oblong rectangle of the transistor radio provided greater visual flexibility for the images he appropriated. It was a brilliant maneuver that came at a time when sales of these hand-sized radios were booming, not only in the United States, but throughout the world. Even more than television, the transistor could represent the triumph of electronic culture and its democratic potential. Television could not escape the connotations its image carried of manipulation of public discourse by a narrow group, in the United States the three networks. Radio, with its AM/FM bands, conveyed an excess of messages. The public system of meaning production had exploded, and this aspect gave Berman hope. The sheer bulk of images created in contemporary society seemed overpowering, but since it was impossible for anybody to absorb everything produced, all

39. Wallace Berman, untitled, Verifax collage, 1965. Courtesy of
 L.A. Louver Gallery, Venice, California.

images risked becoming meaningless. The viewer had to select images out of the plethora that had appeal. The electronic culture willy-nilly reintroduced choice, and therefore the possibility of refusal. In the continuous flow of images one grasped only what caused an emotion to erupt within. Truth lay within the receiver, not in the transmission, which was merely an empty sign, or to use a term prevalent in Berman's circles, a glyphic form, that became meaningful only as one saw oneself refracted through it.

His Verifax posters frequently contained slogans that mimicked advertising statements but transformed random slogans into a kind of concrete poetry. A statement like

RETARD PARA.33. SEC.12.MM
KILO/MAMA RE CANAAN XX.8
LUNARSEED JACJAC. AMER.R
EVOLUTION/ELEK.99VT LOVE

was wonderfully suggestive in numerous directions but pointless to try to decipher as if there were one privileged but hidden meaning awaiting discovery.[7] The message is equivalent to fortune-telling practices, which allow people to organize their hopes and perceptions of the possibilities facing them.

Still the mass production of goods and communications had created only the possibility of a purely private sphere of value. Even if we accept that Berman liberated himself, there was nothing in his program that destroyed the tyranny of the mass media for others. His strategy was to isolate particular images and juxtapose them to suggest that their meanings were in no way closed by their original context. His work stood as testimony that here was an *individual* capable of rereading and reinterpreting the messages bombarding him, an *individual* responsible for protecting his own spiritual state, an *individual* who had protected that which was "nearest and dearest" to him. The context of his art was entirely social, drawn from the everyday refuse of

popular culture, but the response he projected as an alternative was idiosyncratic. As such, it was impotent politically, but could be turned into a valuable commodity in the fine art market.[8]

The irony of using mechanical means to manufacture nonduplicatable results did in fact attract considerable attention in the art world. Irving Blum, owner of the Ferus Gallery after it turned commercial, found the work extremely attractive. From Blum's viewpoint, Berman's collages seemed to derive from Andy Warhol's photosilkscreen paintings with their panels of repeated images drawn from newspaper photographs.[9] On Blum's recommendation, *Artforum* ran a feature article on this work. Reaction to the Verifax work led to exhibitions in London and New York, as well as at the Los Angeles County Museum of Art. Berman made his first sales. His appearance on the *Sergeant Pepper's Lonely Heart's Club Band* album cover may well be homage to the influence of this work on Tony Cooper's design concepts (fig. 40).[10]

In one of the few extant transcripts of an interview with Berman, recorded in London in 1966 in conjunction with his exhibition at the Fraser Gallery, Berman's responses string along in a series of possible answers that reveal that a question has infinite responses with none correct except those relevant to the questioner at the time. "One can hardly ignore the very mystico-magical quantities in these pieces," Tanya Belami began. "Are they purely intuitive or might one search for actual philosophical imports in them?"

His verbal patterns, perhaps exaggerated by the hashish that he and the interviewer shared, are unquestionably what the slang of the day called "spaced." When he expressed himself through a work of art, his thinking coalesced into patterns of sharply clear and brilliant points. In the interview all one can see are the pulsating patterns of possibility: "There is an involvement with choice fragments . . . musical and magical counterpoint . . . the transistor as denominator." He compared "the mysteries of the current event" coded in mass communications to the "magnetic memory of volcanic rocks." He

40. Wallace Berman, *Scope*, Verifax collage, 1965. Collection of Dennis Hopper. Courtesy of L.A. Louver Gallery, Venice, California.

41. Wallace Berman, untitled, mixed media, 1972. Courtesy of
L.A. Louver Gallery, Venice, California.

called his Verifax images "special attack forces" and likened them to "cold and warm windshields," peyote, holography, drama, "waltzing ventriloquists," Vesuvius erupting, and "metal sheaths on underground cables." Ultimately he related the images to his understanding of the kabbalah, particularly the first two letters, aleph, the connection between order and chaos, and beth, symbol of language as the dwelling place of humanity.

> The letter beth which is the mouth as man's organ of speech . . . his interior . . . his habitation . . . denotes among other things interior action and movement . . . when in conjunction with the one preceding it. Aleph forms all ideas of progress . . . of graduated advance . . . the passage of one state into another locomotion. I don't know, dig the works. It's all there. In my work though, an involvement with the mysteries of the current event.[11]

Berman called transistor radios the kabbalah of the twentieth century, a conceit based on the multiple meanings of the Hebrew word. In addition to tradition, *kabbalah* in Hebrew could also mean both transmission and recep-

tion. In the process of conveying heritage, the transistor radio was the most ubiquitous mode for the transmission and reception of messages in human history. Berman consistently tried to replace the everyday view of the media with gnostic and kabbalistic concepts. Mass-media images could be understood as equivalent to a deck of tarot cards (pl. 8), to be reshuffled and redealt infinitely, with each reading, as Berman had attempted to demonstrate in *Semina,* proposing another set of connections.

Turning to the kabbalah for an interpretive key to phenomena was one manifestation of a broad-ranging interest in mystical, religious thought pervasive in the mid-twentieth-century avant-garde. Allen Ginsberg arrived at Tibetan Buddhism, while Gary Snyder followed the more ascetic Zen discipline. Joan Brown's studies of Egyptian religion and Hellenistic mystery cults informed her paintings after 1965, while Wally Hedrick's work turned to an examination of the visual forms used in the kabbalah, particularly in the work of the German Protestant mystic Jakob Boehme, who figured prominently in Kenneth Rexroth's poetry. Robert Duncan, raised in a theosophist family which was otherwise conventionally middle-class, returned to the roots of his childhood religion after a period as a quasi-Marxist. In particular, through his studies of the modernist American poet H. D. (Hilda Doolittle) and the background sources to her work, Duncan spent years reading about the mystery cults of the Mediterranean.

Gnosticism as applied by artists and poets was primarily an approach to cognitive investigation.[12] Symbols and patterns were messages needing decoding to reveal a hidden truth of pervasive, underlying spirituality. Since every manifestation of existence had a symbolic level, students of gnostic philosophies trained their senses to be open to the possibility of meanings. Its practice led to both a heightened awareness of the world in its most material manifestations and awareness of one's own inner responses and cognitive capabilities.

The kabbalah developed in Jewish communities in Spain in the twelfth and thirteenth centuries as a reaction against what the founding figures considered overemphasis on biblical exegesis in rabbinical practices.[13] The early kabbal-

ists based their arguments on the Rabbi Akiba's comment that God had given two revelations of His intent, one in the scriptures, the other in the world itself. Just as the Torah did not reveal its full meanings to a casual reader but demanded interpretation and discussion across centuries to reveal bit by bit its potentialities, God's messages embedded in the course of creation remained invisible to those who had not been trained to see and hear in a special way. Relying on another rabbinical tradition that the Hebrew alphabet pre-existed the creation of the world, kabbalists argued that the alphabet linked the two revelations and provided the key for interpreting sensual experience. But whereas in scriptural studies, debating the potential meanings of words was central to uncovering paths of interpretation, in the kabbalah, the Hebrew letters had no direct connection to the interpretations derived from objects. The letters became a system of abstract symbols, a methodology for categorizing the world into twenty-two primary attributes and the myriad possibilities that appeared when the letters combined with each other. Despite its apparent turn to observation of natural phenomena, the structure of the kabbalah was highly intellectual and speculative. At the same time, however, the mode of categorization, the Hebrew alphabet, had no necessary or motivated connection to natural phenomena, and the kabbalah provided a potentially flexible approach for creative, novel impositions of meaning.[14] As Gershom Scholem argued, kabbalism refocused Jewish inquiry into the nature of the divine from the practice of law to self-reflection: "It is through a descent into one's own self that a person penetrates the spheres separating man from God."[15]

For a man grounded in domestic ideology, the kabbalah provided a particularly comfortable intellectual framework for viewing the processes of the universe. The word *toldot*, for example, signified both divine creation and human procreation. Marriage and reproduction continued the creation of the universe narrated in the first chapter of Genesis. The kabbalah provided a method for recounting the various moments in the process of divine emanation. It allowed its practitioners to interpret human activities as part of, or

contrary to, the unrolling of God's presence. Sexual union was the metaphor without equal for divine process and therefore for the making of all meaning. Kabbalistic studies underscored Berman's commitments to his family by equating them to his commitments as an artist. Both acts, essentially private, generated the world of bodily sensations and the divine presence that gave human experiences meaning.[16]

The glyphic possibilities within Hebrew letters stripped of denotative functions provided a stimulus to poets to examine the world around them without needing to work out a consistent systematic correlation of phenomena to interpretative categories. Like astrology, tarot, and palm reading, the magic inherent in the kabbalah was the ability it gave to strip away the power of given meanings and put one's own import upon the phenomena surrounding a human being. The goal was not to overturn social structures but to create an autonomous space where those excluded from worldly power could exercise personal authority.

Jack Hirschman made one of the most concise statements of the political functions that Jewish mysticism could play for contemporary poets in his 1973 pamphlet *KS* [*Kabbala Surrealism*]. The combination of kabbalistic studies with surrealism, Hirschman argued, aimed at returning language to its original "glyphic state," which he equated with the expression of preverbal need, something similar to the sounds that infants make before they acquire their community's language. To incorporate kabbalistic symbols into contemporary art and poetry, the precise meaning of concepts was unimportant, though a general introduction to the main themes of Jewish mysticism was helpful. The central, specifically surrealist aspect of this interest in the kabbalah was to use the shapes and general ideas as springboards for the imagination. They allowed a "random orchestration of the mind."

Hirschman offered an explicitly political explanation, something that Berman never did. In an age of "showbusiness democracy," kabbalistic surrealism stripped images of their specific manipulative message and freed people

to put their own meanings upon the images they lived with. The glyphic state reduced images from communicative to formal levels and thus freed the images by making them meaningless. The recipient related the form to his or her own experiences, or the sign remained empty, and theoretically harmless. Narratives no longer provided the basis for a continuity of a self, a sense of progression toward ever-increasing mastery of the world. In a new world of amplified media, the self achieved continuity through self-conceptualization as a relatively stable pattern of interests and dislikes that scanned sensory input for sensations of similarity and difference, a process possible only if the majority of possible sensations became emotionally invisible. The self itself became glyphic, as it became a form going through a variety of experiences that recovered the ability of the infant to express needs and wants that had existed prior to social strictures imposed and enforced by everyday language.[17]

Hirschman's explanation can help us see more clearly the historical development of subjective distinctions embodied in the work of Rexroth and Berman, which otherwise treat similar themes. The earlier poet attempted to create a universal subjectivity that could encompass all experience. Implied in his project was a traditional narrative of a soul's progress from innocence to corruption to suffering and then redemption. Rexroth's modernist art proposed values that were validated by their correspondence to universal law. He intended to substitute one understanding of the nature of human being for another in a direct contest of ideologies. Berman's glyphic art focused on form rather than content. The shapes unlocked inner reactions in ways that were not bounded by predetermined meanings. Berman repatterned the self as a set of interests, existing in a state of kinetic potentiality. Rather than master the images, Berman's approach acknowledged their ubiquity in order to dissolve their power. From the fullness of nature so important to Rexroth's relation to the universe, we have moved (descended?) to the fullness of images, which being the basis of our sensory knowledge become in effect the natural

basis for subjective relation with all the rest of being. The foundation was faith in an ability of humans to find meaning even in chaos.

To accept the playfulness of images was therefore to refuse to let "language speak us," as Robert Duncan argued in the unpublished preface to his book of kabbalah-influenced poetry, *Opening of the Field*. Glyphic form repealed all the meanings added to language "from all the generations of human use." These meanings were the roots of the social power of the present. The ideal of individual liberty was a recovery of roots, a return to "radical origins," which was simply the ability to derive meaning from experience.[18] These roots were to be made visible and restored to use in everyday life, and thereby to break the hold of social codes. The concept of working "from within," discovering the "inner design," begins to assume clearer meaning: a statement of a project to break the power of dominant social codes over language and perception. The concept that meaning would be left perpetually undetermined was a challenge to social authority. Its strategy was elusive, since it did not counter given meanings with alternatives but tried to undercut the entire process by which specific meanings achieve normative status and authority.

The avant-garde ideology that Berman and his circle promoted resulted certainly in an alienation of the individual from social matrix, but in no way a separation.[19] Freedom could be determined only by those willful, seemingly perverse acts that distanced one from integration into rational organization of social activity. Joan Brown established her freedom by walking away from the Staempfli Gallery. Berman's situation was more complex. The fiasco of his 1957 exhibition at the Ferus Gallery remained for many years the dominant narrative of his life. He had tried to speak honestly of his most personal values and experiences, and society had humiliated him. For the next decade his work retold that story as a warning to artists and poets to master their own ambitions for public fame. To deepen his critique, he used the Verifax technology to show the power of private imagination over public imagery. To his

own surprise his work attracted attention. At the point when he could reverse the humiliation of his 1957 trial, he chose to do so in a manner that was meaningful only to himself and those in his quasi-imaginary community. The recurrent narrative presented in his work constructed around the bitter Ferus exhibition experience gave way to a new narrative ethos of voluntary renunciation. He told journalists in 1968 that he was not interested in having any more large public exhibitions of his work and returned home to continue working for himself and exhibiting to his small circle of friends.

That Berman never really seemed to enter into professional life, despite his prominent connections and friends, but continued along his own path, apparently untorn by the conflict between ideals and ambition that marked so many of his friends, made him appear increasingly like a saint as the sixties progressed. Turning aside from the mass public that could be his, he became for his friends a genie of creative possibility who could slide past the madness and self-destruction of ambition. He had always preferred to live in the private circle of his family and friends, but that choice was not truly his until he had the option of incorporation into a system he abhorred. Freedom, as he defined it, therefore required the persistence of an oppressive superstructure. That was the rub. The mass media were not to be escaped. One learned to live with them, as one lived with any potentially dangerous natural phenomena. This victory through voluntary renunciation confirmed Berman's status as emblem for his "community" of artist friends. Berman's example, tangible for himself, but symbolic for others, allowed them to maintain an ideal of the arts that suppressed internal contradictions and its actual integration as one institution among many within society. Many lost their innocence, but Berman continued living as if the ideals of the 1950s were still valid and realizable.[20]

In a mentality structured by a theory of the privileged relation of private vision to cosmic truth, the most private, personal, yet inescapably natural event was death. In 1946 Robert Duncan expressed the special role of artistic cre-

ation in facing mortality in a theosophical meditation. "In this life," he wrote in his diary, "we form the infinitesimal seed cells of the next life . . . we do not choose the body of our reincarnation—we make it." Poetry was the vehicle, Duncan mused, by which the soul released itself from the "night of the tomb" (attachment to daily life) into a spiritual existence.[21] The true revolutionary work of poetry, he continued, was to concentrate personal energy into a self-image that could begin the process of embodying a new relationship to one-self and the environment. The ability to move forward through a series of choices meant that everyone remained incomplete and therefore fundamentally unknowable. A perspective that accepted death as central to human experience was able to view all conventionalized attitudes with a feeling of distance. Even if the values one accepted turned out to be essentially the same for all intents and purposes as those validated by one's society, they were experienced as new and self-generated, worked out in an individual way. They were no longer automatic principles by which others guided one's conduct.

Attention to death began the journey of an inner life struggling for autonomy back to the public sphere. The nominal movement into apparent solipsistic irrelevance was the precondition for redefining public standards for personal behavior. The primacy of private values developing within the avant-garde was then only a temporary way station in a broader shift that involved challenging the power of institutionally entrenched groups to define cultural inheritance, religious values, publicly allowable statement, as well as standards for individual behavior. The validation of personal experience was a validation of change, hence a return to history as a source of meaning, even if reflected through self-constructed, somewhat artificial traditions drawn eclectically from myth and hermetic philosophy. The development of a mystical self, seemingly disinterested in rationality or social reality, brought into play an historical self created both by its domestic commitments and its independence from the power-serving myths of the moment.[22]

Artists and poets were not prepared for or competent to handle the kinds

of political stress they would endure—certainly one of Berman's principle messages to his fellow artists. Interpersonal dialogue, however valuable an element in establishing the needs of actual human beings as a foundation to group process, was nonetheless not the same thing as social dialogue, in which the participants attempt to uncover the ways social structure, discourse, and identity are produced, a dialogue that makes explicit the negotiations and mediations that occur between the various orders asserting needs. The resolution of the issues the avant-garde raised fell to other sectors, but not without artists and poets helping to define specific political issues dividing American society in the 1960s.

They had little to contribute to the civil rights movement or to the critique of endemic poverty. Their focus on spiritual states and their embrace of a modest income as a sign of disengagement blocked their interest in social allocation of economic resources. On questions relating to sexuality and gender construction, capital punishment, ecology, and the Vietnam War, for better or worse, the aesthetic vision became a central component. In the concluding chapters, we will examine how the avant-garde challenged both forces of religious tradition and of rational planning. Despite the inherent weaknesses of the aesthetic position, the avant-garde contributed to successfully subverting the ability of either force to impose its will upon the aspects of the American polity that it controlled.

It is a paradox that a movement of artists indifferent to politics should come to have a political effect. The form of their role has been confusing because of the lack of an intentional cause-effect relationship. In seeking to deepen their expressive capabilities, they projected into a society a subjectivity intent on revolutionizing the conditions of mutual understanding. Mysticism, irrelevance, and madness were all part of the game to overthrow all deterministic modes of thought. In a short poem found in his studio shortly after his death, Berman expressed the gamble he and his colleagues were taking, along a path that to others seemed irresponsible, but which from the inside was a

way of treasuring a shared independence that could also be responsible, if only to those to whom one was most directly attached:

> when what
> to my wondering
> eye
> should
> appear
> near madness
>
> as in basketball
> a miss is as good
> as a mile[23]

Part III

Return to History

10 The Politics of Obscenity

Professionalism, "Free Speech," and Realignment

Michael McClure's observation, "The body is behind all poetry, vision, and contact with reality,"[1] summarized a core position of the mid-twentieth-century avant-garde: individual experience rather than tradition or ideology provided the fundamental matrix for truth. His statement places McClure firmly within the liberal tradition and its celebration of an autonomous, universal subject. The disruptive force of McClure's work in the 1960s did not come from a radical view of social organization. Instead, the power of his work derived from his attempt to solve the black hole of liberal philosophy—upon what foundation did independent subjects secure their autonomy and hence their power as subjects capable of governing both their own lives and their society.

McClure did not ignore the overwhelming role of society in constructing experience and its categories. Like many of his colleagues, McClure assumed that historical forces forcefully intervened into the psyche in order to reproduce the existing, unequal power relationships and that art, as an analogue of natural creative process, provided the only basis for countering the colonization of the soul. McClure went further than most in emphasizing the biological aspect of human being as fundamental to the liberatory potential claimed for the arts. The entry of the cosmos into human existence through genetic coding of basic drives sheltered a beleaguered core that potentially could give

each individual freedom from social determination. Sexuality and violence took socially influenced forms, but they were mammalian instincts that pre-existed the development of the human species and hence were not limited by any of their specifically human expressions. In particular, McClure doubted that language shaped experience, since verbal expression was often a deflected form of deeper, repressed desires. Mobilization of the imagination did not mean the construction of ideal—that is, linguistic—images, but an orchestration of moods, bodily states, and verbal forms toward "constant reformation of the body image" until one's physical state matched a spiritual idea of self that McClure equated with "truth."[2]

Emphasis on biology inverted the relation of body and spirit in traditional liberal philosophy, which with its Enlightenment roots grounded individuality in the human capacity for logical thought. The catastrophes of the twentieth century shattered any confidence that men guided by reason chose the greater good. As Kenneth Rexroth had argued in "The Phoenix and the Tortoise," rationality was a tool of the state, a weapon for the expansion of violence. Additionally, the psychoanalytic revolution had revealed the power of unconscious experience to direct human action without individuals even being aware of the forces operating within them, much less being able to combat them. Those who relied upon rational capacity as the basis for individual liberty made a leap of faith as great as acceptance of biblical revelation.

Biology provided an alternative to rationality, and one that more adequately explained the tragic consequences of human action. McClure's poetry and drama were rituals for reorganizing a new image of self as a biological organism that experienced religious, rational, and social connections first through the body in a preverbal form before they achieved conceptual, symbolic statement. The examination of knowledge came through engaging the passions. Lovers had to unite physically to test and retest the actual truth of the emotions they felt about each other. Only in the process of confronting

the truth of bodily response could people develop a valid conceptual or analytic framework for their experience.

McClure's aesthetics required that he re-create, not simply comment upon, sexual experience, and his work therefore pushed against the limits of then-existing legal standards for acceptable public discourse on sexuality. At first, he presented his most explicit writing to a small, private audience of friends. As courts reconsidered legal standards limiting artistic and literary expression and possibilities broached for presenting more daring material, McClure was well positioned to speak to a broader public interested in breaking down sexual taboos. The productions of his play *The Beard* from 1965 to 1968 sparked controversy and repression as society considered the potential meanings of sexuality (fig. 42). Religious conservatives and traditional liberals had both condemned the passions as immoral influences that disrupted the higher faculties of human thought. Their alliance in the post–Civil War period had led to legislation that uncompromisingly censored visual and literary work out of fear that sensual experience might subvert rational process. As liberals became less wedded to rationality as the foundation of a libertarian society, their support for censorship faded. The end of censorship thus involved a re-alignment that was simultaneously cultural and political.[3]

The relaxation of controls on art and literature brought into play a complex intersection of legal, electoral, professional, and aesthetic dimensions. I focus on the interaction of subjective and political events, rather than on legal theory or history, which have been the focus of most discussion on censorship in American life. Three cases from the mid-1960s present a range of the issues involved: the trial of Connor Everts in 1964, in which the claim of obscenity was a pretense for suppression of politically offensive speech; the controversy in 1966 over Edward Kienholz's one-artist exhibition at the Los Angeles County Museum of Art, in which sexual references were part of a larger critique of American cultural priorities that conservatives found offensive; and the multiple crises surrounding the production of Michael McClure's *The*

42. Wallace Berman, poster for Los Angeles production of Michael McClure's *The Beard*, 1968. Wallace Berman papers, Archives of American Art, Smithsonian Institution.

Beard in 1966, 1967, and 1968, an ongoing conflict that allowed contesting ideas about the potential social benefits and harms of explicit sexual discourse to find particularly clear expression.

"You never want to dream something so small that it will be satisfied by reality," Connor Everts observed.[4] Coming from a working-class background—his father was a longshoreman and a union organizer—Everts hoped that his inclinations to artistic expression were part of a movement to democratize culture. An ideal of "modernism from below" was central to the identity he had built for himself as an artist. He believed that what he had to offer to the world was a vision previously excluded from elite cultural expression. His experience in art of personal freedom and enrichment was simply one aspect of a worldwide movement of the poor and oppressed to take charge of their lives. That his family disapproved of his artistic ambitions only complicated the matter for him and perhaps consolidated an idealistic vision of art as a way of mediating the career he actively pursued with the values of his past. He summarized his philosophy of art by distinguishing himself from those who were concerned only with formal characteristics:

> Anyone who thinks art is about art is wrong; art's about everything else. And any person who makes art just about art is making a tremendous mistake. It's become so insidious; it becomes so ingrained that it's weak. Art has to be about discovery. It can be about discovery in terms of aesthetic attitudes and all, but basically I think art is in the nature of self-discovery and the nature of relationships.[5]

After graduating from Chouinard Art Institute, Everts won a Fulbright fellowship to study in England. The monuments of Europe impressed him, but the contemporary art he saw seemed weak and derivative. He sought out left-wing artists and critics, but he thought them overly concerned with the relation of the working-class movement to elite tradition. He came to the "real-

ization that the greatest thing to have is to not have tradition, so that you can look at the problem and you can face the future, instead of turning your ass to the future and looking at what's past and making a decision in the future based on the past." Confronted with the classics of European culture, he reaffirmed his sense of himself as a working-class "bloke." "Societies replenish themselves from the bottom, not from the top," he concluded.[6] When he returned to the United States, he followed in his father's footsteps and went to work as a longshoreman while he continued his career as an artist independent of any need to make money from his work.

In 1956 Everts and five other longshoremen-artists formed the Exodus Gallery in San Pedro, the harbor district thirty miles south of downtown Los Angeles.[7] Following Wallace Berman's trial and conviction in 1957, Everts presented the same show Berman had mounted at the Ferus Gallery. Everts hoped to provoke arrest, and he was better prepared than Berman had been to take on the judicial system. He enlisted the support of the American Civil Liberties Union and the Los Angeles Art Association, with the intention of confronting the prosecution with expert legal representation and a county-wide publicity campaign to build support. Everts believed that only persistent challenges by creative people against censorship laws could develop a counterconstituency pressuring politicians to respect free-expression rights. Even though he called the police three times advising them of the exhibit, his hoped-for confrontation never materialized. The show ran its four-week course without event. Mere knowledge that objectionable, previously condemned material was present evidently was insufficient to engage the police, who may have hesitated to involve themselves in a situation designed to embarrass them.[8]

In the late 1950s Everts's travels in Latin America provided the model for a politically engaged painting that he had sought without success in Europe. He settled in Chile for nearly two years in 1958–1959, writing for newspapers on United States culture and teaching art at the Instituto Popular. During this stay he met and became a close personal friend of Salvador Allende, the presi-

43. Connor Everts, *The Thirst for Extinction*, ink wash and pasted paper, 1960, detail. Courtesy of the artist. Photo: Katherine P. Smith.

dential candidate of the Chilean Socialist Party in the 1958 elections. Allende's ideas of integrating popular and folk art expressions into the political movement as a way of combating the growing power of the mass media intrigued Everts as a model for developing a left-wing cultural movement within the United States.[9]

Rather than exploring North American folk culture, however, Everts incorporated Latin American motifs into his paintings. The tradition of the *calavera*, the semigrisly, semicomic skeleton figures that represent the intersection of life and death, was a particularly prominent source for the work he created after he returned to the United States. Everts used the skeletal form to emphasize the vulnerability of biological existence. The ease with which societies extinguish life emerged as his primary theme. *The Altar* was subtitled "A Comment on Automation," for the wall-sized ink drawing was a response to the sharp increase in fatal accidents on the docks after 1957 when longshore work began to accommodate container cargo technology. In *The Thirst for Extinction* (fig. 43), Everts portrayed social relations as a perpetual effort to mutilate and destroy opponents. In this swirling mass of aggression, most of the figures are both victors and victims.[10]

Between 1959 and 1963 Everts had a series of one-artist shows in Long Beach, Pasadena, San Francisco, and Oakland. Press attention helped him develop a network of local collectors, and curators from eastern museums,

including the Museum of Modern Art, purchased his work for their collections. Everts felt a sense of growing optimism that he could have a serious career as an artist based on prompting discussion of the violence underlying social relations. Still he believed that to produce art exclusively for collectors and museums would cause him to lose the independence that he valued. Like Lorser Feitelson twenty years earlier, Everts believed that he might best retain his integrity of vision if he produced for a broader public. He founded the Los Angeles Printmaking Society in 1960. His goal for the society, he stated, was to "get the notion over to the public that you could go in and you could buy original works of art, of quality, by contemporary artists."[11] A dream of creating a social utopia by a continuous, unfolding cultural awakening guided his career decisions. When offered teaching positions at both San Fernando Valley State College (later California State University, Northridge) and at Chouinard Art Institute in 1960, Everts chose the former school because he wanted to work in the public sector with students who were more likely to come from working-class backgrounds. His experience of moving from a restricted working-class environment into the broader world of art inspired a utopian dream, but not a theory of the institutional structures mediating the relationship of cultural workers and their public. His efforts to function as a spark to others collided against the boundaries of acceptable public discussion.

One of his first projects at San Fernando was organizing a show, "Art at Mid-Century," that he hoped would give students a sense of the variety of styles and themes found in the work of contemporary California artists. Everts included a piece by Edward Kienholz, *Bunny, Bunny, You're So Funny* (fig. 44). Critics and his fellow artists already recognized Kienholz as one of the most important younger artists working in the state, but the school administration insisted the piece was obscene and ordered it removed. The school newspaper, *The Sundial*, reported that several off-campus visitors to the show had complained to campus administrators. The school president

44. Edward Kienholz, *Bunny, Bunny,*
You're So Funny, mixed media, 1960.
Courtesy of the artist.

agreed that the work was inappropriate for a state-funded school because little children visited the campus and might see the piece.[12]

Everts refused. The school administration removed the piece on its own authority. Everts then organized the other artists in the show to pull their works in protest, and the show closed after three days. At the conclusion of the semester, the school declined to renew Everts's contract and told him that he was "weak on institutional image." He lacked the flexibility needed to thrive in a publicly funded institution, particularly one that lacked the prestige that might give its faculty some degree of autonomy. He went instead to teach at the private Chouinard Art Institute, whose administrators were far less concerned about general public opinion.[13]

In 1964 Los Angeles police arrested Everts for violating antiobscenity statutes. He had arranged an exhibit at the Zora Gallery of a series of lithographs entitled *Studies in Desperation.* The lithographs were a response both to the 1963 assassination of President Kennedy and to the execution of Caryl Chessman in 1960. Everts recalled that the series

concerned itself with the notion of birth, that if one had an a priori concept of how difficult life is, that one would perhaps, if he had his druthers, if he

had a choice, would choose not to be born—a kind of perversion of the thought of [Albert] Camus that the real affirmation of life is that suicide exists but so few choose it. . . . So that you would get from this vaginal orifice, that you would get a figure looking out and seeing if the world was really safe enough—not for democracy, but for the person's birth. The idea that assassination is the ultimate censorship—and it seems kind of fitting that I should become involved in censorship then—but assassination is the ultimate form of censorship, where the person's existence is so dangerous, is so frightening, that you must take that person's life. [14]

The police received an anonymous complaint that the exhibit contained pornographic pictures. The day after the opening, five officers from the vice squad appeared at the gallery and requested the removal of three "offensive" works in the window and thirteen others on view in the gallery. They threatened the artist with a felony charge of conspiring to violate the state's antiobscenity laws, an offense with a potential five-year prison term. When directly challenged, Everts had no question about his personal responsibility. He continued to exhibit. He did not consider *Studies in Desperation* to be one of his strongest efforts, but the exhibition had the virtue of demonstrating the degree to which police used antiobscenity legislation to censor ideas. Nothing in the work appealed to a sexual interest in the human body. His imagery of human vulnerability negated all desires before the ubiquitous presence of death. He felt that the relatively abstract images of a child emerging from and returning to the womb were offensive only because they portrayed American society as dangerous for children (figs. 45 and 46).

The art profession rallied to Everts's defense. A committee formed to raise funds to cover expenses. Henry Seldis, the new *Los Angeles Times* art critic, used his column to publicize the case. Richard E. Sherwood, a prominent attorney, art collector, and trustee of the Los Angeles County Museum of Art, agreed to take on the case pro bono. Sherwood negotiated with the police so

45. Connor Everts, lithograph from *Studies in Desperation*, 1964. Courtesy of the artist. Photo: Katherine P. Smith.

46. Connor Everts, lithograph from *Studies in Desperation*, 1964. Courtesy of the artist. Photo: Katherine P. Smith.

that Everts would be arrested and arraigned, but the police would not attempt to close the show. The prosecution agreed to reduce the charge against Everts to one item: the poster that had been placed in the window to advertise the show. The relation of content and form in Everts's work became the crux of the legal battle. The defense claimed that Everts's message required a brutal, shocking presentation, while the prosecution argued that Everts could have expressed the ideas in the lithograph, protected as ideas by the First Amendment, with another image. Central to Everts's defense was a professional critical position that there are no ideas *behind* poetic expression; works of art are objects that create an experience, and ideas are only a by-product of that ex-

perience. The case hinged around two conflicting, if reductive understandings of human aesthetic communication: does art convey an immediate experience or transmit a paraphrasable lesson?[15]

Sherwood presented a well-organized defense with five expert witnesses testifying after Everts's own explanation of his intentions and methods. Henry Hopkins, then chief of educational services at the Los Angeles County Museum of Art, exhibited slides of paintings and sculpture from major American and European museums. He observed that if the standards the prosecution proposed prevailed and were actually applied across the board, curators would have to remove many well-known classics from public view. Henry Seldis, two museum directors, and June Wayne from the Tamarind Lithography Workshop testified to the formal quality of Everts's work. Each of the expert witnesses provided the jury with an art-historical survey of the development of the visual arts since the impressionists in order to underscore the modernist orthodoxy that form was content.

The prosecution presented three witnesses. Two vice squad officers testified that they saw no difference between Everts's lithograph and any other pornographic picture they had encountered in the course of their duties. The prosecution's expert witness in the arts, a member of the California Portrait Painters Society and the California Landscape Painters Society, admitted that he was unfamiliar with contemporary museums, galleries, and artists. During cross-examination he stated that all works by Picasso were obscene and should be destroyed. He also agreed that some of the classic works cited by the defense's witnesses were indeed inappropriate for a general public and should be available only to qualified scholars in study collections.[16]

The first trial ended with a hung jury (six to five in favor of acquittal). At the end of testimony in the second trial, the judge, Andrew J. Weisz, decided not to send the case to the jury for deliberation but directed acquittal. "One may not be attracted to the works of a particular artist," Weisz wrote in his decision. "One may even find the work of an artist to be revolting, or ugly, but these value judgments are to be put aside. The matter involved must be

viewed to determine whether, objectively, a person normally exposed to the various influences at work in our culture would deem this poster to be neither more nor less than an out-and-out 'dirty picture.' Upon considering the evidence in this case, the answer is that he would not." Weisz's reasoning, however, evaded the question of form and content in Everts's lithograph. The judge preferred to rely on the question of discriminatory prosecution. "We are no longer in a tender, unexposed age," he continued. "Not only are our major commodities sold by the artful use of the outthrust bosom and bared leg, but we are deluged from every side with what once were known as 'girlie' magazines but are now merely expensive (and thus sophisticated) ones."[17] In its rulings on obscenity, the Supreme Court had held that application of laws had to be consistent so that similar material in similar contexts was equally liable. Weisz in effect told prosecutors that they could not single out artists until the district attorney's office was ready to indict advertisers, motion picture producers, and the editors of mass-circulation periodicals.

Henry Seldis's column in the *Los Angeles Times* reported the outcome with great jubilation. Seldis confidently predicted that prosecutors would avoid cases against artists simply because they were not winnable. Seldis's conclusion was somewhat overconfident given the actual outcome. A directed acquittal was no stunning public vindication of free-speech rights in the arts. Public opinion was clearly divided, and judicial actions in either direction would likely outrage large and powerful segments of society. The jurors in the first trial who favored acquittal told attorneys afterward that they felt Everts's poster had both artistic value and social importance. The jurors who favored conviction, on the other hand, could not see a face in the poster or make out any details. The "obscene" image of a vagina had remained invisible to them, but the idea that the police officers had seen it was enough for them to condemn Everts. Furthermore, they believed that Everts had sought arrest as a promotional gimmick and that a vote to acquit him might start a "trend."[18]

The most prevalent and politically significant arguments in favor of cen-

sorship came from Catholic and Protestant church groups. For them any public expression of sexuality was immoral, pure and simple. "Natural law" demanded that societies repress immorality or risk collapse through a pervasive disregard for all law. This argument formed the thrust of the solicitor general's speech to the Supreme Court in 1957 during its hearings on the *Roth* case, when the Eisenhower administration urged the Court not to tinker in any way with the then-existing laws: "The collective public conscience pushes the individual in the direction of being honest, fair, law-abiding, and decent. . . . one aspect of [public morality] cannot be corrupted and leave the rest unaffected. The man who finds that the Government will or can do nothing to stop the distribution of pornography to his family will be less willing to abide by society's demands on him, whether it be as to gambling, distribution of narcotics, or the candor with which he fills out his income tax."[19]

More sophisticated defenses for censorship would appear later in 1970 after President Nixon's Commission on Obscenity and Pornography concluded its studies of the effects of pornography and found no evidence to support the claim that pornography had a negative influence on individual behavior. The report provoked a storm of debate, and its opponents rushed into print to question its conclusions. Several appealed to psychoanalytic models to justify strict limits on public discourse. Irving Kristol, writing in the *New York Times*, claimed that antiobscenity laws protected citizens from their own "infantile" and "autoerotic" imaginations. "It is because of an awareness of this possibility towards the infantile condition, a regression which is always open to us," he argued, "that all the codes of sexual conduct ever devised by the human race . . . try to discourage autoerotic fantasies." Even when writers or artists used sexual images to present serious ideas, they released and stimulated libidinal aspects of the psyche completely unrelated to their intellectual issues. Walter Berns argued that a sense of personal shame was essential to maintain civility in public discourse so that ideas rather than passions prevailed. Graphic presentation of nudity and desire tended, he thought, to erase the power of shame and thus release individuals from any sense of responsi-

bility to their fellow citizens. George Steiner, approaching the issue from a complex position in which his sympathies for civil liberties conflicted with his fears of the mass media, wondered if restraints on sexual imagery were not essential to restrict the ability of commercial advertising to manipulate the public through appeal to libidinal desires.[20]

The common assumption of these arguments was that individuals could not be left in control of their own bodies without brute nature overpowering intellect and faith. Be it crime or commerce, lack of restraint would result in unscrupulous forces in society taking advantage of human failing. Conservatives, like liberals, ignored the degree to which social practices constructed desire. They viewed sexual passions to be a fact of nature, "original sin," that could be controlled through legislation and police enforcement and countered by religious education. Those whose sense of self nested in a continuity of civilized tradition proposed to impose a set of behavior standards upon their fellow citizens to protect democracy from the excesses of the majority not yet prepared to accept the lessons that tradition taught on the exercise of self-control and restraint. The issues in the 1960s revolved around questions of representation, but the implications were much broader, for the arguments in favor of censorship assumed that most people lacked the ability to ponder their own experience and make appropriate conclusions about what was in their own best interest.

In December 1965 a coalition, united under the rubric of Mothers United for a Clean Society, turned to the political process to break the judicial deadlock over obscenity. This coalition of Catholic and Protestant church groups proposed to place an initiative on the state ballot that would restore uncompromisingly restrictive standards on public sexual expression.[21] Over the next four months the group collected 700,000 signatures, approximately twice what they needed to qualify the measure as Proposition 16 on the November 1966 ballot. The initiative prohibited any consideration of "redeeming social importance," artistic quality, or intellectual message in the evaluation of a work charged with obscenity. Any public presentation of sexuality or vul-

garity would be illegal, regardless of the context. Exemptions for scientific, medical, or educational texts were banned. This provision was a step backward, as California had been one of the states protecting educational information related to birth control, childbirth, and the reproductive process. This clause in effect outlawed such material and would have hampered all forms of scientific marriage counseling. The measure also denied all courts the power to dismiss obscenity proceedings either before or during a trial on the grounds that the material was not obscene. Juries alone were to be the "exclusive judge" of the "common conscience of the community." Every juror was free to apply personal standards and preferences when reviewing materials for obscenity, but the proposition mandated that individuals who did not believe that obscene materials should be banned were to be excluded from juries trying obscenity cases. Of particular importance to the associations sponsoring the initiative, the measure guaranteed the right of "any individual" to bring civil action against district attorneys for failing to prosecute any material that the individual deemed obscene. The measure also prevented judges from reducing fines fixed by juries and required that charges include felony conspiracy if more than one person was involved in a case.[22]

Voters faced a clear choice in Proposition 16. They could affirm the stable moral values nostalgically associated with the Victorian era, or they could endorse their right to receive a multiplicity of messages, many of which might be offensive. Even though the assumptions guiding antiobscenity legislation grew from fear of the majority, proponents of censorship had to prevail in a political structure that involved democratic suffrage. They needed to couch their arguments in terms of protecting the majority from the excesses of a libertine minority. Artists and poets already established in the mass media as symbols for the dangers of unrestrained personal freedom provided perfect targets for jeremiads on America's wrong direction. In the course of the 1966 election campaign, poet and playwright Michael McClure and assemblage artist Edward Kienholz both found their work thrust into public controversies. Their visions were offensive to many, but the conflict within society over

how much freedom creative people should have in their interpretations of psychological and social reality actually stood in for how much freedom anyone should have in determining the basic decisions of their lives.

Unlike Everts's works which dramatized injustice by emphasizing the frail physiology of human beings, the works of McClure and Kienholz revolved directly and explicitly around sexuality. They presented images that argued that repression of sexual instincts was the most basic source of violence in American society. This source could not be addressed politically because the repressed by definition was unavailable to the conscious state. It always appeared in deflected, symbolic forms. Their work echoed a psychoanalytic paradigm by attempting to bring to the surface infantile sexual desires so they could turn toward mature forms of satisfaction. Artists functioned as the collective psychoanalyst of society, absolutely essential to its health and reform.

Like Everts, McClure and Kienholz found that the price of claiming to be a healer could be high, but the differences of the outcomes of their individual battles indicate the increasing importance of institutional differentiation and development. Alongside the attempt to restore moral verities, another development, the professionalization of the arts, was ineluctably leading to the decay of the ideal that creative people were an active moral force within society. The increasing importance of artistic autonomy presented artists, and perhaps through them the nation, with new forms for social relationship, at once freer but more structured than older models. The resolutions of the Kienholz and McClure controversies helped mark new boundaries between private and public realms, but only by effecting a shift in the ideal relation of individuals to the collective and the emergence of new forms for ensuring social responsibility.

11 Breaking the Pornographic Loop

Obscenity as Politics

The new William Pereira–designed Los Angeles County Museum of Art opened in 1965 with self-congratulation that the nation's second-largest metropolis had finally established itself as the "second city" of art in the United States. Only the Metropolitan Museum of Art in New York City had more floor space. As part of an effort to strengthen its collections, the museum recruited Maurice Tuchman from the Guggenheim Museum in New York to serve as a full-time curator for twentieth-century art. One of his first decisions was to end the *Los Angeles and Vicinity* annual exhibit and replace it with large in-depth shows of contemporary California artists. On the advice of Betty Asher, Tuchman scheduled a one-man show for assemblage artist Edward Kienholz, to run from March 30 to May 15, 1966.[1]

Kienholz imagined that the show would give him six weeks to garner publicity that might generate shows in other cities. Politics arranged much greater publicity than he had anticipated when, one week before the show was to open, Los Angeles County Supervisor Warren Dorn announced to the board that he had attended the preview for Kienholz's exhibit and was shocked to see that the exhibit consisted of "smut and pornography." Dorn asked the board of supervisors to vote to cancel the show since it was not proper for county funds to support art that many county residents would find offensive. Without debate, none of the other four supervisors having seen the show, the

board voted unanimously to order the Kienholz exhibit canceled. Dorn was then in a three-person race with former San Francisco mayor George Christopher and first-time candidate Ronald Reagan for the Republican gubernatorial nomination. Dorn's campaign stressed traditional religious values, real estate development as the engine of economic growth, and opposition to racial integration of housing or schools. Dorn launched his campaign for governor jointly with the effort of Mothers United for a Clean Society to place their initiative on the ballot.[2] As the election grew closer and his standing in the polls slipped, Dorn seized on the upcoming exhibition of Kienholz's assemblages with hope that he had found an issue that could rally the moral right around his cause.

The piece that achieved greatest notoriety was *The Back Seat Dodge '38*, a tableau that portrayed a couple copulating in the back seat of a car. The two figures inside the modified Dodge frame share a single head, which Kienholz said stood for the loss of identity in working for a mutual orgasm.[3] *Roxy's*, a re-creation of a whorehouse in Idaho that Kienholz visited as a teenager, also infuriated Dorn as inappropriate content for a public place where families brought their children for a weekend outing, particularly given that one of tableau's elements, *Five Dollar Billy*, had the word *fuck* carved on the base. Almost any of the works were offensive to conservatives. *They Tarred and Feathered the Angel of Peace* was one of several satires Kienholz constructed on bigotry and opposition to civil rights. *The Illegal Operation* re-created the sordid conditions under which abortions took place prior to their legalization.

Much of Kienholz's work appeared to be relatively straightforward social criticism, and he himself described his work as "social protest."[4] Yet their most effective symbolic work was often on a level divorced from, and possibly antithetical to, political organization. Such ambiguous effects appear in Kienholz's *The Psycho-Vendetta Case* (fig. 47). This piece had a specifically political theme. The artist presented the Caryl Chessman execution as a

47. Edward Kienholz, *The Psycho-Vendetta Case*, mixed media, 1960.
Museum Moderner Kunst, Vienna. Courtesy of the Museum Moderner
Kunst Stiftung Ludwig, Wien, Ehem.Sammlung Hahn, Köln.

participation piece for the audience in a way that would augment revul-
sion against capital punishment.[5] Kienholz described the involvement of the
viewer:

> It's just a box that swings open, made out of tin cans (it's covered with tin
> cans). It's got the great seal of approval of California on the surface of it,
> and when you open it up, it's Chessman shackled with just his ass exposed.
> The hands are holding a tank periscope. And when you look in that, you
> read down there, and it says, "If you believe in an eye for an eye and a tooth
> for a tooth, stick your tongue out. Limit three times." And you realize
> while you're reading that you're lined up exactly with his ass.[6]

This was theater of cruelty apparently directed at the audience, who as mem-
bers of society were responsible for their government's actions. Kienholz ar-

gued that to be philosophically opposed to policies based on denial of human life and dignity was insufficient. One must be outraged, and Kienholz planned on stimulating outrage by ridicule and degradation. Yet the piece also enacted a process of psychological separation. Those who support capital punishment are "ass-lickers," *The Psycho-Vendetta Case* stated, in the vernacular meaning they were unable to think for themselves. Cruelty was directed toward an imaginary antagonist, the "conformist" majority, that amorphous mass which was the opposite of the artistic communities' ideal independent thinker and experimenter. Politics dissolved into morality in a drama that allowed those opposed to capital punishment to reaffirm themselves as superior individuals.

Kienholz described his work as a form of social protest.[7] Yet the primary social effect of *The Psycho-Vendetta Case* was to reinforce a sense of detachment, what Kenneth Rexroth termed "disengagement," and Lawrence Lipton "disaffiliation," from the very processes that could legislate changes. The work augmented a sense of separation from others in society with whom one might need to unite temporarily for the achievement of a specific goal. Subjective reform, not social, was the intent of this theatrical piece. Subjective separation was part of a process of retreating into professional practice, into areas where each individual could assert the potentiality of authority and expertise decaying in the general social role of the citizen.

Kienholz provided a portrait of the repressed American male in his 1959 work *John Doe* (fig. 48), an upright mannikin, hollow inside, with a cross where his heart should be, lodged in a baby stroller that suggests his perpetual infantile nature. A riddle beneath his bust asks, "Why is John Doe like a piano?" The answer: "Because he is square, upright, and grand," affirming at the same time a subtext that the American individualist is someone who can be "played," a variation on the "ass-licker" theme. Two companion pieces, *Jane Doe* and *Boy, Son of John Doe* (1960), complete the nightmare American family: the wife-mother is a bloodied, severed head served on a table covered by a wedding dress; the son is a replica of the father mounted on a toy car

48. Edward Kienholz, *John Doe*, mixed media, 1959. The Menil Collection, Houston. Photo: Frank Thomas.

rather than a stroller, still infantile but caught up in the phallic appeal of self-propelled mobility. Condoms, beer cans, a cigarette pack, playing cards, and a well-thumbed paperback book entitled *The Impotent Fear Through the Erogenous Zones* litter the trunk of the car, clues to the interests and fears that transform the son from apprentice monster to master. In *The Wait* (1964–1965) an old woman sits despondently alone in a room filled with old photographs. Kienholz had found these discarded family pictures rummaging through thrift shops. The disparate pictures in the context of the work link together to create a family for the central figure. At the same time, the work suggests the lack of meaning of family rituals: within the illusion of the piece, the snapshots and portraits have no power to ease the solitude of the character Kienholz created; as a work constructed from junk, the tableau reminded viewers that its images were once supposedly precious mementos ultimately treated as garbage.

Kienholz's most ambitious tableau in the exhibition was *The Beanery*, a nearly life-size reconstruction of a popular cafe and bar that artists frequented in West Hollywood. The inspiration for the work came from a headline Kienholz saw in the newspaper rack in front of the bar one evening as he went to get a drink: "Children Kill Children in Viet Nam Riots." The headline crystallized his concept of what he needed to create about the relationship of popular recreation and global events.[8]

As viewers enter the bar, they pass, as he did, by the newspaper rack with its shocking headline. Inside, music plays, glasses rattle, there is a constant patter of conversation and laughter, but only an occasional word is clear. Time is frozen at ten minutes past ten. The exact moment is inescapable as, except for the bartender, all seventeen figures' heads are made from clocks. The frozen moment accentuates the amnesia of the present, with each person in the establishment caught in the gestures of instant desires. Yet the lively sound track reminds the viewer that the flow of time continues. "A bar is a sad place," Kienholz told an interviewer, "a place full of strangers who are killing time, postponing the idea that they're going to die."[9] Built at 90 percent scale, the environment feels life-size, but also inexplicably compressed and squeezed in by the seventeen figures sitting at the bar or at booths. As the viewer moves deeper into the environment, the sensation of constriction is reinforced by odd, musty smells and the layers of resin poured over every object in the piece. Death is present, the silent partner of the loudly ticking clocks. One has entered a timeless space, but with no connection to eternity. Kienholz recalled that at the first showing of *The Beanery* a friend of his came out of the installation sobbing: "I said, 'Geez, Lavonne, what's the matter?' She said, 'I saw myself in there.' . . . She said, 'You know, I saw myself. I'm wasting my life. . . . I don't need to drink to live.' And she had this big trauma because she'd seen some figure in there she just assumed was her."[10] The anecdote reveals the degree to which Kienholz wanted his art to strike into the soul through initiating a physical sensation and a sense of bodily relationship so arresting that the experience could begin a process of conversion. As con-

cerned as he was with formal issues, he was even more concerned with the social utility of his efforts.[11]

The Vietnam War and military expenditures, the death penalty, race relations, abortion, and the hypocrisy of American sexual mores were common themes in his work. Yet these highly political topics connected to feelings that transcended political solutions. Kienholz thought that the issues themselves were only instances of humanity's fear of what being a biological creature involves: "All my work has to do with living and dying, the fear of death."[12] For Kienholz birth and death created the only space that humans had to shape meaning. Art's power was to reveal the work of nature within and between human beings and reinforce the pressing need to focus one's limited time on what was most important. He claimed to be a social critic, but pressed on the relationship of his work to broader political concerns, Kienholz answered, "Politics are a really murky area for me because politics are really our own abdication of our own responsibility. We hire someone to make decisions for us. We give up our own power to let someone else exercise power over us."[13]

Since the Los Angeles museum was a county institution, the board of supervisors had some sort of ultimate authority, but an ostensibly independent board of trustees, drawn from the most prominent figures in Los Angeles business life, governed its policies and operations. The new museum was a major investment of private and public funds, both of which were necessary to make the expansion viable. The county provided 50 percent of the museum's budget and owned the land on which the building sat. Private funds had paid for the new building, supplied the other 50 percent of operating funds, and all monies for collection development. Museum trustees, most of whom had donated to the museum's building fund, saw the expanded facility as part of an effort to transform Los Angeles into a major international cultural center. It and the new Music Center of Los Angeles County would overcome southern California's reputation for provinciality.[14] The action of

the board of supervisors presented the nightmare lurking in private-public cooperation. In New York, the Museum of Modern Art, the Metropolitan, the Guggenheim, the Whitney Museum of American Art, the Morgan Library, the Frick Collection were all private institutions. They were not immune to criticism for their programs, but their administrators were free to make their decisions without interference from politicians untrained on any level in appreciation of the arts. In the 1960s, all prominent museums in California, with the single exception of the Huntington Library and Art Galleries in San Marino, were municipal or county chartered. The potential for conflict between political and professional needs was built into the divided authority under which cultural institutions had developed on the West Coast.

Nonetheless, Dorn made a political blunder thinking he could attack the museum without in effect attacking the integrity of the men and women who sat on the board of trustees. They were no cultural radicals, but they defined their staff as trained professionals. Dorn's assault was too patently demagogic, too clearly connected to his lagging gubernatorial campaign. His attempt to gain votes by dictating museum policy threatened the ability of the museum to take a leading place in the larger world of international museums. He was about to learn that, contrary to the popular saying, not all publicity in the media is good.

Both major daily newspapers, the *Los Angeles Times* and the *Los Angeles Herald-Examiner*, editorialized against the supervisors' decision. Radio and television editorials ridiculing Dorn were even more damaging to his electoral ambitions because they reached virtually every adult in the county. The greatest damage to Dorn's case was self-inflicted. Dorn handed his critics a sound-bite that in the nascent age of electronic media politics proved disastrous. At a press conference, after reporters challenged his training as an art critic, Dorn declared, "My wife knows art, I know pornography." Every newspaper reported the statement, and the film played on every local television news show. He transformed himself from defender of family values into a replica of "John Doe," evidence of Kienholz's contention in *Roxy's* and *Boy, Son of John Doe*

that pornography was essential to the psychic economy of American white males.[15] One editorial from radio station KPOL gives a sample of the abuse heaped on Dorn after he made what could well be labeled a Freudian slip of the tongue:

> The county supervisors, individually and collectively, are elected by the constituents to oversee many aspects of community life, but it's highly doubtful at best that Warren Dorn was elected a county supervisor because of specific accomplishments in the field of art. For him to set himself up as a one-man board of review of what is or what is not fit to be shown at the County Museum of Art is unfortunate. For his fellow supervisors to limply accept his judgments as sole criteria, without having seen the material in question themselves, borders on the incredible. In defense of his point of view, Supervisor Dorn is reported this morning to have said, "My wife knows art; I know pornography." That's like the situation in Chicago where censorship of motion pictures is exercised by appointed members of the police department, even though these individuals are not chosen because of any specific cultural or intellectual attainments.[16]

The concluding reference to Chicago raised the specter of the Richard Daley machine, at the time a national symbol for corrupt politics. In Chicago, every aspect of social life was supposed to be driven by deal making rather than the merits of issues. California's progressive legacy had led to reforms of electoral process in the 1910s and the 1930s that ostensibly ensured control of the "citizenry" over professional politicians. The radio editorial pointed to what became the central issue for many otherwise conservative people in Los Angeles: if the county was spending millions of dollars annually on the museum, then it should have the best possible, professional administration independent of political interference. The museum should join other important county agencies like the Metropolitan Water District and the Rapid Transit District with an administrative reform that removed the agency from the vagaries of patronage and electoral politics. Abstract standards and principles rather than

patronage, whim, or personal pique should determine areas of vital public policy.

Autonomy of the museum from direct political control was to come only after public pressure humiliated the board of supervisors into retreat on its Kienholz diktat. In the last week of March 1966, a bumper sticker stating "Dorn is a four-letter word" circulated widely. Letters to the editor printed in the *Los Angeles Times* and the *Los Angeles Herald-Examiner* ran five to one in support of the museum's right to mount the Kienholz exhibit without political interference. The letters often expressed resentment that Los Angeles was made to look as if it were a city of bumpkins. Others urged the museum to defy the supervisors. Dorn had not counted on the many people in Los Angeles who liked to think of themselves as culturally and intellectually sophisticated, even if they were politically conservative.

Ernest Debs, an actor turned politician, signaled to the museum staff that a majority of the supervisors wanted a way out of the embarrassment they had inflicted upon themselves. Maurice Tuchman and Kenneth Donahue, the director of the museum, met with the supervisors to negotiate a "compromise." Two changes were made in the exhibition: Kienholz agreed to widen the base of *Five Dollar Billy* so that people would have to stand further away from it and the objectionable if well-known four-letter obscenity worked into the piece would be less prominent. Kienholz also agreed to a guard standing by the door to *The Back Seat Dodge '38*. The guard was to close the door whenever minors approached the car. Nothing else in the show was altered. On the basis of this agreement, the board of supervisors voted to allow the exhibit to proceed.[17] The show attracted large crowds, and television stations sent out news crews to cover the event. The museum directors could not have asked for better publicity or a better outcome.

Dorn finished a distant third in the Republican gubernatorial primary. He remained a county supervisor until 1972, when a popular local television news announcer, Baxter Ward, defeated him. Dorn's stand on the Kienholz exhibit was only incidental to his political fate, though for artists the affair

stood in their memories as confirmation of their alienation. Rather than building on the successful outcome or on the public support gained for "free" expression, memories emphasized outrage, attack, isolation, and the danger of being an artist in a philistine society. The very possibility of being the subject of public controversy was unsettling.[18]

Dorn's failure to manipulate the morality issue provides generalized evidence of a change in political life that he and many others had not anticipated. The power of church- and community-based pressure groups, operating with a high degree of personal commitment, was waning, while the power of the mass media, whose personalities roused passions on a daily basis, was growing. Groups like the Legion of Decency had been a model of grass-roots involvement. They channeled popular political energies with practical activities that generally gained measurable results. They gave their members empowerment and satisfaction because the organizations' activities had definite impact on how everybody lived. In theory, the negative consequences of a minority imposing its morality on fellow citizens could be countered by the rise of opposing citizens groups, but the decline of the Legion came from another source. An increasing reduction of "middle-class" lives into the twin poles of domesticity and work decreased the political influence of organizations that relied on networks of personal contact. Despite a tendency toward apathy, the retreat into the private that marked the post–World War II era was not entirely negative, for it limited the power of organizations like the Legion of Decency. Whether a politics based on atomization into family units, friendship networks, and professional associations could be as socially engaged was doubtful, but it had the distinct advantage of reducing restrictions on individual choice. Atomization was a factor that allowed the suppressed contradictions of individual experience to crystallize into social issues. Thus in 1967 a Republican-controlled state legislature responding to perceived concerns of the electorate passed the first laws decriminalizing abortion, while in 1969 the legislature overrode religious opposition to liberalize divorce procedures.[19] In

the field of culture, a significant portion of the public wanted access to information and resented efforts to limit their experience of the world.

In this shift, artists had a small but significant role to play because they could easily symbolize for the public at large the boundaries between licit and illicit experience. One could decide it was ridiculous to suppress Kienholz's art without having to approve of Kienholz's specific criticisms of American society—or even really having any idea of what the art was about, much less what the mutual responsibilities of artists and society ought to be. As a struggle taking place on the symbolic plane, both within the art itself and in the art's relationship to politics, the debate took place on an idealized plane of "free speech" versus "family values." Beneath the symbolic struggle were institutional shifts in the arts and in politics that would shape the practical outcomes of all those involved.

The Revolt Against Repression

To a degree far beyond Everts or Kienholz, Michael McClure exulted in a poetics of frank sexuality. In 1961 he and his friend Dave Haselwood published McClure's *Dark Brown*, an extended ode to heterosexual love, remarkable at the time for the explicitness of its language and imagery.[20] McClure surreptitiously passed copies to his friends, while City Lights Books sold the volume under the counter only to those known and trusted by the staff. In *Dark Brown* McClure challenged the common assumption that fantasy and sexual passion were incompatible with commitment and caring. The poems move through an undifferentiated sensual awakening to a sense of wisdom reposing in the body, discovered in heightened physical and emotional states, until the cycle climaxes in "Fuck Ode." In an essay explaining the importance of removing all sense of shame from words like *fuck*, McClure wrote that "a man knows what he is by how he names his states. . . . Men

who say *copulate* or *intercourse* feel removed from their bodies. . . . I would rather fuck with my meat body than have intercourse and watch it with my mind."[21]

Read aloud in semiprivate gatherings, the poems in *Dark Brown* continued the revolution of "Howl" by validating physical exploration as a path to intensified spiritual exchange that deepened domestic attachments. Michael's poems, which his private audience knew charted the turbulent but passionate history of his marriage, were matched by Joanna McClure's poems, equally renowned for their frank sexuality. Between 1960 and 1964, their poetry developed in tandem in a dialogue that offered their friends a vision of the McClures' most intimate relations. To those within their community, the poetic work of both McClures was equally well known, though on the professional, public level, Michael alone published books and developed an international readership. Their poetic voices were not equal. Joanna's poems came into being through dialogue with his poems, which inevitably could not express her experience of their relationship. Her work grew out of the relationship, while his existed in a dialectic between his domestic connections and his public ambition. His respondent appeared to be her, but it was actually the poetry-reading world at large, to whom he declaimed his views of social relationships derived from generalizing the specifics of his marriage into public statement. Public exposure brought what had been private into a semipublic realm, in which the concept of community defined new boundaries and a new interpretation of what the private meant. Michael and Joanna both used apparent sexual disclosure to present confessions of private obsessions and the evolution of their spiritual states, the dialogue of which ultimately formed the content of a constantly renewed marriage. Self-display served as declaration that the details of their lives were no longer subject to public morality. Instead, the private, understood as the haven of the imagination, became the standard against which public life could be judged. As such, the private had to throw away the veil and leave the imaginary seraglio to take its place in the public square. Yet at the same time as half that dialogue sought fully public

expression, the other, female half vanished into mere context and remained locked in seclusion. The revolt against repression involved its own amnesia, which would eventually end the postwar avant-garde project of finding in art a universally valid form of liberation and set into motion a new project of dividing human experience into particulars.[22]

When Michael McClure turned to drama, he hoped he was reviving the principles of Shakespearean theater, with its emphasis on emotion and action. Contemporary theater was psychological, but the Elizabethan had been what he liked to term "meat theater." Psychological theater depended upon plot to provide an explanation for the origin and development of human action; the organizing categories were schematic and divorced human beings from the matrix of their physical relationships to place them into abstract, analytic frameworks. Meat theater focused on pride, rage, and joy as perpetual underlying realities in human interaction. "Psychological theater deals with the personal and social problems that seem most relevant," McClure argued. "We deal with these every day, and we know them, whereas the other we inhibit or repress, and we can be very delighted to see them."[23] McClure's dramas stripped away plot, character development, and every aspect of dramatic convention to leave only the arousal of basic emotions through provocative images. He wanted to achieve a theater of pure subjectivity, where the emotions were completely divorced from the accidental events he thought only called them into being: "If you are subjective enough, if you are *utterly* subjective, there's a point where your subjectivity can become objectivity, or universality, or something similar to that. So that if you maintain yourself as purely as possible, and you confront people who maintain *themselves* as purely as possible, then you can almost see through their eyes, and they can almost see through *your* eyes."[24]

In the last sentence, McClure placed himself in a tradition articulated earlier by both Kenneth Rexroth and Clyfford Still. McClure came to San Francisco from his home in Kansas to study painting from Still. Discovering the California School of Fine Arts in the midst of turmoil and Still gone, McClure

fell in with the Rexroth and Duncan poetry circles, as both student in their workshops and friend who participated in their salons. McClure had little training as a dramatist other than his studies in poetry with Robert Duncan and his performance of the role of the Boy in Duncan's play *Faust Foutu* at a staged reading at Duncan's King Ubu Gallery in November 1953.

Purity in drama meant concentrating on emotions. Theater, McClure thought, could directly stimulate emotions by refusing mimetic logic and focusing on sounds and actions presenting pure aggression and pure sexuality in such a way that the audience could not help but participate. He derived his ideas on theater from the theories of Antonin Artaud, but McClure specifically rejected the idea that the playwright should humiliate or in any other way be cruel toward the audience. He wanted to present rituals that allowed people to face what was in them so that, as he had, they too could choose love rather than alienation.[25]

McClure wrote his first full-length play, *The Blossom*, in 1960. Billy the Kid, his employer, his employer's wife, and the two men who killed him are trapped in eternity reliving the emotions they felt at the time of their deaths. In McClure's vision of eternity, which elaborates in dramatic form Robert Duncan's 1946 perceptions of death, the most emotionally searing events of a life repeat themselves without cessation or alteration as the truest indicator of the soul. At the center is the Kid, "an idealistic mystic," according to McClure, who understands that death is more natural than life and that murder is his way of asserting presence in the universe.[26] Paradise for the Kid was reliving that intense feeling preparatory to murder without break or diminution.

The Blossom offered nothing to audiences raised on plot line with its implied scheme that people should go through a series of meaningful experiences which make them grow and become better adjusted to the world. McClure's goal was ritual enactment of the selfish aggression present within each member of the audience. McClure offered no condemnation of unrestrained passion because he saw anger and violence as everyday occurrences.

As an objective aspect of human existence, aggressive passions were part of the "cold lights" McClure saw suffusing the cosmos.[27] They were part of the realm of necessity. The realm of freedom lay in the power of the imagination to create something new. That choice was a struggle and could not occur except through confrontation with the fullness of existence that Jakob Boehme had called the "unground" of freedom. In *The Blossom* only the Kid is content living within the passions of his death, for they revealed his true nature. The other characters are confused as to why they keep circling in the action of a few minutes, for they do not realize that they are trapped within their emotions. The Kid has broken the trap of repression and brought his murderous desires to the surface, where they become the subject of choice. He actively embraces his destiny, while the other characters have fallen into a fate they do not want because they do not comprehend the forces within them. McClure balanced the necessity of passions against a warning that had little to do with morals as a set of predetermined guidelines for behavior. Confront your emotions, he told his audience, or they will control you.

In order to understand the public ramifications of McClure's treatment of human passion, we need to turn to Freud's doctrine that socialization of individuals occurred through the repression and internalization of instinctual drives. Freud proposed that opposition to efforts to bring elements of the unconscious into the conscious was the preliminary condition for the development of neurotic or psychotic symptoms. Repression represents an unrealized emotional process that retains its energy within the psyche. The individual has no conscious memory of the formative episodes, but the process linked sexual desire to infantile phobias. The libido converts into anxiety, which then dangerously and surreptitiously appropriates an aura of sexual excitement. The fear and anger released become a source of unconscious pleasure that the individual constantly seeks. The urgent demands of sexuality flood into behavior that can be violent, paranoid, and ultimately self-destructive.[28]

Lust was a form of repressed sexual attraction that expressed itself through

words. Lust was not inherently a social category: the vocalizations of animals expressed desire before they could act on it. In human society, however, vo-calizations associated with sexuality assumed greater importance than sexual acts. Rather than being a stage in a process of unfolding emotion and action, lust became sexual passion perpetually deferred. Sexual union destroyed lust and thus was experienced as frustration and disappointment. Resentment at the evaporation of anticipation turned real sex into a violent act, in which ag-gression replaced physical pleasure or emotional sharing. Obscenity sprang from words used to shock and thus continue sexual aggression on a level completely detached from intimacy. Freud argued that obscenity arose as the infantile desire to see and touch the genitals of the opposite sex was frustrated and erotic longings were transformed into aggressive impulses to strip away the barriers. Normally those desires were deflected from action into words, and sexuality was entangled in the elaboration of verbal taunts.[29]

Lust as verbal aggression deferring actual physical contact was the subject of McClure's second play on Billy the Kid, *The Beard*, written in 1965. In this play, McClure brought together the Kid and Jean Harlow, in a blue velvet-lined room in paradise. As with his other plays, there is no "action" in the drama. It is a confrontation of two icons of American popular culture that served as expressions of male and female archetypes emerging from the col-lective unconscious in peculiarly mid-twentieth-century American forms, the cowboy and the movie goddess. Yet *The Beard* has little in common with pop art. The forms themselves or the ways in which popular icons establish their hold upon the public imagination were irrelevant for McClure, for he as-sumed that sexual needs always resulted in archetypal figures, the particular form of which was accidental. McClure began with pop icons, but following Wallace Berman's approach, McClure used them as a starting point and filled the forms with his own obsessions.

The Kid and Harlow spend ninety minutes insulting each other in a mat-ing dance that ends with words transforming into oral sex, the Kid kneeling before Harlow and nuzzling her thighs. The reviewer for *Variety* described

the play as a "reduction of all male-female spats, courtships, fetishes, etc., to a simple animal circling, snarling, sniffing, teasing, until they join sexually."[30] The persistent repetition of set exchanges breaks down the immediate denotative sense of the dialogue. The words' semantic functions are overtaken by a more fundamental need to use voice for the physical expression of preverbal demands for attention and desires to vanquish the ego through union. "We want the same thing and [we] enact it between us," the Kid tells Harlow.

The action of the drama grows from the topology of gender relations sketched in part 2 here. McClure gave the male figure attributes traditionally assigned to nature. The Kid is an irrational and therefore redemptive force. The female figure is the nexus of connections, the inner center of both domestic utopia and organized society. Jean Harlow is the prototype of the object of desire fetishized by the motion picture camera, perpetually beyond reach and therefore the perfect projection of lust indefinitely prolonged. Harlow thus speaks within the play of the repressed desires that bind people in modern society. In *The Beard* McClure projected this cognitive map onto an abstract level that balanced but did not equate male and female powers. The male figure is violent, but the Kid's drive to dominate makes him express himself through his body. Immediacy of action and unpredictability help establish the Kid as the symbol for nature. "You bit my fucking toe! AND TORE MY PANTIES UP!" Harlow screams at him. It's what she wanted, he tells her. The execution of male power depends on a myth of voluntary submission by women to uncontrollable male impulse, but the Kid is also confessing that what he wants is to be humiliated and broken of his will to power.[31] As he successfully seduces her, the Kid enacts the triumph of nature overcoming but not vanquishing society. The role of the poet within each male is to seduce the sex goddess in every woman and thereby end a sexual economy based on simultaneously worshiping and despising women. The result is a renesting of society within nature rather than the two aspects of human being existing in disjunction with each other.[32] Through utopian domesticity comes the sexualization of the social so that intensified bodily relations might be the domi-

nant form of social relationship rather than an endless cycle of sexual aggression based on despising and deferring desire.

As with Ginsberg's public readings of "Howl," what happened on the stage was less important than the emotional release the action inspired in the spectators. The action serves primarily to expose sexual passions within the audiences and allow them to experience a form of completion. The characters repeat that they are "all alone," that "there's nobody around to watch," an incantation that liberates the audience from its role as motion picture fans who insist that stars repeat ad infinitum their limited, but familiar routines. The course of the characters' drives, which they themselves describe as projections of the spectators' desires, can move to completion. In their roles as aspects of the imaginary order around which an assumed modal American identity is constructed, the old identity of deferral and frustration—the identity requiring pornography—confronts the germ of a new self in which the presence of physical needs is experienced as immanent rootedness in the natural world. Conversion will not come from denying inner impulses; only allowing them space to develop into their own negation will bring release from the pornographic loop. The vicious and destructive aspects of character must be mobilized before one can progress beyond them. The point of ritual, of McClure's concept of a "Shakespearean" theater, is to allow this process to occur in a forum where the least negative social consequences will result. Instead of excess psychic energies overflowing uncontrolled into everyday life and into politics—the view of the world in McClure's "Dallas Poem"— aesthetic creativity channels dangerous desires into a zone of human activity where the imaginary can be transformed into, though never be replaced by, the symbolic. There is a risk that passions can overpower the liberated subject, but the assumption is that health will be the usual result. There will be an end to the malaises of deferred desire with their attendant individual and social ills.[33]

The Kid's drive, as in the earlier play, is to ride the crest of his emotions through the domination of others. He forces Harlow to let go of the coy,

available yet untouchable stance that makes her a motion picture goddess and reveal to him her own desires. This movement to force revelation of what her image implies but also hides took up the ninety minutes of *The Beard*'s performance. With each repetition of the limited exchanges that pattern the dialogue, the male archetype of violence as a form for possessing and defining the other pushes the female archetype to reveal more of what she wants. In the concluding moments, she licks and caresses the Kid's boots, an act of submission to her fans that frees him to possess her.[34]

The final image of oral sex highlights the role of language in the construction of sexual pleasure as perpetual deferral, for in Freud's psychoanalytic system, the earliest stages of repression begin with projecting specifically oral desires into another sphere.[35] In *The Beard* the linking of orality and sexuality is a symbolic reunion of words and actions that reestablishes the continuum between emotions and actions. There is complete commitment to carnal exploration as a form of mystic knowledge, a theme McClure already explored in *Dark Brown* when he wrote of the tongue exploring a lover's body as a tactile instrument causing and then vanquishing the "tense of shame."[36] Three years earlier, George Herms had written that oral exploration of his wife's body had broken his fears of his own body and had been an essential step to finding his way as an artist: "After years of tongue-tied quasi-submission to maternal anti-genitalia and paternal anti-exploration (both rooted in fear) i was finally to speak upon learning the language of love in the blood school of my wife. (Cunnilinguality is based on language, also.)"[37] The stark graphic image of sexual union had multiple functions: it dramatized the masculine triumph of poetry by externalizing Harlow's pleasure as, according to stage instructions, she stiffens and arches her body, ecstatically chanting, "STAR! STAR! STAR! OH MY GOD—! STAR!"[38] Easier to present on stage than genital union, the concluding action of *The Beard* left no doubt as to what was happening. Yet at the same time, the image transcended mere celebration of pleasure to bring to light a more complicated intersection of desire and shame that left open the sufficiency of the apparent masculine triumph.

Given its abstraction and lack of plot, McClure had not imagined that his play would attract an audience, much less become "a cops-and-robbers game," but he and the cast were arrested nineteen times in 1966 and 1968 for producing the work. The play premiered at the experimental laboratory of the Actor's Workshop in San Francisco on a Sunday evening in December 1965. That performance, with an audience of less than one hundred, was uneventful, though successful in establishing an underground reputation for the play. The reviewer for the *San Francisco Chronicle* praised McClure's ability to raise and resolve the most difficult issues in a way that he could feel the audience's emotional release at the end of the play. Far from finding the play pornographic, the reviewer argued that *The Beard* was hygienic because it purged the hold of antiquated values. Over the next several months word of mouth by those who had seen the performance apparently reported that they had participated in an extraordinary and shattering experience. The growing curiosity about the work prompted Bill Graham to invite McClure and his actors to present the play at the Fillmore Auditorium, the largest rock club in San Francisco. In July 1966 a capacity audience of three thousand jammed into the Fillmore. The venue added an aura of rock opera to the performance. The actors used hand-held microphones, necessary to be heard in the cavernous hall, and Graham reinforced the spectacle by adding a pulsating psychedelic light show and live rock music accompaniment.[39]

At this time, the police took interest in the production. Graham scrapped plans for repeat performances at the Fillmore after officers from the vice squad threatened to revoke his club's operating license. In August the production relocated to The Committee, a North Beach comedy club specializing in political satire, for a planned indefinite run. The San Francisco Police Department secretly audiotaped the first two performances at The Committee and then interrupted the conclusion of the third performance with motion picture cameras recording the oral copulation scene. Officers jumped onto the stage to arrest the actors and sought out the playwright backstage. The district attorney's office charged them with violation of obscenity laws, conspiracy to

commit a felony, and lewd and dissolute conduct in a public place, the charge most frequently used against homosexuals arrested in men's rooms. The production then shifted to an auditorium in Berkeley, where two nights in a row the chief of the police department personally halted the performance and arrested the actors, the director, and the playwright for the same offenses as in San Francisco.

The charge of lewd and dissolute conduct in a public place became the key element in the case and went beyond obscenity law as the district attorney charged that representation of oral copulation was legally not distinguishable from the actual act. "If this act actually took place, they [the actors] could be charged and convicted of a felony, whether or not it was in a public place," the prosecutor's brief argued. "However, we feel that regardless of whether or not the act was actually accomplished, what was done was sufficient to satisfy the requirement."[40]

Marshall Krause, the attorney from the San Francisco chapter of the American Civil Liberties Union representing the defendants, argued that the charge was ridiculous since, following the prosecutor's logic, a representation of murder could lead to a charge of murder even though nobody was physically hurt. In one of those fortuitous admissions that reveals the actual issues at stake, the state attorney general dismissed Krause's argument by contending that there were two classes of crime. One, of which murder was an example, resulted in "tangible, physical harm" to a party; the other damaged society by inserting unlawful thoughts into the imaginations of others. In the case of simulated sex, the result of the crime was identical to witnessing an actual act so that from the viewpoint of law there was no essential difference between representation and execution. The argument had no overtly religious aspects, but its premise was that original sin lurked within the breast of every person.

The judges assigned to hear the cases in both San Francisco and Berkeley dismissed the charges, but the state attorney general, Thomas Lynch, assumed control of the prosecution and sued to have the charges reinstated. He

announced that he personally would lead the prosecution team. McClure was at a loss to explain the intensity of the reaction or the priority given to his case: "I feel that the people who do not like the play are not so much frightened by the sexuality, but that gives them a handle. What threatens them is the statement that we are all divine—and how can we be divine and have a divine war in South Vietnam? How can we be divine and do the things that we're doing? I think that's frightening to some people." He had arrived at an ideological explanation. As the Vietnam War intensified, McClure came to equate sexual repression with the American history of westward expansion through conquest, and his play seemed to have a providential role in the growing antiwar movement. In his mind, helping Americans confront the construction of sexual pleasure and identity was essential to end the Vietnam War and Cold War militarism. "It's the same area of sexual repression that keeps a person from using a 'dirty' word to describe an act of love that eventually causes a powerful, beautiful nation to coil up its hatred and deliver it in the form of bombs and napalm on an innocent, technologically incapable, small Oriental nation," he declared later to a newspaper reporter.[41] American society was a machine for the reproduction of repressed desires; by definition the basic activities of collective life were perversions of natural instincts. Any emotional disturbance from confronting the varieties of sexuality was a product of the social construction of sexual pleasure as illicit. In order to experience pleasure one also had to experience guilt. Pornography was thus essential to the subjective constitution of Americans.

McClure proposed to eliminate the concept of pornography by helping his audiences confront the sexual identity they absorbed from their culture and replace it with another that found pleasure in actualization rather than deferral of sexual contact. The persecution that he and his cast underwent was part of an effort to preserve and protect a deeply rooted libidinal mode. Thus, the irony for him was that he was trying to eliminate pornography but his tormentors wanted to maintain it. Any attempt to repress direct, open expression of sexual emotions was simply an effort to construct a deeply satis-

fying illicit sense of pleasure, the public manifestation of which was violence and the desire to erase other lives. Freud's psychoanalytic reform had begun as a question of individual therapy. McClure, and those working in his vein, saw the roots of social reform in the confrontation with the process by which desire was deflected into public institutions and their actions.

Another, more immediate explanation for Lynch's unusual intervention into local court proceedings can be found in state politics. State Attorney General Lynch faced a difficult reelection challenge. He opposed Proposition 16, the initiative sponsored by Mothers United for a Clean Society on the November ballot, because he felt it was bad law to allow no distinctions between different types of expression or to vest private advocacy groups with special powers to force prosecution. This was politically a difficult and dangerous position for him to take, however justified it was as a defense of the autonomy of law. Lynch's political base had been the San Francisco Irish Catholic community, and Lynch traditionally had been close to the church hierarchy, which was strongly supportive of the measure. His prosecution of *The Beard* cases demonstrated that his opposition to Proposition 16 was pragmatic rather than philosophical. One could be opposed to the measure and still be tough on the issue. Indeed, his unprecedented argument that representation should be equated with actual acts was an attempt to increase the severity of charges and punishments meted out to violators of antiobscenity laws. His stand on *The Beard* was one element in a successful reelection drive. Democrat Lynch was one of two Democratic statewide constitutional officers to survive the Republican sweep accompanying Ronald Reagan's election as governor.

Proposition 16 failed, with 57 percent opposed. Its defeat was not surprising. No candidate for state constitutional office, including Reagan, endorsed the measure, and major metropolitan newspapers opposed it. Given the extent of condemnation, the size of the yes vote might be surprising. In a manner similar to the Everts verdict, the vote on Proposition 16 revealed a split in the electorate. Even a poorly drafted obvious grab for power could get the

assent of 43 percent of the voters. The pattern of yes votes revealed that the conflict between liberal and conservative cultural identifications was assuming a geographic manifestation. Orange County was the only well-populated county where Proposition 16 received a majority, though only a bare 50.52 percent of the vote. Proposition 16 did most poorly in the San Francisco Bay Area and Los Angeles urban cores, gaining only 31 percent of the vote in San Francisco, 34 percent in the city of Los Angeles, and 27 percent in Oakland. The proposition did best in outlying suburban districts of Contra Costa, Alameda, Santa Clara, Ventura, and Los Angeles counties. Yet, as in Orange County, the proposition still only barely gained a majority of votes in those districts. Similar vote patterns appeared in San Diego County. The proposition failed in the central city, gaining 39 percent, but carried the surrounding assembly districts. A gulf, both political and cultural in nature, between core cities and the newer suburban ring began to reveal itself.[42]

Still a defeat is a defeat. The measure's failure sent a message to politicians that a once-powerful constituency had less public support than it claimed. Less than three weeks after the election, the San Francisco Police Department arrested three persons from two bookstores for selling Lenore Kandel's book of verse *The Love Book*. James Schevill, director of the San Francisco Poetry Center, organized a read-in at San Francisco City Hall. The publicity surrounding the protests led Police Chief Thomas Cahill to instruct the Juvenile Bureau to stop responding to complaints about obscene books.[43] As police departments in other cities followed suit, the practical power of the Legion of Decency and similar organizations faded.

The Lure of Autonomy

One defense against censorship was to challenge the competence of those outside the profession to sit in judgment on art and poetry. Stan Brakhage,

writing to the district attorney's office in support of Michael McClure after his arrest for *The Beard* production in San Francisco, observed,

> I do not know how anyone can assume to be an 'authority' on aesthetics: but I think I can safely hope you are an authority on Justice and, as such, will look for the opinion of those who have devoted their attention to 'literature' and, more specifically, the poetry of living men as much as you undoubtedly have to the questions of law and that you will value these opinions in your handling of the censorship charge against Michael McClure's 'The Beard.'

Brakhage's opening sentence reveals reluctance to assert an autonomous realm for aesthetics or literature. He qualified the standing of the arts through the use of quotation marks, while he capitalized justice in recognition of its unquestioned, unchallenged authority and power. The tentative argument and the shift in position within the letter are evidence of a struggle between two subjective positions. An older view of the artist, organized around the equivalence of freedom, irrationality, and identification with the cosmos, yielded to a concept of the artist as a professional, as a master of specialized knowledge and techniques. "A poem requires," Brakhage continued, "as experienced a reader as does a legal document (and it is, surely, this general lack of experience with/of the true nature of poetry in our society that does get works of art hauled into court on charges of 'obscenity,' etcetera, when and while the truly 'obscene' ((Lat. def.: 'bad taste')) is freely available everywhere in the culture-at-large)." Six years earlier Brakhage had been the victim of legal action for his film on natural childbirth *Water Moving Earth*. Moving away from the once motivating sense of art moving through all of life and connecting the diverse forms of creativity, Brakhage asserted a lawful power for the opinions of those who devoted their careers to aesthetic production so that the autonomy of art might be fully equivalent to the autonomy of the law.

Michael McClure is one of the poets who has given me the most of what I shall here call "The Justice of The Senses" . . . that is, articulation of sense experience—a language thru which the sense-experience of men may be shared and, thereby, govern each his relationship to any other as surely as laws do presume to govern us all . . . "The Beard," thus, is itself the very center of the ideals of law in that it permits a man who has carefully read it, and/or fully experienced it as a play, to govern himself and to be just in his relationship with any other.[44]

If the rule of law provided a concept of relationships taken outside of arbitrary whim or chance, then interpretation of signification could not be left to the average person. Obscenity laws assumed for average citizens insights and capabilities they lacked. Avant-garde artists with dreams of a cultural renaissance awakening the suppressed creative instincts of the entire population had to accept, indeed promote, a barrier between themselves and the nonspecialist if they wanted to be left alone to work. Creative people could imagine themselves as powerful or as elite, but not safely as both together. Once they claimed to have a special role within a democratic society, they opened themselves to the vicissitudes of politics.

After hearings in 1967, the California State Supreme Court dismissed without comment all charges stemming from the 1966 arrests of Michael McClure and his cast in *The Beard*.[45] The notoriety surrounding the play led to productions in New York in 1967 and London in 1968, publication of a mass-market paperback edition of the play, and an offer from a Hollywood producer to make a motion picture of the play.[46] In November 1967 an unauthorized student production at California State College, Fullerton, unleashed a new wave of fury against McClure and the play. The state senate demanded that the State College Board of Trustees initiate disciplinary action against the profes-

sors and students involved in the production and then passed legislation to make it a felony offense to simulate sexual acts in any stage or motion picture production.[47] The editors of the *Orange County Register* pointed out that academic and artistic freedom were not unlimited. Those who "really want freedom" to present their ideas without political hindrance "will get out of the political school system. If they accept the tax handouts, political dole, they also must accept the political control. They can't have it both ways."[48] The editors of the *Anaheim Bulletin* agreed; the taxpayer had brought the controversy on by voting bonds to expand the state college system. Without government support, "those twisted souls would have had to buy their own lumber, bricks and mortar for the stage that exhibited their indecencies. . . . Friends, we have a bad system. Tax-supported colleges create a sanctuary for intellectual parasites. True, the marketplace theater, and perhaps some private-college theaters, have the same foulness in them. But at least, in these cases, the God-fearing man can refrain from helping that which he hates."[49]

A tempest in a teapot in the only populous county in which Proposition 16 had passed. Even in Orange County, balancing the respective claims of free speech and moral standards led to division rather than consensus. The response of the county's political leadership to an unadvertised amateur theater production seen by less than two hundred people can help us locate the beginnings of a shift in the viewpoint of social conservatives on the subject of culture. If conservatives could not rally a majority of the state's voters for the maintenance of a single cultural standard, they could use the power of the purse as a lever over artistic production. At the point at which an open interpretation of free speech seemed to have achieved the dominant position in the United States, battle lines were redrawing. Political organizing began an effort to reverse the judicial and legislative changes, endorsed by a majority of voters, that occurred in the 1960s. In those efforts, cultural policy was more a symbolic than substantive issue, but for conservatives as early as 1967, government funding for the arts, whether it took place through direct grants or

through college training, helped define what they believed was wrong with the United States and, therefore, their differences from their opponents. The Fullerton episode linked three issues into an emotionally volatile mix: artistic freedom and adolescent rebellion appeared to be the result of wasteful government spending. Restoration of moral virtue and social stability depended upon ending subsidies for those who were irresponsible. Conservatives, their power sharply curtailed by legislative and judicial defeats, understood earlier and more clearly than their liberal or radical opponents that political organization could overcome the limitations of minority status. Against a unified moral absolute determined to use political contests to impose minority standards upon the majority stood a weak vision of society divided into interlinking but formally autonomous spheres of practice, with each institutional milieu policing its own activities.

State Senator James Whetmore, who represented the county, introduced legislation to define precisely the limits and responsibilities of "academic freedom." He prefaced his bill with a statement that no publicly funded activities could offend or insult the mores and values of the "average citizen." The purpose of the state system of higher education was to teach the young basic skills they would need to function as productive citizens or to perform basic research that administrators deemed valuable for pursuit of knowledge or improvement of the state economy.[50] The thrust of Whetmore's bill was that public education should not be concerned with personal enrichment. Education was an investment to be judged by its practical, primarily economic, returns. The *Los Angeles Times*, in an editorial opposing Whetmore's bill, commented on the history of the controversy. "*The Beard*," the editorial began, "can hardly be said even to pretend to any redeeming social or literary significance." After warning faculty and administrators in state-funded schools that academic freedom depended upon responsibility, the editorial writers continued, "the foolishness of one man in the drama department at Fullerton should not be any excuse for a wholesale attack on the college system." Stricter man-

agement in the future would prevent incursions into a system better administered by those who know the problems of schools on a daily basis.[51]

The distinction in the reaction of the editors of the *Los Angeles Times* to the Kienholz and McClure controversies bears further consideration. Schools, like museums, were public trusts. They had a responsibility to impose professional management practices upon their organizations or else they increased the risk of having unqualified outsiders usurp direction and damage the institution. The McClure controversy developed because faculty and administrators had failed to provide adequate oversight to student productions. The *Times*'s condemnation of *The Beard* was not in contradiction with its support the year before of the Kienholz exhibition at the county museum, for the unstated message of both editorial positions was that professional responsibility was the precondition for the exercise of free speech.

The Fullerton episode haunted the planned Los Angeles production of *The Beard*. In January 1968, four days before the premiere, the Los Angeles Police Commission, on a three-to-two vote, withdrew the license to operate for the theater in Hollywood where the play was scheduled to open. The producers decided to proceed anyway, arguing that the decision was discriminatory. Robert Dornan, then a newsman for KHJ-TV, elected to Congress in 1970, covered the arrests on the opening night. The aired segment began with Dornan accosting McClure and challenging him, "Are you proud of the piece of garbage we just saw?" McClure shouted back, "You're a faggot and a creep!" and challenged Dornan to go outside and fight. In front of the theater, a group of protestors assaulted McClure and punched him in the eye for the benefit of television cameras. Instead of debate, a carnival was staged for the media and its personalities with political ambitions.[52] With encouragement from the *Los Angeles Times*, the police arrested the cast and author each night for two weeks running, until a federal judge issued an injunction against continued police harassment. McClure decided that he would never again subject himself to a confrontation with the state over censorship. "I simply

have to construct a cabinet in my mind for that material," he said in 1969, "and keep it separate from what I am doing."[53]

The continuing controversy over *The Beard* gave those with "serious" artistic ambitions a mixed message: if they wanted to avoid future problems with the law, they should retreat into the obscurity of the experts, but if they relied on public funding, there might well be political tests applied to their content. The ideal of a society constituted by autonomous, self-regulating professional bodies was itself only an imaginary construction and did not represent some natural development of social evolution. If financial contributors always have the right to withhold their funds when they do not like how those funds are spent, there could be professional autonomy only if each profession were completely financially independent. Autonomy thus was a transitional phase, because the haven institutions offered was conditional. Ultimately, all institutions were subject to public scrutiny and control, even if those controls were seldom exercised. The relationship of institutions to society as a whole was fundamentally political, but the ideology of professional autonomy attempted to negate that reality by constructing an imaginary locus for freedom in technical competence and disinterested pursuit of truth.

Despite the provisional character of their victories, the challenges that artists and poets made against censorship laws were significant. Prior to the mid-1960s, public discussion of sexuality had been difficult. Abortion, birth control, sexual preference, rape, or child molestation were topics either ignored or discussed with circumlocutions that obscured or stereotyped the reality behind those experiences. Prominence was no protection. Even *Life* magazine had been subject to harassment: in 1938 the magazine's editors were convicted of violation of antiobscenity laws for publishing photographs of a childbirth in an article intended to educate young women on how to prepare for motherhood. The appeals court overturned the conviction, but the general situation was unpredictable and encouraged most people to refrain from

venturing into public discussions that might suddenly develop into trouble because no clear guidelines existed to demarcate clearly the boundary between frankness and obscenity.[54]

Because the arts always survive, if only through the exploration of metaphorical expression, the issues surrounding censorship of artistic expression really concerned the degree to which sexuality, gender, and aspects of intimate life—its dissatisfactions, oppressions, injustices—could be articulated in ways that would both demand and seek solutions. For a brief period in the 1960s, the issues relating to social controls over private behavior settled on the creative expressions of artists and poets, who on both symbolic and practical levels summarized the dilemmas in integrating the private and public aspects of individual lives. By the beginning of the 1970s, public debate over these dilemmas shifted to the more direct issues of abortion, equal rights for women, and gay liberation. The prelude to those practical, but imminently existential conflicts, the factor that set the stage for their emergence as critical social issues, was the much more modest symbolic issue of artistic freedom.

Equally important were the setbacks that the individuals who put themselves on the line endured. The martyrdom that Berman prophesied for those who sought public roles inevitably struck, so that those who battled for the principle of artistic integrity seldom reaped the rewards. Despite the stunning public and critical success of his one-artist exhibition at the Los Angeles County Museum of Art, Edward Kienholz found it impossible to get another one-man show in a major American museum or gallery. He was not quite sure why. He thought an explanation might be the lack of sympathy for his work in New York, since his tableaux did not fit the new orthodoxy of minimalism and postpainterly abstraction that dominated critical discussion of art after 1965. Barbara Rose, for example, in one of the few reviews Kienholz received from eastern critics, observed that the artist was too thematic, too involved in social commentary. He certainly had something to say, she wrote, and so she wondered why he chose to express himself visually instead of verbally.[55]

In 1973 Kienholz left Los Angeles and moved to Berlin under the sponsorship of the Deutscher Akademische Austauschdienst. His next one-man show in California came in 1981, fifteen years after he became a sort of celebrity. The County Museum of Art acquired *Back Seat Dodge '38* for its permanent collection in 1986, but it was one of only three tableaux from the 1950s and 1960s that remained in the United States. *Roxy's* went to the Södertälje Konstmuseum in Stockholm, *The State Hospital* to the Moderna Museet in Stockholm, *The Beanery* to the Stedelijk in Amsterdam, *The Portable War Memorial* to the Museum Ludwig in Köln, and a dozen other pieces to museums in the Netherlands, Austria, Germany, and Scandinavia. In 1976 Kienholz speculated that the art institutions were the reason Los Angeles had never quite lived up to its promise as an international art center. The artists were there, he thought, exploring and trying. But the institutions, particularly the men and women who claimed to be most interested in contemporary art, had been afraid to take risks. "The art world [is] such a funny place," he observed, expressing his resentment of the separation of art from everyday life, "because it['s] like a big balloon: you push real hard and it's flexible and elastic and resilient; so you push and push and push, and all of a sudden it goes—schwoo. It takes you inside, and you can't get out."[56]

Connor Everts had not been prepared for how little his obscenity trial accomplished of what *he* wanted. His case brought him attention and considerable sales, but the emotional turmoil prevented him from working for nearly a year. And he was appalled by the trivialization that beset him.

> There was some person interested in pornography that wanted to come over to my studio to see some things, to buy some things, and you know, that wasn't my gig, so I was repulsed by that. Someone bought something to destroy; I think the Kinsey Institute bought something.

Even his friends failed to understand the price of being a symbol. Collectively, they all had become symbols in popular culture, but those who engaged the issue of censorship became painfully aware of their reduction. One of Everts's supporters, a museum director, told Everts, "Conner, it couldn't have happened to a better person. You had to come to grips with this censorship thing. . . . you're tough. It will just roll off your back. It won't affect you. Other persons it will really affect. It affected Wally [Berman]." Everts laughed when he recounted this story because the personal outcome of his victory had been demoralization and a series of troubles that dogged him for a decade.[57]

Chouinard fired him the day before he was acquitted. School administrators claimed that the nonrenewal of Everts's contract had "nothing whatsoever to do with the trial" and that the two occurrences were "an unfortunate coincidence," but Walt Disney had taken over the school three months earlier and was concerned about the public image of an institution connected to his name.[58] Everts found a job teaching at California State University, Long Beach, where the next disaster in his life sprang upon him to reveal the degree to which artists had become a symbol of the divisions sundering the country over issues totally unrelated to art. In January 1966 two plainclothes officers of the Long Beach Police Department entered a bar near campus. Saying they had come to beat up some hippies, they demanded that younger-looking customers show their identifications. When Everts asked to see proof that they were police officers, they arrested him. On the way to the police station for booking, they beat him so severely that he lost nerve feeling in his right hand and he was unable to work with any degree of control for three years. Photographs taken by Everts's doctor showed his legs blackened from bruises from below his knees to his buttocks, as was the area between his shoulder blades.[59]

His first reaction to the incident was fear that police knowing about his obscenity trial had targeted him. He then decided that the event probably happened because the Vietnam War had polarized the United States into those who accepted authority and those who challenged it. Artists and stu-

dents were assumed to be against authority, and in Everts's case, the assumption was correct. The United States attorney's office in Los Angeles brought charges against the two policemen for violations of Everts's civil rights. Nine of the twelve jurors voted for conviction of the officers, but the judge ruled a mistrial in December 1968. During the trial against the two policemen, Everts's studio was broken into and trashed. More than a year's work was destroyed. Graffiti was scrawled on the studio walls warning him that "next time" he would be killed.

The Long Beach events provoked a crisis in Everts's life:

You always question, as I questioned with the misunderstanding of my work; I questioned myself. Then when nothing happened in relationship to the trial [against the two policemen], then I questioned that I perhaps was in some way guilty. I had in the past done all of this [subject of] man's inhumanity to man, sociological issues. Since nearly all of society had come down so heavily on me, I started to question my own work. And none of my work had changed anything. My work was becoming more and more misunderstood. I was trying to find some kind of sense, for myself, in terms of my own relationship to these things. I think [because of this] my work started to become more abstract. The elements started flattening out. The figure was more abstracted.[60]

Everts's work turned to the exploration of ugliness and the difficulty of reading messages.

It was very much about mark and then the erasure of the mark and then the reading of the mark and then sometimes reinforcing it. . . . It was almost like a conversation with myself, where I would make the mark and it would reflect. . . . I was also taken back in terms of my longshoring days, and annotation—the messages that happened to be on the boxes. That was a code I didn't understand, because I didn't understand the language. . . . [It] maintains a certain considered ugliness.[61] (fig. 49)

49. Connor Everts, *Graffiti*, lithograph, 1979. Courtesy of the artist.
 Photo: Katherine P. Smith.

In this new work, Everts stood apart self-consciously from the bright colors, simple lines, and ingenious new materials developed by the most critically and commercially successful Los Angeles artists. Everts's sense of alienation from the artistic community came to a head when Henry Seldis committed suicide in 1978. Everts was the last person to see Seldis alive and felt guilty that he hadn't been able to see what was to come in a matter of hours. But the lesson that he drew from the incident may seem surprising and exaggerated: the art "community" in Los Angeles no longer existed. Seldis had been an important man in the arts for a decade, and when he died, nobody knew, nobody came to the funeral, nobody cared. It was as if Seldis had never existed. As Everts related the story of Seldis's death, he connected it to his own life history because the ultimate censorship was not assassination as he had thought in 1964 but forgetting the memory of an associate. The art community had died when it joined the pursuit of glamour and money. He had not sacrificed several years of his life to the fight against censorship, he thought, just so artists could make a lot of money. He had been after something very different: an egalitarian society where men and women could express themselves in painting, poetry, music, not to make money, but to communicate their concerns and their dreams. He had thought the end of censorship would expand the arts in America, and the bitterest outcome for him was a sense that the arts had contracted instead. He left California to teach at the Cranbrook Academy in Michigan because he could not stand to watch the celebrity-posturing he felt had devoured Los Angeles artists. He wondered why he had spent so many years struggling for artistic freedom, why he hadn't simply closed his show of *Studies in Desperation* when the police asked him. He had preserved his personal integrity, but he had thought he was fighting for the integrity of his society.[62]

Everts, like many of his colleagues, found himself split between competing visions of citizenship and professionalism. By winning autonomy he had lost

his claim to influence society through his art, though he may have won without yet knowing it the ability to create social texture with his art. The events surrounding the decline of censorship in California do not support analyses that argue that mass production of goods and communications required a completely open market for intellectual values, or that the realm of art supported the volatility and dynamism of consumer capitalism by expanding the sphere of private value to match the inflation of products.[63] Leaders of the movement to maintain a reified system of cultural values and the strict control of personal behavior came from sectors of the state most closely identified with real estate development and entrepreneurial enterprise. Support for free speech, instead, came from the increasing professionalization of disciplines that had their most secure home in public institutions such as the university or the museum.

Behind artists and poets fighting for the right of creative expression stood another, developing social reality, that of institutions seeking autonomy. The vision was pluralist and thus more capable of preserving a variety of opinions within a single framework. Yet pluralism did not necessarily mean greater freedom, as Everts had imagined. Within a discipline, even more effective mechanisms could exist to ensure conformity to standards and principles. But first, institutions had to gain the right not to be judged by people outside the group using standards developed for other purposes. "Free speech" meant both expanding the scope of communication and limiting legitimation for who could make a meaningful comment upon culture.

It should no longer seem paradoxical that two apparently opposing conceptions of the role of the arts—professional autonomy and the socially redemptive character attributed to the arts—were closely interrelated. Initially the two conceptions coexisted symbiotically. As artists and poets asserted an independent critical role, greater influence and awards adhered to institutions connected to the arts. Increasing wealth demanded stricter forms of management, freedom from capricious interference by other elements of society. A movement that began with a universal claim for the powers of aesthetics

ended with an institutional and subjective reform that protected those who worked in the arts from their fellow citizens.

By the end of the 1960s, as autonomy achieved a tentative position, the symbolic issue of free speech gave way to issues of immediate, direct concern to the lives of men and women—abortion, women's equality, gay liberation. But the symbolic aspect through which American society tentatively approached the discussion of gender issues remained present, continuing to shape discussion and perhaps the experience of sexuality. The experience of artists and poets in the years following World War II had led to the development of a discourse particularly relevant to the confluence of subjective, institutional, and political conflicts troubling United States society in the 1960s. Just as the mid-century avant-garde was fading away within the world of the arts, its ideas and rhetorical forms were adopted by a new generation of rebels who found in the imagination a basis for seceding from the demands of constituted authority. Against the social machine arose an opposition that found in biology a broader stance with which to confront a world apparently existing in a state of permanent war.

12

The Vietnam War and the Fragmentation of American Identity

Crises of Public and Private Foundation Myths

The theory of repression provided artists and poets with a metaphor that shaped their reaction to the Vietnam War. As they defined the structure of American society through a combination of psychoanalytic and mythopoetic theory, they proposed that the root causes of violence lay in a primal scene in American history that had been repressed in public culture but continued to find expression both in everyday life and the affairs of state. "From a revolutionary viewpoint," Lawrence Ferlinghetti (b. ca. 1919) declared in 1969, "it *is* time when shock treatment is necessary!" Gary Snyder (b. 1930) found in an image of the controlled burning of surface shrub a model for renewing the soul by clearing away old dry thoughts and feelings and bringing the raw ground to the surface: "I would like, / with a sense of helpful order, / with respect for laws / of nature, / to help my land / with a burn. a hot clean / burn."[1]

Rather than present rational argument, protest based in this view aimed to exteriorize interior conflict so that each person could confront and overcome the forces that coerced identification with the power of the state. Robert Duncan argued that "the urge to shed our individual responsibility and to become a person of the Nation" provided the foundation to the American concept and practice of democracy.[2] Poets had to awaken their fellow citizens to the crimes they unconsciously committed as citizens through their representatives in government. The slogan "Make love, not war" fit into a definition

of American military policy as an outgrowth of repressed sexual drives. Artists and poets in the 1960s helped shatter an illusion of national consensus through a two-fold realignment of categories of the unspeakable: first, a projection of sexual experience into public discourse; second, acknowledgment of the violence upon which United States society had been built.

"Everywhere living productive forms in the evolution of forms fail, weaken, or grow monstrous, destroying the terms of their existence," Robert Duncan observed in the introduction to his 1968 collection of poems, *Bending the Bow*. "We cannot rid ourselves of the form to which we now belong," he continued. With the Vietnam War the American republic had entered the last days of its history because the fictional nature of its founding ideals had become clear. Since death was prelude to rebirth, the duty of poets was to prepare themselves and their readers for the transformation that was underway.[3] In another essay Duncan argued that the first step to rebirth was acknowledging crimes one does not want to face.

> This is the importance we find in tragedy, where Man comes to know the depths of what he is doing, his righteousness is stripped bare. The bomber overlooks the reality he inflicts—he flies high as the politician who directs his action likes to fly high above the reality of his orders. The State Department agent plays, as if it were a game, moves and countermoves in the name of peace and order, of "honor," that involve unrealities of burning cities and countrysides laid waste. The lies of Johnson and his régime are terms of the language of a grand psychopathology of daily political life that belongs to their refusal to face the facts of what they are doing. . . . The language of this history is to be read as the language of a psychotic episode in which there is no recognition of the madness.[4]

Political protest aimed to force national leadership to address the effects of their actions and not to escape into the abstractions of cause or the teleologies of rational planning. (Hence the importance of the mocking, macabre chant, "Hey, hey, LBJ! How many kids did you kill today?" rather than appeals to

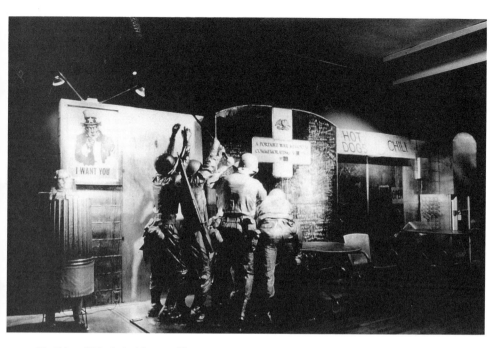

50. Edward Kienholz, *The Portable War Memorial*, mixed media, 1968.
The Museum Ludwig, Museen der Stadt Köln.

humanitarian principles, universal justice, or a variation of patriotic senti-
ment.) Frank confession of the hidden effects of war would wipe away self-
righteousness and force each person to face the costs of their desires for power
over others. The ideology of nationalism was particularly vicious because it
absolved individuals of personal responsibility by imposing upon them an
obligation of conformity to group consensus. To shatter the repressive dy-
namics of nationalism, each individual had to awaken his or her own private
conscience through a deliberate act of separation. Identity had to relocate
from the abstraction of American patriotism to other ideals more rooted in
immediate personal connections that could as easily carry hopes and dreams
of a good life.

Psychological separation required rewriting the foundation myths of the
United States as a nation. Edward Kienholz's *The Portable War Memorial*,
"suitable for any future war," (fig. 50) was the centerpiece of the San Fran-

cisco Museum of Modern Art's 1968 summer exhibit. The source of its imagery was unmistakable to a generation raised on the mythology of World War II as a holy crusade. Kienholz patterned a set of figures after Joseph Rosenthal's famous photograph of marines raising the United States flag over Iwo Jima. But Kienholz's GIs raise the flag over a patio table while a recording of Kate Smith bellows a strained, static-crackling version of "God Bless America." In a corner of the tableau, next to the barbecue stand, is the political heart of the piece: a small bas-relief of an African slave in chains struggling against the suburban utopia that was the ultimate historical product of conquest and exploitation. The small figure dramatizes the force of repression that had screened out, but could not completely eradicate, the origins of American plenty.[5]

The original crime that Kienholz, among many, believed that the war in Indochina revealed was a long history of racial domination and violence. Michael McClure's long poem *Poison Wheat* described American history as a chronicle of continuous war, beginning with the genocide of the Native American peoples during the westward expansion. He ridiculed one of the most apparently peaceful icons of the United States, the sheaf of wheat. American productivity, however bountiful, was poisoned by the blood of victims and the fears of retribution that prolonged the nation's dependency upon military aggression. His volume outlined a program for new economic and foreign policies that could emerge from acknowledgment of past crimes and contrition. With a perhaps quixotic belief in the power of poetry, McClure privately published his poem and sent copies to 576 prominent journalists and politicians. Not one responded, and McClure began to consider whether acts of violence might ultimately be necessary to sabotage the military machine.[6]

Conquest instead of discovery; slavery instead of enterprise; a funeral pyre of indigenous peoples instead of breadbasket of the world or arsenal of democracy; atomic bombs on Hiroshima and Nagasaki instead of the "good war": modal events of American history assumed new, ironical meanings that

bluntly stated that the American state was simply an historical, hence arbitrary, fact, that it had never been the agency of providential redemption. Avant-garde poets and artists entered into political debate over the war with language calculated to insult rather than convince. Shock therapy meant that audiences would know instantly where they stood when facing art and poetry of this nature. Gary Snyder, loosely translating the Tang Dynasty hermit poet Han-Shan, who abandoned society to live on a mountaintop, succinctly stated the developing polarization that his generation desired:

> My heart's not the same as yours.
> If your heart was like mine
> You'd get it and be right here.[7]

Snyder called the shattering of myths of social unity the revolt of the "back country." His phrase meant first and foremost the explosion of unconscious knowledge into consciousness, but he also celebrated the refusal of despised class, sexual, racial, and cultural groups to accept silence, to accept the demeaning status of "minorities."

Linking sexuality and violence in a critique of American psychopolitics preexisted escalation of the Vietnam War, which served as the instance that confirmed already well-developed beliefs that the United States polity was irredeemably brutal. "The same war / continues," Denise Levertov (b. 1923) wrote in 1966. "We have breathed the grits of it in, all our lives / our lungs are pocked with it / the mucous membrane of our dreams / coated with it, the imagination / filmed over with the gray filth of it." Wally Hedrick's early anti–Vietnam War paintings (fig. 51) assaulted the United States government's East Asian allies with sexual innuendo and a stark image that equated American foreign policy with rape. "We weren't really there overtly," he recalled about his early paintings on Vietnam, "but we were there. I was starting to hear things on the news broadcasts, 'We're sending 20 advisers.' And I said, 'Uh oh, here we go.' But see, I'd only been out of the Army five years, and

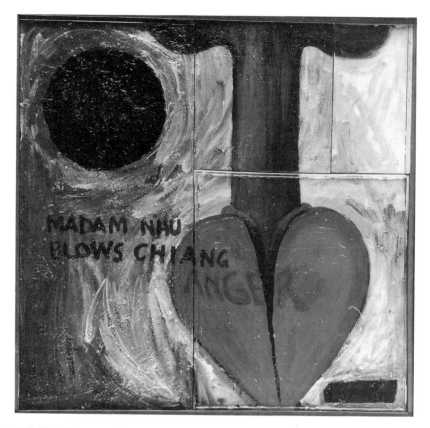

51. Wally Hedrick, *Anger,* oil on canvas, 1959. Private collection.
Courtesy of the Gallery Paule Anglim, San Francisco.

somehow I don't think I knew the difference between Korea and Vietnam. To
me it was all the same. All I knew was we were there and we were going to
get screwed again."[8] His motif of ignorance functioned to intensify the guilt
of those who failed to protest the war: one did not need to *know* the details.
Awareness of the evil in American society should be in one's bones. Those
who didn't "get it" had a problem: they were still colonized by the attractions
of living in the most powerful and power-hungry nation in history. The un-
dercurrent of self-mockery in Hedrick's memory was part of a struggle to
burn away the complicity that arose from simply being born in the United
States.

Ben Talbert's *The Ace* (figs. 52 and 53) presented a similar critique in a humorous self-portrait that dramatized the satisfactions a military society gave the American male. The work drew on his adolescent ambitions to become a jet fighter pilot. After graduating from high school in suburban Los Angeles County, Talbert (1933–1974) entered Texas A&M College to pursue aviation studies. He dropped out after the first year and was drafted into the army. Actual military experience soured his romantic vision of the warrior life. On the completion of his service, he returned home to enroll at UCLA, where he majored first in aeronautical engineering but then switched to real estate courses in the School of Business Administration. Two years later in 1959, after marrying his high school sweetheart, he dropped out of school once and for all. He pursued his calling as an artist in the impoverished beach community of Venice, where he was one of the most personable and frequently photographed beat characters of southern California (fig. 54).

Talbert had no training in the arts whatsoever. His work developed from his love of comic books, hand-decorated hot rods, surfboards, and pornography. Talbert developed his own private comic strip, "Dick Racy," a parody of the popular fictional detective Dick Tracy. This series of work allowed him to comment on the relation of crime fantasies and repression. Filled with non sequiturs, false leads, and witty delight in Racy's disregard for the law to nail his man or woman, Talbert's version strung together exaggerated sexual conquests with the violent deaths of Racy's enemies. Talbert had three one-artist exhibits at the prestigious Dwan Gallery between 1958 and 1963, but most of his work remained unseen because of its explicit sexuality. His reputation during his lifetime stemmed almost entirely from personal contact. People traveled to his house to look at almost legendary works they had heard about only by word of mouth.[9]

The Ace was the single work by which he was best known during his lifetime, in part because it was one of the few that could be reproduced without publishers worrying if they might become liable for prosecution under then existing antiobscenity laws. Its popularity among his contemporaries also

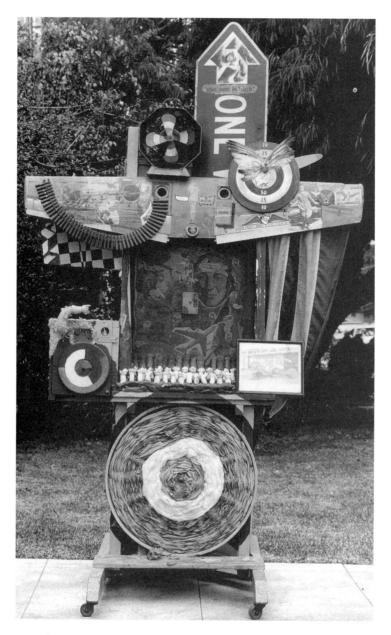

52. Ben Talbert, *The Ace*, front view, mixed media, ca. 1962. Courtesy of Hal Glicksman.
Photo: Hal Glicksman.

53. Ben Talbert, *The Ace*, details. Photo: Hal Glicksman.

54. Wallace Berman, photograph of Ben Talbert, ca. 1960. Wallace Berman
papers, Archives of American Art, Smithsonian Institution.

stemmed from the piece's clear message about militarism and the relation of sexuality to violence. The work reduced imagery drawn from aviation to cartoonlike qualities that made explicit the sexual implications in the design of military hardware. The frame for the work is an artist's easel on which Talbert hung a four-foot-long pair of drone plane wings. Instead of a painting he left a vacant frame into which he dropped a collage about the flying aces of World War I. Directly beneath the pilots he created a collage of doll hands reaching up, in adulation of the flyers. The assemblage contains a variety of iconographic objects, including a cutout of Icarus, a replica of the gum Spencer Tracy put on the aircraft he flew in the World War II action film *Test Pilot*, and two miniature bombsights shaped like erect penises.

Male fascination with militarism, Talbert seemed to be saying, came from the armed services being one of the few institutions in American life where sexual fantasies were openly indulged. The work's delight in its imagery makes it difficult to distinguish glorification of masculine obsessions from a critique of libidinal identification with weapons of destruction. The piece was a particularly honest personal reaction to the opportunities that presented themselves to Talbert when he was a young man. The reverse side of *The Ace* shows bombs raining down on children, sketched with a lighthearted if grisly humor that captured the distanced, casual attitude that air war can encourage toward its victims.

The piece's humor echoes the self-mockery in Wally Hedrick's recollections, but *The Ace* allows us to see more clearly another function to the risqué humor generally adopted by the young men of this generation in their confrontation with authority. Talbert's mockery repudiated the military culture, but without losing the insight that the strength of the American military lay in the satisfactions it provided to men's desires to exercise power over others, an appeal that could be overcome only by providing alternative ways of gratifying those needs. Without the juxtaposition of appeal and repudiation, the critique in Talbert's work would have no substance, nor posit a solution. Un-

covering fantasies of destruction submerged in his self-construction as a hero functioned to distance Talbert from his point of origin and affirm the choice he made to abandon participation in a system based on militarism.

The strategy of mockery contrasts sharply with Kenneth Rexroth's elegiac attitude developed in "The Phoenix and the Tortoise." The older poet's World War II–inspired poetry imagined sexuality as a doorway to cosmic process, as a way of escaping through one's inner nature from the controls of social formation. For Talbert, sexuality was ambivalent. "Make love, not war" promised to break the hold of war over the male imagination, but his work also presented search for sexual gratification as the glue that held together social authority. Talbert understood the nature of sexuality in a more psychologized, power-conscious way. Sexuality was a projection of the ego in its power-seeking aspect. Its pleasures came from the exercise of control over foreign bodies through mastery of their operation and imposing one's own will upon them. The object of pleasure could be a car or an airplane or another human body. The romantic imagination had brought the vertiginous truth closer to the surface that the reduction of women into objects of sexual pleasure was not a question of individual character, or a choice between good and evil, but the prime case-in-point in a structure of personality development in a society in which love of power had been the necessary motivating factor since Europeans had embarked on their conquest of the "new world."

The valuable insights in works like *The Ace* depended upon the use of stereotypes drawn from popular culture, but with their psychosexual subtext amplified to reveal the way they covertly expressed repressed desires. Creative work objectified a subjective response to social imperatives, yet without necessarily harmonizing the inner lives of artists who remained opposed to the society in which they lived. Stereotypes helped bridge this gulf, not by creating a harmony, but by dramatizing the interior battle between continuity and innovation. Social criticism blended with self-criticism, although that self-reformative aspect was often hidden behind externalized rage at those not

sharing in the act of purging inner desires that the critic had determined were shameful. The fury accompanying so much social comment in the 1960s was part of the exorcism. Brutal exposition of the problem burned shared responsibility in crime to cinders in the trial of self-liberation.

Stereotypical images strengthened the transformation because they appeared to be "natural" ways of thinking about the self. A strength of the counterculture lay in its merger of opposition with utterly traditional, even conservative images of self. This process was true for both men and women. "The women in the hippie community are very, very female," Maggie Gaskin, a college dropout in her mid-twenties, told an interviewer with some pride. "There are a lot of children around that are there because they're wanted, and the women are going back and doing very feminine things, like weaving and cooking with a lot of pride, doing it as a woman-thing." Her images echo Kerouac's vision of Christine Monahan in *The Dharma Bums*, but Gaskin completed her statement with a conclusion that went beyond Kerouac: "The hippie girls are very, very feminine, but they're very competent too." Gaskin argued that countercultural women escaped the imprisonment in the home that was the lot of the stereotyped traditional housewife. Hippie women developed their workplace skills, as well. When their husbands or boyfriends tired of working, the women in the Haight went out to work and their resourcefulness made them good employees capable of mastering the changing work environment. Gaskin presented an ideal self-representation, in which the contradictions involved whenever people live or work together barely surfaced. The themes of cooperation, self-control, and independence defined her life and those of her friends. Knowledgeable in the skills of house and work, these were women able to stand on their own and provide decent, comfortable lives for themselves and their children.[10]

The poet Lenore Kandel, who was arrested in 1967 for violating anti-obscenity laws with her volume *The Love Book*, stressed that clear-cut gender differences were important for women to like themselves as women, to value and trust the skills that women had accomplished over the centuries.

A woman's job is feeding her man, taking care of those about her. In her way, radiating the feeling of warmth. . . . A woman takes care of the washing and putting the kids to bed. . . . Some women are painters, some women are writers, some women are dancers, and if they're really that, they're really that. And then you have to learn to make those things work. I'm a writer, but I'm a woman. And I wouldn't sacrifice the woman part of it for the writing part of it. . . . I spend a lot of time in the kitchen, I feed a lot of people all the time. I'm a good cook. . . . Here I was with that hysterical [*Love Book*] trial and reporters up my nose, and there I was with a bundle of wet laundry too, because that had to be done.[11]

Kandel thought women needed men who took pride in masculine tasks: "Hunting a deer. Protecting the house. Taking care of enemies, if there be such."[12] A man should be able to wash dishes or change diapers, but those were not his "primary functions." These were fantastic images, but they were part of a transition that resisted a reduction of femininity to merely physical sexual characteristics. Indeed, Kandel's primary complaint was that contemporary relationships forced women to concentrate on their sexual attractiveness rather than developing a broad range of skills appropriate to a life a woman wanted to lead.

In her poem "The Pigs for Circe in May," Joanne Kyger praised the power of the sorceress in the *Odyssey* who could turn men into pigs, untidy domesticated animals that think they are wild but need a mistress to keep their sensual needs satisfied. Circe has done nothing more than make clear what the inner nature of Odysseus's sailors had always been because they were men. She put them into a position where they could follow their instincts without hurting anybody, always a danger with young males. The implication of this poem was that the homemaker was the real magician, not the adventurer or the poet, whose fables and songs served to pass the evenings at the homestead. Woman as mistress of the loom was the source of myth and meaning, not men who jabbered about being explorers of the unknown but wanted the

comfort of a home. In an earlier poem, "Pan as the Son of Penelope," written while she was a student in Robert Duncan's poetry workshop at the San Francisco Public Library, Kyger presented the possibility that Penelope was the author of the *Odyssey*, composing it as she wove day after day, keeping the men entertained by "concocting [Odysseus's] adventure bringing / the misfortunes to him" as a warning to men who took stereotypes too seriously.[13] Utilizing the stereotypes of American culture, Kyger, Kandel, and Gaskin began to redefine the nature of female power in specifically gendered terms, a necessary step for the emergence of "women's consciousness" to replace the diffuse degendered sense of mystical power that we saw earlier in the self-representations of Joan Brown and Jay DeFeo.

If stereotypes proved necessary for motivating individual innovation, they acted as limits as well. Negative and positive poles were inseparable. Talbert's pornographic vision of women as inherently willing victims, or the lingering patriarchal ethos of the counterculture, were not regrettable vestigial remains to be sloughed off in time as a more basic libertarian message took hold. The negative features were essential to the total message conveyed and operated as inner contradictions that ultimately fissured movements of the 1960s. In the next two chapters, we will examine how Gary Snyder and Robert Duncan, two poets who established their national reputations in the course of the Vietnam War, confronted the linking of progressive and regressive materials in the countercultural imagination. Their work presented very distinctive strategies as to how to make "poems" effective in both individual and public reform. Snyder, Zen adept and leader in the back-to-the-land movement, became one of the most popular American poets of the 1960s. He was a visible, public figure who, combining innovation with stereotypes, attempted to present the counterculture as a rational way of being and a force for social responsibility. Duncan was known only to a few. Private and hermetic, he crafted a critique that suggested from a point of view internal to the avant-garde why the counterculture, despite its optimism and energy, would collapse. Snyder projected subjective division outward by inscribing boundaries between groups based

on ideology. Duncan faced inward to describe the boundaries within the self dissolving and reforming in persistent inner turmoil. These two poets presented contrasting ideas of community and the function of poetry. Snyder returned to ancient traditions to reconstitute a lost whole. He found in domestic utopia, refashioned as "tribalism," an alternative social abstraction with which to oppose nationalism. Duncan examined the constant turnings of the repressed and decided that the whole is never more than fragments, that people spent their lives constantly grasping for the phantom of what might have been. As social turmoil increased during the war's progress, their efforts to propose subjectivities that could mediate needs for structure and freedom made clear the limits of the social and subjective reforms proposed by the mid-century American avant-garde.

13 Gary Snyder on the Responsibilities of Utopia

Expanding the Boundaries of Domesticity

In 1966, while returning home working as a seaman on a petroleum tanker, Gary Snyder pondered the history of the United States and wrote

> Ah, that's America:
>> the flowery glistening oil blossom
>>> spreading on water—
>> it was so tiny, nothing, now it keeps expanding
>> all those colors,
>>>> our world
>>> opening inside outward toward us,
>> each part swelling and turning
>> who would have thought such turning[1]

The lines evoke the mystic image of the rose unfolding, symbol for the soul opening toward God as the mysteries of eternity reveal themselves to the pilgrim on the verge of enlightenment, or in a twentieth-century variant as the conscious mind learns to recognize the coded statements of the unconscious. The idea of America's specter discovered in an oil slick was an ironic statement redolent of social criticism and the inversion of national foundation myths: the image declares that the United States was a pollution, but there was hope for the future. The poison would eventually be broken up and dispersed by the sheer volume of the dark ocean upon which it sits. The United States of

the conquest was a temporary phenomenon, capable during its existence of revealing beauty in its poisons, but still one way or another, it would be absorbed back into the natural world.

Snyder's countercultural formulation grew out of a Marxian-syndicalist viewpoint that may have been a family tradition but which took shape during his undergraduate years at Reed College (1947–1952). Snyder's youthful involvement in left-wing activities was superficial, but sufficient for the United States Forest Service to fire him from his job as a ranger in 1953 when a congressional committee subpoenaed him to testify on communist activity in the forest and parks services. Barred from government employment, he went to work as a logger in the commercial timber fields of Washington and Oregon. Labor radicalism was not to be his path, but his experiences as a logger formed a key strand of his second book of poetry, *Myths and Texts*, published in 1960, a work that synthesized his studies in radical labor traditions of the western United States, Native American cultures, and Buddhism.[2]

A later poem, "Revolution in the Revolution in the Revolution," sketched the relationship of these three traditions and effectively proposed a hierarchy among them:

> If the capitalists and imperialists
> > are the exploiters, the masses are the workers.
> > > and the party
> > > is the communist.

> If civilization
> > is the exploiters, the masses is nature.
> > > and the party
> > > is the poets.

> If the abstract rational intellect
> > is the exploiters, the masses is the unconscious.
> > > and the party
> > > is the yogins.[3]

The yogin in Snyder's metaphysics is not simply a mystic passively contemplating eternity. "Yoga, from the root *Yuj* (related to the English 'yoke') means to be at work, engaged," he wrote.[4] Consistent and disciplined yogic practice unleashed the "dictatorship of the unconscious," essential to break the power of hierarchical social structures created through five centuries of imperial expansion.

Snyder first came to national attention in a fictionalized form as the hero of Jack Kerouac's 1957 novel *The Dharma Bums*, a romanticization of the time the novelist shared a cottage with Snyder in 1956. After one semester at Indiana University, Snyder abandoned graduate study in anthropology and moved to Berkeley to learn Japanese and Chinese prior to leaving for Japan, where he planned to enter a Zen monastery. When Kerouac met him, Snyder was already four years into his self-study of Buddhism. The novel's title referred to the Buddhist tradition of the *bhikku*, young men who abandoned all settled life to search for "dharma" (the path of truth understood as a continuous process of "forming and firming").[5] Kerouac found the image a positive version of the restless journeys of himself and his friends that he had described in several novels. Kerouac turned to Snyder's interpretation of Buddhism as an answer to the nihilism of Dean Moriarty's story in *On the Road*.

On its simplest level, *The Dharma Bums* reads as a "how-to" manual for the counterculture of the 1960s, accurately predicting ten years before its time dress, rituals, living arrangements, and even language that would become faddish. The novel announced that a "rucksack revolution" would sweep the United States as ever larger numbers of people refused to "subscribe to the general demand that they consume production and therefore have to work for the privilege of consuming all that crap they didn't really want anyways." Instead of producing mechanical goods, people would become artists, "go about writing poems that happen to appear in their heads for no reason" and "by strange unexpected acts keep giving visions of eternal freedom to everybody and to all living creatures."[6] Snyder, given the name of Japhy Ryder in

the novel, was a fictional model for a bohemian saint because Kerouac endowed him with the courage to persevere on his quest against the ties of the heart. For Kerouac, freedom meant having done with women, and Ryder floated along unattached to either mother or mate. Freedom was the ability to call into being a man with no ties to women other than casual sex, a man whose most important ties were with other men.[7]

Ryder "was always practicing charity," the narrator says. "In fact he taught me, and a week later I was giving him nice new undershirts I'd discovered in the Goodwill store. He'd turn right around and make me a gift of a plastic container to keep food in." He tells Kerouac's alterego in the novel, "Smith you don't realize it's a privilege to practice giving presents to others." Smith observes, "There was nothing glittery and Christmasy about it, but almost sad, and sometimes his gifts were old beat-up things but they had the charm of usefulness and sadness of his giving."[8]

Ryder's most important lesson was that it was "impossible to fall off mountains." The two climb the highest peak in the northern Sierra range. Smith cannot make it to the top and stops thirty feet below, terrified to scrabble up to the summit. Ryder, in his typically meticulous and disciplined way, finds each footstep. Arriving at the top, he lets loose a "blood-curdling yodel" that Smith describes as an emanation of the divine hidden in all men. Then Ryder runs down the difficult path at full speed safely arriving below without tripping. Ryder explains, "That's what they mean by saying, When you get to the top of a mountain keep climbing."[9] Smith interprets the event to mean that as long as one has trained for a task, boldness is a safer policy than caution in time of crisis. Action rather than words marked the most appropriate response to the challenges of life.

As the novel comes to an end, Ryder embarks for Japan, where he plans to study Zen. Snyder, with his manuscript for *Myths and Texts* completed, left California for Japan in May 1956. He had planned to leave earlier, but because of his suspected political radicalism, he had difficulty in securing a passport. He entered the First Zen Institute of America, located at the Daitoku-ji

temple in Kyoto, while he supported himself as a translator and English language teacher. Aside from one year working as a wiper on an oil tanker, Snyder lived in Japan until 1968. He made frequent trips back to the United States and small press publications of his poetry quickly sold out, but his presence in America loomed through the legendizing portrait Kerouac had crafted, a portrait that seemed confirmed by his immersion in Asian life.[10]

Snyder, however, subjected the philosophies he studied in Asia to a healthy dose of American practicality. He rejected the privileged and parasitical position organized Buddhism had in Asia. Monasteries, whether Christian or Buddhist, he observed, developed in hierarchical societies where the majority labored to support landlords, a warrior class, and religious parasites: "Institutional Buddhism has been conspicuously ready to accept or ignore the inequalities and tyrannies of whatever political system it found itself under."[11] In his Americanized form of Buddhism, everybody worked and everybody was responsible for spiritual development.

Rather than romanticize non-Western societies, Snyder proposed to examine their systems of knowledge and behavior and locate the elements that were useful to modern life. Sensible self-interest should guide cultural interaction as people let go of antiquated loyalties and narrow interpretations of the past to take the best of human inventiveness as a repertory of alternatives to current modes of behavior. Chinese, Amerindian, and Japanese lore, Snyder observed in the introduction to the 1977 reprint of his second published book of poetry, *Myths and Texts*, "are not exotica but part of our whole planetary heritage." Each culture was a storehouse of ideas and experiments in resolving human problems, some successful, many more failed. Thanks to Western technology, there existed the possibility "for the first time in human experience . . . to look in one wide gaze at all that human beings have been and done on the whole planet."[12]

The result, whatever its strengths or weaknesses as social theory, was a synthesis in which neither the European nor the non-European side was caricatured. Snyder's idea of an "international" culture drawing upon all heri-

tages was both romantic and practical. His study of Asian cultural traditions had provided a rupture for Snyder and the freedom to define himself independently of the pressures to conform to a narrow interpretation of European-American behavior. His children turned that rupture into a legacy. Born from his marriage in Japan to Masa Uehara, they, like increasing numbers of Americans, could claim equal rights to both European and non-European heritages. Once the relationship to the past extended into a relationship with the future, Snyder became a transitional figure (as we all are one way or another). The pull to Asia had begun with an artificial element to it, but once accomplished in a way that created responsibilities and ties, there was nothing particularly out of the ordinary or exotic about seeking a synthesis of what had been distinct cultures.

Snyder had been a pacifist in the 1950s, but the success of Castro's revolution in Cuba caused him to rethink his position. Revolutionary ideologies emerging from Cuba and other third world countries emphasizing moral incentives in constructing the "new man" and "new woman" prompted Snyder to think that much more was possible than individual enlightenment.[13] In his 1968 volume *The Back Country,* Snyder explained the fissures of contemporary society through an extended metaphor that he adopted from the Maoist theory of revolution succeeding through peasant uprisings engulfing corrupted urban centers. On a global political level, the wisdom of backward countries such as Vietnam and Cuba would overpower the materialism of the West and establish the basis for an equitable distribution of the world's wealth. On an ecological level, the primal truths about natural process found in the wilderness would scatter arbitrary social formations and help people return to a stable position within the world's "food web." At the same time, liberating the experiences locked in the "back country" of the mind, that is, the unconscious, would disintegrate the hold of rigid social structures as personal experience replaced abstract law as the guide for the good and the true.

Snyder made explicit aspects of New Left enthusiasm for the third world. The poverty of peasant societies wedded ecology, political strife, and the unconscious so that the challenges to American hegemony promised victory of the unconscious as well and the collapse of the imperial personality that had developed around the pursuit of power.

Snyder returned home in the autumn of 1965 to participate in antiwar activities in the San Francisco Bay Area. He designed an antiwar poster, joined in Vietnam Day Committee protests at the army induction center in Oakland, and organized Zen-meditation sit-ins at the Oakland harbor against shipments of military materiel.[14] He soon played a role as well in the developing counterculture. Snyder, Michael McClure, Allen Ginsberg, Lenore Kandel, and the Diggers organized the Human Be-in and Gathering of All the Tribes in San Francisco's Golden Gate Park on January 14, 1967. To speed the "awakening of consciousness" Snyder urged those prepared to rebel against the dominant values of United States society to take LSD. As the Jefferson Airplane played, approximately 20,000 people who attended the self-styled festival took LSD or smoked marijuana.

In 1968, after his marriage and the birth of his first child, Snyder relocated his family permanently to California. They settled first in the Bay Area, but his royalties and reading fees allowed him to buy property in the San Juan Ridge area of Nevada County, in the Sierra foothills ninety miles northeast of Sacramento. In 1971 he designed and built a home that borrowed from both Japanese and native Pacific Coast architectural traditions. He named his settlement Kitkitdizze, the Indian name for a native shrub uprooted during the mining period but beginning to return to its original ecological niche. Others came to live in his vicinity, many with the idea of forming a model community.

He refused to call the grouping a commune, but he did use the word "tribe" to describe a group of people sharing work and living arrangements. Communes, he observed in 1974, were a phase of "sheer romanticism." "The

survivors," he thought, "were the ones who became practical, so to speak, realized their limits and realized that they would have to do a lot of hard work and realized that they would have to get along with their neighbors." Those who came to learn poetry from Snyder found themselves given household tasks to do so that Snyder would have more time for his writing. His critique of their work might easily focus more on their carpentry or gardening skills than on the poetry they drafted, for Snyder believed that the roots of a philosophy of life come to the surface in one's approach to everyday tasks. In an interview, Snyder argued that he himself had learned much of his poetry craft from a master mechanic he knew:

> Whenever I spend any time with him, I learn something from him. . . . About *everything*. But I see it in terms of my craft as a poet. I learn about my craft as a poet. I learn about what it really takes to be a craftsman, what it really means to be committed, what it really means to work. What it means to be *serious* about your craft and no bullshit. Not backing off any of the challenges that are offered to you.[15]

He hoped his community could "hit a balance between American individualism and the need for cooperation."[16] He and his neighbors organized a school district to educate their children. They improved the roads and built a Zen center on Snyder's property, where Snyder led meditation and training until they had enough money to employ a roshi to tend the growing congregation.

His roles as a father figure to the hippies, antiwar activist, ecological propagandist, and a model for the back-to-the-land movement helped make him one of the most popular poets of his generation. His life also encapsulated what Joseph Campbell called the "monomyth," a story Campbell found in all societies and believed was fundamental to most religions: a youth leaves his home, is initiated into the wisdom of the world during his travels, and then returns to his community to become a leader, imbued with knowledge he

could never have acquired had he stayed within the parameters of everyday life in his society.[17] Since Snyder's books largely followed his life experience, they presented a model history of a young man who explored and experimented but ultimately returned and tried to make his experiences meaningful to contemporary American society. Restlessness, adventure, wisdom, and an ever-deepening sense of belonging formed the primary motifs of his books, which achieved remarkable popular and critical success. His 1974 volume *Turtle Island* sold 70,000 copies in the first year of its publication before it won Snyder the Pulitzer Prize for poetry.[18] His work could satisfy a large number of readers approaching him with different levels of sophistication. His central message stressed the importance of personal connections and everyday acts such as hiking, work, sexuality, and prayer. His income was modest, less than he might have made in another profession, but he gained a large enough readership to support himself and his family entirely through his poetry.[19]

"Zazen/fucking/working [art, craft, job]/revolution," Snyder wrote Kenneth Rexroth in 1966 were the four steps of the bodhisattva path: "each step is a fantastic amplifier of the power being passed along, in the proper order" (Snyder's brackets in quotation).[20] It was a telling description that could operate as a model of the progress of his generation, particularly if we accept zazen as a counter standing for a more general mystic apprehension of the cosmos that dwarfs mere historical reality.[21] An erotic relationship to universal process was confirmed through sexual relations with other human beings. The third step on the path to liberation, "working," or developing a new practical sense of responsibility, made a new sexualized relationship to life the basis for a transformed society. Work was the category most likely to be missing from the counterculture in practice and one that Snyder insisted needed constant stressing in the United States. Despite the presence of a puritanical

strain to American culture, young Americans did not have to be told to honor freedom and break conventions. Rebelliousness and a love of change for change's sake were so ingrained in the general culture that Snyder felt it was vital that young Americans hear that freedom and unconventionality were pointless without discipline and commitments.[22]

To be what Snyder called a "dharma revolutionary" meant first and foremost being able to support oneself and one's family through one's own work. The parallels of his philosophy and his community at Kitkitdizze to the European settlement of the Americas were clear, so clear that Snyder had to confront and deny them: "The return to marginal farmland on the part of longhairs is not some nostalgic replay of the nineteenth century. Here is a generation of white people finally ready to learn from the Elders [all indigenous peoples of whatever race, hunting and gathering cultures, Native Americans]. How to live on the continent as though our children, and on down, for many ages, will still be here (not on the moon). Loving and protecting this soil, these trees, these wolves" (my brackets).[23] A desire to erase the founding crimes of American society led to a form of ritual reenactment. This time settlement would be done right, in cooperation rather than conflict.

Snyder thought that the correction to conquest lay in seeing that self-sufficiency was a false goal. The health of the entire community depended upon each person contributing his or her labor or, as Snyder phrased in it in his 1961 essay "Buddhism and the Coming Revolution," "working on one's own responsibility, but willing to work with a group."[24] The revolutionary desire to eradicate the perceived bases of hierarchy, privilege, and violence returned to a reformulation of relatively traditional values. One should enjoy the simple pleasures of work, as Snyder did when he echoed a traditional male viewpoint of having practical know-how and taking pride in his skill at the domestic tasks associated with householding: "I like to polish mahogany! I like to sharpen my chain saw. I like to keep all my knives sharp. I like to change oil in the truck."[25]

Nestled within the rebellious and cosmopolitan embrace of Buddhism and Native American culture were the male craft values of the skilled artisan and the small, self-reliant proprietor. These craft ideas were common to many of the creative men of his generation. Assemblagist John Bernhardt expressed a similar sense of masculine pride at self-sufficiency when he described the creative act by stating, "I solder, I weld, I braize, I glue, I nail them together, I screw them together, I bolt them together—all the standard techniques of the handyman." He wanted to emphasize, and his point was seconded by Edward Kienholz, who had participated in this discussion for radio, that there was no fundamental difference between "art" and the activities of nonartists. It was all "work."[26] On another occasion, Kienholz confessed that he did not want to be boxed into being an artist: "You know, like I make art, I buy and sell some real estate, I shoot some pool, and you know, like that."[27]

"His poetry is based on his own conception of the taste of a reasonable man," Robert Duncan said of Gary Snyder.[28] Snyder agreed: "I guess I must be a reasonable man because people keep telling me that. What I think I would be doing is trying to win the credibility of the reasonable man and then take him deeper. And I have to do that because I live in a very common-sense world. I always lived in a world where you had to be pretty straight because nobody would tolerate too much bullshit."[29] He avoided the rhetorical excess or the grand eschatological vision of Allen Ginsberg, and in another interview Snyder dismissed the literature of alienation as an anomaly: "It belongs only to the last two centuries and does not reflect the overall function or use of literature in culture, which is to go with the culture, not against the culture, which is to serve larger purposes of human sanity rather than to demonstrate craziness. . . . poets and writers who have to be alienated are like soldiers you sacrifice in the battlefield. It's a pity that they have to go that way. I have had too many friends commit suicide or die of alcoholism or die of drug overdoses because they thought that was part of being a writer. And that's not interesting to me. I don't think the writer's purpose is to kill himself."[30]

The central metaphor for Snyder was learning to be "at home" in all one's

relations. This began with the family, and all work was focused around one's responsibilities to the ties one had made. His emphasis on the "real work" placed tasks above ambition, yet his overlays of Native American and Buddhist philosophy placed domesticity in a significant design of recognizing one's home as an outgrowth of the material and spiritual processes of the universe. This replicated the Judeo-Christian tradition, but the exotic form gave a sense of novelty to what was in truth a continuity. Snyder's utopia preserved and gave even more primacy to the immediate social connections that mattered most to daily emotional life. "The niches that I occupy," he said of his work, "or that I hope to occupy, are the warm humane mammal family niche, the archetypal and mythic niche, and the transparent intuitive direct perception niche."[31]

Debunking the myths surrounding the development of the United States polity without providing an alternative vision of social order and justice would lead only to cynicism and distrust of the public sphere. Snyder was one of many who tried to provide new foundation myths. Against a social order perceived as dangerous and dying, he postulated an alternative order that could provide structure, and it consisted of concepts with which Americans were familiar if only on an ideal level: the ability to support oneself through one's labor, domesticity, tolerance for individual differences, the use of intelligence to create abundance, belief in a higher meaning underlying the immediate. The fantastic elements gave an aura of excitement to Snyder's ideas, but they also could seem feasible because they rested on stereotypes that men in particular knew and respected.

His 1970 book *Regarding Wave* brought together the poems in which he worked out his developing ideas that family was the foundation for social revolution. In the earlier *Myths and Texts*, completed in 1956, the central figure had been Coyote, the Native American trickster figure who showed through his jokes the tentative, illusory character of all human institutions. With a penis as large as his body, Coyote was an alterego for a rootless young man. The coyote figure acts to reveal the well of potentiality underlying all

being by disrupting social expectations; he sets the fires that allow new growth and seduces women in order to have his pleasure while overthrowing the complacent authority of older men. As a fantasy figure, Coyote sprang from desires for change without responsibility for the consequences. In *Regarding Wave* the central figure was the wife through whom the procreative, potential-revealing energies of the universe were manifested in human form. Unlike Coyote, the wife shows the permanent, "natural" ground from which the ever-changing forms of human society grow. "Wave," the opening poem in the collection, parsed the etymological connections of the word "wife" and the cognates of the Anglo-Saxon root:

> Wave wife.
> woman—wyfman—
> "veiled; vibrating; vague"

The feminine in its form as mate to the masculine connects Snyder as a man to the plenitude of natural process:

> Ah, trembling spreading radiating wyf
> racing zebra
> catch me and fling me wide
> To the dancing grain of things
> of my mind![32]

"Wife" in this context does not mean a woman as a personality, an individual with projects to achieve and problems to solve. Such a potentiality is not precluded; it is simply irrelevant to the poet's unfolding scheme. Woman is the "wife-man," the human through whom the wave unfolds, that is, the mother, woman as instrumentality, not of their men, but of cosmic process because their babies reveal the "Great majesty of Dharma turning / Great dance of Vajra power."[33]

In a later poem, pride in craft and pride in one's son as the vehicle of a legacy merge. Speaking of Ezra Pound as the mentor Snyder had followed in the craft of poetry and of his teacher at the Department of Oriental Languages at Berkeley, Chen Shih-hsiang, Snyder observed after reading the Chinese proverb, "When making an axe handle the pattern is not far off":

> And I see; Pound was an axe,
> Chen was an axe, I am an axe
> And my son a handle, soon
> To be shaping again, model
> And tool, craft of culture,
> How we go on.[34]

Connection and achievement could link in the form of a legacy that gave meaning to individual action by positing a value for heirs. The underlying stereotype of male craft values in Snyder's work established a ground on which his contemporaries could approach his poetry because the poems idealized and dignified activities of ordinary male life. Snyder's scope of experience was both unusual and limited, but he transcended the aspects of his biography that theoretically limited his appeal by creating a dramatized self with a perspective both relevant and attractive to a much broader spectrum of masculine America. Snyder's renovation of the pioneer image separated his readers from psychic responsibility for the original crimes moving through American history. Robert Boyers unfairly dismissed Snyder in the *Partisan Review* as the Marlborough Man of beat poetry, but the self-representation as a practical, independent-thinking, self-sufficient man with lots of know-how was attractive because it was familiar, an ideal for successful male identity. Snyder's stance included confronting the emotionally complex problems of love and work with a simple, though not simplistic can-do attitude that pruned away anxiety. Life itself was a project which would prosper when ap-

proached with the same craft values a person should adopt when beginning a carpentry or auto repair job.[35]

His solution to the acknowledged inequities and physical violence of male-centered families was to advocate a "return" to matrilineal families. His poetic images suggest that the vocal matrifocal framework he espoused was not in opposition to patriarchal authority, for the man remained the source of specialized knowledge and technique. Women literally provided the matrix around which social units cohered, while men expanded society's boundaries of perception. Snyder discussed marriage as a balanced relationship of co-equal partners. He doubted that biological difference required social differentiation between men and women, but his images that drew upon the stereotypes of male and female principles kept pointing in that direction.[36] In search of universal meaning, his poems empty his figures, including his own persona, of quirky character, of whatever might make them individual or historical. The poems convey little of Masa Uehara's biting humor or her well-known delight in puncturing Snyder's tendency to pedantry. Categories of identity reduced all to traditional visions of male and female difference: men as householders basing their worth on skill, but prone to apply their craft to violence; women as housekeepers nurturing those who enclose them, but liable to "devour" their loved ones.

The structure of abstract polarity grew from Snyder's reflections on his own experiences, which have validity, even if dubious universality, as expressions of male aspirations. His system became more problematic when it dissolved female experience into abstraction because he, at least, faced an acknowledged imaginative gap about the actual choices available to and the demands placed upon women. Discussing psychological factors he thought important in becoming a poet, Snyder confessed, "I don't know *what* applies in the psychology of female poets." He thought that poetry generally grew out of "an intense and deep connection between mother and son, and that the son relationship to the complex [*sic*] tooth-mother ecstatic-mother type is apt to produce environmentally, psychologically, genetically, by whatever

means, the lines of magic that produces poetry." Aside from eliminating women from what he theorized as the root source of poetic inspiration, Snyder also abstracted the mother role:

To be a poet you have to be tuned into some of the darkest and scariest sides of your own nature. And for a male, the darkest and scariest is the destructive side of the female . . . Most people only witness the light side of the mother. Literally. They only see the bright side of the mother, in one way or another. But some people see the *dark* side of the mother. If you only see the dark side you probably go crazy. The poet holds the dark and the light in mind, together. Which by extension, means birth and death in its totality. . . . there's also death, there's also the unknown, there's also the demonic. And that's the womb and the tomb, that's samsara, that's birth and death, that's where the Buddhists go in. And that's where poetry goes in: That's where poetry gets its hands on something real.[37]

Women stand in his vision first as symbols: wives are the gate through which dharma, "forming and firming," enters the human world; mothers provide sustenance toward death, so that the gift of life is also the fattening of the sacrifice.[38]

An irony of his poetry is that Snyder presents "intimacy" but seldom personalities, an apparent contradiction that is a recurrent stylistic feature contributing to the "Buddhist" overtones of his poems. To describe women also as individuals would explode the schematic, formalistic quality of a view that finds support for a sense of relationship with the cosmos in the most intimate of human relations. At the same time abstraction respected difference because Snyder assumed he had no knowledge of the interior states of women. He did not speak for them, but only of the role women and the feminine principle played in *his* interior life.

After 1967 Snyder's poems became increasingly nondramatic. As he found an identity that included social influence and responsibilities, his conception of the "real work" ceased to depend upon the magic of the unique action. The

universe itself with its never-ending permutations sufficed as the locus of drama. One finds salvation by extinguishing the desire to be a hero and accepting the roles one receives from nature. If we view the heroic quest as a search for identity and place, his new position confirms that he had completed his task by establishing a family. That Snyder's representations of his family were abstract does not mean that they were not deeply experienced or lacked a strong emotional substrate. The abstraction of the personalities may indicate how important his personal ties were that he needed to elevate them to a level of universal law independent of the people involved.

Snyder presented his most extensive and radical political program in his 1969 volume of essays and selections from his journals, *Earth House Hold*. The title played on the root meanings of "economy." The earth was humanity's house, which needed better management if we were to hold on to it. The old science of economics needed to give way to the more extensive and expansive study of ecology. Ecological vision merged with the politics of repression as Snyder found the source of damage to the environment in the primal crime of European conquest following Columbus's invasion and the dispossession of the land in the English-speaking settlements from their previous Native American possessors. In Snyder's concept of "energy exchange," the conquerer paid his debt to his victims by assuming their characteristics. America had to become "Turtle Island," translation of a traditional Native American term for the North American land mass. The continent had to return to its network of bioregional cultural zones.[39] The karma of Americans of European ancestry was therefore to become non-European, which might simply mean no longer taking pride in a legacy of conquest and ruthless power exercised over others.[40] The "real work," that is, the work that for millennia had structured the development of human being, was the provision of food and shelter (life in the present), the building of mutually supportive ties between lovers and the raising of children (life toward the future), and the search for meaning through poetic invention (the past as tradition we hand down to the

future and which inspires us to do the daily chores necessary to continue surviving), would replace power as the source of identity.

Snyder's focus on the personal and private as an alternative to a corrupt public order ignored the possibility that the private grew out of public life and might itself be as corrupt. Such a consideration, however, contradicted the assumption that the private was more intimately connected with cosmic process and hence relatively independent of the accident of historical circumstance. Forms of private life were culturally determined and variable, but at the core private life revolved around the universal needs of eating, procreating, and finding meaning. Snyder's goal was the construction of a tradition that was usable on a local level, but denied its strengths to the national mythos.

He had no illusions that an economic and governmental structure based on economics of scale and scope could be dismantled. He assumed that the principle of large-scale, uniform planning was inherently crisis-prone. The future for fundamental reform relied therefore on apocalypse. "Industrial society indeed appears to be finished," Snyder announced with confidence in *Earth House Hold*; the coming age of computers promised that the future belonged to "hunters and gatherers," of information, if not of nuts and berries.[41] In *Turtle Island*, Snyder published his program for social revolutionaries, "Four Changes."[42] The contribution, developed in 1969 as the basis for a political program to unite the counterculture, sketched the need to reduce population, pollution, and consumption, while transforming personal and social ambitions from material to spiritual objectives. Snyder's program intentionally was not "original"; after long discussions with many friends, including Michael McClure, Buddhist popularizer and radio personality Alan Watts, ecological activist Stewart Brand, and poet Diane De Prima, Snyder summarized the objectives for an ecological wing of the counterculture, but the document also stretched the ideal of domestic utopia to its ultimate. "Four Changes" imagines the family as the foundation of all social activities and then proposes a plan for global reorganization.[43]

The piece is torn by a conflict between his desire to see change imposed upon a global society he believes is dying, and his fear that such changes would augment the power of governments over citizens. ("Great care should be taken that no one is ever tricked or forced into sterilization. The whole population issue is fraught with contradictions: but the fact stands that by standards of planetary biological welfare there are already too many human beings.")[44] He hoped that spiritual conversion could effect the changes he outlined, but he knew that structural reform could not be achieved on a piecemeal basis. The only way public power over individual behavior could be limited and a severe program imposed on society was in the aftermath of a climactic global crisis, which he viewed as both inevitable and just, given the crimes from which modern industrial society had grown. The dream of apocalypse, a terrible but cleansing fire burning away the rubbish of society, provided an imaginary focal point where the contradictions of social responsibility and libertarian values could be resolved. ("'In the fires that destroy the universe at the end of the kalpa, what survives?'—'The iron tree blooms in the void!'")[45] Redemption would come through crisis because personal loyalties would be more important to most people than institutional loyalties. At that point the ideas of the counterculture, rooted as they were in protecting and preserving personal ties, would appear as a logical way to develop a technological society in equilibrium with natural resources. The opponents of the Vietnam War would develop a life-style devoted to problem-solving rather than power, and the force of their experiments would impress their fellow citizens as the benefits of their country's bloated power vanished. The rhetoric carefully balanced a need to make apocalypse not only inevitable (a stance that was easy) but reasonable, desirable even because it would save and elevate the features of everyday life that were most personal, shorn of all public complexity.

The lapse into apocalyptic thinking was an unconscious confession that "Four Changes" was not a programmatic manifesto but a prayer for change. It contained proposals for how ecologically minded people could live their

daily lives in greater conformity with their principles, but Snyder could not present any strategy for achieving the larger change he believed necessary. He called for a 90 percent reduction in world population, returning to levels demographers estimated for the total world population around 1500, half a billion people. The ideal resulting would be "a totally integrated world culture with matrilineal descent, free-form marriage, natural-credit communist economy, less industry, far less population and lots more national parks."[46]

Unrealistic as his long-term proposals were to the immediate economic and social construction of the United States, his Turtle Island approach nonetheless squarely confronted the possibility that a redefinition of priorities for living standards might be required if global disparities between rich and poor were to be eliminated. He could not imagine the earth as a whole living at Japanese or Western European standards, much less North American, where waste had been enshrined as the symbol of mastery over every thing and every process.[47] The only way to maintain quality was to reduce quantity without somehow stifling individual creativity. Snyder was not opposed to technology, but he stressed the importance for people to develop their perceptive and creative skills. Intelligence rather than machinery was the basis for any practical standard of living, a theme he aptly illustrated in one of his haiku:

> After weeks of watching the roof leak
> I fixed it tonight
> by moving a single board[48]

His ideas on credit addressed the need to support creativity. Property was not the source of wealth, he thought, only intelligence was. Therefore, borrowing from Ezra Pound, he proposed that any individual be able to receive immediate credit from the government to initiate projects. By having the government as the primary source of credit, society prevented monopoly from clogging innovation. The result would be less industry because concentration and economy of scale would no longer be as important. Individual initiative

would find a variety of ways and means to solve human problems in their particularity. A custom-trade economy would replace mass production, but do it in a manner that would be just as cost-effective in total allocation of resources. He argued that the system of large-scale production developed primarily from what he called the "fossil fuel subsidy." As coal and petroleum resources depleted and their costs rose, labor-intensive work would become more cost-efficient than mass production.[49]

Just as the stereotype of the competent craftsman stabilized personal innovations, the fantastic and the reasonable form a whole in Snyder's outlook. His famous practicality in no way restrained the free operation of the imagination in developing an alternative future. Anything is possible, but ultimately the discoveries of the heart have to make sense. The counterculture had to pose an alternative to the normative, including the humdrum details of work. Otherwise it was simply a temporary escape, a bespangled and glittery rock-music costume that brightened but did not change the relationships that constituted social reality. This has been the dilemma of the aesthetic avant-garde since its emergence at the beginning of the nineteenth century: are poets and artists mere entertainers, poseurs whose spectacles explore the limits of bourgeois identity, or pioneers grappling through the imagination with the contradictions of a rapidly developing society to propose alternatives that might in fact prove meaningful to those with no professional ambitions as artists or poets?[50]

Stereotypes, besides providing an anchor to the individual in a period of personal experimentation, gave ballast to social analysis and utopian proposals. The fantastic element spoke to dissatisfactions and a desire for change; the familiar added an aura of reason and practicality. Stepping outside existing boundaries of social reality could appear feasible. Change need not require an obliteration of the past. It could even mean a selection of those elements that were most emotionally meaningful in contemporary life. The private realm could overthrow the public order and construct a new, more intimately scaled public life. Snyder's ideas may not have been practical, but poets have no re-

sponsibility for administration. Their job, to the degree that they have any function outside of pleasure, might be to suggest possibilities—even if not practical, maybe especially if not practical. The "original" vision of the avant-garde was utopian. As the Vietnam War prompted poets like Snyder to address the immediate concerns of social organization, the more absurd their position within society became. Utopian vision cannot become practical without losing its own character.

The ecstatic revisioning of public life rested on a relatively static image of nuclear family, friendships, neighbors, and work, that is, of the network of relations that most Americans shared. Snyder's family was the center around which he claimed everything revolved that gave him roots. Yet it was a relatively traditional nuclear family, typical of its period. He had taken his children to see the graves of both sets of great-grandparents in Kansas and Japan, but his family lived without daily or even frequent contact with the living grandparents in a home unconnected on either the Japanese or American side with an extended sense of generations. The tribe was an imagining of already existent personal connections as ultimate authority and detaching them from the larger social frameworks that linked together overlapping imaginary communities through law, commerce, and so on. "What history fails to mention," Snyder observed in one short lyric, "is / Most everybody lived their lives / With friends and children, played it cool, / Left truth & beauty to the guys / Who tricked for bigshots, and were fools."[51]

Even on the question of sexual liberation, Snyder's poetry included direct images of sexual passion, but were not a celebration of dionysian energy. Poems in *Riprap*, *Myths and Texts*, and *The Back Country* present youthful sexual adventures as stepping stones in the process of maturation. The tone is often elegiac and self-accusatory, regretful that finding a lifetime companion remained an elusive goal: "Because I once beat you up / Drunk, stung with weeks of torment / And saw you no more, / And you had calm talk for me today / I now suppose / I was less sane than you, / You hung on dago red, / me hooked on books."[52] Other poems show an unsatisfied, even guilt-

ridden male sexuality deflected onto sordid rituals that turn women into objects of humiliation: "The shivering pair of girls / Who dyked each other for a show / A thousand yen before us men / —In an icy room—to buy their relatives / A meal."[53] The casual encounters and affairs charted in the course of his books are part of a growing-up process. He moves past the meaningless aspects of casual sexuality to reflections on his failed marriages, lessons that propel him to the successful consecration of a family. This aspect of his work is one of the chief links between Snyder and Kenneth Rexroth, who stated in his 1944 preface to *The Phoenix and the Tortoise* that the coming together of male and female opened up cosmic multiplicity and established the possibility of sacrifice. Sexuality as a means of imposing a man's will on others becomes through voluntary acceptance of responsibilities the key to imposing discipline upon himself.[54]

One interview that Snyder gave in 1974 contained hints that the social experiments at Kitkitdizze also involved forms of open marriage, that in practice experimental family structures might loosen into less proprietary relationships:

> Part of my personal world is erasing some parts of my ego increasingly into the cooperation of the group, and the decision-making of the group. And a third thing which I won't say too much about because it's too personal, is the ongoing erasure of sexual roles and sexual jealousies that all of us in our community are learning with each other, which is a difficult but very profound learning for us. And I don't know where that's going to lead. And that involves my wife, and others who . . .[55]

These kinds of concerns have not appeared in his published work, at least not in a form as direct as other accounts of his personal life. His poetry presented readers with a model countercultural yet traditional monogamous marriage, denuded of individual conflict, the product of a process of maturation and sign of successful individuation. The importance he placed on his marriage for his public image as poet was emphasized by the illustrations used for the cov-

55. Gary Snyder and family, cover photograph from *The Real Work*, 1980.
Left to right: Masa Uehara Snyder, Gary Snyder, Gen Snyder, Kai Snyder,
Nanao Sakaki. Courtesy of New Directions. Photo: Aka Kitsune.

ers of the New Directions paperback editions of his books in the 1970s,
which always show him with his wife or, on one volume, the couple with
their children (fig. 55). Life in a postapocalyptic world would not be so
strange or deprived. It would be, if anything, a dream come true.

Snyder's propositions assumed that the end of American civilization was
at hand and the 1960s were a prelude to a major transformation. His opinions
were shared by many, although it is curious that aside from the extreme right,
few dared imagine the collapse of communism, in 1969 less than twenty years

away. Fantasies for apocalypse projected instead onto the presumed unavoidable death of the West. The tapping into cosmic force through one of its most fundamental expressions, sexuality, resulted in a sense of change starting from within, a change powered by what Ellen Willis, a critic for the *Village Voice*, later termed "the dream of a beneficent sexual energy flowing freely."[56] Actual sexual behavior contrasted so sharply with official morality that a sense of a new self emerging through rupture with social conventions was so strong that the energy radiating from within seemed likely to expand indefinitely in a vortex that altered everything it touched. Since change emanated from the self, its effects would first be seen close at hand. That which was most powerful would be known by its erotic appeal, so that ecstatic feelings could mark, as if objectively, the truth of phenomena experienced. The counterculture's inability to achieve the transcendent change it imagined, Willis believed, came from an enthusiasm for change that blinded people to the risky side of freedom. They had not considered sufficiently the negative, destructive force locked into sexuality.[57]

The limitation of the imagination as a guide to the future was its tie to the here and now. Snyder was well enough aware of this contradiction that he rejected spontaneous approaches to writing and pursued the more ascetic ethics of zazen. Releasing fantasy, he argued, actually acted as a block to perceiving the variety of possibilities existing in the universe. By restricting the scope of a socially constructed personality to define perception, new visions of the world arose, not independent of the self, but not constructed from its repressed elements either. Snyder was proud of the fact that his group at Kitkitdizze faced the contradictions of living in a real world, where the necessity of surviving forced one to think hard about goals and needs. Many of the men found they could make the most money by working as carpenters in the construction trades building new homes, shopping areas, and vacation cabins. They had become, like it or not, economically dependent upon the cycle of real estate booms that had fueled so much of California's economy since the

gold rush. The community became active in county planning so that economic diversification might provide stable but less environmentally exploitative work for county residents. They also lobbied for changes in the county's building codes, monitored the uses of public land, and fought proposals to reopen the county's gold mines.[58]

Nonetheless, the men's positions and self-images as heads of household placed them in conflict with the ideals that had led them to abandon urban society and move to a rural county. One interview, first published in a local newspaper, captured the complexities of Snyder's relationship to those who admired his example and tried to imitate it. A neighbor, Colin Kowal, a carpenter and poet, wondered if it would ever be possible to escape a growth-based economy. Snyder could afford to meditate upon other possibilities, Kowal argued, because Snyder could survive financially from his writing. He could afford his ideas, but "living off arts and crafts is not for the many." Most had to live off technology and development. They had to transform the Sierras into something different if they and their families were to survive, and indeed even by coming to the mountains, however idealistic their original impulse to reunite with raw nature, they had already contributed to transformation and urbanization. They wanted the county's development to be of a positive, thoughtful nature, but they needed development of some kind if they were to feed their children.[59]

Snyder's locally focused, craft-based philosophy could not really provide an answer to the contradictions Kowal had discovered in trying to bridge innovation and continuity in his own life. "First of all," Snyder told Kowal, "you must realize that these are abnormal times," referring to all social developments that had occurred in the preceding 10,000 years, but with particular reference to the industrial revolution and its aftermath. Kowal needed to maintain faith in apocalypse to correct imbalances. Until then, action meant trying "in your personal lifestyle to do what is right." Work for developers was unfortunate, but if necessary, it could be balanced by working on com-

munity projects. For every resort built, the work crew could erect a community library or medical clinic and contribute the structures to nonprofit organizations to run. He admitted that his practical side told him that ideologies were secondary to economics, but still he hoped that attitude could create new political and economic facts. Each American had to make a choice between being an invader or a native: "Some people act as though they were going to make a fast buck and move on. That's an invader mentality. Some people are beginning to try to understand where they are, and what it would mean to live carefully and wisely, delicately in a place, in such a way that you can live there adequately and comfortably. Also, your children and grandchildren and generations a thousand years in the future will still be able to live there. That's thinking as though you were a native."[60]

Abstraction of immediate experience and its projection onto a universal plane proceeded by repressing the contextual and structural conditions that shaped both the objective and subjective aspects of everyday, immediate experience. The operation was not necessarily retrograde because it focused on the potential meanings of direct experience and opened up questions about the necessity of current practices. Even its ideal, imaginary character allowed poets like Snyder to propose a way of seeing alternatives to existing structures of daily life by honing in on the satisfactions that one did have as the foundation upon which to build a new life.

The problem that hindered, if not prevented, the utopian from breaking through to the practical, was blindness to the complex conditions by which fantasy operated and revealed potentialities for new ways of living. The flaw with the utopias proposed under the rubric of the counterculture lay in their projecting what was genuinely nearest and dearest as the basis for salvation without considering, indeed refusing to consider, how the positive, enlightening aspects of their lives might be the products of what they hated most. Their haven could not exist outside the catastrophe of oppression. The very theory that allowed the avant-garde to criticize the dominant structures of American society applied to their hopes as well, but, with few exceptions,

they did not apply their critique to their own lives, so they did not see, except intuitively, how radical utopia was dependent upon and derivative from the society they hoped to overthrow. The "dictatorship of the unconscious" blocked itself by remaining unconscious of its own roots, or of the necessity of an executive power that could enforce utopian dictates, thus undoing the familial autonomy that a domestic utopia strove to render eternal.

14

Eros' Double Face

Robert Duncan on the Limits of Utopia

Seven years after the Human Be-In and Gathering of All Tribes in 1974, Snyder expressed regret that he had urged the taking of drugs on as wide a scale as he had. He still believed from his own personal experience that psychedelic drugs could have positive effects on both individuals and social interaction, but the responsibility of being a public figure required him to advocate restraint and "to project an image of a little bit more sanity." The sudden revolution in consciousness he had hoped for, but not really expected, had not taken place. The government had lost its war, but remained, even with the then-recent resignation of Nixon, for all practical purposes invincible, if distrusted. Those who had rebelled had paid a price for asserting individual vision against public authority. Neither the government nor the alternative "community" had been prepared to deal with the fear and hatred inside so many people, and Snyder had to admit that he had not considered adequately the high numbers of disoriented and potentially violent people who had gravitated toward the counterculture.

"I've had people turn up at my door who are half insane, who told me that I had set them on their path," he continued. "I've had to deal with them, and it's not easy, because we're talking about real people, real situations. . . . [I] sat down with them and talked and [they] scared shit out of me and my wife one time, and my kids. And you know, like, not knowing where these people are at, and trying to find out where they're at. You've got to realize that there's an

underside to this, that at its bottom is Charlie Manson. But we have to live with that underside too, and in California we see that underside, and it's dangerous."[1]

Robert Duncan (fig. 56) was also concerned with the dark side of the counterculture that arose as people he knew attempted to become a social force. In 1966, just as the often arcane speculations of poets were mobilizing a mass movement, Duncan worried that a system of ideas focused solely on liberating humans from oppressive social dictates would not be well prepared to provide an effective philosophy of government, much less a practical structure of administration. He looked at fellow poets trying to convert their experience of community into projects for social rectification and saw at best naiveté. At worst, poets who had begun their careers as crusaders for personal truth had allowed their utopian hopes to obscure their perception of their own complexities. Gently chiding Snyder's fascination with resurrecting the "old ways," Duncan thought that the "myth of the return" was not innocent, because our imagination of the past was always imbued with passions and hierarchies of the present. The golden age was simply a picture of the best aspects of the present apparently stripped of its ugly features, which nonetheless reappeared in a thirst to eradicate contradiction.[2]

Duncan was one of the most influential and respected American poets of his generation, but he was known only to a select group who took pride in the time needed to work through his texts. His poems seldom told a story that revealed itself in a single reading. He demanded that his readers struggle as he did and reconstruct the poet's contradictory, often misleading responses to images and ideas he had experienced in the course of assembling his work. Duncan knew what he wanted to say when he finished writing, but what made a poem "poetic" for Duncan was that the text was a record of the discovery of meaning that can come only from the process of writing. The payoff for the reader was not the message, or the use of language, or well-crafted images, but a reenactment while reading of the experience that transformed Duncan's initial chaotic emotions about some event or person into a form that

56. Patricia Jordan, photograph of Robert Duncan, late 1950s. Patricia Jordan papers, Archives of American Art, Smithsonian Institution.

could convey a message. In the emergence of meaning from the confusion of raw experience Duncan created himself as subject, knowing who he was and where he stood through the act of narration. This was not a simple task because narration involved many snares, first and foremost the lure of desires to escape the complexity of reality through the creation of personal utopias. To write his poems, Duncan had to learn to listen to the conflicting voices within him, but then say no to the words he often liked best.

The self-image to which Duncan returned throughout his life was that of a contrarian, always searching for the hidden meanings locked in all phenomena in ways that made everybody else uncomfortable:

> The reason I really was only a poet (it was clear even in high school that I wouldn't have a second profession, and that I would be just a poet, which was very distressing to my family) was that I was incapable, absolutely incapable, of living in the double standard. I would just blabber too much; I'm not talking about some great moral courage or something. I was literally incapable. . . . without thinking about it, I understood that no one cares who or what is washing dishes—but by the time you're a busboy they care, and they're patting your bottom or whatever—and nobody cares who's typing his manuscript. . . . But if you try to get an office job! I would take a Civil Service examination and would be A-1 or whatever is the top bracket; but when you'd go to get the job that's at the other end of that, they simply read you out, in no time at all. You never got the job and, more than that, they'd ask you to tell them why. . . . So no wonder I didn't, luckily, remotely believe that I might grow up and be a teacher, maybe, as well as a poet.[3]

Far from being practical, he was "lurid," excitable to the point of helplessness. If somebody said yes, he had to say no. His homosexuality and his parents' participation in theosophy had established his difference from the middle-class American culture to which he otherwise fully belonged. But his differences went further and deeper. He enjoyed contradicting people, he enjoyed

exposing the limitations of all views, his own and those of the people with whom he came into contact. He knew it made him insufferable, but any distinction he received in his social activities seemed to derive from his penchant for contrariety: "I was on the freshman staff of the college literary magazine and had already discovered that when I thought something was good there would be a whole staff full of 'nos' and I would be the only 'yes'; when I thought something was lousy, there would be a whole staff full of 'yeses' and I'd be the only 'no.' Actually, this made me feel like I had an identity for the first time."[4]

Turning contrariety into a positive feature, Duncan found a consolation for the anguish he had experienced growing up feeling that he was somehow a defective member of his society. "What I remember is some utter misery in me that showed up in whatever I did there [as a student in high-school shop class], so that all could see I was not somehow a man, showed up in my crying and being afraid of what a man must do." In an interview, Duncan proposed, "I play heretic so that ideas are moving, and I'm entertaining their ideas, and I know they're entertaining mine." It was no fun to play heretic to fanatics, and Duncan thought the transformation from the 1950s to the 1960s from private to public concerns had involved a suspension of openness. "There was no play left." Being in opposition on principle made him acutely sensitive to the effects of retreating into one's own imaginary community. Difference had given him his particular voice as a poet, but its "play" came from contesting other conceptions of poetry.[5]

The Vietnam War refocused Duncan's long-standing concern over the relationship of poetry and politics. Unlike Snyder, Duncan felt no pressure to propose programs for social reform. He was not personally capable of such a task, but he also believed that programmatic thinking was antithetical to the unique contributions that poets could make toward the resolution of social conflicts. In an interview given as the war was ending, Duncan stated that he believed that "poetics, like politics, is an art of the intensification of what we take to be the principle of individuality in the realization of its identity and

unity (or fulfillment) as an essential part of a society. It is not in whatever social attitudes we protest that the *politics* of our poetry is to be read, but in the actual society of events that that given poetry presents and in the character of the life of the members of that society." Learning how to gauge the ways poetic practice related to social debates had long concerned him. In 1958, he had written that political work involved poetic thinking because laws were accumulated metaphors. A community was a "body of people living in the same place under the same laws"; a community could be defined by its laws, that is, by the collective meanings assigned to shared experiences.[6]

Duncan did not believe that all members of a community shared equally in constructing those meanings, but the broader the basis of experience encompassed, the more stability and cohesion a society had. For poets to argue a specific point, to treat readers as if they were piggy-banks into whom knowledge and preset opinions were to be deposited was to miss the unique ways poetic activity functioned in the social meaning-making process. If poets became aware of the multiplicity of experience moving within them and recaptured those levels within a work that others could share, all would become more conscious of the contradictory forces they contained.[7] Their relationship to their experiences would change as they faced those elements they had not known existed. "The poet of the event," he argued in the introduction to *Bending the Bow*, "senses the play of its moralities belongs to the configuration he cannot see but feels in terms of fittings that fix and fittings that release the design out of itself as he works to bring the necessary image to sight."[8]

The poem was an experience in its own terms, not simply a statement. Because it was an experience, it was personal and private, but because poetry was a collective form of assessing experience, it was also public. The social value of poetry was eviscerated when the balance of public and private foundered. If imagination could enrich politics, might not politics equally be likely to deplete imagination through a transfer of energy into a black hole of unacknowledged, repressed desire? So a dangerous balance existed: if poets

threw themselves into the affairs of the immediate, imagination might disappear from society entirely.

A poem could not be "opposed" to a war, or any other social fact, though the poet as a citizen could and should. The poem proposed another level of experience, so that historical realities, such as war, might not devour people and become the limit of their perspective. Multiplicity of view provided distance rather than engagement, but distance was needed to function effectively as a responsible householder (to use one of Duncan's favorite political terms). By widening the scope of experience, poetry could change political relations, but not without poetry first having changed as it moved from the confrontation of the psyche with the cosmos. The ideas that Lundeberg, Rexroth, and the California School of Fine Arts painters struggled with in order to find aesthetic forms that best linked inner and outer realities had reached a logical culmination. Poetic process was an end to itself, a form of religion without dogma or doxology. For the believer, faith in God has no reward other than itself. Faith does not, cannot, depend upon social amelioration. Poetic experience, to the degree that it provided an experience of the numinous, exercised the same demands upon its practitioners as a religion did.[9] "The State of grace, the Laws of nature, the Structures of the universe, the Force of life," Duncan observed, "all these suggest that we are not wrong to envision our orders as poets as proceeding from an arbitrating Poetic not an arbitrary poetic and proceeding toward that Poetic. We to be realized in it, not it to be realized in us."[10]

In his 1966 essay "The Truth and Life of Myth," first delivered as a series of lectures at the San Francisco Art Institute, the renamed California School of Fine Arts, Duncan elaborated his argument that poetry worked to release and harness the powers that rational thought vainly sought to control through repression. Rationality was driven by the desire for how the "story should be." He inverted the commonsense understanding of the relationship of desire and reason by positing that irrationality, understood philosophically as that which cannot be predicted, was a return to "what the story demands." It

let those factors back into human perception that "official stories" repressed so that nothing need be taken seriously that reason cannot explain or technique quantify.[11] Irrationality allowed us to see features of our lives that were present in our lives, but were seldom useful for predicting what would occur. Lying within the sphere of pure potentiality, the irrational capacity blurred the distinctions between improbable, possible, and probable. Rational functions sharpened those distinctions and provided a necessary, though not infallible basis for planning, but at the cost of reducing the complexity of the present only to those factors that fit the story. In a topology that mimicked Heisenberg's uncertainty principle, one could see either the present or the future, but not both at the same time. This distinction underlay the differences between what Duncan termed mythopoetic truth and likely (which Duncan thought really meant likeable) truth.[12]

Nuclear weapons had increased the need for rational administrative control in government because the price, Duncan argued, for failing to prepare for the future adequately was apocalypse. On the level of the greatest danger, the global contest between the United States and the Soviet Union, Duncan conceded the probability that military planning would succeed in averting conflict—although the possibility of mistaken calculations remained. It was at lower levels of action where rationality could collapse, those areas where predictive decisions were based on information of a too general level. The Vietnam War struck him as a typical mistake of a system that could not take into account adequately the gaps in its knowledge, yet tended to act as if it had sufficient information upon which to judge competing potential futures.

Where history becomes myth, Duncan observed, rationality inevitably fails. The desired ends of economic or military violence often were not achieved because decisions always involved more than "matters of reason and plan."[13] In failure historical actors discovered the fates lurking for them, "the ends they deserve." Only when rationality verges into hubris and the hidden aspect of desire governing purposeful action is clearly revealed do the true meanings of social actions stand forth for all to contemplate. Hitler revealed a

"terrible truth" about Europe, while Johnson betrayed "the character of Babbitt swollen with his opportunity in history." Political leaders and their followers alike believed that leaders were all-powerful, but they mechanically acted out truths that humanity had enshrined for millennia in mythic accounts of chaos, wrath, and envy.[14]

In this situation aesthetics had a new, but limited role. The price of social structure is revealed most clearly on the symbolic level, where images carry the fears and desires that pertain to specific sets of relationships. The mythic, Duncan argued, was exterior reality refracted through personal reaction into a form that corresponded to and revealed actual powers and forces that exist on a supernatural level, that is, as Platonic ideals. The individual, historical moment makes sense because it is part of recurrent, universal patterns that occupy the attention through myth and poetry. Individual experiences, as concrete and unique as they are, are instances of constantly repeating patterns, which the pre-twentieth-century societies personified in the gods, elves, and angels populating their literature and art.[15]

Yet the universal validity of such figures did not contradict their irrational character. These processes could not be reduced to laws, a process that arose from reason's desire to impose order upon forces greater than the capacities of the human intellect. The natural processes that led to myth and poetry were patterns that returned again and again, without ever being exactly identical. Poetry was the "real world" because it pointed to a level of existence that persisted despite the permutations that constituted history. Societies and individuals alike found meaning in their actions by projecting them against the cycles of life and death. Until this had been done, one felt as if one's experience were somehow inauthentic and alien. This suggested to him that the self was the sum of intersecting forces rather than a distinct, autonomous entity, a conclusion similar to Snyder's conception of the ego derived from his studies of Buddhism. If experience, in and of itself, were the ground of reality, then there would be no need to search for meaning. "What does it mean," Duncan asked in 1972, "that in order for [an experience] to come real in the poem we

must *imagine* even what we have actually felt? We must make it up in order to make it real."[16]

The self, he argued, took shape in the story that unfolded. The critical aspect to a narrative was not the events, but meaning, "the sense of truth and life" that the story revealed. The struggle over storytelling was fundamental to the sense individuals made of their daily lives and societies made of their histories. As they told stories, they turned themselves into subjects capable of acting in the world. They had selected those attributes and desires which would give an illusion of continuity. Self-narration was always an innovation, but one that attempted to assert that the created subject was "always" so. There was no understanding of self except as a position within a narrative: "The *psychosis* or principle of the soul-life is its belonging to the reality of what we know to be true to our story-sense." Yet meaning did not lie in the "philosophy" or overt theme of a life-story. Duncan believed instead that people found meaning in the "sense of drama," in their visceral responses to conflicts that revealed patterns of motivations, potentialities, and relative position.

In this sense the self contained within it as an experience a language of boundaries. Identity, temporary as it was, came through regular patterns that established relationships. Changes to those patterns that brought out other potentials of an individual were also a change of identity and often experienced as a threat (they could also be felt as a liberation), to be resisted by repressing the errant potentials that escaped into the realm of consciousness by assuming symbolic form. Symbols embodied potentialities consigned to the churning realm of the repressed, but returning from the unconscious to remind us that the identity constructed for superficial everyday existence was transitory.[17]

Our senses split between official versions and subterranean responses that showed the "dark side" of official reality. Freud had revealed that the child growing into words "hears not what his parents mean to say but what that saying is telling about them." Language was first and foremost about pleasure

57. Jess, *Narkissos*, graphite, pencil, and drawing paste-up, 1979/1991, detail.
Courtesy of the artist and Odyssia Gallery, New York.

and pain derived from relationships and only secondarily about the communication of specific information.[18] Language established power relations by imposing speakers' images of others upon them so they might conform to the roles assigned them. Those with greater social authority, be they parents, employers, or men of affairs, had greater linguistic authority. Hierarchy found expression first in statements of hate and love that proceeded as if people were simply objects, extensions of the speaker's will. Language worked to turn others into instrumentalities contained within by a cage of speakers' conflicting needs, desires for power, and feelings of guilt.

Rationality allowed citizens to accept either as their own or as inevitable the desires of those at the top of hierarchy, but the experience of pain and pleasure involved in relationships remained as a residue of despised emotionality. The expressions of those experiences were inevitably distorted and inaccurate on one level, but they were nonetheless the only record of the emotional price exacted in the attempts to reach an "official story." Those records came from within, but in an externalized, objective form that had to be read and reread carefully to understand the messages conveyed about one's actual place in and response to society. Myth therefore was always a "matter of actual times and actual objects" that revealed the fundamental cruelties, and therefore inadequacies, of specific social relations.[19]

In his poem on Berkeley, "Heavenly City, Earthly City," written in 1947, Duncan proposed an explanation for the mysterious emotional power that unexpected images had upon people, the same power that Lorser Feitelson had observed as a young man when he came across a street sign post and felt lifted out of everyday reality. Images, Duncan argued, appeared mysterious when they connected to experiences repressed into the unconscious. Poetry was the means by which those emotional reactions could be orchestrated to liberate the preverbal from the unconscious and catapult it into a form that allowed the total being, conscious as well as unconscious, to reflect upon and learn from a broader range of experience. The power of hierarchical social structures lay in the ability of its image makers to call forth these compelling

images without explaining them or making them verbal. In Duncan's terminology, "first things" remained "inaccessible" in manipulative art, that is, creative work with a preconceived agenda. In liberatory work, such as poetry in which the writer discovered meaning through the act of writing, the conscious mind became aware of how primal forces moved within it. These forces were neither dispelled nor vanquished. They had to be accepted as part of one's being before they could be used to accomplish specifically human purposes. Mysticism need not be obscurantist if it allowed men and women to apprehend experiences that might be valid, but the conditions of which could not (yet) fit into a rational explanation.

In a 1967 interview, Duncan observed that many poets did not "read" their poetry or their experiences as if they were texts outside their control and therefore visions by which they could learn rather than teach. "For instance, take an awfully good poet like Robert Frost," Duncan went on. "While he writes a poem, he takes it as an expression of something he has felt and thought. He does not read further. It does not seem to be *happening to him*, but coming out of him. Readers too who want to be entertained by [or] to entertain the ideas of a writer will resent taking such writing as evidence of the Real and protest against our 'reading into' poems, even as many protest the Freudians reading meanings into life that are not there." Instead of taking the poem as an "immediate reality," Duncan treated his work as puzzles: "What does it mean that this is happening here like this?" The poetic significance did not dwell in the what of the message but in the why: why these images, why these words, at this time and place? They appear as experiences, but they open onto other orders of human reality from which our "experiences" are constructed as so many illusions.[20]

To discover the hidden message in poetic experiences, one had to surrender the "I" or the ego, which emerged, Duncan thought, as a denial of and defense against subordination, and accept the potentiality of the subject, which Duncan defined as a "readiness" or position in social structure. The ego tried to lift the self outside of time, a factor that made stereotypical think-

ing particularly attractive to a threatened ego attempting to stabilize itself. The subject, on the contrary, placed the self back into the web of discourse and its forms and rehistoricized self-understanding by constantly "rereading" the texts which had constituted it. The subject emerged as part of an ongoing dialogue, sometimes acrimonious, between the contending elements of a social structure. Individuals had as many subjects as they had texts in their lives, but the subject was always the record of an engagement with others. It marked the ability to change or, to use Duncan's phrase, to "repropose" oneself. [21]

This conception of poetry as a process of analyzing the messages one receives from various levels of reality led him to criticize antiwar poetry attempting to serve an agitational political program. Like many other poets, he demonstrated and spoke out, but he believed that was behavior pertinent to the order of polity, not of the poem, even if he did write poetry with agitational purposes. One of his poems, "Up Rising," protesting Johnson's escalation of the bombing of North Vietnam, was printed as a broadside and posted around the San Francisco Bay Area. Another type of antiwar work was the distribution among artists and poets of *Tribunals,* a mimeographed manuscript of poems on the war. He was interested in engaging other poets as to the correct poetic response to social tragedy and in the process understanding his own work better through evaluating the responses he received. Out of this process, many of the poems in *Tribunals* appeared in *Ground Work: Before the War,* Duncan's later volume published for the general reading public by New Directions.

Strangely, however, for a poet so disregardful of the general public, a poet whose focus on deciphering the fragmentary nature of his own life made his work difficult and arcane, Duncan had a broad vision of who his readers might be. In the introduction to *Bending the Bow,* Duncan described his experience at the October 20, 1967, March on the Pentagon, where he was scheduled as a speaker on the second rally planned at the front entrance. [22] His speech was aborted as National Guard soldiers and police charged the demonstrators, arresting those who refused to (or could not) retreat to the parking

lot. Duncan, at the front of the line, found himself caught between the soldiers and the crowd behind him, in which there were many prepared to fight back. Monitors from the march organization advised people to sit down and confront the military with nonviolent, passive resistance instead.

> "Look into their eyes," the doctor's wife tells me. To my right, the onlookers call out, the soldiers are kicking the body of a woman who is everything they despise: they kick her rich clothes; they kick her cultured tone. . . . they kick her meekness that, courageous to lie there affronts their victorious movement forward. "I am all right," she calls back to us.

Duncan considered if there was anything he could possibly say that could defuse the tension. The speech he had planned to give seemed futile, for the soldiers "were under a command that meant to overcome us or to terrify us, a force aroused in the refusal to give even the beginnings of a hearing." In this confrontation, Duncan sensed that a new "we" was in formation, a "we" that at first seemed to be the demonstrators separating politically and morally from the bankrupt authority of the United States. Yet as soon as he suggested that a schism was sundering the American polity, Duncan threw out a second and surprising idea. The soldiers and the police were also his readers. By being part of the same drama, they had formed a community with the demonstrators: "We were, in turn, members of a company of men, moving forward, violently, to overcome in themselves the little company of others kneeling and striving to speak to them."[23]

The protestors had come "to fulfill their humanity," but so had the soldiers. Each had a poem to read to each other: one involving a testimony of opposition in hopefully nonviolent action; the other to express rage, fear, and the "shock of what they were to encounter." Without the other, each "poem" was meaningless. Yet there was a tendency, coming from the highest office of the land, to erect boundaries so that the poems of others were no longer recognized. To think of a community as a group with *common* goals is actually

to sunder the community and seek isolation from contamination. The existence of other human beings as historical actors fell into the dark and churning mass of the repressed. When confronted by external evidence of interior chaos, one reaction was a sense of defilement. "And the people who feel that," Duncan thought, "—and they certainly are to be found in the dominant, ruling majority and in lots of little minorities—want authenticity within their group and then everybody else is experienced as corrupting. . . . One feels a challenge and wants it to be eliminated. Those things are there to be eliminated. . . . Or not even thought of which is the worst pattern of all. . . . The characteristic of the totalitarian is they can't repropose themselves."[24]

Duncan discovered that community was common action, not despite but *because* of conflict and contest. Without drama there is no action and therefore no community. Separating oneself from every instance of a hated enemy was natural for both sides. The contrary logic that Duncan identified as the clearest representation of his self had arrived at its own political conclusions: difference is the basis of unity, commonality is a sundering. Both protestors and soldiers became angry because every person in the situation "knew" that within lay all possibilities and only historical circumstance defined one's position in the drama. Any of the protestors could commit atrocities, and any of the soldiers could find the courage to speak truth to power. The refusal to listen to others' poems was "the nature of all dying orders, a death so strong we are deadend [*sic*] to the life-lines." The antiwar movement was an integral part of the dying social order of America, rather than the transcendent force its adherents believed.[25]

The poetic truth the Vietnam War awakened in Duncan was the conviction that separation was a will-to-death. Social commonality as codetermination of opposites contested a widespread desire for absolute authority. There was no saving remnant because in willful isolation the conscience ossified and "officized."[26] The elements from which people constructed identity were polysemous because they linked both surface continuities with the underlying chaos of potentiality. Meaning came from the specific relationship of con-

scious and repressed contents. The individual reader of all the "poems" that constituted social relations possessed the freedom to transpose all given contexts, as a musician switching a melody from one key to another changes its emotional resonance.

"Where there is no commune, / the individual volition has no ground," Duncan inscribed in "The Multiversity," his poem on the Berkeley Free Speech Movement of 1964, quoting the critique the anarchist leader Bartolomeo Vanzetti had made of Lenin and the Bolshevik revolution in Russia. Vanzetti and Duncan continued, "Where there is no individual freedom, the commune / is falsified."[27] The separation of poets into coteries, of homosexuals from heterosexuals,[28] of the peace movement from the government was a dissolution of identity because each boundary severed a relationship that, however antagonistic, helped a person find his or her position in society. Differences were necessary and productive, but only to the degree that they remained in connection. The question was how to understand the nature of conflict in modern society. Was it inherently disruptive or an indispensable attribute? Duncan's answer was clear and derived from a reinterpretation of the place of chaos in the universe: "Order can't possibly be threatened. Disorder is one of its terms. . . . The themes of possible disorder are interior and orderly to the poem."[29] Duncan was speaking in this particular instance about the use of collage technique in poetic composition, but the term "poem" always contained for Duncan the idea of any experience-making, meaning-revealing action.

His refusal to find in the antiwar movement saving grace constituted the basis for Duncan's disagreements with his close friend Denise Levertov.[30] He was dismayed that she believed that the brutality of the Vietnam War, rather than her own psychic development, could be the "subject" of her work. Commenting on Levertov's "Advent 1966," first published in the *Nation* in 1967, Duncan wrote her that her work gave him "an agonizing sense of how the monstrosity of this nation's War is taking over your life, and I wish that I could advance some—not consolation, there is none—wisdom of how we are

to at once bear constant (faithful and ever-present) testimony to our grief for those suffering in the War and our knowledge that the government of the U.S. is so immediately the agent of death and destruction of human and natural goods, and at the same time as constantly in our work (which must face and contain this appalling and would-be spiritually destroying evidence of what humankind will do—for it has to do with the imagination of what is going on in Man) now, more than ever, to keep alive the immediacy of the ideal and of the eternal."[31]

Levertov, however, responded that she had found relief from the disasters of war in *group* action, while Duncan could only suffer while bearing his conscience. "While the war drags on, always worse," she began her poem, "An Interim," "the soul dwindles sometimes to an ant / rapid upon a cracked surface." She listens to mendacious, soul-tricking language in a laundromat and hears echoes of rationales government officials used to defend the absurdities of their policies: "It became necessary to destroy the town to save it." Language itself had become part of the perversion. Against this only action sufficed, and the hunger strike of an antiwar demonstrator, fasting to protest her jail sentence and prolongation of the war, gives Levertov hope. "We need / the few who could bear no more," she continued, "who would try anything, / who would take the chance / that their deaths among the uncountable / masses of dead might be real to those who / don't dare imagine death." When the daily news brings only accounts of unimaginable suffering, then only the most serious action can awaken the sleeping ("Might burn through the veil that blinds / those who do not imagine the burned bodies / of other people's children") and restore meaning to language, that is the truthful, unveiled expression of experiences and desires.[32]

Duncan's poetic theory left him an individualist, fearful of submitting his voice to the group cause, because it would be less authentic, subservient to the rationalist desire of the group for power to force the future into the projected end, stripping away all aspects of experience that might undermine the predictive power of social theory. For Levertov, collective solidarity founded

upon a sense of shared urgency made her poetry more authentic and opened her voice to share in a process of group imagination. The work carried not only her experience but, she hoped, those of the men and women with whom she worked on a daily basis. The need for collective action against a very powerful opponent went against the fundamentally individualistic drift of postwar avant-garde theory. The war forced all to consider the proper relation of group and individual. For Levertov, it was no longer sufficient to claim the sanctity of individual experience, if that sanctity was incapable of prevailing against concerted power. Poetics that was not also effective as politics was deficient because it did not build the "community" she believed that struggle could cement. The goal of poetry, she wrote, was to wake the "sleepers" from their apathy. While she agreed with Duncan that the primary effects of a poem lay in the nonpolitical, nonsocial realm, of awakening people to a spiritual life within them larger than everyday meanings provided, poems also always had specifically social effects.[33]

In an essay on her experiences as a teacher, she recalled the term spent in 1969 at the English department at the University of California, Berkeley. During her brief tenure, third world student organizations initiated a student strike that led to particularly violent clashes with the police. Conflicts escalated as well over the use of vacant land near the campus that some students had reclaimed as a "People's Park." In May the Highway Patrol and the National Guard occupied the campus area, and a nonstudent was killed during protests.

In the course of deepening crisis, Levertov found her poetry classes transforming into a community "that stayed together each day throughout the terror, and most truly—and with a love and mutual care that made that terror into a time of joy and wonder—practiced the injunction with which a list of points of conduct and tactics for the demonstrators . . . concluded: '*Be your brothers' and sisters' keeper.*'" The experiences at the "barricades" had disrupted the class but also taught her "a new vision of what life might be like in a world of gentle and life-loving people." From this grew a conception for a reformed communal and egalitarian educational system in which a group

would live together as well as study, "cook together . . . and grow vegetables and flowers together, and mend each other's clothes—and study not only one subject as a group, but several related and unrelated ones." Education would become the widening of intellectual horizons upon the foundation of a common emotional life.[34]

It was precisely this utopian vision of community that Duncan disputed, though he did not deny the appeal of apocalyptic thinking. He saw in her imaginary communities a replication in countercultural form of the conformist impulse present in all social interaction. Instead of liberating individual potential, such communal arrangements, to the degree that they could work, would impose another set of dogma and related linguistic clichés upon its members, so pervasive that even Levertov unabashedly professed that the student movement did not need to pressure anyone into participating. Adhesion always appeared "voluntary," Duncan pointed out, because social lies gained their power by granting individuals release from responsibility, an absolution experienced subjectively as ecstatic union.[35]

In Duncan's view, the antiwar movement was a false community, a fragment pretending to be the nucleus for a future whole. Community, he believed, grew from the long-term relationships into which individuals entered. The nucleus of the polity was the hearth, the household linked in immediate practical needs. Daily affections and sexual pleasure protected men and women from their primal desires.[36] In his "Dante Études," Duncan wrote,

The household to provide shelter
and to prepare its members
 to live well even

in atonality setting free
 rearrangement of atonement,
daily new keys in dreams,
 reappearance of the "home"
 note in the melody.

Each household community emerges from "chance encounters / as far as our neighborhood extends." Any broader concept of "community" was an illusion of psyches seeking to augment their power and impress their will upon the world. Will-to-power was one expression of adventurous needs, but it was the "grand exception," the "tragedy the city needs," but gained its meaning for people in its relation to the harmonies of the "home key."[37] Communities that based themselves on thrusting after glory destabilized themselves and ultimately collapsed from the psychological and social tensions such goals promoted.[38] The belief in one's own potential exceptionality enheartened, but it also ultimately increased fear and anxiety as hubris overcame the rational veneer.

> the only king I see
> sickens in our sickness and every night
> ripens to an illness in our need.[39]

What was often good politics subjectively in that it galvanized human action ("the king") was bad politics on a practical level of measuring material accomplishments.

Yet Levertov's position involved an inescapable practical truth: oppositional social movements needed more than wisdom to confront the power of the state. The imagination of community had been a continuous feature of the avant-garde's interaction with itself. As an imaginary category it had a peculiarly static quality. Its growth followed the spiritual development of those who turned to their fellows for sustenance and support. Levertov's antiwar "community" was of a different nature. Constituted in action, be it picketing or simply discussing what to do next, it was dynamic. The poet was engaged in activities outside her craft, outside her psyche. "Robert reminds me *revolution* / implies the circular," Levertov argued back in her poem "Entr'acte," "an exchange / of position, the high / brought low, the low / ascending, a re-

volving, / an endless rolling of the wheel."⁴⁰ She admitted that etymologically the word was wrong, but it was the only word the English language provided to describe the desire for radical change. The word might be inadequate, but the desire, growing from the bodily experience of a society at war and unable to "focus" on justice, was true and therefore necessary to follow. Its potential meanings would unfold as the community growing around a shared desire for change discovered the terms of that change through its own actions.

Still the psyche, Duncan warned, could never be left behind. Its demands lay behind every political step, just as cosmic forces, the process of the universe renewing itself through continual recombination of its basic units, lay behind every psychic motion. The release of the repressed required us to live in a perpetual state of doubt over the nature of United States society, the nature of one's sexual interests, the nature and origins of one's own actions. He found her statement in one poem—"there comes a time when only anger / is love"—a sign that love of violence had seized her imagination. She delighted in the prospect of destruction.⁴¹

Yet in a political struggle, radical doubt was counterproductive. ("Self-reproach can be a form of self-indulgence," Levertov observed.)⁴² There was a need to externalize the enemy in a form that was easily targeted. Eradicating doubt was necessary to accomplishing the social goals developed within the avant-garde, though Duncan was correct in arguing that such a step was contrary to the movement's philosophical foundations about the unique truths found in myth and poetry.⁴³

The crisis of the late 1960s fostered efforts to transform the dream of community into an actual practice. But what would be the basis sufficient to ground the dream? Gary Snyder turned to the creation of utopia by actually living his poetics at Kitkitdizze as if it could also be a politics.⁴⁴ Even at this local level, the complexities of human interaction and organization overwhelmed and disrupted the ideal. When it came to the much larger question of influencing American foreign policy, the situation was even more daunt-

ing. Few believed that their actions, in and of themselves, could end the war. Demonstrations therefore were like poems. Even when violence occurred, events had symbolic rather than practical purposes. Not until the Eugene McCarthy campaign for the Democratic presidential nomination in 1968 and the movement in 1971 to pass the Hatfield-McGovern resolution, expressing the mandate of Congress that the United States withdraw from Indochina, did opponents of the war have vehicles for their position that promised immediate practical consequences. The inability of the political system to accommodate debate about wars forced opponents into an existential rather than a political position. This as well increased the tendency toward demonology, since there was no point to dialogue.

On this level, Duncan was no different from Levertov. In "Up Rising," Duncan linked Johnson to Hitler and Stalin as one of the great criminals of the twentieth century. In "The Fire: *Passages* 13," Duncan describes Johnson and his generals bearing "the faces of the deluded" torturing Jesus in Hieronymus Bosch's painting *Christ Bearing the Cross.* Consumed by the mythic force of wrath, they were instruments of evil, which Duncan understood etymologically to mean a will that placed itself above law.[45] Connecting media images of American politicians with earlier renditions of the demonic, Duncan observed, "as if to drown sweet music out, / Satan looks forth from / men's faces: / Eisenhower's idiot grin, Nixon's / black jaw, the sly glare in Goldwater's eye, or / the look of Stevenson lying in the U.N. that our / Nation save face."[46] In another poem, American politicians, their souls destroyed by their blind choices, were transformed into archaicized caricatures:

> In the great storm of feer and rage
> the heds of evil appeer and disappeer
> heds of state, lords of the cold war,
> the old dragon whose scales are corpses of men
> and whose breth blasts crops and burns villages

demands again his hecatomb,
our lives and outrage going up into his powr
over us. Wearing the unctuous mask of Johnson,
from his ass-hole emerging the hed of Humphrey,
he bellows and begins over Asia and America
the slaughter of the innocents and the reign of wrath.[47]

The debates between Levertov and Duncan were not about how to make po-
etry a more effective political tool or about who could utter the most pro-
found personal truth about the war. Both were angered, dismayed, sickened.
Both were enheartened by the response of so many young people. "The
beautiful young men and women!" Duncan wrote about student protestors.
"Standing against the war their courage / has made a green place in my
heart. / . . . Love in His young innocence / radiant in His depth of time and
night / has waited and now—this is / the message of Christmas—returns
once more, / bearing the light of the Sun / fair in His face."[48]

The question that divided them was how they interpreted the emotional
aspect of their response to the war as effectively transformed into poetry. Be-
cause their dispute was about the craft of poetry, it was about the nature of
human action, for in both writers' terms poets were any people constructing
themselves through the "poems" they gave each other. The dispute then was
about the nature of being in opposition in the United States and the image of
self that one could objectively derive from participating in the antiwar move-
ment. Where Duncan differed from Levertov is that he refused to see his an-
ger as the basis upon which a new society might be built. His anger was a
reflection of the everpresent rage that had erupted into human affairs yet once
again in Vietnam. In "A Lammas Tiding," Duncan observed that as a man he
was a hawk, not a bird of peace. He was a ravenous devourer of weaker crea-
tures, if only psychologically.[49] The lust for power over others ran through his
poetry. This was not to be condemned, simply recognized. He had focused

his ambitions and aggression onto poetry. He had a "lust for vision" rather than a desire for body count, had the chance of history directed him into the military.[50]

In 1972 in a note appended to the republication of *Caesar's Gate*, Robert Duncan announced that he would refrain from further editions of new work while he focused on completing what he believed would be his two final volumes of verse. He projected publishing the first volume in 1983 and the second in 1989. This was no vow of total silence, since Duncan occasionally submitted work-in-progress to literary journals and circulated photocopies of sequences to friends. He also continued to lecture and tour the country on poetry-reading circuits. Still, the hiatus in publication of new work after the 1968 *Bending the Bow* historicized Duncan's work. He largely disappeared as an active voice in the continuing dialogue of contemporary work, exactly the social interaction that Duncan wished to avoid because it distracted him from the completion of his life's work. He did not want to be "current": "When I say I'm not current, I don't mean my work might not be of influence, but the influence will not be the vital one."[51] This quixotic action followed a pattern we have seen before in the careers of Joan Brown, Frank Lobdell, and Jay DeFeo: resolving the contradiction of ambition and ideals by withdrawing to refocus on the work itself.

Duncan had no apparent desire to reach a mass audience, but he wanted to engage those for whom poetry was a serious enterprise, first of all himself: *Ground Work*, he wrote a friend in 1971, was part of an effort to refocus his creative attention onto the creation of an intensely real, but fully private world.[52] In 1983, exactly on schedule, New Directions released Duncan's *Ground Work: Before the War*.[53] Further ensuring that the book communicated his and only his thoughts to the reader, Duncan insisted that the book not be typeset but that the printer prepare photographic plates of Duncan's typescript.

Ground Work: Before the War joined Duncan's meditations on the functions of myth and poetry in society with his responses to political events, par-

ticularly the Vietnam War and the role of poets in the crisis of American institutions that developed with the war. The Vietnam crisis had become, for Duncan, an instance of how psychosocial repression inevitably led to strife and the possibility of cleansing through confrontation with the larger forces that contained human action. "This is the creative strife Heraclitus praised," Duncan wrote, "breaking up, away from what you know how to do into something you don't know . . . Angry, confused, . . . the workers are released from the old order into the Great Work beyond their understanding."[54]

In "Santa Cruz Propositions" Duncan presented poetry as a form of surfing, riding the waves of memory and anticipation, of daily speech, the "facts of the polluted stream," and "the roar / of the giants we begin from." Poetry is the force of Eros, the desire of fragments to combine and bring change into the world. Its muse is "Old Mama Mammemory," the original unity that existed between infant and its mother. Myth, as Duncan liked to point out, derived from the Greek μύζω (múzo), literally murmuring. The sounds that children made to attract the attention of the mother were the origins of myth and poetry, and as poets created their works, they sought to return to the primal community, to "Old Mummummymurmurur."[55] The identification of poetry and dream with primal memory maintained a sense of universality, but stripped the aesthetic of an ability to establish a privileged direction to personal development. The process to which the soul unites precedes any idea of morality: the projections of myth can bless but also harm. "I turn on the flow, / the flickering TV picture feed, / to watch the news, the mind's noose / of violence," he wrote in "In Truth Doth She Breathe Out Poisonous Fumes."[56] Television lets loose the repressed into society in the form of mythic images: "juices from the meat at the mind-trough, the murders, / rapes, conspiracies of evil men." "I know in truth she is deadly," he concluded, moving on to a line from Dante, "exhaling infection whence the neighboring sheep pine even without knowing it." The mythic consciousness "tires the will towards overwhelming heaviness and / night."[57]

In the poem on the facing page, Duncan turned to the Christian myths of

America: "We have long wept upon this shore / confused and without ceasing have implored / the protection of a righteous king." Christ, in Duncan's mythic framework, was the embodiment of Eros, the principle of strife and division that brought hope by separating primal unity. But under the control of the negative face of psychological unity, Eros "sickens in our sickness and every night / ripens to an illness in our need."[58]

In "Santa Cruz Propositions" Duncan presented image making as a way of establishing identity. Therefore it was part of the process of separating the subject from the original "maternal" matrix, "arousing out of Her dream of Chaos / eggs of those forms that await the coming of Man."[59] Or as Duncan observed in another poem, "The Missionaries," "To man the advancing line / carries a message of manliness in its stride." Eros "was our Language come in to the Mothertongue / awakening Images, fecundities / . . . Chaos expiring in the Speech of the Winds."[60] A sense of direction established identity through images strung together to give an illusion of purpose, making poetry the basis of a quest. But the secret object of that quest was the repressed unity in which self was reabsorbed into a chaotic potentiality. The repressed then was the continual rebellion of the not-existent against the direction set in place, which always had in its exclusionary fantasies an imperial aspect. The choices humans made appeared to have the rightness and certainty of law, but within and around was the turmoil of all possibilities rising up to destroy not only faith in change, but the products of change. An underlying desire for multiplicity, a polymorphous being, was inherent to the process of differentiation. One could suppress it brutally as puritan regimes attempted, or channel these desires into carefully controlled environments where their potential for harm was reduced as in the mystery cults of the ancient premonotheistic Mediterranean world, but they could not be eliminated since they were in Duncan's view fundamental to the process of maturation.

The original state and its desires did not evaporate, but rooted in the core of the soul and yearning to return, invaded one's dreams. The reality of death gave the lie to the stability of progress and showed the ultimate triumph of

potentiality. The most fundamental biological aspects of being always broke down the achievements of the individual and returned him or her to the flux of energy exchange. Only the social persisted, only human institutions stood as proof that directionality could persist. But those institutions proved their point through their representation of and identification with death. They were the "monuments" of people long gone. Society could persist only by making death more important than potentiality and suppressing all those elements of memory and culture that tended to remind people of the transitory nature of life and its accomplishments. Society was a system of memorials that denigrated the most important aspect of human being: that each life was finite, that humans had a limited space in which to find each person's mission, in which to nurture hopes and ambitions and achieve individual nonmaterial culminations. The repressed truth that life was finite took hold in myths and elements of culture, but also inevitably in the irrational actions of human beings.

Duncan then turned to a recent murder case. In 1972 a high school dropout and unemployed auto mechanic who lived in a cabin in the Santa Cruz mountains read the tarot while on mescaline and turned over the card of "Eros before Eros, / the terrific first Mover at work toward Love." A conviction within him arose that only massacre could bring the hoped-for return to chaos that would reopen the question of possibility. He went to the home of a dentist half a mile away, tied up the family with scarves, shot each member, and threw the bodies of father, mother, and two small children into the family swimming pool. The murderer left a note claiming that World War III had begun and all who "misused the natural environment" would be killed without mercy. "Is Eros then evil and foul?" Duncan asked, quoting Socrates in Plato's *Symposium*. "He is always poor," Socrates remembered his teacher Diotima of Mantinea answering this question, "and anything but tender and fair, as many imagine him. He is rough and squalid . . . on the bare earth exposed he lies under the open heaven / . . . and like his mother he is always in distress."[61]

Duncan continued his poem by quoting news reports on the distress of members of the local community, who feared that all hippies would murder them in the night. They bought guns, while the county sheriff tried to assure the populace that there was no reason to believe that the crime was part of a conspiracy. Duncan saw the new ideology of law and order arising from unconscious fears. People wanted to protect what was from the mere possibility that something else could be, that is, to protect themselves from their own nightmares, which on the logical level could not be sustained by the insane acts of one man, whose actions suddenly seemed to say all experimentation was dangerous. His crimes were socially powerful because they stimulated forgotten desires for chaos that had to be repressed again by projecting them onto those who could more easily symbolize disorderly change.

At the same time, Duncan observed that the counterculture was not innocent in this drama, for its adherents liked to pretend that they heralded the dawn of a new age without considering the violence and tragedy that accompanied all change. They desired chaos, but were not willing to embrace the price. They thought they stood for a "new age" that could simply superimpose itself upon the old. No one looked at the passions within them, not even the overtly political New Left, some of whose leaders tried to rationalize the murders as an unfortunate by-product of class warfare in the United States. In the final section of "Santa Cruz Propositions" Duncan returned to his controversy with Levertov. What dismayed, but did not surprise him, was that Levertov thought her anger was an expression of positive change, that she too had a law that she intended to impose on others. "SHE appears," he wrote, "Kālī dancing, whirling her necklace of skulls, / trampling the despoiling armies and the exploiters of natural resources / under her feet. Revolution or Death! / Wine! The wine of men's blood in the vat / of the Woman's anger, whirling, / the crackling—is it of bones? castanets? / tommyguns? fire raging in the ghettos? What / is the wrath of Jehovah to this almost blissful Mother-Righteousness / aroused by the crimes of Presidents?"[62]

Kālī was, as a female figure, the giver of birth and therefore the revealer of

death. She gloried in destruction so that room would be made for the new. In assigning this mythical position to Levertov, Duncan made a knowing but cutting reference that implied that her political enthusiasms grew from a female archetype having seized control of her. By refusing to see the mixed sources of her desires, Levertov had lost control and become an agent of passions rather than a shaper of values. It was neither change nor anger that Duncan worried about, but the refusal of those with whose social ideas he felt comfortable to recognize that their ideas sprang from two sources: one was the surface level of political disputation, but the other was the unconscious repressed desire for change at any cost. One level was responsible, the other infantile. He pointed to an image from Levertov's "Life at War" as proof that underneath the politics lay a psychological drive that Levertov did not understand:

> the scheduled breaking open of breasts whose milk
> runs out over the entrails of still-alive babies,
> transformation of witnessing eyes to pulp-fragments,
> implosion of skinned penises into carcass-gulleys. [63]

Duncan argued that the image of the skinned penis was more than a shocking image of wartime brutality. Since *none* of the prominent antiwar poets had directly experienced the effects of combat in Southeast Asia, the particular images they deployed sprang from deep wells of fantasy that were completely independent, Duncan believed, from the desire to end the war. The images, as poetry, were transcriptions of inner obsessions. "When you look at her poetry it tells more to look at that flayed penis and realize that her earlier poems are talking about stripped stalks of grass! She's got one that loves peeling. Suddenly you see a charged, bloody, sexual image that's haunting the whole thing, and the war acts as a magnet, and the poem is not a protest though she thinks she's protesting." [64]

Poets who had devoted their careers to the uncovering of the mythopoetic

process also shared this blindness to the forces within them. Duncan noted that anti-Semitic, profascist Ezra Pound as the master for the American avant-garde had set a disastrous model for poets attempting to catapult their work into a quest for utopia. Even if the succeeding generation abhorred his particular politics, they shared the belief that a truth could be forced from poetry. In this sense, the ambitions of the avant-garde made them doubly susceptible to hubris. Both as Americans and as poets they asserted control over forces much grander than any human capacity: "In the fateful nature of his genius I saw the infection as deep, as the fateful nature of my nation itself—festering America—and as the fateful nature of Poetry too."[65] This surrender to the will-to-power meant that poets had not listened to themselves carefully or understood the messages of their work, which revealed the interaction between levels of being that rational thought could not see.

Much like the avant-garde poets, the New Left and the counterculture saw only their righteousness, but not their complicity, and thus Duncan had consistently predicted that the erotic politics of the 1960s was bound to end in disaster rather than a breakthrough to enlightened social consciousness. The aspect of sexuality as dependence upon and power over others, the desire to use one's spirit and body to force others to do one's will, would overcome the idealistic hope that free sexuality could be the basis for mutual relationships. Rock music would become increasingly misogynistic, Duncan observed, and poets would celebrate the hatreds they felt as a form of purifying love.

On this point, he found Levertov's poems fulfilling his expectations that the antiwar movement was drifting to expression of "terrible longing and outrage."[66] Folk singer Judy Collins, Levertov had reported in "Looking for the Devil Poems," had attempted to calm down a rowdy crowd at an antiwar rally by singing a song about the power of love. The crowd greeted Collins's efforts with stony silence, and Levertov found their reaction cheering. "Judy, understand," Levertov concluded, "there comes a time when only anger / is love."[67] Duncan summarized the scene he imagined from reading Levertov's poem:

to put down the age of revolt with *Love, Sweet Love,* she cries

from the center of terror
that is the still eye of the storm in her:

"*There comes a time when only Anger is Love.*"[68]

Duncan later said about this poem, "I didn't say it was wrong for her to have [violence] on her mind, but I said if it's on your mind the poem had better go into that, because that's its real ground—how come these things are here? . . . you can't scold an earthquake and you can't scold a war. . . . It isn't a moral question at all. It is a catastrophe." Humans are caught up in social events as they are caught up in natural disasters. To cope with them one has to be aware whether one's responses are part of the social catastrophe or an attempt to repair the damage. "I early thought, 'Well, how do I feel about good and evil?' And, then I'd realize that I thought you did good as good, not because it was going to win. I made something beautiful in order that something beautiful exist." Good and evil, beauty and ugliness would always exist because they were equally part of creation. A human worked for one or the other, but the dream of vanquishing evil meant only that good became its opposite.[69]

In "Report," Levertov responded,

> And meanwhile Robert
> sees me as Kali! No,
> I am not Kali, I can't sustain for a day
> that anger.
> 'There comes
> a time
> when only anger
> is love'—
> I wrote it, but know such love
> only in flashes.[70]

She confessed that the daily love of her husband and child did sweep her away from the fearful commitment to do whatever was necessary to bring change. Politics was a responsibility she forced upon herself. In the spring of 1965 she had resigned as poetry editor of the left-wing weekly journal *The Nation* in the hope she could withdraw from all immediate social responsibilities. Explaining her decision in a letter to Kenneth Rexroth, Levertov observed, "I occasionally galvanize myself into (what for me is) political activism but only in somber desperation. It gives me no satisfaction and I can't keep it up for more than a few weeks. It makes me feel I am wasting away. If I stuff envelopes when I might be writing a poem, it is wrong."[71] Escalation of the war in Vietnam and participation in the first teach-ins against administration policy drove her to subordinate poetic work to the antiwar struggle, but the new level of sociality she began to experience confirmed and strengthened her new direction. She argued that the war forced her and everyone else to choose between health-seeking action or disaster-enchanted imagination. She could testify that when the former triumphed, one felt free to sing because "the pulse rhythms / of revolution and poetry / mesh."[72] Instead of politics and poetry existing on two separate, if occasionally interacting, planes, Levertov committed herself to a situation where poetry became the expression of immediate, collective experience, became the potential basis for constructing memory, identity, position.

If Gary Snyder projected a practical side to the counterculture, Duncan faced what he thought were the monsters hidden within it. Not in order to condemn, or, as Levertov thought, to disparage collective action in favor of individual purity, but to plead that the new politics not ignore the application of its theory of repression to its own development. Mythopoetic politics brought the repressed to the surface so that everyone might learn about the complexity of their own motives and avoid replicating on a more banal level, as revolutionary movements had done since 1789, the crimes of the regimes they opposed. The project of enlightenment was false, and would be seen as false by the public at large, if the construct of confronting the repressed were

not applied for self-enlightenment. The project would fail because that anger and desire for change for its own sake would lead to crime: to Charles Manson, to the murder Duncan described in "Santa Cruz Propositions," to the Weatherpeople, to the collapse of the Black Power movement in mutual assassinations, and to the theatrical coups of the Symbionese Liberation Army in murdering the reform-minded African-American superintendent of education in Oakland or kidnapping Patricia Hearst. Turning to the more benign if equally "foolish" phenomena of the "love generation," Duncan observed that anxiety had increased as the expected results of a new millennium failed to materialize and the initial impulse of college dropouts to turn their backs on the "pride and power of the world" quickly decayed into institutional structures. Business organizations that sold New Age mystiques developed to assure those who had once embarked on experimentation that there was indeed a Truth. Each claim would fail to deliver the desired freedom from indeterminacy, and the countercultural movement of the 1960s would fragment into a plethora of secessions, each attempting to protect the little piece of the worldly pride and power it had seized in what had originally been a quest for transcendence. Neither violence nor hypocrisy nor confusion was unnatural, Duncan thought. Eros, the creative force, was first the spirit of strife before its transformation into the spirit of choice (which Duncan located as the symbolic meaning of Christ's sacrifice).[73]

The role of the counterculture had been to reintroduce strife into white American society, tottering toward disaster with interminable conflicts with subjugated peoples, so that white Americans could face at last the penalties of lusting after power over others. Called into being by the arrogance of the war, the counterculture and New Left had been unable to focus on the specific issues of foreign policy because their true, but unknown task was to bring to the surface spiritual states that the "conventional" mind of twentieth-century America had repressed. Rebellion had assumed the language of a psychotic episode to break through the limitations authority had imposed on the understanding of human relationships.[74] Responsible and irresponsible at the

same time, Eros organized dissatisfaction into resistance, at times rebellion, until institution-building forces mobilized to preserve the changes that had been accomplished. At the point that agents of change had something to protect in the new life they had created (be it social or purely individual), the idealism that had generated the change ossified into dogma and a new hierarchy came into being that would in its turn generate new dissatisfactions, desires for change, and a rebirth of idealism from the ashes of cynicism. Community was a subjective illusion. Its sense of connection lasted only as long as its shared hopes, unless a legacy developed that limited the free play of potentiality and bound people together in a shared environment. The source of real community was not utopian hope, but the limitations created by genuine human interaction, by the oppositions that lovers, mates, children and parents, fellow professionals, or even political combatants proposed to each other.[75]

Duncan argued that poets might have helped the movement confront its own rage that sprang from a liberating irrationality that also consumed those who surrendered to its power. Poets could channel passion into forms that would not destroy the moral standing or the psychological health of the "movement." Instead, they helped direct the nascent political and cultural opposition toward self-immolation by singing of anger and rage, as if any merely human position could ever be "correct." The antiwar poets had surrendered the powers unique to poets to influence society, their ability to reveal the source of evil in "the ever-returning scene of brutality and will."[76]

"Bring up from the dark water," he said in a companion poem, "It will be news from behind the horizon." When we can see nothing, he admonishes, we can do nothing. The repressed force of violence burst forth first in government policy, but "The great house of our humanity / no longer stands," and the "worm of man's misery" coils in the heart.[77] In his epigraph to the "Dante Études," Duncan wrote, "It is in the social definition of freedom / that we most sense / the presence of the Law: / pluralistic, multiphasic, / liberal, radical." A poetics of tragedy was needed to confront "the mixture of smooth

and / rough" that exists in the search for brilliancy endemic to civic life.[78] For Duncan, rooted like most of his contemporaries in a vision of domestic utopia, the household provided the most secure model for freedom: "to provide shelter / and to prepare its members / to live well even / in atonality."[79]

Throughout *Ground Work* Duncan returned to the meaning of his forty-year relationship with painter and collagist Jess.

> How has your face
> aged over these years to keep company with mine?
>
> ever anew as I waken endearing. Each night
> in the exchange of touch and speech blessing,
>
> prepared thruout for rest. Is it not
> as if He were almost here? as if we were
> already at rest?[80]

"He" refers to the Eros of homosexual love that had first spoken to Duncan as an adolescent in Bakersfield and drawn him through his unexplainable desires for physical contact with other men inexplicably but ineluctably into the profession of poetry.[81] When he wrote "I did not have to reach for *your* beauty, / Radiant, it entirely flowd out and thru me,"[82] he spoke of both sexual pleasure and the force of poetry bringing him into a "community" where his self-confessed idiosyncratic behavior and attitudes could be shaped to render service to his fellow men and women. Eros was an angel whose message was more than satiate your pleasure:

> *Contend with me!*
> you demand. And I am surrounded by wingd
> confusions. *He*
> is everywhere, nowhere
> now where I am.

In every irreality there is Promise.
 But there
where I am not *He* really is.

 In Whose Presence
 it is as if I had a new name.[83]

The lines evoke the myth contained in the biblical story of Jacob wrestling with the angel at Bethel, a theme to which Duncan had repeatedly returned. Poetry was a vocation, a "calling," brought into being with the same emotions, perhaps the same physical acts, aroused by love. The result was a changed person, renamed as Jacob was to Israel, "he has wrestled with God." Through an ongoing struggle with love, Duncan feels, "I am falling into an emptiness of Me."[84] The self was actually nothing, which in both Buddhism and Western gnostic traditions meant neither absence nor lack, but a fullness of being expressed as potentiality waiting to be called into form, in this case by the actual relationships to which one makes a commitment:

 Let us speak of how these perishing
 things
 uphold me so that

 I fall

 into *Place*.[85]

Emotional commitment and profession brought Duncan to contemplation of human finitude. The acceptance of love through domestic companionship led to confrontation with death, through observation of the changes moving through body and soul of one's companion and contemplation of inevitable loss. Sexuality linked to responsibility forced one to face the limitation of time each man and women had. Choices had to be made of what one wanted to accomplish and leave behind. The legacy was the "Identity," "the Ever-Presence," the character of a poem, which placed each human in a spiri-

tual community that was entered fully only in death. The end of love was to bring into being one's own place

> In the Grand Assemblage of Lives,
>> the Great Assembly-House,
> this Identity, this Ever-Presence,　　arranged
>> rank for rank, person for person,　　each from its own
> sent out from what we were to another place
>> now in the constant exchange
>> rendered true. [86]

By revealing the finitude of each life and by preparing one slowly but surely for the dissolution of all that one valued most highly, the companion becomes the embodiment of the cosmos *and* of one's place in history. The infinite variety of experience fits into a structure of meaning where all attain their place by giving their example as a gift to every other soul, even the monsters. To die *in* one's dream was to create a new self imbued with divine power. Death was the "condition of eternal forms," for only at that most inward moment did the apparent fantasies with which one struggled through one's life vanquish all historical accident and the soul entered an apotheosis of the desires that had constituted its development. [87]

Through Eros nature and society are rejoined, but at the cost of exposing the imaginary nature of community in modern life. Community was a psychic factor that promised unity by containing and balancing the "multiple sets of fields turned in different directions" within the individual. If public order was rotten and new identifications were needed to replace the malaise of nationalism, Duncan suggested as an alternative locus of one's loyalties and concerns confrontation with the limits of one's existence. By focusing on the hard concreteness of one's life as an object heading toward death, a person became a subject narrating the possible stories of that life and the plenitude of its connections. [88]

Duncan's application of poetic vision to the drives of the countercultural

movement provided a self-critical vision of forces within the 1960s protest movements that would subvert their ability to act with social responsibility and thus effect structural change. He revealed the desire for community to be a pious, religious hope for spiritual union. It had no material basis around which to consolidate except the transitory forms that sprang up to protest specific government policies. Ultimately the only real communities Duncan could visualize were the one-on-one relations between lovers and the practical tasks bringing together those engaged in parallel but limited goals. It was a vision that could provide sustenance only to the most ascetic, but it affirmed the tradition of bohemia as a refuge for those who refused standardized, predictable patterns of individuation offered in middle-class society. Their experiments amused and shocked, but the truths they learned remained within their own tradition. Bohemia was a place where truth had to be individual and each victory could only be personal.

15 Subjectivity between Myth and History

In his poems on the Hebrew alphabet, Stuart Perkoff wrote,

> history is the hand's fingers reaching, reaching for power.
> history is the hand's fingers pointing to the future.
> unknown, unknowable. no tool can carve its image.
> man as angel. as debased monster. potential is infinite.[1]

Within the avant-garde this was a statement of a basic, even banal position: if potential were infinite, then men and women needed to make choices. They needed vitally to observe the world they lived in and reflect upon their experiences. Few outside artistic circles were willing to embrace semantic multiplicity and epistemological indeterminacy so readily, for it meant placing their own identities and social roles into perpetual crisis. Labeling the group that dedicated itself to personal freedom through epistemological uncertainty "beats," or more contemptuously "beatniks" and later "hippies," was a way of putting boundaries around a problem much larger than art, but which during the two decades following World War II was most clearly visible in the practice of experimental, elite art.

Scientific languages were powerful in the results they could generate, but understandable only to those in each specific field. Within those fields scientific models tended to follow game theory, as in quantum mechanics. The

58. Wallace Berman, birthday card for Joan Brown, 1972. Wallace Berman
papers, Archives of American Art, Smithsonian Institution.

relation of science and everyday experience had become more attenuated, so that the wealth of society had come to depend upon epistemological uncertainty. Yet when scientific models crossed over into engineering, they underwent a sea change. Achieving a goal with consistency, be it the production of an automobile or the launching of a missile, required accepting the absolute validity of laws and techniques applicable to the situation. Context was discrepancy to be removed. The growth of systematic professions organized to execute specific purposeful rational action satisfied important aspirations, emotional as well as material. Professionalism provided people with clear tasks and consensually approved standards for measuring performance.

Practitioners of aesthetic production were also professionalizing and specializing, but their situation was different in one fundamental respect from the activities of other systems of practice. The purposeful rational action of artists and poets was symbolic interaction directed toward mutual understanding of experiences. The more refined work of artists and poets involved confronting the ambiguities of language and perception.

Professionalization in the arts involved superficially contradictory movements. Poets appeared to be speaking for the continued relevance of generalized discourse that would more effectively share highly individual situations. At the same time, there was a turn to ancient technologies of symbolic interaction. To many poets, premodern societies appeared to be more concerned with social interaction than the accomplishment of purposive-rational tasks.[2] Poets could look back to ancient forms of thought such as the kabbalah, tarot, the *I Ching*, and other gnostic traditions to find sophisticated models for their work. Poets appeared to be reviving archaic modes of thought in opposition to modern society, but they were creating their own episteme of knowledge that would give weight to poetic experimentation.

Conflict between poetic practice and other forms of social activity also derived from poetry's origins as a method of shared interaction. Aesthetic production challenged the priority given noncontextual rationality in other fields. Yet as long as poets and artists produced work in order to seek a place

within society, they were also operating in a rational, functional manner. The challenge to rationality then covered a less sweeping task: to become proponents within society of the need to consider the individual situation, the need not to treat human beings as interchangeable parts of a social machine. The success and dangers of rational thought demanded a growing sphere for personal choice and growth. Poets helped articulate that need by emphasizing the negotiation that went into personal relationships rather than the following of prescribed rules, the individuality of utterance rather than context-free formulae such as those used in production but also found in other areas of society, the need for individuation and choice rather than the growth of productive forces and extension of power. As poets professionalized their claims, they transformed artistic production from the conveyance of stable symbolic values into a game of potential meaning. Language not only did not need firm referents, but the mystique of serious work was enhanced if it dramatized multiplicity and indeterminacy. In the antinomian tendencies of the avant-garde, the word and the thing coincide only temporarily, if only because words become saturated with social context. Pastiche captured a range of meanings that might envelop a thing during a given temporal and social period—much like the electrons surrounding the nucleus of an atom. The specific position can never be pinpointed, but the shape of possible positions can be delimited precisely. Artistic production did not shed its symbolic functions, but aesthetic process itself became a symbol of freedom and creativity, beyond the specific context within a poem or an artwork.[3]

None of this was socially or politically neutral, although these developments involved a move away from politics as a source of interpretive value. By emphasizing the importance of personal experience, the avant-garde in effect challenged the right of those with institutional power to proclaim what the values guiding social activity would be. The avant-garde did this in an anarchist pose, denying the right of all authority, but the question was more profound than simple power relations. Individual experience and a priori norms

59. Noah Purifoy, *Sir Watts*, mixed media, 1966. Courtesy of the artist.

were potentially incompatible approaches to the regulation of social interaction. What had been a problem of interest to technicians of the word and the image undermined the equilibrium of all activities and institutions. Solutions were to freeze meaning, the preference of social conservatives who proffered a reified vision of an enduring Christian civilization of which the United States was the highest instance (or, what was in fact the same thing, the most degenerate); to imagine society proceeding to natural law, which was an unstable concept since the degree that technology increased human power and thereby the potential for expression of individual creativity undercut the lawful basis upon which that progress depended; or to accept the liberating, if dangerous, potential of epistemological uncertainty, a world comprised of effervescent, shifting, pulsating meaning that might or might not be suitable for rational planning.

For reasons both external and internal to the avant-garde, its particular perspectives provided public discourse with a form of dissent based on defining one's needs, which required first examining one's relationship to the total environment. To maintain the possibility of autonomy and personal choice required finding value in confusion. Freedom grew from the possibility of unbounded texts, which, if not based on some utopian scheme, became as ephemeral as human life.

The claims of irrationality were not localized to the West Coast. Around the country, people involved in aesthetic experimentation moved in parallel directions. Paul Goodman and John Cage found national audiences for their critiques of instrumental rationality. Goodman's *Growing Up Absurd,* as well as his books on community planning and Gestalt psychology, were explicitly political and designed to transform personal discontents into rebellion against restrictions on purely personal behavior and against government policies that perpetuated status and privilege at home or abroad. Cage retreated from all political disputes, but he considered his theory of chance operations to be a way of relying upon apparent accident to free oneself from "choices" already predetermined by ideology and social convention. The Black Moun-

tain poets, particularly Robert Bly from Minnesota, replicated many of the developments found in the San Francisco poetry movement, although with somewhat greater attention to formal issues. Walker Percy in New Orleans converted to the Catholic faith and found in the sense of grace following the sacraments an inner experience the truth of which escaped all purely sociological explanation, an experience that led him to reject segregation and racism as the products of a rationality that controlled through categorization and typologizing. Amiri Baraka and the Umbra poets group in New York used poetic practice as a way of expanding what could be said about African-American experiences, an aim that culminated in the revival of Afrocentrism in the mid-1960s. Baraka had also been coeditor with Diane De Prima of *Yugen*, the widely read beat journal published on the East Coast. Alfred Ligon and the Aquarian movement with its interest in ancient Egyptian gnosticism as the hidden source of African wisdom also provided many of the specific cultural features of the black power movement.[4]

The common theme of protest movements in the 1960s influenced by the ideas of artists and poets was the insistent demand that the principal decisions of one's life be voluntary and not coerced. At the very minimum, individual autonomy meant the right to define the meaning of one's own experiences, and that might include the decision that the satisfaction of desires hitherto decreed vicious was positive. Shifts in the boundaries between public and private authority coincided with escalation of United States troop levels in Vietnam, but the war was not the determining factor in the spread of these ideas. Attitudes and styles flowing from the artistic avant-gardes were already a well-developed and expanding force in American society by 1965. The conflict in Indochina stimulated the projection outward of radical utopias as many turned to the subjective powers they experienced to propose alternatives to a public order believed to be completely evil. To see private experience and public life as two distinct, antithetical orders had profound ramifications for how one defined the scope of political life and the proper questions that should be included in its deliberations. The relocation of value from public

order to private experience meant, for example, that "freedom" as the right to participate in civic life with the corresponding obligation to abide by its decisions yielded to a sense of independence from civic life and a diminution of its sacral character.[5]

Yet the relation with social reality was more complicated than the elaboration of myths of freedom that validated the importance of personal choice. In their own movement for personal, subjective freedom—that is, the ability to determine meaning for one's own experiences—artistic creators claimed to speak for all who have been excluded from participation in public symbolic production, even those who might despise the avant-garde and its activities. Even as the figures we have studied asserted the right of personal choice against collective authority, thereby restricting the realm of public life, they sought to redefine and expand the public order as a forum for exchange and perpetual revision of meaning, as an arena where the imaginary could be put into flux so that people could repropose themselves, that is to say, repropose the relationships determining their position in society. In this conception of social life, the arts, both popular and elite, become a primary form of collective governance, though one lacking any effective sanctions other than ridicule.

The degree to which issues of personal morality and symbolic production have replaced substantive economic policy as central questions of political debate in the two decades since American withdrawal from Vietnam should underscore how much the perspectives of mid-century arts and poetry communities pervaded other sectors of United States society, though often in an inflected form. Out of the cultural conflicts of the late 1960s three factors in particular became important political realities, factors that we can use to define the tentative subjective shifts of which avant-garde artists and poets were both authors and representative examples: (1) greater frankness in public expression about varieties of individual behavior, particularly as related to sexuality; (2) distrust of public life as a persistent threat to the primacy of personal

experience; (3) fracturing of a unified American identity based on shared myths of a common natural history.

The first factor stemmed from the suspension of many legal restrictions on personal behavior. Among the rapid changes between 1965 and 1975 in the legal rights of individuals to make fundamental decisions about the conditions of their lives were the end of censorship of artistic statements and circulation of information on sexuality; relaxation of enforcement, if not actual repeal, of laws against homosexual relations; and most important, the Supreme Court's 1973 *Roe* v. *Wade* decision protecting a woman's right to an abortion through an extension of the privacy doctrine. Each of these developments became an area of intense political contest, and by the end of the 1980s, conservatives had succeeded in using their control of the administrative and judicial branches to limit access to abortion and to narrow the speech rights of those who accepted government funds. The American body politic remained divided over the degree to which individuals should be allowed to propose their own interests and identities, while the conservative voting bloc contained a well-organized minority that passionately rejected the transfer of moral authority from established hierarchical institutions to individual decision.

If public opinion polls are to be trusted, the retreat of the government from controlling intimate personal behavior did not initially develop from popular demand. In 1972 two-thirds of women and three-fifths of men in the United States opposed legalization of abortion, and state referenda attempting to win abortion rights consistently failed by large margins.[6] The demand for abortion rights appears to have come from a relatively small but influential group, largely college educated, whose interests converged with those of a long-established civil liberties lobby that had developed legal theories to support abrogation of majority rule in situations concerning purely individual and personal behavior.[7] The sectors in society most strongly supporting abortion were indeed the core cultural consumers in the United States, not only

for elite culture, but for much of popular culture. Their attitudes therefore tended to find a disproportionate share of public cultural expression if only because motion picture and music producers, publishers, advertisers, and, increasingly, television programmers targeted their product toward a younger, college-educated, professionally oriented population.[8]

Motion pictures, popular music, television became freer in the subjects they explored and in the language used, while formal concerns in the elite arts dissolved into a sometimes joyful, sometimes morose, often puzzling aesthetic based on the ruptures between signifiers and signified, which furthered exploration of how the languages we use to represent and analyze experience create what we believe to be the events of our lives. Culture became a field where "anything goes," meaning that vicarious exploration of the wide varieties of individual behavior became a major interest for both creators and audiences. The direction of the counterculture, of the bohemian project as it entered into mass culture, was not social, but subjective reform. The ability to speak of experiences that had always been painful but had only recently become expressible did not mean, however, either that pain vanished or that its causes were known. The narration of self was the first step in a process with no predefined conclusion, but which would at the very least force others in society to acknowledge the variety of experiences their world encompassed.

The second outcome was the success of the antiwar movement in discrediting the motives of public leaders. Opponents to the war appear never at any point between 1965 and 1973 to have gained majority support for their views. The counterculture and the New Left more likely helped establish the conservative hegemony over the executive and judicial branches after 1968. By reducing political questions to existential choices, the countercultural opposition helped a majority of voting Americans (many of whom were not part of the key culture-consuming groups) to clarify their positions. As the public observed the symbolic struggles waged during the intensification of the Vietnam War, many did in fact "get it," and realized that their hearts were not the same as Snyder's and his colleagues'.

Nonetheless, in 1969 the editors of *Fortune* magazine, dubbing antiwar protestors "forerunners," predicted that their general opinions on government and business would ultimately find a receptive audience in the general public, even if attitudes toward demonstrators remained ambivalent.[9] In the aftermath of the war large majorities of the American public did abandon unquestioning trust in the inherent goodness of their government to become equally suspicious of the motivations and competence of all public leaders. In 1978, 74 percent of those interviewed for the *New York Times* agreed that the "government was controlled by big business for its own profit," a statement with which only 18 percent had agreed in 1958. Disenchantment with public solutions to social problems was a factor in decline in voter-participation rates, particularly among those who reached voting age after 1965. A *New York Times* survey of nonvoters in 1979 found that 58 percent of those who did not vote gave as their primary reason that the country needed "greater change than was possible to achieve at the ballot box," while 41 percent of those who voted agreed with the statement. Of those who held this opinion, 67 percent classified themselves as conservatives, 31 percent as liberals, indicating the degree to which distrust of public authority reflected but also crossed ideological alignment.[10] Americans had won greater personal freedom, but had sacrificed in exchange their faith in an effective public order.

The belief that crimes lay at the founding of the American state was a specific instance of a broader distrust of all institutions, which was felt most strongly by those groups finally able to speak of the oppression that had shaped both their collective histories and their members' individual development. A third outcome developing from honoring the truth of personal experience was widespread recognition that American national myths had little relevance for, and often falsified and mocked, the actual histories of the country's many social groups.

The claims of the aesthetic avant-garde foundered in this awakening of multiplicity that it had helped foster. The claim to universal truth found through the special link aesthetic process had to cosmological process in fact

limited the variety of experience by projecting artists' and poets' relatively narrow situations onto a purported universal (counter)subject. The rise of women's, ethnic, gay, and lesbian arts movements in the late 1960s and early 1970s marked the end of an aesthetics-defined avant-garde. These new movements challenged the largely white male contours of the older avant-garde, but more important, artistic process itself no longer provided the critical image of liberation or the adventure that gave a new identity through discovery of timeless elements within and without. These artists and poets turned instead to examine the repressed histories of their groups to help (re)construct autonomous cultures and confirm the identities that those histories gave them as individuals. Creative people were among the first to bring the experiences of women, gays, lesbians, as well as those of the variety of nationalities and races constituting the American polity, to the surface in a form of ongoing national shock treatment. Changing ways of understanding and representing subjectivity were central to the processes by which subordinate groups attempting to assert their own authority and multiplicity contested with some success the previous ideal of a unified, consensual body politic. The battle for increased opportunity and access to the instrumentalities of power had coincided with a claim for the freedom to tell one's own story for oneself.

Radical utopia was a way of turning to the elements within subjective experience for a reformulation of social organization. The known satisfactions of personal life would replace the confusions and frustrations of public life. The imagination of community was a necessary step in achieving a sense of the self that could take its place in society without necessarily accepting the social narratives proposed by those at the top of the hierarchy. Confronting "repression" was part of this process as it stigmatized convention as compulsion and valorized exploratory openness to changing patterns of connections. Yet any vision of community was unstable as long as its foundations lay in the shared

hopes of potentiality rather than mutual obligations that restricted the scope of further change. In 1956 Gary Snyder wrote in his journal that

> the poet must choose: either to step deep in the stream of his people, history, tradition, folding and folding himself in wealth of persons and pasts; philosophy, humanity, to become richly foundationed and great and sane and ordered. Or, to step beyond the bound onto the way out, into horrors and angels, possible madness or silly Faustian doom, possible utter transcendence, possible enlightened return, possible ignominious wormish perishing.[11]

At a period when he supposedly was breaking with his homeland, Snyder already recognized that innovation was a path for affirming continuity through selecting those aspects of one's life that were most meaningful and developing them as the basis for future growth. To formulate hopes for the future required narrating one's experience and reproposing oneself as a subject of a story one did not fully control, nor could ever control without replicating the imperial monster that one sought to escape.

Thirty-five years later, in 1990, Snyder defined freedom as the ability to work within the limitations of impermanence and imperfection. Human inadequacy he felt was the source of freedom, as was the tendency for ideas to fall short of reality, because failure created "play in systems, room for change, though at the cost of pain."[12] Zen had been a path of freedom for him because he learned that nothing was established, everything changed, and no individual was determined. Unlike the fundamental postulate of European rationalist philosophy, *nihil ex nihilo,* Zen taught him that everything ultimately came out of nothing and manifested itself first through action that on its initial appearance had no discernible motive or predictable effect. A Zen roshi might tell an adept who complained that life in the monastery was too rigid:

> "You have complete freedom here. Express yourself. What have you got to show me? Show me your freedom!" This really puts you on the line— "Okay, I've *got* my freedom; what do I want to do with it?"[13]

Judgment and power in and of themselves were not freedom, even if essential aspects of human action. Instead, the scope of free human action was rather narrow: the ability to act and demonstrate one's virtue in specific situations where the end results were not and could not be predictable.

In less dramatic but more commonplace manifestations, freedom meant only an ability to evaluate one's life and make significant life-course decisions with the full knowledge that one's commitments limit further action and reduce the scope for future freedom of responsible action. For if freedom comes into being through action, its presence reveals a need to redefine relationships with other beings. As relationships mature and become more complex, the ability to change them becomes more restricted because the consequences for those involved become increasingly more serious. The life that has been lived is no longer a source of freedom because the story of that life involves the people that its actions enveloped.

In the mid-twentieth-century, youth and artists symbolically occupied a position in United States culture representing popular concerns and yearnings for innovation. Both "youth culture" and the avant-garde increasingly gained more significant and lucrative places in the national imagination. By the early 1960s, elements of youth culture and the avant-garde began to merge so that work directed toward educated young people became vehicles for transmitting the once arcane ideas of artists and poets into the general culture. Americans felt that they had the greatest potential for change at the transition from adolescence to adulthood when a person had no fundamental ties, while artists, demonstrated with particular clarity in Kerouac's novels, seemed to have discovered a method for prolonging that state of transition indefinitely. Kerouac's fame served, however, a double function in the public imagination, for the scandal surrounding him reminded his readers that refusal to enter into responsible relationships in itself becomes a restricting rather than liberating factor. As the range of action coincides more and more with irresponsibility, the costs of freedom increase to a point where the most free act is to accept the consequences of one's previous actions. This was the position at

which most avant-garde poets and painters arrived in their variations on domesticity and professionalism. They affirmed traditional goals and values as the highest, though not obligatory, product of individual liberty.

By far the most common source of utopian vision was found in an ideal of love, family, and household which reached one of its most consistent expositions in Gary Snyder's proposals that the family could become the basis for global reorganization. Those who acted as if domestic relations could provide an alternative to a public order they deemed hopelessly brutal and doomed passed over the possibility that the external oppressive context was essential to what made the promise of domesticity attractive and necessary. To place one's hopes in domesticity was to affirm a pillar of conservative social thought in twentieth-century America, one of the key images in the monolithic ideology of the "American Way of Life" that they fought in so many other ways. In no aspect of human behavior were stereotypes more deeply entrenched than in the areas of sexuality and engenderment. The attempt to find "prelinguistic" truth often meant accepting stereotypes as the expression of an "original," natural order that could be turned against society's dictates.

The result was an apparent anomaly: regressive, if more traditional, aspects of social thought undermine more progressive forms of social organization in order to create a space where the individual can move with greater autonomy from collective authority. Reflection upon experience proved not to be an external fulcrum for changing society. Yet to attack the authority of government, established religion, and employers to impose their meanings upon ostensibly free citizens was to undercut a system of subordination and the structured hierarchy in which domestic relations had derived some of their characteristics. Domesticity was a form of manipulated consent when its institutions constructed an identity the terms of which superiors defined and enforced. But what if people, in assaulting what they considered the arbitrary powers of others over their lives in professional position and employment, chose to idealize living arrangements that had been part of an oppressive social structure? Do they then unknowingly reproduce the oppression from which

they have sought to escape? The question is complicated but central because upon the answer one gives hangs an assessment of the validity of personal judgment and desire as guides to action, of the theoretical capability of people to define a position for themselves that is genuinely theirs and not simply the replication of a subordinating ideological structure. If, as Robert Duncan argued, theory contained at the heart of its rational structures a mythologized form of irrational desire, there could never be an objective fulcrum for leveraging social change. All approaches replicated the contradictions that made transformation seem urgent. Those involved in change also sought to maintain privileges and pleasures, as well as power over others. Theory and experience were needed to correct each other, for they reproduced different aspects of the system from which they emerged. Escape was impossible, so any change had to start at a point of vulnerability. Whether desired or not, innovation always involved an element of continuity.

Could the postwar American aesthetic avant-garde have possibly found a platform for challenging the exercise of power without simultaneously affirming an element of interior life that could act as a counterauthority, that is without necessarily relying on fantasy images of stereotypes that satisfied desires for both change and stasis? Or conversely, to continue with the one issue of domesticity, could they have found a way for companionate marriage to continue as a practical ideal in their own lives without subverting the encrusted, authoritative ideologies surrounding love as unfulfilled sexual need and marriage till death springing from impulsive ignorance? The prevalence of stereotypes guaranteed that the poetic language of post–World War II America was infected with the deception of social lies, but that was a condition for poetic language operating as a challenge to the very falsity and deception infusing it. There could be no untainted experience, so, to use Duncan's paradigm, poetic language was utterance that brought to the surface (even when it refused to acknowledge its own contradictory sources) the civil war of its inception—a desire to belong was yoked to a desire to separate, at least to the point where the basic conditions of one's existence appeared voluntary,

a desire to be free linked to a desire to exercise arbitrary power and to find one's position through "dependents." In this confusion of apparently contradictory demands emanating from different aspects of one's life lay the basis for choice.

Stereotypes that linked people back to the society they criticized nonetheless established the imaginative basis for, hence the possibility of, independent action. One need not have, and indeed is unlikely to have, a fully developed philosophy behind one's actions. "Discipline of following desires, *always* doing what you want to do, is hardest," Snyder wrote in his journal in 1955. "It presupposes self-knowledge of motives, a careful balance of free action and sense of where the culture taboos lay—knowing whether a particular 'desire' is instinctive, cultural, personal, a product of thought, contemplation, or the unconscious."[14] Stereotypes provided an alternative to the hard work of self-reflection. Cultural shifts begin with the opening of a door previously shut, an awareness of having to choose between apparently contradictory demands, with a vision of new possibilities that do not preclude maintaining access to the position from which one began. One possible, indeed likely response is to refuse as long as one can to recognize the distinction between continuity and innovation, as one young girl in the Haight-Ashbury did when she told an interviewer in 1967 that her goal was to enter into a marriage that would last until death. Knowing that this contradicted widely held preconceptions about the counterculture and free love, she added, "The thing that isn't traditional is that I won't get married because I want to sleep with somebody. I'll get married when I feel like I want to have somebody's children, and raise them with him for the rest of my life, their lives, our lives. But I don't feel that you've got to have permission from society in order to live with somebody."[15]

After the 1968 elections public life in the United States entered a period of disjunction between increasingly more open cultural and relatively conservative political preferences. The stalemate left open as a divisive social issue questions of how much control government should have over private deci-

sions. Did the subjective focus of the aesthetic avant-garde that found in private life a haven from the disorders of public life ultimately reaffirm structures that organized consent to a hierarchical and oppressive system? Or did they work to loosen those structures so that play of potential meaning undercut the ability of those who had monopolized power to transmit a single point of view and thus enforce their will with relative ease? Is it possible to develop normative standards for distributive justice without negating heterogeneity of experience? These remain open problems of contemporary American culture because, while the political tensions are real, from a perspective that focuses on subjective process these apparent oppositions dissolve. The balance between private and public components of identity involves the degree to which individuals combine their own experiences with the theories available to them and leave open the ability to act without certainty of the results but within a model of the world that coheres in a relatively predictable way. Innovation stands forth as a strategy for conservation, even apotheosis, of one's past. Processes of consent lead to multiplicity so that, for example, the nearly universal ideal of domesticity becomes the field for the most intense cultural warfare over various definitions of what a family might be.

A retreat into an aesthetic vision proved to be a way of maintaining and deepening critique of social reality, but in a manner that refused to reduce itself to categories subservient to political ideology. The conclusion that art could be autonomous from civic life may be an illusion (as to a degree all human beliefs are), but it was one that grew out of reflection on the history of the times. Nor did it preclude active involvement, but the perspective cautioned that alongside the public persona was a private imagination, the truths of which were also essential for achieving one's goals.

The polarities I have identified in cultural statements from California's poets and artists—potentiality/necessity, commerce/imagination, public/private, rationality/irrationality, innovation/continuity, aesthetics/politics—reflect a stage in the synthesis of what had previously been perceived as historical opposites. Within the subjective consciousness of artists and poets, a

cultural adaptation can be seen, an adaptation that allowed them to move from the interwar posing of tradition and experimentation as *political* opposites—André Breton's choice of social change through automatic writing or T. S. Eliot's choice of social hierarchy and the poem that rooted itself firmly in the collective wisdom of tradition—to the postwar period where conflicting approaches to the function of art within society merged and became a basis for a presumed direct expression of an authentic personal experience. The separation of art and social praxis was a developing fact as artists withdrew into the relative autonomy of their own institutions, but the apparent elitism of the postwar avant-garde was deceptive. Difficulty was not necessarily in conflict with democratic values, nor was the desire to create a practice independent of mass communications. Neither proved insurmountable obstacles to finding celebrity status and relatively large audiences. The practice of art became a field that allowed private concerns to enter into the realm of public discourse in ways that ultimately altered the terms of political contention.

Proliferation of narratives has forced institutions to treat conflict rather than harmony as the practical basis of civic life. To use Robert Duncan's metaphor, social interaction has become a debate between poems, in which each person tries with varying degrees of success to convey the meaning that he or she has found. All that emerged from the travails of the artists and poets whose stories we have turned and returned was mere possibility. They helped for a yet-undetermined length of time to widen the scope of experience to which society will listen and respond. Those so moved can testify in as concrete terms as possible of their lives, bringing to the surface the confusing multiplicity of experience, including the shifting interpretations and the fabulistic roots of consciousness that in its socially determined forms seek expression in stereotypes. There was no happy ending of mania exhausted and order restored, or of tyranny toppled and a new psychosocially therapeutic regime growing from the ruins. There were no utopias whatsoever emerging from the 1960s, of either the right or the left, of stasis or innovation, of freedom unchained or repression reinstated, only a peculiar symbiosis in which

consciousness bridged desires for stability and innovation in unremitting tension. Only a potentiality, a modest increase in "freedom of speech."

Yet through the assertion of needs that poetry and art do little more than describe with varying degrees of eloquence, new social facts sprang into existence, if only because expression required someone else—be it a lover or the president—to make a response. Strangely, freedom is a meaningful category to the degree that it becomes unfreedom, that is, when human action is no longer simply the epiphenomenal play of possibility but creates facts that others must consider in the contingency that presses upon them.

Notes

Abbreviations

AAA	Archives of American Art, Smithsonian Institution.
BL	Bancroft Library, University of California, Berkeley.
CLP	Kenneth Rexroth. *The Collected Longer Poems of Kenneth Rexroth.* New York: New Directions, 1968.
CSP	Kenneth Rexroth. *The Collected Shorter Poems of Kenneth Rexroth.* New York: New Directions, 1966.
DSC	Department of Special Collections, University Library, University of California, Los Angeles.
OHP/UCLA	Oral History Program, University of California, Los Angeles.
PAS	Public Affairs Services, University Research Library, University of California, Los Angeles.
PT	Kenneth Rexroth. *The Phoenix and the Tortoise.* Norfolk: New Directions, 1944.
ROHO	Regional Oral History Office, Bancroft Library, University of California, Berkeley.
SFAA	San Francisco Art Association Archives, Library, San Francisco Art Institute.
WOW	Kenneth Rexroth. *World Outside the Window: The Selected Essays of Kenneth Rexroth.* New York: New Directions, 1987.

Introduction

1. Quoted in Roger Aikin, "Henrietta Shore: A Retrospective, 1900–1963," in *Henrietta Shore: A Retrospective, 1900–1963* (Monterey: Monterey Peninsula Museum of Art, 1986), 21.

2. Mildred Edie Brady, "The New Cult of Sex and Anarchy," *Harper's* 194 (April 1947): 312–322.

3. Jerrold Seigel, *Bohemian Paris: Culture, Politics, and the Boundaries of Bourgeois Life, 1830–1930* (New York: Penguin Books, 1986); Carl E. Schorske, *Fin-de-Siècle Vienna: Politics and Culture* (New York: Vintage Books, 1981). Related works are T. J. Clark, *Image of the People: Gustave Courbet and the 1848 Revolution* (Princeton: Princeton University Press, 1982) and *The Painting of Modern Life: Paris in the Art of Manet and His Followers* (Princeton: Princeton University Press, 1986);

and Debora L. Silverman, *Art Nouveau in Fin-de-Siècle France: Politics, Psychology, and Style* (Berkeley: University of California Press, 1989). I have adopted as a working definition of "avant-garde" Peter Bürger's proposition that formal innovation in an avant-garde was motivated by the goal of eliminating the distinction between art and life. See *Theory of the Avant-Garde* (Minneapolis: University of Minnesota Press, 1984).

4. Luisa Passerini, *Autoritratto di gruppo* (Firenze: Giunti Barbèra, 1988), 39.

5. For further discussion of subjectivity and the use of oral sources to analyze it, see Jean-Crétien Bouvier et al., *Tradition orale et identité culturelle* (Paris: Editions du CNRS, 1980); Maurizio Catani, "Algunas precisiones sobre el enfoque biográfico oral," *Historia y Fuente Oral* 3 (1990): 151–164; E. Culpepper Clark et al., "Communicating in the Oral History Interview: Investigating Problems of Interpreting Oral Data," *International Journal of Oral History* 1 (1980): 28–40; Louis Dumont, *Essais sur l'individualisme: Une perspective anthropologique sur l'idéologie moderne* (Paris: Seuil, 1983); Gelyah Frank, "Finding a Common Denominator: A Phenomenological Critique of Life History Method," *Ethnos* 7 (1979): 68–94; Ronald Fraser, "La Formación de un entrevistador," *Historia y Fuente Oral* 3 (1990): 129–150; Ronald J. Grele, "Listen to Their Voices: Two Case Studies in the Interpretation of Oral History Interviews," in *Envelopes of Sound: The Art of Oral History*, 2d ed. (New York: Praeger, 1991), 212–236; Tamara Hareven, "The Search for Generational Memory: Tribal Rites in Industrial Society," *Daedalus* 107 (1978): 137–149; *International Annual of Oral History, 1990: Subjectivity and Multiculturalism in Oral History*, ed. Ronald J. Grele (New York: Greenwood Press, 1992); Francis Jacques, *Différence et subjectivité: Anthropologie d'un point de vue relationnel* (Paris: Aubier Montaigne, 1982); Lewis Langness and Gelyah Frank, *Lives: An Anthropological Approach to Biography* (Novato: Chandler and Sharp, 1981); Ernesto De Martino, *La Fine del mondo: Contributo all'analisi delle apocalissi culturali* (Torino: Giulio Einauldi editore, 1977), 86–91, 94–112, 389–414, 555; Luisa Passerini, "Documento autobiografico e tempo storico," *Rivista di storia contemporanea* 16 (1987); Luisa Passerini, "Diritto all'autobiografia," in *Storia e soggettività: Le Fonti orali, la memoria* (Firenze: La Nuova Italia, 1988), 1–30; Alessandro Portelli, *Biografia di una città* (Torino: Giulio Einauldi editore, 1985), 3–22; Alessandro Portelli, *The Death of Luigi Trastulli and Other Stories: Form and Meaning in Oral History* (Albany: State University of New York Press, 1991); Richard Cándida Smith, "Popular Memory and Oral Narratives: Luisa Passerini's Reading of Oral History Interviews," *Oral History Review* 16, no. 2 (1988): 95–108; Paul Thompson, "Memory and Self," in *The Voice of the Past: Oral History*, 2d ed. (Oxford: Oxford University Press, 1988), 150–165; Jan Vansina, "Memory and Oral Tradition," in *The African Past Speaks: Essays on*

Oral Tradition and History, ed. Joseph C. Miller (Folkstone: Kent, 1980), 262–279. Warren Susman's discussion of "personality" in *Culture as History* (New York: Pantheon Books, 1984) contains a parallel though distinct discussion of the self as the "fundamental problem of modern cultural development" (p. 274).

6. On this point, see Luisa Passerini, "Diritto all'autobiografia," 6–10, as well as Walter Benjamin, "The Storyteller: Reflections on the Work of Nikolai Leskov," in *Illuminations* (New York: Schocken Books, 1969), 83–110; Émile Benveniste, "Subjectivity in Language," in *Problems in General Linguistics* (Coral Gables: University of Miami Press, 1971), 223–230; Jacqueline Rose, "The State of the Subject (II): The Institution of Feminism," *Critical Quarterly* 29, no. 4 (1987): 9–15; Ramón Saldívar, "Ideologies of the Self: Chicano Autobiography," in *Chicano Narrative: The Dialectics of Difference* (Madison: University of Wisconsin Press, 1990), 154–170. For a contrary view see Paul de Man, "Autobiography as De-Facement," *MLN* 94 (1979): 919–930.

Chapter 1

1. Lorser Feitelson, "Tape-Recorded Interview with Mr. Lorser Feitelson, May 12, 1964," interviewed by Betty Lochrie Hoag, AAA, 11.

2. Lorser Feitelson, "Los Angeles Art Community: Group Portrait, Lorser Feitelson," interviewed 1974 by Fidel Danieli, OHP/UCLA, 1–4, 195, quote on 77.

3. Interview with Kenneth Rexroth, in *The San Francisco Poets,* ed. David Meltzer (New York: Ballantine Books, 1971), 9–10.

4. Kenneth Rexroth, "Disengagement: The Art of the Beat Generation," *New World Writing* 11 (1957): 28–41; Clay Spohn, "Tape-Recorded Interview with Clay Spohn at his Studio in Grand Street, New York City," interviewed 1976 by Paul Cummings, AAA, 5.

5. Nicholas Brigante, "Tape-Recorded Interview with Nicholas Brigante," interviewed 1964 by Betty Hoag, AAA, 7; Lorser Feitelson letter to Francis V. O'Connor, 3 June 1964, in Lorser Feitelson and Helen Lundeberg papers, AAA; George Rodier Hyde, "Color Riots at L.A. Exhibits of 'Modernists,'" reprinted in *Accounts of Early California Art: A Reprint Anthology,* ed. John Alan Walker (Big Pine: John Alan Walker, 1988, First Series). For biographical information on Berlin see Paul J. Karlstrom and Susan Ehrlich, *Turning the Tide: Early Los Angeles Modernists, 1920–1956* (Santa Barbara: Santa Barbara Museum of Art, 1990), 45; Nancy Dustin Wall Mouré, *Dictionary of Art and Artists in Southern California before 1930* (Los Angeles: Publications in Southern California Art, no. 3, 1975), 16; Lionel Rolfe, "L.A. Arts and Letters: From A to Zeitlin," *Los Angeles Reader,* no. 42 (13 August 1982): 9; Ted

LeBerthon, "Night and Day," *Los Angeles News,* 27 June 1940, in artist files, Ferdinand Perret papers, AAA.

6. Edward Kienholz, "Los Angeles Art Community: Group Portrait, Edward Kienholz," interviewed 1976 by Lawrence Weschler, OHP/UCLA, 70–71.

7. Helen Lundeberg, "Los Angeles Art Community: Group Portrait, Helen Lundeberg," interviewed 1974 by Fidel Danieli, OHP/UCLA, 70, 75.

8. Mabel Alvarez papers, AAA, "My Journal 1918–1928," entry January 1928; entries from diaries, 31 March 1917 and 15 November 1919; "My Journal 1918–1928," entry for 11 January 1921; diary entries for 28 and 13 October 1917.

9. See Maurice Halbwachs, *The Collective Memory* (New York: Harper Colophon Books, 1980), 94ff.

10. John Alan Walker's *Accounts of Early California Art* collects together reviews from 1916 to 1945. The files of the Los Angeles Art Association, deposited at AAA, contain a record of exhibitions, lectures, and classes organized by the association. The Ferdinand Perret papers in AAA are an invaluable source for the study of art communities in California. Perret clipped reviews and articles about the visual arts from newspapers across the state. He also collected catalogs and brochures and membership lists of various artists' organizations. Information on the Arensbergs and their circle can be found in Winifred Haines Higgins, "Art Collecting in the Los Angeles Area, 1910–1960," dissertation, University of California, Los Angeles, June 1963. Robert Perine's *Chouinard: An Art Vision Betrayed* (Encinitas: Artra Publishing Inc., 1985) is a highly contentious history of the Chouinard Art School which also includes comparative information on other art schools in Los Angeles and San Francisco. More general information on the art movements and communities in California prior to 1950 can be found in Thomas Albright, *Art in the San Francisco Bay Area 1945–1980* (Berkeley: University of California Press, 1985); *The Art of California: Selected Works from the Collection of the Oakland Museum,* ed. Christina Orr-Cahall (Oakland: Oakland Museum, 1984); Paul J. Karlstrom and Susan Ehrlich, *Turning the Tide*; *Lorser Feitelson and Helen Lundeberg: A Retrospective Exhibition* (San Francisco: San Francisco Museum of Modern Art, 1980); Henry Miller, *Knud Merrild, a Holiday in Paint* (Huntsville: Bern Porter, 1965); Nancy Dustin Wall Mouré, *Painting and Sculpture in Los Angeles, 1900–1945* (Los Angeles: Los Angeles Museum of Art, 1980); *Painting and Sculpture in California: The Modern Era* (San Francisco: San Francisco Museum of Modern Art, 1977); Peter Plagens, *Sunshine Muse: Contemporary Art on the West Coast* (New York: Praeger, 1974); Jake Zeitlin, *Small Renaissance, Southern California Style* (Los Angeles: Zeitlin, 1972).

11. After 1934 there was an increase in interest in surrealism in the American mass media. Salvador Dalí established his reputation in American popular culture as the

quintessential surreal fantasist with five feature articles in *Time* magazine alone, as well as coverage in *Arts and Decoration, Current Biography, Current History, Fortune, Life, Literary Digest,* the *Magazine of Art, Newsweek, New Republic,* the *New York Times Magazine,* and *Theatre Arts Monthly.* See "Salvador Dali," *Time* 28 (13 July 1936): 31–32; "Salvador Dali," *Time* 28 (14 December 1936): 62–64; "Dali's Display," *Time* 33 (27 March 1939): 31; "Dreams Paranoiac," *Time* 33 (3 April 1939): 43; "Not So Secret Life," *Time* 40 (28 December 1942): 30ff.; "Dali's Ladies," *Time* 41 (26 April 1943): 79–80; H. G. Thompson, "If You Were in New York," *Arts and Decoration* 42 (March 1935): 46–48; "Dali: In the News and in the Studio," *Current History* 50 (April 1939): 48–49; "Dali and His Wife Gala," *Fortune* 18 (December 1938): 85–86; "Surrealist Artist Enchants Hampton Manor, Near Fredericksburg, Virginia," *Life* 10 (7 April 1941): 98–101; "Fantastic Zanies of Painter's Brush," *Literary Digest* 122 (12 December 1936): 26; Henry Devree, "Three Exotics: Chagall, Dali, Miró," *Magazine of Art* 30 (January 1937): 60–61; James J. Sweeney, "Miró and Dali," *New Republic* 81 (6 February 1935): 36off.; Malcolm Cowley, "Imp of the Perverse," *New Republic* 108 (18 January 1943): 88ff.; "Dali Dream Come True," *Newsweek* 13 (27 March 1939): 27; "Open Secret," *Newsweek* 21 (11 January 1943): 62ff.; "Rapport of Fatality," *Newsweek* 21 (26 April 1943): 82; "Portraits by Dali," *New York Times Magazine* (11 April 1943): 17; "Salvador Dali + 3 Marxes = Marie Seton," *Theatre Arts Monthly* 23 (October 1939): 734–740. Other articles on surrealism in the popular press included Klaus Mann, "Surrealist Circus," *American Mercury* 56 (February 1943): 174–181; Jean Charlot, "Surrealism: Or, the Reason for Unreason," *American Scholar* 7 (April 1938): 230–242; Bernard Byrne, "Surrealism Passes," *Commonweal* 26 (2 July 1937): 262–263; Andrew McGavick, "Weird Worlds," *Commonweal* 27 (1 April 1938): 630–631; "New Paintings for Connoisseurs," *Country Life* 73 (February 1938): 48–49; "Great Flights of Culture: Twelve Artists in U.S. Exile," *Fortune* 24 (December 1941): 102–115; Elizabeth Gilhagen, "Fantasy Rampant," *Independent Woman* 16 (February 1937): 33ff.; "Max Ernst: Portrait of a Surrealist," *Living Age* 355 (February 1939): 537–538; Eugene Jolas, "Beyond Surrealism," *Living Age* 359 (September 1940): 93–95; Robert M. Coates, "Had Any Good Dreams Lately?" *New Yorker* 17 (29 November 1941): 58ff.; B. M. King, "First Venture in Surrealism," *School Arts* 39 (March 1940): 222ff.; "Max Ernst," *Time* 28 (14 December 1936): 60; "Surrealists in Exile," *Time* 39 (20 April 1942): 48ff.; "Inheritors of Chaos," *Time* 40 (2 November 1942): 47.

12. Helen Lundeberg, "New Classicism," in Feitelson and Lundeberg papers, AAA.

13. Arthur Millier, art critic for the *Los Angeles Times* and active proponent of postsurrealism, wrote in one essay: "Modern man's high place of mystery and world

of adventure is his own mind. Not myth nor substance, but our experience of them—thought and feeling—constitutes the highest reality of our century." Advertising and political demogoguery both relied on manipulation of associative aspects of cognition. Postsurrealist art, by bringing this process to the surface and revealing the "composition of ideas in the spectator's mind," enlarged perception of the forces surrounding modern men and women. See "Postsurrealism or Subjective Classicism: A Means to a Genuinely Contemporary Art," in Notebooks on California Artists, Ferdinand Perret papers, AAA.

14. André Breton, *Manifestoes of Surrealism* (Ann Arbor: University of Michigan Press, 1982), 26.

15. See Lundeberg's statement for *The Mirror* for the 1952 exhibition *Contemporary American Painting and Sculpture,* College of Fine and Applied Arts, University of Illinois; Lundeberg's letter of 1 December 1954 to Edwin C. Rae in Feitelson and Lundeberg papers, AAA; and Lundeberg, "Los Angeles Art Community," OHP/UCLA, 60.

16. *Fantastic Art, Dada, Surrealism* (New York: Museum of Modern Art, 1936), 8. See also *Americans: 1942* (New York: Museum of Modern Art, 1942), 93; *American Realists and Magic Realists* (New York: Museum of Modern Art, 1943). For two art-historical assessments of the relationship of postsurrealism to European surrealism, see Barbara Hartmann, "Dynaton and Post-Surrealism," in *Ceci n'est pas le surréalisme, California: Idioms of Surrealism* (Los Angeles: Fisher Gallery, University of Southern California, 1983), 7–14, and Jeffrey Wechsler, *Surrealism and American Art, 1931–1947* (New Brunswick: Rutgers University Art Gallery, 1976), 43–47. Both Hartmann and Wechsler failed to note the antithetical relationship that the postsurrealists adopted toward surrealism. For a discussion of the development of American surrealism into abstract expressionism, see *The Interpretive Link, Abstract Surrealism into Abstract Expressionism: Works on Paper, 1938–1946,* ed. Paul Schimmel (Newport Beach: Newport Harbor Art Museum, 1986).

17. George Santayana, "The Genteel Tradition in American Philosophy," in *The Genteel Tradition* (Cambridge: Harvard University Press, 1967), 62–63.

18. Jeanne McGahey in Lawrence Hart et al., *Ideas of Order in Experimental Poetry* (Berkeley: Circle Pamphlet [n.d., ca. 1945]), 23.

19. Lundeberg was part of Lewis Madison Terman's Gifted Group, selected at a very early age and then tracked at four-year periods to see how high IQ translated into success in achieving goals and personal adjustment to the social environment. See Lewis Madison Terman, *Mental and Physical Traits of a Thousand Gifted Children* (Stanford: Stanford University Press, 1925); Lewis Madison Terman and Melita H. Oden, *The Gifted Group at Mid-Life: Thirty-five Years' Follow-up of the Superior*

Child (Stanford: Stanford University Press, 1959); and Joel N. Shurkin, *Terman's Kids: The Groundbreaking Study of How the Gifted Grow Up* (Boston: Little, Brown, 1992).

20. Quote from undated typed statement in Feitelson and Lundeberg papers, AAA, probably written prior to 1943, since the text presupposes the ongoing existence of the postsurrealist movement; Gloria Biggs, "Her Paintings Express Quiet Beauty," Women Today section, *Christian Science Monitor*, 16 May 1951.

21. Letter from Lundeberg to Edwin C. Rae, 1 December 1954, Feitelson and Lundeberg papers, AAA.

22. See William Everson, *Archetype West: The Pacific Coast as a Literary Region* (Berkeley: Oyez, 1976), 9–10, for a contrast of social structure with spiritual participation.

23. Lundeberg seldom traveled outside California, and in 1974 she said, "I've never been out of this country, except in imagination" (Lundeberg, "Los Angeles Art Community," OHP/UCLA, 70). She did attend exhibitions at local museums and galleries, and she was part of the social circle invited into the homes of the Arensbergs and Galka Scheyer.

24. Feitelson, "Tape-Recorded Interview," AAA, 4–5.

25. For a perspective of Feitelson by an artist who was more conservative, see Herbert Jepson's observation that Feitelson "would completely take over the whole show, much to the chagrin of the speaker who happened to be up on the front" whenever there were "general meetings open to the public that had something to do with art." Feitelson was "unquestionably the most articulate, the smartest, and the most interesting" of the people who moved in Los Angeles art circles in the 1930s (Herbert Jepson, "Los Angeles Art Community: Group Portrait, Herbert Jepson," interviewed 1976 by Marjorie Rogers, OHP/UCLA, 139). See also Millard Sheets's comment on Feitelson: "He'd painted all over Europe. He knew his way around, and he was not afraid to try anything" (Millard Sheets, "Los Angeles Art Community: Group Portrait, Millard Sheets," interviewed 1976 and 1977 by George M. Goodwin, OHP/UCLA, 366).

26. Feitelson, "Tape-Recorded Interview," AAA, 1–3; Feitelson, "Los Angeles Art Community," OHP/UCLA, 200–201.

27. Feitelson, "Los Angeles Art Community," OHP/UCLA, 188, 73, 92.

28. Arthur Millier expressed this in three principles he proposed to defend the universal importance of postsurrealism: "The characteristic creations of our time are completed in the brain before an ounce of construction material is mined. Ours is the age of pre-calculations so exact that their objectification seems miraculous. . . . To express this century's incredible intellectual effort, art must parallel that effort's precision

of theory and method. It must be as precise as the intricately calculated balance of a steel bridge, as absolute in the relationship of its parts as the elements of a chemical compound. . . . The artist need not be an engineer. But he must create poems for an engineering age" ("Postsurrealism or Subjective Classicism").

29. Feitelson, "Los Angeles Art Community," OHP/UCLA, 91.

30. Ibid., 86–87.

31. Undated note in Feitelson and Lundeberg papers, AAA, probably ca. 1947.

32. Feitelson, "Los Angeles Art Community," OHP/UCLA, 191, 193.

33. Antonin Artaud, "L'Activité du Bureau de recherches surréalistes," in *Oeuvres complètes* (Paris: Gallimard, 1956), 1:269.

34. Arthur Millier, untitled, *Los Angeles Times,* 14 April 1935.

35. See correspondence file, Feitelson and Lundeberg papers, AAA, for record of Feitelson's activity as a public speaker. Quotes from brochure on Hollywood Race Track fine arts program; exhibition catalog *Young Art Patrons,* 3 March 1965; Zuma Palmer, "Feitelson's Art Series Finding an Audience," *Hollywood Citizen-News,* 14 November 1956, 10.

36. William Copley, "Tape-Recorded Interview with William Copley," interviewed 1968 by Paul Cummings, AAA, 3, 10; Betty Asher, "Interview with Betty Asher," interviewed 1980 by Thomas H. Garver, AAA, 14.

37. Letter from Feitelson to Alfred M. Frankfurter, 28 September 1949, in Feitelson and Lundeberg papers, AAA.

38. Letter from Feitelson to Kenneth Ross, 14 March 1949; catalog for *Functionalists West* exhibition, November 1952, Los Angeles Art Association galleries, in Feitelson and Lundeberg papers, AAA.

39. Letter from Feitelson to Arthur Millier, June 1950, in Feitelson and Lundeberg papers, AAA.

40. Kienholz, "Los Angeles Art Community," OHP/UCLA, 86; Bengston quote from *Paintbox Pioneers,* "California Stories," television program, Southern California Community Television, 1987; Carlos Almaraz, "Interview with Carlos Almaraz," interviewed 1986 by Margarita Nieto, AAA, 40.

41. Santayana, "The Genteel Tradition in American Philosophy," 62.

Chapter 2

1. Rexroth to Louis Zukovsky, 10 March 1931, Rexroth papers, DSC.

2. Linda Hamalian, *A Life of Kenneth Rexroth* (New York: W. W. Norton, 1991), 84. Rexroth's posthumously published autobiographical manuscripts deny or-

ganizational membership but paint a picture of close involvement in many Commu-
nist party activities in the 1930s. In the 1930s he worked as an organizer in San Fran-
cisco for the John Reed Club, unemployed councils, the National Maritime Union,
and the Nurses Association. See Kenneth Rexroth, *An Autobiographical Novel*, re-
vised and expanded, ed. Linda Hamalian (New York: New Directions, 1991),
411–414, 417–423, 441–446, 453. From 1940 to 1943 he worked as a volunteer coun-
selor for the National Committee for Conscientious Objectors. James Laughlin and
Morgan Gibson, both of whom knew Rexroth well, thought that the Communist
party had refused Rexroth membership and that he had been a close fellow-traveler
in order to keep his first wife happy. This is not implausible, but their account does
not explain why Rexroth would claim to be a member on his Fellowship of Recon-
ciliation application if he had not been. Another difficulty with their explanation is
that during the period of time noted on the application, Rexroth was separated from
his wife.

3. Kenneth Rexroth, "The Function of Poetry and the Place of the Poet in Soci-
ety," WOW, 6–7.

4. See "Proposal for a National Registry of Artists and Writers" and *Material
Gathered on Federal Writers Project*, on file in Rexroth papers, DSC.

5. Merle Armitage, "Tape-Recorded Interview with Merle Armitage," inter-
viewed 1964 by Betty Hoag, AAA, 7. Rexroth's assignments at the FWP were to
write sections on campgrounds and hiking trails for the *WPA Guide to California*, but
as with many other writers in the FWP, his assignments were relatively light and he
had free time for personal writing projects. In effect, this proved to be a government
subsidy for radical literature, for Rexroth was a frequent contributor to left-wing pe-
riodicals such as *New Masses*, *New Republic*, and *Frontiers*.

6. Kenneth Rexroth, "New Objectives, New Cadres," CSP, 96.

7. Kenneth Rexroth, "August 22, 1939," CSP, 97–99.

8. Proposal on file in Rexroth papers, DSC.

9. This was Rexroth's explanation. It is possible that the FWP laid him off when it
began reducing its staff in 1940. There is some ambiguity about the exact date when
Rexroth left the FWP, since employment records have not been available and Rexroth
at various times gave different accounts of when and how he left. However, the most
likely date is 1940, since he took the job as an orderly in order to be excused from
selective service.

10. Robert Horan to Robert Duncan, May 1940, Robert Duncan papers, BL.
Thomas Parkinson, who knew Rexroth ater 1945, referred to Rexroth's "discontinu-
ous personality." Rexroth attacked his friends for no apparent reason and deliberately

provoked antagonism (*Poets, Poems, Movements* [Ann Arbor: UMI Research Press, 1987], 261–262). Robert Duncan called Rexroth "Mr. Big Bang," referring to surprise explosions of temper. He also described Rexroth as a fabulizer, whose emotions generated strong physical "memories" of events that never occurred ("Interview on Rexroth," *Conjunctions* 4 [1983]: 95).

11. Interview in *The San Francisco Poets*, 26.

12. Kenneth Rexroth, "About the Poems," PT, 9.

13. PT, 13–14; CLP, 63–65.

14. PT, 13, 38; CLP, 63, 88.

15. PT, 15–16; CLP, 66.

16. PT, 34, 36, 41; CLP, 85, 86, 91. In the early 1960s, he wrote "The Wheel Revolves," a poem about camping with his daughter that concluded with the lines: "Ten thousand years revolve without change. / All this will never be again" (CSP, 21).

17. Quoted by Lawrence Lipton, *The Holy Barbarians* (New York: Julian Messner, Inc., 1959), 20.

18. After the war Rexroth agreed that the firebombings of Dresden, Hamburg, and Tokyo, the refusal to come to the assistance of the Warsaw uprising, and the atomic destruction of Hiroshima and Nagasaki were "relatively minor [evils] in comparison with the holocaust." But he added that American responsibility for "millions of dead [has] taught us that men can deliberately and knowingly choose evil" (Kenneth Rexroth, "Letter from America," *Now* [London] no. 7 [May 1947]: 7–9); see also "Excerpts from the Unpublished Autobiography," *Conjunctions* 4 (1980): 108–109.

19. PT, 23–24, 29, 31; CLP, 74, 80, 82.

20. PT, 22; CLP, 73. The Amida Buddha is the most revered of the nonhistorical Buddhas. The name derives from the Sanskrit *amitabha*, "boundless light," and symbolizes the attainment of a nature, both physical and spiritual, that is without flaw. Kwannon is a popular form of the bodhisattva Kannon, "the Great Compassionate One." Kwannon has come to represent unremitting love and benevolence, with understanding for all the causes of suffering. Originally a male figure, Kannon transformed into Kwannon, the Buddha that embraces feminine stereotypes. See Philip Kapleau, *The Three Pillars of Zen: Teaching, Practice, Enlightenment* (Boston: Beacon Press, 1967), 28, 163, 322, 325, 334.

21. PT, 29; CLP, 80.

22. PT, 40; CLP, 91.

23. PT, 47; CSP, 141.

24. PT, 53; CSP, 163. Note that there is no sense that patterns are imposed by imagination nor of a search for statistical probability.

25. Laughlin to Rexroth, 16 May 1945, Rexroth papers, DSC.

26. Reviews by Harvey Curtis Webster, *Louisville Courier-Journal*, 12 December 1944; Conrad Aiken, *New Republic*, 2 April 1945, 452; William Carlos Williams, "In Praise of Marriage," *Quarterly Review of Literature* 2 (1945): 145–149.

27. D. H. Lawrence, *Selected Poems of D. H. Lawrence* (New York: New Directions, 1947); *The New British Poets: An Anthology*, ed. Kenneth Rexroth (New York: New Directions, 1949); Kenneth Rexroth, *The Art of Worldly Wisdom* (Prairie City, Illinois: Decker Press, 1949); Kenneth Rexroth, *The Signature of All Things* (New York: New Directions, 1950).

28. Kenneth Rexroth, "Poetry, Regeneration, and D. H. Lawrence," reprinted in WOW, 11.

29. WOW, 16.

30. Rexroth, ed., *The New British Poets*, vii. In a letter to James Laughlin, 5 March 1941, Rexroth accused Eliot and Auden of using "coercive rhetorical incantation." Rexroth declared his own aesthetic to be one of "immediacy of utterance" (*Kenneth Rexroth and James Laughlin: Selected Correspondence*, ed. Lee Bartlett [New York: W. W. Norton, 1991], 6–8).

31. Lecture notes for the classes are in the Rexroth papers, DSC.

32. Rexroth, "Poetry, Regeneration, and D. H. Lawrence," WOW, 15.

33. In "The Dragon and the Unicorn" Rexroth addressed the claim of the Congress for Cultural Freedom that poets needed to defend American liberty against Soviet tyranny with these lines:

> All the world raises hell about
> Essenin and Mayakovsky.
> Twenty-three poets of "anthology
> Rank" have committed suicide
> In the USA since 1900.
> It is by far the commonest
> Form of death among poets.
> I am far better aware of
> The evils of Stalinism
> Than you are, you ex-Trotskyite
> Warmonger. But it won't get you
> Anywhere to tell me I should
> Welcome the beast who devours me
> Just because a bigger lion
> Is eating somebody else on
> The other side of the arena. (CLP, 235–236)

34. Kenneth Rexroth, "Why San Francisco Is Different," holograph for unpublished lecture, ca. 1948, in Rexroth papers, DSC.

35. Josephine Miles, "Poetry, Teaching, Scholarship," interviewed in 1977 and 1979 by Ruth Teiser and Katherine Harroun, ROHO, 54–55. Miles conceded that Carl Sandburg attracted sizable audiences to readings he gave when he toured in the 1930s and 1940s. Miles and her friends, however, considered Sandburg to be an entertainer and therefore not a serious poet, who by definition was devoted to advancing art and craft.

36. Miles, "Poetry, Teaching, Scholarship," ROHO, 58.

37. The longest-running were *Circle, Goad, Golden Goose,* and *Sulfur.* In addition, Jack Stauffacher's Greenwood Press began publishing low-cost chapbooks. Advertisements and announcements in these publications indicate that another thirteen journals in the San Francisco Bay Area and five in Los Angeles appeared with at least one issue between 1944 and 1953.

38. See William Everson, "Dionysus and the Beat Generation," in *Earth Poetry: Selected Essays and Interviews of William Everson 1950/1977* (Berkeley: Oyez, 1980), 21–28, and *Archetype West,* 132–135, for Everson's account of the development of a performative aesthetic. See also Thomas Parkinson, *Poets, Poems, Movements,* 179. For discussion of the relation of poetic composition to performance, see Michael Davidson, "Notes Beyond the *Notes:* Wallace Stevens and Contemporary Poetics," in *Wallace Stevens and Modernism,* ed. Albert Gelpi (Cambridge: Cambridge University Press, 1985); Michael Davidson, *The San Francisco Renaissance: Poetics and Community at Mid-century* (Cambridge: Cambridge University Press, 1989); Robert Pinsky, *The Situation of Poetry: Contemporary Poetry and Its Traditions* (Princeton: Princeton University Press, 1976); *The Poetry Reading: A Contemporary Compendium on Language and Performance,* ed. Stephen Vincent and Ellen Zweig (San Francisco: Momo's Press, 1981).

39. Rexroth, "Excerpts from the Unpublished Autobiography," 109.

40. See Kenneth Rexroth, "A Selected Bibliography of Poetics/Modern [1947]" (*American Poetry* 1 [Fall 1983]: 65–66), for a reproduction of a reading list. See also Thomas Parkinson, *Poets, Poems, Movements,* 175, 303, for Parkinson's recollections of books read and the tenor of discussions.

41. Laughlin has acknowledged that he trusted Rexroth's judgment on poets "absolutely" (interview with James Laughlin in *Against the Grain: Interviews with Maverick American Publishers,* ed. Robert Dana [Iowa City: University of Iowa Press, 1986], 27, also 22).

42. Rexroth, "Excerpts from an Unpublished Autobiography," 111. George Woodcock, who ran an anarchist bookstore in London in the 1940s, recalled that Rex-

roth ordered large quantities of literature for the Libertarian Circle ("Rage and Serenity: The Poetic Politics of Kenneth Rexroth," *Sagetrieb* 2 [Winter 1983]: 74).

43. Editorial, *The Ark* (San Francisco, 1947).

44. Robert Duncan, "Reviewing *View,* an Attack," *The Ark* (San Francisco, 1947), 62–67.

45. Kenneth Rexroth, "Letter from America," holograph copy in Rexroth papers, DCS. Published in *Now* no. 7 (London, 10 November 1946).

46. Rexroth later blamed his departure from the Libertarian Circle on the activities of three secret Communist party members who infiltrated the group in order to destroy his growing influence upon left-wing politics in San Francisco ("Excerpts from an Unpublished Autobiography," 114).

47. William Everson, "Four Letters on the Archetype," in *The Beats: Essays in Criticism,* ed. Lee Bartlett (Jefferson, North Carolina: McFarland and Co., 1981), 186–194. The descriptions completely confuse aesthetic form and personality.

48. Everson, *Archetype West,* 107; Sanders Russell to Robert Stock, 23 August 1976, Sanders Russell papers, BL; Hamalian, *A Life of Kenneth Rexroth,* 153–154.

49. William Everson, *The Residual Years* (New York: New Directions, 1948), iv; Lee Bartlett, "Creating the Autochthon: Kenneth Rexroth, William Everson, and *The Residual Years,*" *Sagetrieb* 2 (Winter 1983): 57–69; "Regarding Rexroth: Interview with William Everson," *American Poetry* 7 (1989): 82–86. Shortly after his crisis with Rexroth, Everson felt he could no longer live in secular society. He entered a Dominican monastery and remained a lay brother until 1969.

50. "Robert Duncan on Kenneth Rexroth," *Conjunctions* 4 (1983): 92–93.

51. Hamalian, *A Life of Kenneth Rexroth,* 130–134, 167–168.

52. CLP, 278. "Ten foot square hut" refers to the twelfth-century Japanese classic *Hojoki* ("An Account of My Hut") by Kamo no Chomei. Kamo described the destruction of Japanese society in the civil war between the Taira and Minamoto clans and his decision to "abandon" the world by refusing to participate in political disputes. The conclusion of the "The Dragon and the Unicorn" presented an initial syncretization by Rexroth of Buddhism with his ahistorical Christianity.

53. At the end of the first section of "The Phoenix and the Tortoise," the poet represents a mystic illumination of universal "process" drawn from reading Boehme:

> I see in sudden total vision
> The substance of entranc'd Boehme's awe:
> The illimitable hour glass
> Of the universe eternally
> Turning, and the gold sands falling
> From God, and the silver sands rising

> From God, the double splendors of joy
> That fuse and divide again
> In the narrow passage of the Cross. (PT 22; CLP 72)

The narrow juncture of the cross presents an allegorical expression of the momentary, epiphenomenal character of individual human existence.

54. For background to Jakob Boehme, see Nicolas Berdyaev, introduction to Jakob Boehme, *Six Theosophic Points and Other Writings* (Ann Arbor: University of Michigan Press, 1958), and Franz Hartman, *Personal Christianity: The Doctrines of Jacob Boehme* (New York: Frederick Ungar, 1958).

55. CSP, 177–179.

56. Berdyaev, introduction to *Six Theosophic Points*, vii.

57. Thomas Parkinson, in comparing a translation by Rexroth of a Provençal lyric with a translation of the same poem by Ezra Pound, noted how Rexroth's approach stressed the universal, repeatable, common experience within the work, while Pound stressed the artifice and talent of his construction (*Poets, Poems, Movements*, 244–246).

58. Berdyaev, introduction to *Six Theosophic Points*, xix.

59. Jakob Boehme, *On the Divine Intuition*, quoted in Berdyaev, introduction to *Six Theosophic Points*, xxii.

60. PT, 18.

61. "The epistemological steps are bypassed by direct experience" ("Interview with Kenneth Rexroth," *Contemporary Literature* 27 [1968]: 155).

62. Rexroth, interview in *The San Francisco Poets*, 43–44.

63. These points have been influenced by my reading of Pierre Bourdieu's *Outline of a Theory of Practice* (Cambridge: Cambridge University Press, 1977), 35–36.

64. See Brady, "The New Cult of Sex and Anarchy," 312–322.

Chapter 3

1. Clay Spohn, "Tape-Recorded Interview with Clay Spohn, Friday, September 25, 1965," interviewed by Harlan Phillips, AAA, Second Part, 10.

2. Spohn, "Tape-Recorded Interview with Clay Spohn at his Studio in Grand Street, New York City," interviewed 1976 by Paul Cummings, AAA, 2, 5–6, 8, 11–12.

3. Ibid., 21, 83.

4. Ibid., 17–19, 21–23.

5. Ibid., 24.

6. Ibid., 24, 35–39, 41–43, 52. Health collapses were to become a regular feature

throughout Spohn's life. As career pressures built, he was overcome by mysterious stomach ailments and migraine headaches. By the end of the seizure, he had to withdraw from the conflict facing him into the care of his parents or, in later life, the care of the woman in his life at the time.

7. His Paris sketchbooks contain drawings of the originals for Hemingway's characters in *The Sun Also Rises*, people he appears to have known quite well.

8. See Emling Etten and Marina Pacini, "Studio in Paris," *Archives of American Art Journal* 30, no. 1 (April 1990): 24–35, for a student's detailed description of the Académie Moderne during the years Spohn lived in Paris.

9. Spohn, "Tape-Recorded Interview with Clay Spohn at his Studio in Grand Street, New York City," AAA, 46–50.

10. Notebooks, 1927–1929, Spohn papers, AAA.

11. 1929 notebook, Spohn papers, AAA.

12. Kenneth Rexroth had an amusing anecdote he frequently recited of getting lost in the basement of the federal office building amongst all the neglected paintings and sculpture that belonged to the federal government (Hamalian, *A Life of Kenneth Rexroth*, 77–78).

13. See for examples *San Francisco Chronicle*, 30 January 1941, 11; *San Jose Mercury*, 2 February 1941, 21; *San Francisco News*, 8 February 1941, 13.

14. Spohn, "Tape-Recorded Interview with Clay Spohn at his Studio in Grand Street, New York City," AAA, 64–66. For overviews of the New Deal–era art projects, see William F. McDonald, *Federal Relief Administration and the Arts* (Columbus: 1969); Richard D. McKinzie, *The New Deal for Artists* (Princeton: Princeton University Press, 1973); Milton Meltzer, *Violins and Shovels: The WPA Arts Projects* (New York, 1976); Francis V. O'Connor, *Federal Art Patronage: 1933 to 1943* (College Park: University of Maryland Press, 1966); *Government and the Arts in Thirties America: A Guide to Oral Histories and Other Research Materials*, ed. Roy Rosenzweig (Fairfax: George Mason University Press, 1986).

15. Spohn, "Tape-Recorded Interview with Clay Spohn at his Studio in Grand Street, New York City," AAA, 66. The Federal Art Project also encouraged the organization of artists' groups, such as Artists Equity, to represent artists in their dealings both with government employers and with gallery owners.

16. Letter to Mary McChesney, 25 April 1963, Spohn papers, AAA.

17. Spohn quoted in Douglas MacAgy, "Clay Spohn's War Machines," *Circle* 5 (1945): 39.

18. Ibid., 40, 42.

19. Keith W. Olson, *The GI Bill, the Veterans, and the Colleges* (Lexington: University of Kentucky Press, 1974), 44.

20. Byron H. Atkinson, "Veteran vs. Non-Veteran Performance at UCLA," *Journal of Educational Research* 43 (December 1949), 299–302.

21. Ibid., 302.

22. Norman Frederiksen and William B. Schrader, *Adjustment to College* (Princeton: Educational Testing Service, 1951), 63, 93–96, 180–183, 235, 247, 255–257, 308–309, 326–327, 352; quote on 48.

23. A year-by-year examination of student enrollment records at the California School of Fine Arts between 1945 and 1953 shows that veterans using the GI Bill were the following percentages of total student enrollment. For those years where records separate full-time day program enrollment, the overwhelming importance of veterans for the school becomes inescapable.

Veterans Using the GI Bill

Year	Percent of GI-Bill Students in Total Student Body	Percent of GI-Bill Students among Full-Time Students Only
1945	14	49
1946	47	—
1947	57	74
1948	53	74
1949	54	87
1950	53	—
1951	59	—
1952	30	—
1953	—	61

Source: California School of Fine Arts, "Enrollment Figures and Lists 1945–1956," San Francisco Art Association Archives, Library, San Francisco Art Institute.

24. Lee Mullican, "Los Angeles Art Community: Group Portrait, Lee Mullican," interviewed 1976 by Joann Phillips, OHP/UCLA, 15, 32.

25. Ibid., 17–18, 20, 36–37, quotes on 18, 37. Discharged from the Army Signal Corps at the war's end, Mullican decided to settle in San Francisco, where the arts community seemed to him deeply committed to abstraction. Mullican entered the circle surrounding Kenneth Rexroth, and one of his drawings was used for the jacket of James Laughlin's *New Directions* no. 10. Mullican also visited Henry Miller in Big Sur and illustrated Miller's studies of Thoreau and the American transcendentalists. Mullican's closest and most important alliances were with the émigré surrealist dissidents Wolfgang Paalen (1905–1959) and Gordon Onslow-Ford (b. 1912). Mullican, Paalen, Onslow-Ford, and the Venezuelan painter Luchita Hurtado formed the Dynaton group.

26. Connor Everts, "Los Angeles Art Community: Group Portrait, Connor

Everts," interviewed 1976 by Robin Palanker and 1982 by Sylvia Tidwell, OHP/UCLA, 1–54.

27. Ibid., 72.

28. Robert Irwin, "Los Angeles Art Community: Group Portrait, Robert Irwin," interviewed 1976 by Frederick S. Wight, OHP/UCLA, 5–6, 26; Jorge Goya interviewed by Mary Fuller McChesney, quoted in McChesney, *A Period of Exploration: San Francisco, 1945–1950* (Oakland: Oakland Museum, 1973), 6.

29. Frank Lobdell, "Interview with Frank Lobdell, April 9, 1980, Palo Alto," interviewed by Terry St. John, AAA, 14–18, 28; Nathan Oliveira, "Interview with Nathan Oliveira," interviewed 1978 and 1980 by Paul J. Karlstrom, AAA, 30.

30. Wally Hedrick, "Wally Hedrick Interview #1," interviewed 10 June 1974 by Paul Karlstrom, AAA, 13; Suzanne Muchnic, "It's Time to Return to His Art," *Los Angeles Times*, 19 September 1992, F1, F6; see also John Outterbridge, "African-American Artists of Los Angeles: John Outterbridge," interviewed 1990 and 1991 by Richard Cándida Smith, OHP/UCLA; Noah Purifoy, "African-American Artists of Los Angeles: Noah Purifoy," interviewed 1991 by Karen Anne Mason, OHP/UCLA, 17, 29–30.

31. Jay DeFeo, "Tape-Recorded Interview with Jay DeFeo (1) at the Artist's Home, Larkspur, California," interviewed 1975 by Paul Karlstrom, AAA, 13, 15–20; *Jay DeFeo: Works on Paper* (Berkeley: University Art Museum, 1989), 13; Richard Diebenkorn, "Tape-Recorded Interview with Richard Diebenkorn in Santa Monica, California, May 1985 and December 1987, Susan Larsen, Interviewer," AAA, 54.

32. Elmer Bischoff, "Tape-Recorded Interview with Elmer Bischoff, Berkeley, California," interviewed 1965 by Mary McChesney, AAA, 12.

33. Elmer Bischoff, "Interview with Elmer Nelson Bischoff," interviewed 1977 by Paul J. Karlstrom, AAA, 25.

34. Ibid., 26.

35. Ibid., 27–29.

36. Ibid., 30.

Chapter 4

1. See, for example, the statement prepared for *San Francisco: The Bay and Its Cities* (New York: Hastings House, 1946), in San Francisco Art Association papers, AAA.

2. Minutes of Board Meeting, 5 March 1946, SFAA.

3. Douglas MacAgy, "Revising an Art Training Program" (n.d., ca. 1946), holograph in Douglas MacAgy files, San Francisco Art Association papers, AAA; Bis-

choff, "Interview with Elmer Nelson Bischoff," 38; Hubert Crehan, "Is There a California School?" *Art News* 54 (January 1956): 33. Hassel Smith, a student at the California School of Fine Arts from 1936 to 1938 and then a teacher there from 1945 to 1951, felt that the school from 1945 to 1950 was "completely Doug." Every course reflected his theories of art education, which the faculty enthusiastically accepted (interview with Smith by author, 1989, untranscribed).

4. Minutes, Faculty Meeting, 6 November 1947, faculty meeting files, SFAA.

5. Minutes of Board Meeting, 8 February 1945; Minutes of Board Meeting, 5 April 1945, SFAA.

6. Class lists, 1946–1950, SFAA.

7. Douglas MacAgy, "Exopathic Aesthetes" (n.d.), holograph copy in Douglas MacAgy files, San Francisco Art Association papers, AAA, 6; Douglas MacAgy, "Revised Training for the Artist" (n.d., ca. 1947), Douglas MacAgy files, San Francisco Art Association papers, AAA, 3.

8. Robert M. Coates, "Assorted Moderns," *New Yorker* 20 (23 December 1944): 51. Irving Sandler's *The Triumph of American Painting* (New York: Praeger, 1970) offers a basic history of abstract expressionism. Serge Guilbaut's *How New York Stole the Idea of Modern Art: Abstract Expressionism, Freedom, and the Cold War* (Chicago: University of Chicago Press, 1983) challenges Sandler's formalist interpretation by placing the new developments in painting in the context of cold war cultural policies. Sidney Janis's *Abstract and Surrealist Art in America* (New York: Reynal and Hitchcock, 1944) and Schimmel, ed., *The Interpretive Link* provide accounts of the roots of particular abstract expressionist painters in surrealism. It is important to note that while abstract expressionism developed within the context of the New York art world, it also faced opposition from important institutions within that world. Museum exhibitions of the work took place in San Francisco, Chicago, Philadelphia, and Boston several years before the Museum of Modern Art finally acknowledged the existence of abstract expressionism in 1947.

9. Crehan, "Is There a California School?" 35. Hassel Smith dismissed Crehan's version as "sheer nonsense" ("Notes on the École du Pacifique," ca. 1956, Hassel Smith papers, AAA). Smith felt that Clyfford Still, Clay Spohn, Lu Watters, and other local artists had already developed their own forms of abstraction in the early 1940s independent of the New York school. It is certainly true that Clyfford Still's work was fundamental to Smith's shift from figurative to abstract painting, but interviews with participants at the California School of Fine Arts generally support the conclusion that the inspiration to move into abstract expressionism came from observing, however indirectly, developments in New York.

10. Harold Rosenberg, "The American Action Painters," in *The Tradition of the New* (New York: Horizon Press, 1959), 23–39.

11. Albright, *Art in the San Francisco Bay Area*, 39, 42, 44. See also Peter Plagens, *Sunshine Muse: Contemporary Art on the West Coast* (New York: Praeger, 1974), 41–45; Maurice Tuchman, "Diebenkorn's Early Years," in *Richard Diebenkorn: Paintings and Drawings, 1943–1976* (Buffalo: Buffalo Fine Arts Academy, 1976).

12. Clyfford Still, quoted from interview by Ti-Grace Sharpless, in *Clyfford Still* (Philadelphia: Institute of Contemporary Art, University of Pennsylvania, 1963), 4. For biographical material on Still see Albright, *Art in the San Francisco Bay Area*, 15–36; Clyfford Still, *Clifford Still* (San Francisco: San Francisco Museum of Modern Art, 1976); Clyfford Still, *Thirty-three Paintings in the Albright-Knox Art Gallery* (Buffalo: Buffalo Fine Arts Academy, 1966); *Clyfford Still*, ed. John P. O'Neill (New York: Metropolitan Museum of Art, 1979).

13. Alfred Frankenstein, "This World of Art," *San Francisco Chronicle*, 14 March 1943; Arthur Millier, *Los Angeles Times*, 27 March 1943.

14. "Notes on the École du Pacifique," Hassel Smith papers, AAA.

15. Douglas MacAgy interviewed by Mary Fuller McChesney, quoted in *A Period of Exploration*, 5, 83; Jeremy R. Anderson, untitled, *The Artist's View* no. 2 (September 1952).

16. Rothko introduced Still's work to Peggy Guggenheim and arranged his first New York show in 1946 at Guggenheim's Art of This Century gallery. Still was responsible for Rothko teaching two terms at the California School of Fine Arts.

17. Clyfford Still interviewed by Mary Fuller McChesney, quoted in McChesney, *A Period of Exploration*, 36.

18. Ibid.

19. Still to a friend, December 1949, quoted in O'Neill, *Clyfford Still*, 27.

20. The students who formed Metart Galleries were Jeremy Anderson, Ernest Briggs, Jack Cohantz, Hubert Crehan, Edward Dugmore, Jorge Goya, William Huberich, Jack Jefferson, Kiyo Koizumi, Zoe Longfield, Frances Spencer, and Horst Trave.

21. Press release, Metart Galleries, April 1949, Jack Jefferson papers, AAA.

22. Clay Spohn interviewed by Thomas Albright, quoted in "The Critical Year for Rothko," *San Francisco Chronicle*, 13 March 1983; Ernest Briggs and Jeremy Anderson interviewed by Mary Fuller McChesney, quoted in McChesney, *A Period of Exploration*, 40–41, 43.

23. Elmer Bischoff interviewed by Thomas Albright, quoted in *Art in the San Francisco Bay Area*, 26.

24. Bischoff, "Interview with Elmer Nelson Bischoff," AAA, 42.

25. Clyfford Still interviewed by Thomas Albright, quoted in *Art in the San Francisco Bay Area*, 31.

26. Smith grew up in San Mateo, fifteen miles south of San Francisco. His father was an advertising and sales executive for the metals industry. Smith studied art history at Northwestern University and had planned to pursue a Ph.D. in art history at Princeton. But after taking a summer course in painting from Maurice Sterne at the California School of Fine Arts, he impulsively decided to enroll full-time in painting at the San Francisco school. To support himself while painting, Smith found a job as a social worker in 1938. His direct encounters with the "working poor rather changed" his life, he observed. He had lived a protected existence, but as he became aware of the deprivation in American society, he began a quick conversion to Marxism. His left-wing politics do not appear to have been an issue at the school. When the Federal Bureau of Investigation came to the school to ask MacAgy about communist influence in the school, MacAgy escorted them to the door (interview with Smith, by author, 1989, no transcript).

27. Ibid.

28. Ibid.

29. Smith quoted by Douglas MacAgy in his essay "Hassel Smith" (n.d., ca. 1960), holograph copy in Hassel Smith papers, AAA.

30. See Albright, *Art in the San Francisco Bay Area*, 52; Herschel B. Chipp, "This Summer in San Francisco," *Art News* 56 (Summer 1958): 48ff.; Alfred Frankenstein, "New Gallery but an Old Name," *San Francisco Chronicle*, 28 February 1977; Allan Temko, "The Flowering of San Francisco," *Horizon* 1 (January 1959): 4–23; Allan Temko, "Hassel Smith," undated manuscript of essay in Hassel Smith papers, AAA.

31. Some of these figures were students at the school in the late 1950s, long after Smith had left the school's faculty, but he maintained a close, if informal, contact with developments at the institution.

32. Hassel Smith, "Art in Action: The Appeal to Reason," *The Artist's View*, no. 1 (July 1952), BL; Smith to "friends staying in Italy," February 1957, published in *Hassel Smith, Recent Paintings* (San Francisco: San Francisco Art Association, 1957). Smith did not deny that left-wing artists could donate their services to political events by designing posters, banners, and illustrations. He had contributed to an illustrated version of *The Communist Manifesto* in 1948. But such work, he thought, had no closer relationship to his conception of art than working for an advertising agency and developing art to sell cigarettes.

33. MacAgy, "Hassel Smith," Smith papers, AAA.

34. Douglas MacAgy, "Clay Spohn's Museum," typescript in Douglas MacAgy files, San Francisco Art Association papers, AAA.

35. Spohn to Mary McChesney, 15 April 1963, Spohn papers, AAA, 2.

36. Spohn, "Tape-Recorded Interview with Clay Spohn at his Studio in Grand Street, New York City," AAA, 70–72.

37. Spohn to McChesney, 15 April 1963, AAA, 2, 23–26.

38. MacAgy, "Clay Spohn's Museum," AAA; Spohn to McChesney, 25 April 1963, AAA, 3–5.

39. Ibid., 51.

40. Crehan, "Is There a California School?" Crehan wrote his article to dispute a contention by Tapiès and others in Paris that a distinctive school of painting and sculpture had emerged in California which Europeans needed to consider in addition to the work produced in New York. Crehan argued that work in California was nothing more than a provincial variant of ideas elaborated in New York, with nothing original having been contributed. The suppression of the distinct contribution of the CSFA school was so thorough that in 1963 John Coplans wrote a series of articles for *Artforum* to retrieve this history and show that California abstract painting had not begun in the late 1950s, as assumed by most New York critics.

41. Interview with Smith by author, 1989, no transcript.

42. Jazz was clearly an important aesthetic inspiration to the New York school as well.

43. Interview with Smith by author, 1989, no transcript.

44. "Notes on the École du Pacifique," Hassel Smith papers, AAA.

45. Bischoff, "Interview with Elmer Nelson Bischoff," AAA, 35, 44–46. Of course, Bischoff's characterization of abstract expressionism as a "fashion" contains a defense against the harsh criticism he received for returning to figurative painting.

46. In the roster of artists exhibiting in the 1952 San Francisco Art Association annual, forty-one artists submitted abstract expressionist work, while twenty-five artists submitted work based on geometric or biomorphic abstraction. In addition, there were eighteen figurative painters, seven surrealists, and six painters still working with cubism ("Painting and Sculpture, 1952," San Francisco Art Association).

47. Hubert Crehan, "Art Page," *San Francisco Chronicle*, 3 July 1950.

48. Erle Loran, "San Francisco Art News," *Art News* 49 (April 1950): 50.

49. Lobdell, "Interview with Frank Lobdell," AAA, 35–36.

50. Clyfford Still to Betty Parsons, 20 March 1948, in Betty Parsons papers, AAA. In 1952 he broke off relations with Parsons and all dealers, reclaimed his paintings, and refused to exhibit anywhere.

51. Hedrick, "Wally Hedrick Interview #1," AAA, 43–45.

52. Jorge Goya interviewed by Mary Fuller, in "Was There a San Francisco School?" *Artforum* 9 (January 1971): 48; Gordon Cook interviewed 1972 by Dan Tooker, quoted in Plagens, *Sunshine Muse*, 45. In this context, it is interesting to compare West Coast attitudes with those of Clement Greenberg, who helped define abstract expressionism in an environment with a more developed, intermeshed gallery, museum, and critical system. Anticommercialism, Greenberg complained in 1947, was the stock-in-trade of the provincial figure who opposed the formation of an intellectual elite by falling back on the myth of the common man "who re-enacts the life of the early frontiersman in his physical self-assertion, in his communal ego, and in the fact that his pathos emerges in time and space." Anticommercialism stalled artists in a "kind of democratic free-for-all, in which every individual, being as good as every other one, has the right to question any form of intellectual authority." Until objective standards of quality were established, the dominant tradition in American culture would be romantic and subjective. "Sensibility confined, intensified, and repeated . . . has been a staple of American art and literature since Emily Dickinson. . . . The art that results does not show us enough of ourselves and of the kind of life we live in our cities, and therefore does not release enough of our feeling." Greenberg demanded that the dominance of the "wild artist," the "Whitmanesque blowhard," come to an end. Americans needed a cultural milieu in which its leaders discouraged obsession with extreme situations and states of mind. Only when artists placed their relation to the great tradition at the center of their work and discounted entirely their relationship to a mass public, could they hope to create new artistic standards for that public (Clement Greenberg, "The Present Prospects of American Painting and Sculpture," *Horizon* no. 93–94 [October 1947]: 22).

53. Minutes of Board Meeting, 25 March 1948; Minutes of Board Meeting, 18 June 1948, SFAA.

54. Hans M. Wingler, *The Bauhaus: Weimar, Dessau, Berlin, Chicago* (Cambridge: MIT Press, 1969), 17.

55. Walter Gropius, "The Viability of the Bauhaus Idea," in Wingler, *The Bauhaus,* 52; Walter Gropius, "Address to the Students," in Wingler, *The Bauhaus,* 36; Walter Gropius, *The New Architecture and the Bauhaus* (Cambridge: MIT Press, 1965; first published 1935), 65; Gropius, "Program of the Staatliche Bauhaus," in Wingler, *The Bauhaus,* 132; Oskar Schlemmer to Bruno Taut, in Wingler, *The Bauhaus,* 78.

56. László Mohóly-Nágy, *Painting, Photography, Film* (Cambridge: MIT Press, 1969), 17.

57. James Sloan Allen, *The Romance of Commerce and Culture: Capitalism,*

Modernism, and the Chicago-Aspen Crusade for Cultural Reform (Chicago: University of Chicago Press, 1983), 66–70, 76–77.

58. Douglas MacAgy, "The California School of Fine Arts and its Eastern Counterparts 1947," report submitted to faculty and board of trustees, 24 October 1947, SFAA, 2–3.

59. Douglas MacAgy, "Educational Conflicts between the Fine and Commercial Arts," holograph of paper presented at National Association of Schools of Design, Cincinnati, 28 November 1949, MacAgy papers, SFAA.

60. Minutes of Board Meeting, 18 August 1949, SFAA. The school's charter with the state established it as a division of the University of California, even though it had its own board of trustees to set policy and received no funds from the state university system. All faculty appointments and school curricula went to Berkeley for review and approval.

61. David Park's description of MacAgy's plans in Park to Ernest Born, 12 July 1951, faculty correspondence files, SFAA.

62. MacAgy to Board of Trustees, 1 May 1950, in Minutes of Board Meeting, 29 June 1950, SFAA.

63. Smith repeated the story when I interviewed him. Hassel Smith: "Douglas told me that he had been for some time at loggerheads with the board and found it increasingly difficult to carry out his own program. He had persuaded Duchamp to come to the school. The board had refused to accept the appointment, so he quit. That's disputed by others, but that's what Doug told me" (interview with Smith by author, 1989, untranscribed).

64. MacAgy interviewed by Mary Fuller McChesney, in McChesney, *A Period of Exploration*, 83–84. Hassel Smith, who had attended the school from 1936 to 1938, shared this assessment. He noted how unusual the student body was after 1945. The rich young men and women who had filled the school before the war had disappeared (Smith interviewed by author, 1989, untranscribed).

65. Ernest Mundt, "Three Aspects of Contemporary Art," in *Painting and Sculpture: The San Francisco Art Association* (Berkeley: University of California Press, 1952).

66. Minutes of Board Meeting, 24 January 1952, SFAA.

67. Hassel Smith interviewed by the author, 1989, untranscribed; Park to Ernest Born, President, Board of Directors [*sic*], 12 July 1951, faculty correspondence files, SFAA; Minutes of Board Meeting, 24 January 1952, SFAA. Hassel Smith had no doubt that Mundt became director with the goal of undoing the MacAgy program completely and that he wanted to fire all the people associated with MacAgy. If Mundt hesitated at first, he was afraid of student reaction and had waited for the older stu-

dents to graduate before embarking on his plans for restructuring the school (interview with Smith by author, 1989, no transcript). After leaving the California School of Fine Arts, Smith went to work teaching art to elementary school children at a private school. Then in 1953 he bought an apple orchard in Sebastopol, fifty miles north of San Francisco, and ran a farm for ten years, while he continued to paint in a studio he built for himself on his property. Douglas and Jermayne MacAgy remained supporters, and in 1957 Jermayne arranged his first major exhibit outside of California at the Houston Contemporary Arts Museum, where she was the director. Walter Hopps exhibited him to considerable success in Los Angeles at the Ferus Gallery. Commercial sales and critical reviews led Smith back into the classroom, but FBI visits to his employers continued through the mid-1960s and helped convince Smith and his wife in 1966 that they should permanently relocate to Britain, where Smith accepted a faculty position at the Bristol College of Art.

68. Full-Time Enrollment, Fall Terms,
California School of Fine Arts, 1944–1956

Year	Full-Time Enrollment	Year	Full-Time Enrollment	Year	Full-Time Enrollment
1944	54	1949	372	1954	74
1945	92	1950	352	1955	185
1946	480	1951	325	1956	259
1947	413	1952	61		
1948	383	1953	69		

Source: San Francisco Art Association Archives, Library, San Francisco Art Institute.

69. Minutes of Board Meetings, 26 June and 20 November 1952; 19 November and 17 December 1953; 23 November 1954, SFAA.

70. Edward Adams, president, Art Center College of Design, to Mundt, 28 October 1954, correspondence files, SFAA.

71. Mundt to Neil Sinton, chair, School Committee, 23 March 1954, School Committee files; Memo (n.d., ca. April 1954), School Committee files; Robert O. Bach, memo to San Francisco Art Association board (n.d., ca. April 1954), SFAA.

72. Mundt to Ruth Armer, 28 May 1951, correspondence files, SFAA.

73. *Harvard Alumni Bulletin* 46 (22 January 1944): 244; Robert M. Hutchins, "The Threat to American Education," *Collier's* 40 (30 December 1944): 20–21.

74. Jacques Barzun, "The Higher Learning in America," *Horizon* no. 93–94 (October 1947): 99–104.

75. Clement Greenberg, "The Present Prospects of American Painting and Sculpture," 22.

76. "Bursars Rub Hands over GI Bill But College Standards May Suffer," *Newsweek* 27 (8 January 1945): 66–69; "Double Trouble: Are More Studies, More Facilities, More Money the Key to Better Education?" *Time* 58 (26 July 1948).

77. Lionel Trilling, "Our Country and Our Culture," *Partisan Review* 19 (May-June 1952): 318–326.

Chapter 5

1. Miles, "Poetry, Teaching, Scholarship," ROHO, 151–154, quote on 151.

2. Press clipping, *San Francisco Chronicle*, hand dated 1946, in Rexroth clipping book, Rexroth papers, DSC.

3. Jack Pennington, "A Day of Cold Food," *San Francisco Chronicle*, in Rexroth's clipping file, Rexroth papers, DSC.

4. "An Interview with Kenneth Rexroth," *Conjunctions* 1 (1968): 60.

5. Miles, "Poetry, Teaching, and Scholarship," ROHO, 65–66.

Chapter 6

1. John Clellon Holmes, *Go* (New York: Scribner's, 1952), 5; Holmes, "This Is the Beat Generation," *New York Times,* 16 November 1952, reprinted in Holmes, *Nothing More To Declare* (New York: Dutton, 1967), 109–115. In this essay Holmes credited Kerouac as the originator of the phrase.

2. Jack Kerouac, *On the Road* (New York: Viking Press, 1957), 161.

3. Carolyn Cassady on her husband Neal Cassady, the original for Dean Moriarty: "Where again would I ever find such intensity of being we . . . shared. And the fantastic communication Neal and I had . . . the complete lack of *self*-consciousness I could achieve with him, merging objectively into whatever we were discussing together . . . no personalities involved; perfect understanding" (Carolyn Cassady, "Coming Down," in *The Beat Book*, special issue of *Unspeakable Visions of the Individual* 4 [1974]: 19).

4. Robert Lindner, *Rebel Without a Cause: The Hypnoanalysis of a Criminal Psychopath* (New York: Grune and Stratton, 1944), *Prescription for Rebellion* (New York: Rinehart, 1952), and *Must You Conform?* (New York: Rinehart, 1956). Lindner advocated loosening social restrictions to decrease generational tensions. By opening the possibilities for legitimate exploration, young people could explore their interests without feeling in conflict with their society.

5. Erik H. Erikson, *Identity, Youth, and Crisis* (New York: W. W. Norton,

1968), observations on male adolescence, 116, 128–135; observations on female goals, 265–266, 282–283, 291.

6. Ibid., 253–255.

7. In *Visions of Cody* (New York: McGraw-Hill, 1974), Kerouac completed a fifth and final draft of *On the Road.* This version retold the story of his relationship to Cassady from the viewpoint of the westerner. Instead of ending with a break based on Kerouac's imagined reintegration into Manhattan literary life, the story follows more closely the actual developments of Kerouac's life. The narrator moves west and lives with Cassady and his wife while working as a railroad conductor. Kerouac derived much of this novel from audiotape recordings he made during his travels with Cassady. Despite his publisher's desire for additional material after the success of *On the Road,* Viking decided *Visions of Cody* was unprintable, in part because of its obscenity; but its lack of a plot and mythification of Cassady's anarchism were also unpalatable to a mainstream readership. For background on composition and publishing history, see Allen Ginsberg's introduction to the 1974 edition and Tim Hunt, *Kerouac's Crooked Road* (Hamden: Shoe String Press, 1981).

8. See John Modell, *Into One's Own: From Youth to Adulthood in the United States, 1920–1975* (Berkeley: University of California Press, 1989), 177, 193, 201, 203, 206, 209, 211, 250.

9. Allen Ginsberg, "Howl," in *The Postmoderns: The New American Poetry Revised,* ed. Donald Allen and George F. Butterick (New York: Grove Press, 1982), 177. Cassady also appeared in Holmes's novel *Go* as the character Hart Kennedy.

10. Allen Young, *Gay Sunshine Interview: Allen Ginsberg with Allen Young* (Bolinas: Grey Fox Press, 1974), 12.

11. Allen Ginsberg, "Back to the Wall," *Times Literary Supplement,* London *Times,* 6 August 1964, 333.

12. See Barry Miles, *Ginsberg: A Biography* (New York: Simon and Schuster, 1989), 79ff., and Michael Shumacher, *Dharma Lion: A Critical Biography of Allen Ginsberg* (New York: St. Martin's Press, 1992), 115–117, for a discussion of Ginsberg's relationship with Solomon. Solomon has given his own version of these events in *Emergency Messages: An Autobiographical Miscellany* (New York: Paragon House, 1989).

13. Kerouac included the episode in *On the Road,* 6, although in that version he had Moriarty throw on boxer shorts to answer the door. See also Anne Charters, *Jack Kerouac: A Biography* (San Francisco: Straight Arrow Books, 1973), 71; Gerald Nicosia, *Memory Babe: A Critical Biography of Jack Kerouac* (New York: Grove Press, 1983), 175–176; William Plummer, *The Holy Goof: A Biography of Neal Cassady* (Englewood Cliffs: Prentice-Hall, 1981). See chapter 3 of Barry Miles, *Ginsberg: A*

Biography, for an account of Ginsberg's love affair and ongoing friendship with Cassady.

14. Ginsberg has since tried to confront the fear and dislike of women he felt in the 1940s and 1950s. In 1974 he argued that misogyny was the product of "distrust, hatred, paranoia, and competition" between men. He hoped as the gay movement allowed men to accept innate homoerotic attitudes, more men would be able to enter into emotionally satisfying relationships with women (see Allen Young, *Gay Sunshine Interview,* 14). LuAnne Henderson, Cassady's seventeen-year-old wife at the time of the 1946 trip to New York, recalled that Kerouac was the only man in the group who assumed that she too had intellectual and artistic interests, but she was disappointed that he ignored her sexual interest in him (Nicosia, *Memory Babe,* 176). Anne Charters reported that Kerouac was uncomfortable with women and envied Cassady's ease at developing sexual relationships (Charters, *Jack Kerouac,* 76). Carolyn Cassady told an interviewer that her husband was a sexual sadist (Gina Berriault, "Heart Beats: Carolyn Cassady," *Rolling Stone,* 12 October 1972).

15. Paul O'Neil, "The Only Rebellion Around," *Life* 47 (30 November 1959): 114–130. See also J. D. Adams, "On Writers of Beat Generation," *New York Times Book Review,* 18 May 1957, VII, 2; John Ciardi, "Epitaph for the Dead Beats," *Saturday Review* 43 (6 February 1960): 11–13, 42; Irving Feldman, "Stuffed 'Dharma,'" *Commentary* 26 (December 1958): 6; J. Fischer, "Editor's Easy Chair: Old Original Beatnik," *Harper's Magazine* 218 (April 1959): 14–16; Herbert Gold, "The Beat Mystique," *Playboy* 6 (February 1958): 20, 84–87; Irving Howe, "Mass Society and Post-Modern Fiction," *Partisan Review* 36 (Summer 1959): 420–436; G. B. Leonard, Jr., "The Bored, the Bearded, and the Beat," *Look* 22 (19 August 1958): 64–68; John Leonard, "Epitaph for the Beat Generation," *National Review* 7 (12 September 1959): 331; Norman Podhoretz, "The Know-Nothing Bohemians," *Partisan Review* 25 (Spring 1958): 305–318; Diana Trilling, "The Other Night at Columbia," *Partisan Review* 26 (Spring 1959): 214–230; Ernest van den Haag, "Conspicuous Consumption of Self," *National Review* 6 (11 April 1959): 656–658; "Squaresville U.S.A. vs. Beatsville," *Life* 47 (21 September 1959): 31–37; "Every Man a Beatnik?" *Newsweek* 53 (29 June 1959): 83; "Daddy-O," *New Yorker* 34 (3 May 1958): 29–30; "Beatniks just sick, sick, sick," *Science Digest* 46 (July 1959): 25–26; "Cool, Cool Bards," *Time* 70 (2 December 1957): 71; "Blazing and the Beat," *Time* 71 (24 February 1958): 104; "Fried Shoes; Beatniks," *Time* 73 (9 February 1959): 16; "Beat Friar," *Time* 73 (25 May 1959): 58; "Bang bong bing," *Time* 74 (7 September 1959): 74; "Bam; roll along with bam," *Time* 74 (14 September 1959): 28; "Zen-Hur," *Time* 74 (14 December 1959): 66.

16. "The Importance of Not Being Square," *Look* 21 (23 July 1957): 35.

17. United States Office of Education, *How the Office of Education Assists College Students and Colleges* (Washington: United States Government Printing Office, 1968); Elmo Roper, *The Public Pulse* 6 (September 1959): 1; United States Congress, Joint Economic Committee, *The Economics and Financing of Higher Education in the United States: A Compendium of Papers* (Washington: United States Government Printing Office, 1969).

18. W. T. Lhamon, Jr., recounts the emergence of rhythm and blues in chapter 3 of *Deliberate Speed: The Origins of a Cultural Style in the American 1950s* (Washington: Smithsonian Institution Press, 1990).

19. MacAgy, "Clay Spohn's War Machines," 39–42.

20. Richard Centers, "Social Class, Occupation, and Imputed Belief," *American Journal of Sociology* 58 (1953): 543–555.

21. Allen Ginsberg, *Howl and Other Poems* (San Francisco: City Light Books, 1957), 9.

22. Neri's recollections are drawn from an untitled, undated interview at the Archives of California Art, Oakland Museum, and Neri's account in Thomas Albright, "Out of the Time Warp," *Currant* no. 1 (1975–76): 9–13. See also Margarita Nieto, "Manuel Neri," *Latin American Art* 1 (Fall 1989): 52–56. Joan Brown's oral history interviews conducted by the AAA also contain her reflections on Neri's personal development.

23. Albright, "Out of the Time Warp," 11.

24. Ibid., 11, 16. George Segal began working in plaster sculpture at the same time in New York, but his work was unknown on the West Coast. Neri was not aware of Segal's tableaux until his first trip to New York in 1960.

25. Michael Davidson referred to the Six Gallery reading as an "enabling fiction" of the San Francisco poetry scene. See Davidson, *The San Francisco Renaissance: Poetics and Community at Mid-Century* (Cambridge: Cambridge University Press, 1989), 2–4. Accounts of the reading are collected in Allen Ginsberg, *Howl: Original Draft Facsimile, Transcript, and Variant Versions,* ed. Barry Miles (New York: Harper and Row, 1986).

26. Jack Goodman to John Allen Ryan, November 1955, quoted in Rebecca Solnit, *Secret Exhibition: Six California Artists of the Cold War Era* (San Francisco: City Lights Books, 1990), 48.

27. Jack Kerouac, *The Dharma Bums* (New York: New American Library, 1959), 13.

28. Gary Snyder, *The Real Work: Interviews and Talks, 1964–1979* (New York: New Directions, 1980), 5.

29. *Howl of the Censor,* ed. J. W. Ehrlich (San Carlos: Nourse Publishing Co., 1961), 95–96.

30. Richard Roud, "The Beard," *Guardian,* 9 November 1967, 7.

31. Allen Ginsberg, "Contribution Towards the Cuban Revolution" (Detroit: Artists Workshop Press, 1966; first printed 1962 in *Pa'alante*).

32. Quoted in Barbara Gravelle, "Six North Beach Women," *San Francisco Sunday Examiner and Chronicle,* 21 October 1979, *California Living Magazine,* 33.

33. Jack Kerouac, "The Origins of the Beat Generation," *Playboy* 6 (June 1959): 79.

34. Wally Hedrick, "Wally Hedrick Interview #1," AAA, 30–31, 27.

35. Bruce Conner, "Tape-Recorded Interview with Bruce Conner," interviewed 1974 by Paul Karlstrom, AAA, 32; Bruce Conner, "Interview of Bruce Conner," interviewed 1973 by Paul Cummings, AAA, 16; Michael McClure, "Interview with Michael McClure," interviewed 1969 by Richard A. Ogar, BL, 32, 38.

36. Robert Duncan, "Conversations with Robert Duncan during the month of December 1978 relating to Poetry in the Bay Region," interviewed by Eloyde Tovey, BL, 149, 154. However, in pre–World War II San Francisco, the term "bohemian" had connotations of a refined, free-thinking, upper-middle-class life. The Bohemian Club, founded in 1895, had brought together business and intellectual leaders to discuss matters of common interest. In *Bohemian San Francisco* (San Francisco: Paul Elder and Company, 1914), Clarence C. Edwords declared, "To [San Franciscans] Bohemianism means the naturalism of refined people. . . . Bohemianism is the protest of naturalism against the too rigid, and, oft-times, absurd restrictions established by Society. The Bohemian requires no prescribed rules, for his or her innate gentility prevents those things Society guards against" (p. 6).

Chapter 7

1. Joan Brown, "Tape-Recorded Interview with Joan Brown, Session #3," interviewed 1975 by Paul Karlstrom, AAA, 25.

2. "North Beach Poet-Makers," *Holiday* (June 1958): 55–62; Charlotte Willard, "Women of American Art," *Look* 24 (27 September 1960): 70 (the article placed Brown next to Georgia O'Keeffe, Louise Nevelson, and Claire Falkenstein); "Joan Brown," *Cosmopolitan* (November 1961); "Joan Brown," *Glamour* 30 (March 1962); "*Mademoiselle's* Annual Merit Awards," *Mademoiselle* 55 (January 1963): 30–35. Dorothy Walker in the *San Francisco News* predicted a stunning career for Joan Brown in 1957, observing that besides having abundant talent, Brown had flair for

self-publicity. See Dorothy Walker, "Painters Shy? These Youngsters Invited Critics To Joint Exhibit," *San Francisco News,* 26 January 1957, in Joan Brown artist file, SFAA.

3. Philip Leider, "Joan Brown: Her Work Illustrates the Progress of a San Francisco Mood," *Artforum* 1 (June 1963): 28–31. In a dissenting view on Brown, but one based on similar assumptions, John Coplans argued Brown's paintings were parodies of Clyfford Still and Mark Rothko. See "Westcoast Art: Three Images," *Artforum* 1 (June 1963): 25.

4. "Joan Brown: Interview by Lynn Gumpert," in *Lynda Benglis, Joan Brown, Luis Jimenez, Gary Stephan, Lawrence Weiner: Early Work* (New York: The New Museum, 1982), 17.

5. Quoted in Brenda Richardson, *Joan Brown* (Berkeley: University Art Museum, 1975), 24. Noel Neri's baby books, as well as the family photos and sketches that Brown used for her paintings of him, are preserved in the Joan Brown papers, AAA.

6. Brown, "Interview with Lynn Gumpert," 20.

7. For discussions of the status of representational art in the late 1960s and early 1970s, see Lawrence Alloway, "Notes on Realism," *Arts Magazine* 44 (April 1970): 26–27; Linda Nochlin, "The Realist Criminal and the Abstract Law," *Art in America* 61 (September-October 1973): 54–61, and 61 (November-December 1973): 97–103; Leo Steinberg, "Other Criteria," in *Other Criteria* (New York: Oxford University Press, 1972), 55–91; Sidney Tillim, "The Reception of Figurative Art: Notes on a General Misunderstanding," *Artforum* 7 (February 1969), 30–33. Positive critiques of Brown's later work appeared in 1978, when Marcia Tucker described her as a precursor of the New Image school then developing in New York in opposition to the hegemony of formalist thinking (see Introduction, *"Bad" Painting* [New York: New Museum, 1978]; see also Ronny H. Cohen, "Reviews: New York—Joan Brown," *Artforum* 20 [February 1982]: 89). Brown, however, suffered from being too closely identified with a regionalist school. In an article written after her death, Brooks Adams observed that Brown's Bay Area roots had made her seem peripheral and obscured the "international implications of her art" (Brook Adams, "Alternative Lives," *Art in America* 80 [January 1992]: 88).

8. CNM, "Joan Brown's Neo-Naives," *Artweek* 2 (10 July 1971): 3.

9. Andrée Marechal-Workman, "An Interview with Joan Brown," *Expo-See* (March-April 1985); Brown, "Interview with Lynn Gumpert," 19.

10. Ibid., 17.

11. Brown, "Tape-Recorded Interview with Joan Brown, Session #3," AAA, 22–23.

12. Brown's account squared neatly with David Riesman's depiction of the new "other-directed" service-providing middle class in *The Lonely Crowd: A Study of the Changing American Character* (New Haven: Yale University Press, 1950), especially 19–25, 45–49.

13. Joan Brown, "Tape-Recorded Interview with Joan Brown," interviewed 1975 by Paul Karlstrom, AAA, 8, 16. Brown also felt that the antipathy she felt for the apartment was based on a premonition of her mother's suicide there in 1965. Interviews with artists and poets of Brown's generation tend to portray their childhoods in dark colors and troubled relationships with their parents. Yet the self-images as orphans are belied in occasional details that indicate ongoing relationships with the parents. The question of the nature of the relationships requires biographical investigation to determine what the case was in individual circumstances. The presence of a subjective motif in accounts by a relatively broad spectrum of individuals suggests that they augmented biography with a narrative theme that helped emphasize the idea of a generation embarked on a fundamental break with the past. Despite the rather negative picture Brown presented of her parents, they must have been somewhat open-minded, for they readily agreed to pay her tuition to the art school on what must have been very short notice. She transferred to the California School of Fine Arts days before she was to register for her classes at Lone Mountain College. Her mementos of Noel's childhood preserved in the AAA show that her son was christened, attended Sunday school, and was confirmed in the Catholic church.

14. Joan Brown, "Tape-Recorded Interview with Joan Brown, Session #2," interviewed 1975 by Paul Karlstrom, AAA, 17.

15. Hedrick, "Wally Hedrick Interview #1," AAA, 22–23. The structure of Kerouac's novel *On the Road* links loosely around Dean Moriarty's search for his missing father. That search is unsuccessful, but in the process Moriarty forges a brotherhood with the novel's narrator, Sal Valentine. See Erik Erikson, *Identity, Youth, and Crisis,* 135–136, 167–169, where Erikson argued that maturation required separation from paternal authority. Generational confraternity offered a reasonable transition from dependency to autonomy. This contemporary view, presented as a general observation on the process of psychological maturation, suggests that relations between generations was a particular problem in the postwar period. Erikson, however, warned that the attempt to idealize school ties blocked further development to individual integrity and "generativity," that is, the ability to reproduce society through work that others value.

16. See Erikson, *Identity, Youth, and Crisis,* 155–159, for discussion of age-group identifications and the development of competition. The central importance of peers in forming the "other-directed" personality was also a critical element in David Ries-

man's description of American middle-class culture. See Riesman, *The Lonely Crowd*, 69–77.

17. Brown, "Interview by Lynn Gumpert," 16, 19.

18. Brown, "Tape-Recorded Interview with Joan Brown," AAA, 37. See also Joan Brown, "In Conversation with Jan Butterfield," *Visual Dialog* 1 (December 1975, January-February 1976): 15; untranscribed audiotape of "Funk Art Symposium," 22 September 1967, University Art Museum, Berkeley, tape at AAA.

19. Brown, "Interview by Lynn Gumpert," 16.

20. Brown, "Tape-Recorded Interview with Joan Brown," AAA, 19–21, 34–40, 42, 48–49, 65–66.

21. Brown, "Tape-Recorded Interview with Joan Brown, Session #2," AAA, 35.

22. Brown, "Tape-Recorded Interview with Joan Brown," AAA, 40.

23. "Tape-Recorded Interview with Neil Sinton," 15 August 1974, AAA, untranscribed.

24. For a viewpoint that unequivocally embraced the idea of an "essentially feminine attitude" toward art, see Anaïs Nin, "Cornelia Runyon," *Artforum* 2 (August 1963): 54. Runyon, Nin argued, "began with a respect for what the sea or earth had already begun to form in the stone [Runyon used for her sculpture]. She contemplated and meditated over them, permitting them to reveal the inherent patterns they suggested. She never imposed her own will over the image tentatively begun by nature. She discovered and completed the image so that it became visible and clear. She assisted the birth of chaotic masses into recognizable forms. . . . In this way, her way, what came through was not some abstraction torn from its basic roots, its textures, its organic growth, but something her tender maternal intuitive hands allowed to grow organically without losing its connection with the earth or sea. . . . Her work, I believe, is the opposite of an act of will."

25. Brown, "Tape-Recorded Interview with Joan Brown, Session #2," AAA, 22. At the same time, Brown angrily defended herself against accusations that promiscuity had advanced her career. She was certain other women artists, jealous of her success, were the source of these rumors.

26. Quoted in Brenda Richardson, *Joan Brown*, 28. *Fur Rat* also reflects Brown's association with the Rat Bastard Protective Association, so one can read the piece as a portrait of the bohemian artist in opposition to the media stereotype of the beats.

27. Brown, "Tape-Recorded Interview with Joan Brown," AAA, 33–34.

28. See Nancy Azara, "Artists in Their Own Image," *Ms.* 1 (January 1973): 56–60; Lucy Lippard, "Household Images in Art," *Ms.* 1 (March 1973): 22–25.

29. Brown, "Tape-Recorded Interview with Joan Brown, Session #2," AAA, 49,

51–52, 54–56. She also complained that the feminist art movement denied the achievements of women who had made careers for themselves prior to 1970. She noted that Miriam Schapiro and Judy Chicago claimed that the art movements of the 1950s were entirely male and that the Ferus, Six, and Dilexi galleries had never shown women artists. Brown then recalled offhand a dozen women, including herself, Jay DeFeo, Nell Sinton, Deborah Remington, and Cameron, who had had several successful shows at each of these galleries. Brown ignored those aspects of feminist arguments that focused on the marginalization of feminine experience and arts developed by women, such as quilts (see Miriam Schapiro, *Art: A Woman's Sensibility* [Valencia: California Institute of the Arts, 1975]). Brown's position on feminism is a critical marker of the timing of her entrance into the art profession. She began her career at a time when its features were still undifferentiated on the West Coast and a woman could construct a degendered imaginary of art as spiritual journey to find personal autonomy. Women entering art after 1965 encountered a more structured profession, and consideration of their experiences as women offered a more open, autonomous path for the creation of meaning outside of established sets of discourse. See interviews with Miriam Schapiro, Rachel Rosenthal, and Josine Ianco-Starrels, AAA, for examples of how women entering the profession in the 1960s gravitated to feminism as a system explaining their position *within* the art world, rather than looking to an ideology of aesthetics as a liberation from their position in the world at large.

30. Brown, "Tape-Recorded Interview with Joan Brown, Session #3," AAA, 11.

31. Ibid., 24, 25.

32. Jay DeFeo, "Tape-Recorded Interview with Jay DeFeo (1) at the Artist's Home, Larkspur, California," interviewed 1975 by Paul J. Karlstrom, AAA, 2–6. She extended the interior division she used to characterize herself to her mixed ethnic background. Her father was Italian, her mother Austrian, and she felt her moods oscillated between the Germanic and the Latin. DeFeo also recalled spending much of her time alone as a child and adolescent.

33. Ibid., 3.

34. Jay DeFeo, "Tape-Recorded Interview with Jay DeFeo (2) at the Artist's Home," interviewed 1975 by Paul J. Karlstrom, AAA, 5.

35. Brown, "Tape-Recorded Interview with Joan Brown," AAA, 60, 65.

36. Irving Blum, "At the Ferus Gallery," interviewed 1976 by Joann Phillips, 1978 and 1979 by Lawrence Weschler, OHP/UCLA, 161–162; Edward Kienholz, "Los Angeles Art Community," OHP/UCLA, 118–119.

37. Philip Lamantia, untitled, *Semina* 4 (1959).

38. Kienholz said that for years he thought that the painting's title was "Death

Throes." He identified her trouble with the work as the convulsions of a dying ideal to which she clung to desperately (Kienholz, "Los Angeles Art Community," OHP/UCLA, 119).

39. DeFeo, "Tape-Recorded Interview with Jay DeFeo (1)," AAA, 19.

40. See Six Gallery files, Ackerman Library, San Francisco Museum of Modern Art, for exhibition announcements.

41. "A Discussion Between Sir Avid Penultimate and Knute Stiles about Wally Hedrick," in *Rolling Rock Renaissance: San Francisco Underground Art, 1945–1968* (San Francisco: Intersection/Glide Urban Center, 1968). Reflecting on her marriage to Hedrick, DeFeo complained that they had lived entirely within the insular community of artists and poets. "Wally never took me anywhere in the whole time we were married where there wasn't some kind of a thing where he could perform. Not even once out to dinner in ten years, and that's pretty tough" (DeFeo, "Tape-Recorded Interview with Jay DeFeo (2)," AAA, 24). Stiles's image of Penelope creating the stories of her family and community by weaving echoes one of the major themes of Joanne Kyger's first book of poetry, *The Tapestry and the Web* (San Francisco: Four Seasons, 1965).

42. At the time, William Waldren's paintings created by pouring buckets of paint over chicken wire–reinforced canvases were much praised on the West Coast. See *Artforum* 1 (June 1962): 8–9, for a typical review.

43. Jay DeFeo, "Tape-Recorded Interview with Jay DeFeo (3) at the Artist's Home, Larkspur, California," interviewed 1976 by Paul J. Karlstrom, AAA, 25.

44. Ibid., 6–13. See also "Notes on *The Rose*," prepared by J. Kelemen for Merrill Greene, *Art as a Muscular Principle: 10 Artists and San Francisco* (South Hadley, Massachusetts: Mount Holyoke College, 1975).

45. Jay DeFeo to Fred Martin, five undated letters, ca. 1959, in Fred Martin papers, AAA.

46. "Jay DeFeo, *The White Rose*," *Holiday* (May 1961): 34–35; John F. Kennedy, "The Artist in America," *Look* 26 (18 December 1962): 120. See also "New Talent U.S.A.: Painting," *Art in America* 49 (Spring 1961): 30–31.

47. DeFeo, "Tape-Recorded Interview with Jay DeFeo (3)," AAA, 26.

48. Conner, "Interview of Bruce Conner," AAA, 18. See also Douglas M. Davis, "Miss DeFeo's Awesome Painting Is Like Living Things Under Decay," *National Observer* 8 (14 July 1969): 12. As of 1993, new conservation efforts seek to restore *The Rose* to its original condition.

49. Raymond Foye, Editor's Note to Bob Kaufman, *The Ancient Rain: Poems 1956–1978* (New York: New Directions, 1981), ix; obituary notice for Bob Kaufman,

San Francisco Chronicle, 14 January 1986. Eileen Kaufman oversaw the production of the first of the planned New Directions books, *Solitudes Crowded with Loneliness* (1965), as well as another chapbook of previously unpublished material for City Lights Press, *The Golden Sardine* (1967). Bob Kaufman refused to help promote either book or to provide new material for any publisher.

50. Hedrick, "Wally Hedrick Interview #1," AAA, 44–45.

51. Conner, "Tape-Recorded Interview with Bruce Conner," 8–9.

52. Ibid., 14.

53. Wally Hedrick, "Wally Hedrick Interview #2," interviewed 1974 by Paul Karlstrom, AAA, 7–10. See also *San Francisco Chronicle*, 12 December 1958, clipping in Hedrick papers, AAA.

54. Hopper recently reiterated his debts to Conner in his introduction to *Bruce Conner: Assemblages, Paintings, Drawings, Engraving Collages, 1960–1990* (Santa Monica: Michael Kohn Gallery, 1990). See also Stefania Pertoldi, *Il Mito del viaggio in Easy Rider e Zabriskie Point* (Udine: Campanotto Editore, 1987), 145–154.

55. See Frank Gettings, *Different Drummers* (Washington: Smithsonian Institution Press, 1988), 13.

56. "A Conversation with Bruce Conner and Robert Dean," in *Bruce Conner: Assemblages, Paintings, Drawings, Engraving Collages, 1960–1990*.

57. David Meltzer to Bob Alexander, undated, ca. early 1970s, Bob Alexander papers, AAA.

58. Meltzer to Alexander, undated, ca. 1977, Bob Alexander papers, AAA.

59. David Meltzer, "Golden Gate: Introduction," in *The San Francisco Poets*, 3–4.

60. Jack Hirschman, "The Crickets," holograph in Bob Alexander papers, AAA.

61. Brown, "Tape-Recorded Interview with Joan Brown, Session #2," AAA, 17. Compare Lawrence Lipton in *The Holy Barbarians* (New York: Julian Messner, 1959). "*We* is what this generation is all about, whether you call it beat or disaffiliated or anything else. *We* is what its books are about, the name of all those characters in those books and what those characters do and say. Everything that happens to them happens to *us*" (p. 48).

62. Generations that claim to initiate fresh starts, Lawrence Lipton thought, put supreme value upon the appearance of youthful behavior (*The Holy Barbarians*, 91).

63. Allen Ginsberg, "Kral Majales," in *The Postmoderns*, 190.

64. Riesman, *The Lonely Crowd*, 236–241.

65. See Kenneth Rexroth, "The Students Take Over," in WOW, for a discussion of the relationship of the new student movement to politics and an existential quest to

live in a moral state. However, the importance existentialist writers placed on the finitude of life circumscribed their impact upon a generation intent on extending the condition of youth indefinitely.

Chapter 8

1. "The Bored, the Bearded, and the Beat," *Look* 22 (August 1958); award letters in Wallace Berman papers, AAA; *Arts Magazine* (London) July 1966, 67; Dennis Hopper, introduction to *Bruce Conner: Assemblages, Paintings, Drawings, Engraving Collages, 1960–1990* (Santa Monica: Michael Kohn Gallery, 1990). The article in *Look* featured a full-page photograph of the Berman family in their San Francisco home. Berman complained to a friend of the offensive inaccuracies in the article. Among the errors was a description of him as a New York associate of Ginsberg and Kerouac who followed them west. In fact, Berman came to California in 1930 and never set foot outside the state until a trip to London in 1966. See Berman to David Meltzer, October 1958, Berman papers, AAA.

2. Berman to Jay DeFeo, July 1965, Jay DeFeo papers, AAA; Grace Glueck, "Art Notes: From Face to Shining Face," *New York Times*, 29 September 1968, D32; P. Adams Sitney, "A Tour with Brakhage: Underground Movies Are Alive Along the Pacific," *Village Voice*, 5 December 1968, 53. See also Tom Kent, "Everything Changed," *City*, 19 February–4 March 1975, 75. In addition to Dennis Hopper, Berman's entertainment industry collectors included Peter Fonda, Teri Garr, Murray Gribbin, Jack Nicholson, Michelle Phillips, Bob Rafelson, Bert Schneider, Phil Spector, Dean Stockwell, and Russell Tamblyn. See Berman papers, AAA, and *Wallace Berman Retrospective* (Los Angeles: Fellows of Contemporary Art, 1978) for information on collectors.

3. A contrasting, distinctly negative view came from gallery owner Irving Blum, one of the first people to promote Andy Warhol and the owner of the complete Campbell's Soup series. Blum decided to drop Berman from the Ferus Gallery in 1959. "Wally's work somehow, for *me*, lacked a kind of edge." He thought Berman was an "extraordinarily provocative guy who could convince you about anything, and somehow I was a bit suspicious of him, I remember. Although I was assured by everyone that he had extraordinary genius, I somehow felt that there were some problems that his interest was disparate, that it was too scattered, that he wasn't sufficiently focused and would pay a price as a consequence. I still feel that way about him. But he was a provocative guy. A very extraordinary human being, extraordinary person. Sensitive, warm, brilliant, I think, and really the touchstone for all the poetry activity that existed in California" (Irving Blum, "At the Ferus Gallery," OHP/UCLA,

72–73). Blum exaggerated the centrality of Berman's involvement in poetry, but his comment expressed a somewhat commonplace attitude. People in the visual arts tended to play up Berman's importance as a poet, while poets overestimated his professional reputation as an artist.

4. Cameron, interviewed 1986 by Sandra Leonard Starr, *Lost and Found in California: Four Decades of Assemblage Art* (Santa Monica: Corcoran Gallery, 1987), 70.

5. In an undated letter to Berman written ca. 1963, Michael McClure told him, "Unfortunately you and I have some funny thing going and pride and vanity comes up between us. *Now* where I would really like to write a poem ABOUT YOU I wrote one and dedicated it to you" (Berman papers, AAA). The poem McClure mentioned was "Lip, Beginning with a line by Soo Doong-Paw."

6. Joan Brown, "Tape-Recorded Interview with Joan Brown, Session #2," AAA, 25, 27–28.

7. Stan Brakhage to Berman, "Early July 1965," Berman papers, AAA.

8. Michael Fles to Bob and Anita Alexander, 16 November 1986, Bob Alexander papers, AAA.

9. Shirley Berman interviewed 1987 by Sandra Leonard Starr, in *Lost and Found in California*, 90.

10. Charles Brittin, interviewed 1986 by Sandra Leonard Starr, in *Lost and Found in California*, 73.

11. Announcements are in exhibitions folder, Berman papers, AAA. Artists and photographers who exhibited at Berman's "Semina Gallery" include Charles Brittin, George Herms, John Reed, Arthur Richer, and Edmund Teske.

12. Shirley Berman, interviewed 1986 by Sandra Leonard Starr, *Lost and Found in California*, 70. This transition from formal to transcendent concerns also occurred in the work of Edward Kienholz. When Kienholz constructed his first pieces in 1954, he turned to wood as a substitute for paint. He wanted to develop thick textures. "I wanted thick paint and didn't have the money to buy the paint. So I nailed boards onto things and painted them to get that third dimension" (quoted in Arthur Secunda, "John Bernhardt, Charles Frazier, Edward Kienholz," *Artforum* 1 [October 1962]: 30).

13. Description of *Veritas Panel*, and subsequent descriptions of *Cross* and *Temple*, drawn from Merril Greene, "Wallace Berman, Portrait of the Artist as an Underground Man," *Artforum* 16 (February 1978): 56, and John Coplans, "Art is Love is God," *Artforum* 2 (March 1964): 27, as well as observation of Charles Brittin's photographs of these pieces. Neither Greene nor Coplans had seen the pieces and based their descriptions of these destroyed works on discussions with the artist, his wife, and friends of the Bermans. See also Anne Bartlett Ayres, "Berman and Kienholz: Pro-

genitors of Los Angeles Assemblage," in *Art in Los Angeles: Seventeen Artists in the Sixties,* ed. Maurice Tuchman (Los Angeles: Los Angeles County Museum of Art, 1981; Henry Hopkins, "Recollecting the Beginnings," in *Forty Years of California Assemblage* (Los Angeles: Wight Art Gallery, 1989). *Veritas Panel, Temple,* and *Cross* were destroyed in 1958 after Berman left Los Angeles.

14. "An Interview with Walter Hopps," in *Wallace Berman Retrospective,* 9.

15. The kabbalah was a form of gnostic philosophy developed in Jewish communities in twelfth-century Spain. Kabbalists taught that the Hebrew alphabet was an interpretive key to reading God's intentions when he created the world. Interpreters of the kabbalah gave three primary meanings to aleph (א): primal chaos as potentiality of meaning; Adam in his capacity as the bestower of names upon the divine creation; and the ox, the beast of burden that brings order to the wilderness and yet can never be fully tamed of its own streak of inner wildness. Berman was fond of the interpretation of aleph as "the all-encompassing man," which is also how he liked to think of himself (Merril Greene, "Wallace Berman, Portrait of the Artist as an Underground Man," 53). "I speak of the Poet," David Meltzer wrote, explaining his use of א in his second book. "He is my sign for man" (David Meltzer, "Patchen," *We All Have Something To Say To Each Other* [San Francisco: Auerhahn Press, 1962]). Carlo Suarès, editor of the *Cahiers de l'Étoile* in the 1920s and 1930s, wrote that aleph stood for the revelation that could come only from within each human soul, without the intervention of prophet or messiah (Carlo Suarès to Edouard Roditi, 1927, Edouard Roditi papers, DSC). In tarot, aleph presented a feminine aspect, as it represented one of the three mothers that guided creation. The mothers, Aleph, Mem, and Shin, then established the scales of merit and guilt, between which the tongue emerged as balance between the two ways of rendering judgment (Akiba ben Joseph, *The Book of Formation of Sephir Yetzirah,* trans. Knut Stenring [London: William Rider and Son, 1923], 19, 25). Aleph then was a symbol for the pursuit of meaning as the fundamental human activity. It was a symbol that spoke to the creation of community through shared names given to experiences.

16. Interview with Bob Alexander by Sandra Leonard Starr, *Lost and Found in California,* 57. In 1947 Berman designed a phonograph album cover for Dial Records, as well as a series of lithographs on bebop for Jazz Tempo.

17. Phrase quoted from a letter from Berman to Larry and Patricia Jordan, 28 January 1965. In this letter, Berman reported he was rereading Nijinsky's diary, which was "one of the books that lifted me from the poolroom" (Patricia Jordan papers, AAA).

18. The cross symbolized for Boehme "the Fourth Property of Eternal Nature. The Magic Fire. The Fire World. The First Principle. The Generation of the Cross. The Strength, Might and Power of Eternal Nature. The Abyss or Eternal Liberty's

Opening in the dark World, breaking and consuming all the Strong Attraction of the Darkness" (quoted from the *Works of Jacob Behmen* in Charles Poncé, *Kabbalah: An Introduction and Illumination for the World Today* [San Francisco: Straight Arrow Books, 1973], 54). This book was in Berman's library at the time of his death, though of course it could not have been in his possession at the time he created *Cross*. Berman's work reformulated themes central to Kenneth Rexroth's long poem "The Phoenix and the Tortoise," in which the poet argued that a person's intimate associations were the key to fundamental aspects of being. Berman adopted the themes of Rexroth's poem as the basis of his everyday life.

19. Robert Duncan, "Wallace Berman: The Fashioning Spirit," in *Wallace Berman Retrospective*, 21.

20. Quote from back cover, *Semina* 2 (December 1957). The correct spelling of the judge's name is Kenneth Halliday. Placement of pieces in the show in the gallery re-created by George Herms in his 1987 interview by Sandra Leonard Starr in *Lost and Found in California*, confirmed by Charles Brittin in conversation with author, 1993.

21. The piece they are examining is Wally Hedrick's antiwar assemblage *Rest in Pisces*. Berman demonstrates a crank that rotates the disc on the top and rattles the "swords" below.

22. "An Interview with Walter Hopps," in *Wallace Berman Retrospective*, 9.

23. Her husband was Ralph Parsons, the founder of Jet Propulsion Laboratory. Material on Cameron drawn from artist files, Los Angeles Municipal Art Gallery.

24. Quoted in Gerald Nordland, "The Suppression of Art," *Artforum* 2 (November 1962), 26. Judge Halliday had presided over the trial in 1956 against bookseller Jake Zeitlin for selling Henry Miller's *Tropic of Cancer*. Halliday found Zeitlin guilty but had endured days of testimony from expert witnesses. The California Supreme Court overturned his decision in 1962 in *Zeitlin* v. *Arnebergh*.

25. Shirley Berman interviewed by Sandra Leonard Starr, *Lost and Found in California*, 92.

26. Charles Brittin interviewed by Sandra Leonard Starr, *Lost and Found in California*, 93.

27. John Coplans, "Art is Love is God," 27.

28. *Semina* issues, 1956–1964, are on file at DSC and AAA.

29. A complete collection of *The Artist's View* is located in BL. The inspiration and general guidance of the publication came from Claire Mahl. Other contributors were Jeremy Anderson, William Faulkner (a Bay Area poet and painter, not the Mississippi novelist), and Philip Roeber.

30. "The pocket of poems gives me a physical sensation as I take one out and put it back" (Wallace Fowlie to Berman, 26 October 1959, Berman papers, AAA).

31. In a letter from Michael McClure to Berman, 16 November 1957, McClure introduced himself on the recommendation of Walter Hopps and submitted several poems for Berman's consideration. He then suggested that Berman contact Jack Kerouac and Philip Whalen and provided addresses. *Naked Lunch* was first published in Paris by Maurice Girodias's Olympia Press in 1959. The edition could not be sold in the United States until 1962, but excerpts from the novel were published in the *Chicago Review* (Spring and Autumn 1958) and in *Big Table* 1, nos. 1 and 2 (1958).

32. Pantale Xantos makes allusions to several Greek words, but the name has no direct translation. Ξανθòς (xanthòs) means yellow, while χανθòς (khanthòs) can translate as the "lost man." Pantale relates to πανθῶς (panthōs), "wholly, entirely," and to πανθοιῶς (panthoiōs), "all sorts." It is also close to both παντάλας (pantálas), "all wretched," and πανταλεθής (pantalethés), "all truthful."

33. There may have been other alteregos used in *Semina*. Berman's correspondence files are not complete, and many contributions did not come through the mail. Names of contributors that were not known independently within the circle of people surrounding the Bermans may very well be Berman alteregos. See Merril Greene, "Wallace Berman," 54. Paul de Man in "Autobiography as De-facement," *MLN* 94 (1979): 921ff., made the point that all texts serve to create counter-autobiographies. On the distinction between autobiographical and diaristic presentations of self, see Luisa Passerini, *Fascism in Popular Memory: The Cultural Experience of the Turin Working Class* (Cambridge: Cambridge University Press, 1987), 17, 21, 27, 39–40, 61; Philippe Lejeune, *Le Pacte autobiographique* (Paris: Seuil, 1975), 16, 179, 237; Jean Starobinksi, "Le Style de l'autobiographie," *Poétique* 3 (1970): 258–259.

34. Quoted in Solnit, *Secret Exhibition*, 16.

35. Robert Duncan, "Wallace Berman: The Fashioning Spirit," in *Wallace Berman Retrospective*, 21–23. For anthropological discussions of Native American peyote cults see J. S. Slotkin, "Menomini Peyotism," *Transactions of the American Philosophical Society* 42 n.s. (December 1952) and John Smythies, "The Mescalin Phenomena," *British Journal for the Philosophy of Science* 3 (February 1953).

36. Alexander Trocchi, *Cain's Book* (New York: Grove Press, 1960), 236, 218.

37. Philip Lamantia, "Black Sea," in *Narcotica* (San Francisco: Auerhahn Press, 1959).

38. Berman photographed this sequence of pictures for the cover of Lamantia's *Narcotica*. However, the pictures used for the book present Lamantia against a backdrop of a crucifix and a papal portrait, reflecting the poet's Italian Catholic background.

39. Perkoff had for several years condemned heroin and its variants. In 1959, under the influence of poets Tony Rios and Anthony Scibella, Perkoff began to take

heroin regularly. Perkoff had recently been selected for inclusion in Donald Allen's anthology for Grove Press, *The New American Poetry* (1960). Believing that this burst of good fortune had put him in the major leagues of new American poets, Perkoff panicked, because he worked slowly and did not see how he could live up to the honor. He lacked the verbosity and biblical incantatory power of Ginsberg, but "boplicity" points to other virtues, in which language creates its own mental reality that can be experienced as a fact. He hoped that the embrace of heroin would give him the power to meet the challenge. Perkoff's writing virtually halted, and he produced only casual diary entries. He abandoned his family and fled to Mexico, where heroin cost only $14 a gram, and if not legal, was not a substance that the police tried to control. In 1962, after returning to the United States, Perkoff was arrested for possession of heroin. He pleaded guilty to a lesser charge of transporting marijuana and was sentenced to five years in federal prison (see John Arthur Maynard, *Venice West: The Beat Generation in Southern California* [New Brunswick: Rutgers University Press, 1991], 138–148).

40. "You are Captain Turn-On from Los Angeles," McClure wrote in a quick note the following morning, promising a manuscript of the experience (Berman papers, AAA).

41. McClure, "Interview with Michael McClure," BL, 40–42.

42. Ibid.

43. Untitled comments by McClure on *Semina* 8, McClure file, Berman papers, AAA.

44. Joan Brown interviewed 1987 by Sandra Leonard Starr, *Lost and Found in California*, 87.

45. Hirschman, "Wallace Berman," in *Wallace Berman* (Los Angeles: Los Angeles County Museum of Art, 1968).

46. See Stan Brakhage to Larry Jordan, 3 April 1959, in Patricia Jordan papers, AAA.

47. Quoted in Barbara Gravelle, "Six North Beach Women," *San Francisco Sunday Examiner and Chronicle*, 21 October 1979, *California Living Magazine*, 34.

48. Robert Duncan, "Structure of Rime XIX (for Shirley and Wally Berman)," in *Roots and Branches* (New York: New Directions, 1964), 169.

49. Gravelle, "Six North Beach Women," 33.

50. See Charles Mopsik, "The Body of Engenderment in the Hebrew Bible, the Rabbinic Tradition, and the Kabbalah," in *Zone: Fragments for a History of the Human Body*, Part 1, ed. Michel Feher (New York: Urzone, 1989), 51–53.

51. *Voices from the Love Generation*, ed. Leonard Wolf (Boston: Little, Brown, and Company, 1968), 36.

52. Joanne Kyger to Patricia and Larry Jordan, 1962, Patricia Jordan papers, AAA.

53. Gravelle, "Six North Beach Women," 33.

54. Quoted in Joyce Johnson, *Minor Characters* (Boston: Houghton Mifflin, 1983), 79. I choose the word "ideology" to stress that this was a structure of ideas and representations that provided a framework for expressing values on an ideal level, independent of, though not entirely unrelated to, behavior or psychology.

55. Philip Shaw has argued that the progressive character of romanticism lodged on its Dionysian side because it worked to exhaust the possibilities of representation, while the Apollonian remained nostalgically fascinated with the power of previous systems of representation. See "Exceeding Romanticism," in *Subjectivity and Literature from the Romantics to the Present Day,* ed. Philip Shaw and Peter Stockwell (London: Pinter Publishers, 1991). While one must be careful about conflating the details of Kerouac's life with the novels he wrote, one of the effects of Kerouac's success was his gradual withdrawal from the avant-garde social circle and return to family and childhood friendships in Lowell, Massachusetts. In 1962 he married Stella Stampas, the sister of a close boyhood friend and nurse to his ailing mother. By all accounts, the marriage was not romantic, but re-created the system of familial support he had known as a boy and honored ambiguously in his novels' maternal figures.

56. Jack Kerouac, *The Dharma Bums* (New York: New American Library, 1958), 147.

57. Ibid., 105.

58. Jack Kerouac, *On the Road* (New York: New American Library, 1957), 101.

59. Robert Duncan, "Conversations with Robert Duncan," BL, 47.

60. Kerouac, *On the Road,* 104.

61. Ibid., 168.

62. Kerouac, *The Dharma Bums,* 127–128.

63. Ibid., 26–27.

64. For an extended diatribe on Kerouac's female characters, see Eliot D. Allen, "That Was No Lady . . . That Was Jack Kerouac's Girl," in Jack Kerouac, *On the Road, Text and Criticism,* ed. Scott Donaldson (Harmondsworth: Penguin Books, 1979), 504–509. To be fair to Kerouac, his character Marlou in *The Subterraneans* (New York: Grove Press, 1958), a black prostitute with whom the hero lives, is a strong female character determined to remain independent in a world that she is aware despises her because she is a woman, a black, a prostitute, and an heroin addict. In this character, Kerouac projected on a woman the striving for anarchic freedom that otherwise in his writing was an exclusively male quality.

65. Stan Brakhage to Larry Jordan, 3 April 1959, in Patricia Jordan papers, AAA.

Brakhage did not name the "academics," but strident, often hysterical criticism of the beats had come from John Ciardi ("Epitaph for the Dead Beats," *Saturday Review* 43 [6 February 1959]: 11–13), T. S. Eliot (interviewed in Roy MacGregor-Hastie, "Waste Land in Russell Square," *Trace* no. 32 [1959]: 1–5), Norman Podhoretz ("The Know-Nothing Bohemians," *Partisan Review* 25 [Spring 1958]: 305–318), V. S. Pritchett ("The Beat Generation," *New Statesman* 56 [23 August 1958]: 292–294), and Diana Trilling ("The Other Night at Columbia," *Partisan Review* 26 [Spring 1959]: 214–230). *Wagner Literary Magazine* 1 (Spring 1959) published a "Symposium on the Beat Poets" with critical comments by Marianne Moore, Herbert Read, and Dorothy Van Ghent, with replies by Gregory Corso, Allen Ginsberg, and Peter Orlovsky.

66. Gerard Malanga, New Year's card to the Bermans, 18 December 1963, Berman papers, AAA.

67. Quoted in Solnit, *Secret Exhibition*, 34.

68. Robert Duncan, "Conversations with Robert Duncan," BL, 151–152, quote on 154–155.

Chapter 9

1. Untitled statement on *Semina* 8 by Michael McClure, McClure files, Berman papers, AAA.

2. John Coplans, "Art is Love is God," *Artforum* 2 (March 1964): 27–37.

3. Estimates of coverage on civil rights movement in *Los Angeles Times* and *San Francisco Chronicle* based on reviewing issues from the period. Estimates on network news coverage from William H. Chafe, *The Unfinished Journey: America Since World War II* (New York: Oxford University Press, 1986), 174.

4. The most notorious statement of this position was Norman Mailer's 1957 essay "The White Negro," *Dissent* 4 (Summer 1957): 276–293.

5. See Michael McClure, "Mammal Language," in *Meat Essays* (San Francisco: City Light Books, 1962), and "Mozart and the Apple," "Pieces of Being," and "Blake and the Yogin," in *Scratching the Beat Surface* (San Francisco: North Point Press, 1982).

6. See Carl Jung, "Transformation Symbolism in the Mass," in *Psyche and Symbol: A Selection from the Writings of C. G. Jung* (Garden City: Doubleday Anchor Books, 1958), 150.

7. The language has precedents in Hugo Ball's dada poems, the Russian constructivists, and lettrisme.

8. Manfredo Tafuri in *Architecture and Utopia: Design and Capitalist Development* (Cambridge: MIT Press, 1976) argued that the avant-garde served to resolve the

planning contradictions of the twentieth-century city by promoting an ideology of multivalent imagery and by exalting formal complexity. Both aspects of vanguard ideology created an intellectual environment in which the failure to solve the practical problems of contemporary life could be celebrated as triumphs for freedom and unlimited possibility (pp. 137–139).

9. Blum was one of the earliest gallery owners to see the commercial potential of Andy Warhol's work. He organized the first Los Angeles exhibit of Warhol's Campbell Soup series and Brillo boxes at the Ferus Gallery in 1960. Blum owns a large collection of Warhol paintings, including a complete series of the Campbell Soup paintings, the work that first brought Warhol to public attention and ridicule.

10. See "Wallace Berman's Verifax Collages," *Artforum* 4 (January 1966): 39–42; letter from Philip Leider (editor of *Artforum*) to Berman, May-September 1965, and letter from Maurice Tuchman (curator, Los Angeles County Museum of Art) to Berman, 1965–1967, Berman papers, AAA.

11. "Excerpt from taped interview by Tanya Belami, London, at the residence of R. Fraser, London 1967," Berman papers, Box 2, Correspondence-miscellaneous, AAA. Ellipses are in the original and probably represent pauses rather than omissions.

12. By focusing on the practical connections between mysticism and poetic practice, I do not intend thereby to suggest that genuine religious faith was not also involved. Gary Snyder's understanding of Buddhism is legendary. His religious practice has not been simply a technology that he used to augment his craft, but moves through his writing and daily life alike as a basis for understanding his relationship to the universe. Many practiced their religious faith with genuine devotion. Others, Berman among them, refused to participate in organized religion, but absorbed aspects of religious thought into what would otherwise be a secular practice.

13. See the first chapter of Charles Mopsik, *La Lettre sur la sainteté: La Relation entre l'homme et la femme dans la cabale* (Paris: Verdier, 1986), for a recent historically grounded examination of the development of kabbalah as a specifically Jewish tradition.

14. See introductory chapter to Martin Buber, *Hasidism* (New York: Philosophical Library, 1948).

15. Gershom Scholem, *Major Trends in Jewish Mysticism* (New York: Schocken, 1969), 341.

16. Charles Mopsik, "The Body of Engenderment in the Hebrew Bible, the Rabbinic Tradition and the Kabbalah," 51, 57–60, 63–65.

17. Hirschman, *KS [Kabbala Surrealism]: An Essay* (Venice, California: Beyond Baroque Foundation, 1973).

18. Unpublished preface to *Opening of the Field*, notebook 2, Robert Duncan pa-

pers, BL. The parallels to existentialist philosophy are clear enough to warrant a presumption of influence. Yet the reading material that occupied Berman, Duncan, and Rexroth encompassed pre-eighteenth-century hermetic philosophers, religious mystics, and varieties of gnosticism. The influence of existential ideas then widespread in American intellectual life may have been to encourage independent study into pre-Enlightenment thought and the formulation of relatively original conceptions of the roots of existentialism.

19. Consider Harold Rosenberg's statement, "The famous 'alienation of the artist' is the result not of the absence of interest of society in the artist's work but of the potential interest of *all* of society in it. A work not made for but 'sold' to the totality of the public would be a work totally taken away from its creator and totally falsified" ("Everyman a Professional," in Rosenberg, *The Tradition of the New*, 73).

20. Perhaps more appropriate than "saint" would be the Jewish concept of the "zaddik," a man who connected with God so that he was always present to divine mysteries even as he went through his daily routine. A zaddik had a weak sense of individuality from having communed so frequently with God. See Charles Poncé, *Kabbalah*, 86–88. Poncé gave Jakob Boehme as the most famous example of a Christian zaddik, who through contemplating the unground of freedom found divine nature.

21. Robert Duncan papers, BL, notebook 2, 213, 162 (7 September 1946).

22. See Paul de Man on the relationship of mythic and empirical selves in literature in "The Rhetoric of Temporality," in *Interpretation: Theory and Practice*, ed. Charles Singleton (Baltimore: Johns Hopkins University Press, 1969), 196–201. For a discussion of modern society as a dialectical tension between everyday and systemic logics see Detlev Peukert, "Neuere Alltagsgeschichte und Historische Anthropologie," in *Historische Anthropologie*, ed. Hans Süssmuth (Göttingen: Geisteswissenschaft Institut, 1984), 63–64.

23. George Herms file, Bob Alexander papers, AAA.

Chapter 10

1. Quoted in Eric Mottram, "The Romantic Politics of the Body in Michael McClure," *Margins*, no. 18 (March 1975): 9.

2. McClure, *Meat Essays*, 54.

3. Discussions of the legal foundations of obscenity law can be found in *Commentaries on Obscenity*, ed. Donald B. Sharp (Metuchen: Scarecrow Press, 1970); Edward de Grazia, *Girls Lean Back Everywhere: The Law of Obscenity and the Assault on Genius* (New York: Random House, 1992); Donald Alexander Downs, *The New*

Politics of Pornography (Chicago: University of Chicago Press, 1989); Catharine MacKinnon, "Pornography, Civil Rights, and Speech," *Harvard Civil Rights–Civil Liberties Law Review* 20 (1985): 1–35; *Pornography and Censorship,* ed. David Copp and Susan Wendell (Buffalo: Prometheus Books, 1983); David M. Rabban, "The Emergence of Modern First Amendment Doctrine," *University of Chicago Law Review* 50 (1983): 1205–1273.

4. Everts, "Los Angeles Art Community," OHP/UCLA, 54.

5. Ibid., 56.

6. Ibid., 134, 130.

7. See *The Exodus Group* (Long Beach: Long Beach Museum of Art, 1960).

8. Everts, "Los Angeles Art Community," OHP/UCLA, 155–157.

9. Ibid., 178–180, 191, 250–251.

10. While Everts lived in a small village in Chile in the 1950s, he witnessed the lynching of a priest who had murdered a woman he had made pregnant. Another factor he thought formative to his understanding of the precarious nature of human existence was a trip he and his wife made to Hiroshima to visit her relatives (conversation with Everts, November 1992).

11. Ibid., 332. Severely undercapitalized, the society closed in 1963.

12. Quoted in Nordland, "The Suppression of Art," 25.

13. Everts, "Los Angeles Art Community," OHP/UCLA, 241–242.

14. Ibid., 279–280. Compare Everts's description with that made by the trial judge, Andrew J. Weisz: "The main object depicted on the poster is a gross view of the lower female autonomy, showing the pubic hair and a greatly distended vaginal opening. If one were limited to a lightning view, the poster would appear to be a poor example of washroom art, with some lettering thereon. Approached in a more leisurely fashion, one sees the words 'Studies in Desperation,' and also descries that the lines describing the pubic mass contain within themselves the outline of a gross and brutish face. The mouth of this face is the large vaginal opening, and contained therein are large, irregular, and misshapen teeth. Less distinct, but nonetheless discernible, are outlines of two hands on either side of the vagina-mouth" (Memorandum of Decision, *People of the State of California* v. *Connor Everts,* 14 May 1965).

15. Everts, "Los Angeles Art Community," 283–303; *Artforum,* untitled notice, September 1964; memorandum on history of trial, prepared by O'Melveny and Myers, attorneys for the defendant, 28 April 1965. The terms used to describe Everts's images show how far American public sensibilities moved between the mid-1960s and the early 1990s. The bathic character of these lithographs is more visible thirty years later because Everts's reticence to exploit spectacle prevents later viewers from seeing

those features that caused commentators in the 1960s inevitably to refer to his work as "brutal" and "shocking."

16. O'Melveny and Myers, memorandum on history of trial.

17. Memorandum of Decision, *People of the State of California* v. *Connor Everts*, Case no. M-12887, 14 May 1965.

18. Henry J. Seldis, "Everts Obscenity Acquittal a Verdict for Artistic Maturity," *Los Angeles Times*, 30 May 1965, Calendar Section, 17. Seldis referred to Everts's case as the first obscenity charge ever brought against a painter in Los Angeles, indicating that he was unaware of the 1957 Berman case. O'Melveny and Myers, memorandum on history of trial.

19. Brief for United States, *Roth* v. *U.S.* 354 US 476 (1957), 64–65. See Louis A. Zurcher, Jr., and R. George Kirkpatrick, *Citizens for Decency: Antipornography Crusades as Status Defense* (Austin: University of Texas Press, 1976), 125–127; Charles H. Keating, "The Report That Shocked the Nation," *Readers Digest* (January 1971): 2–6.

20. *The Report of the Commission on Obscenity and Pornography* (New York: Bantam, 1970); Irving Kristol, "Pornography, Obscenity, and the Case for Censorship," *New York Times Magazine* (28 March 1971): 23; Walter Berns, "Pornography vs. Democracy: The Case for Censorship," *Public Interest* 22 (Winter 1971): 12; George Steiner, "Night Words: High Pornography and Human Privacy," in *Perspective on Pornography,* ed. Douglas A. Hughes (New York: St. Martin's Press, 1970), 96–108.

21. Mothers United for a Clean Society brought together the two largest and most influential morals advocacy groups in the state: the Legion of Decency and Citizens United for Decency Through Law. The Legion was based in the Catholic Church, with its chapters housed in diocesan offices. Catholics annually pledged to abide by Legion recommendations on the moral acceptability of books, motion pictures, and popular music. The Legion had committees that patrolled bookstores and art galleries and filed complaints with local police departments. The Legion's efforts led to an average of sixty to seventy arrests a year in Los Angeles County, 90 percent of which concerned hardcore pornography. The remaining arrests involved gambling, illegal abortions, and drug dealing. See *Legion of Decency Bulletin,* 1947–1967 (on file at PAS). Citizens United for Decency Through Law was based in conservative but mainstream Protestant congregations and had been particularly effective in building support among businessmen. The organization had been founded in 1957 in Cincinnati with the purpose of establishing uniform national standards restricting public discussion of sexuality. Its national president was banking and real estate entrepreneur

Charles H. Keating, who in the late 1980s gained notoriety as symbol of the fraud prevalent in the savings and loan industry. See Louis A. Zurcher, Jr., and R. George Kirkpatrick, *Citizens for Decency: Antipornography Crusades as Status Defense* (Austin: University of Texas Press, 1976), 125–127; Charles H. Keating, "The Report That Shocked the Nation," 2–6.

22. Proposition 16 (November 1966) ballot statement, on file at PAS.

Chapter 11

1. Peter Plagens, *Sunshine Muse,* 127–128; Kienholz, "Los Angeles Art Community," OHP/UCLA, 376–386.

2. "Obscenity Drive Gains Momentum," *Los Angeles Times,* 16 December 1965. Dorn joined Mothers United for a Clean Society in announcing the petition drive to the press. The board's unanimous vote probably resulted more from supervisorial courtesy than from conviction one way or another on the issue. County supervisors expect to get the assent of their colleagues of issues that are of primarily personal importance.

3. Kienholz, "Los Angeles Art Community," OHP/UCLA, 252.

4. Arthur Secunda, "Bernhardt, Frazier, Kienholz," *Artforum* 1 (1962): 31.

5. Caryl Chessman had been condemned to death for a series of rapes in Los Angeles in 1948 and 1949. He had not taken a life, and opponents to capital punishment hoped to pressure Governor Edmund G. Brown, Sr., into commuting the sentence. The title of Kienholz's piece broadened the context of the issue through a pun on the famous case of Nicola Sacco and Bartolomeo Vanzetti, two anarchist organizers executed in Massachusetts in 1927.

6. Kienholz, "Los Angeles Art Community," OHP/UCLA, 223–224.

7. Arthur Secunda, "Charles Bernhardt, John Frazier, Edward Kienholz," 31–32. The arts communities were actively involved in anti–capital punishment activities. In 1960 the Batman Gallery in San Francisco installed a life-size model of the gas chamber on its premises with graphic explanations of the procedures for executions and how lethal gas killed.

8. Kienholz, "Los Angeles Art Community," OHP/UCLA, 368–370.

9. Quoted in Elena Calas and Nicolas Calas, *Icons and Images of the Sixties* (New York: Dutton and Co., 1971), 46.

10. Kienholz, "Los Angeles Art Community," OHP/UCLA, 373–374.

11. Sidney Tillim in writing on *The Beanery* during its exhibition in New York thought that Kienholz wished to provoke a nostalgia for "an existence uncomplicated by anxiety and ambition" ("The Underground Pre-Raphaelitism of Edward Kien-

holz," *Artforum* 4 [April 1966]: 38). I see this piece, and most of his other work from the 1960s, as attempting to instill anxiety so that the viewer would feel outraged and determined to change the conditions revealed by the work's ability to cause pain.

12. Kienholz, "Los Angeles Art Community," OHP/UCLA, 342. Kienholz, however, was not religious or a spiritual visionary. He prided himself as a hardheaded skeptic: "I think the whole idea of continuance after death is an understandable projection of man's ego" (p. 343).

13. Ibid., 218.

14. *The Arts in California: A Report to the Governor and the Legislature by the California Arts Commission on the Cultural and Artistic Resources of the State of California* (Sacramento, 1966), 26, 65–66.

15. Further evidence for this line of reasoning might be found in an audiotape, now destroyed, that Kienholz made while Dorn and fellow supervisor Kenneth Hahn examined *Roxy's,* the whorehouse installation. Kienholz recalled: "They came into hearing range of the microphone and then go out—but they'd say things like 'Gee, Kenny, look at this. I haven't been in a place like this in twenty years. Look at that over there.' It was like old home week. They're in there, just having a ball. And the next thing you hear them come out of *Roxy's* and they're saying, 'Why it's a moral outrage. Can you imagine women and children seeing that? I can't believe it'" (Kienholz, "Los Angeles Art Community," OHP/UCLA, 387–388). Kienholz's conviction that Dorn was living proof of the documentary accuracy of *John Doe* fortified his position during the struggle.

16. Quoted verbatim in Kienholz, "Los Angeles Art Community," OHP/UCLA, 384–385; portions quoted in the *Los Angeles Times,* 24 March 1966.

17. Summary of events drawn from Kienholz, "Los Angeles Art Community," OHP/UCLA, 376–398 and *Los Angeles Times,* 21–31 March 1966. See also Sandra Leonard Starr, *Lost and Found in California,* 114.

18. In addition to Kienholz's discussion of the affair, the controversy over his show arose as a subject in oral history interviews with Joan Brown, Connor Everts, and Craig Kauffman.

19. See *California News Reporter* 1, nos. 18 and 22 (15 May and 12 June 1967), for analysis of abortion legislation. See James E. Hayes, oral history interview, California State Archives, interviewed 1989 by Carlos Vásquez, 98–105, for an account of efforts to change the state's divorce laws by the bill's author.

20. Michael McClure, *Dark Brown* (San Francisco: Auerhahn Press, 1961).

21. Michael McClure, "Phi Upsilon Kappa," in *Meat Science Essays,* 22, 27.

22. Eric Mottram, the reviewer for the London *Times Literary Supplement* referred to Michael McClure as one of the most remarkable poets of America. Mottram

wrote that McClure's emphasis on physical states of being promoted an economy of self balanced against total absorption into society. See "This is Geryon," *Times Literary Supplement*, 25 March 1965, 236. Joanna McClure's poems were first published in book form in 1974 with the release of *Wolf Eyes* (San Francisco: Bearthm Press). However, she began publishing occasionally in small press magazines in 1966. By the mid-1970s, Joanna McClure's poetry assumed its own autonomous, global concerns. Her second book of poetry, *Extended Love Poem* (Berkeley: Arif Press, 1978), documented her involvements in the ecological movement. The McClures later divorced.

23. Michael McClure, "Interview with Michael McClure," BL, 29.

24. Ibid., 32–33.

25. McClure argued that Artaud's cruelty was toward himself: "He underwent a kind of self-crucifixion, brought on by his intense awareness of a split between his mind and body, and he carried his pain to a degree where we can hold him as an example. We can say that a man can be hallucinated, can go through agonies to the degree that he pushed his pain, and still make it, still survive and be beautiful" (ibid., 4). The roots of McClure's approach to drama lie in Nietzsche's advice, "To be a dramatist all one needs is the urge to transform oneself and speak out of strange bodies and souls" (*The Birth of Tragedy* [New York: Doubleday, 1956], 55).

26. "Notes on *The Beard* by Michael McClure," written on the back of a manila envelope postmarked 21 November 1967 (Michael McClure papers, BL). These notes attempted to develop the origins of McClure's interest in Billy the Kid and thus are more about *The Blossom* than his later play.

27. McClure, "Interview with Michael McClure," BL, 40–42.

28. Sigmund Freud, *A General Introduction to Psychoanalysis* (New York: Pocket Books, 1953), 304–306, 374, 416, 432.

29. Sigmund Freud, "Jokes and their Relation to the Unconscious," in *The Standard Edition of the Complete Psychological Works of Sigmund Freud*, ed. James Strachey (London: Hogarth Press, 1953–1966), 8:99–100.

30. "Is This Show Biz? Really Showing It—At a $3 Top," *Variety*, 8 March 1967, 1, 70.

31. McClure, *The Beard*, 72–73. In *Civilization and Its Discontents* (New York: Pocket Books, 1961), Freud described the ego as a mask for the unconscious "mental entity" he designated the id. "Originally the ego includes everything, later it separates off an external world from itself. Our present ego-feeling is, therefore, only a shrunken residue of a much more inclusive—indeed an all-embracing—feeling which corresponded to a more intimate bond between the ego and the world about it" (p. 15). Aggression is a behavior in which the id tries to reconstruct the original union of self and world by imposing the ego's dominion over others.

32. This is one of the reasons that McClure insisted that *The Beard* was a "nature poem" (McClure, "Interview with Michael McClure," BL, 77).

33. This description reflects analytic categories found in Jacques Lacan, "The Agency of the Letter in the Unconscious or Reason since Freud," *Écrits* (New York: W. W. Norton, 1984), and in Karen Horney, *The Neurotic Personality of Our Time* (New York: W. W. Norton and Company, 1937).

34. As in *Dark Brown*, McClure did not represent female pleasure in *The Beard*. Harlow, as an object brought into being by male lust, cannot and need not act as an independent female subject.

35. See Sigmund Freud, *A General Introduction to Psychoanalysis*, 336–338; Erik Erikson, *Identity, Youth, and Crisis*, 98–102; Karen Horney, *The Neurotic Personality of Our Time*, 124.

36. McClure, *Dark Brown*, last stanza of "A Garland."

37. George Herms, "Oedipus and the Apple Tree," notes for a proposed film for Larry Jordan, Patricia Jordan papers, AAA.

38. McClure, *The Beard*, 93.

39. See John L. Wasserman, "Snarls, Simpers, Coos, Growls," *San Francisco Chronicle*, 24 July, 1966, *Datebook*, 2.

40. 1 Civil No. 24685, Court of Appeal of the State of California, First Appellate District, Division Four, *Billie Dixon, Richard Bright, and Michael McClure* v. *The Municipal Court of the City and County of San Francisco*.

41. McClure, "Interview with Michael McClure," BL, 28; John L. Wasserman, "The Many Sides of Poet Michael McClure," *San Francisco Chronicle*, 25 January 1967, 46.

42. For breakdown of election results by county, city, state senatorial district, and assembly district, see *California Statement of Vote and Supplement, November 8, 1966, General Election* (Sacramento: Office of the Secretary of State, 1966).

43. "Teachers to Defy 'Love Book' Ban," *San Francisco Chronicle*, 22 November 1966, 1, 13; "Five Professors Score a Hit with 'Love Book' Poetry Reading," *San Francisco Examiner*, 24 November 1966, 3; Donovan Bess, "Profs' Reading: Eager Audience for 'Love Book'—But No Cops," *San Francisco Chronicle*, 24 November 1966, 24.

44. Stan Brakhage to John Jay Ferndon, District Attorney of the City and County of San Francisco, 22 August 1966, in Michael McClure papers, BL.

45. *Los Angeles Times*, 6 December 1967, II, 1, 8.

46. The proposed motion picture production deal fell through largely because Andy Warhol had illegally shot and begun marketing a film of the play, with Gerard Malanga as the Kid and Mary Woronova as Harlow. By 1969, when McClure's law-

yers finally succeeded in gaining an injunction against Warhol and reestablishing McClure's sole title to film rights for *The Beard*, interest in the production had expired. See correspondence and depositions in Michael McClure papers, BL.

47. The bill died in the assembly in 1968 after the state attorney general's office advised the legislature that the bill was too broadly written and was probably unconstitutional.

48. *Orange County Register* editorial, 7 December 1967, C8.

49. "The Ugliness of Compulsion," editorial, *Anaheim Bulletin*, 20 November 1967, D6.

50. S.B. 1512, 1967 Reg. Sess., not passed.

51. "The Controversy over 'The Beard,'" editorial, *Los Angeles Times*, 28 November 1967, II, 4.

52. "LAPD Vice Squad Moves to Clip Showing of 'The Beard,' *Open Forum*, February 1968, 1; Paul Eberle, "Cops Bust 'The Beard' Nightly," *Los Angeles Free Press*, 2–8 February 1968, 1, 14; *Los Angeles Times*, editorial, 26 January 1968.

53. McClure, "Interview with Michael McClure," BL, 27.

54. Donald B. Sharp, "Obscenity Law and the Intransigent Threat of *Ginzburg*," in *Commentaries on Obscenity*, ed. Donald B. Sharp, 11–13.

55. Barbara Rose, "New York Letter," *Art International* 7 (25 March 1963): 65–68.

56. Kienholz, "Los Angeles Art Community," OHP/UCLA, 280–282, 323–334.

57. Everts, "Los Angeles Art Community," OHP/UCLA, 315–316.

58. Seldis, "Everts Obscenity Acquittal a Verdict for Artistic Maturity," 17.

59. *Long Beach Argus*, 5 December 1968. Herbert Jepson's secondhand account of the event may indicate that there was considerable antagonism to Everts within the Los Angeles arts community: "One occasion [Everts] was with a gathering of students in a bar after an exhibition at the university where he was teaching . . . and the police came in, and he, you know, right away started to needle them, and so he ended up getting arrested. And then in the elevator on the way up to being booked in the police station, they beat him so badly that he was hospitalized. And he was in handcuffs and they accused him of trying to escape or something. They beat him with their sticks until he was black and blue. But that is, I think, symptomatic of his kind of contempt for authority, no matter who they are" (Herbert Jepson, "Los Angeles Art Community: Group Portrait, Herbert Jepson," interviewed 1976, OHP/UCLA, 244–245).

60. Everts, "Los Angeles Art Community," OHP/UCLA, 359.

61. Ibid., 378–380.

62. Ibid., 374–385, 299–307.

63. For a selection of these arguments, see Marshall Berman, *All That Is Solid Melts Into Air: The Experience of Modernity* (New York: Penguin Books, 1982); Russell Berman, "Critical Theory and Consumer Society," in *Modern Culture and Critical Theory: Art, Politics, and the Legacy of the Frankfurt School* (Madison: University of Wisconsin Press, 1988); Norman Bryson, *Vision and Painting: The Logic of the Gaze* (New Haven: Yale University Press, 1983); Manfredo Tafuri, *Architecture and Utopia: Design and Capitalist Development* (Cambridge: MIT Press, 1976). In addition to developments in the arts, publication of the Kinsey reports and other scientific investigations into sexual behavior also opened up new ways of discussing intimate personal behavior in public.

Chapter 12

1. Interview with Ferlinghetti by David Meltzer in *The San Francisco Poets*, 141; Gary Snyder, "Control Burn," in *Turtle Island* (New York: New Directions, 1974), 19.

2. Robert Duncan, "Man's Fulfillment in Order and Strife," in *Fictive Certainties* (New York: New Directions, 1985), 128. Duncan's observation parallels Herbert Marcuse's point that democracy is a system of government for the "introjection of the masters into their subjects" (Marcuse, *Eros and Civilization: A Philosophical Inquiry into Freud* [Boston: Beacon Press, 1966], xv).

3. Robert Duncan, "Introduction," *Bending the Bow* (New York: New Directions, 1968), i.

4. Duncan, "Man's Fulfillment in Order and Strife," 138.

5. *The Portable War Memorial* is currently in the permanent collection of the Museum Ludwig in Köln, Germany. Description based on personal notes taken while viewing the piece.

6. See Michael McClure, "Interview with Michael McClure," BL, 37–39.

7. Gary Snyder, "Cold Mountain Poems, #6," translation from Han-Shan, in Snyder, *Riprap and Cold Mountain Poems* (San Francisco: North Point Press, 1990), 44; first published in *Evergreen Review* no. 6 (1958).

8. Denise Levertov, "Life at War," in *Poems, 1960–1967* (New York: New Directions, 1983), 229; Wally Hedrick, "Wally Hedrick Interview #2," AAA, 10.

9. On Talbert's background and development as an artist, see Hal Glicksman, "Ben Talbert," in *Assemblage in California* (Irvine: University Art Gallery, 1968), 48–55; "Ben Talbert 'Microspect' set for May, June in Venice," *Ocean Front Weekly* 2, no. 20 (16 May 1979): 2, 13. Robert Duncan's companion Jess also developed a series of collages based on the "Dick Tracy" comic strip that Jess called "Tricky Cad."

10. Wolf, *Voices from the Love Generation*, 90.

11. Ibid., 34–35.

12. Ibid.

13. Joanne Kyger, "Pan as the Son of Penelope," in *Going On: Selected Poems 1958–1980* (New York: E. P. Dutton, Inc., 1983), 2.

Chapter 13

1. Gary Snyder, "For the West," in *The Back Country* (New York: New Directions, 1968), 117.

2. Carol Baker, "1414 SE Lambert Street," in *Gary Snyder: Dimensions of a Life,* ed. Jon Halper (San Francisco Sierra Club Books, 1990), 27. This was a brief reminiscence written by one of Snyder's college roommates for the festschrift prepared in honor of Snyder's sixtieth birthday. Robert Duncan likewise had received a subpoena to appear before the California state legislature's Joint Fact-Finding Committee on Un-American Activities for his activities as an editor of the American Student Union newspaper at Berkeley. The same committee summoned Wally Hedrick for his involvement in the Progressive Art Workers, a club of young artists organized in 1946 at Pasadena City College.

3. Gary Snyder, "Revolution in the Revolution in the Revolution," in *Regarding Wave* (New York: New Directions, 1970), 39.

4. Gary Snyder, "The Yogin and the Philosopher," in *The Old Ways* (San Francisco: City Lights Books, 1977), 11.

5. See Snyder's definition of dharma in "The Etiquette of Freedom," in *The Practice of the Wild* (San Francisco: North Point Press, 1990), 10. Dharma has no fixed meaning. The word is used interchangeably to refer to universal law, the collectivity of all phenomena, truth, or Buddhist doctrine (Kapleau, *The Three Pillars of Zen,* 328). In addition to formal training at a Zen monastery, Snyder found the Vajrayana and Shingon Mikkyo schools of Buddhism attractive. Vajrayana is part of the Tantric tradition, the predominant form of Buddhism in Tibet. Tantric schools plunge their practitioners into their passions, which can when confronted become vehicles of enlightenment. See Chögyam Trungpa, *Cutting through Spiritual Materialism* (Berkeley: Shambhala, 1973), for an exposition of Vajrayana Buddhism. The dialectic between the ascetic Zen and the theatrical Vajrayana traditions of Buddhism appeared very early in Snyder's studies into Asian religion, long before he actually left to live in Japan. Shingon Mikkyo is a branch of Buddhism devoted to esoteric knowledge and the study of the keys to locate and interpret hidden messages in the world of phe-

nomena. It is associated with wilderness and mountain retreats. See Katsumori Ya-mazato, "How to Be in This Crisis: Gary Snyder's Cross-Cultural Vision in *Turtle Island,*" in *Critical Essays on Gary Snyder,* ed. Patrick D. Murphy (Boston: G. K. Hall and Co., 1991), 236–238.

6. Kerouac, *The Dharma Bums,* 78.

7. Snyder has repudiated the sexual portrait of Japhy Ryder as having little rela-tionship to the way he actually lived in the 1950s. At the same time, he has conceded that Kerouac's presentation of Snyder's early studies into Buddhism were generally ac-curate, taking into account the distortions and exaggerations necessary to a popular novel. See Snyder's letter to Sherman Paul printed at the end of Paul's *In Search of the Primitive: Rereading David Antin, Jerome Rothenberg, and Gary Snyder* (Baton Rouge: Louisiana State University Press, 1986), 298–301; and interviews with Snyder in *The Real Work: Interviews and Talks, 1964–1979* (New York: New Directions, 1980), 62, 163. Snyder's three marriages suggest a continuing search through his youth for a mate rather than a desire to escape from women as Kerouac described. Snyder's political and aesthetic philosophies after 1967 explicitly assert that male-female bond-ing is the essential and necessary social fact.

8. Kerouac, *The Dharma Bums,* 61.

9. Ibid., 68–69.

10. Anecdotal accounts of Snyder's life in Japan are found in *Gary Snyder: Di-mension of a Life,* 53–109. See also Janwillem van de Wetering, *The Empty Mirror: Experiences in a Japanese Zen Monastery* (New York: Washington Square Press, 1973), reminiscences of a Dutch student of Zen who entered Daitoku-ji in 1958; and the accounts of Snyder's second wife, Joanne Kyger, in *The Japan and India Journals, 1960–1964* (Bolinas: Tomboctou Press, 1979).

11. In another interview, Snyder observed: "The danger of Zen is not that people become moral anarchists—it's quite the opposite. It's that they become complete sup-porters of whatever establishment is around. That is the *real* moral anarchism of Zen. 'Morals don't matter, so support the government'" (Dom Aelred Graham, *Conversa-tions: Christian and Buddhist, Encounters in Japan* [New York: Harcourt, Brace, and World, 1968], 61).

12. Gary Snyder, *Myths and Texts* (New York: New Directions, 1978), vii–viii. In this volume, Snyder used "text" to represent "pure natural process" and "myth" to stand for imaginative value. See Charles Altieri, "Gary Snyder's Lyric Poetry: Dialec-tic as Ecology," *Far Point* 4 (1970): 55–65, for a discussion of how Snyder developed these two critical terms poetically. Snyder, in the introduction to his undergraduate thesis, defined myth as a "reality lived" that contained "at the moment of telling, the

projected content" of "unarticulated and conscious values: simultaneously ordering, organizing, and making comprehensible the world within which the values exist. One might even reformulate the statement to say 'Reality is a myth lived'" (*He Who Hunted Birds in His Father's Village* [New York: New Directions, 1979], 109–110).

13. Gary Snyder, "Moving the World a Millionth of an Inch," interview taped in 1974, published in *The Beat Vision: A Primary Sourcebook,* ed. Arthur Knight and Kit Knight (New York: Paragon House Publishers, 1987), 10–11. Lawrence Ferlinghetti also felt that the Cuban Revolution had been a decisive factor in changing the attitudes of United States poets, moving them from the "disengaged" stance of the beat period focused on individual self-improvement to a renewed faith in the possibility of radical social change (interview with Ferlinghetti by David Meltzer in *The San Francisco Poets,* 136). Allen Ginsberg, however, expressed a contrary negative evaluation of the Cuban revolution in a pamphlet, "Contribution Towards the Cuban Revolution," published in 1961 by *Pa'alante.* Ginsberg assailed the new regime for its policies persecuting homosexuals, which he viewed as the first steps toward curtailing all forms of free personal expression.

14. See *Gary Snyder: Dimensions of a Life,* 188.

15. Snyder, *The Real Work,* 61.

16. Interview with Ekbert Faas, 1974, in *Towards a New American Poetics: Essays and Interviews,* ed. Ekbert Faas (Santa Barbara: Black Sparrow Press, 1978), 113–114. See Gary Lawless, "My Apprenticeship at Kitkitdizze: Summer of 1973," and Scott McLean, "Thirty Miles of Dust: There Is No Other Life," in *Gary Snyder: Dimensions of a Life,* for accounts of apprenticeships with Snyder.

17. See Joseph Campbell, *The Hero with a Thousand Faces* (Princeton: Princeton University Press, 1949), 30ff.

18. Brisk sales of his poems began with his earliest volumes. The first edition of *Riprap* (Ashland: Origin Press, 1959) sold out very quickly, and *Myths and Texts* (New York: Totem Press, 1960) sold at a steady thousand copies a year until 1969, when New Directions reprinted Snyder's work in larger editions.

19. Snyder, *The Real Work,* 121.

20. Gary Snyder to Kenneth Rexroth, 10 May 1966, correspondence files, Rexroth papers, DSC. A bodhisattva is an enlightened being who helps others achieve enlightenment.

21. Yet in his opinion the perspective that historical formations are not divine came from the West and not from Buddhism: "One of the most interesting things that has ever happened in the world was the Western discovery that history is arbitrary and that societies are human, and not divine, or natural, creations—that we actually have the capacity of making choices in regard to our social systems. This is a discovery that

came to Asia only in this century. We in the West have an older history of dealing with it" (Snyder, *The Real Work*, 101).

22. Graham, *Conversations: Christian and Buddhist*, 69.

23. Gary Snyder, "Energy in Eternal Delight," in *Turtle Island*, 105.

24. Gary Snyder, *Earth House Hold*, 92; essay originally published in 1961 as "Buddhist Anarchism" for Michael McClure's and David Meltzer's *Journal for the Protection of All Beings* no. 1.

25. Snyder, *The Real Work*, 41. In another interview, Snyder cited Rod Coburn, a master mechanic, as the single person from whom he learned most about craft values and an approach to poetry (ibid., 61).

26. Secunda, "John Bernhardt, Charles Frazier, Edward Kienholz," 33.

27. Kienholz, "Los Angeles Art Community," OHP/UCLA, 397.

28. Quoted in Bruce Cook, *The Beat Generation* (New York: Charles Scribner's Sons, 1971), 131.

29. Interview with Ekbert Faas, in *Towards a New American Poetics*, 141.

30. Inger Thorup Lauridsen and Per Dalgard, *The Beat Generation and the Russian New Wave* (Ann Arbor: Ardis, 1990), 74.

31. Interview with Ekbert Faas, in *Towards a New American Poetics*, 131.

32. Gary Snyder, "Wave," in *Regarding Wave*, 3.

33. Snyder, "Kyoto Born in Spring Song," in *Regarding Wave*, 18. Vajra literally means diamond or adamantine. In Buddhist terminology, vajra is a symbol of the highest spiritual power that reflects all other powers in its light and that can cut every other material but cannot itself be cut by anything (Kapleau, *The Three Pillars of Zen*, 349).

34. Gary Snyder, "Axe Handles," in *Axe Handles* (San Francisco: North Point Press, 1983), 6. Although Snyder's themes are closely connected to Rexroth's, Snyder's choice of Pound as a poetic mentor broke with the anti-Pound orthodoxy of the Rexroth circle.

35. Robert Boyers, "A Mixed Bag," *Partisan Review* 36 (1969): 313. See also Charles Altieri, *Enlarging the Temple: New Directions in American Poetry During the 1960s* (Lewisburg: Bucknell University Press, 1979) for an argument that Snyder's experience is too limited to support "his claims to totality" (p. 150). Any one individual's, or for that matter society's, experience is too limited to be an adequate base for a "total" description of reality. In this respect, the situation of poets is no different from that of any other professional group. The problem is not whether authors' lives are too narrow, but how the rhetorical and narrative models they use resonate with the life experiences and dreams of their potential audiences and provide meaningful symbolic resources for efforts to understand the world. Given that poetry audiences are consid-

erably smaller than those for many other art forms, Snyder's book sales make him one of the more popular American poets of the 1960s and 1970s despite all the features, both biographical and stylistic, that ought to have limited his appeal.

36. For women poets who, like Snyder and Duncan, accepted the importance and validity of symbols developed across the centuries as a way of expressing fundamental truths of contemporary experience without succumbing to the dictates of contemporary ideology, the relation of experience to natural "process" was complex. Denise Levertov in her poem "The Son," about the maturing of her teenage boy, began the poem with a reference to Eros: "He-who-came-forth was / it turned out / a man—" (Levertov, "The Son," in *Poems, 1960–1967,* 168–169). The child as well as the mother is a symbol of strife and change, an observation provoked by his silent, moody moving through the house. What prompted her to write the poem, she later explained, was "the capacity for suffering that I had become aware of in him, the suffering for instance of the painful silences of adolescent shyness in a rather conscious and not merely frustrated way." She noted that these emotions of his were beginning to find positive transformation in the fabrication of visual art. She was aware of a general process moving through her only child, a replication of the forces that turned strife into creativity, yet he remained her son Nik. The universal repeated itself in the local, which nonetheless did not lose its individual character no matter how much behavior manifested the power of myth as an expression of irrepressible but unpredictable patterns. Levertov discussed the process of composing this work in "Work and Inspiration: Inviting the Muse," in *The Poet in the World* (New York: New Directions, 1973), 25–42; quotation on 39.

37. Snyder, *The Real Work*, 80–81. Snyder has been reticent in discussing the details of his family background or his childhood. He lived on a farm as a small child, but when he was ten, his parents separated. He and his sister lived with his mother, who moved to Portland to work in the circulation department of the *Oregonian.* She later achieved her goal of becoming a reporter. As a single working mother, she had to struggle to provide her family with a modest standard of living. She was, however, ambitious for her children and pushed both to plan for professional careers. Snyder has suggested that he and his mother often quarreled, but after he left home to attend Reed, he became financially independent and had little contact with her. See J. Michael Mahar, "Scenes from the Sidelines," in *Gary Snyder: Dimensions of a Life,* 8–11. The hint he gave in his interview with Ekbert Faas that his mother was somehow similar to Allen Ginsberg's mother, who had spent the last twenty years of her life in and out of mental hospitals because of schizophrenic behavior, was misleading. The hint however revealed the emotional pain of his relationships with his absent father, a farmer and craftsman that Snyder sought to emulate, and his mother, who in the context of

other statements Snyder has made, appears to be the prime model for the stereotype of the psychologically devouring female.

38. The observation that without death there would be no birth was mythically expressed through the symbol of the womb representing the tomb. This mythic image was then projected on women as social beings. Because they give birth they are also the bearers of death, the devourers, so that the rage that women expressed at the conditions of their existence could be transformed into another instance of women consuming those with whom they live. Myth abstracts and personalizes at the same time, so it appears to conform to and explain the facts but is independent and reductive of the specific manifestations.

39. In 1972 Snyder dramatized his view that the United States needed to be dismembered into biocultural units by insisting that no copies of his collection *Manzanita* (Bolinas: Four Seasons Foundation, 1972) could be sold east of the Rockies. He explained, "It's a different country over there; it's not the same place. . . . It's on the other side of the turtle's backbone" (referring to North America as Turtle Island; quoted in Katherine McNeil, *Gary Snyder: A Bibliography* [New York: Phoenix Bookshop, 1983], 69).

40. Laguna Pueblo novelist Leslie Marmon Silko criticized Snyder for being an "Orientalist" who appropriated other peoples' cultures to enhance the power of his own, without ever addressing the question of restitution ("An Old-Time Indian Attack Conducted in Two Parts," *Shantih* 4 [Summer-Fall 1979]: 4).

41. Snyder, "Passage to More than India," in *Earth House Hold*, 111.

42. Snyder, "Four Changes," in *Turtle Island*, 90–102.

43. Snyder published a mimeographed version of "Four Changes," which he distributed widely in 1969. Four other editions appeared in 1969 and 1970, as the Berkeley-based environmental newsletter *Earth Read Out*, Robert Shapiro from Chicago, Noel Young of the Unicorn Book Shop, and the Whole Earth Truck Store in Santa Barbara each independently reprinted Snyder's mimeographed text. They distributed approximately 300,000 free copies, and in 1974, the Ecology Center Bookstore in Berkeley republished the essay as the second number in its pamphlet series on environmental subjects, while Snyder included the manifesto as the conclusion to *Turtle Island*. For a publishing history, see Snyder's introductory note to "Four Changes" in *Turtle Island*, 91, and McNeil, *Gary Snyder: A Bibliography*, 47–50.

44. Snyder, "Four Changes," in *Turtle Island*, 92.

45. Ibid., 102.

46. Snyder, "Buddhism and the Coming Revolution," in *Earth House Hold*, 92.

47. Compare Herbert Marcuse: "[Contemporary society] delivers the goods bigger and perhaps even better than ever before and it exacts, for the delivery of these

goods, the constant sacrifice of human lives: death, mutilation, enslavement ("Art in the One-Dimensional Society," *Arts Magazine* 41 [May 1967]: 26).

48. From "Hitch Haiku," in Snyder, *The Back Country*, 25.

49. Snyder, *The Real Work*, 132.

50. For treatments of the dilemmas of the aesthetic avant-garde in Europe see: Peter Bürger, *Theory of the Avant-Garde* (Minneapolis: University of Minnesota Press, 1984); Matei Calinescu, *Five Faces of Modernity: Modernism, Avant-Garde, Decadence, Kitsch, Postmodernism* (Durham: Duke University Press, 1987); T. J. Clark, *Image of the People: Gustave Courbet and the 1848 Revolution* (Princeton: Princeton University Press, 1973); T. J. Clark, *The Painting of Modern Life: Paris in the Art of Manet and His Followers* (Princeton: Princeton University Press, 1984); Renato Poggioli, *The Theory of the Avant-Garde* (Cambridge: Harvard University Press, 1968); Jerrold Seigel's *Bohemian Paris: Culture, Politics, and the Boundaries of Bourgeois Life, 1830–1930* (New York: Viking Penguin, 1986).

51. Snyder, "What history fails to mention is," in *Left Out in the Rain: New Poems 1947–1985* (San Francisco: North Point Press, 1986), 161.

52. Snyder, "For a Far-Out Friend," in *Riprap*, 13.

53. Snyder, "This Tokyo," in *The Back Country*, 80.

54. Curiously, Snyder did not publish poems explicitly about the failure of his marriage to Joanne Kyger until 1986.

55. Snyder, "Moving the World a Millionth of an Inch," 21–22.

56. Ellen Willis, "Coming Down Again: After the Age of Excess," *Salmagundi* 81 (Winter 1989): 129.

57. Ibid., 135.

58. Snyder, *The Real Work*, 119–120; "Residents Fighting Modern Gold Rush," *Los Angeles Times*, 26 December 1979, I, 30. See also Snyder, "Moving the World a Millionth of an Inch," for an earlier assessment of the Kitkitdizze experience.

59. Gary Snyder, *The Real Work*, 88–89.

60. Ibid., 86.

Chapter 14

1. Snyder, "Moving the World a Millionth of an Inch," 10–11, 23, 24.

2. Duncan, "The Truth and Life of Myth," in *Fictive Certainties*, 35–36.

3. "An Interview with Robert Duncan, Conducted by Jack R. Cohn and Thomas J. O'Donnell," *Contemporary Literature* 21 (1980): 520.

4. Duncan, "On Pound and Williams," transcription of monologue on tape, recorded 22 April 1983, *American Poetry* 6 (1988): 31.

5. Duncan, "A Letter," in *Roots and Branches* (New York: Scribner's, 1964), 17; "An Interview with Robert Duncan, Conducted by Jack R. Cohn and Thomas J. O'Donnell," 517.

6. "Interview with Robert Duncan," *Maps* 6 (1974); Duncan to Robin Blaser, 14 January 1958, in Duncan, "Letters on Poetry and Poetics," *Ironwood* 22 (1983): 118.

7. Thus in his 1965 dispute with Robin Blaser over translations of Gérard de Nerval's *Les Chimères,* Duncan opposed the idea of the poem as a "thing in itself" and urged the view of poems as meanings in process. He continued, "What I experience . . . in my extreme persuasion to the reality of the world created by the written and read word, where the meaning in language has its definitions in the community of meanings from which I derive whatever meanings I can, is at time a feeling that there is no real me, only the process of derivations in which I have my existence" (Duncan, "Returning to *Les Chimères* of Gérard de Nerval," *Audit* 4, no. 3 [1967]: 49).

8. Duncan, Introduction, *Bending the Bow,* iv.

9. Duncan's philosophy of the poetic experience as a connection to the numinous also considered the poet to be a voice of cosmic forces which he or she had touched. To the degree that poets had "statements" to make, their egos interfered with or even screened out genuine connection to the transcendent. As a teacher, Duncan disliked what he called "evaluation" and "appreciation." Poets as readers had to learn how to experience other poets' work as objects. Attention to meaning dissolved the ways rhythm, leading sounds, syntax, and rhetoric created an experience for the reader. See Duncan, "Letters on Poetry and Poetics," 95–133.

10. Duncan to Blaser, in "Letters on Poetry and Poetics," 118.

11. Duncan, "The Truth and Life of Myth," 2.

12. Ibid., 5. Duncan also observed that Schrödinger's thesis that "every electronic event in every molecule is unique, not entirely equivalent to that of others" was essential knowledge for poets. Assuming that all cosmic phenomena existed in analogical correspondence, Duncan inferred that the very uniqueness of symbolic creation referred back to orderly processes that could not be equated with any one manifestation. Therefore, "poetry enacts . . . the order of first things" ("Towards an Open Universe," in *Fictive Certainties,* 78, 81).

13. Duncan, "Ideas of the Meaning of Form," in *Fictive Certainties,* 101.

14. Duncan, "The Truth and Life of Myth," 15, 33.

15. Ibid., 30. Compare Roland Barthes's conception of mythology as contempo-

rary social practice that has been naturalized. Duncan sees myth as those characteristics of human behavior, the expressions of which are historically determined, but the content derives from basic biological drives. See Roland Barthes, *Mythologies* (New York: Hill and Wang, 1972).

16. Duncan, "The Truth and Life of Myth," 41; Robert Duncan, "Preface (1972)," *Caesar's Gate, Poems 1949–50* (San Francisco: Sand Dollar, 1972, first published 1955), xii.

17. Duncan, "The Truth and Life of Myth," 2, 4; Duncan, "The Self in Postmodern Poetry," in *Fictive Certainties*, 230–231. In the latter essay Duncan argued that the constant search for narrative and image pattern made Narcissus the model for the self, but only if one understood that Narcissus was not admiring his reflection but trying to decode it for the clues it revealed to the mystery of his being (p. 223).

18. Duncan, "The Truth and Life of Myth," 7.

19. Ibid., 10, 13. In an interview, Duncan observed, "Where I don't join Eastern philosophy at all, is that I think that everything we see is posited in the material world. So that an archetype doesn't get to be very arche. Instead of looking at an archetype, we'd better look at a tree or a particular individual" ("Interview: Robert Duncan," in Ekbert Faas, *Towards a New American Poetics*, 72).

20. Quotations from *Robert Duncan: Scales of the Marvelous*, ed. Robert J. Bertholf and Ian W. Reid (New York: New Directions, 1979), 109.

21. Duncan, "The Truth and Life of Myth," 17.

22. Mitchell Goodman, a leader of the Mobilization Committee for the march, was married to Duncan's close friend Denise Levertov. Norman Mailer published an extensive account of the march in *The Armies of the Night: History as a Novel, the Novel as History* (New York: New American Library, 1968).

23. Duncan, Introduction, *Bending the Bow*, ii.

24. Carl André Bernstein and Michael Hatlen, "Interview with Robert Duncan," *Sagetrieb* 4 (Fall and Winter 1985): 117–118, 120.

25. Duncan, Introduction, *Bending the Bow*, ii, iii.

26. See Duncan, "The Multiversity," in *Bending the Bow*, 70.

27. Ibid., 71.

28. In August 1944 Duncan published in Dwight MacDonald's journal *Politics* the article "The Homosexual in Society," in which Duncan argued that the distinctions between heterosexuals and homosexuals were superficial. He refused to see homosexuals as either superior or inferior. The difference was important, but only as proof that the body taught homosexuals a truth different than cultural conditioning. However important social construction was for surface behavior, the persistence of homosexuality demonstrated that there did exist layers of experience that defied social

control. After the rise of gay liberation, Duncan continued to question whether the idea of a norm for gay subculture was not antithetical with the foundations of gay experience.

29. Robert Duncan in class, 11 November 1977, audio tape-recording, tape II, side 1, Archive for New Poetry, University of California, San Diego.

30. The two met through correspondence in 1954 when both were contributors to Cid Corman's journal *Origin*. They found their poetry mutually exhilarating and they stayed in close contact over the next fifteen years because each viewed the other as a virtually ideal reader. In 1959 Levertov wrote in her statement as part of Donald A. Allen's anthology *The New American Poetry* that Duncan was one of the two chief poets among her contemporaries (the other was Robert Creeley). In 1973, after their well-publicized break, she affirmed the importance of Duncan's work as a model for her own and observed that his *Passages* series contained some of the best poems she had read about the chaos emanating from social life. See "A Testament," in *The New American Poetry, 1945–1960,* ed. Donald A. Allen (New York: Grove, 1960), 411–412, and "A Testament and a Postscript, 1959–1973," introduction to Levertov's selected essays, *The Poet in the World* (New York: New Directions, 1973), 5.

31. *Robert Duncan: Scales of the Marvelous,* 110. The text of "Advent 1966" runs:

> Because in Vietnam the vision of a Burning Babe
> is multiplied, multiplied,
>
> the flesh on fire
> not Christ's, as Southwell saw it, prefiguring
> the Passion upon the Eve of Christmas,
>
> but wholly human and repeated, repeated,
> infant after infant, their names forgotten,
> their sex unknown in the ashes,
> set alight, flaming but not vanishing,
> not vanishing as his vision but lingering,
>
> cinders upon the earth or living on
> moaning and stinking in hospitals three abed;
>
> because of this my strong sight,
> my clear caressive sight, my poet's sight I was given
> that it might stir me to song,
> is blurred.
>
> There is a cataract filming over
> my inner eyes. Or else a monstrous insect
> has entered my head, and looks out
> from my sockets with multiple vision,

seeing not the unique Holy Infant
burning sublimely, an imagination of redemption,
furnace in which souls are wrought into new life,
but, as off a beltline, more, more senseless figures aflame.

And this insect (who is not there—
it is my own eyes do my seeing, the insect
is not there, what I see is there)
will not permit me to look elsewhere,

or if I look, to see except dulled and unfocused
the delicate, firm, whole flesh of the still unburned.
(Levertov, *Poems 1968–1972* [New York: New Directions, 1987], 124)

32. Levertov, "An Interim," in *Poems 1968–1972*, 20, 26.

33. Levertov, "A Testament and a Postscript, 1959–1973," introduction to *The Poet in the World*, 5–6.

34. Levertov, "The Untaught Teacher," in *The Poet in the World*, 195–196.

35. See Levertov, *The Poet in the World*, 141, 195, on the voluntary nature of revolutionary struggle.

36. Duncan, "The Truth and Life of Myth," 19.

37. Duncan, "Dante Études: The Household," in *Ground Work: Before the War* (New York: New Directions, 1984), 110–111.

38. "Part of the aftereffect of both the German/Hitlerian thing and my own family preaching 'the will to power' to us when we were little made me feel whenever anyone mentioned power that I practically wanted to wind down so that you couldn't even run a tinker-toy with it. I was not interested in some center that would form, make a dynamo . . . I wanted no rhetoric but rather a launching out" (Duncan, "On Pound and Williams," 34).

39. Duncan, "Then Many a One Sang," in *Ground Work: Before the War*, 129.

40. Levertov, "Entr'acte," in *Poems 1968–1972*, 149.

41. Levertov, "Looking for the Devil Poems," in *Poems 1968–1972*, 165.

42. Levertov, "Glimpses of Vietnamese Life," in *The Poet in the World*, 145.

43. Levertov's Vietnam War poetry has been the subject of much critical debate. On the one hand, see William Aiken, "Denise Levertov, Robert Duncan, and Allen Ginsberg: Modes of the Self in Projective Poetry," *Modern Poetry Studies* 10 (1981): 200–245; Charles Altieri, *Enlarging the Temple: New Directions in American Poetry During the 1960s* (Lewisburg: Bucknell University Press, 1979); Paul Breslin, *From Modern to Contemporary* (Chicago: University of Chicago Press, 1984); James F. Mersmann, *Out of the Vietnam Vortex: A Study of Poets and Poetry Against the War* (Lawrence: University Press of Kansas, 1974); and Peter Middleton, *Revelation and*

Revolution in the Poetry of Denise Levertov (London: Binnacle Press, 1981). These critics have prepared particularly strong arguments that Levertov failed to bridge the gap between imagination and experience in her antiwar poetry, which became increasingly exhortatory as the war progressed. On the other hand, see Kerry Driscoll, "A Sense of Unremitting Emergency: Politics in the Early Work of Denise Levertov," *Centennial Review* 30 (1986): 292–303; Sandra M. Gilbert, "Revolutionary Love: Denise Levertov and the Poetics of Politics," *Parnassus: Poetry in Review* 12 (1985): 335–351; Paul A. Lacey, *The Inner War: Forms and Themes in Recent American Poetry* (Philadelphia: Fortress, 1972); and Lorrie Smith, "Songs of Experience: Denise Levertov's Political Poetry," *Contemporary Literature* 27 (1986): 213–232. These critics have made equally strong arguments that Levertov's antiwar poetry reflects an imagination focused on the problem of the war from the particular perspective of a woman. Excluded from the exercise of power or the processes of political deliberation, Levertov's poetic imagination took her into the hell of her own imagination to emerge from a sentimentalized "womanly love" to the necessity of power if the vision of love and joy peculiar to women is to find realization (Gilbert, p. 349).

44. Levertov wrote approvingly of Snyder's politics as a form of connection. See "Only Connect," in *Poems 1968–1972*, 209.

45. See Duncan, "The Multiversity," 72.

46. Duncan, "The Fire: *Passages* 13," in *Bending the Bow*, 42, 43.

47. Duncan, "Earth's Winter Song," in *Bending the Bow*, 93.

48. Ibid., 93, 94.

49. "At Easter, my sister, who was a year younger than I, and I were given a duckling and a little baby rabbit each. The ducklings we petted to death ourselves. There is a little lesson in the spirit of romance, isn't it? I mean, when I first started to have sexual affairs I think I petted a number of people to death (Virginia Wallace-Whitaker, "Robert Duncan on 'My Mother Would Be a Falconress,'" transcription of extemporaneous lecture Duncan delivered at the University of Maine in March 1983, *Sagetrieb* 4 [Fall and Winter 1985]: 199).

50. Duncan, "A Lammas Tiding," in *Bending the Bow*, 51.

51. "An Interview with Robert Duncan, Conducted by Jack R. Cohn and Thomas J. O'Donnell," 525.

52. Duncan to Jonathan Williams, 11 December 1971, correspondence files, Jonathan Williams papers, Poetry/Rare Books Collection, University Libraries, State University of New York, Buffalo.

53. The primary title signifies work in the ground of being, that is in the myths that emerge through the exploration of language. Ground work was the fundamental examination of the types of connections between people caught in the flux of human

desire and institutional mystiques. Duncan explained the second half of the title when he told one interviewer that those who have gained "the ability to respond" stand "before the war," the preposition having a spatial rather than temporal sense (Andrew Schelling, "Of Maps, Castelli, Warplanes, & Divers Other Things That Come 'Before the War,'" *Jimmy & Lucy's House of "K"* 3 [1985]: 44). The second volume, *Ground Work: Into the Dark*, appeared in 1988, literally days before Duncan's death.

54. Duncan, "Structure of Rime XXVII," in *Ground Work: Before the War*, 55.

55. Duncan, from "Santa Cruz Propositions," in *Ground Work: Before the War*, 36–37, 38.

56. Duncan, "In Truth Doth She Breathe Out Posionous Fumes," in *Ground Work: Before the War*, 128.

57. Duncan's use of gender in relation to Eros generally follows the lines he set in "The Household" (*Ground Work: Before the War*, 110):

> Let us call each voice, his or hers,
> "He" that leads in the rehearsal,
> and "She", the Matrix or Praxis
> the potentiality of Music

Eros in male form appears to have to do with design and innovation, while in female form with execution and tradition.

58. Duncan, "Then Many a One Sang," in *Ground Work: Before the War*, 129.

59. Duncan, "Santa Cruz Propositions," 39.

60. Duncan, "The Missionaries," in *Ground Work: Before the War*, 135.

61. Duncan, "Santa Cruz Propositions," 40–41.

62. Ibid., 45.

63. Levertov, "Life at War," in *Poems 1968–1972*, 122.

64. Duncan interviewed by James F. Mersmann, 9 May 1969, quoted in Mersmann, *Out of the Vietnam Vortex: A Study of Poets and Poetry Against the War* (Lawrence: University Press of Kansas, 1974), 94.

65. Duncan, "Preface (1972)," *Caesar's Gate*, xiii.

66. Ibid., xxxii.

67. Levertov, "Looking for the Devil Poems," in *Poems 1968–1972*, 165.

68. Duncan, "Santa Cruz Propositions," 46.

69. Bernstein and Hatlen, "Interview with Robert Duncan," 131, 132–133, 134.

70. Levertov, "Report," in *Poems 1968–1972*, 188.

71. Levertov to Kenneth Rexroth, 29 May 1965, correspondence files, Rexroth papers, DSC.

72. Levertov, "Report," 190.

73. Eros was also the source of poetry. In his "A Poem Beginning with a Line by

Pindar," Duncan recounted the fable of Eros and Psyche as a mythic enchantment that redefined Eros as a desire to express the ineffable in words. By completing the labors imposed on her by Venus, Psyche finally was reunited with Eros, an allegory for the role of poetry in giving form to the diffuse components of the self. In Duncan, *The Opening of the Field* (New York: New Directions, 1960), 62–69.

74. Duncan, "Man's Fulfillment in Order and Strife," 112–113, 135–138.

75. Duncan, "The Truth and Life of Myth," 41–44.

76. Ibid., 32.

77. Duncan, "Bring It Up From the Dark," in *Ground Work: Before the War*, 53.

78. Duncan, "Dante Études," in *Ground Work: Before the War*, 94.

79. Duncan, "The Household," in *Ground Work: Before the War*, 110. At the same time, Duncan did not try to obscure that the choice of a partner and the responsibilities of establishing a household (or a profession) involved the repression of possibilities, which continued to express themselves through desires over which he had no control. "I have many, many rueful reflections upon domestication as repression, as loss of—denial of—" he confessed in one interview (Steve Abbot and Aaron Shurin, "Interview/Workshop with Robert Duncan," *Soup* no. 1 [1980]: 30). The household and the community coexist with the fantasies of other selves and the possibility of leaving despite the pain it might cause, for without the option of annihilating one's allegiances, the individual choice upon which Duncan's view of social relations rests disappears.

80. Duncan, "Circulations of the Song," in *Ground Work: Before the War*, 167.

81. See Ekbert Faas, *Young Robert Duncan: Portrait of the Poet as Homosexual in Society* (Santa Barbara: Black Sparrow Press, 1983), 31–44, for an account of Duncan's linked self-discovery as poet and as homosexual.

82. Duncan, "Circulations of the Song," 173.

83. Ibid., 171.

84. Ibid.

85. Ibid., 172.

86. Ibid., 175.

87. Duncan, "The Truth and Life of Myth," 58.

88. See Duncan, "Man's Fulfillment in Order and Strife," 112–113; "Self and Postmodern Poetry," in *Fictive Certainties*.

Chapter 15

1. From Stuart Perkoff, "Yod," in *Alphabet* (Los Angeles: Red Hill Press, 1973); quote from author's ms. in Wallace Berman papers, AAA.

2. See Jürgen Habermas, *Toward a Rational Society* (Boston: Beacon Press, 1970), 91.

3. Ibid., 93.

4. The differences between the individuals and movements involved in the turn to irrationality were great, but existentialism provided a common link. A focus on the finitude of human life encouraged seeing each person as a unique occurrence, the meaning of which was best found through narration. On the Umbra poets, see Michel Oren, "The Umbra Poets' Workshop, 1962–1965: Some Socio-Literary Puzzles," in *Studies in Black American Literature,* vol. 2, *Belief vs. Theory in Black American Literary Criticism,* ed. Joe Weixlmann and Chester J. Fontenot (Greenwood, Florida: Penkevill Publishing Company). On the Aquarian movement, see Alfred Ligon, "All the Lights the Light," interviewed 1982 by Ranford B. Hopkins, OHP/UCLA.

5. Hannah Arendt argued that the European concept of political freedom arose from a theological suspicion and hostility toward the public realm as such. While recognizing that the avant-garde of the twentieth century was not a Christian movement, she thought it called upon traditions in the Christian church going back to the last centuries of the Roman empire. See Arendt, *Between Past and Future: Eight Exercises in Political Thought* (New York: Viking Press, 1968), 150ff.

6. Ben J. Wattenberg, *The Real America: A Surprising Examination of the State of the Union* (New York: Capricorn Books, 1976), 158–160, 218–219, 223. The influence of the post–World War II avant-garde on the young people who constituted the New Left and the counterculture is a topic beyond the scope of this study. Daniel Yankelovich's public opinion surveys; Robert Kenniston's psychological tests of young people in Cambridge, Massachusetts; and Robert Wuthnow's survey of students at the University of California, Berkeley, provide rough glimpses of how attitudes in different age cohort and ideological groups shifted between 1965 and 1975. See Kenneth Kenniston, *The Young Radicals* (Cambridge: Harvard University Press, 1968) and *The Uncommitted* (Cambridge: Harvard University Press, 1969); Daniel Yankelovich, *Generations Apart: A Study of the Generation Gap* (Columbia Broadcasting System, 1969), *Youth and the Establishment* (Daniel Yankelovich, Inc., 1971), *Changing Youth Values in the 70s: A Study of American Youth* (Daniel Yankelovich, Inc., 1974), *The New Morality: A Profile of American Youth in the 70s* (New York: McGraw-Hill, 1974), and *New Rules: Searching for Self-Fulfillment in a World Turned Upside Down* (New York: Random House, 1981); and Robert Wuthnow, *The Consciousness Reformation* (Berkeley: University of California Press, 1976). See also *Youth in Turmoil: Adapted from a Special Issue of Fortune* (New York: Time-Life Books, 1969). Opinion polls are difficult to compare with other forms of subjective evidence. Responses to questionnaires fail to show how different people actually incorporated the opinions

they stated into their personal meaning system, as can more open-ended interviews that uncover the choice of words and narrative strategies, the images by which concerns and values take on symbolic form. The study of Ronald Fraser et al. on student activism in five countries provides some insight, but with insufficient detail to the narrative structures that are the evidence of the uses of such material. See *1968: A Student Generation in Revolt, an International Oral History,* ed. Ronald Fraser (New York: Pantheon, 1988). Luisa Passerini's *Autoritratto di gruppo* (Firenze: Giunto Barbèra, 1988) provides a model for studying the subjective response of student activists of the 1960s. Her subjects were Italian, and the United States situation differed from the European in terms of the pervasive, if often contested influence of beat and countercultural values within the New Left.

7. On segments supporting abortion see *Youth in Turmoil,* chapter 2 and following charts; Yankelovich, *Changing Youth Values in the 70s,* tables 5 and 6; and Yankelovich, *New Rules.*

8. Arbitron weekly reports on television and radio audiences show that between 1963 and 1967 the prime audience for radio was the 18-to-34 age group, while the prime audience for television was the 35-to-49 age group. In 1967 a shift began and the prime audience for television became younger, so that by 1973 target audiences for advertisers looking at television and radio were the same age group. Radio remained, however, a much more highly segmented market, with programs aimed at groups with specific tastes, while television programmers were more tentative in developing shows targeted at specific segments of the television viewing audience. The influence of age and social distinctions on cultural product was most dramatically revealed in motion picture distribution. Between 1965 and 1975, 76 percent of motion picture tickets were bought by people under the age of thirty. Sixteen-to-twenty-nine-year-olds purchased 61 percent of motion picture admissions but made up 31 percent of the United States population. Of that group of ticket purchasers, 80 percent were or had been college students. Only 40 percent of the total population in that age group were college students or alumni. See Edd Whetmore, *Media America* (Englewood Cliffs: Prentice-Hall, 1978), 229–231.

9. See *Youth in Turmoil,* 7.

10. "Voters, Non Voters Alike Held Disaffected, Not Disillusioned," *New York Times,* 20 November 1979, 1.

11. Gary Snyder, "Japan First Time Around," in *Earth House Hold,* 39.

12. Snyder, "The Etiquette of Freedom," in *The Practice of the Wild,* 5.

13. Snyder, *The Real Work,* 99.

14. Snyder, "Lookout's Journal," in *Earth House Hold,* 19.

15. Leonard Wolf, ed., *Voices from the Love Generation,* 243.

Index

Berman, Wallace (*continued*)
281, 284–287, 290, 294–295; public recognition, 212–213, 276, 287; self-representation, 294–295; social values in work, 224, 270–274, 276–290, 293–295; Verifax collages, 283–290, 294
Bernhardt, John, 382
Berns, Walter, 314–315
Bischoff, Elmer, 87–88, 92, 95, 110, 129, 132, 162; on San Francisco–based abstract expressionism, 115–116; on Clyfford Still, 103; as teacher, 182–183
Black Mountain poets, 444–445
Blum, Irving, 191, 287, 494n3, 502n9
Bly, Robert, 445
Boehme, Jakob, 58–61, 223, 290, 471n53, 496n18
Bothwell, Dorr, 92
Brakhage, Stan, 214, 253–255, 264, 342–344
Brand, Stewart, 389
Breton, André, 13, 53
Brigante, Nicholas, 4
Briggs, Ernest, 102
Brittin, Charles, 216, 226, 230
Brown, Joan, 107, 169–188, 191, 200, 208, 214, 253, 277, 290; and feminism, 186–187, 491n29; narrative motifs in interviews, 181–187; parents' status anxiety, 179–180; on rebellion, 183; search for autonomy, 173–175, 177–179; subject matter, 176; work, 173, 176, 185–186, 187
Brown, William H., 171, 182, 183–184
Bruce, Lenny, 274
Buddhism, 48, 262–264, 290, 373–376, 378–384, 387, 396, 408, 451–452
Burroughs, William, 238

Cage, John, 444
Cahill, William V., 6
California College of Arts and Crafts, 68, 84, 191
California Palace of the Legion of Honor, 92
California School of Fine Arts, 8, 78, 84–90, 92–98, 100–101, 125–132, 135–137, 160, 161, 173, 177, 180–184, 195, 198, 200, 406; abstract expressionism, response to, 96–98; conflict over direction of school, 125–132, 135; contrast with Bauhaus approach to

training, 93–94; courses and pedagogical philosophy, 93–95, 101, 182–183; effects of GI Bill on, 93, 95, 119–120, 125–132, 135, 136–137, 474n23; faculty, 92–93, 101–101
Cameron, 214, 227, 246, 257–258
Campbell, Joseph, 379–380
Camus, Albert, 310
Capital punishment, 297, 309–310, 319–320, 506n7
Cassady, Neal, 150–151, 153, 167
Catholic church, 315, 341, 505n21
Censorship, 303–305, 308–313, 342, 348; and consumer capitalism, 355; and psychoanalytic theories of development, 314–315; and religion, 314–316
Chessman, Caryl, 309, 319–320, 506n5
Choice, 315, 344, 349, 444
Chouinard Art Institute, 8, 85, 222, 305, 309, 351
Civil rights and black power movements, 274–276, 319
Clements, Grace, 10
Cold war, 270–271, 407; and arts communities, 63–66; effects on young men, 149, 154–155
Communist party, 32, 34–35, 65
Conant, James B., 133
Conformity, 141, 152, 154–156, 157–158, 321
Conner, Bruce, 168–169, 198, 202–205, 214, 269
Connolly, Cyril, 55
Consciousness raising, 167
Cook, Gordon, 119, 171, 176
Cool, 215, 246–247
Cooper, Tony, 213, 287
Coplans, John, 231, 271
Copley, William, 26
Corbett, Edward, 92
Counterculture, 66, 370–371, 374–376, 400–402, 432; dilemma of aesthetic avant-garde, 392; and hippies, 378, 389; mythic role of United States society, 433–434; and popular culture, 446–450, 452–457
Craft values, 29, 379, 381–383, 385–386, 391–392, 396–399
Creative process: as access to cosmos,

139–140, 160, 302, 321, 331–332, 367, 380, 432; and anarchism, 52–54, 56; on autochthonous poetry, 47–48, 55–56; avantgarde, critique of European, 40, 46–47, 48, 55; and Buddhism, 48; and Christianity, 32, 39, 42–43, 49; and Communist party, 32, 34–35, 466n2, 471n46; on creative process, 37, 40, 43–44, 367; on "disengagement," 63, 321; "The Dragon and the Unicorn," 57, 469n33; and environmentalism, 48–49; and Federal Writers Project, 32, 34, 36, 467n5, 467n9; *In Defense of the Earth*, 49; journalist, work as, 57–58; "Letter from America," 53–54, 56; marital life, 45, 56–57; *The New British Poets*, 46–47; and pacifism, 35–36, 39–40, 42, 52, 63; "The Phoenix and the Tortoise," 36, 37–46, 48, 51, 58, 60, 63, 302, 367, 471n53; as promoter, 51–52, 54–57, 139–140; prosody, 60–61; self-representation, 36, 56–58, 60–63, 100, 367; short lyrics, 34–35, 36, 44–45, 56; *The Signature of Things*, 58–60; as viewed by peers, 36, 46, 51, 54–57, 107, 467n10

Rhythm and blues, 156

Rose, Stanley, 50

Rosenberg, Harold, 97, 100, 503n19

Rothko, Mark, 118

Rukeyser, Muriel, 51

Russell, Morgan, 6

Russell, Sanders, 51

San Francisco Art Association, 76, 90, 116, 196

San Francisco Art Institute. *See* California School of Fine Arts

San Francisco Mime Troupe, 201

San Francisco Museum of Art, 10, 50, 84, 90, 92, 96, 99, 115, 116, 177, 202–203, 359–360; Festival of Modern Poetry, 50

San Francisco Museum of Modern Art. *See* San Francisco Museum of Art

San Francisco Poetry Center, 56, 139–140, 342

San Francisco poetry renaissance, 50–52, 54–57, 139–140, 160

San Francisco Police Department, 338, 342

Santayana, George, 15

Savage, Derek, 47

Schevill, James, 342

Scheyer, Galka, 8

Schorske, Carl, xx

Seigel, Jerrold, xx

Seldis, Henry, 310, 312, 313, 354

Semina, 192, 212, 226, 227, 231–253, 257–260, 270–274, 277–283; contents, 236–240; on drugs, 243–252; form, 232–236; as locus of imaginary community, 240–242; on social issues, 270–274, 277–283

Servicemen's Readjustment Act of 1944. *See* GI Bill of Rights

Sexuality: standards for public discourse on, 303, 313–317, 337, 348–349, 356, 396, 430, 435–436, 447–448

Sherwood, Richard E., 310–312

Shore, Henrietta, xvii

Sinton, Nell, 131, 184

Six Gallery, 160, 162–164, 194

Smith, Hassel, 92, 94, 99–100, 104–108, 110, 113–115, 125, 129, 236, 481n67; on abstract expressionism, 107–108, 114–115; and Marxism, 106–107, 478n26, 478n32; paintings, 98, 104–107; relationship to poets, 107; as teacher, 94, 107, 113–114

Snyder, Gary, 52, 160, 164, 290, 357, 361, 370–402, 404, 408, 421, 432, 455; and Buddhism, 373–376, 378–384, 387, 396, 408, 451–452; and craft values, 379, 381–383, 385–386, 391–392, 396–399; and drugs, 378, 400; *Earth House Hold*, 388–389; and environmentalism, 377–378, 381, 388–392, 397–398; and family, 377, 378, 385, 386, 388, 393–395, 516n37; on female archetypes, 384, 386–387; "Four Changes," 389–392, 517n43; on global civilization, 376–378, 388–392, 453; and hippies, 378, 389, 400–402; in Japan, 375–377; and Jack Kerouac, 374–376; on Native American cultures, 373, 376, 378, 381, 383–384, 388; poetry, 372–373, 377, 383–385, 387, 391, 393–394; political thinking and development, 373–374, 376–378, 380–381, 388–393, 396, 398, 451–453; and tribalism, 378–379, 381, 386, 388–392, 396–399, 453; on United States history, 372–373, 381, 385, 388–389, 398; and Vietnam War, 378, 390

Designer:	Sandy Drooker
Compositor:	G & S Typesetters, Inc.
Text:	10/16 Stempel Garamond
Display:	Futura
Printer:	Edwards Brothers, Inc.
Binder:	Edwards Brothers, Inc.